Catalogue Raisonne
Tamarind Lithography Workshop, Inc.
1960–1970

RELEASE

University of New Mexico Art Museum

ISBN 0-944282-08-3

Introduction

Tamarind Lithography Workshop, Inc. was founded in Los Angeles in 1960, under the leadership of June Wayne and with the support of a grant from the Ford Foundation's Program in Humanities and the Arts. At that time, lithography as an artistic medium was in considerable difficulty. Few artists were making lithographs, in part because even fewer printers were available to work with them in the production of fine art prints. Offset lithography had so overwhelmed the traditional stone-based technology that commercial print shops were jettisoning their irreplacable limestone slabs from Bavaria, upon which artists hugely depended.

TLW had multiple goals: to reinterest artists in the expressive potential of lithography; to train master printers in the sensitive collaboration necessary to work with artists; to demonstrate the economic viability of fine art lithography (and insure that the extant lithographic stones were preserved); and—not least—to create a body of the highest quality lithographs.

Tamarind's success has been confirmed in numerous ways. During the 1960s and 1970s, new print workshops, staffed by Tamarind-trained master printers, originated in Los Angeles, New York, Chicago and other art centers in the United States. Whereas in the 1940s and 1950s relatively few artists made lithographs, and prints in all mediums were in the doldrums, the years since the mid-1960s have seen almost all major artists in this country working in the medium and have seen, as well, a boom in the market for contemporary lithographs.

Tamarind moved from Los Angeles to Albuquerque in 1970 and became a division of the College of Fine Arts at the University of New Mexico under a new name—Tamarind Institute. Clinton Adams and Garo Antreasian, both of whom were essential to TLW's early development, were at this time dean of the College of Fine Arts and professor of art at UNM, respectively, and both were again essential to the development of Tamarind in Albuquerque. Adams, as the Institute's director from 1970 to 1985, continued to promote the importance of Tamarind in the world of lithography. Under new leadership, Tamarind not only continues its original mission but also has broadened its programs to include numerous international projects involving artists, students, and teachers from Mexico, the Soviet Union, Japan and many other countries.

Since 1970, the University Art Museum of the University of New Mexico has served as the archival repository for lithographs produced both in Los Angeles and Albuquerque—a total of more than 5,000 prints. These impressions are available for study in the Print and Photography room at the University of New Mexico Art Museum.

This catalogue follows closely the design of a previously issued catalogue of the lithographs produced at Tamarind in New Mexico between 1970 and 1979. Here is presented documentary information on all of the 3,081 prints made between July 1960 and June 1970 at TLW in Los Angeles. A major advance in utility of the catalogue is that all prints contained in the University Art Museum collection are illustrated. (When Tamarind transferred its Los Angeles prints to the University Art Museum, a relative handful of prints were not included; therefore, these prints are not illustrated in this catalogue. Full documentary information on them is listed.)

Major funding for this catalogue was provided by the National Endowment for the Arts, the Office of the Vice President for Research at the University of New Mexico, and the University of New Mexico Foundation, Inc. Many people, on the staffs of Tamarind Institute and the University Art Museum and otherwise, worked to produce this catalogue; a partial listing of their names occurs elsewhere. To all, our profound thanks.

Marjorie Devon, Director
Tamarind Institute

Peter Walch, Director
University Art Museum
Albuquerque, April, 1989

Notes/Definitions/Abbreviations

Sequence

Entries are in alphabetical order by artist. Within each artist's listing, suites appear first and list the Tamarind number in correct sequence. All prints follow in numerical order based on Tamarind number.

Tamarind Number

Each edition is identified by a Tamarind number which is written in pencil on each impression (verso, and rare instances recto), adjacent to the Tamarind chop or blindstamp. The consecutive numbering system is a chronological sequence in which the lithographs are created, beginning with 101 in 1960 and ending with 2946 in 1970. Missing numbers refer to lithographs initiated and then abandoned, usually for technical reasons. Editions with designations I, II, III, or A, B, C, refer to different states of a given image. The visual differences between related images, but not so designated, are described in the notes of the appropriate catalogue entry. In some cases, images printed from the same printing element(s) on one sheet of paper and torn after printing into separate lithographs, are also designated A, B, C, etc. These entries do not have state description.

Titles

Titles are in italic. *Untitled* indicates that at the time the documentation was completed, the artist had not assigned a title to the work.

Dates

Dates refer to the printing of the edition and do not necessarily indicate the date the image was first conceived nor as to when the completed lithograph was released from the workshop.

Colors

Colors are listed in order of printing. When more than one color is printed on a single press-run the listing is as follows:

When separated by commas, the colors are inked individually with separate rollers and printed simultaneously. As example, Red, blue, yellow (A).

When B precedes a listing, the colors are inked with one roller in blended bands. As example, B: Red, blue, yellow (A).

Colors refer to those used in printing and do not correspond in every instance to the exact visual appearance of the lithograph. For example, a lithograph printed in yellow and blue which overlap, the visual appearance may be yellow, blue and green.

Variant colors, as in color trial proofs, are not given in this catalogue but are included in edition documentation.

Dimensions

Dimensions are in centimeters, height preceding width. Unless otherwise indicated, dimensions are those of the paper, measured at its greatest height and width. Because of irregularities in handmade and moldmade papers, dimensions may vary slightly from impression to impression. Unless otherwise indicated, all papers have torn and deckle edges. When paper of varying size is used in printing of proofs or impressions, sizes are noted.

Edition

This catalogue is a complete record of all existing proofs and impressions. When in rare instances an unrecorded number of rough proofs exist, this information is noted. The abbreviations used for various print designations are given and defined below. Types of paper are given in parentheses with each designation. See abbreviations below.

Printer

The printer responsible for the printing of the edition is listed. Where two or more printers share responsibility, they are both listed with notes which explain the responsibility of each. The printer may have collaborated with the artist, or in some cases, the second printer may have earned the printer's proof II as the collaborator. Lithographs printed under the supervision of Garo Antreasian at the University of New Mexico do not bear the chop of the printer-trainee, but only that of the University of New Mexico. The printer-trainee responsible for printing the edition is noted in the catalogue.

Identifying Marks

The notation of all identifying marks including signatures, designations, titles and dates, unless otherwise indicated, are written by the artist in pencil on the recto of the lithograph. They are listed in the order they appear on the print reading from left to right, including the blindstamp (a symbol embossed on the paper) or wetstamp (a symbol in ink on the paper applied with a rubber stamp) of the Tamarind Lithography Workshop, of the printer, and in some cases, of the artist. In most instances, the Tamarind and printer's chops both appear next to each other and the notation only specifies Blindstamp or Wetstamp.

Documentation

Complete and detailed records signed by both artist and printer are maintained at Tamarind Institute, University of New Mexico, Albuquerque. All information is derived from the original records of Tamarind Lithography Workshop, the impressions in their collection, or from correspondence with the artists.

Designations of Proofs and Impressions

Ed The artist's arabic numbered edition, 1/20, 2/20, 3/20–20/20. The bottom number indicates the limited size of the edition; the top number indicates the sequence in which they are signed.

HS The *hors* series are additional artist's impressions which are not a part of the numbered edition.

TI Nine Tamarind impressions are printed as a part of each edition with the exception of experimental editions. These impressions are not numbered, but are designated "Tamarind Impression" (Tam Imp, TI, etc.). The impressions were either sold on a subscription basis or retained for exhibition or study purposes by Tamarind Lithography Workshop.

UNMI One University of New Mexico Impression exists for each edition printed at the University of New Mexico as part of the Tamarind printer-training program and is part of the collection of the University of New Mexico Art Museum.

BAT The *bon à tirer* is the impression pulled during proofing which is signed and designated by the artist and serves as the standard of quality against which each impression is compared. In 1964, this term *bon à tirer* came into usage and subsequently replaced the use of the term printer's proof. It is the property of the printer responsible for printing the edition.

PrP The printer's proof is the term used between the years 1960 and 1965 for *bon à tirer*.

PrP II A printer's proof is pulled when more than one printer participates to a substantial extent in the printing or proofing of an edition. Between November, 1964 and 1970, the definition is limited to a proof for those in supervision of an entire project such as a suite or a *livre de luxe,* where the *bon à tirer* is the property of the printer in charge of the entire project and another printer prints an individual lithograph in the series.

AP An artist's proof is an impression of a quality and character essentially comparable to impressions included within the numbered edition, and is the property of the artist.

PP A presentation proof is similar to an artist's proof but is usually inscribed by the artist to a friend or collaborator and is the property of the recipient.

TP A trial proof is by definition an impression printed prior to the printing of the *bon à tirer.* Trial proofs may differ from the numbered edition if they are printed before corrections in the stone or plate. It is Tamarind practice to designate as trial proofs only impressions printed in black or in colors identical to those used in the edition. The trial proof is the property of the artist.

CTP A color trial proof is a trial proof that differs from the edition in the color of the inks that are used.

CStP A color separation proof is printed in color from a single stone or plate of a multi-color lithograph, and is the property of the artist.

PgP A series of progressive proofs is sometimes printed to record the development of a color lithograph. A set of progressive proofs for a four-color lithograph includes the following: Stone A, B, A + B, C, A + B + C, D.

PTP Paper trial proofs are those impressions pulled to test the properities of various types of paper.

ExP An experimental proof is the result of an aesthetic or technical experiment from which only a few proofs exist. When possible, an edition of eleven is pulled, five for the artist (Proofs A, C, E, G, I), five for Tamarind (Proofs B, D, F, H, J), and one for the printer (printer's experimental proof).

CPgP A color progressive proof is usually one of several proofs printed from more than one printing element of a multicolor lithograph to show the progressive sequence of the printing.

State proofs are impressions that differ markedly from the numbered edition; they sometimes come into being when an image is modified in preparation of the printing of a second, variant edition.

FSP First state proofs are those impressions pulled prior to the *bon à tirer* which show the first state of development of the image.

SSP Second state proofs are those impressions pulled prior to the *bon à tirer* which show the second state of the development of the image.

wp A working proof is a rough proof pulled during proofing.

CP A cancellation proof is an impression pulled after the stone or plate has been altered so as partially to destroy the image. A cancellation proof is not always pulled for an edition even though all printing elements have been effaced.

***** An asterisk indicates that a proof differs from the artist's edition in color and/or in image.

nr This indicates information that is not fully recorded.

blurb re: missing photos (those not illustrated are not part of Tamarind Archive Collection)

Printing Elements

A	Aluminum
S	Stone
Z	Zinc
O	Onyx

Inking Variations

B	Blended inking
M	Marbled inking

Identifying Marks

BS	Blindstamp
WS	Wetstamp
S	Signature
I	Initials
T	Title
D	Designation (Tamarind Impression, Artist's Proof)
Dat	Date
Tam	Tamarind chop
UNM	University of New Mexico chop
pr	Printer's chop
NC	No chop
H	Horizontal
V	Vertical

Paper

A	Arches		JT	Japanese Troya
AEP	American Etching paper		JY	Japanese Yamato
bA	buff Arches		J 48	Japanese 48
bkA	black Arches		dLM	de Laga Mandeur
wA	white Arches		dLN	de Laga Narcisse
BG	Barcham Green		3–M	3–M paper
C	Copperplate		MI	Magnani Italia
CD	Copperplate Deluxe		N	Nacre
cream CD	cream Copperplate Deluxe		nN	natural Nacre
CW	Crisbrook Waterleaf		wN	white Nacre
EVB	Energy Vellum Bristol		R	Rives
F	Fabriano		BFK	Rives BFK
GEP	German Etching Paper		BFK III	Rives BFK Type III
G	Goya		BFK IV	Rives BFK Type IV
H	Hanshito		BFK V	Rives BFK Type V
nHP	natural Hosho Pure		bR	buff Rives
wHP	white Hosho Pure		cR	calendered Rives
Ig	Iyo glazed		ucR	uncalendered Rives
JG	J. Green		light-weight R	lightweight Rives
J	Japanese		TR	Test Rives
JA	Japanese Asagi		SW	Saunders Waterleaf
JC	Japanese Catermole		Scs	Strathmore cover stock
JS	Japanese Shirakawa		Tcs	Ticonderoga cover stock
			W	Weimar paper

Definition of Chops: 1960–1970

 The Tamarind Chop (the alchemist's symbol for stone) appears on all lithographs pulled at Tamarind during its decade in Los Angeles.

 University of New Mexico. This chop is used alone or in conjunction with the Tamarind Chop on many lithographs pulled at the University of New Mexico in the Tamarind program conducted there between 1960 and 1970.

 June Wayne, artist and founder/director of the Tamarind Lithography Workshop, has used this mushroom symbol as her chop since 1950. It appears on all of her prints and drawings.

Due to the subtlety of Billy Al Bengston's images, he chose to initial and number his lithographs on the recto in pencil the same color as the images. The artist also designed rubber stamps for the designations "trial proof," "artist proof," and "Tamarind Impression." These were wet-stamped on the verso of the appropriate impressions in lieu of handwritten designations. After the completion of the artist's grant, the three rubber stamps were destroyed.

When a Tamarind printer-fellow demonstrates that he is able to print an edition of professional calibre, he designs his own chop which, from then on, appears on those editions for which he is responsible. Printer-fellows who complete the full printer training program are certified s, indicating they have the skill to collaborate with artists of every esthetic. Each Tamarind lithograph printed between 1960 and 1970 bears the chop of one of the following printers:

 Kinji Akagawa, printer-fellow from January 1965–July 1966.

 Frank Akers, printer-fellow from September 1967–September 1968.

 Garo Antreasian, artist, Tamarind MasterPrinter, Tamarind Technical Director from July 1960–July 1961, Technical Consultant to Tamarind from 1961–1970, Co-Director of the Tamarind Institute, University of New Mexico, Albuqueruqe, 1970–1972.

 John Beckley, printer-fellow from June-September 1965.

 Frank Berkenkotter, printer-fellow from June-August 1964.

 Robert Bigelow, printer-fellow from February-September 1966.

 Bernard Bleha, printer-fellow from September 1964–September 1965.

 John Butke, printer-fellow from September 1966–September 1967.

 Wesley Chamberlin, printer fellow from January-May 1962.

 Paul Clinton, printer-fellow from February 1969–March 1970.

 Ernest de Soto, printer-fellow from March 1965–December 1966.

 John Dowell, Jr., printer-fellow from February 1963–August 1964.

 Kaye Dyal, printer-fellow from August–November 1964.

 Erwin Erickson, printer-fellow from February–September 1966.

 Robert Evermon, printer-fellow from May 1965–December 1966. Tamarind research-fellow from January 1967–April 1968.

Jurgen Fischer, printer-fellow from April 1965–July 1966.

David Folkman, printer-fellow from February 1967–July 1968.

Manuel Fuentes, printer-fellow from September 1967–April 1969.

Joe Funk, printer-fellow from July 1960–June 1961.

Walter Gabrielson, printer-fellow from October 1964–March 1966.

Robert Gardner, printer-fellow from June-September 1962, August 1963–September 1964.

Fred Genis, printer-fellow from December 1966–July 1967.

Ronald Glassman, printer-fellow from September 1968–July 1969.

Edward Hamilton, printer-fellow from March 1969–June 1970.

Irwin Hollander, printer-fellow from September 1961–June 1963, Tamarind Technical Director from July 1963–August 1964.

Bohuslav Horak, printer-fellow from November 1960–July 1961, Tamarind Technical Director from July 1961–August 1963.

Edward Hughes, printer-fellow from September–December 1967, March–August 1968.

Harold Emerson Keeler, printer-fellow from August 1961–February 1962.

Donald Kelley, printer-fellow from September 1966–January 1968, September 1968–June 1969.

 Michael Knigin, printer-fellow from October–December 1964.

 Anthony Ko, printer-fellow from September 1966–December 1967.

 Aris Koutroulis, printer-fellow from February 1963–July 1964.

 William Law III, from February 1969–June 1970.

 Ian Lawson, printer-fellow from July–September 1966.

 Jason Leese, printer-fellow from January–December 1963.

 Jack Lemon, printer-fellow from April–September 1966.

 Bruce Lowney, printer-fellow from July–December 1967.

 Serge Lozingot, printer-fellow from December 1966–July 1968, Tamarind Studio Manager from July 1968–June 1970.

 Jean Milant, printer-fellow from February 1968–June 1970.

 George Miyasaki, printer-fellow from August–September 1961.

 John Muench, printer-fellow from August–September 1961.

 Kenjilo Nanao, printer-fellow from October 1968–January 1969.

 Thom O'Connor, printer-fellow from February–August 1964.

 Charles Ringness, Master Tamarind Printer; printer-fellow from September 1968–January 1970.

 Donald Roberts, printer-fellow from September–November 1962.

 John Rock, printer-fellow from November 1962–March 1963, August–November 1965.

 Robert Rogers, printer-fellow from January 1968–April 1969.

 Ernest Rosenthal, printer-fellow from April 1964–April 1965.

 Jeff Ruocco, printer-fellow from April–September 1964.

 Maurice Sanchez, printer-fellow from August 1966–September 1968.

 Clifford Smith, printer-fellow from February–March 1964, July 1964–July 1965, Tamarind Studio Manager from July 1965–July 1968, Tamarind Director of Education from July 1968–June 1970.

 Daniel Socha, printer-fellow from June 1968–August 1969.

 John Sommers, printer-fellow from September 1968–January 1970.

 Emiliano Sorini, printer-fellow from September–December 1961.

 Donn Steward, printer-fellow from November 1965–July 1966.

 Anthony Stoeveken, printer-fellow from September 1966–September 1968.

 Eugene Sturman, printer-fellow from June–August 1968, July 1969–June 1970.

 Hitoshi Takatsuki, printer-fellow from March 1969–June 1970.

 Larry Thomas, printer-fellow from June 1969–June 1970.

 David Trowbridge, printer-fellow from June 1969–June 1970.

 Kenneth Tyler, printer-fellow from June 1963–July 1964. Tamarind Technical Director from August 1964–July 1965.

 Emil Weddige, printer-fellow from June–August 1962.

 Harry Westlund, printer-fellow from February–June 1970.

 S. Tracy White, printer-fellow from June 1969–June 1970.

 Theodore Wujick, printer-fellow from September 1967–August 1968.

 Joe Zirker, printer-fellow from January 1962–April 1963, September–November 1964.

University Art Museum

Pam Allen, Sales Desk Manager
Linda Bahm, Associate Director
Tiska Blankenship, Jonson Gallery Assistant Curator
Jackie Chavez-Cunningham, Registrar
Nancy Montoya, Staff Assistant
Susan Nunemaker Braun, Education Curator
Joe Traugott, Exhibitions Curator
Peter Walch, Director
MaLin Wilson, Jonson Gallery Curator

Tamarind Institute

Clinton Adams, Editor, *The Tamarind Papers*
Marjorie Devon, Director
Bethany Nelson Fuller, Staff Assistant
Eric Katter, Senior Printer
Bill Lagattuta, Master Printer
Patricia Savignac, Administrative Manager
Rebecca Schnelker, Curator
Jeffrey Sippel, Educational Director
Anya K. Szykitka, Senior Printer
Linda Tyler, Gallery Manager

We also gratefully acknowledge the following for their contribution
in helping to complete this project:
Chris Abdalla
Andra Aguirre
Damian Andrus
Ivan Boyd
Kevin Donovan
Pamela Grossi
Katherine Guinn
Michael Hudock
Nita Kroninger
Jim Langell
Susan Lucke
Becci Martone
Denise Meade-Warren
Roselyn Sands
Lisa Savard
Sheri Schroth
Kim Stillwell
Melissa Strickland
Poem Swentzell
Robert Ware

Rodolfo Abularach

City of Eyes, a suite of ten lithographs. In order: 1868, 1836, 1870, 1872, 1867, 1864, 1871, 1869, 1873.

1826
Untitled. Oct 4–13, 1966. Black (S). 63.5 × 34.9. Ed 20 (CD), 9 TI (MI), BAT (CD), 1 TP (CD), 2 CTP (CD), CP (EVB). Clifford Smith. D, BS, S.

1827
Window. Oct 4–13, 1966. Black (S). 63.5 × 48.9. Ed 20 (CD), 9 TI (MI), BAT (CD), 3 AP (CD), 1 TP (CD), 2 CTP (CD), CP (EVB). Clifford Smith. D, T, BS, S.

1829
Untitled. Oct 7–21, 1966. Black (S). 69.9 × 54.0. Ed 10 (CD), 9 TI (BFK), BAT (CD), 2 AP (CD). Clifford Smith. D, BS, S.

1829II
Untitled. Oct 7–27, 1966. Light brown (S), black (S)[1]. 69.9 × 54.0. Ed 20 (CD), 9 TI (MI), BAT (CD), 3 AP (2 MI, 1 CD), 3 TP (2 CD, 1 BFK[2]), 2 PTP (1 Daumier, 1 American handmade paper)[3], CP (EVB). Clifford Smith. D, BS, S.

1. Stone held from 1829.
2. Pulled for paper testing, retained by Tamarind.
3. Unsigned, undesignated, unchopped, retained by Tamarind. 1829II differs from 1829 in color and in image. A bleed background tone has been added.

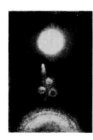

1830
Ascension. Oct 11–19, 1966. Black (S). 95.3 × 66.0. Ed 20 (BFK), 9 TI (CD), BAT (BFK), 2 AP (CD), 3 TP (1 BFK, 1 CD, 1 MI)[1], CP (EVB). Clifford Smith. D, T, BS, S.

1. Pulled for paper testing.

Print not in
University Art Museum
Archive

1831
Untitled. Oct 18–24, 1966. Black (S). 69.9 × 54.0. Ed 18 (BFK), 9 TI (MI), BAT (BFK), 2 AP (MI), 2 TP (BFK). Clifford Smith. D, BS, S.

1832
Untitled. Oct 20–28, 1966. Black (Z). 48.6 × 71.1. 6 TP (1 N, 5 CD)[1]. Clifford Smith. D, BS, S.

1. 1 TP (CD) retained by Tamarind.

1833
Untitled. Oct 20–31, 1966. Black (Z). 77.5 × 57.2,(wN), 76.20 X 57.20 (wA). Ed 20 (wA), 9 TI (wN), BAT (wA), 1 AP (wN), 2 TP (wA), CP (EVB). Clifford Smith. D, BS, S.

1834
Enigma. Oct 30–Nov 2, 1966. Black (S). 77.5 × 57.2,(wN), 76.20 × 52.20 (wA). Ed (wA), 9 TI (wN), BAT (wA), 3 AP (2 wA, 1 wN), 2 TP (wA). Ernest de Soto. D, BS, S.

1834II
Untitled. Nov 14–21, 1966. Violet, blue (S), dark brown (S)[1]. 76.2 × 57.2. Ed 20 (wA), 9 TI (MI), BAT (wA), 1 AP (wA), 5 TP (wA). Ernest de Soto. D, BS, S.

1. Stone held from 1834. 1834II differs from 1834 in color and in image. The circle has been darkened, the horizontal bars have been filled in with a tone and a tonal band has been added at bottom of the image.

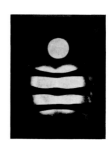

1834III
Untitled. Nov 23–29, 1966. Black (S)[1]. 76.2 × 57.2. Ed 10 (GEP), 9 TI (wA), BAT (GEP), 3 AP (2 GEP, 1 wA), 1 TP (GEP), CP (EVB). Ernest de Soto. D, BS, S.

1. Stone held from 1834II, run 2; reversal. 1834III differs from 1834II in color and in image. The background and the three horizontal bars are a solid dark tone, leaving a heart-shaped light area within

which two oval shapes have been lightened considerably. The circle has been lightened considerably also.

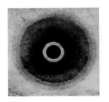

1835
Untitled. Nov 2–9, 1966. Black (S). 30.5 × 30.5. Ed 20 (BFK), 9 TI (wN), BAT (BFK), 2 AP (1 BFK, 1 wN), 4 TP (BFK)[1]. Ernest de Soto. D, BS, S.

1. 2 TP printed on same sheet with 1836–1840, untorn.

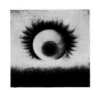

1836
Untitled (City of the Eyes II). Nov 2–9, 1966. Black (S). 30.5 × 30.5. Ed 20 (BFK), 9 TI (wN), BAT (BFK), 2 AP (1 BFK, 1 wN), 4 TP (BFK)[1]. Ernest de Soto. D, BS, S.

1. 2 TP printed on same sheet with 1835, 1837–1840, untorn.

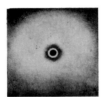

1837
Untitled. Nov 2–9, 1966. Black (S). 30.5 × 30.5. Ed 20 (BFK), 9 TI (wN), BAT (BFK), 3 AP (2 BFK, 1 wN), 4 TP (BFK)[1]. Ernest de Soto. D, BS, S.

1. 2 TP printed on same sheet with 1835–1836, 1838–1840, untorn.

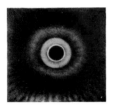

1838
Untitled. Nov 2–9, 1966. Black (S). 30.5 × 30.5. Ed 20 (BFK), 9 TI (wN), BAT (BFK), 3 AP (2 BFK, 1 wN), 4 TP (BFK)[1]. Ernest de Soto. D, BS, S.

1. 2 TP printed on same sheet with 1835–1837, 1839–1840, untorn.

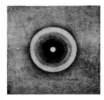

1839
Untitled. Nov 2–9, 1966. Black (S). 30.5 × 30.5. Ed 20 (BFK), 9 TI (wN), BAT (BFK), 3 AP (1 BFK, 2 wN), 4 TP (BFK)[1]. Ernest de Soto. D, BS, S.

1. 2 TP printed on same sheet with 1835–1838, 1840, untorn.

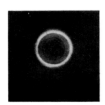

1840
Untitled. Nov 2–9, 1966. Black (S). 30.5 × 30.5. Ed 20 (BFK), 9 TI (wN), BAT (BFK), 3 AP (2 BFK, 1 wN), 4 TP (BFK)[1]. Ernest de Soto. D, BS, S.

1. 2 TP printed on same sheet with 1835–1839, untorn.

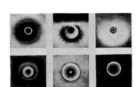

1841
Untitled. Nov 9–10, 1966. Black (S)[1]. 61.0 × 91.4. Ed 10 (BFK), 9 TI (wN), BAT (BFK), 2 TP (BFK), CP (EVB). Ernest de Soto. D, BS, S.

1. Stone held from 1835–40. 1841 differs from 1835–40 in image and in size. 1841 combines all six images reading numerically left to

right, top to bottom. The upper three images have been turned 180 degrees.

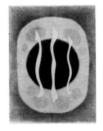

1860
Untitled. Nov 25, 1966–Jan 24, 1967. Black (S). 76.2 × 57.2. Ed 20 (MI), 9 TI (wA), BAT (MI), PrP II for Ernest de Soto (MI), 1 AP (MI), 2 TP (MI)[1], 2 PTP (JG)[2], CP (MI). Serge Lozingot. D, BS, S.

1. 1 TP originally designated BAT, redesignated TP as a horizontal presentation. 2. Unsigned, undesignated, unchopped, retained by Tamarind.

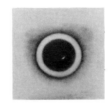

1862
Untitled. Nov 11–16, 1966. Black (S). 30.5 × 30.5. Ed 20 (BFK), 9 TI (wN), BAT (BFK), 3 AP (2 BFK, 1 wN), 2 TP (BFK). Maurice Sanchez. D, BS, S.

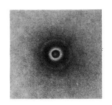

1863
Untitled. Nov 7–16, 1966. Black (S). 30.5 × 30.5. Ed 20 (BFK), 9 TI (wN), BAT (BFK), 3 AP (2 BFK, 1 wN), 2 TP (BFK). Maurice Sanchez. D, BS, S.

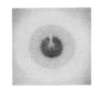

1864
Untitled (City of the Eyes VI). Nov 7–16, 1966. Black (S). 30.5 × 30.5. Ed 20 (BFK), 9 TI (wN), BAT (BFK), 4 AP (BFK), 2 TP (BFK). Maurice Sanchez. D, BS, S.

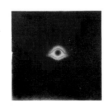

1865
Untitled. Nov 7–16, 1966. Black (S). 30.5 × 30.5. Ed 20 (BFK), 9 TI (wN), BAT (BFK), 3 AP (2 BFK, 1 wN), 1 PP (BFK), 2 TP (BFK). Maurice Sanchez. D, BS, S.

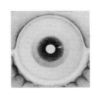

1866
Untitled (City of the Eyes X). Nov 7–16, 1966. Black (S). 30.5 × 30.5. Ed 20 (BFK), 9 TI (wN), BAT (BFK), 3 AP (1 BFK, 2 wN), 2 TP (BFK). Maurice Sanchez. D, BS, S.

1867
Untitled (City of the Eyes V). Nov 7–16, 1966. Black (S). 30.5 × 30.5. Ed 20 (BFK), 9 TI (wN), BAT (BFK), 3 AP (2 BFK, 1 wN). Maurice Sanchez. D, BS, S.

1868
Untitled (City of the Eyes I). Nov 10–22, 1966. Blue (Z), black (S). 30.5 × 30.5. Ed 20 (BFK), 9 TI (wN), BAT (BFK), 4 AP (2 BFK, 2 wN), 3 TP (BFK)[1]. Ernest de Soto. D, BS, S.

1. 2 TP printed on same sheet with 1869–1873, untorn.

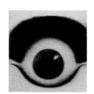

1869
Untitled (City of the Eyes VIII).
Nov 10–22, 1966. Black (S). 30.5 × 30.5. Ed 20 (BFK), 9 TI (wN), BAT (BFK), 6 AP (4 BFK, 2 wN), 2 TP (BFK)[1]. Ernest de Soto. D, BS, S.

1. 2 TP printed on same sheet with 1868, 1870–1873, untorn.

1870
Untitled (City of the Eyes III). Nov 10–22, 1966. Blue (Z), black (S). 30.5 × 30.5. Ed 20 (BFK), 9 TI (wN), BAT (BFK), 4 AP (2 BFK, 2 wN), 1 PP (BFK), 3 TP (BFK)[1]. Ernest de Soto. D, BS, S.

1. 2 TP printed on same sheet with 1868–1869, 1871–1873, untorn.

1871
Untitled (City of the Eyes VII). Nov 10–22, 1966. Red (Z), black (S). 30.5 × 30.5. Ed 20 (BFK), 9 TI (wN), BAT (BFK), 3 AP (1 BFK, 2 wN), 3 TP (BFK)[1]. Ernest de Soto. D, BS, S.

1. 2 TP printed on same sheet with 1868–1870, 1872–1873, untorn.

1872
Untitled (City of the Eyes IV). Nov 10–22, 1966. Violet (Z), black (S). 30.5 × 30.5. Ed 20 (BFK), 9 TI (wN), BAT (BFK), 2 AP (1 BFK, 1 wN), 3 TP (BFK)[1]. Ernest de Soto. D, BS, S.

1. 2 TP printed on same sheet with 1868–1871, 1873, untorn.

1873
Untitled (City of the Eyes IX). Nov 10–22, 1966. Violet (Z), black (S). 30.5 × 30.5. Ed 20 (BFK), 9 TI (wN), BAT (BFK), 2 AP (1 BFK, 1 wN), 3 TP (BFK)[1]. Ernest de Soto. D, BS, S.

1. 2 TP printed on same sheet with 1868–1872, untorn.

1874
Untitled. Nov 14–15, 1966. Dark violet, dark blue (S)[1]. 77.5 × 57.2,(wN). Ed 20 (wA), 9 TI (wN), BAT (wA), 1 AP (wA), 3 TP (wA). Ernest de Soto. D, S, BS.

1. Stone held from 1834II, run 1. 1874 differs from 1834II in color and in image. The two oval shapes and the background tone with the exception of the horizontal band at the bottom of the image has been eliminated. The circle has been lightened.

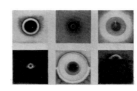

1875
Untitled. Nov 17–18, 1966. Orange, blue, violet (Z), black (S)[1]. 61.6 × 91.4. Ed 10 (BFK), 9 TI (wN), BAT (BFK), 2 AP (wN), 3 TP (BFK). Maurice Sanchez. D, BS, S.

1. Stone held from 1862–67. 1875 differs from 1862–67 in color, image and size. 1875 combines all 6 images reading numerically left to right, top to bottom. Color accent has been added to the upper center and lower three images.

Print not in
University Art Museum
Archive

1875II
Untitled. Nov 18, 1966. Black (S)[1]. 61.0 × 91.4. Ed 10 (BFK), BAT (BFK), 2 TP (BFK), CP (EVB). Maurice Sanchez.

1. Stone held from 1875, run 2. 1875II differs from 1875 in color and in image. Color accents added to the upper center and the lower three images have been eliminated.

1876
Shrine. Nov 21–27, 1966. Black (S). 63.5 × 45.7. Ed 20 (MI), 9 TI (GEP), BAT (MI), 3 AP (2 MI, 1 GEP), 2 PP (MI), 2 TP (MI), CP (EVB). Maurice Sanchez. D, BS, S.

1877
Shrine. Nov 21–27, 1966. Black (S). 63.5 × 45.7. Ed 20 (MI), 9 TI (GEP), BAT (MI), 2 AP (GEP), 2 PP (MI), CP (EVB). Maurice Sanchez. D, BS, S.

1878
Untitled. Nov 22–23, 1966. Black (S)[1]. 61.6 × 91.4. Ed 10 (MI), 9 TI (wN), BAT (MI), 1 AP (wN), CP (EVB). Ernest de Soto. D, BS, S.

1. Stone held from 1868–73. 1878 differs from 1868–73 in color, image, and size. 1878 combines all 6 images reading numerically left to right, top to bottom. Color accents added to the upper left and right images and the lower three images have been eliminated.

Clinton Adams

The Window Series, a suite of ten lithographs plus title and colophon pages, enclosed in a beige cloth covered box, measuring 48.9 × 40.6, lined with black cover paper, made by the Schuberth Bookbindery, San Francisco. Title page and colophon printed at the Plantin Press, Los Angeles. In order: 122, 124, 124A, 137, 108, 157, 161, 103, 103A, 144.

Tablets, a suite of ten lithographs plus colophon, enclosed in an orange cloth covered box, measuring 48.9 × 40.6, lined with white cover paper, made by the Schuberth Bookbindery, San Francisco. Title page and colophon printed at the Plantin Press, Los Angeles. In order: 290, 241A, 261, 327, 326, 322, 241B, 267, 296, 320A.

Venus in Cibola, a suite of ten lithographs plus title and colophon pages, enclosed in a plexiglas combination box and hanging frame with transparent front and opaque white sides and back made by Art Services, Los Angeles. Title page and colophon printed at the Plantin Press, Los Angeles. Each lithograph enclosed in a chemise of white Tableau paper. In order: 2519, 2521, 2526, 2518, 1731, 2516, 2520, 1730, 2517, 2522.

103
Untitled (Window Series VIII). Jul 12, 1960. Black (S). 45.7 × 38.1. Ed 15 (BFK), 9 TI (BFK), PrP (BFK), 2 AP (1 BFK, 1 J), 2 TP (BFK), 1 SSP (W), 1 ExP (J)[1]. Garo Z. Antreasian. BS (Tam), D, BS (pr), T (Suite), S, Dat.

1. Unsigned, retained by Tamarind.

103A
Untitled (Window Series IX). Jul 22–29, 1960. Blue-grey (S), green-brown (S)[1], ochre (S), transparent red-black (S)[2]. 45.7 × 38.1. Ed 12 (BFK), 9 TI (BFK), PrP (BFK), 2 AP* (BFK), 2 TP* (BFK), 4 PgP (BFK)[3], 1 color variant proof (BFK). Garo Z. Antreasian. BS (Tam), D, BS (pr), T (Suite), S, Dat.

1. Stone held from 103; deletions and additions.
2. Same stone as run 2, deletions. 103A differs from 103 in color and in image. The dark areas in the upper two-thirds of the image have been lightened. A tone has been added delineating the various shapes throughout the image.
3. Retained by Tamarind.

108
Untitled (Window Series V). Aug 1–24, 1960. Grey-blue (S), blue-green, red-brown (S), green-ochre (S), light gret (S), medium grey (S), dark grey (S). 45.7 × 38.1. Ed 18 (BFK), 9 TI (BFK), PrP (BFK), 2 AP (BFK), 2 TP (BFK), 2 CStP (BFK), 1 CPgP (BFK), 4 PgP (BFK)[1], 1 color variant proof (BFK). Joe Funk. BS (Tam), D, BS (pr), T (Suite), S, Dat.

1. Retained by Tamarind.

109
Dark Window. Aug 1–Sep 6, 1960. Black (S). 76.8 × 56.5. Ed 20 (BFK), 9 TI (wN), PrP (BFK), 3 AP (BFK), 2 TP (1 BFK, 1 wN), 1 proof* (W)[1], CP (nr)[1]. Garo Z. Antreasian. BS (Tam), D, BS (pr), T, S, Dat.

1. Unsigned, unchopped.

122
Untitled (Window Series I). Sep 9–12, 1960. Dark beige (S), black (S). 45.7 × 38.1. Ed 20 (BFK), 9 TI (BFK), 2 PrP (BFK)[1], 5 AP (BFK)[2], 1 TP (BFK), CP* (BFK). Garo Z. Antreasian. BS (Tam), D, BS (pr), T (Suite), S, Dat.

1. 1 PrP varies from the edition. 2. 3 AP vary from the edition.

124
Untitled (Window Series II). Sep 20, 1960. Black (S)[1]. 45.7 × 38.1. Ed 20 (BFK), 9 TI (BFK), PrP (BFK), 2 AP (BFK), 2 TP (BFK), 1 proof(BFK). Joe Funk. BS (Tam), D, BS (pr), T (Suite), S, Dat.

1. Stone held from 122, run 2; deletions and additions. 124 differs from 122 in color and in image. The background tone has been eliminated. The drawing is different except for the inner square shape and tone border around it.

124A
Untitled (Window Series III). Sep 26–Oct 13, 1960. Grey-green (S), light grey (S), red-brown (S), blue (S)[1], transparent black (S)[2]. 45.7 × 38.1. Ed 20 (BFK), 9 TI (BFK), PrP (BFK), 2 AP (BFK), 1 TP (BFK), 2 CPgP (BFK)[3]. Joe Funk. BS (Tam), D, BS (pr), T (Suite), S.

1. Same stone as run 2; deletions and additions.
2. Stone held from 124 with addition of transfer of 124A, run 1. 124A differs from 124 in color and in image. A two-tone border has been added around the image. The drawing is different except for the texture in the inner square and lower rectangle.
3. 1 CPgP has added work in black crayon.

137
Untitled (Window Series IV). Oct 19–21, 1960. Green-beige (S), black (S). 45.7 × 38.1. Ed 18 (BFK), 9 TI (BFK), PrP (BFK), 2 AP (BFK), 2 TP (BFK), 2 proofs* (CD). Joe Funk. BS (Tam), D, BS (pr), T (Suite), S, Dat.

144
Untitled (Window Series X). Oct 26–Nov 5, 1960. Green-grey (S), yellow, ochre (S), violet-grey (S), transparent blue-grey (S), transparent black (S). 45.7 × 38.1. Ed 20 (BFK), 9 TI (BFK), PrP (BFK), 2 AP (BFK), 2 TP (BFK), 2 CStP (BFK), 1 intermediate stateproof (BFK), 1 proof (BFK). Garo Z. Antreasian. BS (Tam), D, BS (pr), T (Suite), S, Dat.

157
Untitled (Window Series VI). Nov 11, 1960. Black (S). 45.7 × 38.1. Ed 20 (BFK), 9 TI (BFK), PrP (BFK), 2 AP (BFK), 2 TP (BFK), 1 proof *(W). Garo Z. Antreasian. BS (Tam), D, BS (pr), T (Suite), S, Dat.

161
Untitled (Window Series VII). Nov 16–Dec 1, 1960. Ochre (S), grey (S), white (Z), brown-grey (S). 45.7 × 38.1. Ed 18 (BFK), 9 TI (BFK), PrP (BFK), 1 AP (BFK), 1 TP (BFK), 4 CStP (2 BFK, 2 bA), 3 PgP (BFK), 1 color variant proof (BFK), 2 proofs (1 BFK, 1 bA). Joe Funk. BS (Tam), D, BS (pr), T (Suite), S, Dat.

170
Broken Land, I. Dec 6, 1960. Black (S). 28.6 × 38.1. Ed 20 (bA), 9 TI (BFK), BAT (bA), 2 AP (1 bA, 1 BFK), 2 TP (BFK), 3 SP (bA), CP (BFK). Joe Funk. BS (Tam), D, BS (pr), S, Dat.

172
Broken Land, II. Dec 1, 1960–Jan 31, 1961. Grey (Z), grey-brown (S), dark grey (S), white (S), transparent grey (S). 56.5 × 76.8. Ed 18 (wA), 9 TI (wN), BAT (wA), 2 AP (wA)[1], 2 TP (1 wA, 1 BFK)*, 2 CStP (1 BFK, 1 wA), 4 PgP (wA). Garo Z. Antreasian. BS (Tam), D, BS (pr), S.

1. 1 AP varies from the edition.

191
Reflection I. Dec 22–27, 1960. Black (S). 76.2 × 56.5. Ed 10 (wA), 9 TI (BFK), BAT (wA), 2 AP (wA)[1], 1 TP (wA), 3 SP (wA)[1]. Bohuslav Horak. BS (Tam), D, T, S, Dat, BS (pr).

1. 1 AP and 3 SP on paper 58.4 × 41.9.

199
Above and Below. Jan 10, 1961. Black (S). 76.5 × 56.5. Ed 10 (wA), 9 TI (BFK), BAT (wA), 2 AP (1 wA, 1 BFK), 3 SP (BFK)[1], CP (BFK)[1]. Garo Z. Antreasian. BS (Tam), D, T, S, BS (pr).

1. 3 SP, CP on paper 58.4 × 41.9.

212
Broken Land, III. Jan 19–24, 1961. Brown (S), black (S). 38.1 × 43.2. Ed 10 (BFK), 9 TI (wA), BAT (BFK), 3 AP (BFK), 3 TP (BFK), 2 PgP (BFK). Garo Z. Antreasian. BS (Tam), D, BS (pr), S, Dat.

225
Desert Landscape. Feb 1–23, 1961. Ochre (S), green (S), red-brown (S), light blue (S)[1], dark grey, blue-green (S)[2], blue-black (S)[3]. 76.2 × 56.5. Ed 20 (wA), 9 TI (wN), BAT (wA), 3 AP (wA), 2 TP (wA). Garo Z. Antreasian. BS (Tam), D, BS (pr), S, Dat.

1. Same stone as run 3. 2. Same stone as run 4. 3. Same stone as run 1.

241A
Untitled (Tablets II). Mar 9–Apr 17, 1961. Black (S), black (S)[1]. 45.7 × 38.1. Ed 12 (BFK), 9 TI (wA), PrP (BFK), 3 AP (nN, 1 BFK), 3 TP (BFK)[2], 1 FSP (BFK), 2 SSP (BFK). Garo Z. Antreasian. BS (Tam), D, BS (pr), S, Dat.

1. Stone held from 241B, run 1; additions, reversal. 2. 2 TP vary from the edition.

241B
Untitled (Tablets VII). Mar 17–21, 1961. Dark red-brown (S)[1], red-brown (S). 45.7 × 38.1. Ed 12 (BFK), 9 TI (wA), PrP (BFK), 2 AP (nN), 1 TP (BFK), 1 FSP (BFK). Garo Z. Antreasian. BS (Tam), D, BS (pr), S, Dat.

1. Stone held from 241A, run 1. 241B differs from 241A in color and in image. Over-all tone is lighter and shapes more distinct. Texture has been removed from small central rectangle.

261
Untitled (Tablets III). Apr 3–17, 1961. Dark beige (S), black (S). 45.7 × 38.1. Ed 12 (BFK), 9 TI (wA), PrP (BFK), 3 AP (2 nN, 1 BFK), 3 TP (BFK)[1]. Garo Z. Antreasian. BS (Tam), D, S, Dat, BS (pr).

1. 1 TP varies from the edition.

262
Golden Tablet. Apr 3–May 22, 1961.
Violet-grey (S), light green-ochre (S),
orange, ochre (S), light grey (S), light
yellow (S), dark transparent grey (S),
yellow, dark grey (S). 76.8 × 56.5. Ed
15 (wA), 9 Tl (wN), BAT (wA), 4 AP (3
wA, 1 wN), 3 TP (wA). Garo Z.
Antreasian. BS (Tam), D, BS (pr), T, S,
Dat.

267
Untitled (Tablets VIII). Apr 11, 1961.
Black (S). 45.7 × 38.1. Ed 12 (BFK), 9
Tl (wA), PrP (BFK), 3 AP (2 nN, 1 BFK),
2 TP (1 BFK, 1 wA). Joe Funk. D, BS
(pr), S, BS (Tam).

1. image measures 12 × 14 on paper
 16.5 × 18.

290
Untitled (Tablets I). May 8–9, 1961.
Black (S). 45.7 × 38.1. Ed 12 (BFK), 9
Tl (wA), PrP (BFK), 3 AP (2 nN, 1
BFK*), 2 TP (BFK). Joe Funk. BS (Tam),
D, S, BS (pr).

296
Untitled (Tablets IX). May 25, 1960
Black (S). 45.7 × 38.1. Ed 12 (BFK), 9
Tl (wA), PrP (BFK), 3 AP (1 CW, 2 nN),
1 TP (BFK), 1 FSP (CW)[1]. Garo Z.
Antreasian. D, BS (pr), S, BS (Tam).

1. FSP on paper 40.6 × 45.7.

320
Grey Tablet. Jun 15–20, 1961. Dark
grey (S), light grey-green (S), light
blue-grey (S). 45.7 × 38.1. Ed 12
(BFK), 9 Tl (wA), BAT (BFK), 2 AP (nN),
3 TP (2 wA, 1 BFK)[1], 3 PgP (1 BFK, 2
wA). Garo Z. Antreasian. BS (Tam), D,
T, S, BS (pr).

1. 2 TP (1 wA, 1 BFK) vary from the
 edition.

320A
Untitled (Tablets X). Jun 26–Jul 13,
1961. Yellow-grey (S), light green-
yellow, red-brown (S)[1], ochre, light
yellow (S)[2]. 45.7 × 38.1. Ed 12
(BFK), 9 Tl (wA), PrP (wA), 4 AP (2 wA,
2 nN), 2 TP (BFK), 3 CStP (BFK). Joe
Funk. BS (pr), D, S, BS (Tam).

1. Stone held from 320, run 2;
 additions.
2. Stone held from 320, run 1;
 deletions and additions. 320A differs
 from 320 in color and in image.
 Most of the tone around the circle
 and square has been removed. The
 circle has been filled in. The square

is lighter. A solid rectangle has been
added around the square within
which a dark textured horizontal bar
has been added.

322
Untitled (Tablets VI). Jun 19–23,
1961. Dark brown (S), black-green (S).
45.7 × 38.1. Ed 12 (BFK), 9 Tl (wA),
PrP (BFK), 3 AP (1 wA, 2 nN), 4 TP (3
wA, 1 BFK)[1], 1 FSP (BFK). Garo Z.
Antreasian. BS (Tam), D, S, BS (pr).

1. 1 TP (wA) varies from the edition.

326
Untitled (Tablets V). Jun 24–26,
1961. Red-black (S). 45.7 × 38.1. Ed
12 (BFK), 9 Tl (wA), PrP (BFK), 3 AP (2
nN, 1 BFK), 2 TP (1 BFK, 1 wA). Joe
Funk. BS (Tam), D, S, Dat, BS (pr).

327
Untitled (Tablets IV). Jun 27–28,
1961. Black (S). 45.7 × 38.1. Ed 12
(BFK), 9 Tl (wA), PrP (wA), 2 AP (nN), 2
TP (BFK). Joe Funk. BS (Tam), D, S, BS
(pr).

939
Requiem. Nov 26–27, 1963. Black (S).
76.2 × 55.9. Ed 20 (BFK), 9 Tl (wA),
BAT (BFK), 3 AP (2 BFK, 1 wA), 2 TP
(BFK). Irwin Hollander. BS (Tam), D, T,
S, BS (pr).

1300
Cleft. Mar 29–31, 1965. Black (S). 56.8
× 38.1,(wA), 52.10 × 36.8 (BFK). Ed
15 (BFK), 9 Tl (wA), UNMI (wA), PrP
(wA), 2 AP (BFK), 3 TP (BFK), CP (R).
Garo Z. Antreasian, NC. BS (UNM), D,
S, Dat, BS (Tam).

1303
Nocturne. Apr 15–Jun 1, 1965. Grey
(S), transparent blue (S), blue-violet
(S), ochre (S), light blue (S), dark blue
(S). 50.8 × 33.0,, cut. Ed 10 (BFK), 9 Tl
(wA), UNMI (wA), PrP (BFK), 3 AP
(BFK), 1 TP (BFK). Garo Z. Antreasian,
NC. BS (Tam), D, S, Dat, BS (UNM).

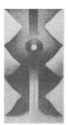

1310
Sorceress. Jun 8–Jul 9, 1965. Black (S). 27.9 × 20.3. Ed 15 (BFK), 9 TI (bA), UNMI (J laid down on bA), BAT (wA), 2 AP (1 BFK, 1 J laid down on bA), 3 TP (wA). Jurgen Fischer, NC. BS (UNM), S, D, BS (Tam).

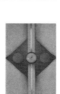

1311
Circe I. Jun 3–8, 1965. Dark beige (S), black (S). 56.5 × 38.1. Ed 18 (BFK), 9 TI (wA), UNMI (wA), PrP (wA), 2 AP (1 wA, 1 BFK). Garo Z. Antreasian, NC. BS (Tam), D, T, S, Dat, BS (UMM).

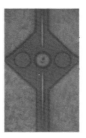

1311A
Circe II. Jun 11–17, 1965. Dark beige (S)[1], violet (S), red-orange (S), dark red-orange (S)[2]. 53.5 × 38.1. Ed 15 (BFK), 9 TI (wA), UNMI (wA), BAT (BFK), 3 TP (1 BFK, 2 wA). John Beckley, NC. BS (Tam), D, T, S, Dat, BS (UNM).

1. Stone held from 1311, run 1.
2. Stone held from 1311, run 2; deletions and additions. 1311A differs from 1311 in color and in image. Texture has been added to the background. The vertical bar and the diamond shape have been filled in creating a solid tone.

1509
Enchantress. Oct 7–24, 1965. Green (S), light red (S). 53.3 × 38.1. Ed 20 (bA), 9 TI (bA), BAT (bA), 3 AP (bA), 2 TP (bA). John Beckley, NC. Recto: BS (UNM), D, S, Dat, BS (Tam). Verso: T.

1513
Arabesque I. Apr 9–May 3, 1966. Green (S), black (S). 76.2 × 43.2,(wA), 73.6 × 43.2 (BFK). Ed 10 (BFK), 9 TI (wA), UNMI (BFK), BAT (BFK), 3 TP (BFK). Erwin Erickson, NC. BS (Tam), D, S, Dat, BS (UNM).

1513A
Arabesque II. Apr 21–May 17, 1966. Beige-red (S)[1], transparent pink (S), red-brown (S)[2], light blue-violet (S). 76.2 × 43.2,(wA), 73.6 × 43.2 (BFK). Ed 10 (2 BFK, 8 wA), 9 TI (BFK), UNMI (BFK), BAT (BFK), 2 TP (BFK). Erwin Erickson, NC. BS (Tam), D, S, Dat, BS (UNM).

1. Stone held from 1513, run 1.
2. Stone held from 1513, run 2. 1513A differs from 1513 in color only.

1518
Little Red Arabesque. Mar 15–Apr 14, 1966. Pink (S), red-orange (S), dark pink (S), dark red (S). 28.3 × 20.3. Ed 20 (wA), 9 TI (CD), UNMI (CD), 1 AP (wA), 3 TP (wA). Robert Bigelow. BS (Tam), D, S, Dat, BS (UNM).

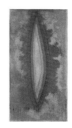

1519
Helios. Mar 15–Apr 14, 1966. Pink (S), red-orange (S), dark pink (S), pink (S), red-brown (S). 27.9 × 20.3. Ed 15 (wA), 9 TI (CD), UNMI (wA), 3 AP (wA), 2 TP (wA). Robert Bigelow. BS (Tam), D, S, Dat, BS (UNM).

1718
Astarte. Jun 20–29, 1966. Black (S). 63.5 × 56.5. Ed 20 (R), 9 TI (wA), UNMI (wA), BAT (R), 3 AP (1 R, 1 wA, 1 J #48), 1 TP (R). Garo Antreasian, NC. BS (Tam), D, S, Dat, BS (UNM).

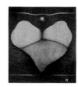

1721
Sequence. Dec 12, 1966–Nov 8, 1967. Brown (S), ochre (S), blue-grey (S), white (S), grey (S). 46.4 × 76.2. Ed 10 (7 wA, 3 BFK), 9 TI (wA), UNMI (BFK), BAT (BFK), 4 AP (3 wA, 1 bA), 1 TP (BFK). Anthony Stoeveken. BS (Tam), D, S, BS (UNM).

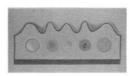

1728
Untitled. Nov 27–Dec 4, 1967. Grey (S), dark grey (S), pink-beige (S). 31.8 × 25.4, cut. Ed 20 (CD), 9 TI (GEP), UNMI (CD), PrP (GEP), 3 AP (2 CD, 1 GEP), 2 TP (GEP). Daniel Socha, NC. Recto: D, I Verso: WS (Tam, UNM).

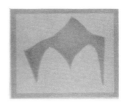

1730
Untitled (Venus in Cibola VIII). Dec 11–22, 1967. Yellow (S), beige (S), dark beige (S). 31.8 × 25.4,, cut. Ed 20 (CD), UNMI (CD), PrP (GEP), 3 AP (2 CD, 1 GEP), 2 PgP (GEP). Daniel Socha, NC. Recto: D, I Verso: WS (Tam, UNM).

1731
Untitled (Venus in Cibola V). Dec 26, 1967–Jan 12, 1968. Dark beige (S), grey (S). 31.8 × 25.4,, cut. Ed 20 (CD), 9 TI (GEP), UNMI (CD), PrP (CD), 3 AP (2 CD, 1 GEP), 2 TP (GEP). Daniel Socha, NC. Recto: D, I Verso: WS (Tam, UNM).

1732
Untitled. Dec 26, 1967–Jan 30, 1968. Beige (S), dark beige (S), transparent blue-green (S). 31.8 × 25.4, cut. Ed 20 (CD), 9 TI (GEP), UNMI (CD), PrP (GEP), 3 AP (2 CD, 1 GEP), 2 TP (1 CD, 1 GEP). Daniel Socha, NC. Recto: D, I. Verso: WS (Tam, UNM).

2515
Cibola Series (Blue). Dec 12, 1968–Jan 13, 1969. Grey (S), blue (A), red-brown (A), blue (A). 31.8 × 25.4, cut. Ed 10 (CD), 9 TI (GEP), BAT (CD), 2 AP (CD), 1 TP* (CD)[1], CP (CD). Donald Kelley. Recto: D, S Verso: WS.

1. Unchopped.

2516
Untitled (Venus in Cibola VI). Dec 12, 1968–Jan 13, 1969. Red (S), green (A), red (A). 31.8 × 25.4, cut. Ed 20 (CD), 9 TI (GEP), BAT (CD), 2 AP (1 CD, 1 GEP), 3 TP (CD)[1], 1 CTP (GEP, CP (CD). Don Kelley. Recto: D, I Verso: WS.

1. 2 TP vary from the edition.

2517
Untitled (Venus in Cibola IX). Dec 11–16, 1968. Grey (A), grey (S). 31.8 × 25.4,, cut. Ed 20 (CD), 9 TI (GEP), BAT (CD), 2 AP (1 GEP, 1 CD), 1 TP (GEP), CP (GEP). Manuel Fuentes. Recto: D, I Verso: WS.

2518
Untitled (Venus in Cibola IV). Dec 16–31, 1968. Blue (A), blue (S), green (A), green (S), green (A). 31.8 × 25.4, cut. Ed 20 (CD), 9 TI (GEP), BAT (CD), 2 AP (1 GEP, 1 CD), 1 TP (GEP), CP (CD). Jean Milant. Recto: D, I Verso: WS.

2519
Untitled (Venus in Cibola I). Dec 16–26, 1968. Grey (A), grey (S), red (A), orange (S), orange (S). 31.8 × 25.4, cut. Ed 20 (CD), 9 TI (GEP), BAT (GEP), 2 AP (1 GEP, 1 CD), 2 TP (1 GEP, 1 CD*), 1 CP (CD). Jean Milant. Recto: D, I Verso: WS.

2520
Untitled (Venus in Cibola VII). Dec 23, 1968–Jan 6, 1969. Red (A), blue (S). 31.8 × 25.4, cut. Ed 20 (CD), 9 TI (GEP), BAT (CD), 3 AP (CD), 1TP (CD), CP (CD). Kenjilo Nanao. Recto: D, I Verso: WS.

2521
Untitled (Venus in Cibola II). Dec 31, 1968–Jan 6, 1969 Grey (A), red-brown (S). 31.8 × 25.4, cut. Ed 20 (CD), 9 TI (GEP), BAT (CD), 3 AP (1 CD, 2 GEP), 3 CTP (CD), CP (GEP). John Sommers. Recto: D, I Verso: WS.

2522
Untitled (Venus in Cibola X). Jan 7–23, 1969. Orange (A), light blue (A), orange (S), blue (S). 31.8 × 25.4, cut. Ed 20 (CD), 9 TI (GEP), BAT (CD), 3 AP (1 CD, 2 GEP), 1 TP* (CD), CP (GEP). Robert Rogers. Recto: D, I Verso: WS.

2523
Untitled. Dec 18–20, 1968. Black (S). 37.2 × 30.8, cut. Ed 10 (wA), 9 TI (BFK), BAT (wA), 2 AP (wA), 1 TP (BFK), CP (CW). Manuel Fuentes. BS (Tam), D, S, Dat, BS (pr).

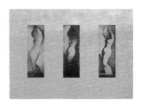

2524
Venus Three Times (after Chasseriau). Dec 31, 1968–Jan 14, 1969. Black (S). 50.2 × 66.0,[1]. Ed 20 (wA)[1], BAT (wA)[1], 9 TI (BFK), 3 AP (2 BFK, 1 wA)[1], 2 PP (wA), CP (wA). Serge Lozingot. BS (Tam), D, T, S, Dat, BS (pr).

1. Ed 11/20–20/20, BAT, 1 AP were torn into three separate lithographs (titled Venus I, Venus II, Venus III), 42.6 × 18.4; 28.0 × 8.2.

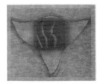

2525
Figure in Green. Jan 7–29, 1969. Grey (A)[1], grey (S)[2], green (A)[3], violet-blue (A)[4], green (A). 57.2 × 61.0. Ed 10 (CD), 9 TI (GEP), BAT (CD), 2 AP (1 CD, 1 GEP), 2 PP (1 CD, 1 GEP), 4 CTP (CD), 4 PgP (CD), CP (GEP). Jean Milant. BS (Tam), D, S, Dat, BS (pr).

1. Plate held from 2525II, run 1.
2. Stone held from 2525II, run 2.
3. Plate held from 2525II, run 3.
4. Plate held from 2525II, run 4. 2525 differs from 2525II in color only.

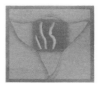

2525II
Figure in Yellow. Jan 7–24, 1969. Light brown (A), brown (S), yellow (A), orange (A). 57.2 × 61.3. Ed 10 (CD), 9 TI (GEP), BAT (GEP), 3 AP (2 CD, 1 GEP), 4 CTP (CD). Jean Milant. BS (Tam), D, S, Dat, BS (pr).

2526
Untitled (Venus in Cibola III). Jan 14–20, 1969. Grey (A)[1], yellow (S), light yellow (S). 31.8 × 25.4, cut. Ed 20 (CD), 9 TI (GEP), BAT (CD), 2 AP (CD), 1 TP (CD), 1 CTP (CD), CP (CD). John Sommers. Recto: D, I Verso: WS.

1. Plate held from 2515, run 4. 2526 differs from 2515 in color and in image. The entire image is darker and the shape is more angular.

Kenneth M. Adams

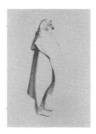

1312
Taos Indian. Jun 7–9, 1965. Black (S). 56.8 × 38.1,(wA), 53.0 × 38.1 (BFK). Ed 15 (BFK), 9 TI (wA), 1 UNMI (wA), BAT (R), 3 AP (R). Garo Antreasian, NC. BS (Tam), T D, S, Dat, BS (UNM).

Kinji Akagawa

Black Rainbow, a suite of eight lithographs including title and colophon pages, enclosed in a folder of black construction paper, measuring 50.8 × 66.7, lined with Japanese Troya paper. A poem by the artist has been handwritten in white pencil on the inner flap. In order: 1534, 1497, 1498, 1528, 1499, 1526, 1527, 1549.

Pink Jelly, by Joan Root, a suite of six lithographs plus title, dedication and colophon pages, enclosed in a three-part light grey cloth covered wrapper, measuring 27.9 × 30.5, and in a dark grey cloth covered slipcase. The suite title has been stamped on the spine of the wrapper in red. The title page, dedication page and colophon printed by Walter Hamedy, Detroit. In order: 1551, 1626, 1552, 1627, 1685, 1701.

1235
Play the Piano. Mar 5–21, 1965. Black (S). 52.1 × 37.2. Ed 12 (BFK), 9 TI (wA), BAT (BFK), 2 AP (wA), 1 TP (BFK), CP (Tcs). Kinji Akagawa. S, D, BS.

1351
Rainbow Talk. May 1–27, 1965. Blue, yellow (S), red (A), dark brown (S). 38.1 × 56.8. Ed 10 (BFK), 9 TI (wA), BAT (BFK), 2 AP (wA), 3 PP (BFK), CP (Tcs). Kinji Akagawa. D, BS, S.

1497
Untitled (Black Rainbow II). Aug 30–Sep 3, 1965. Black (S). 24.1 × 29.5. Ed 10 (BFK), 9 TI (wA), BAT (BFK), 3 AP (wA), 1 TP (BFK), CP (Tcs). Kinji Akagawa. Verso: WS, T, D, S.

1498
Untitled (Black Rainbow III). Sep 2–3, 1965. Black (S). 24.5 × 30.2. Ed 10 (9 BFK, 1 wA), 9 TI (wA), BAT (BFK), 1 AP (wA), 2 PP (BFK), CP (Tcs). Kinji Akagawa. Verso: WS, T, D, S.

1499
Untitled (Black Rainbow V). Sep 3–4, 1965. Black (S). 24.5 × 29.2. Ed 10 (BFK), 9 TI (wA), BAT (BFK), 3 AP (wA), 2 TP (BFK), 1 PP (BFK), CP (Tcs). Kinji Akagawa. Verso: WS, T, D, S.

1526
Untitled (Black Rainbow VI). Sep 3–5, 1965. Black (S). 24.5 × 28.9. Ed 10 (BFK), 9 TI (wA), BAT (BFK), 3 AP (wA), 2 PP (BFK), 2 TP (BFK), CP (Tcs). Kinji Akagawa. Verso: WS, T, D, S.

1527
Untitled (Black Rainbow VII). Sep 10–11, 1965. Black (S). 24.1 × 29.2. Ed 10 (BFK), 9 TI (CD), BAT (BFK), 3 AP (CD), 2 TP (BFK), CP (Tcs). Kinji Akagawa. Verso: WS, T, D, S.

1528
Untitled (Black Rainbow IV). Sep 10–13, 1965. Black (S). 24.1 × 28.6. Ed 10 (BFK), 9 TI (CD), BAT (BFK), 2 AP (1 BFK, 1 CD), 1 TP (BFK), CP (Tcs). Kinji Akagawa. Verso: WS, T, D, S.

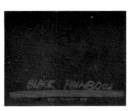

1534
Title Page (Black Rainbow I). Sep 14–Oct 3, 1965. White (A), black (A). 24.1 × 29.2. Ed 10 (BFK), 9 TI (CD), BAT (BFK), 1 AP (CD), 2 TP (BFK)[1], CP (Tcs). Kinji Akagawa. Recto: BS Verso: D, S.

1. 1 TP varies from the edition.

1548
Someone's Rainbow. Nov 26, 1965. Yellow (Z), orange (Z), brown (Z). 42.5 × 57.2. Ed 10 (wN), 9 TI (nN), BAT (wN), 1 AP (nN), CP (Tcs). Kinji Akagawa. D, S, Dat, BS.

1549
Colophon (Black Rainbow VIII). Oct 1, 1965. Black (Z). 24.1 × 28.9. Ed 10 (BFK), 9 TI (CD), BAT (BFK), CP (Tcs). Kinji Akagawa. Recto: BS, T, S (in black ink) Verso: D, S.

1550
Boku No Niji. Nov 25, 1965. Brown-green (Z), brown (Z). 39.1 × 57.2. Ed 10 (nN), 9 TI (wN), BAT (nN), 1 TP (nN), CP (Tcs). Kinji Akagawa. D, T, S, Dat, BS.

1551
Upsidedown (Pink Jelly I). Dec 13–15, 1965. Dark blue (S), green (S), brown (Z), red-violet (Z). 25.4 × 55.9. Ed 10 (wA), 9 TI (CD), BAT (wA), 3 AP (CD), 1 PP (wA), 5 TP (wA), CP (Tcs). Kinji Akagawa, NC. Verso: I, D (top).

1552
A Tart Sound (Pink Jelly III). Dec 5–27, 1965. Dark blue (S), red (S), orange (Z), dark brown (Z). 25.4 × 55.9. Ed 10 (wA), 9 TI (CD), BAT (wA), 3 AP (CD), 1 PP (wA), 5 TP (wA), CP (Tcs). Kinji Akagawa, NC. Verso: I, D (center).

1626
The Clanging Cataclysm (Pink Jelly II). May 2–9, 1966. Dark blue (S), blue (S), pink (Z), yellow-green (Z). 25.4 × 55.9. Ed 10 (wA), 9 TI (CD), BAT (wA), 3 AP (CD), 1 PP (wA), 5 TP (wA), CP (Tcs). Kinji Akagawa, NC. Verso: I, D (top).

1627
The Ten O'clock Lion (Pink Jelly IV). Mar 2–May 10, 1966. Dark blue (S), light brown (S), yellow (Z), yellow-orange (Z). 25.4 × 55.9. Ed 10 (wA), 9 TI (CD), BAT (wA), 3 AP (CD), 1 PP (wA), 5 TP (wA), CP (Tcs). Kinji Akagawa, NC. Verso: D (bottom), I (center).

1685
The Sun Moves Round (Pink Jelly V). Mar 1–May 13, 1966. Dark blue (S), brown-black (S), red (Z), black (Z). 25.4 × 55.9. Ed 10 (wA), 9 TI (CD), BAT (wA), 3 AP (CD), 1 PP (wA), 5 TP (wA), CP (Tcs). Kinji Akagawa, NC. Verso: I, D (center).

1701
While We Play with the Joy of Life (Pink Jelly VI). May 7–23, 1966. Dark blue (S), red (Z), blue (Z), dark blue (S). 25.4 × 55.9. Ed 10 (wA), 9 TI (CD), BAT (wA), 3 AP (CD), 1 PP (wA), 5 TP (wA), CP (Tcs). Kinji Akagawa, NC. Verso: I, D (center).

Anni Albers

Line Involvements, a suite of seven lithographs including title page, enclosed in a wrap-around folder of white Nacre with the artist's name and the suite title on the front cover, printed at the Plantin Press, Los Angeles. The lithographs are separated with slipsheets of white Tableau paper. In order: 1115, 1098, 1111, 1113, 1117, 1116, 1118.

909
Enmeshed I. Oct 18–25, 1963. Red-brown (Z)[1], black (S). 50.8 × 68.6. Ed 20 (bA), 9 TI (nN), PrP (bA), PrP II for Irwin Hollander (bA), 6 PP (1 BFK, 5 bA), 2 TP (1 BFK, 1 nN). Robert Gardner. BS, D, S.

1. Image from run 2 transferred to plate; reversal.

911
Enmeshed II. Oct 23–25, 1963. Grey-brown (Z)[1], black (S)[2]. 43.2 × 68.6. Ed 20 (BFK), 9 TI (wA), PrP (BFK), PrP II for Irwin Hollander (BFK), 2 AP (BFK), 2 TP (wA). Robert Gardner. BS, D, S.

1. Image from 909, run 2 transferred to plate; reversal.
2. Stone held from 909, run 2. 911 differs from 909 in color, image and size. The background has been changed from a mottled to a solid color area.

1098
Untitled (Line Involvements II). Jun 2–17, 1964. Brown (S)[1], grey (Z), black (S). 50.2 × 36.8. Ed 20 (BFK), 9 TI (8 wA, 1 BFK), PrP (BFK), PrP II for Irwin Hollander (BFK), 2 AP (BFK), 2 TP (BFK). Jeff Ruocco. D, BS (Tam), S, BS (pr).

1. Image from run 3 transferred to new stone; reversal.

1111
Untitled (Line Involvements III). Jun 8–15, 1964. Green-black (Z). 36.8 × 50.2. Ed 20 (BFK), 9 TI (wA), PrP (BFK), PrP II for Irwin Hollander (BFK), 2 AP (BFK), 3 PP (wA), 3 TP (2 BFK, 1 wA). John Dowell. BS (Tam), D, S, BS (pr).

1113
Untitled (Line Involvements IV). Jun 11–24, 1964. Beige (S)[1], grey (Z)[2], black (S). 50.2 × 36.8. Ed 20 (BFK), 9 TI (wA), PrP (BFK), PrP II for Irwin Hollander (BFK), 3 AP (wA), 2 TP (BFK). Thom O'Connor. D, BS (Tam), S, BS (pr).

1. Image from run 3 transferred to new stone; reversal.
2. Plate held from 1098, run 2. 1113 differs from 1098 in color and in

image. The curvilinear image has been replaced by a curvilinear image of a more horizontal configuration.

1115
Title Page [1] (Line Involvements I). Jun 16–18, 1964. Yellow-grey (Z). 36.8 × 50.2. Ed 20 (BFK), 9 TI (wA), PrP (BFK), PrP II for Irwin Hollander (BFK), 3 AP (BFK), 3 TP (BFK). Ernest Rosenthal. Recto: I Verso: WS.

1. Typography printed at the Plantin Press, Los Angeles.

1116
Untitled (Line Involvements VI).
Jun 22–29, 1964. Black (S), black (S)[1]. 50.2 × 36.8. Ed 20 (BFK), 9 TI (wA), PrP (BFK), PrP II for Ernest Rosenthal (BFK), 2 AP (1 BFK, 1 wA), 3 TP (2 BFK, 1 wA). Thom O'Connor. D, BS, S.

1. Same stone as run 1; reversal with additions.

1117
Untitled (Line Involvements V).
Jun 23–29, 1964. Black (S)[1], black (S)[2]. 36.8 × 50.2. Ed 20 (BFK), 9 TI (wA), PrP (BFK), PrP II for Irwin Hollander (BFK), 3 AP (BFK), 2 TP (BFK). Ernest Rosenthal. D, BS, S.

1. Stone (transferred to plate for 1115) held from 1115; reversal.
2. Same stone as run 1; reversal with additions. 1117 differs from 1115 in color and in image. The curvilinear image is more distinct and the background has been filled in emphasizing the horizontal striations.

1118
Untitled (Line Involvements VII).
Jun 23–29, 1964. Black (Z)[1], black (S). 50.2 × 36.8. Ed 20 (BFK), 9 TI (wA), PrP (BFK), PrP II for Irwin Hollander (BFK), 3 AP (BFK), 2 TP (BFK). Aris Koutroulis. D, BS, S.

1. Image from run 2 transferred to plate; reversal.

Josef Albers

Day and Night/Homage to the Square, a suite of ten lithographs plus title and colophon pages, enclosed in a beige cloth covered box, measuring 50.8 × 54.3, lined with white cover paper, made by the Schuberth Bookbindery, San Francisco. Each lithograph enclosed in a chemise of white Tableau paper. During the preparation of this suite, 53 working proofs on various papers and 1 matrix

on graph paper were created. These proofs were unsigned, undesignated, unchopped, and retained by Tamarind. In order: 898, 903, 915, 919, 905, 926, 950, 946, 941, 921, 912.

Midnight and Noon, a suite of 8 Homage to the Square, a suite of eight lithographs plus title and colophon pages, enclosed in a beige cloth covered box, measuring 51.1 × 54.6, lined with white cover paper, and in a black cloth covered slipcase, measuring 53.7 × 55.9; both made by the Schuberth Bookbindery, San Francisco. The initials of the artist imprinted in grey on the spine of the box and case. Title page and colophon printed at the Plantin Press, Los Angeles. Each lithograph enclosed in a chemise of white Tableau paper. In order: 1100, 1101, 1104, 1105, 1102, 1103, 1106, 1107.

574
Interlinear N 65. May 8–Jun 1, 1962. Brown-black (S). 55.9 × 76.2. Ed 10 (BFK), 9 TI (BFK), PrP (BFK), 2 AP (BFK), 4 TP (BFK), CP (BFK). Irwin Hollander. T, D, S, Dat, BS.

576
Interliner K 50. May 10–Jun 5, 1962. Brown-black (S). 55.9 × 76.2. Ed 20 (BFK), 9 TI (BFK), PrP (BFK), 2 AP (BFK), 3 TP (BFK), CP (BFK). Irwin Hollander. T, D, S, Dat, BS.

579
Interlinear N 32 bl. May 11–Jun 6, 1962. Brown-black (S). 56.5 × 76.2. Ed 15 (BFK), 9 TI (BFK), PrP (BFK), 2 AP (BFK), 3 TP (BFK). Joe Funk. T, D, S, Dat, BS.

579A
Interlinear N 32 gr. Jun 7–11, 1962. Grey (S)[1]. 0.0 × 0.0. Ed 10 (BFK), 9 TI (BFK), PrP (BFK), 2 AP (BFK), 3 TP (BFK), CP (BFK). Bohuslav Horak. T, D, S, Dat, BS.

1. Stone held from 579; differs from 579 in color only.

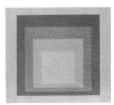

898
Untitled (Day and Night I). Oct 2–10, 1963. Dark grey (Z), light grey (Z). 47.6 × 51.8, cut. Ed 20 (BFK), 9 TI (wA), BAT (BFK), 3 AP (1 wA, 2 BFK), 2 TP (BFK). Kenneth Tyler. Recto: T (Suite), D, S, Dat Verso: WS.

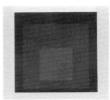

903
Untitled (Day and Night II). Oct 15–18, 1963. Black (Z), blue-grey (Z). 47.6 × 51.8, cut. Ed 20 (BFK), 9 TI (wA), BAT (BFK), PrP II for Kenneth Tyler (BFK), 3 AP (1 wA, 2 BFK), 1 PP (BFK), 2 TP (BFK). Robert Gardner. Recto: T (Suite), D, S, Dat Verso: WS.

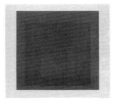

905
Untitled (Day and Night V). Oct 15–22, 1963. Blue-grey (Z), violet-grey (Z), black (Z). 47.6 × 51.8, cut. Ed 20 (BFK), 9 TI (wA), BAT (BFK), 3 AP (1 wA, 2 BFK), 2 PP (BFK), 1 TP (BFK). Kenneth Tyler. Recto: T (Suite), D, S, Dat Verso: WS.

No photograph

912
Title/Colophon Page (Day and Night XI). Oct 23–Dec 9, 1963. Black (S). 48.6 × 104.8,(title page), 8.90 × 19.10 (colophon). Ed 15 (BFK), 9 TI (BFK), BAT (BFK), 1 PP (BFK). Kenneth Tyler. Recto (title page): I, Dat Verso (colophon): WS.

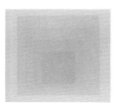

915
Untitled (Day and Night III). Oct 30–Nov 5, 1963. Light green-grey (Z), light green-grey (Z), medium green-grey (Z), dark green-grey (Z). 47.6 × 51.8,. cut. Ed 20 (BFK), 9 TI (wA), BAT (BFK), PrP II for Kenneth Tyler (BFK), 3 AP (1 BFK, 2 wA), 4 TP (1 BFK, 3 wA). John Dowell. Recto: T (Suite), D, S, Dat Verso: WS.

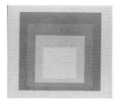

919
Untitled (Day and Night IV). Nov 6–8, 1963. Brown (Z), green-grey (Z). 48.0 × 51.8, cut. Ed 20 (BFK), 9 TI (wA), BAT (BFK), PrP II for Kenneth Tyler (BFK), 3 AP (1 BFK, 2 wA), 2 TP (BFK). Aris Koutroulis. Recto: T (Suite), D, S, Dat Verso: WS.

1. During the preparation of this suite, 53 working proofs on various papers and 1 matrix on graph paper were created. These proofs were unsigned, undesignated, unchopped, and retained by Tamarind.

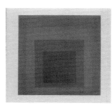

921
Untitled (Day and Night X). Nov 11–13, 1963. Brown (Z), grey (Z), violet (Z), black (Z). 47.6 × 51.8, cut. Ed 20 (BFK)[1], 9 TI (wA), BAT (BFK), 3 AP (wA), 2 PP (BFK)[1], 3 TP (wA). Kenneth Tyler. Recto: T (Suite), D, S, Dat Verso: WS.

1. Ed 16–20/20, 2 PP on paper slightly smaller than edition. Exact dimensions unrecorded.

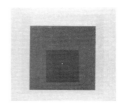

926
Untitled (Day and Night VI). Nov 14–22, 1963. Light grey (Z), black (Z), green grey (Z). 48.0 × 51.8, cut. Ed 20 (BFK), 9 TI (wA), BAT (BFK), 3 AP (wA), 2 TP (BFK). Kenneth Tyler. Recto: T (Suite), D, S, Dat Verso: WS.

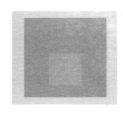

941
Untitled (Day and Night IX). Nov 26–Dec 2, 1963. Light brown (Z), light green (Z). 47.6 × 51.8, cut. Ed 20 (BFK), 9 TI (wA), BAT (BFK), 3 AP (1 BFK, 2 wA), 2 TP (BFK). Kenneth Tyler. Recto: T (Suite), D, S, Dat Verso: WS.

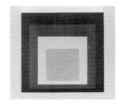

946
Untitled (Day and Night VIII). Dec 3–4, 1963. Black (Z), light grey (Z), green-grey (Z). 47.6 × 51.8, cut. Ed 20 (BFK), 9 TI (wA), BAT (BFK), 3 AP (1 wA, 2 BFK), 2 TP (BFK). Kenneth Tyler. Recto: T (Suite), D, S, Dat Verso: WS.

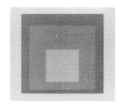

950
Untitled (Day and Night VII). Dec 5–7, 1963. Blue-grey (Z), light grey (Z). 48.0 × 51.8, cut. Ed 20 (BFK), 9 TI (wA), BAT (BFK), 3 AP (1 BFK, 2 wA), 2 TP (BFK). Kenneth Tyler. Recto: T (Suite), D, S, Dat Verso: WS.

1100
Untitled (Midnight and Noon I). Jun 11–18, 1964. Black (Z), black (Z). 48.0 × 52.1, cut. Ed 20 (wA), 9 TI (wA), PrP (wA), PrP II for Kenneth Tyler (wA), 3 AP (wA), 4 TP (wA). Aris Koutroulis. Recto: T (Suite), D, S, Dat Verso: WS.

1101
Untitled (Midnight and Noon II). Jun 16–18, 1964. Black (Z), grey (Z). 48.0 × 52.1,. cut. Ed 20 (wA), 9 TI (wA), PrP (wA), PrP II for Kenneth Tyler (wA), 2 AP (wA), 2 TP (wA). Aris Koutroulis. Recto: T (Suite), D, S, Dat Verso: WS.

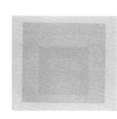

1102
Untitled (Midnight and Noon V). Jun 18–22, 1964. Light yellow (Z), yellow (Z). 48.0 × 52.1, cut. Ed 20 (wA), 9 TI (wA), PrP (wA), PrP II for Kenneth Tyler (wA), 3 AP (wA), 1 PP (wA), 2 TP (wA). Thom O'Connor. Recto: T (Suite), D, S, Dat Verso: WS.

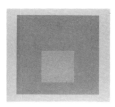

1103
Untitled (Midnight and Noon VI).
Jun 22–24, 1964. Yellow-ochre (Z),
light yellow-ochre (A). 48.0 × 52.1,
cut. Ed 20 (wA), 9 TI (wA), PrP (wA),
PrP II for Kenneth Tyler (wA), 3 AP
(wA), 3 TP (wA). Robert Gardner.
Recto: T (Suite), D, S, Dat Verso: WS.

1104
Untitled (Midnight and Noon III).
Jun 22–27, 1964. Green-black (Z), light
green-black (Z). 48.0 × 52.1, cut. Ed
20 (wA), 9 TI (wA), PrP (wA), PrP II for
Kenneth Tyler (wA), 3 AP (wA), 3 TP
(wA). John Dowell. Recto: T (Suite), D,
S, Dat Verso: WS.

1105
Untitled (Midnight and Noon IV).
Jun 23–29, 1964. Blue-black (A), light
blue-black (Z). 48.3 × 52.1, cut. Ed 20
(wA), 9 TI (wA), PrP (wA), PrP II for
Thom O'Connor (wA), 3 AP (wA), 3 PP
(wA), 4 TP (wA). Kenneth Tyler. Recto:
T (Suite), D, S, Dat Verso: WS.

1106
Untitled (Midnight and Noon VII).
Jun 25–29, 1964. Yellow (A), light
yellow (Z). 48.3 × 52.1, cut. Ed 20
(wA), 9 TI (wA), PrP (wA), PrP II for
Kenneth Tyler (wA), 3 AP (wA), 2 PP
(wA), 3 TP (wA). John Dowell. Recto:
T (Suite), D, S, Dat Verso: WS.

1107
Untitled (Midnight and Noon VIII).
Jun 23–25, 1964. Yellow (A), light
yellow (Z). 48.3 × 52.1, cut. Ed 20
(wA), 9 TI (wA), PrP (wA), PrP II
(wA)[1], 3 AP (wA), 4 TP (wA). Kenneth
Tyler. Recto: T (Suite), D, S, Dat Verso:
WS.

1. Recipient not recorded.

Glen Alps

254
Untitled. Mar 28–29, 1961. Black (S).
38.7 × 53.7. Ed 20 (BFK), 9 TI (wN),
PrP (BFK), 2 AP (1 wN, 1 BFK), 3 TP (1
wN, 2 BFK), CP (BFK). Garo Z.
Antreasian. BS (pr), D, S, Dat, BS
(Tam).

255
Untitled. Mar 29–30, 1961. Black (Z).
38.1 × 52.7. Ed 20 (BFK), 9 TI (wN),
PrP (BFK), 2 AP (1 wN, 1 BFK), 2 TP (1
wN, 1 BFK). Garo Z. Antreasian. D, S,
Dat, BS.

257
Untitled. Mar 30–31, 1961. Black (S).
76.8 × 56.8. Ed 20 (bA), 9 TI (nN), PrP
(bA), 5 AP (1 nN, 4 bA). Garo Z.
Antreasian. BS (pr), D, S, Dat, BS
(Tam).

258
Untitled. Apr 3, 1961. Black (S). 56.8
× 76.8. Ed 20 (bA), 9 TI (nN), PrP (bA),
4 AP (2 nN, 2 bA), CP (bA). Joe Funk.
BS (pr), D, S, Dat, BS (Tam).

265
T-7. Apr 4–12, 1961. Ochre (Z), dark
ochre (S). 77.5 × 57.2. Ed 20 (wA), 9
TI (wN), PrP (wA), 5 AP (3 wN, 2 wA).
Bohuslav Horak. BS (pr), D, S, T, Dat,
BS (Tam).

265A
T-6. Apr 4–12, 1961. Grey (S)[1]. 77.5
× 57.2. Ed 10 (wA), 9 TI (wN), PrP
(wA), 2 AP (1 wN, 1 wA). Bohuslav
Horak. BS (pr), D, S, T, Dat, BS (Tam).

1. Stone held from 265, run 2. 265A
 differs from 265 in color and in
 image. The background tonal area
 has been eliminated.

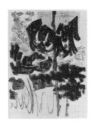

266
T-8. Apr 4–14, 1961. Black (S), dark
grey-violet (S). 77.2 × 56.8. Ed 20
(bA), 9 TI (nN), PrP (nN), 4 AP (1 nN, 3
bA), 7 TP* (bA), CP (bA). Bohuslav
Horak. BS (pr), D, S, T, Dat, BS (Tam).

Print not in
University Art Museum
Archive

271
Untitled. Apr 11, 1961. Black (S). 38.7
× 48.9. Ed 12 (BFK), 9 TI (wN), PrP
(BFK), 1 AP (nN). Garo Z. Antreasian.
BS (pr), D, S, Dat, BS (Tam).

275
T-9. Apr 12–17, 1961. Black (S). 56.8
× 76.8. Ed 20 (bA), 9 TI (nN), PrP (bA),
5 AP (2 nN, 3 bA), CP (bA). Bohuslav
Horak. BS (pr), D, S, Dat, BS (Tam).

280
Untitled. Apr 25, 1961. Violet (Z), blue (Z), black (S). 57.2 × 77.2. Ed 20 (bA)[1], 9 TI (nN), PrP (bA), 5 AP (3 nN, 2 bA), 2 TP (bA), CP* (bA). Bohuslav Horak. BS (Tam), D, S, BS (pr).

1. Designated only as "Ed. 20".

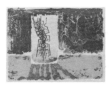

281
T-11. Apr 19–28, 1961. Dark beige (S), green-black (S). 38.7 × 52.1. Ed 20 (BFK)[1], 9 TI (wN), PrP (BFK), 5 AP (3 wN, 2 BFK), CP (BFK). Bohuslav Horak. BS (Tam), D, S, T, BS (pr).

1. Designated only as "Ed. 20".

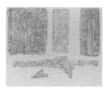

283
Untitled. Apr 26–May 3, 1961. Red-brown (S), ochre (S), blue-green (S)[1]. 38.7 × 52.7. Ed 20 (BFK)[2], 9 TI (wN), PrP (BFK), 5 AP (3 wN, 2 BFK), 1 CSP (BFK). Bohuslav Horak. BS (Tam), D, S, BS (pr).

1. Same stone as run 1; additions.
2. Designated only as "Ed. 20".

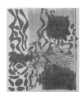

287
Untitled. May 1–16, 1961. Grey-violet (S), yellow (S), red-brown (S). 56.8 × 38.7. Ed 20 (BFK)[1], 9 TI (wN), PrP (BFK), 5 AP (2 wN, 3 BFK). Joe Funk. BS (Tam), D, S, BS (pr).

1. Designated only as "Ed. 20".

288
Untitled. May 7–11, 1961. Green-ochre (Z), yellow (Z), green (S). 76.8 × 57.2. Ed 20 (BFK)[1], 9 TI (wN), PrP (BFK), 5 AP (3 wN, 2 BFK), 1 TP (BFK), 2 rough proofs (offset paper).

1. Designated only as "Ed. 20".

293
Untitled. May 15–25, 1961. Blue-grey (S), blue (S), violet (S), orange-ochre (S), dark blue (S). 57.2 × 76.8. Ed 20 (BFK), 9 TI (wN), PrP (BFK), 5 AP (BFK). Garo Z. Antreasian. BS (Tam), D, S, BS (pr).

295
Untitled. May 16–24, 1961. Green-grey (Z), black (S). 77.2 × 57.2. Ed 20 (BFK), 9 TI (wN), PrP (BFK), 2 AP (wN), 1 TP (BFK), 3 PgP (2 BFK, 1 wN), CP* (BFK). Bohuslav Horak. BS (Tam), D, S, BS (pr).

Print not in
University Art Museum
Archive

Harold Altman

Untitled Suite, a suite of eleven lithographs. In order: 430, 434, 440, 445, 447, 448, 450, 458, 459, 463, 464.

401
Woman. Sep 29–Oct 6, 1961. Light brown (S). 57.2 × 76.8. Ed 20 (bA), 9 TI (nN), PrP (bA), 2 AP (1 bA, 1 nN), 3 TP (2 bA, 1 BFK[1]), CP (bA). Harold Keeler. D, S, BS.

1. 1 TP has the same image printed in black on the verso.

403
Figures. Oct 1–5, 1961. Brown (S). 28.6 × 38.7. Ed 20 (bA), 9 TI (nN), PrP (bA), 2 AP (1 bA, 1 nN), 2 TP (bA), CP (Tcs). Joe Funk. D, BS (Tam), S, BS (pr).

406
Face to Face. Oct 6–9, 1961. Brown (Z). 56.8 × 75.6. Ed 20 (BFK), 9 TI (wA), PrP (BFK), 1 TP (BFK), CP (BFK). Emiliano Sorini. D, S, BS.

407
Untitled. Oct 5–11, 1961. Black (S). 73.4 × 93.3,(BFK), 66.0 × 101.0 (Tcs), torn and cut. 4 ExP (2 BFK[1], 2 Tcs). Emiliano Sorini. BS, S.

1. 2 ExP (BFK) printed on recto and verso, undesignated. 1 ExP retained by Tamarind.

311
Matriarch I. Jun 8, 1961. Black (S). 38.1 × 53.3. Ed 12 (wA), 9 TI (7 BFK, 2 CW), 2 AP (wA), 3 TP (1 BFK, 2 bA). Garo Z. Antreasian. BS, D, S.

311A
Matriarch II. Jun 8–12, 1961. Black (S)[1]. 38.1 × 53.3. Ed 12 (wA), 9 TI (BFK), PrP (BFK)[2], 2 AP (wA), 2 TP (BFK). Garo Z. Antreasian. BS, D, S.

1. Stone held from 311; additions and deletions. 311A differs from 311 in image. Additions and deletions have been made to the lower part of the body of the central figure eliminating one leg and filling in the Shading has been added filling in the head.
2. Unsigned.

312
Figure in Foliage. Jun 9, 1961. Black (S). 38.1 × 53.3. Ed 10 (wA), 9 TI (BFK), 3 AP (2 BFK, 1 wA), 2 TP (1 BFK, 1 wA). Garo Z. Antreasian. BS, D, S.

412A
Mother and Child. Oct 12–13, 1961. Black (Z). 57.2 × 79.7,(CW), 55.9 × 76.2 (BFK). Ed 50 (20 BFK, 30 nr)[1], 9 TI (CW), PrP (BFK), 2 AP (BFK), 1 TP (BFK). Emiliano Sorini. S, D, BS.

1. Ed 21–50/50 were printed by the Kanthos Press and do not bear Tamarind's chop.

415
Seated Woman. Oct 13–17, 1961. Brown (Z). 57.8 × 80.6,(CW), 55.9 × 76.2 (BFK). Ed 50 (20 BFK, 30 nr)[1], 9 TI (CW), PrP (BFK), 3 TP (BFK). Emiliano Sorini. D, S, BS.

1. Ed 21–50/50 were printed by the Kanthos Press and do not bear Tamarind's chop.

422
Park Bench. Oct 18–27, 1961. Blue-grey (Z), dark grey (Z). 56.8 × 75.6. Ed 50 (20 BFK, 30 nr)[1], 9 TI (wA), PrP (BFK), 2 AP (BFK), 1 TP (BFK). Emiliano Sorini. D, T, S, BS.

1. Ed 21–50/50 were printed by the Kanthos Press and do not bear Tamarind's chop.

429
Conversation II[1]. Oct 24–25, 1961. Brown (Z). 27.9 × 66.0. Ed 200 (20 BFK, 180 nr)[2], 9 TI (wA), PrP (BFK), 1 AP (BFK), 1 TP (BFK). Emiliano Sorini. D, S, BS.

1. Commissioned by the Society of American Graphic Arts. 2. Ed 21–200/200 were printed by the Kanthos Press and do not bear Tamarind's chop.

430
Figure and Foliage (Untitled Suite I). Oct 26–Nov 10, 1961. Pink (Z), green (Z), blue (Z). 56.5 × 75.9. Ed 50 (20 BFK, 30 nr)[1], 9 TI (wA), PrP (BFK), 1 AP (BFK). Emiliano Sorini. S, D, BS.

1. Ed 21–50/50 were printed by the Kanthos Press and do not bear Tamarind's chop.

432
Man. Oct 30–Nov 9, 1961. Brown (Z). 36.2 × 48.9. Ed nr (20 BFK, nr)[1], 9 TI (wA), PrP (BFK), 2 AP (1 BFK, 1 wA), 3 TP (BFK). Joe Funk. S, D, BS.

1. The artist intended to print a larger edition under contract with Kanthos Press, exact number not recorded. The artist's edition bearing the

Tamarind chop is numbered 1–20 without accompanying number indicating edition size.

434
Reader (Untitled Suite II). Oct 30–Nov 2, 1961. Orange (Z), blue (Z). 56.5 × 75.9. Ed 50 (20 BFK, 30 nr)[1], 9 TI (wA), PrP (BFK), 2 AP (1 BFK, 1 wA). Emiliano Sorini. S, D, BS.

1. Ed 21–50/50 were printed by the Kanthos Press and do not bear Tamarind's chop.

435
Standing Mother and Child. Oct 30–Nov 8, 1961. Grey (Z), brown (Z). 76.2 × 56.5. Ed 50 (20 BFK, 30 nr)[1], 9 TI (wA), PrP (BFK), 1 AP (BFK), 2 TP (1 BFK, 1 wA). Emiliano Sorini. S, D, BS.

1. Ed 21–50/50 were printed by the Kanthos Press and do not bear Tamarind's chop.

440
Man II (Untitled Suite III). Nov 7–20, 1961. Brown (Z), blue (Z). 56.8 × 75.9. Ed 50 (20 BFK, 30 nr)[1], 9 TI (wA), PrP (BFK), 1 AP (BFK), 1 TP (BFK). Emiliano Sorini. S, D, BS.

1. Ed 21–50/50 were printed by the Kanthos Press and do not bear Tamarind's chop.

445
Park Conversation (Untitled Suite IV). Nov 8–14, 1961. Green (Z), red-brown (Z). 56.5 × 75.9. Ed 50 (20 BFK, 30 nr)[1], 9 TI (wA), 2 TP (BFK), CP* (BFK). Emiliano Sorini. S, D, BS.

1. Ed 21–50/50 were printed by the Kanthos Press and do not bear Tamarind's chop.

447
Approaching Figure (Untitled Suite V). Nov 10–22, 1961. Blue-green (Z), blue (Z). 56.5 × 75.9. Ed 50 (20 BFK, 30 nr)[1], 9 TI (wA), PrP (BFK), 1 AP (BFK), 1 TP (BFK). Emiliano Sorini. S, D, BS.

1. Ed 21–50/50 were printed by the Kanthos Press and do not bear Tamarind's chop.

448
Yellow Dress (Untitled Suite VI). Nov 14–21, 1961. Yellow (Z), grey (Z). 56.5 × 75.9. Ed 50 (20 BFK, 30 nr)[1], 9 TI (wA), PrP (BFK), 1 AP (BFK), 1 TP (BFK). Emiliano Sorini. S, D, BS.

1. Ed 21–50/50 were printed by the Kanthos Press and do not bear Tamarind's chop.

450
Figure and Foliage II (Untitled Suite VII). Nov 15–23, 1961. Brown-grey (Z). 56.5 × 75.6. Ed 50 (20 BFK, 30 nr)[1], 9 TI (wA), PrP (BFK), 2 AP (BFK), 2 TP (wA). Emiliano Sorini. S, D, BS.

1. Ed 21–50/50 were printed by the Kanthos Press and do not bear Tamarind's chop.

458
Street with Figures (Untitled Suite VIII). Nov 21–Dec 1, 1961. Green (Z), blue (Z). 56.5 × 75.9. Ed 50 (20 BFK, 30 nr)[1], 9 TI (wA), PrP (BFK), 2 AP (1 BFK, 1 wA), 2 TP (BFK). Emiliano Sorini. S, D, BS.

1. Ed 21–50/50 were printed by the Kanthos Press and do not bear Tamarind's chop.

459
Profile (Untitled Suite IX). Nov 23–Dec 8, 1961. Pink (Z), grey (Z), blue (Z). 56.5 × 75.9. Ed 50 (20 BFK, 30 nr)[1], 9 TI (wA), PrP (BFK), 3 AP (2 BFK, 1 wA), 1 TP (BFK). Emiliano Sorini. S, D, BS.

1. Ed 21–50/50 were printed by the Kanthos Press and do not bear Tamarind's chop.

463
Market Street (Untitled Suite X). Nov 22–27, 1961. Blue (Z). 56.5 × 75.9. Ed 50 (20 BFK, 30 nr)[1], 9 TI (wA), PrP (BFK), 2 AP (BFK), 1 TP (wA). Emiliano Sorini. S, D, BS.

1. Ed 21–50/50 were printed by the Kanthos Press and do not bear Tamarind's chop.

464
Park Figure (Untitled Suite XI). Nov 27–Dec 6, 1961. Pink (Z), green (Z), blue (Z). 56.5 × 75.9. Ed 50 (20 BFK, 30 nr)[1], 9 TI (wA), PrP (BFK), 2 AP (1 BFK, 1 wA), 1 TP (BFK). Emiliano Sorini. S, D, BS.

1. Ed 21–50/50 were printed by the Kanthos Press and do not bear Tamarind's chop.

John Altoon

1328
Untitled. Apr 28–30, 1965. Black (S). 56.8 × 76.2. Ed 20 (BFK), 9 TI (wA), BAT (BFK), 2 AP (BFK), 2 TP (BFK). Kenneth Tyler. BS, D, S.

1329[1]
Untitled. Apr 28–May 4, 1965. Orange (A), blue (Z), pink (Z), black (S). 56.8 × 76.2. Ed 20 (BFK), 9 TI (wA), BAT (BFK), 2 AP (wA), 4 TP (BFK), CP (Tcs). Kenneth Tyler. BS, D, S.

1. This number also inadvertently assigned to James Strombotne.

1330
Untitled. Apr 29–May 3, 1965. Yellow (A), blue (A), pink (A), black (S)[1]. 56.5 × 76.2. Ed 20 (BFK), 9 TI (wA), BAT (BFK), 3 AP (wA), 4 TP (BFK), CP (Tcs). Kenneth Tyler. BS, D, S.

1. Stone held from 1328. 1330 differs from 1328 in color and in image. The linear image has been filled in with color accents.

1333
Untitled. May 4–12, 1965. Black (S). 56.8 × 76.2. Ed 20 (BFK), 9 TI (wA), BAT (BFK), 1 AP (wA), 2 TP (1 BFK, 1 Tcs). Kenneth Tyler. BS, D, S, Dat.

1352
Untitled. May 12, 1965. Brown (S). 57.2 × 76.8. Ed 20 (bA), 9 TI (nN), BAT (bA), 1 AP (nN), 2 TP (bA)[1], CP (Tcs). Kenneth Tyler. BS, D, S, Dat.

1. 1 TP varies from the edition.

1354
Untitled. May 13–18, 1965. Black (S)[1], yellow (Z), blue (Z), red-violet (Z). 56.8 × 76.2. Ed 20 (BFK), 9 TI (wA), BAT (BFK), 3 AP (wA), 1 PP (BFK), 4 TP (3 BFK, 1 Tcs*), CP (Tcs). Kenneth Tyler. BS, D, S, Dat.

1. Stone held from 1333. 1354 differs from 1333 in color and in image. The linear image has been filled in with color accents.

2180
Untitled. Jan 5–12, 1968. Silver (S), green, light violet, pink (A), orange (A), violet (A). 56.8 × 76.2. Ed 20 (BFK), 9 TI (wA), BAT (BFK), 3 AP (2 wA, 1 BFK), 2 TP (BFK)[1], CP* (wA). David Folkman. D, S, Dat, BS.

1. 1 TP varies from the edition.

2181
Untitled. Jan 5–15, 1968. Light beige (A), gold, light blue-green, dark pink (A), blue (A). 56.8 × 76.5. Ed 20 (BFK), 9 TI (wA), BAT (BFK), 3 AP (1 BFK, 2 wA), 1 TP (BFK), CP (BFK). Manuel Fuentes. Verso: WS, D, S, Dat.

2183
Untitled. Jan 10–16, 1968. Light blue
(Z), light violet, orange, yellow-green
(Z), red (Z). 56.8 × 76.2. Ed 20 (BFK),
9 TI (wA), BAT (BFK), 3 AP (wA), 1 TP
(BFK), CP (BFK). Serge Lozingot. D, S,
Dat, BS.

2184
Untitled. Jan 11–25, 1968. Yellow (A),
violet (A), red (A), blue (A), green (A),
blue (A). 55.9 × 76.2. Ed 20 (wA), 9 TI
(GEP), BAT (wA), 3 AP (1 wA, 2 GEP),
CP (wA). Robert Rogers. Verso: D, S,
Dat, BS.

2185
Untitled. Jan 11–23, 1968. Pink (A),
light yellow (A), light green, yellow-
green (A), blue-green (A). 57.2 × 76.2.
Ed 20 (BFK), 9 TI (GEP), BAT (wA), 3
AP (1 wA, 2 GEP), 2 TP (wA)[1], CP
(wA). Anthony Stoeveken. Verso: D, S,
Dat, WS.

1. 1 TP varies from the edition.

2186
Untitled.[1] Jan 11–19, 1968. Yellow-
green (A), pink (A). 56.8 × 76.8. Ed 20
(wA), 9 TI (GEP), BAT (wA), 3 AP (wA),
CP (BFK). Maurice Sanchez. D, S, Dat,
BS.

1. The artist informed Tamarind in
 1968 that the impressions in his
 possession had been destroyed.

2187
Untitled. Jan 13–31, 1968. Light
green (A), blue, yellow, brown (A),
black (A). 55.2 × 76.2,(CD), 56.5 ×
80.6 (GEP). Ed 20 (GEP), 9 TI (CD), BAT
(GEP), 3 AP (GEP), 2 TP* (GEP), CP
(GEP). David Folkman. D, S, Dat, BS.

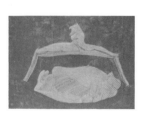

2188
Untitled. Jan 16–Feb 10, 1968. Pink
(Z), light blue-green (A), light blue (A),
violet (A), orange (Z), green (A). 56.8
× 76.5. Ed 20 (wA), 9 TI (GEP), BAT
(wA), 3 AP (1 wA, 2 GEP), 1 TP* (wA),
CP (wA). Robert Rogers. BS, D, S, Dat.

2189
Untitled. Jan 16–25, 1968. Orange
(Z), ochre (Z), blue (Z), red (Z). 56.8 ×
76.5. Ed 20 (wA), 9 TI (GEP), BAT (wA),
3 AP (2 wA, 1 GEP), CP (wA). Manuel
Fuentes. BS, D, S, Dat.

2190
Untitled. Jan 22–30, 1968. Pink (Z),
yellow, blue (Z), light blue-green (Z),
silver (Z), violet (Z). 55.6 × 76.2. Ed 20
(wA), 9 TI (CD), BAT (wA), 3 AP (1 CD,
2 wA), 1 TP (wA), CP (wA). Serge
Lozingot. BS, D, S, Dat.

2191
Untitled. Jan 25–Feb 1, 1968. Yellow
(A), light blue-green (A), violet (A),
dark green (A). 57.2 × 76.2. Ed 20
(wA), 9 TI (GEP), BAT (wA), 7 AP (3
GEP, 4 wA), 1 TP (wA), CP (wA).
Anthony Stoeveken. Verso: WS, D, S,
Dat.

2192
Untitled. Jan 29–Feb 12, 1968. Yellow
(Z), blue (Z), red (Z), light green (Z).
55.2 × 76.2,(CD), 56.5 × 76.2 (wA) Ed
20 (wA), 9 TI (CD), BAT (wA), 2 AP
(CD), 1 TP* (wA), 5 CTP (4 wA, 1 bA),
CP* (wA). Maurice Sanchez. Recto: BS
Verso: D, S, Dat.

2193
Untitled. Jan 31–Feb 13, 1968. Pink
(Z), orange (Z), green (Z), blue (Z),
brown (Z). 55.2 × 76.2,(CD), 56.50 ×
76.20 (wA). Ed 20 (wA), 9 TI (CD), BAT
(wA), 3 AP (1 wA, 2 CD), 2 TP* (wA),
CP (wA). Serge Lozingot. Recto: BS
Verso: D, S, Dat.

2213
Untitled. Feb 5–19, 1968. Gold (Z),
green (A), blue (S). 57.2 × 76.2. Ed 20
(wA), 9 TI (GEP), BAT (wA), 3 AP (2
GEP, 1 wA), 1 TP (wA), 1 CTP (wA).
Anthony Stoeveken. Verso: WS, D, S,
Dat.

2213II
Untitled. Feb 7–19, 1968. Pink (Z)[1],
gold (A)[2], blue (S)[3]. 57.8 × 76.2.
Ed 10 (wA), 9 TI (GEP), BAT (wA), 4 AP
(2 wA, 2 GEP), CP (wA). Anthony
Stoeveken. Verso: WS, D, S, Dat.

1. Plate held from 2213, run 1.
2. Plate held from 2213, run 2.
3. Stone held from 2213, run 3. 2213II
 differs from 2213 in color only.

2214
Untitled. Feb 13–22, 1968. Gold,
violet, yellow-green (Z), pink (Z), silver
(Z), black (Z). 55.2 × 76.5,(CD), 56.5 ×
76.2 (wA). Ed 20 (wA), 9 TI (CD), BAT
(wA), 2 AP (CD), CP (wA). Serge
Lozingot. Verso: D, S, Dat, WS.

2218
Untitled. Feb 16–21, 1968. Blue-black
(A). 57.2 × 77.5. Ed 20 (wN), 9 TI (nN),
BAT (wN), 3 AP (wN), CP (wN). Robert
Rogers. D, S, Dat, BS.

2220
Untitled. Feb 21–23, 1968. Blue (S).
55.6 × 76.2. Ed 20 (wA), 9 TI (ucR),
BAT (wA), 3 AP (1 ucR, 2 wA), 1 TP*
(wA), CP (ucR). Theodore Wujcik.
Verso: WS, D, S, Dat.

2221
Untitled. Feb 22–26, 1968. Brown (Z).
55.9 × 76.2. Ed 20 (wA), 9 TI (cR), BAT
(wA), 3 AP (1 ucR, 2 wA), CP (wA).
Serge Lozingot. Verso: WS, D, S, Dat.

2222
Untitled. Feb 23–26, 1968. Brown (A).
57.8 × 76.2. Ed 20 (JG), 9 TI (CW),
BAT (JG), 3 AP (2 JG, 1 CW), 1 TP
(JG), CP (CW). David Folkman. D, S,
Dat, BS.

Garo Z. Antreasian

Fragments, a suite of fourteen
lithographs plus title and colophon
pages, enclosed in a beige cloth
covered box, measuring 23.2 × 40.6,
lined with white cover paper, made by
the Schuberth Bookbindery, San
Francisco. In order: 240, 198, 211, 220,
238, 222, 221, 181, 226, 208, 175, 235,
227, 243.

Tokens, a suite of ten lithographs
including title and colophon pages,
enclosed is a black covered portfolio,
measuring 80.8 × 59.7, lined with
Rives BFK paper, made by the
Schuberth Bookbindery, San
Francisco. In order: 309, 306, 277, 246,
253, 247, 274, 273, 206A, 299.

Quantum, a suite of eleven
lithographs including title page and
colophon. The entire suite was printed
at the University of New Mexico, but
does not bear its chop. Errata:
Reference on colophon to German
Etching should read Copperplate
Deluxe. In order: 1723, 1523, 1515,
1525, 1522, 1719, 1717, 1516, 1524,
1720, 1722.

Silver Suite, a suite of eleven
lithographs including title and
colophon pages. The entire suite was
printed at the University of New
Mexico but does not bear its chop. In
order: 2253, 1733, 1729, 1736, 1737,
1734, 1738, 2252, 2251, 2254.

Octet, a suite of ten lithographs
including title and colophon pages.
The entire suite was printed at the
University of New Mexico but does
not bear its chop. In order: 2270,
2266, 2262, 2260, 2267, 2264, 2263,
2269, 2261, 2271.

106
The Sea. Jul 15–Aug 5, 1960. Brown-
green (S), brown (S), blue-green (S),
ochre (S), blue-black (S), grey (S). 75.9
× 106.0. Ed 16 (CD)[1], 3 CPgP (CD).
Garo Antreasian. BS (Tam), T, D, BS
(pr), S, Dat.

1. Designated in roman numerals. Ed
 8 retained by Tamarind.

112
Specimen. Aug 10–24, 1960. Dark
beige (S), dark brown (S), red-brown
(S)[1], light grey (S), grey (S). 57.2 ×
76.8. Ed 18 (BFK), 9 TI (4 wN, 5 BFK), 3
AP (2 W, 1 BFK). Garo Z. Antreasian.
BS (Tam), D, S, Dat, BS (pr).

1. Same stone as run 2; additions.

119
The Land. Sep 4–21, 1960. Light
brown (S), dark ochre (S)[1], brown
(S)[2], yellow-green (S), orange-yellow
(S), light yellow-green (S), red-brown
(S), light yellow (S), dark brown (S),
yellow-orange, blue (S). 75.5 ×
107.3,(CD), 74.9 × 105.3 (BFK). Ed 20
(CD), 9 TI (BFK). Garo Z. Antreasian.
BS (Tam), D, T, S, Dat, BS (pr).

1. Same stone as run 1; deletions.
2. Same stone as run 2; deletions.

119A
Sea Wake. Sep 14–16, 1960. Green-
black (S)[1]. 75.6 × 107.3,(CD), 74.9 ×
105.3 (BFK). Ed 15 (CD), 9 TI (BFK), 1
AP (BFK), 3 TP (BFK). Garo Z.
Antreasian. D, BS (Tam), T, S, Dat, BS
(pr).

1. Stone held from 119, run 3;
 deletions, additions. 119A differs
 from 119 in color and in image. The
 transparent light textural tones over
 the dark lower three-fourths and the
 upper one-fourth of the image have
 been eliminated. The dark lower
 three-fourths of the image has been
 lightened and the texture increased
 throughout. The upper one-fourth of
 the image has been filled as a solid
 dark tone.

Print not in
University Art Museum
Archive

134
Arabic Script.[1] Oct 1, 1960. Silver-violet (S), transparent blue (S), blue (S), light transparent green (S) with gold leaf, embossed. Unknown. 8 TP (BFK)[2]. Garo Antreasian.

1. The artist informed Tamarind in 1973 that all the impressions in his possession were destroyed.
2. 4 TP with gold leaf, 4 TP without gold leaf.

208
Untitled (Fragments X). Jan 16–18, 1961. Black (S), green-black (S), black (S). 45.7 × 37.5. Ed 12 (wA), 9 TI (BFK), 2 AP (1 BFK, 1 wA), 2 TP (1 BFK, 1 wA). Garo Z. Antreasian. BS (Tam), D, S, Dat, BS (pr).

151
Breakwater. Nov 3, 1960–Jan 9, 1961. Light blue (S), yellow-green (S), white (S), dark blue-green (S), blue (S), white (S), dark green (S), red, orange, blue (S), white (S), blue-green (S). 75.6 × 107.3,(C), 74.9 × 105.4 (BFK). Ed 18 (C), 9 TI (BFK), 3 AP (2 BFK, 1 C), 1 TP (BFK). Garo Z. Antreasian. BS (Tam), D, S, Dat, BS (pr).

211
Untitled (Fragments III). Jan 18–23, 1961. Dark transparent green (S), transparent green (S). 45.7 × 37.5. Ed 12 (wA), 9 TI (BFK), 2 AP (1 BFK, 1 wA), 3 TP (2 BFK, 1 wA). Garo Z. Antreasian. BS (Tam), D, S, Dat, BS (pr).

175
Untitled (Fragments XI). Dec 11–18, 1960. Dark brown (S). 45.7 × 37.5. Ed 12 (wA), 9 TI (BFK), 2 AP (wA), 6 TP (1 BFK, 2 wA, 3 lightweight R*), CP (wN). Garo Z. Antreasian. BS (Tam), D, S, Dat, BS (pr).

220
Untitled (Fragments IV). Jan 26–27, 1961. Dark brown (S). 45.7 × 38.1. Ed 12 (wA), 9 TI (BFK), 3 AP (1 BFK, 2 wA), 3 TP (2 BFK, 1 wA). Garo Z. Antreasian. BS (Tam), D, S, Dat, BS (pr).

181
Untitled (Fragments VIII). Dec 16, 1960. Black (Z). 45.7 × 38.1. Ed 12 (wA), 9 TI (BFK), 2 AP (BFK), 2 TP (wA), CP (wN). Garo Z. Antreasian. D, BS, S, Dat.

221
Untitled (Fragments VII). Jan 27–28, 1961. Blue-black (S). 45.7 × 37.8. Ed 12 (wA), 9 TI (BFK), 2 AP (BFK), 3 TP (1 BFK, 2 wA). Garo Z. Antreasian. BS (Tam), D, S, Dat, BS (pr).

Print not in
University Art Museum
Archive

197
Untitled. Jan 1–8, 1961. Black (S), embossed. 38.1 × 28.3. Ed 8 (wA)[1], 3 AP (2 BFK[2], 1 wA), 2 TP (1 BFK, 1 wA)[2], 2 FSP (wA). Garo Antreasian. BS (Tam), D, S, Dat, BS (pr).

1. Designated in roman numerals. Ed 4 retained by Tamarind. 2. 1 AP (BFK) and 1 TP (wA) retained by Tamarind.

222
Untitled (Fragments VI). Jan 26–29, 1961. Red-black (S). 45.4 × 37.5. Ed 12 (wA), 9 TI (BFK), 2 AP (1 BFK, 1 wA), 3 TP (BFK). Garo Z. Antreasian. BS (Tam), D, S, Dat, BS (pr).

198
Untitled (Fragments II). Jan 1–6, 1961. Black (S). 46.1 × 37.2. Ed 12 (wA), 9 TI (BFK), 6 AP (4 BFK, 2 wA), 1 SP (BFK), CP (wA). Garo Z. Antreasian. BS (Tam), D, S, Dat, BS (pr).

226
Untitled (Fragments IX). Feb 1–2, 1961. Yellow (S), ochre (S)[1]. 45.7 × 37.5. Ed 12 (wA), 9 TI (BFK), 2 AP (1 BFK, 1 wA), 2 TP (1 BFK, 1 wA). Garo Z. Antreasian. BS (Tam), D, S, Dat, BS (pr).

1. Same stone as run 1; reversal.

227
Untitled (Fragments XIII). Feb 3–26, 1961. Beige (S), dark blue-grey (S), black (S), red (S), papier collé and gold leaf. 46.1 × 37.5. Ed 12 (wA), 9 TI (BFK), 3 AP (1 BFK, 2 wA), 4 TP (2 BFK, 2 wA). Garo Z. Antreasian. BS (Tam), D, S, Dat, BS (pr).

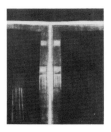

235
Untitled (Fragments XII). Feb 13–15, 1961. Black (S). 45.7 × 37.5. Ed 12 (wA), 9 TI (BFK), 3 AP (1 BFK, 2 wA), 1 TP (wA). Garo Z. Antreasian. BS (Tam), D, S, Dat, BS (pr).

238
Untitled (Fragments V). Feb 17–24, 1961. Dark blue (S). 45.7 × 37.5. Ed 12 (wA), 9 TI (BFK), 3 AP (2 BFK, 1 wA), 3 TP (2 BFK, 1 wA). Garo Z. Antreasian. BS (Tam), D, S, Dat, BS (pr).

240
Title Page (Fragments I). Mar 5–11, 1961. Grey-violet (S), green (S)[1], green (S), red-violet (S). 45.7 × 37.8. Ed 12 (wA), 9 TI (BFK), 4 AP (BFK), 2 TP (wA). Garo Z. Antreasian. BS.

1. Same stone as run 1; reversal, additions.

243
Colophon (Fragments XIV). Mar 14, 1961. Red-brown (S). 45.7 × 37.5. Ed 12 (wA), 9 TI (BFK), 5 AP (BFK), 5 TP (3 BFK, 2 wA). Garo Z. Antreasian. BS (Tam), D, S, D (in black India ink), BS (pr).

246
Untitled (Tokens IV). Mar 13–22, 1961. Yellow (Z), black (S). 76.8 × 57.2. Ed 15 (wA), 9 TI (wN), 6 TP (3 wA, 2 wN, 1 bA*). Garo Z. Antreasian. BS (Tam), D, S, Dat, BS (pr).

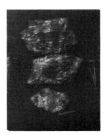

247
Untitled (Tokens VI). Mar 13–24, 1961. Brown-black (S). 76.2 × 56.5. Ed 15 (bA), 9 TI (nN), 1 AP (nN), 2 TP (bA). Garo Z. Antreasian. BS (Tam), D, S, Dat, BS (pr).

253
Untitled (Tokens V). Mar 27–Apr 8, 1961. Red-black (S), embossed. 76.2 × 56.5. Ed 15 (bA), 9 TI (wA), 3 AP (wA), 2 TP (bA). Garo Z. Antreasian. BS (Tam), D, S, Dat, BS (pr).

273
Untitled (Tokens VIII). Apr 11–26, 1961. Green (S), green-brown (S)[1], transparent grey (S). 76.8 × 56.8. Ed 15 (wA), 9 TI (wN), 7 TP (6 wA[2], 1 coverstock). Garo Z. Antreasian. BS (Tam), D, S, Dat, BS (pr).

1. Same stone as run 1; partial reversal.
2. 3 TP vary from the edition.

274
Untitled (Tokens VII). Apr 11–May 1, 1961. Blue-black (S), blue-violet (S)[1], light blue (Z), orange, grey-green (Z). 76.8 × 56.5. Ed 15 (wA), 9 TI (wN), 6 TP (1 wA, 2 wN[2], 1 bA*, 2 coverstock). Garo Z. Antreasian. BS (Tam), D, S, Dat, BS (pr).

1. Same stone as run 1; partial reversal.
2. 1 TP (wN) varies from the edition.

277
Untitled (Tokens III). Apr 14–May 18, 1961. Grey (S), transparent dark grey (S), brown (Z), green, orange (S), blue (Z). 77.5 × 56.8. Ed 15 (wA), 9 TI (wN), 2 AP (1 wA, 1 wN), 6 TP (3 wA, 2 wN, 1 coverstock). Garo Z. Antreasian. BS (Tam), D, S, Dat, BS (pr).

291
Untitled. May 10, 1961. Black (Z). 56.8 × 76.5. Ed 15 (wA), 9 TI (wN), 2 AP (wA), 4 TP (3 wA, 1 wN). Garo Z. Antreasian. BS (Tam), D, S, Dat, BS (pr).

294
Untitled. May 19–27, 1961. Violet (Z), black (S), embossed. 76.2 × 56.5. Ed 15 (wA), 9 TI (BFK), 2 AP (1 wA, 1 BFK), 2 TP (1 wA, 1 BFK). Garo Z. Antreasian. BS (Tam), D, S, Dat, BS (pr).

299
Colophon (Tokens X). May 28–Jun 5, 1961. Black (S), grey (Z). 76.8 × 56.8. Ed 15 (wA), 9 TI (wN), 2 AP (1 wA, 1 wN), 3 TP (2 wA, 1 wN). Garo Z. Antreasian. BS (bottom), D, S, Dat (top).

306
Untitled (Tokens II). Jun 4, 1961. Green-black (S). 76.8 × 56.5. Ed 15 (wA), 9 TI (wN), 1 AP (wN), 3 TP (wA). Garo Z. Antreasian. BS (Tam), D, S, Dat, BS (pr).

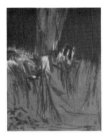

306A
Untitled (Tokens IX). Jun 6–14, 1961.
Red-black (S)[1], red (S), orange blue, green, yellow-green, dark blue (S). 76.8 × 57.2. Ed 15 (wA), 9 TI (wN), 5 AP (2 wA, 3 wN), 3 TP (coverstock)[2]. Garo Z. Antreasian. BS (Tam), D, S, Dat, BS (pr).

1. Stone held from 306; deletions. 306A differs from 306 in color and in image. Part of the crayon drawing at the lower left and lower right corners has been eliminated. A red bleed tone has been added. Orange crayon drawing has been added in the black line areas. The other colors have been added in discreet areas in the central portion of the image.
2. Unchopped.

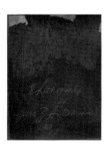

309
Title page (Tokens I). Jun 2–6, 1961. Black (S), blue (S), blue-green (S). 76.8 × 56.5. Ed 15 (wA), 9 TI (wN), 3 AP (2 wN, 1 wA), 5 TP (3 wA, 2 wN*). Garo Z. Antreasian. BS.

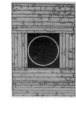

1304
Black on black. Apr 16–20, 1965. Black (S), light violet (S), black (S). 51.4 × 38.1. Ed 10 (nr), 9 TI (wA), UNMI (wA), PrP (BFK), 2 AP (1 wA, 1 BFK), 1 TP (BFK). Garo Z. Antreasian, NC. BS (Tam), T, D, S, Dat, BS (UNM).

1308
Glow Box. Mar 29–Jun 8, 1965. Grey (S), pink (S), grey-pink (S), black (S), light blue-grey (S), green (S), red (S), light grey (S). 76.2 × 56.8. Ed 12 (BFK), 9 TI (wA), UNMI (BFK), 2 AP (wA), 2 TP (1 BFK, 1 wA). Garo Z. Antreasian, NC. BS (Tam), T, D, S, Dat, BS (UNM).

1424
New Mexico IV. Nov 1, 1964. Orange-yellow (S), yellow (S), dark violet (S), red-violet (S), red (S), blue (S), transparent yellow (S). 76.8 × 57.2. Ed 14 (wA), 9 TI (wA). Garo Z. Antreasian. BS (Tam), T, D, S, Dat, BS (pr).

1425
Eagles. Dec 1, 1965. Black (S), red (S), blue (S), orange-yellow (S). 86.7 × 61.3. Ed 16 (12 BFK, 4 C), 9 TI (BFK), 1 TP (Radar Vellum Bristol). Garo Z. Antreasian. BS (Tam), T, D, S, Dat, BS (pr).

1505
Ojo. Nov 16–Dec 3, 1965. Red (S), black (S), blue-black (S), pink (S), light green (S). 101.0 × 72.7, cut. Ed 15 (GEP), 9 TI (GEP), BAT (GEP), 1 AP (GEP)[1], 3 TP (2 GEP, 1 Radar Vellum Bristol). Garo Z. Antreasian. BS (Tam), T, D, S, Dat, BS (pr).

1. Also designated UNMI.

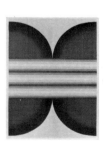

1515
Untitled (Quantum III). Mar 4–18, 1966. Light blue (S), medium blue (S), blue (S), yellow (S), grey-yellow (S), grey (S), dark grey (S), dark blue (S). 76.5 × 56.2. Ed 15 (wA), 9 TI (CD), UNMI (CD), 1 AP (wA), 6 TP (2 wA, 3 CD, 1 Radar Vellum Bristol). Garo Z. Antreasian. BS (Tam), D, S, Dat, BS (pr).

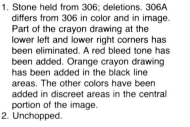

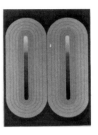

1516
Untitled (Quantum VIII). Mar 9–18, 1966. Light blue (S), blue (S), blue-green (S), medium grey (S), B: light grey, medium grey, dark grey, black (S), dark blue-green (S)[1], transparent blue-green (S)[2]. 76.5 × 56.2. Ed 15 (wA), 9 TI (CD), UNMI (wA), 6 TP (3 CD, 2 wA, 1 Radar Vellum Bristol). Garo Z. Antreasian. BS (Tam), D, S, Dat, BS (pr).
1. Same stone as run 4.
2. Same stone as run 3.

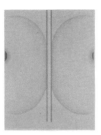

1517
Untitled. Apr 4–21, 1966. Transparent pink (S), pink (S), grey-pink (S), dark grey-pink (S), transparent light blue (S), light grey-blue (S), blue (S), light pink (S), light red-brown (S), grey-pink (S), light transparent grey-pink, red-brown (S). 76.5 × 56.2. Ed 15 (wA), 9 TI (CD), UNMI (CD), 1 AP (CD), 4 TP (1 CD, 3 wA). Garo Z. Antreasian. BS (Tam), D, S, Dat, BS (pr).

1522
Untitled (Quantum V). Apr 25–28, 1966. B: Yellow, red, blue, yellow-green (S), grey (S), dark grey (S), grey-black (S). 76.5 × 56.2. Ed 15 (wA), 9 TI (CD), UNMI (wA), BAT (wA), 1 AP (wA). Garo Z. Antreasian. BS (Tam), D, S, Dat, BS (pr).

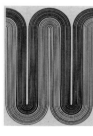

1523
Untitled (Quantum II). Jun 9–13, 1966. Black (S). 76.5 × 56.2. Ed 15 (wA), 9 TI (CD), UNMI (CD), 2 AP (CD), 3 TP (wA). Garo Z. Antreasian. BS (Tam), D, S, Dat, BS (pr).

1524
Untitled (Quantum IX). Jun 9–14, 1966. Black (S). 76.5 × 56.5. Ed 15 (wA), 9 TI (CD), UNMI (CD), 4 AP (CD), 3 TP (2 wA, 1 CD). Garo Z. Antreasian. BS (Tam), D, S, Dat.

1525
Untitled (Quantum IV). May 3–17, 1966. Yellow (S), green (S), blue (S), grey-brown (S), violet (S), red-violet (S), B: dark grey, medium grey, light grey (S), light beige (S), violet-beige (S)[1]. 76.5 × 56.2. Ed 15 (wA), 9 TI (CD), UNMI (CD), BAT (CD), 4 AP (2 CD, 2 wA), 3 TP (1 CD, 2 wA). Garo Z. Antreasian. BS (Tam), D, S, Dat, BS (pr).
1. Same stone as run 8; deletions.

1717
Untitled (Quantum VII). Jun 20–Jul 7, 1966. B: Dark blue-grey, dark red, black (S). 76.8 × 56.5. Ed 15 (wA), 9 TI (CD), UNMI (CD), 2 AP (1 wA, 1 CD), 2 TP (1 wA, 1 CD). Garo Z. Antreasian. D, S, Dat.

1719
Untitled (Quantum VI). Jul 2–19, 1966. B: Beige, light pink, light violet-grey (S), black (S). 76.5 × 56.2. Ed 15 (wA), 9 TI (CD), 1 UNMI (CD), 3 AP (2 wA, 1 CD), 2 TP (wA). Garo Z. Antreasian. BS (Tam), D, S, Dat, BS (pr).

1720
Untitled (Quantum X). Jul 2–21, 1966. B: Light pink, light violet, violet, violet-black (S), B: green-black, green, yellow-green, light yellow-green (S). 76.5 × 56.2. Ed 15 (wA), 9 TI (CD), UNMI (CD), 4 AP (wA), 2 TP (1 wA, 1 CD). Garo Z. Antreasian. BS (Tam), D, S, Dat, BS (pr).

1722
Colophon (Quantum XI). Dec 21, 1966–Jan 3, 1967. B: Red, brown, green-brown (S). 76.5 × 56.5. Ed 15 (wA), 9 TI (CD), UNMI (wA), 3 AP (1 CD, 2 wA), 2 TP (CD). Garo Z. Antreasian. BS (Tam, pr) (bottom), S, D (center).

1723
Title Page (Quantum I). Dec 21, 1966–Jan 11, 1967 Dark brown, grey-blue, light grey (S). 76.5 × 56.2. Ed 15 (wA), 9 TI (CD), UNMI (wA), 1 AP (CD), 4 TP (2 wA, 2 CD). Garo Z. Antreasian. BS (Tam, pr).

1726
Untitled. Oct 13–27, 1967. White (S), red, violet (S), blue, orange (S), on silver foil. 57.4 × 52.1, cut. Ed 15 (CD), 9 TI (GEP), UNMI (GEP), 1 AP (CD), 2 TP (CD). Garo Z. Antreasian. BS (Tam), D, S, Dat, BS (pr).

1727
Untitled (Silver Suite IV). Oct 31–Dec 1, 1967. B: Light grey, grey, dark grey (S), B: light grey, grey, dark grey (S), red (S), blue (S), on silver. 57.5 × 52.1, cut, (foil). Ed 15 (CD), 9 TI (GEP), UNMI (GEP), 9 AP (CD)[1], 4 TP (CD). Garo Z. Antreasian. BS (Tam), D, S, Dat, BS (pr).

1. 4 AP are printed directly on paper without foil.

1729
Untitled (Silver Suite III). Dec 4–22, 1967. White (S), yellow (S), red (S), light blue (S), blue (S), dark grey (S), on silver foil. 57.5 × 52.1, cut. Ed 15 (CD), 9 TI (GEP), UNMI (GEP), 3 AP (CD), 4 TP (CD). Garo Z. Antreasian. BS (Tam), D, S, Dat, BS (pr).

1733
Untitled (Silver Suite II). Jan 6–12, 1968. Light beige (S), B: pink, light red-brown, dark red-brown (S), blue grey (S), on silver foil. 57.5 × 52.1, cut. Ed 15 (CD), 9 TI (GEP), UNMI (CD), 7 AP (6 CD, 1 GEP). Garo Z. Antreasian. BS (Tam), D, S, Dat, BS (pr).

1734
Untitled (Silver Suite VII). Jan 12–19, 1968.
Green (S), B: pink, light pink, light beige, grey, white (S), on silver foil. 22.5 × 20.5, cut. Ed 15 (CD), 9 TI (GEP), UNMI (GEP), 5 AP (CD). Garo Z. Antreasian. BS (Tam), D, S, Dat, BS (pr).

1736
Untitled (Silver Suite V). Feb 9–19, 1968. Transparent yellow (S), transparent blue-green (S), red (S), black (S), on silver foil. 57.5 × 52.1, cut, (foil). Ed 15 (CD), 9 TI (GEP), UNMI (GEP), 8 AP (7 CD, 1 GEP), 1 TP (CD). Garo Z. Antreasian. BS (Tam), D, S, Dat, BS (pr).

1737
Untitled (Silver Suite VI). Feb 23–Mar 1, 1968. Orange (S), black (S), light blue (S), red (S), on silver foil. 57.5 × 52.1, cut. Ed 15 (CD), 9 TI (GEP), UNMI (GEP), 6 AP (CD), 2 TP (CD). Garo Z. Antreasian. BS (Tam), D, S, Dat, BS (pr).

1738
Untitled (Silver Suite VIII). Mar 4–8, 1968. Dark brown (S), red (S), violet (S), on silver foil. 57.5 × 52.1, cut. Ed 15 (CD), 9 TI (GEP), UNMI (GEP), 6 AP (4 CD, 2 GEP), 3 TP (CD). Garo Z. Antreasian. BS (Tam), D, S, Dat, BS (pr).

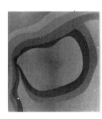

2251
Untitled (Silver Suite X). Mar 11–22, 1968. Transparent copper (S), B: white, light green-blue, light blue, blue-violet (S), black (S), blue (S), on silver foil. 57.5 × 52.1, cut. Ed 15 (CD), 9 TI (GEP), UNMI (GEP), 5 AP (3 CD, 2 GEP), 5 TP (CD). Garo Z. Antreasian. BS (Tam), D, S, Dat, BS (pr).

2252
Untitled (Silver Suite IX). Mar 25–Apr 10, 1968. Light grey (S), light grey (S), medium grey (S), dark grey (S), on silver foil. 57.5 × 52.1, cut. Ed 15 (CD), 9 TI (GEP), UNMI (GEP), 6 AP (4 CD, 2 GEP), 4 TP (CD). Garo Z. Antreasian. BS (Tam), D, S, Dat, BS (pr).

2253
Title Page (Silver Suite I). Apr 22, 1968. Transparent brown-black (S), on silver foil. 57.5 × 52.1, cut . Ed 15 (CD), 9 TI (GEP), UNMI (GEP), 6 AP (4 CD, 2 GEP), 1 TP (CD). Garo Z. Antreasian. BS (Tam, pr).

2254
Colophon (Silver Suite XI). Apr 24, 1968. Brown-black (S), on silver foil. 55.9 × 52.1, cut. Ed 15 (CD), 9 TI TI (GEP), UNMI (GEP), 6 AP (4 CD, 2 GEP), 1 TP (CD). Garo Z. Antreasian. BS (Tam, pr) (bottom), D, S (center).

2258
Untitled. Jan 23–27, 1969. B: Transparent blue-grey, transparent violet-grey, transparent beige (S), on Fasson Aluminum Foil and Fasson Chromecote. 73.7 × 53.9, cut. Ed 15 (bA), 9 TI (bA), UNMI (bA), 1 AP (bA), 2 TP (bA). Garo Z. Antreasian. BS (Tam), D, S, Dat, BS (pr).

2259
Untitled. Jun 23–26, 1969. Yellow-orange (S), red (S), blue (S). 74.9 × 54.6, cut. Ed 16 (CD), 9 TI (wA), 1 UNMI* (CD)[1]. Garo Z. Antreasian. BS (Tam), D, BS (pr).

1. Numbered 2/16.

2260
Untitled (Octet IV). Jun 27–Jul 1, 1969. Light grey (S), B: light grey, medium grey, dark grey (S), B: light grey, medium grey, dark grey (S). 61.0 × 50.8, cut. Ed 20 (wA), 9 TI (BFK), UNMI (BFK), 6 AP (2 BFK, 4 wA). Garo Z. Antreasian. BS (Tam), D, S, Dat, BS (pr).

2261
Untitled (Octet IX). Jul 3–14, 1969. Yellow (S), light blue-grey (S), medium blue-grey (S), dark grey (S), black (S). 61.0 × 50.8, cut, . Ed 20 (wA), 9 TI (BFK), UNMI (BFK), 3 AP (2 BFK, 1 wA), 1 TP (wA). Garo Z. Antreasian. BS (Tam), D, S, Dat, BS (pr).

2262
Untitled (Octet III). Jul 15–19, 1969. B: Light grey, grey (S), B: light grey, grey (S), B: light grey, grey (S), red-violet (S), yellow-green (S). 61.0 × 50.8, cut. Ed 20 (wA), 9 TI (BFK), UNMI (BFK), 1 AP (wA), 1 TP (BFK). Garo Z. Antreasian. BS (Tam), D, S, Dat, BS (pr).

2263
Untitled (Octet VII). Jul 21–25, 1969. B: Dark blue, light blue, pink, light pink, yellow, light yellow (S), violet-grey (S), dark grey (S). 61.0 × 50.8, cut. . Ed 20 (wA), 9 TI (BFK), UNMI (BFK), 2 AP (wA), 2 TP (BFK). Garo Z. Antreasian. BS (Tam), D, S, Dat, BS (pr).

2264
Untitled (Octet VI). Jul 28–Aug 1, 1969. Light blue (S), B: light grey, medium grey, dark grey (S), B: light violet-grey, dark grey (S). 61.0 × 50.8, cut, . Ed 20 (wA), 9 TI (BFK), UNMI (BFK), 2 AP (1 BFK, 1 wA), 3 TP (1 BFK, 2 wA). Garo Z. Antreasian. BS (Tam), D, S, Dat, BS (pr).

2265
Untitled. Aug 4–6, 1969. Black (S), dark grey (S), blue-grey (S). 61.0 × 50.8, cut. Ed 20 (wA), 9 TI (BFK), UNMI (BFK), 3 AP (wA), 1 TP (BFK). Garo Z. Antreasian. BS (Tam), D, S, Dat, BS (pr).

2266
Untitled (Octet II). Aug 8–10, 1969. Yellow (S), violet (S), yellow-green (S). 61.0 × 50.8, cut. Ed 20 (wA), 9 TI (BFK), UNMI (BFK), 1 AP (BFK), 1 TP (wA). Garo Z. Antreasian. BS (Tam), D, S, Dat, BS (pr).

2267
Untitled (Octet V). Aug 11–14, 1969. B: Blue-violet, pink, light pink, light beige (S), black (S), blue-grey (S), green (S). 61.0 × 50.8, cut. Ed 20 (wA), 9 TI (BFK), UNMI (BFK), 4 AP (1 BFK, 3 wA). Garo Z. Antreasian. BS (Tam), D, S, Dat, BS (pr).

2268
Untitled. Aug 15–28, 1969. B: Orange-red, dark pink, red, dark red, dark red-brown (S), B: yellow, yellow-green, dark ochre, brown, black-brown (S), B: light blue-green, light blue, medium blue-green, dark blue-green, dark black- green (S), B: dark brown, dark red-brown, brown-black (S). 61.0 × 50.8, cut. Ed 20 (wA), 9 TI (BFK), UNMI (BFK), 7 AP (4 BFK, 3 wA), 1 TP (wA). Garo Z. Antreasian. BS (Tam), D, S, Dat, BS (pr).

2269
Untitled (Octet VIII). Aug 29–Sep 12, 1969. Light pink (S), light brown (S), light grey (S), B: light yellow-brown, grey-brown (S), B: medium grey, dark grey (S). 61.0 × 50.5, cut. Ed 20 (wA), 9 TI (BFK), UNMI (BFK), 5 AP (2 BFK, 3 wA). Garo Z. Antreasian. BS (Tam), D, S, Dat, BS (pr).

2270
Title Page (Octet I). Sep 16–18, 1969. Blue (S). 61.0 × 50.8, cut. Ed 20 (wA), 9 TI (BFK), UNMI (BFK), 4 AP (2 BFK, 2 wA). Garo Z. Antreasian. BS (Tam, pr).

2771
Colophon (Octet X). Sep 16–18, 1969. Blue (S). 61.3 × 50.8, cut. Ed 20 (wA), 9 TI (BFK), UNMI (BFK), 5 AP (2 BFK, 3 wA). Garo Z. Antreasian. BS (Tam, pr) (bottom), D, S (center).

François Arnal

279
Untitled. Apr 19, 1961. Black (S)[1]. 56.5 × 76.2. Ed 11 (BFK), 9 TI (BFK), PrP (BFK). Garo Z. Antreasian. BS (pr), S, D, BS (Tam).

1. Crack visible at lower left.

540
Tales of the Meep. Mar 17–24, 1962. Red (Z), black (Z). 56.8 × 75.9. Ed 30 (BFK)[1], 9 TI (wA), PrP (BFK), 5 TP (4 BFK, 1 wA)[1], CP (BFK)[2]. Joe Funk. BS (pr), D, S, BS (Tam).

1. Ed 21–30/30 and 2 TP were printed by Kanthos Press and bear their chop.
2. Unsigned, undesignated, retained by Tamarind.

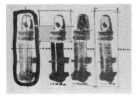

541
Targets. Mar 8–13, 1962. Yellow (Z), black (Z). 56.8 × 76.2. Ed 30 (BFK)[1], 9 TI (wA), PrP (BFK), 2 AP (wA), 5 TP (BFK)[1], CP (BFK)[2]. Joe Funk. BS (Tam), D, S, BS, (pr).

1. Ed 21–30/30 and 2 TP printed by Kanthos Press and bear their chop.
2. Unsigned, undesignated, retained by Tamarind.

Ruth Asawa

Flowers, a suite of twelve lithographs including title and colophon pages. In order: 1571, 1480, 1481, 1483, 1492, 1493, 1535, 1559, 1560, 1561, 1562, 1572.

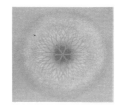

1460
Desert Plant. Oct 13–21, 1965. Orange (A), yellow (A), pink (S). 45.7 × 45.7, cut. Ed 11 (wA), 9 TI (BFK IV), BAT (wA), 2 TP (wA)[1]. John Rock. Verso: D, S, WS.

1. 1 TP varies from the edition.

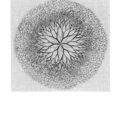

1460II
Desert Flower. Oct 21–22, 1965. Red-brown (S)[1], light orange (S)[2]. 46.7 × 47.6. Ed 10 (wA), 9 TI (BFK IV), BAT (wA), 3 AP (BFK IV), 1 TP (wA), CP (Tcs). John Rock. BS, D, S.

1. Stone held from 1460, run 3.
2. Same stone as run 1, registration moved slightly. 1460II differs from 1460 in color, image and size. The background tone around the flower and the small darker core have been eliminated. The flower appears as a double image.

Print not in
University Art Museum
Archive

1469II
Desert Flower. Oct 11–12, 1965. Black (S). 50.8 × 50.8. Ed 20 (GEP), 9 TI (BFK IV), BAT (GEP), 1 AP (BFK IV). Robert Evermon. BS, D, S.

1469II
Desert Flower. Oct 14–15, 1965. Black (S)[1]. 55.9 × 70.2. Ed 20 (wA), 9 TI (GEP), BAT (wA), 2 AP (GEP). Robert Evermon. BS, D, S.

1. Stone held from 1469; additions. 1469II differs from 1469 in image and in size. The border around the central square has been enlarged. A crackled texture of thin white lines has been added to the border and to the dark center of the flower.

1469III
Desert Flower. Oct 15–18, 1965. Black (S)[1]. 51.4 × 66.4. Ed 10 (wA), 9 TI (BFK V), BAT (wA), 1 AP (wA), 2 TP (wA), CP (Tcs). Robert Evermon. BS, D, S.

1. Stone held from 1469II; partial reversal. 1469III differs from 1469II in image and in size. The border around the central square appears white with a crackled texture of thin black lines.

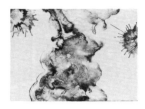

1470
Plane Tree. Aug 31–Sep 2, 1965.
Black (S). 48.6 × 63.5. Ed 20 (BFK), 9
TI (wA), BAT (BFK), 3 AP (1 BFK, 2
wA), 2 TP (BFK)[1]. Clifford Smith. BS,
D, S.

1. 1 TP varies from the edition.

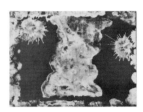

1470A
Plane Tree Reversal. Sep 8–9, 1965.
Black (S)[1]. 62.9 × 80.6. Ed 20 (BFK),
9 TI (CD), BAT (BFK), 3 AP (2 BFK, 1
CD)[2], 2 TP (BFK)[2], CP (Tcs). Clifford
Smith. D, S, BS.

1. Stone held from 1470; reversal.
 1470A differs from 1470 in image
 and in size. 1470A includes a larger
 area of drawing on all four sides
 beyond the image area that appears
 in 1470.
2. 2 TP, 1 AP inadvertently chopped
 with the chop of Kinji Akagawa.

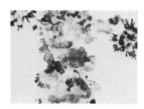

1471
Plane Trees. Sep 7–8, 1965. Black (S).
48.9 × 63.5. Ed 9 (BFK), 9 TI (BFK),
BAT (BFK), 2 TP (BFK)[1]. Kinji
Akagawa. BS, D, S, Dat.

1. 1 TP varies from the edition.

1472
Plane Trees II. Sep 8–10, 1965. Blue-
black (S). 57.2 × 76.2. Ed 20 (BFK), 9
TI (wA), BAT (BFK), 3 AP (wA), 2 TP
(BFK), CP (Tcs). Jurgen Fischer. D, S,
Dat, BS.

1473
Aiko. Sep 9–14, 1965. Black (S). 55.9
× 57.2. Ed 20 (BFK), 9 TI (wA), BAT
(BFK), 3 AP (1 BFK, 2 wA), 2 TP (BFK),
CP (Tcs). Kinji Akagawa. BS, D, S.

1474
Spring. Sep 13–17, 1965. Green
(S)[1], green-brown (S), dark green
(S). 57.2 × 76.2. Ed 20 (BFK), 9 TI
(wA), BAT (BFK), 2 AP (wA), 4 TP
(BFK)[2], CP (Tcs). Clifford Smith. BS,
D, S.

1. Stone held from 1471; additions.
 1474 differs from 1471 in color,
 image and size. A central radiating
 spatter, serpentine wash shapes on
 the left and right sides and spatter
 at top left and right have been
 added.

1475
Succulents. Sep 15–16, 1965. Black
(S). 50.2 × 37.8. Ed 20 (10 JC, 10 wN),
9 TI (nN), BAT (wN), 3 AP (1 wN, 1 nN,
1 JC), 6 TP (1 JY[1], 1 JS, 1 JA[1], 1
JT[1], 1 wN, 1 BFK), CP (Tcs). Jurgen
Fischer. D, S, BS.

1. Printed on recto and verso.

1476
Umakichi. Sep 15–17, 1965. Black (S).
57.5 × 51.4. Ed 20 (bA), 9 TI (nN), BAT
(bA), 3 AP (1 bA, 2 nN), 2 TP (bA).
Kinji Akagawa. D, S, BS.

1476II
Umakichi. Sep 20, 1965. Dark brown
(S)[1]. 56.8 × 33.0. Ed 10 (nN), 9 TI
(bA), BAT (nN), 2 TP (nN). Kinji
Akagawa. BS, D, S.

1. Stone held from 1476; additions.
 1476II differs from 1476 in color,
 image and size. A tone has been
 added to the face of the figure.

1476III
Umakichi. Sep 27–28, 1965. Black
(S)[1]. 58.8 × 50.8. Ed 20 (BFK), 9 TI
(wA), BAT (BFK), 3 AP (2 BFK, 1 wA), 2
TP (BFK). Kinji Akagawa. D, S, BS.

1. Stone held from 1476II; additions.
 1476III differs from 1476II in color,
 image and size. A floral pattern has
 been added to the background and
 light streaks have been added to
 the garment of the figure on the
 right side.

1476IV
Umakichi. Sep 29–Oct 1, 1965. Black
(S)[1]. 74.9 × 50.8. Ed 20 (BFK), 9 TI
(BFK V), BAT (BFK), 3 AP (2 BFK, 1 BFK
V), 2 TP (BFK), CP (Tcs). Jurgen
Fischer. D, S, BS.

1. Stone held from 1476III; reversal,
 additions. 1476IV differs from
 1476III in image and in size. Textural
 areas have been added along the
 top and bottom.

1477
Chrysanthemums. Sep 17–21, 1965.
Black (S). 76.2 × 57.2. Ed 20 (BFK), 9
TI (wA), BAT (BFK), 2 AP (1 BFK, 1
wA), 1 TP (wA). Jurgen Fischer. BS, D,
S.

1477II
Chrysanthemums. Sep 22–23, 1965.
Brown-red (S), red-black (S)[1]. 76.2 ×
57.2. Ed 20 (BFK), 9 TI (wA), BAT
(BFK), 3 AP (1 wA, 2 BFK), 3 TP (BFK).
Jurgen Fischer. BS, D, S.

1. Stone held from 1477. 1477II differs
 from 1477 in color and in image.
 The flower pot has been filled in
 with a solid tone and details added
 to two central flowers.

1477III
Chrysanthemums. Sep 23, 1965.
Red-black (S)[1]. 53.3 × 55.9. Ed 20
(F), 9 TI (F), BAT (F), 2 AP (F), 1 TP (F),
1 CP (Tcs), 1 proof (de Laga
Cement)[2]. Jurgen Fischer. D, S, BS.

1. Stone held from 1477II, run 2.
 1477III differs from 1477II in color,
 image and size. The image is cut off
 at the top edge of the flower pot
 and the tone in the pot and the
 details in the two central flowers
 have been eliminated.
2. Unsigned, unchopped,
 undesignated, retained by
 Tamarind.

1478
Pigeons on Cobblestones. Sep 24–
28, 1965. Black (S). 59.1 × 89.5. Ed 20
(BFK), 9 TI (CD), BAT (BFK), 1 AP (CD),
2 TP (BFK), CP (Tcs). Clifford Smith. D,
S, BS.

1479
Poppy. Oct 14–20, 1965. Yellow (A),
red (S), dark green-blue (S). 76.2 ×
52.1. Ed 20 (BFK), 9 TI (wA), BAT
(BFK), 2 AP (wA), 4 TP (BFK), CP (Tcs).
Walter Gabrielson. D, S, BS.

1480
Untitled (Flowers II). Oct 25–27,
1965. Black (S). 27.9 × 27.9. Ed 20
(wA), 9 TI (GEP), BAT (wA), 3 AP (2
GEP, 1 wA), 1 TP (wA), CP (Tcs). Ernest
de Soto. D, S, BS.

1481
Untitled (Flowers III). Oct 25–27,
1965. Black (S). 27.9 × 28.3. Ed 20
(wA), 9 TI (GEP), BAT (wA), 3 AP (2
GEP, 1 wA), 1 TP (wA), CP (Tcs). Ernest
de Soto. D, S, BS.

1482
Untitled. Oct 25–27, 1965. Black (S).
28.3 × 28.3. Ed 20 (wA), 9 TI (GEP),
BAT (wA), 3 AP (2 GEP, 1 wA), 1 TP
(wA), CP (Tcs). Ernest de Soto. D, S,
BS.

1483
Untitled (Flowers IV). Oct 25–27,
1965. Black (S). 27.9 × 28.3. Ed 20
(wA), 9 TI (GEP), BAT (wA), 3 AP (2
GEP, 1 wA), 1 TP (wA), CP (Tcs). Ernest
de Soto. D, S, BS.

1484
Babies. Sep 29, 1965. Black (S). 56.8
× 76.2. Ed 20 (BFK), 9 TI (wA), BAT
(BFK), 3 AP (1 BFK, 2 wA), 1 TP (BFK),
CP (Tcs). Kinji Akagawa. BS, D, S.

1485
Haru. Sep 29–Oct 4, 1965. Black (S).
69.9 × 53.3. Ed 20 (19 BFK, 1 wA), 9
TI (wA), BAT (BFK), 1 AP (wA), 1 TP
(BFK), CP (Tcs). Robert Evermon. BS,
D, S.

1486
Owl. Oct 1–4, 1965. Black (S). 61.6 × 89.9. Ed 20 (BFK), 9 TI (CD), BAT (BFK), 3 AP (1 BFK, 2 CD), 3 PP (BFK), 1 TP (BFK), CP (Tcs). John Rock. BS, D, S.

1491
Owl II. Oct 2–9, 1965. Brown (Z), black (S). 53.0 × 76.2. Ed 20 (BFK), 9 TI (wA), BAT (BFK), 2 AP (wA), 3 TP (BFK), CP (Tcs). Kinji Akagawa. Recto: D, S Verso: WS.

1487
Untitled. Sep 30–Oct 2, 1965. Black (S). 50.8 × 67.3. Ed 20 (BFK), 9 TI (BFK IV), BAT (BFK), 2 AP (1 BFK, 1 BFK IV), 2 TP (BFK). John Rock. D, S, BS.

1492
Untitled (Flowers V). Oct 8–13, 1965. Red (S), green (S), violet (S). 28.3 × 27.9. Ed 20 (wA), 9 TI (GEP), BAT (wA), 3 AP (GEP), 3 TP (wA), CP (Tcs). Walter Gabrielson. D, S, BS.

1487II
Untitled. Oct 5–6, 1965. Blue (Z), dark blue-violet (S)[1]. 51.1 × 67.6. Ed 20 (18 BFK, 2 BFK III), 9 TI (BFK III), BAT (BFK), 1 AP (BFK III), 1 TP (BFK), CP (Tcs). John Rock. D, S, BS.

1. Stone held from 1487. 1487II differs from 1487 in color and in image. A bleed background has been added.

1493
Untitled (Flowers VI). Oct 8–13, 1965. Red (S), green (S), violet (S). 27.9 × 27.9. Ed 20 (wA), 9 TI (GEP), BAT (wA), 2 AP (GEP), 3 TP (wA), CP (Tcs). Walter Gabrielson. D, S, BS.

1488
Untitled. Oct 4–6, 1965. Pink (S). 56.2 × 89.5. Ed 20 (BFK), 9 TI (CD), BAT (BFK), 3 AP (2 BFK, 1 CD), 2 TP (BFK), CP (Tcs). Robert Evermon. D, S, BS.

1494
Untitled. Oct 8–13, 1965. Red (S), green (S), violet (S). 27.9 × 27.9. Ed 20 (wA), 9 TI (GEP), BAT (wA), 2 AP (GEP), 3 TP (wA), CP (Tcs). Walter Gabrielson. D, S, BS.

1489
Nude. Oct 6–13, 1965. Black (S). 62.9 × 91.8. Ed 20 (GEP), 9 TI (CD), BAT (GEP), 2 AP (CD), 1 TP (GEP). Clifford Smith. BS, D, S.

1535
Untitled (Flowers VII). Oct 8–13, 1965. Red (S), green (S), violet (S). 28.3 × 28.6. Ed 20 (wA), 9 TI (GEP), BAT (wA), 2 AP (GEP), CP (Tcs). Walter Gabrielson. D, S, BS.

1489II
Nude. Oct 18–19, 1965. Black (S)[1]. 62.2 × 91.4. Ed 20 (BFK), 9 TI (CD), BAT (BFK), 1 TP (BFK), CP (Tcs). Clifford Smith. BS, D, S.

1. Stone held from 1489; partial reversal. 1489II differs from 1489 in image. The upper torso and face of the figure and a horizontal strip near the bottom edge have been darkened. The strip along the bottom edge has been lightened. The texture of the background is less distinct.

1557
Nasturtiums. Oct 19–25, 1965. Brown (S), orange (S), yellow-green (Z). 57.2 × 76.5. Ed 20 (BFK), 9 TI (wA), BAT (BFK), 2 AP (wA), 4 TP (BFK), CP (Tcs). Jurgen Fischer. D, S, BS.

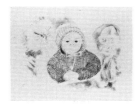

1490
Faces. Oct 7–8, 1965. Black (S). 50.8 × 63.5. Ed 20 (BFK), 9 TI (BFK V), BAT (BFK), 3 AP (2 BFK, 1 BFK V), 2 TP (BFK), CP (Tcs). Walter Gabrielson. BS, D, S.

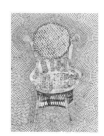

1558
Chair. Oct 22–23, 1965. Black (S). 104.8 × 75.6. ED 20 (BFK), 9 TI (CD), BAT (BFK), 3 AP (CD), 3 PP (BFK), 1 TP (BFK). John Rock. D, S, BS.

1558II
Chair. Oct 24–25, 1965. Black (S)[1]. 105.1 × 75.6. Ed 10 (BFK), 9 TI (CD), BAT (BFK), 1 AP (CD), CP (Tcs). John Rock. D, S, BS.

1. Stone held from 1558; reversal, additions. 1558II differs from 1558 in image. An irregular solid dark border has been added on the left, right, and bottom.

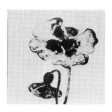

1559
Untitled (Flowers VIII). Oct 25–27, 1965. Brown-red (S). 27.9 × 28.3. Ed 20 (wA), 9 TI (GEP), BAT (wA), 3 AP (1 GEP, 2 wA), 2 TP (wA), CP (Tcs). Ernest de Soto. D, S, BS.

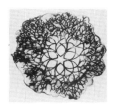

1560
Untitled (Flowers IX). Oct 25–27, 1965. Brown-red (S). 28.3 × 28.3. Ed 20 (wA), 9 TI (GEP), BAT (wA), 3 AP (1 GEP, 2 wA), 2 TP (wA), CP (Tcs). Ernest de Soto. D, S, BS.

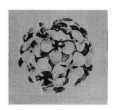

1561
Untitled (Flowers X). Oct 25–27, 1965. Brown-red (S), green (S), grey (S). 27.9 × 28.6. Ed 20 (wA), 9 TI (GEP), BAT (wA), 3 TP* (wA), CP (Tcs). Ernest de Soto. D, S, BS.

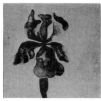

1562
Untitled (Flowers XI). Oct 25–27, 1965. Brown-red (S), green (S), grey (S). 27.9 × 28.3. Ed 20 (wA), 9 TI (GEP), BAT (wA), 3 TP* (wA), CP (Tcs). Ernest de Soto. D, S, BS.

Print not in University Art Museum Archive

1565
Hudson. Oct 26–29, 1965. Black (S). 25.1 × 24.1, cut. Ed 20 (BFK), 9 TI (wA), BAT (BFK), 3 AP (1 BFK, 2 wA), 2 TP (BFK), CP (Tcs). Clifford Smith. BS, D, S.

1566
Bud. Oct 26–29, 1965. Black (S). 27.9 × 25.4, cut. Ed 20 (BFK), 9 TI (wA), BAT (BFK), 3 AP (1 BFK, 2 wA), 2 TP (BFK), CP (Tcs). Clifford Smith. BS, D, S.

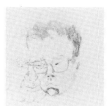

1567
Fritz and Larry. Oct 26–29, 1965. Black (S). 28.3 × 24.8, cut. Ed 20 (BFK), 9 TI (wA), BAT (BFK), 3 AP (1 BFK, 2 wA), 2 TP (BFK), CP (Tcs). Clifford Smith. D, S, BS.

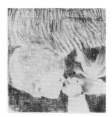

1568
Henry and Adam. Oct 26–29, 1965. Black (S). 27.3 × 25.1, cut. Ed 20 (BFK), 9 TI (wA), BAT (BFK), 3 AP (1 BFK, 2 wA), 2 TP (BFK), CP (Tcs). Clifford Smith. BS, D, S.

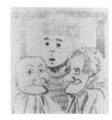

1569
Paul. Oct 26–29, 1965. Black (S). 27.3 × 24.5, cut. Ed 20 (BFK), 9 TI (wA), BAT (BFK), 3 AP (1 BFK, 2 wA), 2 TP (BFK), CP (Tcs). Clifford Smith. D, S, BS.

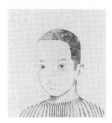

1570
Xavier. Oct 26–29, 1965. Black (S). 27.3 × 24.5, cut. Ed 20 (BFK), 9 TI (wA), BAT (BFK), 3 AP (1 BFK, 2 wA), 2 TP (BFK), CP (Tcs). Clifford Smith. D, S, BS.

1571
Title Page (Flowers I). Oct 27–28, 1965. Red-brown (S). 28.6 × 28.3. Ed 20 (wA), 9 TI (GEP), BAT (wA), 3 AP (1 wA, 2 GEP), 2 TP (wA), CP (Tcs). Walter Gabrielson. D, S, BS.

1572
Colophon (Flowers XII). Oct 27–28, 1965. Red-brown (S). 27.9 × 27.9. Ed 20 (wA), 9 TI (GEP), BAT (wA), 3 AP (2 wA, 1 GEP), 1 TP (wA), CP (Tcs). Walter Gabrielson. D, S, BS.

Mario Avati

957
Non! Dec 11–18, 1963. Black (S). 56.5 × 38.1. Ed 20 (wA), 9 TI (wA), BAT (wA), 2 working proofs (nr)[1]. Irwin Hollander. T, D, BS, S, Dat.

1. Unsigned, undesignated, unchopped, retained by Tamarind. One printed on verso and recto.

958
Valentine pour Tamarind. Dec 11–19, 1963. Red (Z), black (S). 39.4 × 56.8. Ed 20 (wA), 9 TI (wA), BAT (wA), 3 AP (wA), 2 TP (wA), 2 CSP (wA), 3 working proofs (nr)[1], CP (wA). Irwin Hollander. D, T, BS, S, Dat.

1. Unsigned, undesignated, unchopped, retained by Tamarind. One printed on verso and recto.

1946
Citron, Bol et Compotier. Mar 6–11, 1967. Beige (Z), black (S). 54.0 × 60.3. Ed 20 (GEP), 9 TI (CD), BAT (GEP), 3 AP (1 CD, 2 GEP)[1], 3 TP (GEP)[2], 4 PTP (1 CD, 1 wN, 1 A, 1 R)[3]. Serge Lozingot. D, BS, S, Dat.

1. Designated "Epreuve d'artiste 1–3/3".
2. Designated "Essai 1–3/3".
3. Designated "Essai sur papier 1/1".

1946II
Citron, Bol et Compotier. Mar 8–11, 1967. Beige (Z)[1], yellow (S), blue (S), light red (S), black (S)[1]. 53.7 × 60.3. Ed 20 (GEP), 9 TI (CD), BAT (GEP), 3 AP (CD), 7 TP (2 CD, 4 GEP, 1 wA)[2]. Serge Lozingot. D, BS, S, Dat.

1. Plate and stone held from 1946. 1946II differs from 1946 in color only.
2. Designated "Essai 1–4/4" and "Essai Jaune et Noir 1–3/3". Essai Jaune et Noir 1–3/3 vary from the edition. One retained by Tamarind.

1947
Les Artichauts de Los Angeles.
Mar 13–14, 1967. Beige (S), black (S). 54.0 × 60.7. Ed 20 (19 GEP, 1 CD), 9 TI (CD), BAT (GEP), 3 AP (GEP), 2 TP (GEP). Serge Lozingot. D, BS, S, Dat.

1947II
Les Artichauts de Los Angeles.
Mar 15–Apr 13, 1967. Beige (S)[1], blue (S), red (S), black (S)[2]. 53.7 × 60.3. Ed 10 (GEP), 9 TI (8 CD, 1 GEP), BAT (GEP), 3 AP (GEP), 6 TP* (5 GEP, 1 CD)[2], 2 CTP (GEP)[2], 3 working proofs (nr)[3], CP (GEP). Serge Lozingot. D, T, BS, S, Dat.

1. Stone held from 1947, run 1. The artist's edition and the artist's proofs include several impressions without the beige border.
2. Stone held from 1947, run 2 and was used in the printing of 2 CTP and 1 TP. The image then broke

down and a new image identical to the latter was drawn on a new stone. 1947II differs from 1947 in color only.

3. Unsigned, unchopped, undesignated, retained by Tamarind.

Edward Avedisian

1288
Untitled. Apr 7–8, 1965. Yellow (Z), transparent dark ochre (S). 50.8 × 51.1. Ed 20 (BFK), 9 TI (BFK), BAT (BFK), 3 AP (BFK), 1 PP (BFK), 3 TP (BFK). Kenneth Tyler. Verso, center: D, WS, S, Dat.

Kengiro Azuma

Print not in
University Art Museum
Archive

1396
Nothingness. Jul 1–4, 1965. Yellow (A), blue-black (S)[1]. 76.2 × 55.9. Deckle edge with bleed image. Ed 20 (wN), 9 TI (nN), BAT (wN), 3 AP (wN), 3 PP (2 wN, 1 nN), 3 TP (wN), CP (Tcs). Kinji Akagawa. D, S, BS.

1. Stone held from 1397. 1396 differs from 1397 in color and image. A yellow tonal area has been added under the dark image.

1397
Nothing. Jul 1–4, 1965. Black (S). 56.5 × 76.2. Ed 10 (BFK), 9 TI (wA), BAT (BFK), 1 AP (wA), 1 TP (BFK). Kinji Akagawa. D, S, BS.

Herbert Bayer

8 Monochromes, a suite of eight lithographs plus title and colophon pages, enclosed in a blue cloth covered box, measuring 52.1 × 52.1, lined with white cover paper, stamped with the artist's name in red on the front cover, made by the Schuberth Bookbindery, San Francisco. Each lithograph enclosed in a chemise of white Tableau paper. In order: 1594, 1585, 1586, 1587, 1588, 1589, 1595, 1599, 1597.

1585
Untitled (8 Monochromes I). Nov 5–17, 1965. Blue (S), dark blue (S). 50.8 × 51.1. Ed 20 (18 wA, 2 CD), 9 TI (CD), BAT (wA), 2 AP (1 wA, 1 CD), 1 TP* (wA), CP (Tcs). Ernest de Soto. Recto: D, S, Dat Verso: WS.

1586
Untitled (8 Monochromes II). Nov 8–11, 1965. Brown (S), dark brown (S). 51.1 × 51.1. Ed 20 (wA), 9 TI (CD), BAT (wA), 1 AP (wA), 1 TP* (wA), CP (Tcs). Walter Gabrielson. Recto: D, S, Dat Verso: WS.

1587
Untitled (8 Monochromes III). Nov 8–15, 1965. Grey (S), dark grey (S). 51.1 × 51.1. Ed 20 (wA), 9 TI (CD), BAT (wA), 2 AP (CD), 1 TP* (wA), CP (Tcs). Jurgen Fischer. Recto: D, S, Dat Verso; WS.

1588
Untitled (8 Monochromes IV). Nov 13–18, 1965. Red (S), dark red (S). 50.8 × 50.8. Ed 20 (wA), 9 TI (CD), BAT (wA), 1 AP (CD), 2 TP (wA), CP (Tcs). Robert Evermon. Recto: D, S, Dat Verso: WS.

1589
Untitled (8 Monochromes V). Nov 19–23, 1965. Blue (S). 51.1 × 51.1. Ed 20 (wA), 9 TI (CD), BAT (wA), 2 AP (wA), 3 TP (2 CD*, 1 wA), CP (Tcs). Kinji Akagawa. Recto: D, S, Dat Verso: WS.

1590
Untitled (8 Monochromes VI). Nov 16–24, 1965. Dark blue (S). 50.8 × 50.8. Ed 20 (wA), 9 TI (CD), BAT (wA), 1 AP (CD), 2 TP (wA), CP (Tcs). Jurgen Fischer. Recto: D, S, Dat Verso: WS.

Print not in University Art Museum Archive

1591
Floating. Nov 23–30, 1965. Red (S), dark red (S). 50.8 × 50.8. ED 9 (wA)[1], BAT (wA), CP (Tcs). Ernest de Soto.

1. In addition, one rejected impression, unsigned, unchopped and defaced, retained by Tamarind.

1592
Structure with Three Squares. Nov 29–Dec 4, 1965. Green (S), blue (Z), black (Z), grey (Z). 76.5 × 55.9. Ed 20 (18 wA, 2 CD), 9 TI (CD), BAT (wA), 2 AP (CD), 1 TP* (wA). Robert Evermon. BS, D, S, Dat.

1592II
Structure in Yellow. Dec 6–11, 1965. Yellow (S)[1], light red (Z)[1], grey (Z)[1], transparent blue (Z)[1]. 76.2 × 55.9. Ed 20 (18 A, 2 CD), 9 TI (CD), BAT (A), 3 AP (A), 2 TP (A), CP (Tcs). Robert Evermon. BS, D, S, Dat.

1. Stone and plate held from 1592. 1592II differs from 1592 in color and in image. The oval at the upper center has been filled in with solid background.

1593
Celestial Wheel. Nov 30–Dec 2, 1965. Blue (Z), blue-black (S). 101.6 × 71.1. Ed 20 (MI), 9 TI (CD), BAT (MI), 1 AP (CD), 3 TP [1] (MI), CP (Tcs). Jurgen Fischer. BS, D, S, Dat.

1. 1 TP varies from the edition.

1594
Title Page (8 Monochromes). Dec 1–3, 1965. Blue (A). 50.8 × 50.8. Ed 20 (wA), 9 TI (CD), BAT (wA), 2 AP (wA), CP (Tcs). Walter Gabrielson. BS, D, S, Dat.

1595
Untitled (8 Monochromes VII). Nov 22–24, 1965. Dark brown (S), dark brown (S)[1]. 50.8 × 50.8. Ed 20 (wA), 9 TI (CD), BAT (wA), 2 AP (wA), 2 TP* (wA), CP (Tcs). Clifford Smith. Recto: D, S, Dat Verso: WS.

1. Same stone as run 1, paper turned 180 degrees.

1596
Las Vegas. Dec 2–10, 1965. Blue (Z), red (Z), black (Z), black (Z). 55.9 × 76.2. Ed 20 (wA), 9 TI (CD), BAT (wA), 3 AP (wA), 4 TP[1] (1 AEP[2], 3 wA), CP (Tcs). Jurgen Fischer. BS, D, S, Dat.

1. 2 TP vary from the edition.
2. Pulled for paper testing, retained by Tamarind.

1597
Colophon (8 Monochromes IX).
Dec 1–2, 1965. Blue (A). 51.1 × 51.1.
Ed 20 (wA), 9 TI (CD), BAT (wA), 2 AP
(wA), 1 TP (wA), CP (Tcs). Walter
Gabrielson. D, S, Dat, BS.

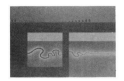

1598
Two Progressions. Dec 6–24, 1965.
Brown-grey (Z), blue (Z), dark brown
(Z). 56.2 × 76.8. Ed 20 (wA), 9 TI (CD),
BAT (wA), 3 AP (CD), 5 TP (3 wA, 2
dLN[1]), 1 PTP* (AEP)[2], CP (Tcs).
Clifford Smith. BS, D, S, Dat.

1. Pulled for paper testing, one
 retained by Tamarind.
2. Unchopped, undesignated, retained
 by Tamarind.

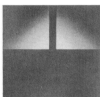

1599
Untitled (8 Monochromes VIII). Dec
11–22, 1965. Orange-brown (S),
orange-brown (Z). 50.8 × 51.1. Ed 20
(wA), 9 TI (CD), BAT (wA), 2 AP (CD), 3
TP (1 wA, 2 dLN[1]), CP (Tcs). Kinji
Akagawa. Recto: D, S, Dat Verso: WS.

1. Pulled for paper testing, one
 retained by Tamarind.

1620
Horizontally Oriented. Dec 7–20,
1965. Yellow (S), red (Z), green (Z),
blue (Z). 73.7 × 104.1. Ed 20 (BFK), 9
TI (CD), BAT (BFK), 1 AP (BFK), 3 PP
(BFK), 3 TP (BFK)[1], CP (Tcs). Walter
Gabrielson. D, S, Dat, BS.

1. 1 TP varies from the edition.

1621
Event. Dec 14–15, 1965. Black (S).
55.9 × 76.5. Ed 20 (wA), 9 TI (dLN),
BAT (wA), 3 AP (2 wA, 1 dLN), 1 TP
(wA), CP (Tcs). Jurgen Fischer. BS, D,
S, Dat.

1622
Explorer's Notebook. Dec 20–23,
1965. Red-brown (S). 57.5 × 76.8. Ed
20 (bA), 9 TI (nN), BAT (bA), 2 AP (nN),
3 PP (A), 2 TP (dLN)[1], CP (Tcs).
Clifford Smith. BS, D, S, Dat.

1. Pulled for paper testing, one TP
 retained by Tamarind.

1623
Graph of the Seven Year Cycle.
Dec 24–27, 1965. Black (S). 56.2 ×
76.5. Ed 20 (wA), 9 TI (CD), BAT (wA),
2 AP (1 wA, 1 CD), 2 TP (wA), CP (Tcs).
Walter Gabrielson. BS, D, S, Dat.

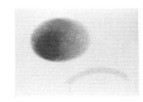

1625
Untitled. Dec 28–30, 1965. Blue (S).
55.9 × 76.2. Ed 20 (wA), 9 TI (CD),
BAT (wA), 2 AP (1 wA, 1 CD), 4 TP (2
wA, 2 dLN[1]), CP (Tcs). Kinji Akagawa.
BS, D, S, Dat.

1. Pulled for paper testing, one TP
 retained by Tamarind.

J.J. Beljon

1423
Soyons Amoureux. Jul 14–17, 1965.
Light ochre (A), brown (S). 75.6 ×
56.8. Ed 20 (BFK), 9 TI (F), BAT (BFK),
1 AP (F), 3 TP (BFK), CP (Tcs). Kenneth
Tyler. D, S, BS.

Billy Al Bengston

2271
Viking Dracula. Apr 1–May 1, 1968.
Silver-violet (A), yellow (Z), grey (A),
orange (A), light grey (A). 29.5 × 27.6,
cut.[1] Ed 20 (cR), 9 TI (ucR), BAT (cR),
2 AP (ucR), 2 CTP (cR), CP* (cR). Jean
Milant. Recto: I Verso: WS.

1. Parallelogram.

2272
Paradise Dracula. Apr 2–3, 1968.
Grey (S). 38.1 × 35.6. Ed 20 (cR), 9 TI
(ucR), BAT (cR), 3 AP (2 ucR, 1 cR), 3
TP* (cR), CP (ucR). Maurice Sanchez.
Recto: I Verso: WS.

2273
Royal Viking Dracula. Apr 1–May 1,
1968. Silver-violet (A), yellow (Z), grey
(A), orange (A), light grey (A). 26.7 ×
24.8, cut.[1] Ed 20 (cR), 9 TI (ucR), BAT
(cR), 3 AP (1 cR, 2 ucR), 2 CTP (cR), CP
(cR). Jean Milant. Recto: I Verso: WS.

1. Parallelogram

2274
Cockatoo AAA Dracula. Apr 1–May 1, 1968. Silver-violet (A), yellow (Z), grey (A), orange (A), grey (A). 28.6 × 26.7, cut.[1] Ed 20 (19 ucR, 1 cR), 9 TI (ucR), BAT (cR), 3 AP (ucR), 2 CTP (cR), CP (cR). Jean Milant. Recto: I Verso: WS.

1. Parallelogram

2275
Cockatoo Dracula. Apr 1–May 1, 1968. Silver-violet (A), yellow (Z), grey (A), orange (A), grey (A). 29.5 × 27.9, cut.[1] Ed 20 (cR), 9 TI (ucR), BAT (cR), 3 AP (ucR), 2 CTP (cR), CP (cR). Jean Milant. Recto: I Verso: WS.

1. Parallelogram

2276
Executive Party Dracula. Apr 4–May 9, 1968. Yellow (Z)[1], beige (A), black (A). 29.2 × 27.3, cut.[2] Ed 18 (cR), 9 TI (ucR), BAT (cR), 3 TP* (cR), CP* (cR). Jean Milant. Recto: I Verso: WS.

1. Plate held from 2271, run 2. 2276 differs from 2271 in color and in image. Outer margin is narrower, angular forms are fainter and more subtle and the light tone inside the oval shape around the iris has been eliminated.
2. Parallelogram.

2277
Twilight Executive Dracula. Apr 4–May 9, 1968. Yellow (Z)[1], beige (A), black (A). 27.3 × 26.7, cut.[2] Ed 20 (cR), 9 TI (ucR), BAT (cR), 3 TP* (cR), CP* (cR). Jean Milant. Recto: I Verso: WS.

1. Plate held from 2273, run 2. 2277 differs from 2273 in color and in image. The outer margin is plain, the tone around the two ovals has been eliminated.
2. Parallelogram.

2278
Downtowner Dracula. Apr 4–May 9, 1968. Yellow (Z)[1], beige (A), black (A). 27.9 × 26.7, cut.[2] Ed 18 (cR), 9 TI (ucR), BAT (cR), 3 TP* (cR), CP* (cR). Jean Milant. Recto: I Verso: WS.

1. Plate held from 2274, run 2. 2278 differs from 2274 in color and in image. The outer margin is plain and a narrow light band has been added around the dark central parallelogram. The light parallelogram framing the oval shape and the drawing around the iris has been eliminated.
2. Parallelogram.

2279
Hollywood Hawaiian Dracula. Apr 4–May 9, 1968. Yellow (Z)[1], beige (A). 29.2 × 27.9, cut.[2] Ed 20 (18 cR, 2 ucR), 9 TI (ucR), BAT (cR), 1 AP (ucR), CP (cR). Jean Milant. Recto: I Verso: WS.

1. Plate held from 2275, run 2. 2279 differs from 2275 in color and in image. The outer margin is plain and wider. The band around the two inner parallelograms is narrower. The background drawing around the innermost parrallelogram has been simplified.
2. Parallelogram.

2280
Sunset Marvel Dracula. Apr 8–12, 1968. Grey (S), pink (A). 55.9 × 54.6. Ed 20 (ucR), 9 TI (cR), BAT (ucR), 3 AP (1 ucR, 2 cR), 2 TP (ucR)[1]. Maurice Sanchez. Recto: I Verso: WS.

1. 1 TP varies from the edition.

2280II
Satellite Dracula. Apr 16–26, 1968. White (S)[1], light yellow (A). 55.9 × 54.6. Ed 20 (cR), 9 TI (ucR), BAT (cR), 3 AP (ucR), 1 TP (cR), CP* (cR). Maurice Sanchez. Recto: I Verso: WS.

1. Stone held from 2280, run 1. 2280II differs from 2280 in color and in image. The outer rectangular border that frames the central image is so subtle in color (white) that it only appears distinct when reflected in certain positions and directions of light. The pink tone in the central image which circumscribed the inner oval has been eliminated and a tonal area has been added around and within the oval ring.

2281
Galaxie Dracula. Apr 8–29, 1968. Light blue-green (S), light pearly orange (S). 39.4 × 31.8. Ed 20 (cR), 9 TI (ucR), BAT (cR), 3 AP (2 cR, 1 ucR). Theodore Wujcik. Recto: I Verso: WS.

2281II
Winona's Dracula. Apr 8–29, 1968. Light pearly orange (S)[1], light pearly blue (S)[2]. 39.4 × 31.8. Ed 20 (ucR), 9 TI (cR), BAT (ucR), 2 AP (1 cR, 1 ucR), CP* (ucR). Theodore Wujcik. Recto: I Verso: WS.

1. Stone held from 2281, run 1.
2. Stone held from 2281, run 2. 2281II differs from 2281 in color. In this state, the linear image appears more distinct.

2282
Moytel Dracula. Apr 9–26, 1968. Beige-white (S), white (A), yellow (A). 41.9 × 41.9. Ed 20 (nN), 9 TI (wN), BAT (nN), 1 AP (wN), 2 CTP (nN), CP (nN). Maurice Sanchez. Recto: I Verso: WS.

2283
Bamby's Dracula. Apr 11–May 9, 1968. Light pearly orange (A). 35.6 × 34.3, cut [1]. Ed 15 (JG), 9 TI (7 BFK, 2 JG), BAT (JG), CP (JG). Maurice Sanchez. Recto: I Verso: WS.

1. Parallelogram.

2284
Hollywood Tropics Dracula. Apr 11–May 9, 1968. Light pearly orange (A). 35.6 × 34.3, cut [1]. Ed 16 (JG), 9 TI (8 BFK, 1 JG), BAT (JG), CP (JG). Maurice Sanchez. Recto: I Verso: WS.

1. Parallelogram.

2285
One-O-Eight Dracula. Apr 12–15, 1968. Light green-grey (S). 54.6 × 53.3. Ed 20 (bA), 9 TI (CD), BAT (bA), 3 AP (bA), 3 TP (bA)[1], CP (CD). Frank Akers. Recto: I Verso: WS.

1. 2 TP vary from the edition.

2286
Saga Dracula Primero. Apr 18–May 2, 1968. Pink (S), light green-grey (A). 12.7 × 11.8, cut. Ed 20 (wA), 9 TI (BFK), BAT (wA), CP (wA)[1]. Edward Hughes. Recto: I Verso: WS.

1. Printed on same sheet with 2287–2289, uncut.

2287
Saga Dracula Segundo. Apr 18–May 2, 1968. Pink (S), light green-grey (A). 12.7 × 11.8, cut. Ed 20 (wA), 9 TI (BFK), BAT (wA), 2 AP (wA), CP (wA)[1]. Edward Hughes. Recto: I Verso: WS.

1. Printed on same sheet with 2286, 2288–2289, uncut.

2288
Saga Dracula Tercero. Apr 18–May 2, 1968. Pink (S), light green-grey (A). 12.7 × 11.8, cut. Ed 20 (wA), 9 TI (BFK), BAT (wA), 2 AP (1 BFK, 1 wA), CP (wA)[1]. Edward Hughes. Recto: I Verso: WS.

1. Printed on same sheet with 2286–2287, 2289, uncut.

2289
Saga Dracula Cuarto. Apr 18–May 2, 1968. Pink (S), light green-grey (A). 12.7 × 11.8, cut. Ed 20 (wA), 9 TI (BFK), BAT (wA), 2 AP (wA), CP (wA)[1]. Edward Hughes. Recto: I Verso: WS.

1. Printed on same sheet with 2286–2288, uncut.

2290
Oasis Dracula. Apr 19–26, 1968. Light pearly grey (S), light pearly yellow (S). 34.3 × 33.0. Ed 20 (BFK), 9 TI (wA), BAT (BFK), 3 AP (1 BFK, 2 wA), 1 TP* (BFK), CP (BFK). Frank Akers. Recto: I Verso: WS.

2296
Joiner's Unique Dracula. Apr 20–May 8, 1968. Dark gold (S), pearly blue-black (A). 54.6 × 54.6. Ed 20 (GEP), 9 TI (GEP), BAT (GEP), 3 TP* (1 BFK, 2 GEP). Robert Rogers. Recto: I Verso: WS.

2296II
Jet Inn Dracula. Apr 26–May 26, 1968. Dark pearly blue-grey (A)[1], silver-grey (S)[2]. 54.6 × 54.6. Ed 20 (GEP), 9 TI (GEP), BAT (GEP), 3 AP (GEP), 3 TP* (GEP), CP* (GEP). Robert Rogers. Recto: I Verso: WS.

1. Plate held from 2296, run 2.
2. Stone held from 2296, run 1. 2296II differs from 2296 in color making the quatrefoil appear more distinct.

2297
Nido Dracula. Apr 22–May 1, 1968. Light yellow (A), light grey-green (A). 19.7 × 19.1, cut [1]. Ed 20 (wA), 9 TI (wA), BAT (wA), 3 AP (wA), 1 TP (wA), 1 CTP (wA), CP (wA). Theo Wujcik. Recto: I Verso: WS.

1. Parallelogram.

2298
Dan River Dracula. Apr 22–May 1, 1968. Light yellow (A), light grey-green (A). 19.7 × 19.1, cut [1]. Ed 20 (wA), 9 TI (wA), BAT (wA), 3 AP (wA), 1 TP (wA), 1 CTP (wA), CP (wA). Theo Wujcik. Recto: I Verso: WS.

1. Parallelogram

2299
Mecca Dracula. Apr 28–May 8, 1968. Gold-black (S), grey-black (A). 54.6 × 54.6. Ed 20 (GEP), 9 TI (GEP), BAT (GEP), 2 AP (GEP), 2 TP* (GEP). Maurice Sanchez. Recto: I Verso: WS.

2299II
Le Roi Dracula. Apr 29–May 11, 1968. Gold-black (A)[1], gold-black (S)[2]. 54.6 × 54.6. Ed 20 (GEP), 9 TI (GEP), BAT (GEP), 3 AP (GEP), 1 TP* (GEP), 1 PTP* (BFK), CP (GEP). Maurice Sanchez. Recto: I Verso: WS.

1. Plate held from 2299, run 2.
2. Stone held from 2299, run 1. 2299II differs from 2299 in color only and as a result, in the increased subtlety of the image.

2303
Players Dracula Primero. May 1–9, 1968. Black (S). 14.0 × 13.3, cut. Ed 20 (MI), 9 TI (MI), BAT (MI), 2 AP (MI), 1 CTP (MI), CP (MI). Anthony Stoeveken. Recto: I Verso: WS.

2304
Players Dracula Segundo. May 1–9, 1968. Black (S). 14.0 × 13.3, cut. Ed 20 (MI), 9 TI (MI), BAT (MI), 2 AP (MI), 1 CTP (MI), CP (MI). Anthony Stoeveken. Recto: I Verso: WS.

2305
Players Dracula Tercero. May 1–9, 1968. Black (S). 14.0 × 13.3, cut. Ed 20 (MI), 9 TI (MI), BAT (MI), 2 AP (MI), 1 CTP (MI), CP (MI). Anthony Stoeveken. Recto: I Verso: WS.

2306
Players Dracula Cuarto. May 1–9, 1968. Black (S). 14.0 × 13.3, cut. Ed 20 (MI), 9 TI (MI), BAT (MI), 2 AP (MI), 1 CTP (MI), CP (MI). Anthony Stoeveken. Recto: I Verso: WS.

2307
Players Dracula Quinto. May 1–9, 1968. Black (S). 14.0 × 13.3, cut. Ed 20 (MI), 9 TI (MI), BAT (MI), 2 AP (MI), 1 CTP (MI), CP (MI). Anthony Stoeveken. Recto: I Verso: WS.

2308
Players Dracula Sexto. May 1–9, 1968. Black (S). 14.0 × 13.3, cut. Ed 20 (MI), 9 TI (MI), BAT (MI), 2 AP (MI), 1 CTP (MI), CP (MI). Anthony Stoeveken. Recto: I Verso: WS.

2309
Players Dracula Septimo. May 1–9, 1968. Black (S). 14.0 × 13.3, cut. Ed 20 (MI), 9 TI (MI), BAT (MI), 2 AP (MI), 1 CTP (MI), CP (MI). Anthony Stoeveken. Recto: I Verso: WS.

2310
Players Dracula Octavo. May 1–9, 1968. Black (S). 14.0 × 13.3, cut. Ed 20 (MI), 9 TI (MI), BAT (MI), 2 AP (MI), 1 CTP (MI), CP (MI). Anthony Stoeveken. Recto: I Verso: WS.

2311
Players Dracula Noveno. May 1–9, 1968. Black (S). 14.0 × 13.3, cut. Ed 20 (MI), 9 TI (MI), BAT (MI), 2 AP (MI), 1 CTP (MI), CP (MI). Anthony Stoeveken. Recto: I Verso: WS.

2312
Players Dracula Decimo. May 1–9, 1968. Black (S). 14.0 × 13.3, cut. Ed 20 (MI), 9 TI (MI), BAT (MI), 2 AP (MI), 1 CTP (MI), CP (MI). Anthony Stoeveken. Recto: I Verso: WS.

2313
Players Dracula Undecimo. May 1–9, 1968. Black (S). 14.0 × 13.3, cut. Ed 20 (MI), 9 TI (MI), BAT (MI), 2 AP (MI), 1 CTP (MI), CP (MI). Anthony Stoeveken. Recto: I Verso: WS.

2314
Players Dracula Duodecimo. May 1–9, 1968. Black (S). 14.0 × 13.3, cut. Ed 20 (MI), 9 TI (MI), BAT (MI), 2 AP (MI), 1 CTP (MIL), CP (MI). Anthony Stoeveken. Recto: I Verso: WS.

2315
Players Dracula Grande. May 1–9, 1968. Black (S), grey (A). 14.0 × 48.3, cut. Ed 20 (MI), 9 TI (MI), BAT (MI), 2 AP (MI), 1 CTP (MI), CP (MI). Anthony Stoeveken. Recto: I Verso: WS.

2326
Bostic Dracula. May 13–18, 1968. Black (S). 34.3 × 34.3, cut [1]. Ed 20 (MI), 9 TI (MI), BAT (MI), 3 AP (MI), 2 CTP (MI), CP (MI). Maurice Sanchez. Recto: I Verso: WS.

1. Parallelogram.

2327
El Reposo Dracula. May 13–18, 1968. Black (S). 35.6 × 34.3, cut [1]. Ed 20 (MI), 9 TI (MI), BAT (MI), 3 AP (MI), 2 CTP (MI), CP (MI). Maurice Sanchez. Recto: I Verso: WS.

1. Parallelogram.

2328
Rocket Dracula Primero. May 14–Jun 1, 1968. Light pearly grey (S), light pearly pink (S). 29.8 × 60.0, cut. Ed 20 (GEP), 9 TI (CD), BAT (GEP), 3 AP (1 CD, 2 GEP), CP (GEP). Theodore Wujcik. Recto: I Verso: WS.

2329
Lotus Dracula. May 16, 1968. Light pearly blue (S). 34.3 × 33.0, cut. Ed 20 (GEP), 9 TI (GEP), BAT (GEP), 2 AP (GEP), CP (GEP). Serge Lozingot. Recto: I Verso: WS.

2332
Hi-Pal Dracula. May 20–28, 1968. Light pearly grey (S), light pearly pink (S). 62.2 × 77.5. Ed 20 (GEP), 9 TI (CD), BAT (GEP), 3 AP (1 CD, 2 GEP). Theodore Wujcik. Recto: I Verso: WS.

2332II
Hi Hat Dracula. Jun 3, 1968. Light pearly grey (S)[1]. 62.2 × 77.5. Ed 10 (GEP), 9 TI (CD)[2], BAT (GEP)[2], 3 AP (1 CD, 2 GEP)[2], 1 TP* (GEP), CP (GEP). Theodore Wujcik. Recto: I Verso: WS.

1. Stone held from 2332, run 1. 2332II differs from 2332 in color and in image. The image contains only five "dracula - iris" images in light pearly grey.
2. Mistorn to 62.2 × 76.2.

2332III
Hi Hat AAA Dracula. May 20–Jun 5, 1968. Light pearly pink (S)[1]. 62.2 × 76.2. Ed 10 (GEP), 9 TI (CD), BAT (GEP), 3 AP (2 GEP, 1 CD), CP (CD). Theodore Wujcik. Recto: I Verso: WS.

1. Stone held from 2332, run 2. 2332III differs from 2332 in color and in image. The image contains only six "dracula - iris" images in light pearly pink.

2344
Rocket Dracula Segundo. May 14–Jun 1, 1968. Light pearly grey (S), light pearly pink (S). 15.2 × 60.0, cut. Ed 20 (GEP), 9 TI (CD), BAT (GEP), 3 AP (CD), CP (GEP). Theodore Wujcik. Recto: I Verso: WS.

2345
Rocket Dracula Tercero. May 14–Jun 1, 1968. Light pearly grey (S), light pearly pink (S). 29.8 × 29.8, cut. Ed 20 (GEP), 9 TI (CD), BAT (GEP), 2 AP (GEP), CP (GEP). Theodore Wujcik. Recto: I Verso: WS.

2346
Rocket Dracula Cuarto. May 14–Jun 1, 1968. Light pearly grey (S), light pearly pink (S). 29.8 × 29.8, cut. Ed 20 (GEP), 9 TI (CD), BAT (GEP), 3 AP (1 CD, 2 GEP), CP (GEP). Theodore Wujcik. Recto: I Verso: WS.

2347
Rocket Dracula Quinto. May 14–Jun 1, 1968. Light pearly grey (S). 15.2 × 29.8, cut. Ed 20 (GEP), 9 TI (CD), BAT (GEP), 3 AP (1 CD, 2 GEP), CP (GEP). Theodore Wujcik. Recto: I Verso: WS.

2348
Rocket Dracula Sexto. May 14–Jun 1, 1968. Light pearly pink (S). 15.2 × 29.8, cut. Ed 20 (GEP), 9 TI (CD), BAT (GEP), 3 AP (1 CD, 2 GEP), CP (GEP). Theodore Wujcik. Recto: I Verso: WS.

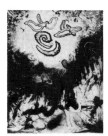

Frank Berkenkotter

1114
Roots and Flying Things. Jun 15–
30, 1964. Orange (S), yellow (S), black
(S). 37.2 × 30.8. Ed 20 (BFK), 9 TI
(wA), BAT (BFK), 3 AP (BFK), 2 TP
(BFK). Frank Berkenkotter. BS (Tam),
D, T, S, Dat, BS (pr).

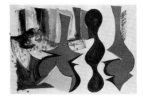

Robert Bigelow

1794
Untitled. Jul 1–Sep 30, 1966. Grey
(Z), red (Z), yellow (Z), green (Z), black
(S), blue (Z). 56.5 × 76.5. Ed 20 (JG),
9 TI (JG), BAT (JG), 1 AP (JG), 2 TP
(JG). Robert Bigelow. D, BS, S, Dat.

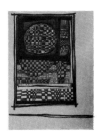

Bernard Bleha

1249
Checkerboard Square. Mar 1, 1965.
Black (S). 40.6 × 28.3. Ed 15 (BFK), 9
TI (wA), BAT (BFK), 1 AP (wA), 2 TP
(BFK), CP (Tcs). Bernard Bleha. D, S,
BS.

Andre Bloc

1451
Evocation. Aug 12–13, 1965. Black
(S). 92.1 × 61.0. Ed 20 (BFK), 9 TI
(BFK), BAT (BFK), 2 AP (BFK), 1 TP
(BFK), CP (Tcs). Clifford Smith. D, BS,
S.

James Boynton

*Packaged Horizon, or a Guided Tour to
Oblivion,* a suite of ten lithographs,
enclosed in a wooden box, measuring
56.8 × 55.2, lined and backed with
green felt, closed with a grey plexiglas
cover secured with two bolts. The
lithographs are enclosed in a wrap-

around folder of white Nacre with the
suite title handwritten in black ink by
the artist on the front cover. In order:
2084, 2080, 2083, 2089, 2090,2083,
2086, 2085ll, 2087, 2088.

Pandorasville Revisited, a suite of
twelve lithographs, enclosed in a
wrap-around folder of white Nacre
with the suite title handwritten in
black ink by the artist on the front
cover. In order: 2104, 2105, 2106,
2107, 2108, 2109, 2110, 2111, 2112,
2113, 2114, 2115.

2079
Landscape. Jul 7–13, 1967. Grey-
black (S), black (S). 43.8 × 43.5. Ed 20
(CD), 9 TI (GEP), BAT (CD), 3 AP (GEP),
1 TP (CD), 1 CTP (CD), CP* (CD). Serge
Lozingot. D, BS (Tam), S, BS (pr).

2080
Adam (Packaged Horizon II). Jul 7–
18, 1967. Black (S). 47.6 × 47.0. Ed 20
(CD), 9 TI (R), BAT (CD), 2 AP (R), CP
(CD). Donald Kelley. D, S, BS.

2082
***And Don't Come Back (Packaged
Horizon VI).*** Jul 11–19, 1967. Yellow
(Z), violet (A), brown (S). 47.6 × 47.0.
Ed 20 (CD), 9 TI (R), BAT (CD), 3 AP
(R), 1 TP (CD), CP (CD). Serge
Lozingot. D, S, BS.

2083
Eve (Packaged Horizon III). Jul 17–
27, 1967. Green (Z), orange (S), violet
(S). 47.6 × 47.3. Ed 20 (CD), 9 TI (R),
BAT (CD), 3 AP (2 R, 1 CD), 1 TP (CD),
CP* (CD). Serge Lozingot. D, S, BS.

2084
Genesis (Packaged Horizon I). Jul
18–27, 1967. Violet-brown (S), blue (Z).
47.6 × 47.3. Ed 20 (CD), 9 TI (R), BAT
(CD), 3 AP (2 CD, 1 R), 1 TP (CD), CP
(CD). Donald Kelley. D, S, BS.

2085
Big Channel in the Sky. Jul 18–Aug 2, 1967. Light blue (A), yellow-ochre (A), dark violet (S). 47.6 × 47.0. Ed 20 (CD), 9 TI (R), BAT (CD), 3 AP (R). Bruce Lowney. D, S, BS.

2085II
Big Channel in the Sky (Packaged Horizon VIII). Aug 2–14, 1967. Silver (A)[1], black (S)[2]. 47.6 × 47.0. Ed 20 (CD), 9 TI (R), BAT (CD), 3 AP (R), CP (CD). Bruce Lowney. D, S, BS.

1. Plate held from 2085, run 1.
2. Stone held from 2085, run 3. 2085II differs from 2085 in color and in image. Some crayon drawing has been eliminated from the lower half of the image.

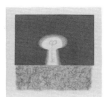

2086
Key (Packaged Horizon VII). Jul 24–Aug 15, 1967. Red (A)[1], red-violet (S), ochre (S), yellow (A). 47.6 × 47.0. Ed 20 (CD), 9 TI (R), BAT (CD), 3 AP (2 R, 1 CD), CP (CD). Anthony Stoeveken. D, S, BS.

1. Plate held from 2085, run 2.

2087
Orbit Edged in Black (Packaged Horizon IX). Jul 27–31, 1967. B: Red, yellow, blue, black (A), black (S). 47.6 × 47.0. Ed 20 (CD), 9 TI (R), BAT (CD), 3 AP (2 CD, 1 R), 1 TP (CD), CP (CD). David Folkman. BS (Tam), D, S, BS (pr).

2088
Bleed Image (Packaged Horizon X). Jul 31–Aug 4, 1967. Black (S), red (S). 47.3 × 47.6. Ed 20 (CD), 9 TI (R), BAT (CD), 3 AP (2 CD, 1 R), 1 TP (CD), CP (CD). Anthony Ko. BS, D, S.

2089
Snake (Packaged Horizon IV). Aug 2–10, 1967. Blue (S), yellow-green (S), violet (A). 46.1 × 47.0. Ed 20 (CD), 9 TI (R), BAT (CD), 2 AP (1 R, 1 CD), 3 TP (CD), 1 CTP (CD), CP (R). David Folkman. D, S, BS.

2090
The Word (Packaged Horizon V). Aug 3–25, 1967. Pink (A), red (A), green (S), gold (A). 47.6 × 47.0. Ed 20 (CD), 9 TI (R), BAT (CD), 3 AP (2 R, 1 CD), 1 TP (CD), 1 CTP (CD), CP (R). David Folkman. D, S, BS.

2091
Swinger. Aug 8–15, 1967. Violet (A), black (S). 76.2 × 55.9. Ed 20 (CD), 9 TI (R), BAT (CD), 3 AP (2 CD, 1 R), 1 TP* (R), CP (CD). Maurice Sanchez. D, S, BS.

2093
Teeth. Aug 10–21, 1967. B: Black, brown (A), gold (S). 104.5 × 75.6. Ed 20 (CD), 9 TI (GEP), BAT (CD), 3 AP (GEP), 6 PP (CD), 1 TP (CD), 1 CTP (CD), CP (CD). Serge Lozingot. D, S, BS.

2104
Kremlin (Pandorasville I). Aug 15–26, 1967. Red-brown (A), dark brown (S), grey-green (A). 28.6 × 25.4. Ed 20 (CD), 9 TI (GEP), BAT (CD), 11 AP (6 CD[1], 5 GEP), 1 TP (CD), CP (CD). John Butke. D, S (top), BS (bottom).

1. 1 AP exists on paper 55.9 × 76.2 with 2105–2109, untorn.

2104II
Untitled. Aug 15–17, 1967. Black (S)[1]. 28.6 × 25.4. Ed 10 (CD), 9 TI (GEP), BAT (CD), 3 AP (2 CD[2], 1 GEP). John Butke. D, S (top), BS (bottom).

1. Stone held from 2104, run 2. 2104II differs from 2104 in color and in image. This is the keystone with the addition of a line defining a rectangle.
2. 1 AP exists on paper 55.9 × 76.2 with 2105II-2109II, untorn.

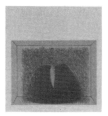

2105
Pink (Pandorasville II). Aug 15–26, 1967. Red-brown (A), dark brown (S), blue (A), pink (A). 28.6 × 25.4. Ed 20 (CD), 9 TI (GEP), BAT (CD), 6 AP (5 CD[1], 1 GEP), 1 TP (CD), CP (CD). John Butke. D, S (top), BS (bottom).

1. 1 AP exists on paper 55.9 × 76.2 with 2104, 2106–2109, untorn.

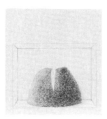

2105II
Untitled. Aug 15–17, 1967. Black (S)[1]. 28.9 × 25.4. Ed 10 (CD), 9 TI (GEP), BAT (CD), 3 AP (2 CD[2], 1 GEP). John Butke. D, S (top), BS (bottom).

1. Stone held from 2105, run 2. 2105II differs from 2105 in color and in image. This is the keystone only with the addition of a line defining a rectangle.
2. 1 AP exists only on paper 55.9 × 76.2 with 2104II, 2106II-2109II, untorn.

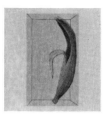

2106
Standing Room Only
(Pandorasville III). Aug 15–26, 1967.
Red-brown (A), dark brown (S), yellow
(A). 28.6 × 25.7. Ed 20 (CD), 9 TI
(GEP), BAT (CD), 9 AP (4 CD[1], 5
GEP), 1 TP (CD), CP (CD). John Butke.
D (top), S, BS (bottom).

1. 1 AP exists on paper 55.9 × 76.2
 with 2104–2105, 2107–2109, untorn.

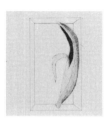

2106II
Untitled. Aug 15–17, 1967. Black
(S)[1]. 28.9 × 25.7. Ed 10 (CD), 9 TI
(GEP), BAT (CD), 3 AP (2 CD[2], 1
GEP). John Butke. D (top), S, BS
(bottom).

1. Stone held from 2106, run 2. 2106II
 differs from 2106 in color and in
 image. This is the keystone only
 with the addition of a line defining
 a rectangle.
2. 1 AP exists on paper 55.9 × 76.2
 with 2104II-2105II, 2107II- 2109II,
 untorn.

2107
Purple (Pandorasville IV). Aug 15–
26, 1967. Red-brown (A), dark
brown (S), blue (A), violet (A). 28.6 ×
25.4. Ed 20 (CD), 9 TI (GEP), BAT (CD),
7 AP (4 CD[1], 3 GEP), 1 TP (CD), CP
(CD). John Butke. D, S (top), BS
(bottom).

1. 1 AP exists on paper 55.9 × 76.2
 with 2104–2106, 2108–2109, untorn.

2107II
Untitled. Aug 15–17, 1967. Black
(S)[1]. 28.3 × 25.4. Ed 10 (CD), 9 TI
(GEP), BAT (CD), 3 AP (2 CD[2], 1
GEP). John Butke. D, S (top), BS
(bottom).

1. Stone held from 2107, run 2. 2107II
 differs from 2107 in color and in
 image. This is the keystone only
 with the addition of a line defining
 a rectangle.
2. 1 AP exists on paper 55.9 × 76.2
 with 2104II–2106II, 2108II–2109II,
 untorn.

2108
Portable Cave (Pandorasville V).
Aug 15–26, 1967. Green (A), dark
brown (S), blue (A). 28.6 × 25.4. Ed
20 (CD), 9 TI (GEP), BAT (CD), 5 AP (2
CD[1], 3 GEP), 1 TP (CD), CP (CD).
John Butke. D, S (top), BS (bottom).

1. 1 AP exists on paper 55.9 × 76.2
 with 2104–2107, 2109, untorn.

2108II
Untitled. Aug 15–17, 1967. Black
(S)[1]. 28.6 × 25.4. Ed 10 (CD), 9 TI
(GEP), BAT (CD), 3 AP (2 CD[2], 1
GEP). John Butke. D, S (top), BS
(bottom).

1. Stone held from 2108, run 2. 2108II
 differs from 2108 in color and in
 image. This is the keystone only
 with the addition of a line defining
 a rectangle.
2. 1 AP exists on paper 55.9 × 76.2
 with 2104II–2107II, 2109II, untorn.

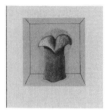

2109
Trunkated Elephant (Pandorasville
VI). Aug 15–26, 1967. Red-violet (A),
dark brown (S), orange (A). 28.6 ×
25.7. Ed 20 (CD), 9 TI (GEP), BAT (CD),
7 AP (5 CD[1], 2 GEP), 1 TP (CD), CP
(CD). John Butke. D, S, BS.

1. 1 AP exists on paper 55.9 × 76.2
 with 2104–2108, untorn.

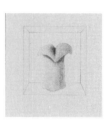

2109II
Untitled. Aug 15–17, 1967. Black
(S)[1]. 28.6 × 25.7. Ed 10 (CD), 9 TI
(GEP), BAT (CD), 3 AP (2 CD[2], 1
GEP). John Butke. D, S, BS.

1. Stone held from 2109, run 2. 2109II
 differs from 2109 in color and in
 image. This is the keystone only
 with the addition of a line defining
 a rectangle.
2. 1 AP exists on paper 55.9 × 76.2
 with 2104II–2108II, untorn.

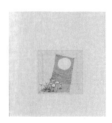

2110
Tacks (Pandorasville VII). Aug 20–
29, 1967. Green (A), violet (S), pink
(A). 28.6 × 25.4. Ed 20 (CD), 9 TI
(GEP), BAT (CD), 11 AP (7 CD, 4
GEP[1]), CP (CD). Anthony Stoeveken.
D, S (top), BS (bottom).

1. 1 AP exists on paper 55.9 × 76.2
 with 2111–2115, untorn.

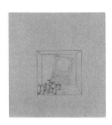

2110II
Untitled. Aug 20–21, 1967. Black
(S)[1]. 28.9 × 25.4. Ed 10 (CD), 9 TI
(GEP), BAT (CD), 2 AP (1 CD[2], 1
GEP). Anthony Stoeveken. D, S (top),
BS (bottom).

1. Stone held from 2110, run 2. 2110II
 differs from 2110 in color and in
 image. This is the keystone image.
2. 1 AP exists on paper 55.9 × 76.2
 with 2111II–2115II, untorn.

2111
Coupled Mushrooms
(Pandorasville VIII). Aug 20–29,
1967. Green (A), violet (S), pink (A).
28.6 × 25.7. Ed 20 (CD), 9 TI (GEP),
BAT (CD), 11 AP (6 CD, 5 GEP[1]), CP
(CD). Anthony Stoeveken. D, S (top),
BS (bottom).

1. 1 AP exists on paper 55.9 × 76.2
 with 2110, 2112–2115, untorn.

2111II
Untitled. Aug 20–21, 1967. Black
(S)[1]. 28.9 × 25.4. Ed 10 (CD), 9 TI
(GEP), BAT (CD), 2 AP (1 CD[2], 1
GEP). Anthony Stoeveken. D, S (top),
BS (bottom).

1. Stone held from 2111, run 2. 2111II
 differs from 2111 in color and in
 image. This is the keystone image.
2. 1 AP exists on paper 55.9 × 76.2
 with 2110II, 2112II–2115II, untorn.

2112
Fetish (Pandorasville IX). Aug 20–
29, 1967. Yellow (A), pink (A), violet
(S). 28.6 × 25.4. Ed 20 (CD), 9 TI
(GEP), BAT (CD), 7 AP (3 CD, 4
GEP[1]), CP (CD). Anthony Stoeveken.
D, S (top), BS (bottom).

1. 1 AP exists on paper 55.9 × 76.2
 with 2110–2111, 2113–2115, untorn.

2112II
Untitled. Aug 20–21, 1967. Black
(S)[1]. 28.9 × 25.7. Ed 10 (CD), 9 TI
(GEP), BAT (CD), 2 AP (1 CD[2], 1
GEP). Anthony Stoeveken. D, S (top),
BS (bottom).

1. Stone held from 2112, run
2. 2112II differs from 2112 in color and
 in image. This is the keystone
 image.
2. 1 AP exists on paper 55.9 × 76.2
 with 2110II–2111II, 2113II–2115II,
 untorn.

2113
***Condensed History of Art
(Pandorasville X).*** Aug 20–29, 1967.
Blue (A), yellow-ochre (A), violet (S).
28.6 × 25.4. Ed 20 (CD), 9 TI (GEP),
BAT (CD), 11 AP (5 CD, 6 GEP[1]), CP
(CD). Anthony Stoeveken. D, S (top),
BS (bottom).

1. 1 AP exists on paper 55.9 × 76.2
 with 2110–2112, 2114–2115, untorn.

2113II
Untitled. Aug 20–21, 1967. Black
(S)[1]. 28.6 × 25.4. Ed 10 (CD), 9 TI
(GEP), BAT (CD), 2 AP (1 CD[2], 1
GEP). Anthony Stoeveken. D, S (top),
BS (bottom).

1. Stone held from 2113, run
2. 2113II differs from 2113 in color and
 in image. This is the keystone
 image.
2. 1 AP exists on paper 55.9 × 76.2
 with 2110II–2112II, 2114II–2115II,
 untorn.

2114
Striped Wizard (Pandorasville XI).
Aug 20–29, 1967. Green (A), yellow-
ochre (A), violet (S), red (A). 28.6 ×
25.4. Ed 20 (CD), 9 TI (GEP), BAT (CD),
8 AP (5 GEP[1], 3 CD), CP (CD).
Anthony Stoeveken. D, S (top), BS
(bottom).

1. 1 AP exists on paper 55.9 × 76.2
 with 2110–2113, 2115, untorn.

2114II
Untitled. Aug 20–21, 1967. Black
(S)[1]. 27.9 × 25.4. Ed 10 (CD), 9 TI
(GEP), BAT (CD), 2 AP (1 CD[2], 1
GEP). Anthony Stoeveken. D, S (top),
BS (bottom).

1. Stone held from 2114, run
2. 2114II differs from 2114 in color and
 in image. This is the keystone
 image.
2. 1 AP exists on paper 55.9 × 76.2
 with 2110II–2113II, 2115II, untorn.

2115
Ball (Pandorasville XII). Aug 20–29,
1967. Green (A), violet (S), blue (A).
28.6 × 25.4. Ed 20 (CD), 9 TI (GEP),
BAT (CD), 11 AP (6 CD, 5 GEP[1]), CP
(CD). Anthony Stoeveken. D, S, BS.

1. 1 AP exists on paper 55.9 × 76.2
 with 2110–2114, untorn.

2115II
Untitled. Aug 20–21, 1967. Black
(S)[1]. 27.9 × 25.4. Ed 10 (CD), 9 TI
(GEP), BAT (CD), 2 AP (1 CD[2], 1
GEP). Anthony Stoeveken. D, S (top),
BS (bottom).

1. Stone held from 2115, run
2. 2115II differs from 2115 in color and
 in image. This is the keystone
 image.
2. 1 AP exists on paper 55.9 × 76.2
 with 2110II–2114II, untorn.

Paul Brach

The Negative Way, a suite of ten
lithographs plus title page and
colophon with text by Arthur Cohen,
enclosed in a white cloth covered box,
measuring 41.6 × 40.3, lined with
grey velvet, stamped on the spine
with the artist's name in dark grey. A
circular motif in relief, repeating the
image of the last lithograph in the
suite, appears on the front of the box.
Each lithograph enclosed in a folder
sheet of Rives BFK with Arabic
numerals and the text printed on the
front and on the first inside fold. A
slipcase of white Japanese paper is
placed in front of each image.
Typography and binding designed by
Elaine Lustig, printed by Clark and
Way, Inc. New York and bound by
Moroquain, Inc. In order: 1119, 1121,
1122, 1125, 1126, 1127, 1128, 1129,
1130.

1119
#1 (The Negative Way). Jul 1–9,
1967. Dark blue-green (Z)[1], grey (S).
38.1 × 38.1, cut. Ed 20 (BFK), 9 TI
(wA), BAT (BFK), PrP II for Irwin
Hollander (BFK), 3 AP (BFK), 1 PP
(BFK), 2 TP (1 BFK, 1 wA). Thom
O'Connor. Verso: T, D, S, Dat, WS.

1. This plate was used in printing the
 solid tonal background of all
 impressions in this suite.

1121
#2 (The Negative Way). Jul 2–23, 1964. Dark blue-green (Z)[1], dark grey (S), light grey (S), light grey (S). 38.1 × 38.1, cut. Ed 20 (BFK), 9 TI (wA), BAT (BFK), PrP II for Kenneth Tyler (BFK), 3 AP (BFK), 2 TP (1 BFK, 1 wA). Thom O'Connor. Verso: T, D, S, Dat, WS.

1. cf. #1119 above, footnote 1.

1122
#3 (The Negative Way). Jul 10–17, 1964. Dark blue-green (Z)[1], dark grey (S), light grey (S). 38.1 × 38.1, cut. Ed 20 (BFK), 9 TI (wA), BAT (BFK), PrP II for Irwin Hollander (BFK), 3 AP (wA), 2 TP (BFK). Thom O'Connor. Verso: T, D, S, Dat, WS.

1. cf. #1119 above, footnote 1.

1125
#4 (The Negative Way). Jul 9–21, 1964. Dark blue-green (Z)[1], black (S), light grey (S). 38.1 × 38.1, cut. Ed 20 (BFK), 9 TI (wA), BAT (BFK), PrP II for Irwin Hollander (BFK), 3 AP (wA), 2 TP (1 BFK, 1 wA). Thom O'Connor. Verso: T, D, S, Dat, WS.

1. cf. #1119 above, footnote 1.

1126
#5 (The Negative Way). Jul 20–22, 1964. Dark blue-green (Z)[1], light grey (S). 38.1 × 38.1, cut. Ed 20 (BFK), 9 TI (wA), BAT (BFK), PrP II for Irwin Hollander (BFK), 3 AP (1 BFK, 2 wA), 2 TP (BFK). Thom O'Connor. Verso: T, D, S, Dat, WS.

1. cf. #1119 above, footnote 1.

1127
#6 (The Negative Way). Aug 3–14, 1964. Dark blue-green (Z)[1], blue-black (S), light grey (S), transparent grey (Z). 38.1 × 38.1, cut. Ed 20 (BFK), 9 TI (wA), BAT (BFK), PrP II for Kenneth Tyler (wA), 2 AP (wA), 3 TP (wA). Clifford Smith. Verso: T, D, S, Dat, WS.

1. cf. #1119 above, footnote 1.

1128
#7 (The Negative Way). Jul 22–Aug 4, 1964. Dark blue-green (Z)[1], dark grey (S). 38.1 × 38.1, cut. Ed 20 (BFK), 9 TI (wA), BAT (BFK), PrP II for Kenneth Tyler (BFK), 3 AP (BFK), 3 TP (BFK). Clifford Smith. Verso: T, D, S, Dat, WS.

1. cf. #1119 above, footnote 1.

1129
#8 (The Negative Way). Aug 7–17, 1964. Dark blue-green (Z)[1], light grey (S), dark grey (S). 38.1 × 38.1, cut. Ed 20 (BFK), 9 TI (wA), BAT (BFK), PrP II for Kenneth Tyler(BFK), 2 AP (wA), 4 TP (BFK). Jeff Ruocco. Verso: T, D, S, Dat, WS.

1. cf. #1119 above, footnote 1.

1130
#9 (The Negative Way). Aug 11–18, 1964. Dark blue-green (Z)[1], light grey (S), blue-green (Z)[2], dark grey (S). 38.1 × 38.1, cut. Ed 20 (BFK), 9 TI (wA), BAT (BFK), PrP II for Kenneth Tyler(BFK), 2 TP (1 BFK, 1 wA). Jeff Ruocco. Verso: T, D, S, Dat, WS.

1. cf. #1119 above, footnote 1.
2. Same plate as run 1 with circular areas masked out.

1131
#10 (The Negative Way). Aug 12–20, 1964. Dark blue-green (Z)[1], silver (Z). 38.1 × 38.1, cut. Ed 20 (BFK), 9 TI (wA), BAT (BFK), PrP II for Kenneth Tyler (BFK), 3 AP (wA), 4 PP (BFK), 3 TP (2 BFK, 1 wA). Clifford Smith. Verso: T, D, S, Dat, WS.

1. cf. #1119 above, footnote 1.

1135
Oracle. Aug 21–31, 1964. Green-blue (Z), transparent blue-green (Z), light green-blue (Z). 55.9 × 40.6, cut. Ed 20 (BFK), 9 TI (wA), BAT (BFK), PrP II for Kenneth Tyler (BFK), 3 AP (BFK), 1 PP (BFK), 6 TP (wA). Jeff Ruocco. Verso: T, D, S, Dat, WS.

1506
Vessel. Nov 22–Dec 7, 1965. Dark grey (S), white (S). 53.3 × 53.3, cut. Ed 20 (GEP), 9 TI (BFK), UNMI (GEP), BAT (GEP). John Beckley. Verso: WS (Tam, UNM), T, D, S, Dat, WS (pr).

1507
Silver Series. Nov 23–Dec 14, 1965. Light grey (S)[1], B: light, medium, dark grey (S), blue-grey (S). 53.3 × 53.3, cut. Ed 20 (GEP), 9 TI (BFK), UNMI (GEP), BAT (GEP), 2 AP (BFK), 4 TP (2 BFK, 2 GEP). John Beckley. Verso: WS (Tam, UNM), T, D, S, Dat, WS (pr).

1. Same stone as 1506, run 1. This stone was used to print the solid tonal background.

1508
Dark Vessel. Dec 7–10, 1965. Dark grey (S)[1], dark blue-grey (S)[1]. 53.3 × 53.3, cut. Ed 20 (GEP), 9 TI (8 BFK, 1 GEP), UNMI (GEP), BAT (GEP), 4 TP (2 GEP, 2 BFK). John Beckley. Verso: WS (Tam, UNM), T, D, S, Dat, WS (pr).

1. Stones held from 1506, runs 1 and 2. 1508 differs from 1506 in color only.

William Brice

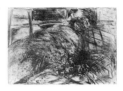

460
Interior I. Nov 24–Dec 4, 1961. Black (Z). 75.6 × 95.6. Ed 20 (BFK), 9 TI (BFK), PrP (BFK), 3 TP (BFK), CP (BFK). Irwin Hollander. BS, D, S.

461
Interior II. Nov 24–28, 1961. Black (Z). 83.8 × 66.4. Ed 20 (BFK), 9 TI (BFK), PrP (BFK), 2 TP (BFK), CP (BFK)[1]. Irwin Hollander. BS, D, S.

1. CP on paper 104.1 × 73.6.

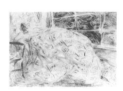

462
Interior III. Nov 27, 1960–Dec 18, 1961. Black (Z). 65.4 × 84.5. Ed 20 (BFK), 9 TI (wN), PrP (BFK), 2 AP (wN), 3 TP (BFK), CP (BFK). Irwin Hollander. BS, D, S.

467
Interior IV. Dec 4–8, 1961. Black (Z). 75.9 × 56.8. Ed 20 (BFK), 9 TI (wA), PrP (BFK), 2 AP (1 BFK, 1 wA), 3 TP (2 BFK, 1 wA), CP (BFK)[1]. Irwin Hollander. BS, D, S.

1. Unchopped.

468
Interior V. Dec 4–8, 1961. Black (Z). 75.9 × 56.8. Ed 20 (BFK), 9 TI (wA), PrP (BFK), 2 AP (BFK), 3 TP (BFK), CP (BFK). Harold Keeler. BS, D, S.

469
Striped Robe. Dec 11–15, 1961. Black (Z). 104.8 × 74.6. Ed 20 (BFK), 9 TI (wN), PrP (BFK), 2 AP (wN), 1 TP (BFK), CP (BFK). Harold Keeler. BS, D, S.

471
Circus. Dec 18, 1961–Jan 12 1962. Yellow (S), red (S). 76.2 × 56.5. Ed 20 (BFK), 9 TI (wA), PrP (BFK), 3 AP (wA), 6 TP (3 BFK, 3 wA), CP* (wA). Irwin Hollander. D, BS, S.

479
Reclining Figure. Jan 3, 1962. Black (Z). 82.9 × 57.8. Ed 20 (BFK), 9 TI (wN), PrP (BFK), 2 AP (1 BFK, 1 wN), 2 TP (1 BFK, 1 wN), CP (BFK). Irwin Hollander. D, BS, S.

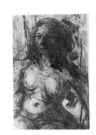

485
Female Figure. Jan 8–10, 1962. Black (Z). 55.9 × 38.1. Ed 20 (BFK), 9 TI (wA), PrP (BFK), 3 AP (BFK), 3 TP (2 BFK, 1 wA). Harold Keeler. D, S, BS.

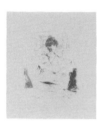

486
Young Woman. Jan 8–15, 1962. Light grey-brown (Z). 35.9 × 28.3. Ed 10 (BFK), 9 TI (wA), PrP (BFK), 2 AP (BFK), 3 TP (BFK), CP (BFK). Irwin Hollander. D, S, BS.

488
Two Figures. Jan 15–16, 1962. Black (Z). 76.2 × 53.3. Ed 20 (BFK), 9 TI (wA), PrP (BFK), 3 AP (BFK), 5 TP (3 BFK, 2 wA), CP (BFK)[1]. Irwin Hollander. D, S, BS.

1. CP on paper 76.2 × 55.9.

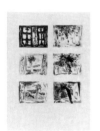

489
Ensenada Windows. Jan 16–18, 1962. Black (Z). 56.8 × 38.7. Ed 20 (bA), 9 TI (nN), PrP (bA), 3 AP (1 bA, 2 nN), 3 TP (2 bA, 1 nN), CP (bA). Irwin Hollander. D, S, BS.

492
Sitting Figure. Jan 19–20, 1962.
Black (Z). 76.2 × 56.8. Ed 20 (BFK), 9
TI (wA), PrP (BFK), 2 AP (1 BFK, 1 wA),
5 TP (4 BFK, 1 wA). Joe Funk. D, S,
BS.

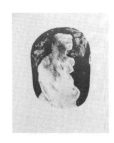

507
Female Torso II. Feb 6–9, 1962. Black
(Z). 66.0 × 51.4. Ed 20 (BFK), 9 TI
(wA), PrP (BFK), 2 AP (A), 3 TP (BFK),
CP (BFK). Wesley Chamberlin. D, S,
BS.

495
Figure and Storm. Jan 23–Feb 3,
1962. Grey (Z), black (Z). 75.3 × 105.9.
Ed 10 (BFK), 9 TI (BFK), PrP (BFK), 3
TP (BFK), CP* (BFK). Joe Funk. D, S,
BS.

547
Reclining Figure II. Apr 2–7, 1962.
Black (Z). 57.2 × 76.2. Ed 20 (BFK), 9
TI (wA), PrP (BFK), 1 AP (wA), 3 TP
(BFK), CP (BFK). Wesley Chamberlin.
D, S, BS.

498
Two Figures and Sea. Jan 26–Feb 2,
1962. Black (Z). 74.9 × 104.8. Ed 20
(BFK), 9 TI (wN), PrP (BFK), 2 AP (BFK),
3 TP (2 wN, 1 BFK), CP (BFK).
Bohuslav Horak. BS, D, S.

551
Woman in a Flowered Blouse. Apr
9–10, 1962. Black (Z). 76.2 × 56.5. Ed
20 (BFK), 9 TI (wA), PrP (wA), 1 AP (A),
6 TP (4 BFK, 2 bA[1]), CP (BFK). Irwin
Hollander. D, BS (pr), S, BS (Tam).

1. Color trial proofs on paper 76.2 ×
 50.8.

499
Winter Orchard. Jan 29–31, 1962.
Black (Z). 57.5 × 76.8. Ed 15 (BFK), 9
TI (wN), PrP (BFK), 4 AP (3 BFK, 1 wN),
3 TP (2 BFK, 1 wN), CP (BFK). Irwin
Hollander. D, S, BS.

556
Figures in Landscape. Apr 21, 1962.
Black (Z). 30.8 × 56.5. Ed 20 (BFK), 9
TI (CW), PrP (BFK), 2 AP (BFK), 3 TP (1
BFK, 2 CW), CP (CW). Wesley
Chamberlin. D, BS (Tam), S, BS (pr).

504
Female Torso I. Feb 6–10, 1962. Black
(Z)[1]. 56.5 × 38.1. Ed 20 (BFK), 9 TI
(wA), PrP (BFK), 3 AP (1 BFK, 2 wA), 3
TP (1 BFK, 2 wA). Joe Funk. D, S, BS.

1. Some impressions exist on paper
 56.5 × 37.5.

558
Figures and Sea. Apr 19–24, 1962.
Black (Z). 57.2 × 76.2. Ed 20 (BFK), 9
TI (wA), PrP (BFK), 2 AP (wA), 3 TP
(BFK), CP (BFK). Irwin Hollander. D, S,
BS.

506
Standing Figure. Feb 6–9, 1962.
Black (Z). 92.1 × 54.0. Ed 20 (BFK), 9
TI (BFK), PrP (BFK), 1 AP (BFK), 3 TP
(BFK), CP (BFK). Joe Funk. D, S, BS.

559
Landscape with Figure. Apr 19–25,
1962. Black (Z). 58.8 × 63.8. Ed 20
(BFK), 9 TI (BFK), PrP (BFK), 2 AP
(BFK), 3 TP (BFK). Irwin Hollander. D,
S, BS.

1808
Figures and Stream. Aug 30–Sep 8,
1966. Pink (S), red (S), blue (S). 61.0
× 48.3. Ed 20 (GEP), 9 TI (CD), BAT
(GEP), 3 AP (2 GEP, 1 CD), 1 TP (GEP),
2 PTP (dLM)[1], CP (EVB). Ernest de
Soto. D, BS, S.

1. Unsigned, unchopped,
 undesignated, retained by
 Tamarind.

1810
Two Figures. Sep 6–30, 1966. Yellow (S), red (S), blue (S), violet (S), black (S). 56.2 × 76.5. Ed 20 (MI), 9 TI (GEP), BAT (MI), 3 AP (1 MI, 2 GEP), 1 TP (MI), CP (EVB). Erwin Erickson. D, BS, S.

2760
Cabeza Emergente con Arco Iris. Oct 8–21, 1969. Beige, B: violet, red-violet, orange, yellow (A), brown (S). 61.0 × 83.8. Ed 20 (ucR), 9 TI (BFK), BAT (ucR), 2 AP (BFK), 2 TP* (1 ucR, 1 BFK), CP (cR). S. Tracy White. D, BS, S, Dat.

William Brown

110
The Room. Aug 8–30, 1960. Black (S). 38.4 × 45.7. Ed 29 (CD), 9 TI (wN), 1 ExP (CD)[1], BAT (CD), 5 TP (CD)[2]. Garo Antreasian. BS (Tam), D, T, BS (prs), S, Dat.

1. Retained by Tamarind.
2. 2 TP vary from the edition, unchopped. One retained by Tamarind.

Print not in
University Art Museum
Archive

111
Untitled. Aug 9, 1960. Black (S). 45.7 × 61.0. 3 TP (C)[1]. Joe Funk or Garo Antreasian, NC, D, S.

1. Unchopped. 1 TP retained by Tamarind.

2761
El Edan Pez Cósmico. Oct 11–23, 1969. Brown (A), black (S), B: violet, white and pink, green (A). 61.0 × 83.8. Ed 20 (CD), 9 TI (cR), BAT (CD), 3 AP (1 CD, 2 cR), 3 TP (CD)[1], CP (cR). Paul Clinton. D, BS, S, Dat.

1. 2 TP vary from the edition.

2762
Homo Escorpio Universal. Oct 14–20, 1969. Brown-black (S). 41.9 × 59.7. Ed 20 (cR), 9 TI (ucR), BAT (cR), 3 AP (1 cR, 2 ucR), 2 PTP (1 CD, 1 GEP), CP (ucR). Eugene Sturman. D, BS, S, Dat.

2763
La Gran Maquina creando Planetas. Oct 14–20, 1969. Grey (S). 41.9 × 59.7. Ed 20 (cR), 9 TI (ucR), BAT (cR), 3 AP (2 cR, 1 ucR), 1 PP (cR), 2 PTP (CD), CP (ucR). Eugene Sturman. D, S, Dat, BS.

Salvador Bru

2757
La Gran Máquina. Sep 30–Oct 6, 1969. Black (S), white (S). 51.1 × 73.7. Ed 20 (CD), 9 TI (GEP), BAT (CD), 3 AP (2 CD, 1 GEP), 2 PP (GEP), 6 CTP (2 ucR, 2 GEP, 2 CD), 1 PTP (ucR), CP (GEP). William Law III. D, BS, S, Dat.

2764
La Ciudad Blanda. Oct 17–31, 1969.
Pink (Z), black (S). 43.2 × 61.0. Ed 20 (wA), 9 TI (CD), BAT (wA), 2 AP (1 wA, 1 CD), 1 TP (bA), CP (CD). William Law III. D, BS, S, Dat.

2758
Homenaje al Desierto de Nevada. Oct 3–10, 1969. Brown (A), black (S). 53.3 × 78.7. Ed 20 (19 ucR, 1 cR), 9 TI (cR), BAT (ucR), 1 TP* (CD), CP (ucR). Paul Clinton. D, BS, S, Dat.

2765
Proceso Piramidal Planetas. Oct 17–31, 1969. Grey (Z), black (S). 43.5 × 61.0. Ed 20 (wA), 9 TI (CD), BAT (wA), 1 TP (bA), CP (CD). William Law III. D, BS, S, Dat.

2759
The Onion Flower. Oct 3–24, 1969. Light brown (A), violet (A), black (S). 61.0 × 84.2. Ed 20 (CD), 9 TI (GEP), BAT (CD), 2 AP (CD), 2 CTP (1 cR, 1 GEP), CP (GEP). Hitoshi Takatsuki. D, BS, S, Dat.

2766
Universal Fly. Oct 23–Nov 10, 1969. Blue (Z), black (S), white and green, B: brown, silver-grey and dark pink, yellow-green (Z). 53.3 × 78.7. Ed 20 (CD), 9 TI (cR), BAT (CD), 2 AP (CD), 4 TP (3 CD, 1 cR), CP (cR). David Trowbridge. D, BS, S, Dat.

2767
Tongue of the Universal Fly. Oct
27–Nov 6, 1969. B: Pink, red (Z), black
(S), on silver Fasson foil, laid down.
54.6 × 69.9. Ed 20 (BFK), 9 TI
(BFK), BAT (BFK), 3 AP (BFK), 2 PP
(BFK), 3 TP (2 ucR, 1 BFK)[1]. S. Tracy
White. D, BS, S, Dat.

1. 2 TP vary from the edition.

2767II
Tongue of the Universal Fly. Oct
27–Nov 8, 1969. B: Green, light green
(Z)[1], white (S)[2], on silver Fasson
foil, laid down. 54.6 × 69.9. Ed
10 (BFK), 9 TI (BFK), BAT (BFK), 3 AP
(BFK), CP (BFK). S. Tracy White. D, BS,
S, Dat.

1. Plate held from 2767, run 1.
2. Stone held from 2767, run 2. 2767II
 differs from 2767 in color only.

2768
The Seven Terrible Tongues. Oct 28,
1969. Brown, B: pink, green (Z), B:
brown, violet (Z). 53.3 × 78.7. Ed 20
(ucR), 9 TI (cR), BAT (ucR), 3 AP (ucR),
CP (cR). Eugene Sturman. D, BS, S,
Dat.

2769
La Casa del Mosquito. Oct 28–Nov
11, 1969. Brown (Z), black (S), B:
white, blue, green (Z). 53.7 × 78.7. Ed
20 (GEP), 9 TI (CD), BAT (GEP), 3 AP (1
CD, 2 GEP), 1 PP (GEP), 1 CTP (CD), CP
(GEP). Edward Hamilton. D, BS, S,
Dat.

2770
La Flor de Piedra. Oct 30–Nov 7,
1969. Grey (Z), black (S). 43.8 × 61.0.
Ed 20 (19 wA, 1 GEP), 9 TI (GEP), BAT
(wA), 2 AP (GEP), 2 TP (wA)[1], CP
(wA). Larry Thomas. D, BS, S, Dat.

1. 1 TP varies from the edition.

2798
Karo Rojo. Nov 13–21, 1969. Orange-
red (Z), B: red, pink (Z), black (S). 54.0
× 79.4. Ed 20 (18 CD, 2 GEP), 9 TI
(GEP), BAT (CD), 3 CTP (1 GEP, 2 CD),
CP (CD). Hitoshi Takatsuki. D, BS, S,
Dat.

2799
Icaro. Nov 11–21, 1969. B: Yellow-
ochre, red, black, orange-red, light
yellow-ochre (Z), black (S). 53.3 ×
78.7. Ed 20 (GEP), 9 TI (cR), BAT (GEP),
2 AP (cR), 3 TP (2 GEP, 1 CD)[1]. Paul
Clinton. D, BS, S, Dat.

1. 2 TP vary from the edition.

2799II
Icaro II. Nov 17–21, 1969. B: Yellow-
green, dark green, white, light yellow-
green (Z)[1], black (S)[1]. 53.3 × 79.4.
Ed 10 (cR), 9 TI (GEP), BAT (cR), 3 AP
(1 cR, 2 GEP), CP (cR). Paul Clinton. D,
BS, S, Dat.

1. Plate and stone held from 2799.
 2799II differs from 2799 in color
 only.

2800
Jupiter Fish. Nov 12–20, 1969. Silver
(Z), grey-black (A). 53.3 × 78.7. Ed 20
(BFK), 9 TI (GEP), BAT (BFK), 3 AP
(GEP), 3 TP* (1 GEP, 1 BFK, 1 CD), CP
(GEP). Larry Thomas. D, BS, S, Dat.

2801
Los Dos Universos[1]. Nov 13–22,
1969. Black (S). 61.0 × 45.7. Ed 20
(CD), 9 TI (GEP), BAT (CD), 3 AP (1 CD,
2 GEP), 1 TP (CD), CP (GEP). David
Trowbridge. D, S, Dat, BS.

1. The artist intends this to be seen
 with 2803 as one unit. (cf. 2803,
 note 1).

2802
Guitar of Flesh. Nov 17–22, 1969.
Blue and brown (A), black (S)[1]. 75.3
× 105.1. Ed 18 (16 cR, 2 ucR), 9 TI
(ucR), BAT (cR), 1 AP (cR), CP (cR).
Edward Hamilton. D, S, Dat, BS.

1. Two black grommets were fastened
 1.90 from top and bottom in the
 center of each impression. A red
 cotton string was tied through these
 two eyelets.

2803
Los Dos Universos[1]. Nov 13–22,
1969. Black (S). 61.0 × 45.7. Ed 20
(CD), 9 TI (GEP), BAT (CD), 3 AP (CD),
1 TP (CD), CP (GEP). David
Trowbridge. D, S, Dat, BS.

1. The artist intends this as one unit
 with 2801 to be seen in the
 following arrangements:

David Budd

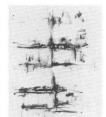

549
Monica Variety. Apr 7–9, 1962. Black (S). 50.8 × 38.1. Ed 20 (BFK), 9 TI (wA), PrP (BFK), 2 BAT (BFK)[1], 1 AP (BFK), CP (BFK). Joe Funk. D, S, BS.

1. 1 BAT, unchopped, retained by printer. On verso, effaced impression of another addition.

Louis Bunce

Untitled Suite, a suite of ten lithographs. In order: 635, 244, 264, 282A, 256, 276A, 282, 270, 268, 276, 278.

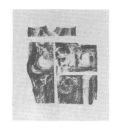

244
Untitled (Untitled Suite I). Mar 14–21, 1961. Black (S). 46.1 × 38.4. Ed 20 (BFK), 9 TI (wN), PrP (BFK), 5 AP (3 BFK, 2 wN). Garo Z. Antreasian. BS (Tam), D, S, BS (pr).

248
Untitled. Mar 17–23, 1961. Dark beige (S), grey (Z), orange (Z), black (S). 38.7 × 46.1. Ed 20 (BFK), 9 TI (wN), PrP (BFK), 2 AP (1 BFK, 1 wN), 3 TP (BFK). Joe Funk. BS (Tam), D, S, BS (pr).

250
Untitled. Mar 21–24, 1961. Light grey (S), black (Z). 46.4 × 38.7. Ed 20 (BFK), 9 TI (wN), PrP (BFK), 2 AP (wN), 2 TP (1 BFK, 1 wN). Garo Z. Antreasian. BS (Tam), D, S, BS (pr).

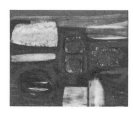

251
Untitled. Mar 24–Apr 28, 1961. Brown (S), black (S), blue-green (Z). 38.7 × 46.4. Ed 20 (BFK), 9 TI (wN), PrP (BFK), 2 AP (BFK). Joe Funk. BS (Tam), D, S, BS (pr).

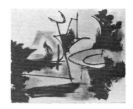

256
Untitled (Untitled Suite IV). Mar 30–Apr 4, 1961. Yellow (Z), green (Z), black (S). 38.7 × 46.4. Ed 20 (BFK), 9 TI (wN), PrP (BFK), 4 AP (3 BFK, 1 wN), 2 PgP (BFK). Garo Z. Antreasian. D, S, BS.

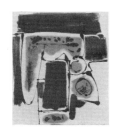

264
Untitled (Untitled Suite II). Apr 4–7, 1961. Grey-brown (Z), blue (Z), black (Z). 46.4 × 38.7. Ed 20 (BFK), 9 TI (wN), PrP (BFK), 3 AP (2 BFK, 1 wN), 1 TP* (wN). Garo Z. Antreasian. BS (Tam), D, S, BS (pr).

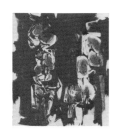

268
Untitled (Untitled Suite VIII). Apr 5–6, 1961. Black (S). 46.7 × 38.7. Ed 20 (BFK), 9 TI (wN), PrP (BFK), 4 AP (1 BFK, 3 wN). Garo Z. Antreasian. BS (Tam), D, S, BS (pr).

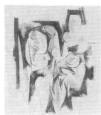

270
Untitled (Untitled Suite VII). Apr 10, 1961. Black (S). 46.1 × 38.4. Ed 20 (BFK), 9 TI (wN), PrP (BFK), 5 AP (3 BFK, 2 wN). Garo Z. Antreasian. BS (Tam), D, S, BS (pr).

Print not in
University Art Museum
Archive

272
Untitled. Apr 10–13, 1961. Red-brown (S), black (Z). 39.1 × 47.0. Ed 20 (BFK), 9 TI (wN), PrP (BFK), 5 AP (BFK). Joe Funk. BS (Tam), D, S, BS (pr).

276
Untitled (Untitled Suite IX). Apr 13–17, 1961. Blue (Z), black (Z). 38.7 × 46.1. Ed 20 (BFK), 9 TI (wN), PrP (BFK), 5 AP (3 BFK, 2 wN). Joe Funk. BS (Tam), D, S, BS (pr).

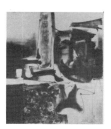

276A
Untitled (Untitled Suite V). Apr 20, 1961. Black (Z)[1]. 46.4 × 38.7. Ed 20 (BFK), 9 TI (wN), PrP (BFK), 3 AP (2 BFK, 1 wN). Garo Z. Antreasian. BS (Tam), D, S, BS (pr).

1. Plate held from 276, run 2; additions. 276A differs from 276 in color, image and in presentation as a vertical. The two light central broad strokes have been eliminated. Extensive additions have been made at the lower left, a vertical section at the center and minor additions throughout the image.

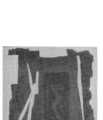

278
Untitled (Untitled Suite X). Apr 14–25, 1961. Light beige (Z), grey-brown (S), brown-black (Z). 46.4 × 38.4. Ed 20 (BFK), 9 TI (wN), PrP (BFK), 3 AP (2 BFK, 1 wN). Joe Funk. BS (Tam), D, S, BS (pr).

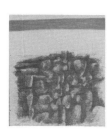

282
Untitled (Untitled Suite VI). Apr 24–28, 1961. Yellow-orange, violet (Z), red-orange, brown (S). 46.4 × 38.7. Ed 20 (BFK), 9 TI (wN), PrP (BFK), 5 AP (4 BFK, 1 wN). Garo Z. Antreasian. BS (Tam), D, S, BS (pr).

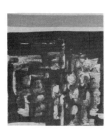

282A
Untitled (Untitled Suite III). May 1–2, 1961. Black, dark pink (S)[1]. 46.4 × 38.4. Ed 20 (BFK), 9 TI (wN), PrP (BFK), 5 AP (3 BFK, 2 wN). Joe Funk. D, S, BS.

1. Stone held from 282, run 2; additions. 282A differs from 282 in color and in image. The color tone underneath the pen drawing has been eliminated. Deletions and redrawing have been made throughout the image opening the density of the cross-hatching. Extensive solid areas have been added around and throughout the pen drawing. The horizontal band has been widened extending close to the top edge.

284
Untitled. May 4–5, 1961. Blue (S), brown-green (S)[1]. 38.7 × 46.7. Ed 20 (BFK), 9 TI (wN), PrP (BFK), 4 AP (1 BFK, 3 wN), 1 TP (BFK). Bohuslav Horak. BS (Tam), D, S, BS (pr).

1. Same stone as run 1; reversal.

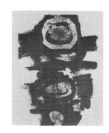

286
Untitled. May 5–8, 1961. Black (S). 76.8 × 56.8. Ed (BFK), 9 TI (wN), PrP (BFK), 5 AP (2 BFK, 3 wN). Bohuslav Horak. BS (Tam), D, S, BS (pr).

289
Untitled. May 9–11, 1961. Light grey (Z), black (S). 56.5 × 76.8. Ed 20 (BFK), 9 TI (wN), PrP (BFK), 5 AP (4 BFK, 1 wN), 2 SP (BFK), CP (BFK). Bohuslav Horak. BS (Tam), D, S, BS (pr).

No photograph

635
Title Page (Untitled Suite)[1]. Aug 27, 1962. Brown (S). 46.3 × 39.4. Ed 20 (BFK), 9 TI (BFK), PrP (BFK), 2 AP (BFK), 2 PP (wN), 3 TP (BFK), CP (wN). Robert Gardner.

1. During the preparation of this suite, the original title page (Tam. #292) was inadvertently effaced after 12 proofs were pulled from stone on various fine and offset papers (45.7 × 38.1) in colors ranging from red-brown to light violet- grey (image size: 17.8 × 12.7), printed by Bohuslav Horak, May 11–12, 1961.

John Butke

1950
Untitled. Mar 6–12, 1967. Black (Z). 56.5 × 76.2. Ed 10 (wA), 9 TI (BFK), BAT (wA), 2 TP (wA). John Butke. D, BS, S.

1950II
Untitled. Mar 6–30, 1967. Blue (Z)[1], light blue (Z), dark blue (Z), orange-red (Z). 56.5 × 76.2. Ed 10 (wA), 9 TI (BFK), BAT (wA), 2 AP (BFK), 4 TP (wA), CP (EVB). John Butke. D, BS, S.

1. Stone held from 1950. 1950II differs from 1950 in color and in image. Two dark areas in the lower center and right have been eliminated. Small solid areas have been added throughout the image and in the upper right.

1999
Untitled. Apr 2–21, 1967. Yellow (Z), red (Z), blue (Z), orange, green, yellow-green (Z). 56.8 × 76.5. Ed 10 (BFK), 9 TI (wA), BAT (BFK), 2 AP (wA), 4 TP (BFK), CP (BFK). John Butke. Recto: BS Verso: D, S.

Fred Cain

2019
Elkins Park. May 9–10, 1967. Silver-brown (S). 45.4 × 38.4. Ed 20 (MI), 9 TI (wA), BAT (MI), 3 AP (wA), 2 PP (1 CW, 1 MI), 2 TP[1] (MI), 1 CTP (MI), 1 PTP (CW), CP (wA). Maurice Sanchez. D, BS, S, Dat.

1. 1 TP on paper 55.9 × 38.1.

Lawrence Calcagno

878
Untitled. Aug 28, 1963. Violet (Z), black (S). 57.2 × 77.5. Ed 14 (BFK), 9 TI (wN), BAT (BFK), 1 PrP II for John Dowell (BFK), 3 AP (2 BFK, 1 wN), 1 TP (BFK), CP (BFK). Kenneth Tyler. BS, D, S, Dat.

Rafael Canogar

The Earth, a suite of fourteen lithographs including introduction and colophon, enclosed in a blue cloth covered box, measuring 78.7 × 58.4, secured with ties, stamped on the front cover with the artist's name and suite title in silver, made by Earle Grey Bookbinding Co. Los Angeles. Each lithograph enclosed in a chemise of white Tableau paper numbered in Arabic numerals at the lower right. In order: 2610, 2596, 2599, 2594, 2595, 2597, 2593, 2598, 2615" 2608, 2612, 2602, 2609, 2611.

2591
Saludo a una Personalidad. Apr 2–10, 1969. Light brown (S), black (S). 50.8 × 71.1. Ed 20 (GEP), 9 TI (wA), BAT (GEP), 3 AP (1 wA, 2 GEP), 1 TP* (GEP), CP (wA). John Sommers. BS, D, S, Dat.

2592
El Tumulto. Apr 4–21, 1969. Grey (S), silver (S), black (S)[1]. 51.1 × 71.5. Ed 20 (1 CD, 19 GEP), 9 TI (CD), BAT (CD), 1 AP (GEP), 1 TP* (GEP), 2 CTP (GEP), CP (CD). Donald Kelley. D, S, Dat, BS.

1. Same stone as run 2.

2593
El Llanto (The Earth 7). Apr 9–21, 1969. Red-brown (S), black (S), white (A). 76.2 × 55.9. Ed 20 (cR), 9 TI (ucR), BAT (cR), 4 AP (3 cR, 1 ucR), 1 PP (ucR), 1 TP (cR), 2 CTP (cR), CP (cR). Charles Ringness. D, T, S, Dat, BS.

2594
Cordon de Policiá (The Earth 4). Apr 11–24, 1969. Black (A), black (S), embossed. 55.9 × 76.2. Ed 20 (cR), 9 TI (ucR), BAT (ucR), 3 AP (1 cR, 2 ucR), 1 CTP (cR), CP (cR). Ronald Glassman. D, T, S, Dat, BS.

2595
Vivo Tiempos Sombrios (The Earth 5). Apr 15–23, 1969. Grey (A), black (S). 76.5 × 55.9. Ed 20 (cR), 9 TI (ucR), BAT (cR), 2 AP (ucR), 1 TP (ucR)[1], 1 CTP (cR), CP (cR). John Sommers. D, T, S, Dat, BS.

1. Handpainted with grey Liquitex acrylic polymer emulsion.

2596
Entre el Pueblo Estoy (The Earth 2). Apr 14–22, 1969. Red-black (S). 55.9 × 76.2. Ed 20 (cR), 9 TI (ucR), BAT (cR), 3 AP (1 cR, 2 ucR), 1 TP* (cR), CP (ucR). Daniel Socha. BS, D, T, S, Dat.

2597
El Carcelero (The Earth 6). Apr 17–28, 1969. Black (S). 76.2 × 55.9. Ed 20 (cR), 9 TI (ucR), BAT (cR), 2 AP (cR), 1 PTP (wA), CP (cR). Daniel Socha. D, T, BS, S, Dat.

2598
Larga Espero (The Earth 8). Apr 16–
May 2, 1969. Black (A), dark blue-grey
(S). 56.2 × 76.5. Ed 20 (cR), 9 TI (cR),
BAT (cR), 4 AP (cR), 2 TP* (cR), CP
(cR). Charles Ringness. D, BS, T, S,
Dat.

2599
Tus Gritos Oirán (The Earth 3). Apr
28–May 5, 1969. Light brown (A),
violet-black (S). 55.9 × 76.5. Ed 20
(cR), 9 TI (ucR), BAT (cR), 3 AP (1 cR, 2
ucR), 1 TP* (ucR), CP (cR). Ronald
Glassman. D, T, S, Dat, BS.

2600
El Muerto (La Violencia 7). Apr 28–
May 1, 1969. Violet-black (S). 76.5 ×
56.2. Ed 20 (cR), 9 TI (ucR), BAT (cR), 4
AP (2 cR, 2 ucR), 1 PTP (wN), CP (ucR).
John Sommers. D, T, S, Dat, BS.

2601
***Descolorida paz, preciosa guerra
(La Violencia 2).*** May 1–5, 1969.
Green-black (S). 55.9 × 76.5. Ed 20
(cR), 9 TI (ucR), BAT (cR), 5 AP (2 cR, 3
ucR), 2 CTP (cR), CP (cR). Paul Clinton.
D, T, S, Dat, BS.

2602
El Abrazo (The Earth 12). May 2–12,
1969. Silver-black (A), black (S). 76.5
× 56.2. Ed 20 (cR), 9 TI (ucR), BAT
(cR), 3 AP (1 cR, 2 ucR), 1 TP
(coverstock), 3 CTP (cR), CP (ucR).
William Law III. D, T, S, Dat, BS.

2608
El Paseo (The Earth 10). May 6–12,
1969. Pink (A), black (S). 76.5 × 55.9.
Ed 20 (cR), 9 TI (ucR), BAT (cR), 3 AP
(cR), 2 PP (ucR), 3 CTP (ucR, 1 cR), CP
(cR). Daniel Socha. D, BS, T, S, Dat.

2609
Escena Urbana (The Earth 13). May
9–13, 1969. Green-black (S). 56.2 ×
76.2. Ed 20 (cR), 9 TI (ucR), BAT (cR), 3
AP (cR), 1 PP (ucR), 1 CTP (cR), 1 PTP
(bA), CP (ucR). Paul Clinton. D, T, S,
Dat, BS.

2610
***Untitled (Introduction, The Earth
1).*** May 13–14, 1969. Blue-black (S).
76.5 × 56.2. Ed 20 (cR), 9 TI (ucR),
BAT (cR), 2 AP (1 cR, 1 ucR), CP (ucR).
Ronald Glassman. BS, D, S, Dat.

2611
Untitled (Colophon, The Earth 14).
May 12–13, 1969. Black (Z). 76.2 ×
55.9. Ed 20 (cR), 9 TI (ucR), BAT (cR), 3
AP (cR), CP (ucR). John Sommers. D,
S, Dat, BS.

2612
El Político (The Earth 11). May 14–
16, 1969. Brown (S). 76.2 × 55.9. Ed
20 (cR), 9 TI (7 ucR, 2 cR), BAT (cR), 5
AP (1 cR, 4 ucR), 2 CTP (cR), CP (cR).
Paul Clinton. D, T, S, Dat, BS.

2613
***Los Revolucionarios (La Violencia
3).*** May 14–19, 1969. Green-black (S).
55.9 × 76.2. Ed 20 (cR), 9 TI (ucR),
BAT (cR), 1 TP* (cR), 1 PTP (bA), CP
(ucR). William Law III. D, BS, T, S, Dat.

2614
Los Prisioneros (La Violencia 5).
May 16–23, 1969. Violet-black (S), red
(A). 56.2 × 76.5. Ed 20 (cR), 9 TI (ucR),
BAT (cR), 3 AP (1 cR, 2 ucR), 1 PTP
(bA), CP (ucR). Jean Milant. D, BS, T,
S, Dat.

2615
El Diálogo (The Earth 9). May 19–
21, 1969. Black (S). 76.2 × 55.9. Ed 20
(cR), 9 TI (ucR), BAT (cR), 4 AP (cR), 1
PP (cR), 1 CTP (cR), 1 PTP (ucR)[1], CP
(cR). Charles Ringness. D, BS, T, S,
Dat.

1. Printed on Fasson self-adhesive
 chrome mylar adhered to paper.

2616
La Pelea (La Violencia 4). May 20–
21, 1969. Silver-black (S). 56.2 × 76.2.
Ed 20 (cR), 9 TI (ucR), BAT (cR), 1 TP*
(cR), 2 CTP (cR), CP (cR). John
Sommers. D, T, S, Dat, BS.

2617
El Herido (La Violencia 6). May 20–
22, 1969. Black (S). 55.9 × 76.2. Ed 20
(cR), 9 TI (ucR), BAT (cR), 6 AP (4 cR, 2
ucR), 1 PP (cR), 1 CTP (cR), CP (cR).
Ronald Glassman. D, BS, T, S, Dat.

2648
*Untitled (Colophon, La Violencia
8).* May 22–26, 1969. Black (S). 76.2 ×
55.9. Ed 20 (cR), 9 TI (ucR), BAT (cR), 3
AP (cR), CP (cR). John Sommers. D,
BS, S, Dat.

2649
*Untitled (Introduction, La
Violencia I).* May 23–26, 1969. Red
(S). 76.2 × 55.9. Ed 20 (cR), 9 TI (ucR),
BAT (cR), 3 AP (2 cR, 1 ucR), CP (ucR).
Charles Ringness. D, BS, S, Dat.

Vija Celmins

2870
Untitled. Apr 15–May 7, 1970. Light
grey (A), dark grey (S). 51.4 × 74.3.
Ed 20 (cR)[1], 9 TI (cR), BAT (cR), 2 AP
(cR), 9 CTP (cR)[2], CP (cR)[1]. S. Tracy
White. Recto: BS Verso: D, S.

1. Ed 11–20/20, CP on paper larger
 than the image, 58.4 × 81.3.
2. 1 CTP on paper 55.9 × 78.1. 1 CTP
 on 59.7 × 81.3, 4 CTP on 57.9 ×
 80.0.

Wesley Chamberlin

*Print not in
University Art Museum
Archive*

496
Man's Head. Jan 22, 1962. Black (Z).
36.8 × 27.9. 12 ExP (6 BFK, 6 light
weight R)[1]. Wesley Chamberlin, NC.
D, BS (Tam), S.

1. Designated A-L. 6 ExP (3 BFK, 3
 lightweight R) retained by Tamarind.

*Print not in
University Art Museum
Archive*

505
Second Coover's Head. Feb 2–3,
1962. Black (Z). 76.2 × 56.5. 12 ExP
(BFK)[1]. Wesley Chamberlin, NC. T, D,
S, BS (Tam).

1. Designated A-L. 6 ExP retained by
 Tamarind.

*Print not in
University Art Museum
Archive*

508
Ain't Nolde's Russians. Feb 10,
1962. Black (Z). 52.1 × 38.1. 12 ExP
(BFK)[1], 1 proof (Tcs)[2]. Wesley
Chamberlin, NC. T, D, S, BS (Tam).

1. Designated A-L. 6 ExP retained by
 Tamarind.
2. Undesignated and unchopped.

530
Still Life for a Catholic Vintner.
Mar 17, 1962. Black (Z). 76.2 × 56.8,
(BFK), . Ed 15 (10 BFK, 5 lightweight
R), 9 TI (BFK), 2 AP (BFK), 1 TP
(lightweight R), CP (lightweight R).
Wesley Chamberlin, NC. BS (Tam), T,
D, S.

545
Household Table with Priest. Mar
31, 1962. Black (Z). 76.2 × 56.8, (BFK).
Ed 15 (10 BFK, 5 lightweight R), 9 TI
(BFK), 5 PP (BFK), CP (lightweight R).
Wesley Chamberlin, NC. BS (Tam), T,
D, S.

548
Sunday's Ladies. Apr 7–12, 1962.
Black (Z). 52.1 × 38.1. Ed 12 (6 BFK, 6
lightweight R[1]), 9 TI (BFK), 1 AP
(BFK), 3 PP (1 BFK, 2 lightweight R), 3
TP (1 BFK, 1 lightweight R*, 1
coverstock*). Wesley Chamberlin, NC.
T, D, BS (Tam), S.

1. Ed 7/12 on paper 50.1 × 38.1.

561
After the Hunt. Jun 2, 1962. Black
(S). 38.1 × 28.3. Ed 20 (6 BFK[1], 3
lightweight R, 11 bA), 9 TI (BFK), 1 AP
(bA), 1 TP* (bA)[2], CP (lightweight R).
Wesley Chamberlin, NC. BS (Tam), T,
D, S.

1. Ed 19–20/20 (BFK) on paper 55.9 ×
 38.1.
2. No Tamarind chop.

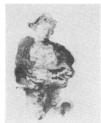
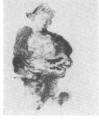

582
Red Queen and Samuel. May 12–19,
1962. Black (Z). 82.6 × 49.5. Ed 10 (8
BFK, 2 lightweight R), 9 TI (BFK)[1], 1
AP (BFK)[1], 4 PP (BFK)[1]. Wesley
Chamberlin, NC. D, S, T, BS (Tam).

1. 9 TI, 1 AP, 1 PP on paper 94.0 ×
 72.4.

Lee Chesney

1995
Promise. Apr 18–28, 1967. Black (S),
blue (Z). 76.2 × 56.5. Ed 20 (wA), 9 TI
(BFK), BAT (wA), 3 AP (BFK), 3 TP
(wA), CP (wA). Anthony Stoeveken. D,
BS, S.

Paul Clinton

2756
Untitled. Sep 5–Oct 19, 1969. Silver-
brown (S), red (A)[1], white (A)[1].
66.0 × 51.1. Ed 10 (CD), 9 TI (ucR),
BAT (CD), 3 AP (ucR), 1 TP (ucR), CP
(CD). Paul Clinton. D, BS, S.

1. Same plate for runs 2 and 3.

2795
Untitled. Oct 30–Nov 15, 1969. Black
(S). 63.5 × 48.6. Ed 10 (wA), 9 TI (CD),
BAT (wA), 2 CTP (1 GEP, 1 wA), CP
(CD). Paul Clinton. BS, D, S.

Print not in
University Art Museum
Archive

P102
Untitled. Jul 7–Aug 18, 1969. Light
beige (A), black (S). 57.2 × 58.4. Ed 7
(GEP)[1], BAT (GEP), 5 CTP (1 wA, 4
GEP), CP (CD). Paul Clinton. D, S,
BS[2] (pr).

1. Ed 7/7 retained by Tamarind.
2. No Tamarind chop.

Print not in
University Art Museum
Archive

P108
Untitled. Feb 28–Mar 7, 1970. B:
Light green, light orange, light blue,
light beige (A), light beige (A). 101.6
× 49.5. Ed 15 (GEP)[1], BAT (GEP), 6
TP* (2 BFK, 1 CD, 3 GEP), CP (GEP).
Paul Clinton. Recto: BS Verso: D, S.

1. Ed 15/15 retained by Tamarind.

Bernard Cohen

2772
New Mexico No. 1. Oct 7–Nov 18,
1969. Yellow (S), opaque white (S)[1],
opaque white (S)[1], opaque white
(S)[1], opaque white (S)[1], opaque
white (S)[1]. 61.3 × 91.4. Ed 16
(MI)[2], 9 TI (MI). Herman Shark.
Verso: WS (Tam), T, D, S, Dat, WS
(UNM).

1. Same stone as previous run with
 one shape deleted.
2. 4/16 inscribed UNMI.

2773
New Mexico No. 2. Dec 1, 1969–Jan
22, 1970. Light blue-white (S),
transparent yellow (S)[1], transparent
yellow (S)[1], transparent yellow
(S)[1], transparent yellow (S)[1]. 61.6
× 91.4. 9 TI (MI), 1 UNMI (MI), BAT
(MI), 3 AP (MI), 2 TP (MI). Herman
Shark. Verso: WS (Tam), T, D, S, Dat,
WS (UNM).

1. Same stone as previous run with
 one shape deleted.

2774
New Mexico No. 3. Feb 12–Mar 20, 1970. Light green-grey (S), white (S)[1], white (S)[1], white (S)[1], white (S)[1]. 61.0 × 91.8. Ed 20 (MI), 9 TI (MI), 1 UNMI (MI), BAT (MI), 5 AP (MI). Herman Shark. Verso: WS (Tam), T, D, S, Dat, WS (UNM).

1. Same stone as previous run with one shape deleted.

Bruce Conner

La Violencia, a suite of eight lithographs including introduction and colophon. In order: 2649, 2601, 2613, 2616, 2614, 2617, 2600, 2648.

The artist chose to sign all of his lithographs with his thumbprint in black ink rather than his written signature. In the following entries, the abbreviation "S" refers to this thumbprint.

1266
Mandala. Apr 1–9, 1965. Black (S), transparent orange (S). 45.7 × 44.5. Ed 20 (BFK), 9 TI (wA), BAT (BFK), 2 AP (BFK), 1 PP (wA), 1 TP (BFK). Kenneth Tyler. Verso: S, D, WS.

1270
Untitled. Apr 3–7, 1965. Transparent light brown (S). 51.1 × 43.8. Ed 20 (bA), 9 TI (bA), BAT (bA), 1 AP (bA), 2 TP (bA), CP (Tcs). Kenneth Tyler. BS (Tam), S, D, BS (pr).

1285
Untitled. Apr 5–7, 1965. Black (S). 54.3 × 45.1. Ed 20 (BFK), 9 TI (wA), BAT (BFK), 3 AP (2 BFK, 1 wA), CP (Tcs). Kenneth Tyler. Verso: WS, S, D.

1286
Untitled. Apr 5–8, 1965. Black (S). 36.8 × 31.1. Ed 20 (BFK), 9 TI (wA), BAT (BFK), 2 AP (wA), 2 TP (1 wA, 1 BFK), CP (Tcs). Bernard Bleha. Verso: WS, S, D.

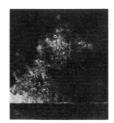

1287
Rain. Apr 6–14, 1965. Black (S). 66.0 × 57.2. Ed 20 (BFK), 9 TI (wA), BAT (BFK), 2 AP (wA), 2 TP (BFK), CP (Tcs). Kenneth Tyler. Verso: WS, S, D.

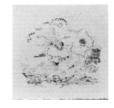

1289
Landscape. Apr 11–14, 1965. Black (A). 40.6 × 40.6. Ed 20 (BFK), 9 TI (wA), BAT (BFK), 2 AP (BFK), 2 TP (1 BFK, 1 wA), CP (Tcs). Bernard Bleha. Verso: WS, S, D.

1290
Green Line. Apr 11–15, 1965. Green (A). 38.1 × 60.0. Ed 20 (BFK), 9 TI (wA), BAT (BFK), CP (Tcs). Kenneth Tyler. Verso: WS, S, D.

1291
Untitled. Apr 12–16, 1965. Black (A). 30.5 × 50.8. Ed 20 (BFK), 9 TI (wA), BAT (BFK), 1 AP (wA), 2 TP (1 BFK, 1 wA), CP (Tcs). Kenneth Tyler. Verso: WS, S, D.

1293
Sunset Strip. Apr 15–28, 1965. Red-orange (S), black (A). 37.2 × 50.2. Ed 20 (BFK), 9 TI (wA), BAT (BFK), 1 PP (BFK), 3 TP (2 BFK, 1 wA). Kenneth Tyler. Verso: WS, S, D.

1294
Landscape. Apr 15–19, 1965. Brown (A). 30.5 × 33.7. Ed 20 (BFK), 9 TI (wA), BAT (BFK), 1 AP (wA), 2 TP (BFK), CP (Tcs). Kenneth Tyler. Verso: WS, S, D.

1295
This Space Reserved for June Wayne. Apr 15–27, 1965. Dark blue (S), black (S). 19.4 × 44.5. Ed 20 (BFK), 9 TI (wA), BAT (BFK), 2 AP (BFK), 2 TP (BFK), CP (Tcs). Clifford Smith. Verso: WS, S, D.

1297
Cancellation. Apr 16–27, 1965. Black
(S). 55.2 × 81.9. Ed 20 (BFK), 9 TI
(wN), BAT (BFK), 2 AP (1 BFK, 1 wN), 2
TP (BFK), CP (Tcs). Kenneth Tyler. BS,
S, D.

1298
Jelly Fish. Apr 12–28, 1965. Black (A).
53.3 × 36.8. Ed 20 (BFK), 9 TI (wA),
BAT (BFK), 2 AP (1 BFK, 1 wA), 2 TP
(BFK), CP (Tcs). Kenneth Tyler. Verso:
WS, S, D.

1299
Thumb Print. Apr 26, 1965. Black (Z).
105.1 × 75.9. Ed 2 (BFK), 9 TI (BFK),
BAT (BFK), 1 AP (BFK), 3 TP (BFK), CP
(BFK). Kenneth Tyler. BS, S, D.

William Copley

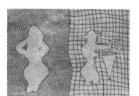

1136
Start Thinking. Sep 1–4, 1964. Blue
(S), black (S). 56.8 × 76.2. Ed 20
(BFK), 9 TI (wA), BAT (BFK), PrP II for
Kenneth Tyler (BFK), 4 AP[1] (A), 6 PP
(BFK). Kaye Dyal. S, D, BS.

1. 1 AP for printer Jeff Ruocco for
assistance in printing.

1137
Gin Sin. Sep 2–4, 1964. Black (S).
33.0 × 43.5. Ed 20 (BFK), 9 TI (BFK),
BAT (BFK), PrP II for Kenneth Tyler
(BFK), 2 AP (BFK), 2 TP (1 BFK, 1 wA).
Ernest Rosenthal. D, S, BS.

1138
Blue Pussy Cat. Sep 2–4, 1964. Red-
brown (S), transparent blue (S). 48.3
× 34.9. Ed 20 (BFK), 9 TI (wA), BAT
(BFK), PrP II for Kenneth Tyler (BFK), 3
AP (2 BFK, 1 wA), 4 TP (2 BFK, 2 wA),
CP (BFK). Joe Zirker. BS, D, S.

Gloria Cortella

1668
Tam. Lithograph No. I. Feb 12–19,
1966. Brown-black (S). 57.2 × 41.9. Ed
9 (BFK), 9 TI (wA), BAT (BFK), 1 AP
(wA), 1 TP* (BFK), CP (Tcs). Gloria
Cortella, NC. BS (Tam), D, S[1], Dat.

1. The edition is signed Cortella Imp.

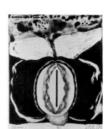

1669
Mary. Feb 22–Mar 2, 1966. Dark beige
(Z), red-black (S). 57.5 × 51.1. Ed 10
(wA), 9 TI (CD), BAT (wA), 3 AP (CD), 3
TP (wA), CP (Tcs). Gloria Cortella, NC.
D, S[1], Dat, BS (Tam).

1. The edition is signed Cortella Imp.

Steven Cortright

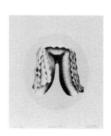

1314
Blossom. Jul 12, 1965. Black (S). 46.4
× 38.4. Ed 12 (BFK), 9 TI (bA), 1 AP
(bA). Steven Cortright, NC. BS (Tam,
UNM), D, T, S, Dat.

1315
Blossom Cameo. Jul 23–27, 1965.
Pink-beige (S), black (S). 46.4 × 38.4.
Ed 12 (BFK), 9 TI (Japanese paper)[1],
UNMI (Japanese paper)[1], 3 AP
(Japanese paper)[1], 2 TP (Japanese
paper)[1]. Steven Cortright, NC. BS
(Tam), D, T, S, Dat, BS (UNM).

1. TI, INMI, AP and TP were printed on
thin white Japanese paper cut to
the image size and laid down on bA
during printing.

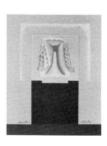

1316
Shrine Shrine. Jul 21–31, 1965.
Yellow (S), pink (S)[1], dark pink (S),
dark red-violet (S), transparent green
(S), transparent blue (S). 61.3 × 52.7.
Ed 10 (BFK), 9 TI (wA), UNMI (wA), 1
TP (wA). Steven Cortright, NC. BS
(Tam), T, D, S, Dat, BS (UNM).

1. Stone held from 1315, run 2.

Robert Cremean

The Fourteen Stations of the Cross, a suite of fourteen lithographs plus title and colophon pages, enclosed in a wooden box, measuring 62.2 × 43.2, lined with green felt, closed with a hinged lid incised with lines forming a cross motif. The lithographs are placed on a pull-tab cardboard liner. The lid, when opened, is designed as a presentation stand. The title and colophon printed at the Plantin Press, Los Angeles. In order: 1879, 1880, 1881, 1882, 1883, 1884, 1885, 1886, 1887, 1888, 1889, 1890, 1891, 1892.

1662
Study. Mar 31–Apr 1, 1966. Black (S). 56.5 × 76.5. Ed 20 (CD), 9 TI (GEP), BAT (CD), 2 AP (GEP), 2 TP (CD), CP (Tcs). Kinji Akagawa. BS, D, S.

1879
#1 (Fourteen Stations). Dec 6–22, 1966. Light pink-brown (S), light pink (S), black (S). 55.9 × 38.1. Ed 20 (CD), 9 TI (wN), BAT (CD), 3 AP (wN), 2 PP (1 CD, 1 wN), 4 TP (CD), 1 PTP (GEP), CP (CD). Clifford Smith. Verso: WS, S, D.

1880
#2 (Fourteen Stations). Dec 9–23, 1966. Light pink-brown (S), light pink (S), black (S). 56.5 × 38.7. Ed 20 (CD), 9 TI (wN), BAT (CD), 3 AP (wN), 4 TP (CD), CP (CD). Clifford Smith. Verso: WS, S, D.

1881
#3 (Fourteen Stations). Dec 9–29, 1966. Light pink-brown (S), light pink (S), black (S). 56.5 × 38.7. Ed 20 (CD), 9 TI (wN), BAT (CD), 3 AP (1 CD, 2 wN), 4 TP (CD), CP (CD). Clifford Smith. Verso: WS, S, D.

1882
#4 (Fourteen Stations). Dec 13, 1966–Jan 5, 1967. Light pink-brown (S), pink (S), black (S). 55.9 × 38.7. Ed 20 (CD), 9 TI (wN), BAT (CD), PrP II for Maurice Sanchez (CD), 3 AP (wN), 1 PP (CD), 4 TP (CD), CP (CD). Clifford Smith. Verso: WS, S, D.

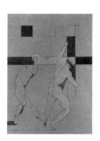

1883
#5 (Fourteen Stations). Dec 13, 1966–Jan 4, 1967. Light pink-brown (S), light pink (S), black (S). 56.2 × 38.4. Ed 20 (CD), 9 TI (wN), BAT (CD), PrP II for Maurice Sanchez (CD), 3 AP (CD), 4 TP (CD), CP (CD). Clifford Smith. Verso: WS, S, D.

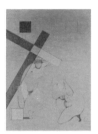

1884
#6 (Fourteen Stations). Dec 19, 1966–Jan 6, 1967. Light pink-brown (S), light pink (S), black (S). 56.5 × 38.4. Ed 20 (CD), 9 TI (wN), BAT (CD), 3 AP (1 wN, 2 CD), 4 TP (CD), 1 CTP (CD), CP (CD). Clifford Smith. Verso: WS, S, D.

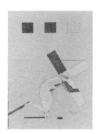

1885
#7 (Fourteen Stations). Dec 19, 1966–Jan 6, 1967. Light pink-brown (S), light pink (S), black (S). 56.5 × 38.4. Ed 20 (CD), 9 TI (wN), BAT (CD), 3 AP (1 CD, 2 wN), 4 TP (CD), CP (CD). Clifford Smith. Verso: WS, S, D.

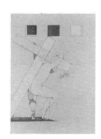

1886
#8 (Fourteen Stations). Dec 28, 1966–Jan 15, 1967. Light pink-brown (S), light pink (S), black (S). 56.2 × 38.4. Ed 20 (CD), 9 TI (wN), BAT (CD), 3 AP (wN), 4 TP (1 wN, 3 CD), CP (CD). Clifford Smith. Verso: WS, S, D.

1887
#9 (Fourteen Stations). Dec 28, 1966–Jan 15, 1967. Light pink-brown (S), light pink (S), black (S). 56.2 × 38.4. Ed 20 (CD), 9 TI (wN), BAT (CD), 3 AP (wN), 4 TP (CD), CP (CD). Clifford Smith. Verso: WS, S, D.

1888
#10 (Fourteen Stations). Jan 5–19,
1967. Light pink-brown (S), light pink
(S), black (S). 56.2 × 38.4. Ed 20 (CD),
9 TI (wN), BAT (CD), 3 AP (wN), 4 TP
(CD), CP (CD). Clifford Smith. Verso:
WS, S, D.

1889
#11 (Fourteen Stations). Jan 5–19,
1967. Light pink-brown (S), light pink
(S), black (S). 56.2 × 38.4. Ed 20 (CD),
9 TI (wN), BAT (CD), 3 AP (wN), 4 TP
(CD), CP (CD). Clifford Smith. Verso:
WS, S, D.

1890
#12 (Fourteen Stations). Jan 11–19,
1967. Light pink-brown (S), light pink
(S), black (S). 55.9 × 38.1. Ed 20 (CD),
9 TI (wN), BAT (CD), 3 AP (wN), 4 TP
(CD), CP (CD). Clifford Smith. Verso:
WS, S, D.

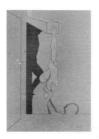

1891
#13 (Fourteen Stations). Jan 11–19,
1967. Light pink-brown (S), light pink
(S), black (S). 56.2 × 38.4. Ed 20 (CD),
9 TI (wN), BAT (CD), 3 AP (1 CD, 2
wN), 4 TP (CD), CP (CD). Clifford
Smith. Verso: WS, S, D.

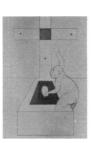

1892
#14 (Fourteen Stations). Jan 19–25,
1967. Light pink-brown (S), light pink
(S), black (S). 56.2 × 38.7. Ed 20 (CD),
9 TI (wN), BAT (CD), 3 AP (1 CD, 2
wN), 1 PP (CD), 4 TP (1 EVB, 3 CD), CP
(CD). Clifford Smith. Verso: WS, S, D.

William Crutchfield

Air Land Sea, a suite of thirteen
lithographs including title and
colophon pages, enclosed in a wrap-
around folder of white Nacre. The title
page and colophon on the verso of
the same sheetprinted by Vernon
Simpson, Los Angeles. In order: 2904,
2899, 2900, 2901, 2902, 2903, 2905,
2906, 2907, 2908, 2909, 2910, 2911.

879
Mr. No. Sep 3–4, 1963. Black (S). 77.5
× 43.2. Ed 20 (bA), 9 TI (nN), PrP (bA),
3 AP (2 bA, 1 nN), 4 PP (bA), CP (bA).
Kenneth Tyler. D, BS (Tam), T, BS (pr),
S, Dat.

2899
Playground, (Air Land Sea I). May
8, 1970. Black (A). 31.8 × 29.2. Ed 20
(wA), 9 TI (cR), BAT (wA), 3 AP (cR), 2
TP (wA), CP (cR). Harry Westlund. BS,
D, S, Dat.

2900
2–8–4 Flyer, (Air Land Sea II). May
11–12, 1970. Red (S). 31.8 × 29.2. Ed
20 (BFK), 9 TI (cR), BAT (BFK), 2 AP
(BFK), 1 TP (BFK), 2 CTP (BFK), CP
(cR). Larry Thomas. BS, D, S, Dat.

2901
*Formation Flying, (Air Land Sea
III).* May 11–12, 1970. Red (S). 31.8 ×
29.2. Ed 20 (BFK), 9 TI (cR), BAT (BFK),
3 AP (1 cR, 2 BFK), 1 PP (BFK), 1 TP
(BFK), 2 CTP (BFK), CP (cR). Larry
Thomas. D, S, Dat, BS.

2902
*The Great Southeastern, (Air Land
Sea IV).* May 11–12, 1970. Blue (S).
31.8 × 29.2. Ed 20 (BFK), 9 TI (cR),
BAT (BFK), 3 AP (1 cR, 2 BFK), 1 TP
(BFK), 1 CTP (BFK), CP (cR). Larry
Thomas. BS, D, S, Dat.

2903
Biplane, (Air Land Sea V). May 11–12, 1970. Blue (S). 31.8 × 29.2. Ed 20 (BFK), 9 TI (7 cR, 2 BFK), BAT (BFK), 1 AP (BFK), 1 TP (BFK), 1 CTP (BFK), CP (cR). Larry Thomas. BS, D, S, Dat.

2904
Air Land Sea Alphabet, (Air Land Sea Title Page)[1]. May 15–18, 1970. B: Blue, brown (A). 31.8 × 29.2. Ed 20 (BFK), 9 TI (cR), BAT (BFK), 4 AP (BFK), CP (BFK). Eugene Sturman. BS, D, S, Dat.

1. Typography (Centaur) printed on recto and verso by Vernon Simpson, L.A. (cf. Section V).

2905
Block of Sea, (Air Land Sea VI). May 15–18, 1970. B: Light blue, blue (A). 31.8 × 29.2. Ed 20 (BFK), 9 TI (cR), BAT (BFK), 4 AP (BFK), CP (BFK). Eugene Sturman. D, S, Dat, BS.

2906
Fuji at Pisa, (Air Land Sea VII). May 15–18, 1970. B: Light blue, blue (A). 31.8 × 29.2. Ed 20 (BFK), 9 TI (cR), BAT (BFK), 4 AP (BFK), CP (BFK). Eugene Sturman. D, S, Dat, BS.

2907
Cathedral Steamer, (Air Land Sea VIII). May 15–18, 1970. B: Light blue, blue (A). 31.8 × 29.2. Ed 20 (BFK), 9 TI (cR), BAT (BFK), 5 AP (3 BFK, 2 cR), CP (BFK). Eugene Sturman. BS, D, S, Dat.

2908
Zepp (Air Land Sea IX). May 19–20, 1970. B: Blue, violet (A). 31.8 × 29.2. Ed 20 (BFK), 9 TI (cR), BAT (BFK), 5 AP (4 BFK, 1 cR), CP* (BFK). S. Tracy White. BS, D, S, Dat.

2909
Dam Valley (Air Land Sea X). May 19–20, 1970. Violet (A). 31.8 × 29.2. Ed 20 (BFK), 9 TI (cR), BAT (BFK), 3 AP (cR), CP* (BFK). S. Tracy White. BS, D, S, Dat.

2910
Skiff Car at Malibu (Air Land Sea XI). May 19–20, 1970. B: Blue, violet (A). 31.8 × 29.2. Ed 20 (BFK), 9 TI (cR), BAT (BFK), 3 AP (2 BFK, 1 cR), CP (BFK). S. Tracy White. BS, D, S, Dat.

2911
Narrow-Gauge Valley (Air Land Sea XII). May 19–20, 1970. B: Blue-violet, blue, blue-green, green (A). 31.8 × 29.2. Ed 20 (BFK), 9 TI (cR), BAT (BFK), 3 AP (2 BFK, 1 cR), CP* (BFK). S. Tracy White. BS, D, S, Dat.

2939
Eucalyptus II. May 25–Jun 4, 1970. B: Yellow, green (Z), blue (A), B: dark red, red, pink (A). 76.2 × 55.9. Ed 20 (cR), 9 TI (cR), BAT (cR), 4 AP (cR), 2 PP (cR), 2 TP (1 cR, 1 bA), CP (bA). David Trowbridge. BS, D, S, Dat.

2944
Tamarind-Tanic. Jun 4–16, 1970. Blue-green (A), red-brown (A). 76.2 × 55.9. Ed 20 (wA), 9 TI (wA), BAT (wA), 3 AP (wA), 1 TP (wA), 8 CTP (wA), CP (wA). Edward Hamilton. BS, D, S, Dat.

José Luis Cuevas

Charenton, a suite of fifteen lithographs including title, table of contents and colophon pages, enclosed in a red-brown cloth covered box, measuring 81.3 × 60.3, lined with black Fabriano paper, silk-screened with the artist's name and the suite title in black on the front cover, made by the Schuberth Bookbindery, San Francisco. The box is secured with leather straps and snaps. Each lithograph enclosed in a chemise of white Tableau paper numbered in Arabic numerals at the lower right. In order: 1617, 1650, 1602II, 1606, 1604, 1611, 1614, 1610, 1612, 1615, 1607, 1648II, 1608, 1618.

654
Untitled. Oct 2–4, 1962. Black (S). 57.2 × 76.8. Ed 20 (BFK), 9 TI (wN), PrP (BFK), 2 PP (BFK), 3 AP (2 BFK, 1 wN), 2 TP (1 BFK, 1 wN), CP (BFK). Joe Zirker. D, BS (Tam), S, BS (pr).

1602
The Marquis de Sade and the King of Diamonds. Nov 30–Dec 1, 1965. Black (S). 57.5 × 77.5. Ed 20 (BFK), 9 TI (nN), BAT (BFK), 2 TP (dLN)[1], 1 proof (AEP)[2]. Kinji Akagawa. D, S, Dat, BS.

1. 1 TP pulled for paper testing, retained by Tamarind.
2. Unsigned, undesignated, unchopped, defaced, retained by Tamarind.

1602II
Justine and the Marquis de Sade (Charenton III). Dec 3–10, 1965. Brown-orange (S), green-black (S)[1]. 57.2 × 77.5. Ed 20 (BFK), 9 TI (wN), BAT (BFK), 1 AP (BFK), 1 TP (BFK), CP (Tcs). Kinji Akagawa. D, BS, S, Dat.

1. Stone held from 1602; deletions and additions. 1602II differs from 1602 in color and in image. The body of the left figure has been eliminated, the light contour of the back of the head and the hair has been filled in solid except for some hair texture. The dark tones of the face have been eliminated except for the delineation of the features. The dark tone along the bottom on the left has been eliminated and writing added in its place. The dark tone on the right side has been extended to the top of the sheet. A brown-orange bleed tone has been added to the left and right sides.

Print not in University Art Museum Archive

1603
Cast of Characters. Dec 6–10, 1965. Black (S). 56.8 × 76.2. 10 ExP (wA)[1], CP* (Tcs). Kinji Akagawa. BS, D, S, Dat.

1. Designated A-J. 6 ExP retained by Tamarind.

1603II
Cast of Characters. Dec 10–11, 1965. Black (S)[1]. 26.7 × 83.8. Ed 20 (BFK), 9 TI (CD), BAT (BFK), 3 AP (CD)[2], 2 TP (BFK), CP (Tcs). Kinji Akagawa. D, BS, S.

1. Stone held from 1603. 1603II differs from 1603 in image and in size. It is the bottom row from 1603.
2. 2 AP inadvertently chopped with chop of Jurgen Fischer.

1604
Double Portrait of Doctor Laforet (Charenton V). Dec 7–21, 1965. Dark red-brown (S), dark brown (S). 55.9 × 76.2. Ed 20 (wA), 9 TI (wN), BAT (wA), 2 AP (wN), 5 TP (4 wA, 1 Tcs*)[1], CP (Tcs). Ernest de Soto. D, BS, S, Dat.

1. 2 TP (wA) vary from the edition.

1605
The Marquis de Sade-Pig. Dec 13–27, 1965. Black (S). 55.6 × 76.2. Ed 20 (bA), 9 TI (dLN), BAT (bA), 1 AP (bA), CP (Tcs). Clifford Smith. D, BS, S, Dat.

1606
Doctor Laforet and his Patients (Charenton IV). Dec 14–18, 1965. Transparent green (A), dark brown (S). 76.2 × 55.9. ED 20 (wA), 9 TI (wN), BAT (wA), 2 AP (1 wA, 1 wN), 5 TP (2 wA, 2 dLN, 1 AEP)[1], CP (Tcs). Robert Evermon. D, BS, S, Dat.

1. 3 TP (2 dLN, 1 AEP) pulled for paper testing. 2 TP (1 dLN, 1 AEP) retained by Tamarind.

1607
Procuress with Meat (Charenton XI). Jan 4–17, 1966. Brown-orange (S), black (S). 55.9 × 76.2. Ed 20 (wA), 9 TI (wN), BAT (wA), 3 AP (1 wA, 2 wN), 5 TP (3 wA, 2 JG*)[1], CP (Tcs). Ernest de Soto. D, BS, S, Dat.

1. 2 TP (JG) pulled for paper testing, one retained by Tamarind.

1608
Worm Pit (Charenton XIV). Dec 17, 1965–Jan 6, 1966. Green-black (S), black (S). 57.2 × 77.5. Ed 20 (wA), 9 TI (wN), BAT (wA), 3 AP (wN), 4 TP (2 wA, 2 dLN[1]), 1 PTP (AEP)[2], CP (Tcs). Clifford Smith. BS, D, S, Dat.

1. 1 TP (dLN) pulled for paper testing, retained by Tamarind.
2. Unsigned, undesignated, unchopped, retained by Tamarind.

1609
Beast Eating (Charenton XII). Dec 18–24, 1965. Black (S). 57.2 × 77.5. Ed 20 (wA), 9 TI (wN), BAT (wA), 1 AP (wN), 2 TP (wA), CP (Tcs). Jurgen Fischer. D, BS, S, Dat.

1614
Tortured One (Charenton VII). Dec 24, 1965–Jan 6, 1966. Black (S). 57.2 × 76.8. Ed 20 (wA), 9 TI (wN), BAT (wA), 3 AP (1 wA, 2 wN), 2 TP (wA), CP (Tcs). Clifford Smith. D, BS, S, Dat.

Print not in
University Art Museum
Archive

1609A
Composition. Dec 20–22, 1965. Black (S)[1]. 76.2 × 19.4. 4 ExP (CD)[2]. Jurgen Fischer. D, BS, S, Dat.

1. Stone held from 1609. This is a remarque from the larger stone.
2. Designated A-D. 2 ExP retained by Tamarind.

1615
Happenings at Charenton (Charenton X). Jan 3–4, 1966. Dark green-brown (S). 57.2 × 77.5. Ed 20 (wA), 9 TI (wN), BAT (wA), 3 AP (1 wA, 2 wN), CP (Tcs). Walter Gabrielson. D, BS, S, Dat.

1610
Visions of the Marquis de Sade (Charenton VIII). Dec 21–29, 1965. Dark brown (S). 57.8 × 78.7. Ed 20 (wA)[1], 9 TI (wN), BAT (wA), 3 AP (1 wA, 2 wN), 3 TP (1 wA, 2 dLN)[2], 1 PTP (AEP)[3], CP (Tcs). Robert Evermon. D, BS, S, Dat.

1. Ed 20/20 was inadvertently marked with Walter Gabrielson's chop.
2. 2 TP (dLN) pulled for paper testing, one retained by Tamarind.
3. Unsigned, undesignated, unchopped, retained by Tamarind.

1616
Happenings at Charenton. Jan 5–11, 1966. Red-brown (S), black (S). 57.2 × 76.8. Ed 20 (wA), 9 TI (wN), BAT (wA), 3 AP (wN), 3 TP (wA), CP (Tcs). Walter Gabrielson. D, BS, S, Dat.

1611
Ghosts of the Asylum (Charenton VI). Dec 22–24, 1965. Black (S). 57.8 × 77.8. Ed 20 (wA), 9 TI (wN), BAT (wA), 3 AP (2 wA, 1 wN), 2 TP (dLN)[1], CP (Tcs). Ernest de Soto. D, BS, S, Dat.

1. Pulled for paper testing, one retained by Tamarind.

1617
Title page (Charenton I). Jan 13–19, 1966. Brown (S). 76.8 × 56.8. Ed 20 (wA), 9 TI (wN), BAT (wA), 2 AP (wA), 2 TP (wA), CP (Tcs). Ernest de Soto. D, BS, S, Dat.

1612
Visitors (Charenton IX). Dec 22, 1965–Jan 3, 1966 Light brown (A), black (S). 77.8 × 57.5. Ed 20 (wA), 9 TI (wN), BAT (wA), 3 AP (2 wA, 1 wN), 1 TP (wA), 5 proofs* (4 dLN, 1 AEP)[1], CP (Tcs). Ernest de Soto. D, BS, S, Dat.

1. Unsigned, undesignated, unchopped, pulled for paper testing, retained by Tamarind.

1618
Colophon (Charenton XV). Jan 13–18, 1966. Black (S). 77.5 × 57.2. Ed 20 (wA), 9 TI (wN), BAT (wA), 2 AP (wA), CP (Tcs). Ernest de Soto. D, BS, S, Dat.

1613
Head with Worms. Dec 20, 1965–Jan 21, 1966. Beige (A), grey-green (S), black (S). 57.8 × 77.5. Ed 20 (wA), 9 TI (wN), BAT (wA), 3 AP (wN)[1], 2 TP (dLN)[2], CP (Tcs). Ernest de Soto. D, S, Dat, BS.

1. 1 AP was inadvertently chopped with the chop of Kinji Akagawa.
2. Pulled for paper testing, one retained by Tamarind.

1646
Untitled[1]. Jan 13–19, 1966. Black (S). 31.4 × 21.9. Ed 20 (wA), 9 TI (dLN), BAT (wA), 2 AP (wA), 3 TP (2 wA, 1 dLN), CP (Tcs). Ernest de Soto. D, BS, S, Dat.

1. This lithograph was intended to be used as the cover of an exhibition catalogue for the Charenton suite to be published at a later date.

1647
The Marquis de Sade. Jan 13–19, 1966. Black (S). 31.4 × 21.9. Ed 20 (wA), 9 TI (dLN), BAT (wA), 3 AP (2 wA, 1 dLN), 2 TP (wA), CP (Tcs). Ernest de Soto. D, BS, S, Dat.

Print not in
University Art Museum
Archive

1648
The Marriage of Arnolfini. Jan 14–24, 1966. Black (S). 57.5 × 77.8. Ed 10 (wA), 9 TI (wN), BAT (wA), 1 AP (wA). Ernest de Soto. D, S, Dat, BS.

1648II
The Marriage of Arnolfini (Charenton XIII). Jan 14–24, 1966. Yellow-beige (S), black (S)[1]. 55.9 × 76.2. Ed 20 (wA), 9 TI (wN), BAT (wA), 7 TP (4 wA[2], 1 wN*, 1 Millbourn*, 1 JG*), CP (Tcs). Ernest de Soto. D, BS, S, Dat.

1. Stone held from 1648; additions. 1648II differs from 1648 in color and in image. The artist's signature has been added in the stone at the lower right. A yellow-beige tone has been added.
2. 1 TP (wA) varies from the edition.

1649
Interior. Jan 14–18, 1966. Black (S). 39.4 × 57.8. Ed 20 (bA), 9 TI (nN), BAT (bA), 3 AP (1 nN, 2 bA), 6 PP (bA), 3 TP (bA)[1], CP (Tcs). Walter Gabrielson. D, BS, S, Dat.

1. 2 TP vary from the edition.

1650
Table of Contents (Charenton II). Jan 18–22, 1966. Black (S). 77.2 × 57.2. Ed 20 (wA), 9 TI (wN), BAT (wA), 1 AP (wA), CP (Tcs). Ernest de Soto. D, BS, S, Dat.

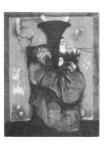

1652
"Music is a higher revelation than philosophy" Beethoven[1]. Jan 23–Feb 3, 1966. Orange-brown (S), black (S). 76.8 × 57.2. Ed 133 (100 CD[2], 10 wA[3], 5 BFK[4], 6 MI[5], 6 CW[6], 6 dLN[7]), 9 TI (wN), BAT (wA), 2 TP (wA)[8], 4 CSP (Tcs)[9], CP (Tcs). Ernest de Soto. BS, D, S, Dat.

1. Commissioned by the Los Angeles Orchestral Society to commemorate the 20th anniversary of the Los Angeles Music Festival.
2. Designated in Arabic numerals 1–100/100 for the Los Angeles Orchestral Society.

3. Designated Cuevas Imps. 1–10/10 for the artist.
4. Designated R 1–5/5 for the Los Angeles Orchestral Society.
5. Designated M 1–6/6 for the Los Angeles Orchestral Society.
6. Designated CW 1–6/6 for the Los Angeles Orchestral Society.
7. Designated L 1–6/6 for the Los Angeles Orchestral Society.
8. Retained by the Los Angeles Orchestral Society.
9. Unsigned, unchopped, undesignated, 2 proofs retained by Tamarind, 2 proofs for Los Angeles Orchestral Society.

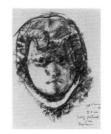

1663
Self Portrait like Musicians. Feb 4–7, 1966. Black (S). 39.4 × 56.5. Ed 20 (wA), 9 TI (nN), BAT (wA), 1 TP (wA), CP (wA). Ernest de Soto. BS, D, S.

1664
Portrait like Beethoven. Feb 4–7, 1966. Black (S). 39.1 × 27.6. Ed 20 (wA), 9 TI (nN), BAT (wA), 1 TP (wA), CP (wA). Ernest de Soto. D, BS, S.

Print not in
University Art Museum
Archive

1665
Cuevas-Charenton. Feb 4–7, 1966. Black (S). 31.8 × 26.7. Ed 20 (wA), 9 TI (nN), BAT (wA), 1 TP (wA), CP (wA). Ernest de Soto. D, BS, S.

Ernest de Soto

1456
Remembrances of Spain. Aug 10–15, 1965. Black (Z). 39.4 × 50.8. Ed 10 (bA), 9 TI (bA), BAT (bA), CP (Tcs). Ernest de Soto. D, T, BS, S.

1543
Barney's Girls. Sep 18–22, 1965.
Black (S). 57.8 × 42.5. Ed 10 (BFK), 9
TI (wA), BAT (BFK), 2 AP (wA), 2 TP
(BFK), CP (Tcs). Ernest de Soto. D, T,
BS, S.

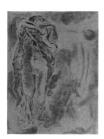

1544
Lamenting Figure. Sep 29–Oct 4,
1965.
Black (Z), dark beige (S). 38.4 × 27.9.
Ed 10 (BFK), 9 TI (wA), BAT (BFK), 2
AP (wA), 1 TP (BFK). Ernest de Soto.
BS, D, S.

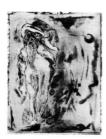

1544II
Lamenting Figure. Oct 5–11, 1965.
Black (S)[1]. 41.3 × 31.8. Ed 10 (bA), 9
TI (wA), BAT (bA), 2 AP (1 wA, 1 bA), 2
TP (bA), CP (Tcs). Ernest de Soto. BS,
D, S.

1. Stone held from 1544, run #2;
reversal, additions. 1544II differs
from 1544 in color and in image.
The light tones in the image are
lighter. More drawing details have
been added in the figures. More
shading added in the background
on the right and less shading on the
left. Mottled, narrow light bands
have been added on all sides.

1666
Espana 3. Feb 13–17, 1966.
Black (S). 27.6 × 38.1. Ed 10 (BFK), 9
TI (CD), BAT (BFK), 1 AP (BFK), 1 TP
(BFK), CP (Tcs). Ernest de Soto. D, BS,
S.

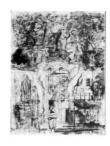

1670
Spanish Entrance. Feb 23–28, 1966.
Brown-black (S). 61.0 × 45.1. Ed 10
(bA), 9 TI (CW), BAT (bA), 1 TP (bA),
CP (Tcs). Ernest de Soto. BS, D, S, Dat.

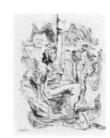

1687
Justine. Mar 15–21, 1966.
Brown-black (S). 38.1 × 27.9. Ed 10
(wA), 9 TI (BFK), BAT (wA), 2 AP (wA),
1 TP (wA), CP (Tcs). Ernest de Soto. D,
BS, S.

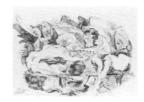

1688
Juliette. Mar 15–21, 1966.
Brown-black (S). 27.9 × 38.1. Ed 10
(wA), 9 TI (BFK), BAT (wA), 2 AP (wA),
2 TP (wA), CP (Tcs). Ernest de Soto. D,
BS, S.

1689
Juliette. Mar 15–21, 1966.
Brown-black (S). 38.1 × 27.9. Ed 10
(wA), 9 TI (BFK), BAT (wA), 2 AP (wA),
2 TP (wA), CP (Tcs). Ernest de Soto. D,
BS, S.

1690
Juliette. Mar 15–21, 1966.
Brown-black (S). 28.3 × 38.1. Ed 10
(wA), 9 TI (BFK), BAT (wA), 2 AP (wA),
2 TP (wA), CP (Tcs). Ernest de Soto. D,
BS, S.

Barbaralee Diamonstein

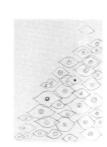

2397
Shutter Opened, Passive. Jul 30–
31, 1968. Black or brown (S). 71.1 ×
50.8. Ed 20 (10 MI, 10 bA[1]), 9 TI
(wA), BAT (MI), 3 AP (1 MI, 1 wA, 1
bA[1]), 1 TP (MI), CP (bA)[1]. Anthony
Stoeveken. D, BS, T, S, Dat.

1. Printed in brown.

Richard Diebenkorn

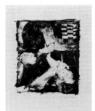

342

Untitled. Jun 17–18, 1961. Black (S). 69.9 × 53.3, (BFK), 74.6 × 62.8 (wN). Ed 10 (BFK), 9 TI (wN), PrP (BFK), 1 AP (BFK), 1 proof (BFK)[1]. Bohuslav Horak. BS, D, S, Dat.

1. A proof after changes in drawing (the right hand and fingers are extended). Unsigned, undesignated, unchopped on paper 71.1 × 52.1, printed recto and verso, retained by Tamarind.

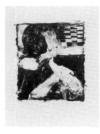

342A

Untitled. Jun 18–19, 1961. Black (S)[1]. 69.9 × 53.3. Ed 20 (BFK), 9 TI (wA), PrP (BFK), 3 AP (2 BFK, 1 wA), 1 TP (BFK), CP (BFK). John Muench. BS, D, S, Dat.

1. Stone held from 342; additions and deletions. 342A differs from 342 in image. Some open sections of the dark areas to the left and right of the arms and in the hair have been filled in. The lower arms and the light areas to the left and right of the face have been lightened.

Print not in University Art Museum Archive

345

Untitled. Jul 16, 1961. Black (Z). 55.9 × 38.1 cut. 1 ExP (coverstock)[1]. Bohuslav Horak.

1. Unsigned, unchopped, undesignated proof with the upper portion of an image by Emerson Woelffer (#329) on the verso, retained by Tamarind.

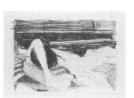

348

Untitled. Jul 25–27, 1961. Black (Z). 38.4 × 51.1. Ed 15 (BFK), 9 TI (JG), PrP (BFK), 4 AP (BFK), 2 working proofs (CW)[1]. Joe Funk. D, BS (Tam), S, Dat, BS (pr).

1. Retained by artist, hand colored with chalk.

Print not in University Art Museum Archive

349

Untitled. Jul 25–Aug 1, 1962. Black (Z). 38.1 × 54.0. 10 ExP (1 wA, 9 BFK)[1], BAT (BFK)[2]. Harold E. Keeler. D, BS.

1. All of the impressions with the exception of the BAT were cancelled and rejected by the artist. 5 ExP (BFK), unsigned, retained by Tamarind.
2. BAT was printed by Bohuslav Horak.

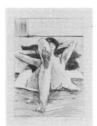

350

Untitled. Jul 25–26, 1961. Black (Z). 57.8 × 41.3. Ed 15 (BFK), 9 TI (JG), BAT (BFK), 4 AP (BFK), CP (BFK). Bohuslav Horak. D, BS, S, Dat.

Print not in University Art Museum Archive

564

Reclining Figure I. Apr 24, 1962. Black (S). 57.2 × 40.3. Ed 9 (BFK), 9 TI (wA), PrP (BFK). Joe Funk. D, BS, I, Dat.

567

Reclining Figure II. Apr 25–May 8, 1962. Yellow (S), red (S)[1], blue (S), dark blue-violet (S). 66.0 × 48.9. Ed 20 (BFK), 9 TI (wA), PrP (BFK), 2 AP (1 BFK, 1 wA), 6 PP (3 wA, 3 BFK), 3 TP (2 BFK, 1 wA), CP* (BFK)[2]. Joe Zirker. D, BS, I, Dat.

1. Stone held from 564; deletions. 567 differs from 564 in color, image, and size. Much of the crayon shading in the stripes and the triangle at the upper right have been eliminated. Color tones have been added throughout.
2. CP on paper 57.2 × 41.2.

568

Landscape with Awning. Apr 27–May 8, 1962. Black (Z). 31.1 × 41.3. Ed 20 (BFK), 9 TI (wA), PrP (BFK), 2 AP (BFK), 7 PP (BFK), 4 TP (3 BFK, 1 wA). Joe Zirker. D, BS, I, Dat.

Print not in University Art Museum Archive

569

Landscape. Apr 26–27, 1962. Black (Z). 53.3 × 40.0. 6 ExP (4 BFK, 2 Tcs)[1], PrP (BFK). Joe Funk. D, BS, I, Dat.

1. Designated A-F. 3 ExP (2 BFK, 1 Tcs) retained by Tamarind.

569A

Seascape. Apr 27–May 10, 1962. Black (Z)[1]. 54.3 × 38.1. Ed 20 (BFK), 9 TI (bA), PrP (BFK), 2 AP (bA), 3 TP (2 bA, 1 BFK), CP (Tcs). Joe Funk. D, BS, I, Dat.

1. Stone held from 569; additions and deletions. 569A differs from 569 in image. The area around the house and trees has been lightened. Small additions have been made throughout.

570

Reclining Woman. Apr 30–May 1, 1962. Black (S). 49.2 × 71.1. Ed 20 (BFK), 9 TI (wA), PrP (BFK), 2 AP (BFK), 3 TP (2 BFK, 1 wA), CP (BFK). Bohuslav Horak. D, BS, I, Dat.

572
L.A. Landscape. May 3–11, 1962.
Black (S). 28.9 × 41.0. Ed 20 (BFK), 9
TI (wA), PrP (BFK), 2 AP (BFK), 3 TP (2
BFK, 1 wA), CP (BFK). Joe Zirker. D,
BS, I, Dat.

575
Nude. May 8–10, 1962. Black (S). 49.2
× 37.8. Ed 20 (BFK), 9 TI (bA), PrP
(BFK), 3 AP (1 BFK, 2 bA), 2 PP (BFK),
3 TP (BFK). Joe Zirker. D, BS, I.

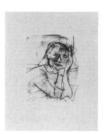

577
M.W. May 11–14, 1962. Black (Z). 55.9
× 42.5 (lg), 58.7 × 44.4 (wHP), 57.2
× 42.6 (nHP), 57.2 × 45.7 (H). Ed 20
(6 lg, 8 H, 6 nHP), 9 TI (wHP), PrP
(nHP), 2 AP (1 nHP, 1 wHP), 4 TP (1
nHP, 1 wHP, 1 lg, 1 H). Joe Zirker. D,
BS, I, Dat.

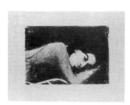

583
Sleeping Girl. May 14–15, 1962.
Black (Z). 38.1 × 47.6. Ed 20 (BFK), 9
TI (wA), PrP (BFK), 2 AP (BFK), 4 TP (2
BFK, 2 wA). Joe Zirker. D, BS, I, Dat.

2835
Untitled. Jan 21–Feb 9, 1970. Light
yellow (Z), yellow (Z), orange, black
(Z), blue (S). 74.6 × 48.0. Ed 20 (MI), 9
TI (GEP), BAT (MI), 3 AP (GEP), 1 CTP
(MI), CP (MI). Hitoshi Takatsuki. D, I,
Dat, BS.

2838
Untitled. Feb 5–17, 1970. Dark yellow,
light yellow (Z), pink, grey (Z), blue
(S), green, black (Z). 76.2 × 56.5. Ed
20 (GEP), 9 TI (A), BAT (GEP), 6 AP (2
A, 4 GEP), 1 PP (GEP), 4 TP (2 A, 2
GEP)[1], CP (GEP). David Trowbridge.
D, BS, I, Dat.

1. 3 TP (1 A, 2 GEP) vary from the
 edition.

Burhan Dogancay

Walls V, a suite of eleven lithographs
including title and colophon pages,
enclosed in a natural Belgian linen
and dark brown leather box,
measuring 60.3 × 50.2, stamped with
the artist's name and suite title in gold
on the front cover and on the spine,
made by the Earle Grey Bookbinding
Co. Los Angeles. The lithographs are
separated with slipsheets of white
Tableau paper. In order: 2694, 2656,
2657, 2660, 2659, 2658, 2690, 2689,
2691, 2692, 2655.

2650
Untitled. Jun 2–13, 1969. Pink (A),
red (A), blue-black (A), black (S). 48.3
× 38.1. Ed 20 (17 wA, 3 GEP), 9 TI
(GEP), BAT (wA), 1 AP (GEP), 2 CTP (1
wA, 1 GEP), CP (GEP). John Sommers.
D, BS, S, Dat.

2651
Untitled. Jun 5–23, 1969. Yellow (A),
pink (A), light blue (A), dark blue (S).
48.3 × 38.1. Ed 20 (wA), 9 TI (GEP),
BAT (wA), 1 AP (wA), 3 CTP (1 wA, 2
GEP), CP (GEP). William Law III. D, BS,
S, Dat.

2652
Untitled. Jun 23–Jul 7, 1969. Yellow
(A), red (A), black (S), blue (A). 61.0 ×
48.9. Ed 14 (wA), 9 TI (GEP), BAT (wA),
1 PP (GEP), 3 CTP (wA), CP (wA). Paul
Clinton. D, BS, S, Dat.

2655
Untitled (Walls V–XI). Jun 20–30,
1969. Red (A), blue (A), black (S). 58.4
× 48.9. Ed 20 (cR), 9 TI (ucR), BAT
(cR), 3 AP (1 cR, 2 ucR), 1 TP (cR).
Daniel Socha. D, BS, S, Dat.

2655II
Untitled. Jun 30–Jul 2, 1969. Red
(A)[1], blue (A)[2]. 59.1 × 48.9. Ed 10
(cR), 9 TI (ucR), BAT (cR), 2 AP (1 cR, 1
ucR), 1 PTP (bA), CP (ucR). Daniel
Socha. D, BS, S, Dat.

1. Plate held from 2655, run 1.
2. Plate held from 2655, run 2. 2655II
 differs from 2655 in color and in
 image. All parts of the image except
 the striped shape have been
 eliminated.

2656
Untitled (Walls V–II). Jun 24–27, 1969. Red, blue (A), black (S). 58.8 × 49.2. Ed 20 (cR), 9 TI (ucR), BAT (cR), 3 AP (1 cR, 2 ucR), 1 CTP (cR). Charles Ringness. D, BS, S, Dat.

2656II
Untitled. Jun 30–Jul 1, 1969. Red (A)[1], black (S)[2]. 58.8 × 49.2. Ed 10 (cR), 9 TI (ucR), BAT (cR), 1 AP (cR), CP (ucR). Charles Ringness. D, BS, S, Dat.
1. Plate held from 2656, run 1; deletions.
2. Stone held from 2656, run 2. 2656II differs from 2656 in image. The number "69" has been eliminated.

2657
Untitled (Walls V–III). Jun 25–Jul 9, 1969. Yellow (A), red (A), blue (S). 58.8 × 49.2. Ed 20 (cR), 9 TI (ucR), BAT (cR), 2 AP (cR), 1 TP* (cR), CP* (cR). John Sommers. D, BS, Dat.

2658
Untitled (Walls V–VI). Jul 1–15, 1969. Yellow (Z), blue (A), red (S). 58.8 × 48.9. Ed 20 (19 cR, 1 ucR), 9 TI (ucR), BAT (cR), 1 AP (cR), 1 TP (cR), CP (cR). Charles Ringness. D, BS, S, Dat.

2659
Untitled (Walls V–V). Jul 2–15, 1969. Yellow (Z), red (Z), blue (S). 58.8 × 48.9. Ed 20 (cR), 9 TI (ucR), BAT (cR), 2 AP (1 cR, 1 ucR), 2 CTP (cR), CP (cR). Eugene Sturman. D, BS, S, Dat.

2660
Untitled (Walls V–IV). Jul 10–22, 1969. Yellow (S), red (Z), blue (Z). 58.4 × 48.9. Ed 20 (cR), 9 TI (ucR), BAT (cR), CP (cR). Edward Hamilton. D, BS, S, Dat.

2689
Untitled (Walls V–VIII). Jul 11–23, 1969. Black (A), yellow (A), red (S). 58.8 × 48.9. Ed 20 (cR), 9 TI (ucR), BAT (cR), 3 AP (cR), CP (cR). Hitoshi Takatsuki. D, BS, S, Dat.

2690
Untitled (Walls V–VII). Jul 14–22, 1969. Red (S), blue (A). 58.4 × 48.9. Ed 20 (cR), 9 TI (ucR), BAT (cR), 3 AP (2 cR, 1 ucR), CP (ucR). Paul Clinton. D, BS, S, Dat.

2691
Untitled (Walls V–IX). Jul 18–25, 1969. Yellow (S), black (A). 58.8 × 48.9. Ed 20 (cR), 9 TI (ucR), BAT (cR), 3 AP (2 cR, 1 ucR), 3 CTP (cR), CP (ucR). Eugene Sturman. D, BS, S, Dat.

2692
Untitled (Walls V–X). Jul 18–25, 1969. Blue (A), red (S). 58.8 × 49.2. Ed 20 (cR), 9 TI (ucR), BAT (cR), 5 AP (3 cR, 2 ucR), CP (ucR). Charles Ringness. D, BS, S, Dat.

2693
Untitled. Jun 24–27, 1969. Violet-black (S). 61.3 × 51.1. Ed 20 (bA), 9 TI (CD), BAT (bA), 3 AP (2 bA, 1 CD), 1 TP* (CD), 2 CTP (bA), CP (CD). William Law III. D, BS, S, Dat.

2694
Title/Colophon Page (Walls V–I). Jul 24–26, 1969. Brown (S). 58.8 × 48.9, . Ed 20 (cR), 9 TI (ucR), BAT (cR), 3 AP (2 cR, 1 ucR), 1 CTP (cR), CP (ucR). Hitoshi Takatsuki. D, BS, S, Dat.

Tadeusz Dominik

584
Untitled. May 15–17, 1962. Black (S). 57.2 × 76.2. Ed 20 (bA), 9 TI (bA), PrP (bA), 2 AP (bA), 4 PP (bA). Joe Funk. BS, D, S.

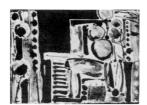

586
Untitled. May 17–18, 1962. Black (S). 37.5 × 50.2. Ed 20 (BFK), 9 TI (wN), PrP (BFK), 2 AP (1 BFK, 1 wN), 4 PP (BFK), 2 TP (BFK), CP (BFK). Bohuslav Horak. BS, D, S.

Seena Donneson

2417
Phoenix. Aug 12–16, 1968. Green-yellow (A), black (S). 56.5 × 56.5. Ed 20 (nN), 9 TI (nN), BAT (nN), 1 CTP (CD), 1 PTP (wA), CP (nN). Anthony Stoeveken. D, BS, S.

John Dowell

Print not in
University Art Museum
Archive

797
Man. Apr 26–May 3, 1963. Black (Z). 76.2 × 56.5. 10 ExP (BFK)[1]. John Dowell. D, T, BS, S.

1. Designated A–J. 5 ExP retained by Tamarind.

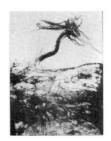

804
Flight IV. May 13–19, 1963. Black (Z). 62.9 × 45.7. Ed 20 (BFK), 9 TI (wA), PrP (BFK), 2 AP (BFK), 2 TP (BFK), CP (BFK). John Dowell. BS, T, D, S.

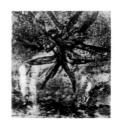

818
Icarus. May 29–Jun 3, 1963. Black (Z). 52.1 × 46.7. Ed 18 (BFK), 9 TI (wA), PrP (BFK). John Dowell. T, D, BS, S.

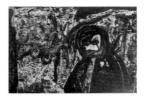

831
Mr. J.C. Jun 17–Jul 5, 1963. Light yellow (Z), violet (Z), ochre (Z), red-black (S). 55.9 × 80.0. Ed 20 (BFK), 9 TI (BFK), PrP (BFK), 3 AP (BFK), 3 TP (BFK), CP (BFK). John Dowell. D, T, S, BS.

Print not in
University Art Museum
Archive

854
Lithos. Jul 25–27, 1963. Black (Z). 25.4 × 74.9. Ed 20 (BFK), 9 TI (BFK), PrP (BFK), 2 AP (BFK), 1 TP (BFK). John Dowell. BS, D, T, S.

854A
Lithos II. Jul 26–Aug 23, 1963. Brown-black (Z)[1]. 76.2 × 56.2. Ed 10 (BFK), 9 TI (BFK), PrP (BFK), 3 AP (BFK), 1 PP (BFK), 2 TP (BFK). John Dowell. D, T, BS, S.

1. Plate held from 854. 854A differs from 854 in color, image, size and presentation as a vertical. Tone areas have been added on both sides of the central image.

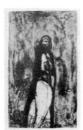

862
The Don III. Aug 8–Sep 4, 1963. Dark beige (Z), black (Z). 75.6 × 45.7. Ed 20 (BFK), 9 TI (wA), PrP (BFK), 3 AP (1 BFK, 2 wA), 2 PP (wA), 2 TP (BFK). John Dowell. D, T, BS, S.

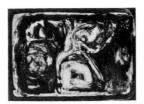

910
Untitled. Oct 17–22, 1963. Black (S). 37.5 × 50.8. Ed 20 (BFK), 9 TI (wA), PrP (BFK), 3 AP (2 BFK, 1 wA), 1 TP (BFK), CP (BFK). John Dowell. D, BS, S.

Print not in
University Art Museum
Archive

936
Untitled. Nov 8–Dec 12, 1963. Black (S). 49.5 × 38.1. Ed 20 (BFK), 9 TI (wA), PrP (BFK), 3 AP (2 BFK, 1 wA), 2 PP (BFK), 2 TP (BFK), CP (BFK). John Dowell. D, BS, S.

750A
Valley. Feb 26, 1963. Brown (S)[1]. 50.5 × 53.0. Ed 10 (BFK), 9 TI (wA), PrP (BFK), PrP II (wA)[2], 3 AP (BFK). Jason Leese. D, S (top), BS (bottom).

1. Stone held from #750, run 2. 750A differs from 750 in color and in image. Two trapezoid color areas on the sides were eliminated.
2. Recipient unrecorded.

938
The Flight of the Don. Nov 8–Dec 3, 1963. Dark beige (Z), dark green (S). 38.1 × 51.1. Ed 20 (BFK), 9 TI (wA), PrP (BFK), 3 AP (1 BFK, 2 wA), 2 TP (BFK). John Dowell. D, T, S, BS.

Caroline Durieux

625
Young Sarai[1]. Aug 9–17, 1962. Grey-blue (S), ochre (S), red-brown (S). 76.5 × 56.8. Ed 20 (BFK), 9 TI (BFK), PrP (BFK), 2 AP (BFK), 1 TP (BFK), 1 CTP (Tcs), 3 PgP (Tcs), CP (BFK). Robert Gardner. T, D, S, BS.

1. Created as part of suite, *Great Ladies of the Old Testament,* undertaken outside Tamarind.

1682
Free Jazz. Apr 2–11, 1966. Black (S). 76.2 × 56.8. Ed 10 (bA), 9 TI (wA), BAT (bA), 3 AP (1 wA, 2 bA). John Dowell. D, T, S, BS.

Kosso Eloul

1459
Hardfact. Sep 9–11, 1965. Red (Z), black (S). 64.8 × 44.5. Ed 20 (BFK), 9 TI (wA), BAT (BFK), 2 AP (wA), 2 TP (BFK), 3 PTP (2 3-M, 1 Tcs)[1], CP (Tcs). Robert Evermon. BS, D, S, Dat.

1. Unsigned, undesignated, unchopped, and cancelled, retained by Tamarind.

1683
Easter Drawing. Apr 10–13, 1966. Black (S). 76.2 × 56.2. Ed 10 (BFK), 9 TI (GEP), BAT (BFK), 3 AP (1 BFK, 2 GEP). John Dowell. D, BS, T, S, Dat.

1684
Coleman Sadness. Apr 16–May 5, 1966. Light orange (Z), light green (Z), blue (S), red (S). 56.8 × 76.5. Ed 10 (GEP), 9 TI (wA), BAT (GEP), 3 AP (wA), 4 TP (GEP), CP (Tcs). John Dowell. D, BS (Tam), T, S, BS (pr).

Jules Engel

For the edition printed between November, 1960 and April, 1961, some rough proofs exist in addition to those recorded. No other record was maintained of these proofs.

In addition, four other images were executed by the artist during this period. Three of these (121A, 138 and 174) were abandoned after proofing. A few rough proofs of these exist in the possession of the artist. The fourth image, Tam. #231, was rejected after printing.

Lynne Drexler

750
Window onto Valley. Feb 19–27, 1963. Blue-green, red-violet (Z), dark blue (S). 50.8 × 53.3. Ed 20 (BFK), 9 TI (wN), PrP (BFK), PrP II (BFK)[1], 3 AP (BFK), 1 PP (BFK). Jason Leese. D, S (top), BS (bottom).

1. Recipient unrecorded.

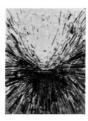

121
Alamogordo. Oct 10–12, 1960. Grey (S), black (S). 43.2 × 32.1. Ed 20 (BFK), 9 TI (wN), PrP (BFK)[1], 5 AP (BFK). Joe Funk. BS (Tam), D, S (in black India ink), BS (pr).

1. Also designated AP.

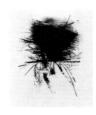

162
Curfew. Nov 19–Dec 16, 1960. Black (Z). 104.8 × 74.3. Ed 20 (BFK), 9 TI (wN), PrP (BFK), 2 TP (BFK), CP (BFK). Joe Funk. S, D, BS.

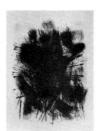

169
Ambush. Dec 3, 1960. Black (Z). 105.1 × 74.3. Ed 16 (BFK), 10 TI (nN)[1], PrP (BFK), 2 TP (BFK), CP (CD). Joe Funk. BS (Tam), D, S, BS (pr).

1. 1 TI may exist unsigned.

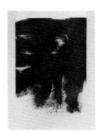

189
Winter Landscape. Dec 17, 1960–Jan 11, 1961. Black (Z). 104.8 × 48.9 (nN), 92.7 × 61.0 (BFK) Ed 15 (BFK), 9 TI (nN), PrP (BFK), 2 AP (BFK), 4 TP (BFK), CP (JY). Joe Funk. BS, D, S.

190
Constant Image. Dec 17, 1960–Jan 17, 1961. Black (Z). 76.8 × 57.2. Ed 20 (BFK), 9 TI (wN), PrP (BFK), 1 AP (BFK), 2 TP (BFK), CP (BFK). Joe Funk. BS (Tam), D, BS (pr), S.

201
Landscape. Jan 1, 1961. Black (Z). 104.8 × 74.9 (nN), 94.0 × 63.5 (BFK). Ed 20 (BFK), 9 TI (nN), PrP (BFK), 1 AP (nN), 1 TP (BFK), CP (BFK). Joe Funk. BS (Tam), D, S, BS (pr).

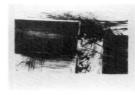

Print not in
University Art Museum
Archive

213
Red Poppies. Jan 1–Feb 1, 1961. Red (Z), black (Z). 59.1 × 84.5. Ed 20 (BFK), 9 TI (wN), PrP (BFK), 1 AP (BFK), 1 TP (BFK). Joe Funk. BS (Tam), D, S, BS (pr).

231
Untitled. Feb 4–Mar 18, 1961. Orange (Z), red (Z), violet (Z), black (Z). 53.3 × 38.1. Ed 11 (nr)[1], PrP (nr). Joe Funk.

1. Unchopped, retained by the artist.

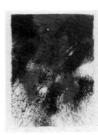

242
Meadow. Mar 4–Apr 8, 1961. Green (Z), black (Z). 76.8 × 57.2. Ed 15 (wA), 9 TI (wN), PrP (wA), 4 AP (2 wA, 2 wN), 1 proof (nr)[1]. Joe Funk. BS (Tam), D, S, BS (pr).

1. Unsigned, designated "Rough Proof—Abandoned Plate," retained by Tamarind.

2198
Homage to Nevelson I. Jan 16–19, 1968. Gold (S), black (S). 66.0 × 56.2. Ed 20 (wA), 9 TI (BFK), BAT (wA), 3 AP (2 BFK, 1 wA), 3 PP (wA), 1 TP (wA). David Folkman. D, BS, S, Dat.

2198II
Homage to Nevelson II. Jan 20, 1968. Blue (S)[1]. 66.4 × 55.9 (JG), 66.0 × 57.2 (GEP). Ed 10 (GEP), 9 TI (JG), BAT (GEP), 5 AP (GEP), CP* (wA). David Folkman. D, BS, S, Dat.

1. Stone held from 2198, run 2. 2198II differs from 2198 in color and in image. The solid tone has been eliminated from all of the squares.

2217
Twins. Feb 12–16, 1968. Green (A), black (S), blue (A). 66.4 × 55.9. Ed 20 (JG), 9 TI (cR), BAT (JG). Maurice Sanchez. Recto: BS Verso: D, S, Dat.

2217II
Twins II. Feb 21–23, 1968. Black
(S)[1], violet (A)[2], red-orange (A)[3].
66.0 × 55.9. Ed 12 (10 JG, 2 cR), 9 TI
(cR), BAT (JG), 4 AP (3 JG, 1 cR), 1 TP
(JG), CP (JG). Maurice Sanchez. Verso:
D, WS, S, Dat.

1. Stone held from 2217, run 2.
2. Plate held from 2217, run 1.
3. Plate held from 2217, run 3. 2217II
 differs from 2217 in color only.

2243
Monument II. Apr 3–15, 1968. Red-
orange (A), black (A). 55.9 × 64.8. Ed
20 (JG), 9 TI (cR), BAT (JG), 3 AP (2 cR,
1 JG), 1 TP* (JG), CP* (JG). Robert
Rogers. D, BS, S, Dat.

2471
Untitled. Oct 28–Nov 6, 1968. Red-
orange (A), green (A), black (S). 53.3
× 53.3. Ed 20 (JG), 9 TI (CD), BAT
(JG), 3 AP (2 JG, 1 CD). Jean Milant.
Recto: BS Verso: D, S.

Print not in
University Art Museum
Archive

2471II
Untitled. Nov 11–15, 1968. Light
green-blue (A)[1], green (A)[2], black
(S)[3]. 53.3 × 53.3. Ed 10 (JG), 9 TI
(CD), BAT (JG), 3 AP (2 JG, 1 CD), CP
(CD). Jean Milant. Recto: BS Verso: D,
S.

1. Plate held from 2471, run 1.
2. Plate held from 2471, run 2.
3. Stone held from 2471, run 3. 2471II
 differs from 2471 in color only.

2605
Untitled. Apr 9–21, 1969. Red (A),
black (S). 53.3 × 53.3. Ed 20 (JG), 9 TI
(wA), BAT (JG), 3 AP (2 wA, 1 JG), 3
CTP (2 JG, 1 wA), CP (wA). Daniel
Socha. D, BS, S, Dat.

2605II
Untitled. Apr 9–21, 1969. Blue (A)[1],
black (S)[2]. 53.3 × 53.3. Ed 10 (JG), 9
TI (wA), BAT (JG), 3 AP (1 wA, 2 JG).
Daniel Socha. D, BS, S.

1. Plate held from 2605, run 1.
2. Stone held from 2605, run 2. 2605II
 differs from 2605 in color only.

Robert Evermon

1536
Two. Sep 17–18, 1965. Red (Z), black
(Z). 28.6 × 38.1. Ed 10 (BFK), 9 TI
(wA), BAT (BFK), 2 AP (wA), 2 TP
(BFK), CP (Tcs). Robert Evermon. D,
BS, S, Dat.

Conner Everts

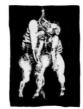

123
Execution. Sep 22–29, 1960. Black
(S)[1]. 104.8 × 74.6. Ed 20 (CD)[2], 9 TI
(wN)[2], PrP (CD)[2], 4 AP (1 BFK, 3
CD)[2], 2 TP (CD)[2], CP (J)[2]. Garo
Antreasian. D, BS (pr), T, S, Dat, BS
(Tam).

1. During printing, a crack appeared in
 the stone which finally caused a
 fragment to break away. The edition
 was printed in four stages of this
 development. A: original image, B:
 crack visible in lower corner of
 image, C: reduced image showing
 embossment of crack in lower
 margin, D: reduced image after
 fragment had broken away.
2. Edition as printed during cracking,
 except 2 TP (not recorded) A: 1 AP
 (BFK), 9 TI. B: 3 AP (CD). C: BAT, Ed
 1–3/20. D: Ed 4–20/20, CP.

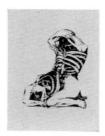

142
Two Faces of Fear. Oct 29–Nov 12,
1960. Black (Z)[1]. 76.8 × 56.5. Ed 20
(BFK), 9 TI (nN), PrP (nN), 3 AP (BFK),
CP (proof paper). Joe Funk. D, S, Dat,
T, BS.

1. Water stain and plate line visible on
 many impressions including all on
 nN.

Claire Falkenstein

1458
The Moving Point. Oct 21–22, 1965.
Red-black (S). 76.5 × 57.2. Ed 20
(BFK), 9 TI (wA), BAT (BFK), 3 TP*
(BFK), CP (Tcs). Walter Gabrielson. D,
BS, S.

Jurgen Fischer

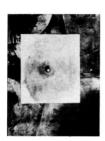

1320
Untitled. Jul 24–27, 1965. Black or violet-black (S). 76.5 × 56.5. Ed 12 (BFK), 9 TI (wA)[1], UNMI (wA)[1], 3 AP (2 wA, 1 BFK)[1], 2 TP (BFK)[1]. Jurgen Fischer, NC. BS (Tam), D, S, Dat, BS (UNM).

1. Printed in violet-black.

1325
Untitled. Jul 11–25, 1965. Black (S), violet-grey (S), red-brown (S). 38.1 × 53.3. Ed 10 (BFK), 9 TI (wA), UNMI (wA), 3 AP (wA), 3 TP (BFK). Jurgen Fischer, NC. BS (Tam), D, S, Dat, BS (UNM).

1495
Untitled. Sep 13–14, 1965. Black (Z). 33.4 × 28.6. Ed 10 (BFK), 9 TI (wA), BAT (BFK), 2 AP (1 BFK, 1 wA), CP (Tcs). Jurgen Fischer. BS (Tam), D, S, Dat, BS (pr).

1500
Untitled. Jul 31–Aug 6, 1965. Black (S). 76.5 × 52.7. Ed 12 (BFK), 9 TI (wA), UNMI (wA), 3 AP (2 BFK, 1 wA), 2 TP (BFK)[1]. Jurgen Fischer, NC. BS (Tam), D, S, Dat, BS (UNM).

1. A few TP* exist on ordinary paper, number unrecorded.

1501
Untitled. Aug 4–8, 1965. Black (S). 76.5 × 52.7. Ed 12 (BFK), 9 TI (wA), UNMI (wA), 3 AP (2 wA, 1 BFK), 1 TP (wA). Jurgen Fischer, NC. BS (Tam), D, S, Dat, BS (UNM).

Print not in University Art Museum Archive

1530
Untitled. Sep 13–14, 1965. Black (Z). 33.4 × 28.6. Ed 10 (BFK), 9 TI (wA), BAT (BFK), CP (Tcs). Jurgen Fischer. BS (Tam), D, S, Dat, BS (pr).

1531
Untitled. Sep 13–15, 1965. Black (Z). 33.0 × 28.3. Ed 10 (BFK), 9 TI (CD), BAT (BFK), CP (Tcs). Jurgen Fischer. D, S, Dat, BS.

1532
Untitled. Sep 13–16, 1965. Black (Z). 33.0 × 27.9. Ed 10 (9 BFK, 1 CD), 9 TI (CD), BAT (BFK), 1 TP (BFK), CP (Tcs). Jurgen Fischer. BS (Tam), D, BS (pr), S, Dat.

1533
Untitled. Sep 18, 1965. Black (S). 33.0 × 27.9. Ed 10 (BFK), 9 TI (CD), BAT (BFK), CP (Tcs). Jurgen Fischer. BS (Tam), D, BS (pr), S, Dat.

1539
Untitled. Sep 20, 1965. Black (Z). 33.0 × 25.7. Ed 10 (BFK), 9 TI (CD), BAT (BFK), CP (Tcs). Jurgen Fischer. BS, D, S, Dat.

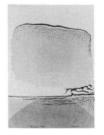

1540
Untitled. Sep 24–Oct 20, 1965. Black (Z), yellow (S). 55.9 × 38.1. Ed 10 (BFK), 9 TI (wA), BAT (BFK), 3 AP (1 BFK, 2 wA), 1 TP (BFK), CP (Tcs). Jurgen Fischer. D, S, Dat, BS.

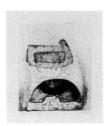

1541
Untitled. Sep 25, 1965. Black (Z). 33.0 × 27.9. Ed 10 (BFK), 9 TI (wA), BAT (BFK), 1 TP (BFK), CP (Tcs). Jurgen Fischer. D, S, Dat, BS.

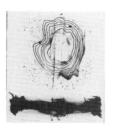

1542
Untitled. Sep 25, 1965. Black (Z). 33.0 × 28.3. Ed 10 (BFK), 9 TI (wA), BAT (BFK), 1 TP (BFK), CP (Tcs). Jurgen Fischer. D, BS, S, Dat.

1545
Untitled. Oct 16–20, 1965. Black (Z). 33.0 × 28.3. Ed 10 (BFK), 9 TI (wA), BAT (BFK), 2 AP (1 BFK, 1 wA), CP (Tcs). Jurgen Fischer. D, S, Dat, BS.

1546
Untitled. Oct 16–20, 1965. Black (Z). 33.4 × 27.9. Ed 10 (BFK), 9 TI (wA), BAT (BFK), 1 AP (wA), CP (Tcs). Jurgen Fischer. D, BS, S, Dat.

1547
Untitled. Oct 16–20, 1965. Black (Z). 33.0 × 27.9. Ed 10 (BFK), 9 TI (wA), BAT (BFK), 1 AP (wA), CP (Tcs). Jurgen Fischer. D, S, Dat, BS.

1563
Untitled. Oct 21, 1965. Black (Z). 33.4 × 28.6. Ed 10 (BFK), 9 TI (wA), BAT (BFK), 1 AP (wA), CP (Tcs). Jurgen Fischer. D, BS (Tam), S, Dat, BS (pr).

1564
Untitled. Oct 21, 1965. Black (Z). 33.0 × 28.6. Ed 10 (BFK), 9 TI (wA), BAT (BFK), 2 AP (wA), CP (Tcs). Jurgen Fischer. D, S, Dat, BS.

Print not in
University Art Museum
Archive

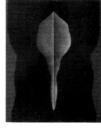

David Folkman

2020
American Shield. Apr 29–May 6, 1967. Red (A), silver-blue (A). 71.1 × 50.8. Ed 15 (wN), 9 TI (nN), BAT (wN), 3 AP (nN)[1], 2 TP (wN), CP (nN)[1]. Maurice Sanchez. D, T, S, BS.

1. 1 AP, CP on paper 70.2 × 50.8.

2055
See Slug. May 26–Jun 1, 1967. Red (A), green (A), dark red (A). 56.5 × 58.4. Ed 10 (GEP), 9 TI (BFK), BAT (GEP), 3 AP (BFK), 3 TP (GEP), CP (wN). Maurice Sanchez. D, T, S, BS[1].

1. David Folkman's chop also appears.

2064
Mandala I. Aug 31–Oct 29, 1967. Dark blue-violet (A), green (A), red-violet (A), red (A). 57.8 × 78.7[1]. Ed 15 (GEP), 9 TI (JG), BAT (GEP), 2 AP (1 GEP, 1 JG), 3 TP* (2 GEP, 1 JG). Maurice Sanchez. D, BS (Tam), T, S, BS (pr).

1. Torn to an irregular shape.

2064II
Mandala II. Jan 8–29, 1968. Red (A)[1], yellow-green (S)[2], black (A). 57.2 × 80.0[3]. Ed 10 (GEP), 9 TI (JG), BAT (GEP), 1 TP (GEP), CP (GEP). David Folkman. D, BS (Tam), T, S, BS (pr).

1. Plate held from 2064, run 4.
2. Same plate as run 1; reversal. 2064II differs from 2064 in color and in image. The solid tone around the central shape has been eliminated and a dark outline has been added. The texture within the central shape is darker.
3. Torn to an irregular shape.

2219
Untitled. Apr 6–13, 1968. Light blue (O)[1], black (A), black (A), on silver foil. 76.2 × 55.2[1], cut and deckle. Ed 15 (14 wA, 1 CD), 9 TI (CD), BAT (wA), 3 AP (1 wA, 2 CD), 1 TP (wA). David Folkman. BS, D, S, Dat.

1. Cut to an irregular shape.

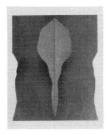

2219II
Untitled. Apr 11–Jun 29, 1968. Blue
(A), blue (Z), black (O)[1], on silver
foil, embossed. 76.2 × 55.2[1],
cut and deckle. Ed 14 (JG), 9 TI (CW),
BAT (JG), 2 AP (CW), 1 TP* (JG), CP
(CW). David Folkman. D, BS, S, Dat.

1. Stone held from 2219, run 1. 2219III
 differs from 2219 in color, image
 and size. The shading in the central
 shape is darker. The tone area
 around the central shape is lighter
 and margins have been added on
 all four sides.

Vicki Folkman

2194
Untitled. Dec 24–26, 1967. Black (A).
56.8 × 55.9. Ed 10 (GEP), 9 TI (wA),
BAT (GEP), 3 AP (2 GEP, 1 wA), 1 TP
(GEP), CP (EVB). David Folkman. D,
BS, S, Dat.

Jan Forsberg

Print not in
University Art Museum
Archive

1584
Brev fran en stad. Nov 8–9, 1965.
Dark blue-green (S). 77.5 × 57.2. Ed
20 (nN), 9 TI (wN), BT (nN), 2 AP (1
wN, 1 nN), CP (Tcs). Kinji Akagawa. D,
S, BS.

Sam Francis

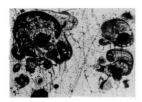

761
Untitled. Mar 4–12, 1963. Yellow (Z),
blue (S), red (S), green, violet (Z). 57.5
× 76.2. Ed 20 (BFK), 9 TI (wA), BAT
(BFK), PrP II for Jason Leese (BFK), 3
AP (BFK), 1 PP (BFK), 3 TP (wA), CP
(BFK). Irwin Hollander. D, BS, S.

763
Untitled. Mar 7–25, 1963. Yellow (Z),
blue (S), green (Z), red (S). 66.7 ×
92.1. Ed 40 (BFK), 9 TI (wN), BAT
(BFK), PrP II for Bohuslav Horak (BFK),
2 AP (1 BFK, 1 wN), 2 PP (1 BFK, 1
wN), CP (BFK). Irwin Hollander. D, BS,
S.

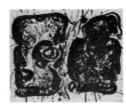

765
Untitled. Mar 11–14, 1963. Black (S).
43.2 × 51.1. Ed 20 (BFK), 9 TI (wA),
BAT (BFK), 3 AP (BFK), 1 PP (wA), CP
(J). Bohuslav Horak. D, BS, S.

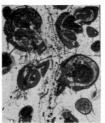
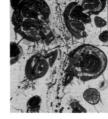

768
Bright Nothing. Mar 18–Apr 11,
1963. Green (Z), yellow (Z), red (S),
blue (S). 64.1 × 51.4. Ed 23 (BFK), 9 TI
(wA), BAT (BFK), PrP II for Bohuslav
Horak (BFK), 2 AP (wA). Irwin
Hollander. D, BS, S.

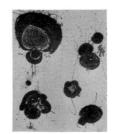

769
Chinese Planet. Mar 19–28, 1963.
Red (Z), blue (Z). 76.5 × 57.2. Ed 20
(BFK), 9 TI (wA), BAT (BFK), PrP II For
Bohuslav Horak (BFK), 2 AP (1 BFK, 1
wA), 1 TP (wA), 2 CTP (BFK)[1], 1
proof* (3–M)[2], CP (BFK). Irwin
Hollander. D, BS, S.

1. 1 CTP retained by Tamarind.
2. Unsigned, undesignated,
 unchopped, retained by Tamarind.

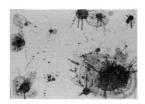

771
Untitled. Mar 20–Apr 18, 1963.
Yellow (Z), violet (Z), red (Z). 56.2 ×
76.2. Ed 20 (BFK), 9 TI (wA), BAT
(BFK), PrP II for Bohuslav Horak (BFK),
3 AP (2 BFK, 1 wA), 2 PP (BFK). Irwin
Hollander. D, BS, S.

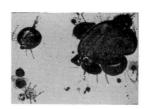

772
Another Disappearance. Mar 22–
Apr 2, 1963. Blue (Z), yellow (Z), red
(Z). 57.2 × 76.5. Ed 20 (BFK), 9 TI
(wA), BAT (BFK), PrP II for Bohuslav
Horak (BFK), 3 AP (1 BFK, 2 wA), 2 PP
(BFK), 2 TP (BFK)[1]. Irwin Hollander.
D, BS, S.

1. Color trial proofs, designated TP.
 One retained by Tamarind.

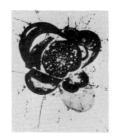

777
Essai. Mar 27–Apr 25, 1963. Black (Z).
40.3 × 32.1. Ed 20 (BFK), 9 TI (wA),
BAT (BFK), PrP II for Bohuslav Horak
(BFK), 2 AP (BFK). Jason Leese. D, BS,
S.

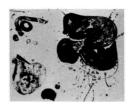

778
Untitled. Mar 29–Apr 5, 1963. Black (S). 45.7 × 53.7. Ed 20 (BFK), 9 TI (wA), BAT (BFK), PrP II for Bohuslav Horak (BFK), 3 AP (BFK). Jason Leese. D, BS, S.

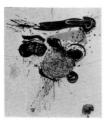

782
Untitled. Apr 10–22, 1963. Yellow (Z), blue (Z). 58.4 × 50.8. Ed 20 (BFK), 9 TI (wA), BAT (BFK), PrP II for Bohuslav Horak (BFK), 2 AP (1 BFK, 1 wA), 1 PP (BFK), 2 TP (BFK), 2 CSP (BFK)[1]. Irwin Hollander. D, BS, S.

1. Retained by Tamarind.

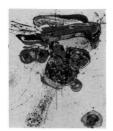

789
Flying Love. Apr 19–25, 1963. Yellow (Z)[1], red (Z)[2], blue (Z). 60.3 × 47.6. Ed 10 (BFK), 9 TI (BFK), BAT (BFK), 3 AP (BFK), 2 TP (BFK), CP (BFK). Irwin Hollander. D, BS, S.

1. Plate held from 789A, run 1.
2. Plate held from 789A, run 2. 789 differs from 789A in color and in image. The shape at the lower right has been enlarged. Wash drawing has been added between and above the central shapes.

789A
Untitled. Apr 19–24, 1963. Yellow (Z)[1], black (Z)[2]. 60.7 × 47.6. 10 ExP (wA)[3], BAT (wA), 3 AP (wA), 1 PP (BFK). Irwin Hollander. BS, S.

1. Plate held from 782, run 1.
2. Plate held from 782, run 2. 789A differs from 782 in color and size. There has been a slight reduction in the width of the image.
3. Designated A-J. 5 ExP retained by Tamarind.

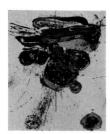

859
Untitled. Aug 6–Sep 20, 1963. Yellow (Z), red (Z), blue (Z), green (S). 76.2 × 56.5. Ed 20 (BFK), 9 TI (wA), BAT (BFK), PrP II for Irwin Hollander (BFK), 4 AP (2 BFK[1], 2 wA), 2 PP (1 BFK, 1 wA), 2 TP (BFK), 7 CTP (nr)[2]. Kenneth Tyler. BS, D, S.

1. 1 AP inscribed "Essais d'artiste, Amitas de Sam Francis" Marcel Durassier, guest printer. No printer's chop for this impression.
2. 1 CTP printed on recto and verso. 4 CTP retained by Tamarind.

865
For Miro I. Aug 12–Oct 4, 1963. Yellow (Z), blue (Z), black (Z). 56.5 × 76.5. Ed 20 (BFK), 9 TI (wA), BAT (BFK), PrP II for Bohuslav Horak (BFK), 3 AP (wA), 10 CTP (nr)[1], 1 proof (nr)[2]. Aris Koutroulis. D, BS, S.

1. 3 CTP retained by Tamarind.
2. Unsigned, undesignated, unchopped, retained by Tamarind.

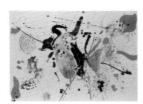

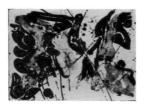

Print not in
University Art Museum
Archive

865A
Blue-Violet. Nov 4–8, 1963. Light blue (Z)[1], dark violet (Z)[2]. 56.5 × 76.2. Ed 20 (BFK), 9 TI (wA), BAT (BFK), PrP II for Irwin Hollander (BFK), 3 AP (1 BFK, 2 wA), 2 TP (BFK). Robert Gardner. BS, S, D.

1. Plate held from 865, run 1.
2. Plate held from 865, run 2. 865A differs from 865 in color and in image. The majority of dark shapes have been eliminated.

932
Untitled. Nov 19–20, 1963. Black (Z)[1]. 57.2 × 77.5. Ed 20 (BFK), 9 TI (wN), BAT (BFK), PrP II for Irwin Hollander (BFK), 3 AP (1 BFK, 2 wN), 2 TP (BFK), CP (BFK). John Dowell. D, BS, S.

1. Plate held from 865, run 3. 932 differs from 865 in color and in image. All of the light shapes and the blue central spatters have been eliminated.

934
Untitled. Nov 20–21, 1963. Red-black (S)[1]. 43.2 × 45.4. 10 ExP (BFK)[2], BAT (BFK), 1 TP (BFK), 1 Proof (wA)[3]. Kenneth Tyler. BS, S, D.

1. Stone held from 859, run 4. 934 differs from 859 in color, image and size. This is the upper right one quarter of 859. The dark calligraphic spatters which were over the present image have been eliminated.
2. Designated A-J. 5 ExP retained by Tamarind.
3. 1 proof, a reversal in bronze-black with an image like the ExP on the verso, unsigned, unchopped, undesignated, on paper 43.2 × 45.7, retained by Tamarind.

1809
Untitled. Sep 2–26, 1966. Blue (S), yellow (S), red (S), green (S). 78.7 × 58.4. Ed 20 (GEP), 9 TI (CD), BAT (GEP), 3 AP (CD), 4 TP* (GEP), 4 PTP (2 G, 2 dLM)[2], CP (EVB). Robert Bigelow. S, D, BS.

1. 1 TP was signed as a horizontal.
2. Unsigned, unchopped, undesignated, retained by Tamarind.

2583
Untitled. Mar 3–12, 1969. Yellow, orange (Z), red, red-orange (Z), blue, dark green-blue (S). 55.9 × 76.5. Ed 20 (cR), 9 TI (ucR), BAT (cR), 5 AP (cR), 1 PP (cR), 3 CTP (2 ucR, 1 cR), CP (cR). Serge Lozingot. BS, D, S.

2584
Untitled. Mar 4–12, 1969. Yellow, orange (Z), red, red-orange (Z), blue, violet (S). 55.9 × 76.2. Ed 20 (cR), 9 TI (ucR), BAT (cR), 5 AP (4 cR, 1 ucR), 1 CTP (cR), CP (ucR). Jean Milant. Recto: BS Verso: D, S.

2585
Damp. Mar 10–20, 1969. Yellow (Z), orange-red, red (Z), blue (S). 66.4 × 94.3. ED 20 (cR), 9 TI (ucR), BAT (cR), 4 AP (2 cR, 2 ucR), 7 CTP (3 ucR, 4 cR), CP (cR). Daniel Socha. D, S, BS.

2586
Untitled. Mar 17–28, 1969. Blue, blue-green (S), yellow, light blue (Z), red (Z). 76.8 × 56.5. Ed 20 (wA), 9 TI (cR), BAT (wA), 1 PP (cR), 2 TP (1 cR, 1 wA), 5 CTP (4 wA, 1 cR), CP (wA). Don Kelly. D, S (bottom), BS (top).

1. 1 TP on paper 58.4 × 86.3.

2587
Untitled. Mar 18–27, 1969. Yellow, orange (Z), blue, blue-green (S), red, orange-red (Z). 88.9 × 63.5. Ed 20 (cR), 9I TI (ucR), BAT (cR), 5 AP (4 cR, 1 ucR), 1 PP (ucR), 10 CTP (cR)[1], CP (cR). John Sommers. Recto: BS Verso: D, S.

1. Numbered 1–6/6, I–IA and II–IIA. 6 TO on paper 55.9 × 76.2.

2588
Untitled. Mar 26–Apr 7, 1969. Red, blue, green (Z), orange, yellow (Z), violet, green (S). 66.0 × 97.2. Ed 20 (cR), 9 TI (ucR), BAT (ucR), 3 AP (ucR), 7 CTP (cR), CP (cR). Charles Ringness. D, S, BS.

2589
Untitled. Mar 28–Apr 16, 1969. Yellow (Z), red, orange-red (Z), green, blue-green, blue (S). 91.4 × 63.5. Ed 20 (cR), 9 TI (ucR), BAT (cR), 5 AP (4 cR, 1 ucR), 1 TP (cR), 2 CTP (cR), CP (cR). Ronald Glassman. Recto: BS Verso: D, S.

Antonio Frasconi

Oda a Lorca, a suite of sixteen lithographs including title, colophon and poetry pages, enclosed in a dark brown burlap covered portfolio, measuring 80.0 × 59.7, lined with white Nacre, with the suite title printed in black on the front cover, made by Margaret Lecky, Los Angeles. In order: 521, 531, 533, 514, 520, 516, 537, 536, 542, 515, 512, 538, 522, 529, 525, 543.

509
Death of a Poet I. Feb 14–19, 1962. Black (Z). 69.5 × 94.9. Ed 20 (BFK), 9 TI (wN), BAT (BFK), 1 AP (BFK), 4 TP (3 BFK, 1 nN), CP (BFK). Irwin Hollander. BS, D, S.

1. 9 TI and unrecorded number of edition printed by Joe Funk.

511
Death of a Poet II. Feb 16–20, 1962. Black (Z). 68.6 × 94.0. Ed 8 (BFK), 9 TI (BFK), BAT (BFK). Irwin Hollander. BS (bottom), S, D (top).

512
Franco III (Oda a Lorca XI). Feb 19–Apr 3, 1962. Black (Z). 76.8 × 57.2. Ed 20 (BFK), 9 TI (wN), BAT (BFK), 7 AP (4 BFK, 2 wN, 1 nN), 1 PP (BFK), 3 TP (BFK), CP (BFK). Joe Funk. BS (bottom), S, D (top).

514
Guns (Oda a Lorca IV). Feb 26–28, 1962. Black (S). 56.5 × 76.8. Ed 20 (BFK), 9 TI (wN), BAT (BFK), 3 AP (2 BFK, 1 nN), 1 PP (BFK), 3 TP (BFK), CP (BFK). Bohuslav Horak. BS (bottom), D, S (top).

515
Franco II (Oda a Lorca X). Feb 28–Mar 2, 1962. Black (S). 77.2 × 56.8. Ed 20 (BFK), 9 TI (wN), BAT (BFK), 2 AP (1 BFK, 1 nN), 3 TP (BFK), CP (BFK). Bohuslav Horak. S, D, BS.

516
Falling (Oda a Lorca VI). Mar 2–8, 1962. Grey (Z), black (S). 76.8 × 57.2. Ed 20 (BFK), 9 TI (wN), BAT (BFK), 2 AP (1 wN, 1 nN), 1 PP (BFK), 3 TP (BFK), CP (BFK). Bohuslav Horak. BS (bottom), D, S (top).

520
Stake (Oda a Lorca V). Mar 5–7, 1962. Black (S). 76.8 × 56.8. Ed 20 (BFK), 9 TI (wN), BAT (BFK), 3 AP (1 BFK, 1 wN, 1 nN), 1 PP (BFK), 3 TP (BFK), CP (BFK). Bohuslav Horak. D, S, BS.

521
Title Page (Oda a Lorca I). Mar 6–12, 1962. Black (S). 76.8 × 56.8. Ed 20 (BFK), 9 TI (wN), BAT (BFK), 3 AP (2 BFK, 1 nN), 3 TP (BFK), CP (BFK). Bohuslav Horak. BS (Tam), D, BS (pr), S.

522
Monster (Oda a Lorca XIII). Mar 8–14, 1962. Brown (S), black (S). 76.8 × 57.2. Ed 20 (BFK), 9 TI (wN), BAT (BFK), 3 AP (2 BFK, 1 nN), 1 PP (BFK), 3 TP (BFK), CP (BFK). Bohuslav Horak. BS, S, D.

525
Memento (Oda a Lorca XV). Mar 12–19, 1962. Light brown (S), black (S). 76.8 × 56.8. Ed 20 (BFK), 9 TI (wN), BAT (BFK), 3 AP (1 BFK, 1 wN, 1 nN), 1 PP (BFK), 4 TP (BFK), CP (wN). Bohuslav Horak. BS (Tam), S, D, BS (pr).

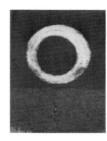

529
Moon (Oda a Lorca XIV). Mar 16–23, 1962. Green (S), black (Z). 76.8 × 57.2. Ed 20 (BFK), 9 TI (wN), BAT (BFK), 3 AP (2 wN, 1 nN), 1 PP (BFK), 3 TP (BFK), CP (BFK). Bohuslav Horak. D, S, BS.

531
Machado (Oda a Lorca II). Mar 18–21, 1962. Dark brown (Z). 76.5 × 56.5. Ed 20 (BFK), 9 TI (wN), BAT (BFK), 3 AP (2 wN, 1 nN), 1 PP (BFK), 3 TP (BFK), CP (BFK). Joe Zirker. BS, S, D.

533
Portrait of Garcia Lorca (Oda a Lorca III). Mar 19–28, 1962. Dark beige (S), dark brown (S). 76.8 × 57.2. Ed 20 (BFK), 9 TI (wN), BAT (BFK), 6 AP (3 BFK, 2 wN, 1 nN), 2 PP (BFK), 3 TP (BFK), CP (BFK). Bohuslav Horak. D, BS (Tam), S, BS (pr).

536
Marching (Oda a Lorca VIII). Mar 22–27, 1962. Black (S). 56.8 × 76.8. Ed 20 (BFK), 9 TI (wN), BAT (BFK), 3 AP (2 wN, 1 nN), 4 PP (BFK), 3 TP (BFK), CP (BFK). Bohuslav Horak. BS, D, S.

537
Dead Poet (Oda a Lorca VII). Mar 24–29, 1962. Black (S). 56.8 × 76.5. Ed 20 (BFK), 9 TI (wN), BAT (BFK), 5 AP (2 BFK, 2 wN, 1 nN), 3 TP (BFK), CP (BFK). Bohuslav Horak. BS (bottom), S, D (top).

538
Dead and Bats (Oda a Lorca XII). Mar 27–Apr 3, 1962. Black (S). 57.2 × 76.8. Ed 20 (BFK), 9 TI (wN), BAT (BFK), 9 AP (7 BFK, 1 wN, 1 nN), 3 TP (BFK), CP (BFK). Bohuslav Horak. D, BS (pr), S, BS (Tam).

542
Franco I (Oda a Lorca IX). Mar 29–
Apr 4, 1962. Black (S). 76.8 × 57.2. Ed
20 (BFK), 9 TI (wN), BAT (BFK), 7 AP (5
BFK, 1 wN, 1 nN), 3 TP (BFK), CP
(BFK). Bohuslav Horak. BS (bottom),
S, D (top).

543
Colophon (Oda a Lorca XVI). Mar
29–Apr 2, 1962. Black (S). 76.8 × 56.8.
Ed 20 (BFK), 9 TI (wN), BAT (BFK), 5
AP (3 BFK, 1 wN, 1 nN), 3 TP (BFK), CP
(BFK). Bohuslav Horak. WS[1], BS
(Tam), S, D, BS (pr).

1. The artist's initials and Tamarind
 chop wetstamped in red ink.

Elias Friedensohn

588
Three. May 21, 1962. Black (Z). 39.1
× 51.4. Ed 20 (BFK), 9 TI (wN), PrP
(BFK), 2 AP (wN), 5 PP (BFK), 3 TP (1
BFK, 1 bA, 1 wN), CP (BFK). Bohuslav
Horak. BS, S, D.

589
One. May 21–22, 1962. Black (Z). 51.4
× 38.1. Ed 10 (BFK), 9 TI (BFK)[1], 2
PrP (BFK)[2], 3 AP (BFK), 3 TP (BFK).
Irwin Hollander. BS, D, S.

1. TI vary from edition in minor
 differences.
2. 1 PrP for Bohuslav Horak.

Manuel Fuentes

2202
Spooky Loop. Jan 29–May 25, 1968.
Blue (Benelux)[1], silver (S). 65.4 ×
86.7. Ed 9 (GEP), 9 TI (CD), BAT (GEP),
2 AP (CD), 1 CTP (GEP). Manuel
Fuentes. D, BS, S, Dat.

1. Printing varies in lightness,
 darkness and texture throughout
 the edition.

2330
Your Haven Mohr Keep It. May 16–
17, 1968. Black (S). 35.6 × 56.5. Ed 20
(BFK), 9 TI (BFK), BAT (BFK), 3 AP
(BFK), CP (BFK). Manuel Fuentes.
Recto: BS Verso: D, S, Dat.

2331
Untitled. May 17–Oct 15, 1968. Blue
(A), B: yellow, light red (A)[1]. 50.8 ×
22.9, cut. Ed 20 (wN), 9 TI (nN), BAT
(wN), 2 AP (1 wN, 1 nN), 1 TP* (nN), 3
CTP (2 wN, 1 nN). Manuel Fuentes.
Verso: S, Dat, BS, D.

1. Same plate as run 1.

2349
Thy Womb, Sophos I. May 26, 1968.
Violet-silver (S), blue-silver (S). 65.4 ×
87.0. Ed 16 (CD), 9 TI (GEP), BAT (CD),
2 AP (GEP). Manuel Fuentes. D, T, BS,
S, Dat.

2349II
Thy Womb, Sophos II. Jun 1–9,
1968. Violet-silver (S)[1], blue-silver
(S)[2]. 63.5 × 86.4. Ed 13 (BFK), 9 TI (2
BFK, 7 MI), BAT (BFK). Manuel
Fuentes. D, T, BS, S, Dat.

1. Stone held from 2349, run 1.
2. Stone held from 2349, run 2; partial
 reversal. 2349II differs from 2349 in
 image. A rectangular area in the
 center has been reversed, negative
 areas appear as positive areas.

2372
Don Ellis-Indian Lady. Jun 22–Jul 3,
1968. Violet-silver (A), blue-silver (S).
67.3 × 92.7. Ed 20 (MI), 9 TI (GEP),
BAT (MI), 3 AP (1 GEP, 2 MI), 2 TP
(MI)[1], CP (EVB). Manuel Fuentes. D,
BS, T, S, Dat.

1. 1 TP varies from the edition.

2394
La Famille Tuyau de Poêle. Jul 4–
31, 1968. Light silver (A), silver (S),
orange-silver (A). 66.4 × 91.8. Ed 12
(MI), 9 TI (MI), BAT (MI), 3 AP (MI)[1], 2
CTP (MI). Manuel Fuentes. D, T, BS, S,
Dat.

1. 1 TP varies from the edition.

2399
Baby-San. Sep 20–Oct 9, 1968. Yellow
(A)[1], blue (A)[2], light red (A)[3]. 65.4
× 65.4 (diameter), cut. Ed 20 (MI), 9
TI (MI), BAT (MI), 2 AP (MI), 1 TP
(MI)[4], 5 CTP (MI)[5]. Manuel Fuentes.
Verso: D, T, WS (Tam), S, Dat, WS (pr).

1. Same plate as 2331, run 2.
2. Same plate as run 1, printed 2.5
 clockwise.
3. Same plate as run 2, printed 2.5
 clockwise. 2399 differs from 2331 in

image and presentation. The image is denser and the colors are applied in discreet areas rather than as a blend. 2399 is a circle.

4. TP is an octagon.
5. 1 CTP is a rectangle, three are octagons, and one is a circle.

2414
Thy Eye, Sophos. Aug 9–12, 1968. Silver (A), blue-silver (S). 66.0 × 91.4. Ed 20 (MI), 9 TI (MI), BAT (MI), 3 AP (MI), 2 TP (MI)[1], 1 CTP (MI), CP (MI). Manuel Fuentes. D, T, BS, S, Dat.

1. 1 TP varies from the edition.

2424
Tripper. Oct 17–20, 1968. Blue (S), yellow (S)[1], light red (S)[1]. 59.4 × 85.1, cut. Ed 20 (GEP), 9 TI (CD), BAT (GEP), 3 AP (GEP), 2 TP* (GEP)[2]. Manuel Fuentes. Verso: D, T, WS, S, Dat.

1. Same stone used for runs 1, 2 and 3. Registration moved 1.9 to right for each run.
2. 1 TP is a circle, 61.6 diameter, cut.

2470
Three Maries. Oct 25–Nov 16, 1968. Light yellow (S)[1], light grey (A)[2], light blue (A)[2], light red (A)[2]. 63.5 × 87.0, cut. Ed 20 (MI), 9 TI (GEP), BAT (MI), 2 AP (GEP), 4 TP* (MI), 2 CTP (MI). Manuel Fuentes. Verso: D, T, WS, S, Dat.

1. Stone held from 2424.
2. Same plate used for run 2, 3 and
4. Registration moved 2.5 horizontally for each run. 2470 differs from 2424 in color, image and size. The overall image is lighter. The dominant spots are darker. The over-all rectilinear grid of light lines has been eliminated.

Robert Gardner

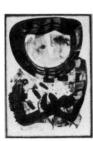

918
Fantasy I. Nov 9, 1963. Black (S)[1]. 54.6 × 35.6. Ed 20 (BFK), 9 TI (wA), CP (BFK). Robert Gardner. T, D, BS, S, Dat.

1. Stone was counter etched and drawing added five times. Artist retained impressions of the five states on proofing paper.

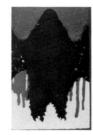

960
Black Angel. Dec 15, 1963–Jan 5, 1964 Red (Z), black (Z). 56.5 × 35.9. Ed 20 (BFK), 9 TI (wA), BAT (BFK)[1]. Robert Gardner. T, D, BS, S, Dat.

1. A few trial (no more than 2) and artist's (no more than 3) proofs exist, details not recorded.

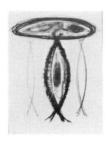

1047
Mother and Sons. Mar 25–27, 1964. Black (Z). 76.2 × 56.5. Ed 10 (BFK), 9 TI (wA), BAT (BFK), 3 AP (2 wA, 1 BFK), 2 TP (BFK). Robert Gardner. T, D, BS, S, Dat.

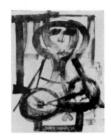

1065
Bust of a Woman. Apr 9–11, 1964. Black (Z). 76.2 × 56.2. Ed 10 (BFK), 9 TI (wA), BAT (BFK), 1 AP (BFK), 2 TP (BFK). Robert Gardner. T, D, BS, S, Dat.

1066
Self-Portrait as a Youth. Apr 12, 1964. Black (Z). 76.2 × 56.8. Ed 10 (BFK), 9 TI (wA), BAT (BFK), 2 AP (BFK), 2 TP (BFK). Robert Gardner. T, D, BS, S, Dat.

1080
Back of a Woman. Apr 18–25, 1964. Black (Z). 53.7 × 66.0. Ed 10 (BFK), 9 TI (wA), BAT (BFK), 2 AP (wA), 2 TP (BFK). Robert Gardner. T, D, BS, S, Dat.

1081
Young Girl. Apr 26–May 3, 1964. Black (S). 56.5 × 38.1. Ed 12 (BFK), 9 TI (wA), BAT (BFK), 2 AP (wA), 3 TP (BFK). Robert Gardner. T, D, BS, S, Dat.

Winifred Gaul

566
Homage to Los Angeles. Apr 26–27, 1962. Black (S). 68.6 × 53.3. Ed 20 (BFK), 9 TI (wA), PrP (BFK), 2 AP (1 BFK, 1 wA), 4 PP (BFK), 3 TP (2 BFK, 1 wA), CP (BFK). Irwin Hollander. D, BS, S.

Sonia Gechtoff

6 Icons, a suite of eight lithographs including title and colophon pages, enclosed in a blue cloth covered box, measuring 40.6 × 48.2, lined with white cover paper, made by the Schuberth Bookbindery, San Francisco. In order: 864, 842, 848, 850, 847, 843, 852, 867.

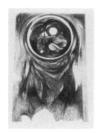

839
Untitled. Jul 1–3, 1963. Black (S). 59.7 × 40.6. Ed 20 (BFK), 9 TI (wA), PrP (BFK), 2 AP (wA), 2 TP (BFK), CP (BFK). Jason Leese. D, S, Dat, BS.

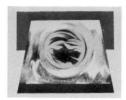

842
Icon I (6 Icons II). Jul 2–29, 1963. Yellow (Z), violet (Z), red (Z), black (S). 38.1 × 45.7. Ed 20 (BFK), 9 TI (wA), PrP (BFK), PrP II for Irwin Hollander (BFK), 3 AP (1 BFK, 2 wA), 3 PP (wA), 2 TP (BFK), CP (BFK). John Dowell. D, BS, S, Dat.

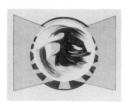

843
Icon V (6 Icons VI). Jul 10–Aug 8, 1963. Light blue (Z), ochre (S), black (S). 39.5 × 46.1. Ed 20 (BFK), 9 TI (wA), PrP (BFK), PrP II for Irwin Hollander(BFK), 3 AP (2 BFK, 1 wA), 1 PP (wA). Kenneth Tyler. D, T, BS, S, Dat.

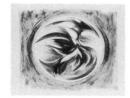

847
Icon IV (6 Icons V). Jul 16–19, 1963. Grey-green (S), black (S). 38.1 × 45.7. Ed 20 (BFK), 9 TI (wA), PrP (BFK), PrP II for Irwin Hollander (BFK), 2 AP (BFK), CP (BFK). Kenneth Tyler. D, T, S, Dat, BS.

848
Icon II (6 Icons III). Jul 17–25, 1963. Dark blue (S), black (S). 38.1 × 45.7. Ed 20 (BFK), 9 TI (wA), PrP (BFK), PrP II for Irwin Hollander (BFK), 2 AP (wA), 3 TP (2 BFK, 1 wA). John Dowell. D, T, BS, S, Dat.

850
Icon III (6 Icons IV). Jul 17–Aug 1, 1963. Beige (S), brown (S), black (S). 38.1 × 45.7. Ed 20 (BFK), 9 TI (wA), PrP (BFK), PrP II for Irwin Hollander (wA), 3 AP (1 BFK, 2 wA), CP (BFK). Kenneth Tyler. D, T, BS, S, Dat.

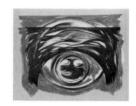

852
Icon VI (6 Icons VII). Jul 22–Aug 26, 1963. Pink (S), red (S), black (S). 38.1 × 46.4. Ed 20 (BFK), 9 TI (wA), PrP (BFK), PrP II for Irwin Hollander (BFK). John Dowell. D, T, BS, S, Dat.

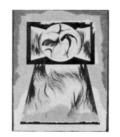

858
Untitled. Aug 2–27, 1963. Light blue (Z), pink (Z), blue-black (S). 77.2 × 57.2. Ed 20 (bA), 9 TI (nN), PrP (bA), 3 AP (nN), 4 TP (bA), CP (BFK). Kenneth Tyler. D, BS, S, Dat.

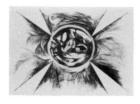

863
Untitled. Aug 9–16, 1963. Black (Z). 57.2 × 76.8. Ed 20 (BFK), 9 TI (wN), PrP (BFK), 3 AP (1 BFK, 2 wN), 1 PP (wN), 1 TP (BFK), CP (BFK). Kenneth Tyler. D, BS, S, Dat.

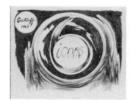

864
Title Page (6 Icons I). Aug 9–19, 1963. Red-violet (Z), blue (Z), black (S). 37.5 × 46.4. Ed 20 (BFK), 9 TI (wA), PrP (BFK), PrP II for Irwin Hollander (BFK), 3 AP (BFK), 1 TP (BFK), CP (BFK). Kenneth Tyler. D, BS, S, Dat.

867
Colophon (6 Icons VIII). Aug 13–26, 1963. Yellow (S), blue-black (S)[1]. 38.1 × 46.1. Ed 20 (BFK), 9 TI (wA), PrP (BFK), PrP II for Irwin Hollander (BFK), 3 AP (BFK), 2 TP (BFK), CP (BFK). Kenneth Tyler. D, BS, S, Dat.

1. Stone held from 848, run 2; additions, deletions. 867 differs from 848 in color and in image. Shading around the circle,

background tone and line border have been eliminated. A wider crayon border and writing underneath the circle have been added.

869
Untitled. Aug 15–22, 1963. Black (Z). 61.3 × 57.2. Ed 20 (BFK), 9 TI (wN), PrP (BFK), PrP II for Irwin Hollander (BFK), 3 AP (1 BFK, 2 wN), 1 PP (BFK), 2 TP (1 BFK, 1 wN), CP (BFK). John Dowell. D, BS, S, Dat.

872
Untitled. Aug 21–22, 1963. Black (S). 61.3 × 56.2. Ed 20 (BFK), 9 TI (wA), PrP (BFK), PrP II for Irwin Hollander (BFK), 3 AP (2 BFK, 1 wA), CP (BFK). Kenneth Tyler. D, BS, S, Dat.

873
Untitled. Aug 23–26, 1963. Black (S). 33.4 × 26.4. Ed 20 (BFK), 9 TI (wA), PrP (BFK), PrP II for Irwin Hollander (BFK), 3 AP (1 BFK, 2 wA), 2 TP (BFK), CP (BFK). Jason Leese. D, BS, S, Dat.

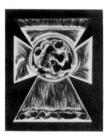

874
Untitled. Aug 23–27, 1963. Black (S). 33.0 × 26.0. Ed 20 (BFK), 9 TI (wA), PrP (BFK), PrP II for Irwin Hollander (BFK)[1], 2 AP (BFK), 2 TP (BFK), CP (BFK). John Dowell. D, BS, S, Dat.

1. Inscribed "artist's proof".

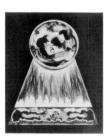

877
Untitled. Aug 27–28, 1963. Black (S). 33.0 × 26.4. Ed 20 (BFK), 9 TI (wA), PrP (BFK), PrP II for Irwin Hollander (BFK), 3 AP (1 BFK, 2 wA), 2 TP (BFK), CP (BFK). John Dowell. D, BS, S, Dat.

Gego

Lines, a book of twelve pages, six printed on recto and verso, plus title page, colophon and two pages of end papers. Poem by Amy Baker, bound in boards, measuring 19.7 × 41.3, covered in white Nacre, oriental-stab binding finished in red silk buttonhole twist, made by Margaret Lecky, Los Angeles. The title page and colophon handwritten in red ink by the artist. In order: 1848, 1848A.

Untitled, a continuous four part folding lithograph tipped into a three-part wrap-around binding, measuring 19.1 × 19.7, covered in grey silk, lined with white Nacre paper and secured with grey grosgrain ribbon, made by Margaret Lecky, Los Angeles. The lithograph was designed to be exhibited standing similar to a Japanese folding screen. In order: 1843.

5 X Gego, a suite of five lithographs, enclosed in a wrap-around folder of white coverstock and transparent mylar with cut edges, measuring 27.9 × 27.9. The following have been silk-screened in brown on the mylar: the suite title on the front cover; the initials of the Museo de Bellas Artes de Caracas, the suite, title and description on the inside flaps; and "Edition Auspiciado por el Museo de Bellas Artes de Caracas, Venezuela, 1967" on the back cover. Untitled lithograph (Tamarind #1896) is intended to be placed between the mylar and coverstock on the front cover. In order: 1896, 1854, 1855, 1856, 1857.

961
Untitled. Dec 17, 1963. Black (Z). 45.7 × 38.1. Ed 20 (BFK), 9 TI (wA), BAT (BFK), 3 AP (BFK), 3 PP (BFK), 2 TP (BFK), CP (BFK). John Dowell. D, S, Dat, BS.

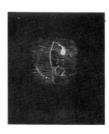

963
Untitled. Dec 18, 1963. Dark blue (Z). 45.7 × 38.1. Ed 20 (BFK), 9 TI (wA), BAT (BFK), 3 AP (2 BFK, 1 wA), 2 TP (BFK), CP (wA). Robert Gardner. D, S, Dat.

1843
Untitled. Nov 1–21, 1966. Yellow (Z), white (S), grey (Z). 19.1 × 221.0. Ed 20 (JG), 9 TI (wN), BAT (JG), 3 AP (2 wN, 1 JG), 1 PP (JG)[1], 4 TP (JG)[2], 5 CTP (1 MI[1], 1 CD[1], 1 BFK[1], 1 JG[1], 1 wN), 4 PTP (1 MI, 1 BFK, 1 wA, 1 bA). Clifford Smith. D, S, Dat, BS.

1. Untorn.
2. 2 TP untorn.

1843II
Untitled. Nov 4–Dec 27, 1966. Pink (S)[1], red (S)[2]. 47.3 × 26.4. Ed 20 (MI), 9 TI (wA), BAT (MI), 1 AP (wA), 1 TP* (MI), 2 CSP (MI), CP (MI)[3]. Fred Genis. D, S, Dat, BS.

1. Stone held from 1843V.
2. Same stone as run 1, registration moved 1.3 cm. 1843II differs from 1843V in color, image and size. 1843III is the lower right eighth of 1843V.
3. Printed on same sheet with 1843II and 1843IV, untorn.

1843III
Untitled. Nov 4–Dec 27, 1966. Pink (S)[1], red (S)[2]. 47.3 × 31.8. Ed 20 (MI), 9 TI (wA), BAT (MI), 1 AP (wA), 1 TP* (MI), 2 CSP (MI), CP (MI). Fred Genis. D, S, Dat, BS.

1. Stone held from 1843V.
2. Same stone as run 1, registration moved slightly. 1843III differs from 1843V in color, image and size. 1843III is the upper left eighth of 1843V turned 90 degrees.

1843IV
Untitled. Nov 4–Dec 27, 1966. Pink (S)[1], red (S)[2]. 47.0 × 32.1. Ed 20 (MI), 9 TI (wA), BAT (MI), 1 AP (wA), 2 TP (1 MI*, 1 BFK[3]), 2 CSP (MI), CP (MI)[4]. Fred Genis. BS, D, S, Dat.

1. Stone held from 1843V.
2. Same stone as run 1, registraiton moved 1.3 cm. 1843IV differs from 1843V in color, image and size. 1843IV is the bottom left quarter of 1843V.
3. 1 TP on paper 38.1 × 27.9.
4. Printed on same sheet with 1843II and 1843IV, untorn.

1843V
Untitled. Nov 17, 1966. Black (S)[1]. 76.2 × 55.9. Ed 10 (MI), 9 TI (wN), BAT (MI), 2 AP (1 wN, 1 MI). Clifford Smith. D, S, BS.

1. Stone held from 1843, run 2. 1843V differs from 1843 in color, image, size and in presentation as a vertical. The darker horizontal shapes have been eliminated. 1843V combines all four secitons of the light linear drawing.

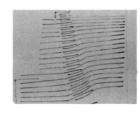

1844
Untitled. Nov 2–10, 1966. Brown (A). 35.9 × 46.4. Ed 20 (GEP), 9 TI (wN), BAT (GEP), 2 AP (1 wN, 1 GEP), 2 TP (GEP), CP (EVB). Robert Evermon. BS, S, Dat, D.

1845
Untitled. Nov 3–22, 1966. Red (Z), black (Z). 56.5 × 56.5. Ed 20 (CD), 9 TI (wN), BAT (CD), 3 AP (wN), 3 TP (CD)[1]. Clifford Smith. BS, D, S, Dat.

1. 2 TP vary from the edition.

1845II
Untitled. Nov 28–Dec 2, 1966. Black (S)[1]. 56.5 × 56.5. Ed 20 (MI), 9 TI (wN), BAT (MI), 1 AP (wN), 2 TP (MI), CP (EVB). Clifford Smith. Recto: D, S, Dat Verso: WS.

1. Image from 1845, run 2 transferred to stone; reversal. 1845II differs from 1845 in color and in image.

Print not in
University Art Museum
Archive

1846
Untitled. Nov 11–Dec 2, 1966. Black (Z). 55.9 × 56.2. 4 TP (MI)[1], 1 proof (MI)[2]. Ernest De Soto. BS, S, Dat, D.

1. Designated in Arabic numerals. 1 TP retained by Tamarind.
2. Designated "deterioration." Unsigned and unchopped, retained by Tamarind.

1846
Untitled. Dec 5–6, 1966. Black (S)[1]. 56.5 × 56.2. Ed 20 (MI), 9 TI (wN), BAT (MI), 1 AP (wN), CP (EVB). Ernest de Soto. BS, D, S, Dat.

1. Stone held from 1846; deletions. 1846II differs from 1846 in image. Lines have been eliminated in the upper half of the image defining circular shapes.

1847
Untitled. Nov 11–Dec 9, 1966. Light brown (Z), white (Z). 56.2 × 56.2. Ed 20 (bA), 9 TI (nN), BAT (bA), 2 AP (nN), 3 TP (bA), CP (EVB). Ernest de Soto. Recto: BS Verso: D, S, WS.

1848
Lines II, III, VI, VII, X, XI. Nov 28–Dec 21, 1966. Red (S). 19.7 × 40.6. Ed 20 (MI), 9 TI (wN), BAT (MI), 3 AP (2 wN, 1 MI), 3 TP (MI), 2 proofs* (EVB)[1], CP (EVB)[2]. Maurice Sanchez.

1. Unsigned, unchopped, undesignated.
2. Untorn.

1848
Untitled. Dec 12–14, 1966. Black (S).
81.6 × 58.8. Ed 10 (GEP), 9 TI (wN),
BAT (GEP), 3 AP (1 GEP, 2 wN), 2 TP
(BFK). Maurice Sanchez. D, S, Dat, BS.

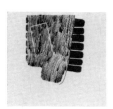

1849
Untitled. Dec 1–2, 1966. Blue-black
(S). 56.2 × 56.5. Ed 20 (MI), 9 TI (wN),
BAT (MI), 3 AP (2 MI, 1 wN), 2 TP (MI).
Maurice Sanchez. D, S, Dat, BS.

1849II
Untitled. Dec 2–5, 1966. White (S)[1].
56.2 × 56.8. Ed 20 (wA), 9 TI (wN),
BAT (wA), 3 AP (1 wA, 2 wN), 2 TP
(wA), CP (EVB). Maurice Sanchez.
Recto: BS Verso: WS, D, S, Dat.

1. Stone held from 1849. 1849II differs
 from 1849 in color only.

Print not in
University Art Museum
Archive

1850
Untitled. Nov 15–Dec 6, 1966. Black
(Z). 55.9 × 55.9. 8 TP (5 EVB[1], 3
wA[2]). Maurice Sanchez. D, S, Dat,
BS.

1. 2 TP retained by Tamarind.
2. 1 TP (wA) designated "trial proof
 deterioration."

1848
Lines I, IV, V, VIII, IX, XII. Nov 28–
Dec 21, 1966. Light green-grey (S)[1].
19.7 × 40.6. Ed 20 (MI), 9 TI (wN), BAT
(MI), 3 AP (2 wN, 1 MI), 3 TP (MI), 4
CTP (3 MI, 1 wN)[2], CP (EVB)[2].
Maurice Sanchez. D, S, Dat (XII), D, S,
Dat, BS (colophon).

1. Stone held from 1848B. 1848A
 differs from 1848B in color, size and
 in presentation as three horizontal
 sheets.
2. Untorn.

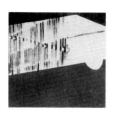

1851
Untitled. Nov 16–Dec 12, 1966. Dark
violet (Z), black (S). 51.4 × 51.4. Ed 20
(GEP), 9 TI (wN), BAT (GEP), 3 AP
(GEP), 3 TP (GEP)[1], CP (GEP).
Maurice Sanchez. BS (bottom), D, S,
Dat (center).

1. 1 TP on paper 52.1 × 66.0 varies
 from the edition.

1852
Untitled. Dec 2–7, 1966. Black (Z).
56.2 × 56.5. Ed 20 (GEP), 9 TI (wN),
BAT (GEP), 1 AP (wN), CP (EVB).
Ernest de Soto. BS, D, S, Dat.

1853
Untitled. Dec 8–12, 1966. Black (S). 56.2 × 56.2. Ed 20 (BFK), 9 TI (CD), BAT (BFK), 3 AP (wN), 2 TP (BFK). Ernest de Soto. S, Dat, D, BS.

1853II
Untitled. Dec 12, 1966. Dark grey (S), blue-black (S)[1]. 56.2 × 56.2. Ed 20 (GEP), 9 TI (CD), BAT (GEP), 2 AP (CD), 1 TP (GEP), 2 CSP (GEP). Ernest de Soto. Verso: D, S, Dat, WS.

1. Stone held from 1853; reversal, additions. 1853II differs from 1853 in color and in image. 1853II reversal image has been turned 180 degrees. A narrow vertical strip of lines has been eliminated. A streaked pattern has been added in the major central area of the image.

1853III
Untitled. Dec 20–22, 1966. Light yellow (S)[1], dark yellow (S)[2]. 56.2 × 56.2. Ed 10 (GEP), 9 TI (CD), BAT (GEP), 3 AP (GEP), 1 TP (GEP), 2 CSP (GEP), CP (CD). Ernest de Soto. Verso: D, S, Dat, WS.

1. Stone held fromm 1853II, run 1.
2. Stone held from 1853II, run 2. 1853III differs from 1853II in color only.

1854
Untitled (Suite 5X, II). Dec 6–12, 1966. Black (S). 27.9 × 27.9, cut. Ed 20 (GEP), 9 TI (CD), BAT (GEP), 2 AP (1 GEP, 1 CD), 2 TP (GEP), CP (GEP)[1]. Maurice Sanchez. Recto: D, S, Dat Verso: WS.

1. Printed on same sheet with 1855–1857, uncut.

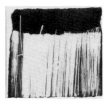

1855
Untitled (Suite 5X, III). Dec 6–12, 1966. Black (S). 27.9 × 27.9, cut. Ed 20 (GEP), 9 TI (CD), BAT (GEP), 1 TP (GEP), CP (GEP)[1]. Maurice Sanchez. Recto: D, S, Dat Verso: WS.

1. Printed on same sheet with 1854, 1856–1857, uncut.

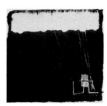

1856
Untitled (Suite 5X, IV). Dec 6–12, 1966. Black (S). 27.9 × 27.9, cut. Ed 20 (GEP), 9 TI (CD), BAT (GEP), 1 AP (CD), 2 TP (GEP), CP (GEP)[1]. Maurice Sanchez. Recto: D, S, Dat Verso: WS.

1. Printed on same sheet with 1854–1855, 1857, uncut.

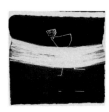

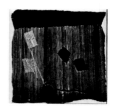

1857
Untitled (Suite 5X, V). Dec 6–12, 1966. Black (S). 27.9 × 27.9, cut. Ed 20 (GEP), 9 TI (CD), BAT (GEP), 3 AP (2 GEP, 1 CD), 2 TP (GEP), CP (GEP)[1]. Maurice Sanchez. Recto: D, S, Dat Verso: WS.

1. Printed on same sheet with 1854–1856, uncut.

1893
Untitled. Dec 12–20, 1966. Black (S). 27.9 × 27.9, cut. Ed 20 (BFK), 9 TI (wN), BAT (BFK), 3 AP (2 BFK, 1 wN)[1], 2 TP (BFK), CP (BFK)[1]. Maurice Sanchez. Recto: D, S, Dat Verso: WS.

1. Printed on same sheet with 1894–1898, uncut.

1894
Untitled. Dec 12–20, 1966. Black (S). 27.9 × 27.9, cut. Ed 20 (BFK), 9 TI (wN), BAT (BFK), 3 AP (2 BFK, 1 wN)[1], 2 TP (BFK), CP (BFK)[1]. Maurice Sanchez. Recto: D, S, Dat Verso: WS.

1. Printed on same sheet with 1893, 1895–1898, uncut.

1895
Untitled. Dec 12–20, 1966. Black (S). 27.9 × 27.9, cut. Ed 20 (BFK), 9 TI (wN), BAT (BFK), 3 AP (2 BFK, 1 wN)[1], 1 TP (BFK), CP (BFK)[1]. Maurice Sanchez. Recto: D, S, Dat Verso: WS.

1. Printed on same sheet with 1893–1894, 1896–1897, uncut.

1896
Untitled (Suite 5X, I). Dec 12–20, 1966. Black (S). 27.9 × 27.9, cut. Ed 20 (BFK), 9 TI (wN), BAT (BFK), 3 AP (2 BFK, 1 wN)[1], 1 TP (BFK), CP (BFK)[1]. Maurice Sanchez. Recto: D, S, Dat Verso: WS.

1. Printed on same sheet with 1893–1895, 1897–1898, uncut.

1897/1898
Untitled. Dec 12–20, 1966. Black (S). 33.4 × 63.2, cut and deckle. Ed 20 (BFK), 9 TI (wN), BAT (BFK), 3 AP (2 BFK, 1 wN)[2], 1 TP (BFK), CP (BFK)[2]. Maurice Sanchez, NC. D, S, Dat.

1. 1897 and 1898 printed on the same sheet, uncut. When folded, it is used as a soft chemise enclosing 1893–1895.
2. Printed on same sheet with 1893–1896, uncut.

James Gill

1372
Untitled. May 28–Jun 1, 1965.
Brown-black (S). 66.0 × 45.7. Ed 20
(BFK), 9 TI (BFK), BAT (BFK), 2 TP
(BFK). Kenneth Tyler. D, S, Dat, BS.

1373
Untitled. May 28–Jun 1, 1965.
Brown-black (S). 66.0 × 50.8. Ed 20
(BFK), 9 TI (BFK), BAT (BFK), 1 AP
(BFK), 3 TP (BFK)[1]. Kenneth Tyler. D,
S, Dat, BS.

1. 1 TP varies from the edition.

1375
Untitled. May 28–Jun 1, 1965.
Brown-black (S)[1]. 60.3 × 85.7. Ed 10
(BFK), 9 TI (BFK), BAT (BFK), PrP II for
Bernard Bleha (BFK), 2 TP (BFK), CP
(Tcs). Kenneth Tyler. D, BS, S, Dat.

1. Images from 1372 and 1373
 transferred to stone with additions.
 1375 differs from 1372 and 1373 in
 image and size. 1375 is a
 combination of 1372 and 1373 as
 the right and left sides, respectively.
 Lettering, a face and tone areas
 have been added in a vertical strip
 through the center and along the
 top.

Françoise Gilot

2619
Lions and Butterflies. May 7–9,
1969. Black (S). 55.9 × 76.2. Ed 20
(GEP), 9 TI (CD), BAT (GEP), 4 AP (3
GEP, 1 CD), 1 TP (GEP), CP (CD). Jean
Milant. D, BS, S.

2620
The Goddess and the Owl. May 6–
7, 1969. Black (S). 56.8 × 76.5. Ed 20
(10 bA, 10 CD), 9 TI (bA), BAT (bA), 5
AP (3 bA, 2 CD), CP (bA). Serge
Lozingot. BS, D, S.

Ronald Glassman

Dreams, Love and Death, a suite of
eleven lithographs including title,
colophon pages and suite folder. In
order: 2668, 2667, 2641II, 2641III, 2554,
2554II, 2662, 2663, 2664, 2545, 2545II,
2552, 2570, 2570II.

2545
***Untitled (Dreams, Love and Death
X).*** Jan 13–25, 1969. Black (S). 57.2 ×
45.4. Ed 16 (JG), 9 TI (wA), BAT (JG), 2
AP (wA). Ronald Glassman. BS (Tam),
D, S, BS (pr).

2545II
***Untitled (Dreams, Love and Death
XI).*** Jan 13–Feb 9, 1969. Blue-green
(S)[1], orange (S)[2]. 57.5 × 45.4. Ed
15 (CD), 9 TI (GEP), BAT (GEP), 1 AP
(CD), 3 TP* (2 GEP, 1 CD). Ronald
Glassman. BS (Tam), D, S, BS (pr).

1. Stone held from 2545.
2. Same stone as run 1; partial
 reversal, deletions. 2545II differs
 from 2545 in color and in image. A
 mottled texture area at the upper
 right has been filled in. Some areas
 on the lower right, center and left
 have been filled in.

2552
Untitled. Mar 6–8, 1969. Black (A).
61.3 × 86.4. Ed 10 (MI), 9 TI (MI), BAT
(MI), CP (JG). Ronald Glassman. BS,
D, S.

2554
***Untitled (Dreams, Love and Death
V).*** Mar 20–May 4, 1969. Yellow (S),
pink (S). 57.2 × 45.1. Ed 14 (GEP), 9 TI
(wA), BAT (wA), 2 CTP (1 GEP, 1 wA),
CP* (wA). Ronald Glassman. BS
(Tam), D, S, BS (pr).

2554II
***Untitled (Dreams, Love and Death
VI).*** Mar 20–May 4, 1969. Pink (S)[1].
57.2 × 45.4. Ed 14 (wA), 9 TI (MI), BAT
(MI), 2 AP (MI), 2 TP* (wA), CP (wA).
Ronald Glassman. BS (Tam), D, S, BS
(pr).

1. Stone held from 2554, run 2. 2554II
 differs from 2554 in color and in
 image. The light areas have been
 opened up completely.

2570
***With John's Family and Chuck's
Family.*** Dec 1, 1968–Feb 16, 1969.
Black (A). 61.0 × 86.4. Ed 15 (cR), 9 TI
(cR), BAT (cR). Ronald Glassman. D, S,
BS.

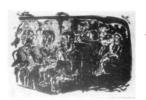

2570II
***Riding through the Mountains
with John's Family and
Chuck's Family.*** Feb 15–23, 1969.
Blue (A)[1]. 61.3 × 86.4. Ed 10 (CD), 9
TI (CD), BAT (CD), CP (CD). Ronald
Glassman. D, S, BS.

1. Stone held from 2570. 2570II differs
 from 2570 in color only.

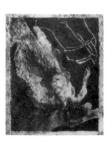

2641II
***Untitled (Dreams, Love and Death
III).*** May 3–31, 1969. Violet (S)[1],
black (S)[2]. 57.2 × 45.4. Ed 10 (bA), 9
TI (wA), BAT (bA), 2 AP (wA), 1 TP
(wA), 1 CTP (wA), CP (bA). Ronald
Glassman. Verso: D, S, WS.

1. Stone held from 2641, which was
 abandoned.
2. Same stone as run 1; reversal,
 additions. Printed slightly off
 register to the right.

2641III
***Untitled (Dreams, Love and Death
IV).*** May 3–31, 1969. Orange (S)[1].
57.2 × 45.1. Ed 13 (wA), 9 TI (CD),
BAT (CD), 3 AP (2 CD, 1 wA), 1 TP
(wA). Ronald Glassman. Verso: D, S,
WS.

1. Same stone as 2641II, run 2. 2641III
 differs from 2641II in color and in
 image. The over-all image is lighter.
 The inner rectangular solid tone has
 been eliminated.

2662
***Untitled (Dreams, Love and Death
VIII).*** Jun 5–8, 1969. Green (S). 57.5 ×
45.4. Ed 10 (wA), 9 TI (cR), BAT (wA), 1
AP (cR), CP (bA). Ronald Glassman.
BS, S, D.

2663
***Untitled (Dreams, Love and Death
VIII).*** Jun 5–7, 1969. Red (A). 57.2 ×
45.4. Ed 10 (wA), 9 TI (bA), BAT (wA),
2 AP (1 wA, 1 bA), CP (bA). Ronald
Glassman. S, D, BS.

Print not in
University Art Museum
Archive

2664
***Untitled (Dreams, Love and Death
IX).*** Jun 5–7, 1969. Pink (A). 57.2 ×
45.4. Ed 10 (bA), 9 TI (wA), BAT (wA),
2 AP (1 wA, 1 bA), CP (bA). Ronald
Glassman. S, D, BS.

2667
***Title Page and Colophon (Dreams,
Love and Death II).*** Jun 6–15, 1969.
Blue (Z). 57.2 × 90.5. Ed 10 (CD), 9 TI
(cR), BAT (CD), 3 AP (1 cR, 2 CD), CP
(newsprint)[1]. Ronald Glassman. BS,
S, D.

1. Destroyed.

2668
***Suite folder (Dreams, Love and
Death I).*** Jun 6–14, 1969. Orange (A).
74.9 × 105.7. Ed 10 (cR), 9 TI (ucR),
BAT (cR). Ronald Glassman. Recto: BS
Verso: S, D.

Shirley Goldfarb

2786
Tamarind Yellow. Oct 1–2, 1969.
Yellow (S). 56.2 × 76.2. Ed 20 (MI), 9
TI (BFK), BAT (MI), 2 AP (MI), 1 TP
(MI). Eugene Sturman. Recto: BS
Verso: D, T, S, Dat.

2786II
Is that all there is? Oct 3, 1969.
Light beige (S)[1]. 55.9 × 75.9. Ed 10
(MI), 9 TI (BFK), BAT (MI), 1 AP (BFK),
1 TP (MI), CP (BFK). Eugene Sturman.
Recto: BS Verso: D, S, T.

1. Stone held from 2786. 2786II differs
 from 2786 in color only.

Leon Golub

Agon, a suite of eight lithographs
including title page. Colophon printed
at the Plantin Press, Los Angeles. In
order: 1464, 1410, 1408, 1406, 1415,
1403, 1452, 1405.

1399
Fallen Fighter. Jul 8–14, 1965. Black
(S). 56.5 × 76.2. Ed 20 (BFK), 9 TI
(wA), BAT (BFK), 2 AP (wA), 1 TP (wA).
Kenneth Tyler. D, S, BS.

1407
The Orange Sphinx. Jul 19–30, 1965.
Orange (S), blue-green (A). 56.5 ×
76.2. Ed 14 (11 BFK, 3 wA), 9 TI (wA),
BAT (BFK), 3 AP* (BFK), 3 TP* (BFK),
CP (Tcs). Ernest de Soto. BS, D, S.

1401
Running Man II. Jul 9–19, 1965.
Brown (S). 76.5 × 57.2. Ed 20 (bA), 9
TI (bA), BAT (bA), 2 AP (bA), 2 TP (bA),
CP (Tcs). Kenneth Tyler. BS, D, S.

1408
Fallen Warrior (Agon III). Jul 20–29,
1965. Dark brown (S). 76.5 × 56.8. Ed
20 (bA), 9 TI (bA), BAT (bA), 3 AP (bA),
1 TP (bA), CP (Tcs). Kinji Akagawa. BS,
D, S.

1403
Wounded Warrior (Agon VI). Jul 15–
27, 1965. Light pink (S)[1], blue (S),
transparent red (S), red (S). 57.8 ×
56.8. Ed 20 (BFK), 9 TI (F), BAT (BFK),
3 AP (2 BFK, 1 F), 3 TP (BFK)[2], CP
(Tcs). Clifford Smith. BS, D, S.

1. Stone held from 1399; deletions.
 1403 differs from 1399 in color,
 image and in presentation as a
 vertical. The drawing is different
 except for the head and back of the
 figure.
2. 2 TP vary from the edition.

1409
Niobe. Jul 22–Aug 4, 1965. Orange-
brown (S), black (S), dark green (S).
105.1 × 75.9. Ed 20 (BFK), 9 TI (BFK),
BAT (BFK), 3 AP (BFK), 3 TP (BFK), CP
(Tcs). Bernard Bleha. T, BS, D, S.

1404
Fleeing Man. Jul 16–27, 1965. Red-
orange (S), red-brown (S), light blue
(S). 76.2 × 56.8. Ed 20 (bA), 9 TI (bA),
BAT (bA), 3 AP (bA), CP (Tcs). Clifford
Smith. BS, D, S.

1410
Orator (Agon II). Jul 23–Aug 2, 1965.
Dark green (S), light blue-green (S),
black (S). 57.2 × 76.2. Ed 20 (BFK), 9
TI (wA), BAT (BFK), 3 AP (wA), 4 TP
(BFK), CP (Tcs). Robert Evermon. BS,
D, S.

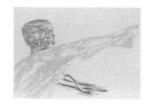

1411
Orator II. Jul 24–Aug 6, 1965. Pink-
orange (S), red (S), grey-violet (S).
56.8 × 76.2. Ed 20 (BFK), 9 TI (wA),
BAT (BFK), 1 AP (wA), 2 TP (1 BFK, 1
wA), CP (Tcs). Clifford Smith. D, BS, S.

1405
The Winged Sphinx (Agon VIII). Jul
16–Aug 2, 1965. Orange (S), light blue
(S), green (S). 56.8 × 76.2. Ed 20
(BFK), 9 TI (wA), BAT (BFK), 3 AP (2
BFK, 1 wA), 4 TP (BFK), CP (Tcs). John
Beckley. D, BS, S.

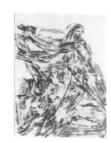

1413
Fleeing Girls. Jul 28–29, 1965. Dark
green (S). 105.1 × 75.6. Ed 20 (BFK), 9
TI (BFK), BAT (BFK), 1 AP (BFK), 2 TP
(BFK)[1], CP (Scs). Clifford Smith. BS,
D, S.

1. 1 TP varies from the edition.

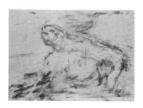

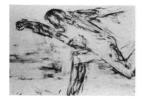

1406
Running Man (Agon IV). Jul 16–20,
1965. Red (S). 56.8 × 76.5. Ed 20 (bA),
9 TI (bA), BAT (bA), 3 AP (bA), 2 TP
(bA), CP (Tcs). Clifford Smith. BS, D, S.

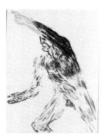

1414
Niobid. Jul 30–Aug 11, 1965. Orange (S), blue-green (S), black (S). 104.8 × 75.9. Ed 20 (BFK), 9 TI (BFK), BAT (BFK), 1 AP (BFK), 3 TP (BFK), CP (Tcs). John Beckley. D, S, BS.

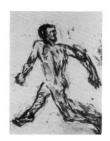

1415
Running Man II (Agon V). Aug 3–7, 1965. Dark green (S). 76.5 × 56.8. Ed 20 (bA), 9 TI (bA), BAT (bA), 2 AP (bA), 2 TP (bA), CP (Tcs). Robert Evermon. D, BS, S.

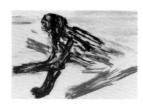

1416
Wounded Sphinx. Aug 16–20, 1965. Blue (S), black (S), red (S). 75.9 × 104.5. Ed 20 (BFK), 9 TI (CD), BAT (BFK), 3 AP (1 BFK, 2 CD), 3 TP (BFK), CP (Tcs). Bernard Bleha. T, D, BS, S.

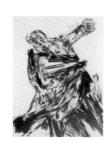

1417
Struggle. Aug 9–13, 1965. Brown (S), black (S). 104.8 × 75.6. Ed 20 (BFK), 9 TI (BFK), BAT (BFK), 1 AP (BFK), 3 PP (BFK), 1 TP* (BFK), CP (Tcs). Bernard Bleha. D, BS, S.

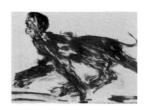

1452
Running Blue Sphinx (Agon VII). Aug 9–14, 1965. Blue (S), violet (S). 56.8 × 76.2. Ed 20 (BFK), 9 TI (wA), BAT (BFK), 3 AP (BFK), 1 TP (BFK), CP (wA). Clifford Smith. BS, D, S.

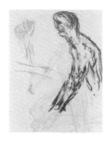

1453
Seated Man. Aug 16–20, 1965. Violet (S), light green (S), brown-orange (S). 76.5 × 56.8. Ed 20 (BFK), 9 TI (wA), BAT (BFK), 3 AP (1 BFK, 2 wA), 3 PP (BFK), CP (Tcs). Jurgen Fischer. Recto: T, D, S Verso: WS .

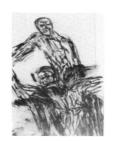

1454
Combat. Aug 18–24, 1965. Black (S). 104.8 × 75.6. Ed 20 (BFK), 9 TI (CD), BAT (BFK), 2 AP (CD), 2 TP (BFK), CP (Tcs). John Rock. T, BS, D, S.

1457
Man and Woman. Aug 14–17, 1965. Dark red (S). 106.4 × 75.7. Ed 20 (BFK), 9 TI (CD), BAT (BFK), 3 AP (2 BFK, 1 CD), 2 TP (BFK), CP (Tcs). Clifford Smith. BS, D, S.

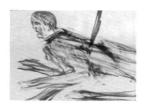

1461
Wounded Sphinx II. Aug 13–23, 1965. Dark blue (S), red (S). 57.2 × 76.5. Ed 20 (BFK), 9 TI (wA), BAT (BFK), 3 AP (1 BFK, 2 wA), 2 TP (1 BFK, 1 wA), CP (Tcs). Clifford Smith. BS, D, S.

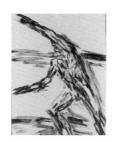

1462
Niobid II. Aug 20–21, 1965. Black (S). 76.5 × 56.8. Ed 20 (bA), 9 TI (wA), BAT (bA), 3 AP (wA), 2 TP (bA), CP (Tcs). Bernard Bleha. BS, D, S.

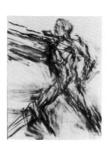

1463
The Fighter. Aug 23–24, 1965. Red-black (S). 76.5 × 56.5. Ed 20 (bA), 9 TI (wA), BAT (bA), 2 AP (wA), 2 TP (bA), CP (Tcs). John Beckley. D, BS, S.

1464
Title Page (Agon I). Aug 24–26, 1965. Pink (S). 76.2 × 56.8. Ed 20 (BFK), 9 TI (wA), BAT (BFK), 3 AP (1 BFK, 2 wA), 2 TP (BFK), CP (Tcs). Robert Evermon. D, BS, S.

John Grillo

Illuminations of Time and Space, a suite of ten lithographs including title and colophon pages, enclosed in a grey-green linen covered portfolio, measuring 38.7 × 53.3, lined with Rives BFK, made by Margaret Lecky, Los Angeles. In order: 1064, 1056, 1049, 1041, 1037, 1073, 1042, 1072, 1038, 1068.

1029
Untitled. Mar 4–Apr 7, 1964. Red (Z), orange (Z), blue-green (Z), dark blue (Z). 48.6 × 66.7. Ed 20 (BFK), 9 TI (wA), BAT (BFK), 3 AP (BFK), 3 PP (BFK), 5 TP (BFK). Thom O'Connor. BS, D, S, Dat.

1034
Untitled. Mar 9–13, 1964. Red (Z), blue (S). 44.8 × 62.6. Ed 20 (BFK), 9 TI (wA), BAT (BFK), 3 AP (1 BFK, 2 wA). Thom O'Connor. BS, D, S, Dat.

1037
Untitled (Illuminations of Time and Space V). Mar 12–Apr 8, 1964. Yellow (S), violet (Z). 53.3 × 38.1. Ed 20 (BFK), 9 TI (wA), BAT (BFK), 2 AP (BFK), 2 TP (1 BFK, 1 wA). Aris Koutroulis. D, S, Dat, BS.

1038
Untitled (Illuminations of Time and Space IX). Mar 12–Apr 1, 1964. Red (S), grey (Z), blue (Z)[1]. 53.0 × 38.7. Ed 20 (BFK), 9 TI (wA), BAT (BFK), 3 AP (2 BFK, 1 wA), 2 TP (BFK). Aris Koutroulis. BS, D, S, Dat.

1. Plate held from 1041, run 2. 1038 differs from 1041 in color and in image. The image is different except for the four rectangular shapes that appear in the four corners and an area of wash along the lower border.

1041
Untitled (Illuminations of Time and Space IV). Mar 16–Apr 1, 1964. Blue (S), grey (Z), dark violet-brown (Z). 53.3 × 38.7. Ed 20 (BFK), 9 TI (wA), BAT (BFK), PrP II for Aris Koutroulis (BFK), 3 AP (1 BFK, 2 wA), 2 TP (1 BFK, 1 wA). Robert Gardner. D, S, Dat, BS.

1042
Untitled (Illuminations of Time and Space VII). Mar 16–Apr 10, 1964. Orange (S), red (Z), grey (Z), green (Z)[1]. 52.7 × 38.1. Ed 20 (BFK), 9 TI (wA), BAT (BFK), PrP II for Robert Gardner (BFK), 2 AP (BFK), 2 PP (BFK), 4 TP (BFK). Aris Koutroulis. BS, S, Dat.

1. Plate held from 1041, run 3. 1042 differs from 1041 in color and in image. The image is different except for the dark portion which has been turned 180 degrees.

1044
Untitled. Mar 17–Apr 16, 1964. Yellow (Z), violet-brown (S). 78.7 × 58.4. Ed 20 (BFK), 9 TI (BFK), BAT (BFK), PrP II (BFK)[1], 3 AP (BFK), 2 TP (BFK). Thom O'Connor. D, S, Dat, BS.

1. Recipient unrecorded.

1049
Untitled (Illuminations of Time and Space III). Mar 20–24, 1964. Orange (S), red (Z). 37.5 × 53.0. Ed 20 (BFK), 9 TI (wA), BAT (BFK), PrP II for Irwin Hollander (BFK), 2 AP (BFK), 1 TP (wA). Aris Koutroulis. D, S, Dat, BS.

1052
Untitled. Mar 30–Apr 3, 1964. Violet (Z). 38.1 × 53.0. Ed 15 (BFK), 9 TI (BFK), BAT (BFK), 1 TP (BFK). Aris Koutroulis. D, S, Dat, BS.

1056
Untitled (Illuminations of Time and Space II). Apr 3–15, 1964. Black (S), violet (S). 38.1 × 53.3. Ed 20 (BFK), 9 TI (wA), BAT (BFK), PrP II for Irwin Hollander (BFK), 3 AP (wA), 2 TP (BFK). Aris Koutroulis. D, S, Dat, BS.

1064
Title Page (Illuminations of Time and Space I). Apr 9–14, 1964. Yellow (S), brown (Z). 37.5 × 53.0. Ed 20 (BFK), 9 TI (wA), BAT (BFK), 2 AP (wA), 2 TP (BFK). Aris Koutroulis. BS, D, S, Dat.

1068
Colophon (Illuminations of Time and Space X). Apr 13–23, 1964. Black (Z), violet (Z). 38.1 × 52.4. Ed 20 (BFK), 9 TI (wA), BAT (BFK), PrP II for Irwin Hollander (BFK), 3 AP (2 BFK, 1 wA), 3 TP (BFK). Aris Koutroulis. BS, D, S, Dat.

1072
Untitled (Illuminations of Time and Space VIII). Apr 16–17, 1964. Dark blue-green (Z). 38.1 × 53.0. Ed 20 (BFK), 9 TI (wA), BAT (BFK), 3 AP (2 BFK, 1 wA), 1 PP (wA), 2 TP (BFK). Aris Koutroulis. BS, D, S, Dat.

1073
Untitled (Illuminations of Time and Space VI). Apr 16–17, 1964. Violet-brown (S)[1]. 37.8 × 52.4. Ed 20 (BFK), 9 TI (wA), BAT (BFK), 3 AP (wA), 2 TP (BFK). Robert Gardner. D, S, Dat, BS.

1. Stone held from 1044, run 2. 1073 differs from 1044 in color, image, size and in presentation as a horizontal. The background tone has been eliminated. The lower third and top edge of the image and the white borders have been eliminated.

1076
Untitled. Apr 17–21, 1964. Black (Z). 42.2 × 56.5. Ed 20 (BFK), 9 TI (wA), BAT (BFK), PrP II (BFK)[1], 2 AP (wA), 2 TP (BFK). Aris Koutroulis. D, S, Dat, BS.

1. Recipient unrecorded.

William Gropper

Unfinished Symphony, a suite of nine lithographs. In order: 1905, 1900, 1901, 1902, 1903, 1904, 1906, 1907, 1924.

The Shtetl, a suite of eight lithographs. In order: 1911, 1912, 1913, 1914, 1915, 1916, 1917, 1918.

Sunset Strip, a suite of five lithographs. In order: 1925, 1926, 1927, 1941, 1942.

1899
Untitled. Jan 4–14, 1967. Orange (A), violet (A), yellow-brown (A), blue-green (S). 46.1 × 36.2. Ed 17 (16 GEP, 1 wA), 9 TI (wA), BAT (GEP), 3 TP* (GEP)[1], 2 CTP (GEP), 8 CSP (GEP)[2], CP (wA). Fred Genis. S, WS, BS, D.

1. 3 TP on paper 45.6 × 71.1 with 1900, untorn. 1 TP unsigned and unchopped, retained by Tamarind.
2. 1 CSP on paper 45.6 × 71.1 with 1900, untorn. 4 CSP retained by Tamarind.

1900
Untitled (Unfinished Symphony II). Jan 4–16, 1967. Yellow-brown (A), violet (A), light yellow (A), blue-green (S), grey (A). 46.1 × 34.9. Ed 20 (18 GEP, 2 wA), 9 TI (wA), BAT (GEP), 3 TP* (GEP)[1], 2 CTP (GEP), 10 CSP (GEP)[2], CP (GEP). Fred Genis. D, S, WS, BS.

1. 3 TP on same sheet with 1899, untorn. 1 TP, unsigned and chopped, retained by Tamarind.
2. 1 CSP on paper 45.7 × 71.1 with 1899. 5 CSP retained by Tamarind.

1901
Untitled (Unfinished Symphony III). Jan 8, 1967. Yellow-grey (S), blue-grey (S), red-brown (S). 46.1 × 35.6. Ed 20 (GEP), 9 TI (wA), BAT (GEP), 2 AP (wA), 4 TP (GEP), CP (wA). Maurice Sanchez. D, S, WS, BS.

1902
Untitled (Unfinished Symphony IV). Jan 8, 1967. Grey (S), blue (S), red-brown (S). 46.1 × 35.6. Ed 20 (GEP), 9 TI (wA), BAT (GEP), 2 AP (wA), 4 TP (GEP), CP (wA). Maurice Sanchez. D, S, BS, WS.

1903
Untitled (Unfinished Symphony V). Jan 5–25, 1967. Brown (S), green (S), pink-orange (Z). 46.1 × 35.6. Ed 20 (GEP), 9 TI (wA), BAT (GEP), 2 AP (wA), 4 TP (GEP), 1 CTP (GEP), CP (wA). Serge Lozingot. S, WS, D, BS.

1904
Untitled (Unfinished Symphony VI). Jan 23–Feb 1, 1967. Blue-grey (A), orange (A), red (S). 46.1 × 35.6. Ed 20 (GEP), 9 TI (wA), BAT (GEP), 1 AP (wA), 2 TP (GEP), 6 PTP (2 AEP, 4 JG)[1], CP (GEP). Fred Genis. S, WS, D, BS.

1. Unsigned, unchopped, undesignated, retained by Tamarind.

1905
Untitled (Unfinished Symphony I).
Jan 24–Feb 1, 1967. Yellow-green (S),
blue-green (S), violet (S). 46.1 × 35.6.
Ed 20 (GEP), 9 TI (wA), BAT (GEP), 2
AP (wA), 4 TP (GEP), 2 CTP (GEP)[1], 3
CSP (EVB), CP (GEP). Maurice
Sanchez. D, S, WS, BS.

1. 1 CTP retained by Tamarind.

1906
*Untitled (Unfinished Symphony
VII).* Feb 1–16, 1967. Violet (A), green
(S), black (S). 45.7 × 35.6. Ed 20
(GEP), 9 TI (wA), BAT (GEP), 3 AP
(wA), 5 TP (GEP)[1], 2 CTP (GEP), 3
CSP (EVB)[2], CP (GEP). Fred Genis. D,
BS, S, WS.

1. 1 TP varies from the edition.
2. Unsigned and unchopped.

1907
*Untitled (Unfinished Symphony
VIII).* Feb 1–28, 1967. Blue (S), green
(S), grey (S), dark blue (A). 46.1 ×
35.6. Ed 20 (GEP), 9 TI (wA), BAT
(GEP), 3 AP (2 GEP, 1 wA), 5 TP (4
GEP, 1 wA), 4 CSP (EVB)[1], CP (GEP).
Fred Genis. BS, D, S.

1. Unsigned and unchopped.

1908
Untitled. Feb 2–9, 1967. Brown (S),
yellow-green (S), transparent grey (A).
46.1 × 35.6. Ed 20 (GEP), 9 TI (wA),
BAT (GEP), 2 AP (1 wA, 1 GEP), 3 CTP
(2 GEP, 1 wA), 3 CSP (EVB), CP (GEP).
Maurice Sanchez. D, S, BS, WS.

1909
Untitled. Jan 5–13, 1967. Violet (A),
brown (S). 31.8 × 25.4. Ed 20 (GEP), 9
TI (wA), BAT (GEP), 3 AP (wA), 2 TP
(GEP, CP (GEP). Serge Lozingot. BS, D,
S.

1910
Untitled. Jan 5–12, 1967. Violet (A).
19.4 × 25.7. Ed 20 (GEP), 9 TI (wA),
BAT (GEP), 3 AP (wA), 2 TP (GEP), 1
CTP (GEP). Serge Lozingot. D, S, BS.

1911
Untitled (The Shtetl I). Jan 16–18,
1967. Red-brown (S). 58.1 × 77.5. Ed
20 (bA), 9 TI (nN), BAT (bA), 2 AP (nN),
2 TP (bA), CP (bA). Fred Genis. D, WS,
S, BS.

1912
Untitled (The Shtetl II). Jan 18–19,
1967. Brown (S). 57.5 × 77.5. Ed 20
(bA), 9 TI (nN), BAT (bA), 2 AP (bA), 2
TP (bA), CP (bA). Maurice Sanchez. S,
WS, BS, D.

1913
Untitled (The Shtetl III). Jan 19–23,
1967. Green-ochre (S). 57.2 × 77.5. Ed
20 (bA), 9 TI (nN), BAT (bA), 3 AP (2
bA, 1 nN), 2 TP (bA), CP (bA). Fred
Genis. S, WS, D, BS.

1914
Untitled (The Shtetl IV). Jan 23–27,
1967. Yellow-grey (A), dark yellow-
green (S). 57.2 × 77.5. Ed 20 (bA), 9 TI
(nN), BAT (bA), 2 TP (bA), CP (bA).
Maurice Sanchez. D, S, BS, WS.

1915
Untitled (The Shtetl V). Jan 25–27,
1967. Grey-brown (S). 57.8 × 77.5. Ed
20 (bA), 9 TI (nN), BAT (bA), 2 AP (1
bA, 1 nN), 2 TP (bA), CP (bA). Serge
Lozingot. D, S, BS, WS.

1916
Untitled (The Shtetl VI). Jan 27–30,
1967. Light pink-brown (S). 57.8 ×
77.5. Ed 20 (bA), 9 TI (nN), BAT (bA), 2
AP (nN), 1 TP (bA), CP (bA). Serge
Lozingot. S, BS, WS, D.

1917
Untitled (The Shtetl VII). Jan 30–31,
1967. Light violet (S). 57.2 × 77.5. Ed
20 (bA), 9 TI (nN), BAT (bA), 3 AP (1
bA, 2 nN), 2 TP (bA), CP (bA). Serge
Lozingot. S, BS, WS, D.

1918
Untitled (The Shtetl VIII). Feb 1, 1967. Blue (S). 57.5 × 76.8. Ed 20 (bA), 9 TI (nN), BAT (bA), 2 AP (nN), 1 TP (bA), CP (bA). Serge Lozingot. D, S, BS, WS.

1918
Untitled. Jan 31, 1967. Black (S)[1]. 57.2 × 76.5. Ed 10 (BFK), 9 TI (wA), BAT (BFK), 2 AP (wA), 2 TP (BFK). Serge Lozingot. D, S, BS, WS.

1. Stone held from 1918. 1918A differs from 1918 in color only.

1919
Untitled. Jan 24–30, 1967. Brown (S). 35.9 × 26.0. Ed 20 (wA), 9 TI (GEP), BAT (wA), 1 AP (wA), 2 TP (wA), CP (GEP). Maurice Sanchez. D, BS, S, WS.

Print not in
University Art Museum
Archive

1920
Untitled. Feb 2–3, 1967. Brown (S). 45.7 × 30.5. 4 proofs (nr)[1]. Maurice Sanchez.

1. Unsigned, unchopped, undesignated, defaced by the artist in pencil.

1921
Untitled. Feb 2–23, 1967. Green-brown, green (S)[1], light violet (Z)[1], yellow-green (S)[1]. 56.2 × 38.4,[2]. Ed 20 (GEP)[2], 9 TI (CD), BAT (GEP)[2], 2 AP (CD), 5 TP (GEP)[2], 7 CSP (3 CD[3], 4 GEP), CP (GEP). Donald Kelley. BS, D, S, WS.

1. Edition exists in two color variations. Variation I in three colors without yellow-green and Variation II in four colors.
2. Impressions in four colors are bleed images.
3. Indicates Variation II, Ed 11–20/20, BAT, 4 TP.
4. Retained by Tamarind.

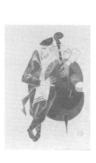

1923
Untitled. Feb 2–23, 1967. Green-brown, green (S)[1], light violet (Z), yellow-green (S)[1]. 56.2 × 38.4. Ed 20 (GEP)[3], 9 TI (CD), BAT (GEP)[3], 2 AP (CD), 5 TP (GEP)[3], 7 CSP (4 CD[4], 3 GEP), CP (GEP). Donald Kelley. BS, D, S, WS.

1. Edition exists in two color variations. Variation I in three colors without yellow-green and Variaiton II in four colors.

2. Impressions with four colors are bleed images.
3. Indicates Variation II, Ed 11–20/20, BAT, 4 TP.
4. Retained by Tamarind.

1924
Untitled (Unfinished Symphony IX). Feb 6–13, 1967. Red (A), black (S). 46.1 × 35.6. Ed 20 (GEP), 9 TI (wA), BAT (GEP), 3 AP (GEP), 2 TP (GEP), 2 CSP (EVB)[1], CP (GEP). Maurice Sanchez. BS, D, S, WS.

1. Unsigned and unchopped.

1925
Untitled (Sunset Strip I). Feb 8–16, 1967. Red-brown (S). 26.0 × 57.2. Ed 20 (bA), 9 TI (nN), BAT (bA), 3 AP (nN)[1], 2 TP (bA)[2], 1 PTP (wA)[3], CP (bA). Anthony Stoeveken. BS.

1. 2 AP on paper 25.4 × 44.4.
2. 1 TP on paper 25.4 × 44.2.
3. 3 PTP on paper 25.4 × 44.2.

1926
Untitled (Sunset Strip II). Feb 8–16, 1967. Red-brown (S). 26.0 × 57.2. Ed 20 (bA), 9 TI (nN), BAT (bA), 1 AP (nN), 2 TP (bA)[1], 1 PTP (wA)[2], CP (bA). Anthony Stoeveken. BS.

1. 1 TP on paper 25.4 × 42.5.
2. 1 PTP on paper 25.4 × 42.5.

1927
Untitled (Sunset Strip III). Feb 8–16, 1967. Red-brown (S). 26.0 × 57.2. Ed 20 (bA), 9 TI (nN), BAT (bA), 1 AP (nN), 2 TP (bA)[1], 1 PTP (wA)[2], CP (bA). Anthony Stoeveken. BS.

1. 1 TP on paper 25.4 × 41.3.
2. 1 PTP on paper 25.4 × 41.9.

1941
Untitled (Sunset Strip IV). Feb 13–17, 1967. Red-brown (S). 26.0 × 56.8. Ed 20 (bA), 9 TI (nN), BAT (bA), 2 AP (nN)[1], 1 TP (bA), CP (bA). John Butke. BS .

1. 1 AP on paper 25.4 × 41.3.

1942
Untitled (Sunset Strip V). Feb 13–17, 1967. Red-brown (S). 26.0 × 57.2. Ed 20 (bA), 9 TI (nN), BAT (bA), 2 AP (nN)[1], 1 TP (bA), CP (bA). John Butke. D, S, BS.

1. 1 AP on paper 25.4 × 43.2.

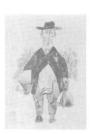

1943
Untitled. Feb 13–23, 1967. Red-brown
(S). 57.2 × 39.1. Ed 20 (bA), 9 TI (nN),
BAT (bA), 2 AP (1 bA, 1 nN), 2 TP (bA),
1 CTP (EVB), CP (bA). Fred Genis. D, S,
BS, WS.

1944
Untitled. Feb 13–23, 1967. Red-brown
(S). 57.2 × 39.4. Ed 20 (bA), 9 TI (nN),
BAT (bA), 2 AP (1 bA, 1 nN), 2 TP (bA),
1 CTP (EVB), CP (bA). Fred Genis. D, S,
BS, WS.

Ronald L. Grow

1301
Mavis' Temple. Apr 1–5, 1965. Black
(S), orange (S), green (S), blue (S),
yellow (S). 37.8 × 38.1. Ed 15 (bA), 9
TI (wA), 1 UNMI (wA), PrP (bA), 3 AP
(bA). John Beckley, NC. BS (Tam), T,
D, S, BS (UNM).

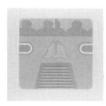

1307
Transcon Floater. Apr 28–May 4,
1965. Blue (S), orange (S), grey (S).
40.6 × 40.6. Ed 15 (bA), 9 TI (wA), 1
UNMI (BFK), PrP (BFK), 2 AP (BFK).
John Beckley, NC. BS (Tam), T, D, S,
BS (UNM).

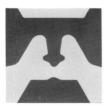

1309
Interlock. May 3–8, 1965. Black (S).
50.8 × 50.8. Ed 15 (BFK), 9 TI (BFK), 1
UNMI (BFK), PrP (BFK), 2 AP (BFK).
Robert Evermon, NC. Recto: BS (Tam,
UNM) Verso: T, D, S.

Philip Guston

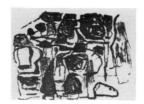

835
Untitled. Jun 20–26, 1963. Black (S).
63.8 × 84.8. Ed 25 (20 BFK, 5 nN[1]), 9
TI (wN), PrP (BFK), PrP II for Irwin
Hollander (BFK), 3 AP (1 BFK, 2 wN),
CP (BFK). John Dowell. D, S, Dat, BS.

1. Numbered in Roman numerals.

836
Untitled. Jun 20–26, 1963. Black (Z).
57.2 × 77.5. Ed 20 (15 BFK, 5 nN[1]), 9
TI (wN), PrP (BFK), PrP II for Irwin
Hollander, 3 AP (1 BFK, 2 wN), 2 TP
(BFK), CP (BFK). Jason Leese. D, BS,
S, Dat.

1. Numbered in Roman numerals.

Edward Hamilton

Print not in
University Art Museum
Archive

2946
*Torn and Deckle Edges, White
Arches.* Jun 29–30, 1970. Yellow-
orange (A). 76.2 × 56.8. Ed 6 (wA), 9
TI (wA), BAT (wA), 3 AP (bA), CP
(newsprint)[1]. Edward Hamilton.
Recto: BS Verso: I, D, T.

1. Destroyed.

P110
Flaming Heart. Aug 25–27, 1969. Red
(Z). 67.6 × 49.9. Ed 8 (GEP)[1], BAT
(GEP). Edward Hamilton. T, D, BS
(pr)[2], S.

1. Ed 1/8 retained by Tamarind.
2. No Tamarind chop.

Robert Hansen

Satan's Saint, by Guy Endore, a *livre
de luxe* consisting of 60 pages
including 20 pages of illustrations, 28
pages of text, title page and colophon,
2 pages of flat color and 8 pages of
end papers, enclosed in a three-part
black linen covered wrapper,
measuring 33.7 × 36.2, lined with
black Moriki paper, and in a red linen
covered slipcase, measuring 34.9 ×
36.8. The slipcase is silk-screened in
red on the front and back leaves and
on the spine with a design by the
artist. The lithographs are enclosed in
a chemise of red Moriki paper. Each
folded page enclosed in a chemise of
white Tableau paper. A slipsheet of
white Tableau paper is placed
between each printed page. The

binding was designed by the artist and made by the Schuberth Bookbindery, San Francisco. In order: 1233, 1233A/1233B, 1231/1231B, 1231A, 1242A, 1242/1242B, 1246, 1246A, 1214A, 1214B/1214, 1259A, 1259, 1251, 1251A/1251B, 1210B/ 1210A, 1210, 1212A, 1212, 1220A, 1220, 1245, 1245B/1245A, 1209A, 1209, 1252A/1252B, 1348.

1139
Man-Men 140. Sep 8–10, 1964. Black (S). 50.8 × 34.9. Ed 20 (BFK), 9 TI (wA), BAT (BFK), PrP II for Kenneth Tyler (BFK), 3 AP (BFK), 2 TP (BFK), CP (BFK). Jeff Ruocco. BS, S, Dat, T, D.

1140
Man-Men 141. Sep 8–11, 1964. Red-black (S). 44.1 × 64.8. Ed 20 (BFK), 9 TI (CW), BAT (BFK), PrP II for Kenneth Tyler (CW), 3 AP (1 BFK, 2 CW), 3 TP (BFK), CP (BFK). Clifford Smith. BS, S, Dat, T, D.

1141
Christ Ascended. Sep 10–21, 1964. Grey-brown (S), brown-black (S). 61.9 × 47.0. Ed 20 (BFK), 9 TI (wA), BAT (BFK), PrP II for Kenneth Tyler (BFK), 3 AP (BFK), 2 TP (BFK). Kaye Dyal. BS, S, Dat, T, D.

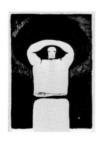

1144
Christ Ascended. Sep 12–14, 1964. Blue-black (S). 48.6 × 33.7. Ed 20 (BFK), 9 TI (CW), BAT (BFK), PrP II for Kenneth Tyler (BFK), 3 AP (BFK), 4 TP (BFK), CP (BFK). Bernard Bleha. BS, S, Dat, D, T.

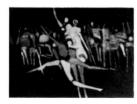

1146
Man-Men 142. Sep 15–17, 1964. Black (S). 31.4 × 43.2. Ed 20 (BFK), 9 TI (wA), BAT (BFK), PrP II for Kenneth Tyler (BFK), 4 AP (3 BFK, 1 wA), 4 TP (BFK). Bernard Bleha. BS, S, Dat, T, D.

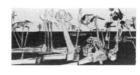

1209
Pages 46 and 47 (Satan's Saint). Dec 1, 1964–May 31, 1965. Black (S). 33.4 × 71.1. cf. Ed for 1209A. Kenneth Tyler. S, BS.

1209A
Pages 48 and 45 (Satan's Saint). Dec 1, 1964–May 31, 1965. Red (A). 33.4 × 71.1. Ed 20 (BFK), 9 TI (wA), BAT (BFK), 3 AP (2 BFK, 1 JG), 9 Endore Impressions (JG), 5 TP (2 BFK, 2 A, 1 JG), CP (Tcs). Kenneth Tyler.

1210
Pages 30 and 31 (Satan's Saint). Dec 1, 1964–May 1, 1965. Black (S). 33.4 × 71.1. cf. Ed for 1210B and 1210A. Kenneth Tyler. BS (Tam), S, BS (pr).

1210B/1210A
Pages 32 and 29 (Satan's Saint). Dec 1, 1964–May 31, 1965. Red (A), black, red (S). 33.4 × 71.1. Ed 20 (BFK), 9 TI (wA), BAT (BFK), 3 AP (A), 9 Endore Impressions (JG), 6 TP (2 A, 3 JG, 1 BFK), CP (Tcs). Kenneth Tyler. S.

1212
Pages 34 and 35 (Satan's Saint). Dec 1, 1964–May 31, 1965. Black (S). 33.4 × 71.1. cf. Ed for 1212A. Kenneth Tyler. BS (pr), S, BS (Tam).

1212A
Pages 36 and 33 (Satan's Saint). Dec 1, 1964–May 31, 1965. Red (A). 33.4 × 71.1. Ed 20 (BFK), 9 TI (wA), BAT (BFK), 3 AP (JG), 9 Endore Impressions (JG), 4 TP (3 BFK, 1 JG), CP (Tcs). Kenneth Tyler.

1214A
Pages 20 and 17 (Satan's Saint). Dec 1, 1964–May 31, 1965. Red (A). 33.4 × 71.1. Ed 20 (BFK), 9 TI (wA), BAT (BFK), PrP II (BFK)[1], 3 AP (2 A, 1 JG), 9 Endore Impressions (JG), 4 TP (BFK). Kenneth Tyler.

1. Recipient unrecorded.

1214B/1214
Pages 18 and 19 (Satan's Saint).
Dec 1, 1964–May 31, 1965. Black (S),
red (A). 33.4 × 71.1. cf. Ed for 1214A.
Kenneth Tyler. BS (Tam), I, BS (pr).

1242/1242B
Page 10 and 11 (Satan's Saint).
Dec 1, 1964–May 31, 1965. Black (S),
red (A). 33.4 × 71.1. cf. Ed for 1242A.
Kenneth Tyler. BS (Tam), S, BS (pr).

1220
Pages 38 and 39 (Satan's Saint).
Dec 1, 1964–May 31, 1965. Black (S).
33.4 × 71.1. cf. Ed for 1220A. Kenneth
Tyler. BS (pr), S, BS (Tam).

1220A
Pages 40 and 37 (Satan's Saint).
Dec 1, 1964–May 31, 1965. Red (A).
33.4 × 71.1. Ed 20 (BFK), 9 TI (wA),
BAT (BFK), 3 AP (A), 9 Endore
Impressions (JG), 2 PP (nr), 4 TP
(BFK). Kenneth Tyler.

1242A
Pages 12 and 9 (Satan's Saint).
Dec 1, 1964–May 31, 1965. Red (A).
33.4 × 71.1. Ed 20 (BFK), 9 TI (wA),
BAT (BFK), 3 AP (1 A, 2 JG), 9 Endore
Impressions (JG), 5 TP (2 A, 1 BFK, 2
JG), CP (Tcs). Kenneth Tyler.

1231/1231B
Pages 8 and 5 (Satan's Saint). Dec
1, 1964–May 31, 1965. Black (A), red
(A). 33.4 × 71.1. Ed 20 (BFK), 9 TI
(wA), BAT (BFK), 3 AP (BFK), 20
Endore Impressions (JG), 4 TP (2 BFK,
2 A), CP (BFK). Kenneth Tyler. BS (pr),
I, I, BS (Tam).

1245
Pages 44 and 41 (Satan's Saint).
Dec 1, 1964–May 31, 1965. Red (A).
33.4 × 71.1. Ed 20 (BFK), 9 TI (wA),
BAT (BFK), 3 AP (1 JG, 2 A), 9 Endore
Impressions (JG), 2 TP (1 BFK, 1 A),
CP (Tcs). Kenneth Tyler.

1231A
Pages 6 and 7 (Satan's Saint). Dec
1, 1964–May 31, 1965. Black (A). 33.4
× 71.1. cf. Ed for 1231 and 1231B.
Kenneth Tyler.

1245B/1245A
Pages 42 and 43 (Satan's Saint).
Dec 1, 1964–May 31, 1965. Black (S),
red (A). 33.4 × 71.1. cf. Ed for 1245.
Kenneth Tyler. BS (Tam), BS (pr).

1233
Pages 4 and 1 (Satan's Saint). Dec
1, 1964–May 31, 1965. Red (A). 33.4 ×
71.1. Ed 20 (BFK), 9 TI (wA), BAT
(BFK), 3 AP (A), 9 Endore Impressions
(JG), 4 TP (3 BFK, 1 A), CP (Tcs).
Kenneth Tyler. I.

1233A/1233B
Pages 2 and 3 (Satan's Saint). Dec
1, 1964–May 31, 1965. Black (S), red
(A). 33.4 × 71.1. cf. Ed for 1233.
Kenneth Tyler. BS (Tam), I, BS (pr).

1246
Pages 16 and 13 (Satan's Saint).
Dec 1, 1964–May 31, 1965. Black (S).
33.4 × 71.1. Ed 20 (BFK), 9 TI (wA),
BAT (BFK), 3 AP (JG), 9 Endore
Impressions (JG), 5 TP (BFK), CP (Tcs).
Kenneth Tyler. BS (pr), I, BS (Tam).

1246A
Pages 14 and 15 (Satan's Saint).
Dec 1, 1964–May 31, 1965. Red (A).
33.4 × 71.1. cf. Ed for 1246. Kenneth
Tyler.

Blank
pages

1251
Pages 28 and 25 (Satan's Saint).
Dec 1, 1964–May 31, 1965. Red (A).
33.4 × 71.1. Ed 20 (BFK), 9 TI (wA),
BAT (BFK), 3 AP (A), 9 Endore
Impressions (JG), 5 TP (1 BFK, 4 JG).
Kenneth Tyler.

1251A/1251B
Pages 26 and 27 (Satan's Saint).
Dec 1, 1964–May 31, 1965. Red (A),
black (S). 33.4 × 71.1. cf. Ed for 1251.
Kenneth Tyler.

1252
Pages 52 and 49 (Satan's Saint).
Dec 1, 1964–May 31, 1965. Red (A).
33.4 × 71.1. Ed 20 (BFK), 9 TI (wA),
BAT (BFK), PrP II for Bernard Bleha
(A), 3 AP (1 A, 2 JG), 9 Endore
Impressions (JG), 4 TP (2 JG, 2 BFK),
2 proofs (SW)[1]. Kenneth Tyler.

1. Unsigned, unchopped proofs of
 page 52 (#1252B) on paper smaller
 than edition, designated "Saunders
 Waterleaf Rough Side" and
 "Saunders Waterleaf Smooth Side,"
 retained by Tamarind.

1252A/1252B
Pages 50 and 51 (Satan's Saint).
Dec 1, 1964–May 31, 1965. Red (A),
black (S). 33.4 × 71.1. cf. Ed for 1252.
Kenneth Tyler.

1259
Pages 22 and 23 (Satan's Saint).
Dec 1, 1964–May 31, 1965. Red (A).
33.4 × 71.1. cf. Ed for 1259A. Kenneth
Tyler.

1259A
Pages 24 and 21 (Satan's Saint).
Dec 1, 1964–May 31, 1965. Black (S).
33.4 × 71.1. Ed 20 (BFK), 9 TI (wA),
BAT (BFK), 3 AP (1 BFK, 1 A, 1 JG), 9
Endore Impressions (JG), 1 PP (nr), 5
TP (2 BFK, 3 A), CP (Tcs). Kenneth
Tyler. BS (pr), S, I, BS (Tam).

1348
Colophon (Satan's Saint). Dec 1,
1964–May 31, 1965. Black (A). 33.4 ×
71.1. Ed 20 (BFK), 9 TI (wA), BAT
(BFK), 3 AP (1 BFK, 1 A, 1 JG), 9
Endore Impressions (JG), 3 TP (BFK).
Kenneth Tyler. S, D, BS.

1353
Multiple Mirror. May 13–14, 1965.
Black (A). 44.1 × 62.6. Ed 20 (bA), 9 TI
(bA), BAT (bA), 2 AP (bA), 3 TP (bA),
CP (Tcs). Kinji Akagawa. T, S, Dat, D.

1356
Man-men 163. May 21–Jul 18, 1965.
Black (S). 32.1 × 42.5. Ed 20 (BFK), 9
TI (CD), BAT (BFK), 2 AP (BFK), 2 TP
(BFK), 1 PTP (C)[1], CP (Tcs). Ernest de
Soto. BS, S, T, D.

1. Unsigned, unchopped,
 undesignated, retained by
 Tamarind.

1361
Man-Men 160. May 10–28, 1965.
Black (S). 44.1 × 69.2. Ed 20 (BFK), 9
TI (wA), BAT (BFK), 2 AP (1 wA, 1
BFK), 2 TP (BFK), CP (Tcs). Kenneth
Tyler. T, D, S, Dat, BS.

1365
Man-Men 162. May 24–Jun 4, 1965.
Black (A). 54.9 × 37.2. Ed 20 (bA), 9 TI
(bA), BAT (bA), 3 AP (bA), 2 TP (bA), 2
PTP (bA)[1], CP (Tcs). Kenneth Tyler. T,
BS, D, S, Dat.

1. Unsigned, unchopped, designated
 "Arches Trial A," retained by
 Tamarind.

2867
Mama Mudra. Apr 14–21, 1970. Red
(S), blue, dark red (Z). 56.8 × 76.2. Ed
16 (wA), 9 TI (wA), BAT (wA), CP*
(wA). Eugene Sturman. D, T, S, Dat,
BS.

Paul Harris

Shut-in-Suite, a suite of twenty-one
lithographs. In order: 2804, 2805,
2806, 2807, 2808, 2809, 2810, 2811,
2812, 2813, 2814, 2814II, 2815, 2816,
2817, 2818, 2819, 2820, 2821, 2822,
2823.

2804
The Other Room (Shut-in Suite I).
Nov 3–Dec 23, 1969. Blue, pink (Z),
blue (Z), yellow-green (A), light pink,
green-blue, green (S), green (A),
green-grey (A). 54.6 × 74.9, cut. Ed 20
(CD), 9 TI (GEP), BAT (GEP), 3 AP
(GEP), CP* (CD). Eugene Sturman.
Verso: T, S, Dat, D, WS.

2805
Living Room (Shut-in Suite II). Nov
4–Dec 8, 1969. Pink (A), red (S), blue
(A), black (A). 57.8 × 78.7. Ed 16 (CD),
9 TI (GEP), BAT (CD), CP (GEP).
William Law III. Verso: T, S, Dat, D,
WS.

2806
*The Window Screen (Shut-in Suite
III).* Nov 13–19, 1969. Black (A). 77.5
× 57.2, cut. Ed 20 (ucR), 9 TI (GEP),
BAT (ucR), 1 AP (GEP), 1 PP (ucR), 1
TP (GEP), 2 PTP (1 BFK, 1 CD), CP
(ucR). S. Tracy White. Verso: T, S, Dat,
D, WS.

2807
Lawn Party (Shut-in Suite IV). Nov
11–Dec 3, 1969. Brown-green (A), dark
green (S). 77.5 × 57.2, cut. Ed 20
(ucR), 9 TI (cR), BAT (ucR), 2 AP (1 cR,
1 ucR), CP (ucR). David Trowbridge.
Verso: T, S, Dat, D, WS.

2808
At Night (Shut-in Suite V). Nov 22,
1969. Blue, black (A). 76.2 × 55.9. Ed
20 (ucR), 9 TI (cR), BAT (ucR), 1 AP
(cR), 1 TP* (cR), CP (cR). Eugene
Sturman. Verso: T, S, Dat, D, WS.

2809
Bathroom (Shut-in Suite VI). Nov
24–26, 1969. Violet-blue (A), on Fasson
foil. 76.2 × 55.9, cut . Ed 20 (cR), 9 TI
(cR), BAT (cR), 4 AP (cR), 1 PP (cR), 1
TP (cR, CP* (cR). Hitoshi Takatsuki.
Verso: T, S, Dat, D, WS.

2810
*One Night in Tunisia (Shut-in Suite
VII).* Nov 23–Dec 3, 1969. B: Orange,
green, blue (Z), blue (S). 76.2 × 55.9.
Ed 16 (cR), 9 TI (GEP), BAT (cR), 1 PP
(cR), 1 TP (cR), CP (cR). S. Tracy White.
Verso: T, S, Dat, D, WS.

2811
*The Good Tablecloth (Shut-in
Suite VIII).* Nov 23–Dec 13, 1969.
Brown-green (S), violet (A), on Fasson
foil. 76.2 × 55.9, cut. Ed 20 (ucR), 9 TI
(ucR), BAT (ucR), 2 AP (ucR), CP (ucR).
Larry Thomas. Verso: T, S, Dat, D, WS.

2812
Left a Light On (Shut-in Suite IX).
Nov 26–Dec 9, 1969. Dark beige (S),
grey (S). 76.2 × 55.9. Ed 20 (GEP), 9
TI (CD), BAT (GEP), 3 AP (2 CD, 1
GEP), 1 PP (GEP), 1 TP (CD), 1 CTP
(GEP), CP (CD). Edward Hamilton.
Verso: T, S, Dat, D, WS.

2813
*The Girl on the Beach (Shut-in
Suite X).* Dec 6–16, 1969. B: Violet,
blue, green, yellow, red (Z), grey-black
(A). 56.2 × 76.5. Ed 20 (CD), 9 TI
(GEP), BAT (CD), 2 AP (CD), CP* (GEP).
Hitoshi Takatsuki. Verso: T, S, Dat, D,
WS.

2814
One Morning in Munich (Shut-in Suite XI). Dec 16, 1969–Jan 2, 1970. Yellow-orange (Z), red-orange (S), light violet (S). 76.5 × 56.2. Ed 20 (GEP), 9 TI (cR), BAT (GEP), 4 AP (cR), 1 TP (GEP), 3 CTP (GEP). S. Tracy White. Verso: T, S, Dat, D, WS.

2814II
Later That Morning in Munich (Shut-in Suite XII). Dec 16, 1969–Jan 5, 1970. Yellow (Z)[1], red-orange (S)[1], orange (S)[1]. 76.5 × 56.2. Ed 10 (GEP), 9 TI (cR), BAT (GEP), 5 AP (3 cR, 2 GEP), 1 CTP (GEP), CP* (cR). S. Tracy White. Verso: T, S, Dat, D, WS.

1. Stones and plate held from 2814, run 1, 2,
3. 2814II differs from 2814 in color only.

2815
The South of France (Shut-in Suite XIII). Dec 15, 1969–Jan 5, 1970. Orange (S), green (Z). 76.2 × 55.9, cut. Ed 20 (GEP), 9 TI (CD), BAT (GEP), 3 AP (2 CD, 1 GEP), 1 TP (GEP), CP* (GEP). Eugene Sturman. Verso: T, S, Dat, D, WS.

2816
Newspaper (Shut-in Suite XIV). Dec 16–19, 1969. Black (S). 55.9 × 76.2. Ed 20 (CW), 9 TI (JG), BAT (CW), 4 AP (3 CW, 1 JG), 2 PP (JG), 1 TP (CW), 2 PTP (1 cream CD, 1 wN), CP (JG). Larry Thomas. Verso: T, S, Dat, D, WS.

2817
El Cemetario Central (Shut-in Suite XV). Dec 20, 1969–Jan 16, 1970. B: Light blue, green (S), B: red, pink, red-orange, orange, pink (S). 55.2 × 76.5. Ed 25 (CD), 9 TI (CD), BAT (CD), 1 AP (CD), 1 TP* (CD), 6 CTP (4 GEP, 1 JG, 1 CD), CP* (CD). Edward Hamilton. Verso: T, S, Dat, D, WS.

2818
Traveling Case (Shut-in Suite XVI). Jan 5–6, 1970. Black (S). 55.9 × 76.2, cut. Ed 22 (JG), 9 TI (ucR), BAT (JG), 5 AP (3 JG, 2 ucR), 1 PTP (GEP), CP (ucR). Paul Clinton. Verso: T, S, Dat, D, WS.

2819
Outdoors (Shut-in Suite XVII). Jan 7–13, 1970. Blue, green (S), black (Z). 76.5 × 55.9. Ed 21 (wA), 9 TI (GEP), BAT (wA), 3 AP (2 wA, 1 GEP), CP (GEP). Paul Clinton. Verso: T, S, Dat, D, WS.

2820
Glasses (Shut-in Suite XVIII). Jan 10–22, 1970. Pink (Z), red (S), blue (S). 55.9 × 76.2. Ed 20 (19 GEP, 1 CD), 9 TI (CD), BAT (GEP), 2 AP (CD), 4 CTP (1 wA, 1 CD, 1 GEP, 1 ucR), CP (CD). David Trowbridge. Verso: T, S, Dat, D, WS.

2821
Rain (Shut-in Suite XIX). Jan 15–26, 1970. Red (S), blue (S), on dark yellow Fasson vinyl. 76.2 × 55.9, cut . Ed 20 (BFK), 9 TI (BFK), BAT (BFK), 3 AP (BFK), 4 CTP (BFK), CP (BFK). William Law III. Verso: T, S, Dat, D, WS.

2822
The Dining Room Window (Shut-in Suite XX). Jan 22–23, 1970. Black, silver (S). 76.2 × 55.9. Ed 20 (MI), 9 TI (ucR), BAT (MI), 3 AP (ucR), 2 PTP (1 CD, 1 GEP), CP (MI). Eugene Sturman. Verso: T, S, Dat, D, WS.

2823
Blind (Shut-in Suite XXI). Jan 23–29, 1970. Blue-green (Z), brown-pink (S). 76.8 × 56.2. Ed 20 (CD), 9 TI (GEP), BAT (CD), CP (GEP). David Trowbridge. Verso: T, S, Dat, D, WS.

Stanley William Hayter

2035
Eddy. May 15–19, 1967. Red (S), blue (S). 76.2 × 57.2. Ed 20 (GEP), 9 TI (CD), BAT (GEP), 3 AP (CD), 3 TP (GEP), CP (GEP). John Butke. D, BS, S, Dat.

2036
Ripple. May 16–19, 1967. Yellow (S), red (S), green (S)[1]. 51.1 × 68.9. Ed 20 (GEP), 9 TI (CD), BAT (GEP), 3 AP (CD), 4 TP (GEP), 6 CSP (BFK)[2], CP (GEP). Maurice Sanchez. D, BS, S, Dat.

1. Same stone as run 1; reversal.
2. 3 CSP retained by Tamarind.

David Hockney

1036
Pacific Mutual Life Building with Palm Trees. Mar 12–13, 1964. Black (S). 51.4 × 63.5. Ed 20 (BFK), 9 TI (wA), PrP (BFK), PrP II for Irwin Hollander (BFK), 3 AP (BFK), 1 TP (wA), CP (BFK). Aris Koutroulis. BS, D, S, Dat.

Irwin Hollander

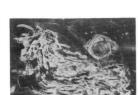

560
Vesta. Apr 19–May 1, 1962. Black (Z), black (Z). 24.1 × 34.9. Ed 20 (BFK), 9 TI (wA), PrP (BFK), 2 AP (BFK), 3 TP (BFK). Irwin Hollander. D, BS, I.

Bohuslav Horak

452
Flowers. Nov 17–Dec 7, 1961. Yellow (Z), light blue (Z), red (Z)[1], dark grey-beige (Z), dark blue (Z), dark violet (S). 82.6 × 62.6. Ed 20 (BFK), 9 TI (wN), PrP (BFK), 2 AP (wN), 3 TP (2 BFK, 1 wN). Bohuslav Horak. BS (Tam), D, S, BS (pr).

1. Plate held from run 2; deletions.

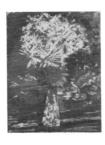

470
Untitled. Dec 12–26, 1961. Orange-red (Z)[1], grey-green (S)[2]. 75.9 × 57.2. Ed 20 (BFK), 9 TI (wA), 2 AP (wA), 4 TP (3 BFK, 1 wA). Bohuslav Horak. D, S, BS.

1. Plate held from 452, run 2.
2. Stone held from 452, run 6. 470 differs from 452 in color, image and size. The over-all image is lighter. The border on all four sides has been eliminated. The darkest portion of the over-all image has been eliminated.

484
Concerto. Jan 5–14, 1962. Red-brown (S), yellow, green (S), grey (Z), pink (S). 76.8 × 56.5. Ed 10 (BFK), 9 TI (wN), PrP (BFK), 2 AP (wN), 3 TP (BFK). Bohuslav Horak. D, BS (Tam), S, BS (pr).

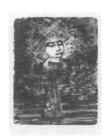

491
Untitled. Jan 17–20, 1962. Black (S)[1], grey-pink (Z). 89.2 × 66.0. Ed 20 (BFK), 9 TI (BFK), BAT (BFK), 2 AP (BFK), 3 TP (BFK). Bohuslav Horak. D, BS, S.

1. Stone held from 470, run 2; additions and deletions. 491 differs from 470 in color, image and size. A border has been added on all four sides. The center of the flower arrangement has been eliminated and dark outline drawing of a face has been added. Dark drawing has been added in the lower portion of the image partially covering the shapes to either side of the vase. A light line has been added to the right side of the vase.

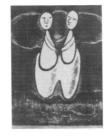

624
Couple with Red Flower. Aug 16–19, 1962. Pink (Z), yellow (Z), blue (Z), red (S). 80.6 × 58.1. Ed 20 (JG), 9 TI (JG), PrP (JG), 2 AP (JG), 1 PP (JG), 3 TP (JG). Bohuslav Horak. D, BS (Tam), S, BS (pr).

628
Untitled. Aug 23, 1962. Black (Z). 31.8 × 39.4. Ed 15 (BFK), 9 TI (BFK), 1 AP (BFK). Bohuslav Horak. D, BS, S.

628A
Untitled. Aug 25, 1962. Black (Z)[1]. 28.6 × 35.6. Ed 15 (BFK), 9 TI (wA), PrP (wA), 3 AP (1 BFK, 2 wA), 1 TP (wA). Bohuslav Horak. D, BS, S.

1. Plate held from 628; deletions. 628A differs from 628 in image and size. The outer white and dark borders have been eliminated on all four sides. The light areas are less distinct.

643
Untitled. Sep 11–15, 1962. Pink (S), black (S)[1], ochre (Z), red (Z). 81.0 × 58.1. Ed 20 (JG), 9 TI (JG), PrP (JG), 3 AP (JG), 2 PP (JG), 2 TP (JG). Bohuslav Horak. D, BS (Tam), S, BS (pr).

1. Same stone as run 1; deletions.

652
Untitled. Sep 28, 1962–Jan 22, 1963. Black (Z), yellow-green (Z), red-brown (S), dark grey (S). 45.7 × 57.2. Ed 15 (BFK), 9 TI (wN), 3 AP (BFK), 2 TP (BFK). Bohuslav Horak. D, BS, S.

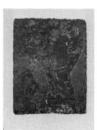

693
Untitled. Dec 9, 1962–Jun 1, 1963. Yellow-ochre (S), red (Z), green (S)[1], violet (Z), black (Z), blue (Z)[2]. 77.5 × 57.2. Ed 15 (BFK), 9 TI (wN), 3 AP (BFK), 1 TP (wN). Bohuslav Horak. D, BS, S.

1. Same stone as run 1; deletions.
2. Same plate as run 5; deletions, printed slightly upand to left of previous run.

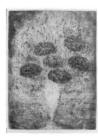

791
Untitled. Apr 23–May 11, 1963. Yellow (Z), red (Z), blue (Z), violet (Z)[1], violet-blue (Z)[2]. 80.6 × 57.8. Ed 15 (JG), 9 TI (JG), 2 AP (JG), 1 PP (JG), 3 TP (JG). Bohuslav Horak. D, BS, S.

1. Same plate as run 3, printed slightly off-register.
2. Same plate as run 3; reversal.

Edward Hughes

2413
"?". Aug 4–18, 1968. Green (S). 33.7 × 42.5, cut. Ed 8 (CD), 9 TI (CD), BAT (CD), 3 CTP (CD), 2 PTP (1 bA, 1 CD), CP (bA). Edward Hughes. Recto: T, D, S, Dat (bottom) Verso: BS (top).

Robert Hughes

1112
Untitled. Jun 8–9, 1964. Black (S). 37.8 × 46.1. Ed 20 (BFK), 9 TI (wA), PrP (BFK), PrP II for Irwin Hollander, 3 AP (2 BFK, 1 wA), 2 TP (BFK), CP (BFK). Aris Koutroulis. BS, D, S, Dat.

John Hultberg

710
Incredible Speed. Jan 3–4, 1963. Black (S). 45.7 × 60.7. Ed 20 (BFK), 9 TI (wA), PrP (BFK), PrP II for Bohualav Horak (BFK), 2 AP (BFK), 1 TP (BFK), CP (BFK). John Rock. D, S, BS.

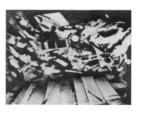

713
Storm Driver. Jan 5–8, 1963. Black (S). 43.2 × 54.0. Ed 20 (BFK), 9 TI (wA), PrP (BFK), PrP II for Bohuslav Horak (BFK), 3 AP (2 BFK, 1 wA). John Rock. D, S, BS.

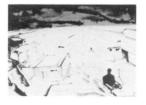

716
Tractor Demon. Jan 9–29, 1963. Blue-grey (Z), black (S). 56.5 × 76.5. Ed 20 (BFK), 9 TI (wA), PrP (BFK), PrP II for Bohuslav Horak (BFK), 3 AP (2 BFK, 1 wA), 2 PP (BFK). Joe Zirker. BS, D, S.

716A
Escape in Anguish. Jan 30–Feb 1, 1963. Black (S)[1]. 56.5 × 76.5. Ed 20 (BFK), 9 TI (wA), PrP (BFK), PrP II for Bohuslav Horak (BFK), 2 AP (BFK), 2 TP (BFK). Joe Zirker. D, S, BS.

1. Stone held from 716, run 2, additions, deletions. 716A differs from 716 in color and image. Blue-grey has been eliminated from the sky. There is additional drawing throughout the image except in the sky where the only addition is a circle at the upper right.

717
Green Earthquake. Jan 9–17, 1963. Light blue-green (Z), green-black (Z). 51.1 × 76.2. Ed 20 (BFK), 9 TI (wA), PrP (BFK), 3 AP (BFK), 2 PP (BFK), 2 TP (BFK). Irwin Hollander. BS, D, S.

718
Great Broken Wing. Jan 10–25, 1963. Black (S). 48.3 × 68.6. Ed 20 (BFK), 9 TI (wA), PrP (BFK), 3 AP (1 BFK, 2 wA), 3 PP (BFK), 2 TP (BFK). Irwin Hollander. D, S, BS.

724
Take Off in Storm. Jan 21–23, 1963. Black (S). 59.4 × 91.4. Ed 20 (BFK), 9 TI (BFK), PrP (BFK), 3 AP (BFK), 1 PP (BFK). Irwin Hollander. BS, S, D.

726
Hurricane. Jan 22–28, 1963. Black (S). 46.1 × 63.5. Ed 20 (BFK), 9 TI (wA), PrP (BFK), 2 AP (BFK), 1 TP (BFK). John Rock. D, S, BS.

729
In Prison. Jan 31–Feb 1, 1963. Dark grey (S). 59.7 × 91.4. Ed 20 (BFK), 9 TI (BFK), PrP (BFK), 3 AP (BFK), 1 PP (BFK), 1 TP (BFK). Irwin Hollander. D, S, BS.

731
Garage. Feb 4–5, 1963. Black (S). 52.4 × 68.6. Ed 20 (BFK), 9 TI (wA), PrP (BFK), PrP II for Bohuslav Hoark (BFK), 3 AP (2 BFK, 1 wA). Joe Zirker. D, BS, S.

733
My Roof of Cloud. Feb 5–7, 1963. Black (S). 61.6 × 91.4. Ed 20 (BFK), 9 TI (BFK), PrP (BFK), 3 AP (BFK), 2 TP (BFK). Irwin Hollander. BS, D, S.

735
Dreamer and Dreams. Feb 6–8, 1963. Black (S). 59.1 × 84.2. Ed 20 (BFK), 9 TI (wN), PrP (BFK), PrP II for Bohuslav Horak (BFK), 3 AP (2 BFK, 21 wN), 1 TP (BFK). Irwin Hollander. D, S, BS.

739
Loft Explosion. Feb 8–12, 1963. Black (S). 56.8 × 76.8. Ed 20 (bA), 9 TI (nN), PrP (bA), 2 AP (1 bA, 1 nN), 2 TP (bA). Irwin Hollander. D, S, BS.

742
Porch Serenity. Feb 11–14, 1963. Black (S). 58.4 × 81.6. Ed 20 (BFK), 9 TI (BFK), PrP (BFK), 3 AP (BFK), 1 PP (BFK). Irwin Hollander. D, S, BS.

742A
Phosphorescence. Feb 14–19, 1963. Black (S)[1], blue (Z)[2]. 57.2 × 76.2. Ed 20 (BFK), 9 TI (wA), PrP (BFK), 3 AP (BFK), 3 PP (1 BFK, 2 wA), 2 TP (1 BFK, 1 wN). Irwin Hollander. D, S, BS.

1. Stone held from 742; additions.
2. Part of image from run 1 reversed; additions. 742A differs from 742 in color, image and size. A blue bleed tone has been added and there is additional drawing in black in the lower third of the image.

743
Sleep-Walk Forest. Feb 12–19, 1963. Green-black (S). 56.8 × 77.2. Ed 20 (BFK), 9 TI (wN), PrP (BFK), PrP II for Bohuslav Horak(BFK), 3 AP (2 wN, 1 BFK), 2 PP (1 BFK, 1 wN), 2 TP (BFK). Joe Zirker. S, D, BS.

746
Red Cloud Wing. Feb 14–20, 1963. Red-black (S). 57.2 × 76.2. Ed 20 (BFK), 9 TI (wA), PrP (BFK), PrP II for Bohuslav Horak (BFK), 3 AP (2 BFK, 1 wA). Irwin Hollander. BS, D, S.

749
The Plague. Feb 18–20, 1963. Brown (S). 48.9 × 63.5. Ed 20 (BFK), 9 TI (wA), PrP (BFK), PrP II for Bohuslav Horak (BFK), 3 AP (2 BFK, 1 wA), 1 PP (wA), 1 TP (BFK). Joe Zirker. D, BS, S.

753
Haunted Tent. Feb 21–26, 1963. Red-black (S). 57.2 × 76.2. Ed 20 (BFK), 9 TI (wA), PrP (BFK), PrP II for Bohuslav Horak (BFK), 3 AP (BFK), 1 TP (bA). Irwin Hollander. D, S, BS.

757
Head in Landscape. Feb 27–28, 1963. Blue-black (S). 57.2 × 76.2. Ed 20 (BFK), 9 TI (wA), PrP (BFK), 3 AP (BFK), 2 PP (BFK). Irwin Hollander. D, BS, S.

Richard Hunt

Details, a suite of eight lithographs plus title and colophon pages, enclosed in a black linen covered box, measuring 40.6 × 40.0, lined with white cover paper, made by the Schuberth Bookbindery, San Francisco. The title page and colophon printed at the Plantin Press, Los Angeles. In order: 1236, 1240, 1247, 1250, 1243, 1272, 1276, 1277.

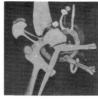
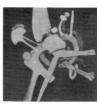

1234
Untitled. Feb 2–Mar 1, 1965. Transparent blue-grey (A), transparent brown-grey (S), blue-black (S), yellow, light blue-green (A). 45.7 × 45.7, cut. Ed 20 (BFK), 9 TI (wA), BAT (BFK), 2 AP (wA), 5 TP (3 BFK, 2 wA), 6 PTP* (1 Kochi, 1 Tableau, 2 Umbria Fabriano, 2 Perusia Fabriano)[1], 2 proofs (nr)[2], CP (BFK). Kenneth Tyler. D, S, BS.

1. Unsigned, undesignated, unchopped, retained by Tamarind.
2. Unsigned, undesignated, defaced.

1236
Untitled (Details I). Feb 23–26, 1965. Black (S). 38.4 × 38.4. Ed 20 (BFK), 9 TI (wA), BAT (BFK), 2 AP (1 BFK, 1 wA), 2 TP (BFK), CP (Tcs). Bernard Bleha. BS, D, S.

1239
Untitled. Feb 10–25, 1965. Yellow (A), black (S), yellow (Z). 38.1 × 38.4. Ed 20 (BFK), 9 TI (wA), BAT (BFK), 2 AP (1 BFK, 1 wA), 3 TP (BFK), 2 proofs (nr)[1], CP (Tcs). Kenneth Tyler. D, BS, S.

1. Unsigned, undesignated, defaced.

1240
Untitled (Details II). Mar 5, 1965. Black (A). 38.1 × 38.4. Ed 20 (BFK), 9 TI (wA), BAT (BFK), 2 AP (wA), 2 TP (BFK), CP (Tcs). Kenneth Tyler. D, S, BS.

1241
Untitled. Feb 10–Mar 8, 1965. Light brown (A), black (S), blue-grey (Z), orange (S). 38.4 × 38.4. Ed 20 (BFK), 9 TI (wA), BAT (BFK), 5 TP (4 BFK, 1 wA), 1 proof (nr)[1], CP (Tcs). Kenneth Tyler. D, BS, S.

1. Unsigned, undesignated, defaced.

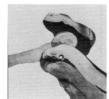
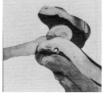

1243
Untitled (Details V). Feb 15–Mar 1, 1965. Black (S). 38.4 × 38.4. Ed 20 (BFK), 9 TI (wA), BAT (BFK), 2 AP (wA), 2 TP (BFK), CP (Japanese Torinoko). Kenneth Tyler. D, S, BS.

1244
Untitled. Feb 16–25, 1965. Black (A). 56.5 × 76.8. Ed 20 (bA), 9 TI (nN), BAT (bA), 2 AP (bA), 1 TP (nN), CP (Tcs). Kenneth Tyler. D, BS, S.

1247
Untitled (Details III). Feb 19–Mar 3, 1965. Dark grey (A). 38.4 × 38.1. Ed 20 (BFK), 9 TI (wA), BAT (BFK), 2 AP (wA), 2 TP (BFK), CP (Tcs). Kenneth Tyler. D, S, BS.

1250
Untitled (Details IV). Feb 22–26, 1965. Black (S). 38.1 × 38.7. Ed 20 (BFK), 9 TI (wA), BAT (BFK), 1 AP (wA), 2 TP (BFK), CP (Japanese Torinoko). Clifford Smith. D, BS, S.

1253
Untitled. Feb 4–24, 1965. Black (S).
53.7 × 68.9. Ed 20 (BFK), 9 TI (wA),
BAT (BFK), 2 TP (BFK), CP (Tcs).
Kenneth Tyler. D, S, BS.

1254
Untitled. Feb 24–Mar 26, 1965. Blue
(S), black (S)[1], red (S)[2]. 56.5 ×
76.5. Ed 20 (BFK), 9 TI (wA), BAT
(BFK), 3 AP (1 BFK, 2 wA), 6 PP (BFK),
4 TP (BFK), CP (Tcs). Kenneth Tyler. D,
S, BS.

1. Stone held from 1268; additions,
 deletions.
2. Stone held from 1254, run 1;
 additions. Two tones have been
 added over all of the image except
 a crescent at bottom right. The
 black image has been filled in
 extensively on the right and center
 and in small areas on the left.

1255
Untitled. Feb 25–26, 1965. Black (S).
56.8 × 76.2. Ed 20 (BFK), 9 TI (wA),
BAT (BFK), 2 AP (wA), CP (Tcs).
Kenneth Tyler. D, S, BS.

1256
Untitled. Feb 18–Mar 2, 1965. Black
(A). 38.4 × 38.4. Ed 6 (BFK), 9 TI
(BFK), BAT (BFK). Kenneth Tyler. D, S,
BS.

1257
Untitled. Mar 1–17, 1965. Dark green
(S), transparent grey (Z), transparent
blue-black (S). 38.4 × 38.1. Ed 20
(BFK), 9 TI (wA), BAT (BFK), 3 AP (wA),
4 TP (BFK), CP (BFK). Kenneth Tyler. D,
S, BS.

1260
Untitled. Mar 3–19, 1965. Black (S),
transparent grey (A), black (S). 57.2 ×
71.1. Ed 20 (BFK), 9 TI (wA), BAT
(BFK), 2 AP (1 wA, 1 BFK), 3 TP (BFK).
Kenneth Tyler. D, BS, S.

1261
Untitled. Mar 22–26, 1965. Black (S).
61.3 × 88.0. Ed 20 (BFK), 9 TI (wN),
BAT (BFK), 2 AP (BFK), 2 TP (wN).
Clifford Smith. D, S, BS.

1268
Untitled. Mar 4, 1965. Black (S). 57.2
× 76.2. Ed 20 (BFK), 9 TI (wA), BAT
(BFK), 2 AP (wA), 2 TP (BFK). Kenneth
Tyler. D, S, BS.

1269
Untitled. Mar 29–31, 1965. Black (S).
83.8 × 61.0. Ed 20 (BFK), 9 TI (wN),
BAT (BFK), 3 AP (2 BFK, 1 wN), 2 TP
(BFK). Kenneth Tyler. D, BS, S.

1272
Untitled (Details VI). Mar 10–11,
1965. Black (S)[1]. 38.1 × 38.4. Ed 20
(BFK), 9 TI (wA), 1 AP (wA), 1 TP
(BFK)[2], CP (Tcs). Kenneth Tyler. D,
BS, S.

1. Stone held from 1254; additions,
 deletions. 1272 differs from 1254 in
 color, image and size. The bottom
 third of the image has been filled in
 solid. A majority of the remaining
 image has been lightened.
2. Retained by printer in lieu of BAT.

1275
Untitled. Mar 10–15, 1965. Black (S). 38.4 × 38.4. Ed 20 (BFK), 9 TI (wA), BAT (BFK), 1 AP (wA), 1 TP (BFK), CP (Tcs). Kenneth Tyler. D, BS, S.

1276
Untitled (Details VII). Mar 10–15, 1965. Black (S). 38.1 × 38.1. Ed 20 (BFK), 9 TI (wA), BAT (BFK), 2 TP (BFK), CP (Tcs). Kenneth Tyler. D, BS, S.

1277
Untitled (Details VIII). Mar 17, 1965. Black (S). 38.4 × 38.4. Ed 20 (BFK), 9 TI (wA), BAT (BFK), 2 AP (wA), 2 TP (BFK), CP (Tcs). Kenneth Tyler. D, S, BS.

1278
Untitled. Mar 18–22, 1965. Black (S). 77.2 × 57.2. Ed 20 (BFK), 9 TI (wN), BAT (BFK), 3 AP (wN), 2 TP (BFK), CP (Tcs). Bernard Bleha. D, S, BS.

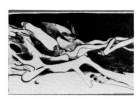

1282
Untitled. Mar 23–31, 1965. Black (S). 58.8 × 87.0. Ed 20 (BFK), 9 TI (wN), BAT (BFK), 3 AP (BFK), 2 TP (BFK), CP (Tcs). Kenneth Tyler. D, BS, S.

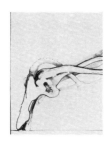

1283
Untitled. Mar 26–29, 1965. Black (S). 76.5 × 56.8. Ed 20 (bA), 9 TI (nN), BAT (bA), 3 AP (bA), 2 TP (bA), CP (Tcs). Kenneth Tyler. BS, D, S.

John Hunter

Going Hollywood, a suite of ten lithographs including title and colophon pages. In order: 2558, 2562, 2564, 2561, 2559, 2566, 2560, 2563, 2565, 2567.

2556
Mr. Hunter Receives. Feb 3–5, 1969. Brown (S). 51.1 × 71.5. Ed 20 (bA), 9 TI (cream CD), BAT (bA), 3 AP (1 bA, 2 cream CD), 1 TP (bA), 2 PTP (1 cR, 1 GEP), CP (cream CD). Manuel Fuentes. D, T, BS (Tam), S, BS (pr).

2557
At the Honey Bunny. Feb 5–7, 1969. B: Violet, pink, blue (S). 50.8 × 71.1. Ed 20 (bA), 9 TI (bA), BAT (bA), 3 AP (bA), 3 TP (bA)[1], 1 CTP (bA), CP (bA). Charles Ringness. D, BS, T, S.

1. 2 TP vary from the edition.

2558
Title Page (Going Hollywood I). Feb 8–18, 1969. Red (S), green (A). 36.2 × 50.8. Ed 20 (wA), 9 TI (cR), BAT (wA), 3 AP (wA), 4 CTP* (3 cR, 1 wA), CP (wA). Ronald Glassman. D, BS (Tam), S, BS (pr).

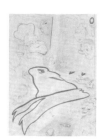

2559
Untitled (Going Hollywood V). Feb 8–18, 1969. Red (S), green (A). 50.8 × 35.6. Ed 20 (wA), 9 TI (cR), BAT (wA), 3 AP (wA), 5 CTP (3 cR, 2 wA), CP (wA). Ronald Glassman. BS, D, S.

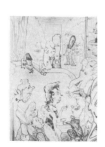

2560
Untitled (Going Hollywood VII). Feb 11–18, 1969. Violet (S), yellow (A). 51.1 × 35.9. Ed 20 (wA), 9 TI (cR), BAT (wA), 3 AP (wA), 2 CTP (wA), CP (cR). Charles Ringness. BS (bottom), D, S (top).

2561
Untitled (Going Hollywood IV). Feb 11–18, 1969. Violet (S), yellow (A). 50.8 × 35.6. Ed 20 (wA), 9 TI (cR), BAT (wA), 3 AP (wA), 2 CTP (wA), CP (cR). Charles Ringness. BS (bottom), D, S (top).

2562
Untitled (Going Hollywood II). Feb 12–19, 1969. B: Orange, yellow (S), B: light violet, pink (A). 35.9 × 51.1. Ed 20 (wA), 9 TI (cR), BAT (wA), 3 AP (wA), 1 TP (wA), 1 CTP (wA), CP (wA). John Sommers. BS (Tam), D, S, BS (pr).

2563
Untitled (Going Hollywood VIII). Feb 12–19, 1969. B: Orange, yellow (S), B: light violet, pink (A). 35.6 × 50.8. Ed 20 (wA), 9 TI (cR), BAT (wA), 3 AP (wA), 1 TP (wA), 2 CTP (wA), CP (wA). John Sommers. BS (Tam), D, S, BS (pr).

2564
Untitled (Going Hollywood III). Feb 18–21, 1969. B: Pink, grey, blue, violet (S). 35.9 × 50.8. Ed 20 (wA), 9 TI (cR), BAT (wA), 3 AP (2 wA, 1 cR), CP (cR). Charles Ringness. BS (Tam), D, S, BS (pr).

2565
Untitled (Going Hollywood IX). Feb 18–21, 1969. B: Pink, grey, blue, violet (S). 50.8 × 35.9. Ed 20 (wA), 9 TI (cR), BAT (wA), 3 AP (2 wA, 1 cR), CP (cR). Charles Ringness. D, BS (Tam), S, BS (pr).

2566
Untitled (Going Hollywood VI). Feb 25–26, 1969. B: Green, grey-green, light grey-green (S). 50.8 × 35.9. Ed 20 (wA), 9 TI (cR), BAT (cR), 3 AP (1 cR, 2 wA), CP (cR). Ronald Glassman. BS (Tam), D, BS (pr), S.

2567
Untitled (Going Hollywood X). Feb 25–26, 1969. B: Green, grey-green, light grey-green (S). 50.8 × 35.6. Ed 20 (wA), 9 TI (cR), BAT (cR), 3 AP (1 cR, 2 wA), CP (cR). Ronald Glassman. BS (Tam), D, S, BS (pr).

2571
The Day the Kids Finally Took Over. Feb 26–Mar 12, 1969. Orange (A), B: blue, pink, yellow, B: pink, blue, violet (A), green (S). 61.3 × 89.2. Ed 20 (ucR), 9 TI (cR), BAT (ucR), 3 AP (1 ucR, 2 cR), 6 PP (ucR), CP (ucR). John Sommers. BS (Tam), T, D, BS (pr), S.

2572
Melrose & Vine. Feb 26–Mar 11, 1969. Red (A), yellow (A), violet (S). 61.0 × 84.2. Ed 20 (CD), 9 TI (cR), BAT (CD), 3 AP (cR), 3 TP* (2 cR 1 CD), 2 CTP (CD), CP (CD). Daniel Socha. T, D, BS (Tam), S, BS (pr).

2573
Your Hour of Stars/ Entertainments. Feb 28–Mar 10, 1969. B: Yellow, brown, red (S)[1]. 55.9 × 88.0. Ed 15 (cR), 9 TI (6 ucR, 3 cR), BAT (cR), 1 TP (ucR), 2 CTP (1 MI, 1 cR), CP (ucR). Charles Ringness. T (top), D, T, BS, S (bottom).

1. One silver star is glued to the upper left corner of the paper and one in the upper right corner.

2574
Fiji. Mar 10–15, 1969. B: Orange, red-orange, violet-pink (Z), light blue (S). 42.5 × 42.5, cut[1]. Ed 20 (cR), 9 TI (ucR), BAT (cR), 3 AP (cR), 1 TP (cR), CP (ucR). Donald Kelley. D, T, S, BS.

1. Measured diagonally.

2575
Eat Up, America. Mar 10–15, 1969. B: Violet-pink, pink, violet (Z), light blue (S). 43.5 × 43.5, cut[1]. Ed 20 (cR), 9 TI (ucR), BAT (cR), 3 AP (cR), 1 TP (cR), CP (ucR). Donald Kelley. BS (Tam), D, S, BS (pr) (bottom), T (top).

1. Measured diagonally.

2576
An Affectionate Portrait of Sam Francis. Mar 10–15, 1969. B: Orange, red-orange, violet-pink (Z), light blue (S). 29.2 × 30.5, cut. Ed 20 (cR), 9 TI (ucR), BAT (cR), 3 AP (2 cR, 1 ucR), 1 TP (cR), CP (ucR). Donald Kelley. BS (Tam), T, BS (pr), S, D.

2577
The Fuzz on the Strip. Mar 10–15, 1969. B: Violet-pink, pink, violet (Z), light blue (S). 30.5 × 30.5, cut. Ed 20 (cR), 9 TI (ucR), BAT (cR), 3 AP (2 cR, 1 ucR), 1 TP (cR), CP (ucR). Donald Kelley. BS (Tam), T, D, BS (pr), S.

2578
Greedy Toadies. Mar 10–15, 1969. B: Orange, red-orange, violet-pink, pink, violet (Z), light blue (S). 59.7 × 20.3, cut. Ed 20 (cR), 9 TI (ucR), BAT (cR), 3 AP (2 cR, 1 ucR), 1 TP (cR), CP (ucR). Donald Kelley. T, D, S, BS.

2579
Surf's Up. Mar 11–23, 1969. Silver, green, B: blue, blue-violet, violet, dark blue-green, medium blue-green, light blue (S), B: red, yellow, brown (A). 76.2 × 58.4. ED 20 (cR), 9 TI (ucR), BAT (cR), 3 AP (2 ucR, 1 cR), 1 TP (cR), CP (cR). Jean Milant. BS (Tam), T, D, S, BS (pr).

2580
Proud Livery. Mar 17–27, 1969. Orange (Z), green, dark pink, red (A), violet, blue, B: light violet, pink, dark yellow, red (S). 63.5 × 94.0. Ed 16 (cR), 9 TI (8 ucR, 1 cR), BAT (cR), 1 CTP (cR), CP (cR). Ronald Glassman. BS (Tam), T, D, S, BS (pr).

2581
International High Life Society.
Mar 24–27, 1969. Gold or brown-green (S). 20.3 × 28.6. Ed 20 (ucR)[1], 9 TI (cR), BAT (ucR)[1], 3 AP (ucR)[1], 2 TP (1 ucR[1], 1 MI*), CP (cR). Daniel Socha. BS (bottom), D, T, S (top).

1. Ed 1–10/20, BAT, 1 TP, 1 AP printed in gold.

2582
Strangers in the Night. Mar 24–27, 1969. Gold or brown-green (S). 20.3 × 30.2. Ed 20 (ucR)[1], 9 TI (cR), BAT (ucR)[1], 2 AP (1 cR, 1 ucR), 2 TP (1 ucR[1], 1 MI*), CP (cR). Daniel Socha. T, BS, D, S.

1. Ed 1–10/20, BAT, 1 TP, printed in gold.

2590
An Hour with the Promotions Committee of the Art Department Department at San Jose State College is like two Months in the Country. Mar 24–27, 1969. Gold or brown-green (S). 58.8 × 56.2. Ed 20 (ucR)[1], 9 TI (cR), BAT (ucR)[1], 3 AP (ucR)[1], 3 TP (2 ucR[1], 1 MI)[2], CP (cR). Daniel Socha. T (top), D, BS, S[3] (bottom).

1. Ed 1–10/20, BAT, 2 TP (ucR), 2 AP printed in gold.
2. 2 TP (1 ucR, 1 MI), vary from the edition.
3. Inscribed in pencil by the artist within the image: Ill Randall, Maynard Stewart, Warren Faus, Robert Freimark, Harry Powers, James Lovera.

2606
Tamarind[1]. Apr 11–21, 1969. Orange (Z), brown-green (S), light violet (A). 83.8 × 50.8. Ed 20 (cR), 9 TI (ucR), BAT (cR), 3 AP (cR), 4 CTP (cR)[2], 2 CSP (cR)[3], CP (cR). John Sommers. T, BS, D, S[4] (bottom).

1. This lithograph was photographed and printed by Lynton Kistler as an offset lithograph poster to celebrate the occasion of the "Tamarind: Homage to Lithography" exhibition at the Museum of Modern Art.
2. 2 CTP inscribed by the artist in pencil within the image; one has a 5.1 × 1.3 rectangle cut out.
3. Unsigned, unchopped.
4. Inscribed in black ink by the artist: Tamarind National Forest no dragons.

Luchita Hurtado

2852
Untitled. Feb 17–Mar 4, 1970. Blue (S), gold (Z), black (A). 55.2 × 76.2, (CD), 55.9 × 76.2 (ucR) Ed 20 (ucR), 9 TI (CD), BAT (ucR), 2 AP (ucR), 5 TP (3 GEP, 1 wA, 1 ucR), 3 CTP (1 ucR, 1 GEP, 1 CD), CP* (CD). David Trowbridge. D, S, Dat, BS.

2853
Untitled. Mar 4–13, 1970. Pink-beige (Z), grey (S), green (A). 76.2 × 55.2, (CD), 76.2 × 55.9 (ucR). Ed 20 (CD), 9 TI (ucR), BAT (CD), 3 AP (CD), 3 TP* (CD), 3 PTP (1 bA, 1 wA, 1 GEP), CP (ucR). Edward Hamilton. D, BS, S.

Masuo Ikeda

1811
Dream of Summer, #2. Sep 9–Oct 6, 1966. Light green-grey (A), yellow (Z), blue (Z), dark grey (S). 76.2 × 58.1. Ed 20 (CD), 9 TI (GEP), BAT (CD), 3 AP (GEP), 3 TP (CD), CP (EVB). Ian Lawson. D, S, Dat, BS.

1812
Dream of Summer, #3. Sep 9–19, 1966. Blue, pink (Z), light blue, light pink (S), red-brown (S). 76.5 × 58.8. Ed 20 (CD), 9 TI (GEP), BAT (CD), 3 AP (GEP), 4 TP (CD), CP (EVB). Ernest de Soto. D, S, Dat, BS.

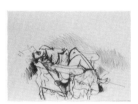

1813
First Drawing. Sep 12–13, 1966. Black (S). 56.2 × 76.2. Ed 20 (CD), 9 TI (GEP), BAT (CD), 3 AP (2 CD, 1 GEP). Robert Evermon. D, S, Dat, BS.

1814
My Bicycle in California. Sep 14–22, 1966. Green, blue (Z), black (S). 61.3 × 76.2. Ed 20 (CD), 9 TI (GEP), BAT (CD), 2 AP (1 CD, 1 GEP), 1 TP (CD), CP (EVB). Ian Lawson. D, S, Dat, BS.

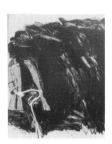

1817
Something Again, A. Sep 19–23, 1966. Red (Z), red-black (S). 67.3 × 52.1. Ed 20 (CD), 9 TI (MI), BAT (CD), 3 AP (MI), 2 TP (CD). Ernest de Soto. D, BS, S, Dat.

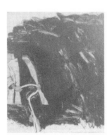

1817II
Something Again, B. Sep 27–29, 1966. Pink (Z)[1], dark grey (S)[2]. 66.0 × 52.1. Ed 10 (CD), 9 TI (MI), BAT (CD), 3 AP (MI), 2 TP (CD), CP (EVB). Ernest de Soto. D, BS, S, Dat.

1. Plate held from 1817, run 1.
2. Stone held from 1817, run 2. 1817II differs from 1817 in color and in image. A pink tone has been added as a rectangular area around the coat including the opening of the coat and in the figure's hands.

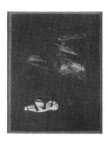

1818
Night of a Single Life. Sep 28–Oct 7, 1966. Red (Z), blue (Z), dark grey (S). 52.1 × 39.4. Ed 10 (CD), 9 TI (MI), BAT (CD), CP (EVB). Ernest de Soto. D, BS, S, Dat.

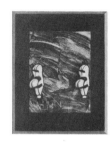

1818II
For Your Secret Night, A. Sep 28–Oct 6, 1966. Red (Z)[1], yellow (Z)[2], dark grey (S). 52.4 × 39.4. Ed 10 (CD), 9 TI (MI), BAT (CD), 3 AP (MI). Ernest de Soto. D, BS, S, Dat.

1. Plate held from 1818, run 1.
2. Plate held from 1818, run 2; before addition.

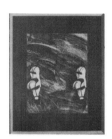

1818III
For Your Secret Night, B. Sep 28–Oct 17, 1966. Yellow (Z)[1], blue (Z)[2], red (S)[3]. 52.4 × 39.4. Ed 10 (9 CD, 1 MI), 9 TI (MI), BAT (CD), 2 AP (1 CD, 1 MI), CP (EVB). Ernest de Soto. D, BS, S, Dat.

1. Plate held from 1818, run 1.
2. Plate held from 1818, run 2, before additions.
3. Stone held from 1818II, run 3. 1818III differs from 1818II in color and in image. The color accent around the garter of the two figures has been eliminated.

1818IV
For Your Secret Night, C. Sep 28–Oct 11, 1966. Yellow (Z)[1], red (Z)[2], blue (S)[3]. 52.1 × 39.4. Ed 10 (CD), 9 TI (MI), BAT (CD), 3 AP (1 CD, 2 MI). Ernest de Soto. D, BS, S, Dat.

1. Plate held from 1818, run 1.
2. Plate held from 1818, run 2.
3. Stone held from 1818II, run 3. 1818IV differs from 1818III in color only.

1819
American Girl. Sep 23–28, 1966. Light green-grey, blue (Z), dark grey (S). 84.5 × 61.9. Ed 16 (CD), 9 TI (MI), BAT (CD), 3 AP (MI), 3 TP (CD)[1], CP (EVB). Ernest de Soto. D, S, Dat, BS.

1. 1 TP varies from the edition.

1820
Open Blouse. Sep 21–28, 1966. Light yellow-grey (Z), red (Z), black (S). 73.7 × 53.3. Ed 20 (CD), 9 TI (MI), BAT (CD), 3 AP (1 CD, 2 MI), 1 TP (CD), CP (EVB). Ian Lawson. D, BS, S, Dat.

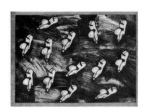

1821
Dream of Single Life, or, Night of Maurice. Sep 29–Oct 20, 1966. Dark pink (Z), grey (Z)[1], brown (S). 58.4 × 76.2. Ed 20 (CD)[1], 9 TI (MI)[1], BAT (CD), 3 AP (1 CD, 2 MI)[1], 2 TP (CD), CP (EVB). Maurice Sanchez. D, BS, S, Dat.

1. Ed 14–20/20, 9 TI, 2 AP (MI) vary from the edition.

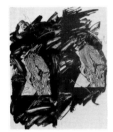

1822
Woman-Come from New York. Oct 10–11, 1966. Brown, ochre (S), blue, pink (S). 70.5 × 55.2. Ed 20 (CD), 9 TI (MI), BAT (CD), 3 AP (MI), 1 TP (CD), CP (EVB). Ernest de Soto. D, S, Dat, BS.

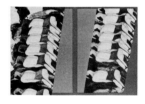

1823
Landscape from Window, A. Oct 18–24, 1966. Green (Z), red (Z), dark grey (S). 53.0 × 73.7. Ed 20 (CD), 9 TI (MI), BAT (CD), 2 AP (MI), 1 TP (CD). Ernest de Soto. Recto: D, S, Dat Verso: WS.

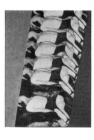

1823II
Landscape from Window, B.[1] Oct 25–28, 1966. Ochre (Z)[2], violet (Z)[3], dark grey (S)[4]. 53.3 × 36.8. Ed 20 (CD), 9 TI (GEP), BAT (C), 2 AP (GEP), 4 TP (CD). Ernest de Soto. D, BS, S, Dat.

1. Right half of 1823.
2. Plate held from 1823, run 1.
3. Plate held from 1823, run 2.
4. Stone held from 1823, run 3. 1823II differs from 1823 in color and in image. It is the right half of 1823.

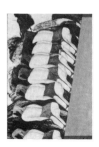

1823III
Landscape from Window, C[1]. Oct 25–28, 1966. Ochre (Z)[2], violet (Z)[3], dark grey (S)[4]. 53.0 × 36.8. Ed 20 (CD), 9 TI (GEP), BAT (C), 3 AP (GEP), 4 TP (CD). Ernest de Soto[5]. D, S, Dat, BS.

1. Left half of 1823.
2. Plate held from 1823, run 1.
3. Plate held from 1823, run 2.
4. Stone held from 1823, run 3. 1823III differs from 1823 in color and in image. It is the left half of 1823.
5. Erroneously chopped with Maurice Sanchez's chop, which appears lightly around that of EdS.

1823IV
Window at 1116 1/5. Oct 29, 1966. Dark grey (S)[1]. 72.4 × 49.5. Ed 10 (CD), 9 TI (MI), BAT (CD), 2 AP (MI), 1 TP (CD), CP (EVB). Ernest de Soto. D, S, Dat, BS.

1. Stone held from 1823, run 1; additions. 1823IV differs from 1823 in color, size, image, and in presentation as a vertical rather than a horizontal. Part of the image on the sides has been eliminated. The diagonal area in the center has been made solid. A wedge-shaped tonal area at the bottom has been eliminated.

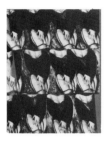

1824
Secret Year. Oct 21–29, 1966. Blue, red-violet (Z), brown-black (S). 62.2 × 45.1. Ed 20 (CD), 9 TI (MI), BAT (CD), 3 AP (MI), 3 TP* (CD), CP (EVB). Maurice Sanchez. BS, D, S, Dat.

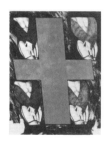

1825
Secret Season. Oct 21–29, 1966. Blue (Z), brown-black (S). 62.2 × 44.5. Ed 20 (CD), 9 TI (MI), BAT (CD), 3 AP (MI), 3 TP* (CD), CP (EVB). Maurice Sanchez. D, BS, S, Dat.

Paul Jenkins

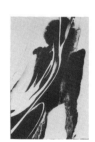

2060
Phenomena Synanon. Jul 10, 1967. Black (S). 62.9 × 39.7. Ed 20 (CD), 9 TI (GEP), BAT (CD), 9 AP (8 CD, 1 GEP), 2 TP (1 BFK, 1 CD), CP (CD). David Folkman. D, BS, S, Dat.

Alfred Jensen

A Pythagorean Notebook, a suite of twenty lithographs plus title and colophon pages, enclosed in a blue cloth covered box, measuring 61.0 × 44.4, lined with white coverstock, silk-screened with the suite title and the artist's name in white on the front cover, made by the Schuberth Bookbindery, San Francisco. The box is secured with leather straps and snaps. The title page and colophon printed at the Plantin Press, Los Angeles. In order: 1358, 1364, 1377, 1378, 1380, 1381, 1382, 1383, 1384, 1385, 1386, 1387, 1388, 1389, 1390, 1391, 1392, 1393, 1394, 1395.

1358
Untitled (A Pythagorean Notebook I). Jul 6–24, 1965. Blue (S), red-violet (A), black (A). 57.5 × 42.2. Ed 20 (BFK), 9 TI (wA), BAT (BFK), 3 AP (1 BFK, 2 wA), 4 TP (3 BFK, 1 wA), CP (Tcs). Kenneth Tyler. D, S, BS.

1364
Untitled (A Pythagorean Notebook II). Jul 2–16, 1965. Yellow (A), blue (S), red (A), violet (A), black (A). 42.2 × 57.2. Ed 20 (BFK), 9 TI (wA), BAT (BFK), 3 AP (1 BFK, 2 wA), 1 TP (BFK), CP (Tcs). Kenneth Tyler. D, S, BS.

1377
Untitled (A Pythagorean Notebook III). Jul 2–28, 1965. Yellow (A), blue (S), red (A), red-violet (A), black (A). 42.2 × 57.2. Ed 20 (BFK), 9 TI (wA), BAT (BFK), 3 AP (1 BFK, 2 wA), 3 TP (1 wA, 2 BFK), CP (Tcs). Kenneth Tyler. D, S, BS.

1378
Untitled (A Pythagorean Notebook IV). Jul 22–28, 1965. Yellow (A), blue (S), red (A), red-violet (A), black (A). 57.5 × 41.9. Ed 20 (BFK), 9 TI (wA), BAT (BFK), 3 AP (1 BFK, 2 wA), 3 TP (2 BFK, 1 wA), CP (Tcs). Kenneth Tyler. D, S, BS.

1380
Untitled (A Pythagorean Notebook V). Jun 1–11, 1965. Yellow (S), blue (S), red (S), violet (S), black (S). 42.5 × 57.2. Ed 20 (BFK), 9 TI (wA), BAT (BFK), 2 AP (wA), 1 TP* (BFK), CP (Tcs). Kenneth Tyler. D, S, BS.

1381
Untitled (A Pythagorean Notebook VI). Jun 2–15, 1965. Yellow (S), blue (S), red (S), violet (S), black (S). 57.2 × 42.2. Ed 20 (BFK), 9 TI (wA), BAT (BFK), 2 AP (wA), 2 TP (BFK), CP (Tcs). Kenneth Tyler. D, S, BS.

1382
Untitled (A Pythagorean Notebook VII). Jun 4–18, 1965. Yellow (A), blue (S), red (A), violet (A), black (A). 57.2 × 42.2. Ed 20 (BFK), 9 TI (wA), BAT (BFK), 2 AP (wA), 3 TP (2 BFK, 1 wA), CP (Tcs). Kenneth Tyler. D, S, BS.

1383
Untitled (A Pythagorean Notebook VIII). Jun 8–23, 1965. Yellow (A), blue (S), red (A), violet (A), black (S). 57.2 × 42.2. Ed 20 (BFK), 9 TI (wA), BAT (BFK), 2 AP (wA), 2 TP (1 wA, 1 BFK*), CP (Tcs). Kenneth Tyler. D, S, BS.

1384
Untitled (A Pythagorean Notebook IX). Jun 14–25, 1965. Yellow (A), blue (S), red (Z), violet (Z), black (S). 57.2 × 41.9. Ed 20 (BFK), 9 TI (wA), BAT (BFK), 2 AP (wA), 3 TP (Tcs), CP (Tcs). Kenneth Tyler. D, S, BS.

1385
Untitled (A Pythagorean Notebook X). Jun 14–21, 1965. Yellow (A), blue (S), red (A), violet (A), black (A). 57.2 × 41.9. Ed 20 (BFK), 9 TI (wA), BAT (BFK), 3 AP (wA), 2 TP (BFK), CP (Tcs). Kenneth Tyler. D, S, BS.

1386
Untitled (A Pythagorean Notebook XI). Jun 16–Jul 1, 1965. Yellow (A), blue (S), red (A), violet (A), black (A). 42.5 × 57.2. Ed 20 (BFK), 9 TI (wA), BAT (BFK), 2 AP (wA), 1 TP (BFK), CP (Tcs). Kenneth Tyler. D, S, BS.

1387
Untitled (A Pythagorean Notebook XII). Jun 18–29, 1965. Blue (S), yellow (A), red (S), red-violet (S), black (A), white (A). 42.5 × 57.2. Ed 20 (BFK), 9 TI (wA), BAT (BFK), 3 AP (1 BFK, 2 wA), 6 PP (BFK), 7 TP (2 BFK, 5 wA), 6 CPgP (BFK), CP (Tcs). Kenneth Tyler. D, S, BS.

1388
Untitled (A Pythagorean Notebook XIII). Jun 18–28, 1965. Black (A). 42.2 × 57.2. Ed 20 (BFK), 9 TI (wA), BAT (BFK), 2 AP (1 BFK, 1 wA), CP (Tcs). Kenneth Tyler. D, S, BS.

1389
Untitled (A Pythagorean Notebook XIV). Jun 17–Jul 2, 1965. Yellow (A), blue (S), red (A), violet (A), black (A). 42.2 × 57.2. Ed 20 (BFK), 9 TI (wA), BAT (BFK), 3 AP (1 BFK, 2 wA), 2 TP (BFK), CP (Tcs). Kenneth Tyler. D, S, BS.

1390
Untitled (A Pythagorean Notebook XV). Jun 21–Jul 9, 1965. Yellow (A), blue (S), red (A), violet (A), black (A). 42.2 × 57.2. Ed 20 (BFK), 9 TI (wA), BAT (BFK), 2 AP (1 BFK*, 1 wA), 1 TP* (BFK), CP (Tcs). Kenneth Tyler. D, S, BS.

1391
Untitled (A Pythagorean Notebook XVI). Jun 22–Jul 12, 1965. Yellow (A), blue (S), red (A), violet (A), black (A). 42.2 × 57.2. Ed 20 (BFK), 9 TI (wA), BAT (BFK), 3 AP (1 wA, 2 BFK), 2 TP (1 BFK, 1 wA), CP (Tcs). Kenneth Tyler. D, S, BS.

1392
Untitled (A Pythagorean Notebook XVII). Jun 23–Jul 12, 1965. Yellow (A), blue (S), green (S), red (A), red-violet (S), violet (A), black (A). 57.2 × 41.9. Ed 20 (BFK), 9 TI (wA), BAT (BFK), 3 AP (1 BFK, 2 wA), 2 TP (wA), CP (Tcs). Kenneth Tyler. D, S, BS.

1393
Untitled (A Pythagorean Notebook XVIII). Jun 25–Jul 20, 1965. Yellow (A), blue (S), red (A), violet (A), black (A). 42.2 × 57.2. Ed 20 (BFK), 9 TI (wA), BAT (BFK), 3 AP (1 BFK, 2 wA), 2 TP (BFK), CP (Tcs). Kenneth Tyler. D, S, BS.

1394
Untitled (A Pythagorean Notebook XIX). Jun 29–Jul 21, 1965. Yellow (A), blue (S), red (A), violet (A), black (A). 56.8 × 41.9. Ed 20 (BFK), 9 TI (wA), BAT (BFK), 3 AP (1 BFK, 2 wA), 5 TP (BFK), 1 PTP (nr)[1], CP (Tcs). Kenneth Tyler. D, S, BS.

1. Unsigned, unchopped, undesignated, retained by Tamarind.

1395
Untitled (A Pythagorean Notebook XX). Jun 29–Jul 21, 1965. Yellow (A), blue (S), red (A), violet (A), black (A). 41.9 × 57.2. Ed 20 (BFK), 9 TI (wA), BAT (BFK), 3 AP (1 BFK, 2 wA), 4 TP (BFK), 2 PTP (CD)[1], CP (Tcs). Kenneth Tyler. D, S, BS.

1. Unsigned, unchopped, undesignated, retained by Tamarind.

Ynez Johnston

Principalities, a suite of thirteen lithographs including title, colophon and cover page with text by John Berry. It is enclosed in a portfolio, measuring 40.6 × 62.5, covered with the title page (Tamarind #1651), lined with Rives BFK, made by Margaret Lecky, Los Angeles. In order: 1651, 1645, 1628, 1629, 1633, 1634, 1630, 1637, 1631, 1635, 1636, 1632, 1644.

The Black Pagoda, a suite of ten lithographs. In order: 1654, 1653II, 1655, 1653, 1660, 1656, 1656II, 1658, 1657, 1659.

Voyages, a suite of six lithographs. In order: 1643, 1642, 1641, 1639, 1640, 1638.

1600
Londinium. Nov 18–19, 1965. Black (S). 57.2 × 76.2. Ed 20 (BFK), 9 TI (wA), BAT (BFK), 2 AP (1 BFK, 1 wA), 2 TP (BFK), CP (Tcs). Kinji Akagawa. D, S, BS.

1628
Untitled (Principalities III). Jan 4–5, 1966. Black (S). 38.4 × 29.2. Ed 20 (wA), 9 TI (JG), BAT (wA), 3 AP (2 wA, 1 JG), 1 TP (wA). Walter Gabrielson. BS, S, D.

1628A
Untitled. Jan 4–5, 1966. Black (S).
38.7 × 17.8. Ed 20 (wA), 9 TI (JG),
BAT (wA), 3 AP (2 wA, 1 JG), 1 TP
(wA). Walter Gabrielson. BS, S, D.

1632
Untitled (Principalities XII). Jan 6–
10, 1966. Black (S). 38.4 × 29.2. Ed 20
(wA), 9 TI (JG), BAT (wA), 3 AP (1 wA,
2 JG), 1 TP (wA), CP (Tcs). Donn
Steward. BS, S, D.

1629
Untitled (Principalities IV). Jan 4–
5, 1966. Black (S). 38.7 × 29.5. Ed 20
(wA), 9 TI (JG), BAT (wA), 3 AP (wA).
Walter Gabrielson. BS, S, D.

1632A
Untitled. Jan 6–8, 1966. Black (S).
38.4 × 18.1. Ed 20 (wA), 9 TI (JG),
BAT (wA), 3 AP (2 wA, 1 JG), 1 TP
(wA), CP (Tcs). Donn Steward. BS, S,
D.

1630
Untitled (Principalities VII). Jan 5–
6, 1966. Black (S). 38.4 × 29.8. Ed 20
(wA), 9 TI (JG), BAT (wA), 3 AP (wA), 2
TP (wA), CP (Tcs). Kinji Akagawa. BS,
S, D.

1633
Untitled (Principalities V). Jan 6–8,
1966. Black (S). 38.4 × 29.2. Ed 20
(wA), 9 TI (JG), BAT (wA), 3 AP (JG), 1
TP (wA), CP (Tcs). Donn Steward. BS,
D, S.

1630A
Untitled. Jan 5–6, 1966. Black (S).
38.1 × 17.8. Ed 20 (wA), 9 TI (JG),
BAT (wA), 3 AP (wA), 2 PP (JG)[1], 2
TP (wA), CP (Tcs). Kinji Akagawa. BS,
S, D.

1. The customary designation
 "Presentation proof" was omitted.

1634
Untitled (Principalities VI). Jan 7–
11, 1966. Black (S). 38.4 × 29.8. Ed 20
(wA), 9 TI (JG), BAT (wA), 3 AP (2 wA,
1 JG), 2 TP (wA), CP (Tcs). Kinji
Akagawa. BS, S, D.

1631
Untitled (Principalities IX). Jan 5–
6, 1966. Black (S). 38.7 × 29.2. Ed 20
(wA), 9 TI (JG), BAT (wA), 3 AP (1 wA,
2 JG), 2 TP (wA), CP (Tcs). Kinji
Akagawa. BS, S, D.

1634A
Untitled. Jan 7–11, 1966. Black (S).
38.4 × 17.8. Ed 20 (wA), 9 TI (JG),
BAT (wA), 3 AP (2 wA, 1 JG), 2 TP
(wA), CP (Tcs). Kinji Akagawa. BS, S,
D.

1635
Untitled (Principalities X). Jan 7–11, 1966. Black (S). 38.4 × 29.2. Ed 20 (wA), 9 TI (JG), BAT (wA), 3 AP (2 wA, 1 JG), 2 TP (wA), CP (Tcs). Kinji Akagawa. BS, S, D.

1636
Untitled (Principalities XI). Jan 10–17, 1966. Red (S), black (S). 38.4 × 29.8. Ed 20 (wA), 9 TI (JG), BAT (wA), 3 AP (1 wA, 2 JG), 1 TP (wA), CP (Tcs). Clifford Smith. BS, S, D.

1637
Untitled (Principalities VIII). Jan 10–17, 1966. Ochre (S), black (S). 38.4 × 29.8. Ed 20 (wA), 9 TI (JG), BAT (wA), 3 AP (1 wA, 2 JG), 2 TP (wA), CP (Tcs). Clifford Smith. BS, D, S.

1638
Untitled (Voyages VI). Jan 17–Feb 11, 1966. Yellow-orange (S), violet-pink (S), blue-violet (S), black (S). 28.6 × 17.8. Ed 20 (wA), 9 TI (MI), BAT (wA), 3 AP (1 wA, 2 MI), 1 PP (nr), 2 TP (wA), CP (Tcs)[1]. Clifford Smith. D, BS, S.

1. Printed on same sheet with 1939–1943, untorn.

1639
Untitled (Voyages IV). Jan 17–Feb 11, 1966. Yellow-orange (S), violet-pink (S), blue-violet (S), black (S). 28.6 × 18.7. Ed 20 (wA), 9 TI (MI), BAT (wA), 3 AP (1 wA, 2 MI), 2 TP (wA), CP (Tcs)[1]. Clifford Smith. D, BS, S.

1. Printed on same sheet with 1638, 1640–1643, untorn.

1640
Untitled (Voyages V). Jan 17–Feb 11, 1966. Yellow-orange (S), violet-pink (S), blue-violet (S), black (S). 28.9 × 19.1. Ed 20 (wA), 9 TI (MI), BAT (wA), 3 AP (1 wA, 2 MI), 1 PP (nr), 2 TP (wA), CP (Tcs)[1]. Clifford Smith. D, BS, S.

1. Printed on same sheet with 1638–1639, 1641–1643, untorn.

1641
Untitled (Voyages III). Jan 17–Feb 11, 1966. Yellow-orange (S), violet-pink (S), blue-violet (S), black (S). 14.3 × 55.2. Ed 20 (wA), 9 TI (MI), BAT (wA), 3 AP (1 wA, 2 MI), 2 TP (wA), CP (Tcs)[1]. Clifford Smith. D, BS, S.

1. Printed on same sheet with 1638–1640, 1642–1643, untorn.

1642
Untitled (Voyages II). Jan 17–Feb 11, 1966. Yellow-orange (S), violet-pink (S), blue-violet (S), black (S). 13.3 × 55.6. Ed 20 (wA), 9 TI (MI), BAT (wA), 3 AP (1 wA, 2 MI), 2 TP (wA), CP (Tcs)[1]. Clifford Smith. D, BS, S.

1. Printed on same sheet with 1638–1641, 1643, untorn.

1643
Untitled (Voyages I). Jan 17–Feb 11, 1966. Yellow-orange (S), violet-pink (S), blue-violet (S), black (S). 56.2 × 21.3. Ed 20 (wA), 9 TI (MI), BAT (wA), 3 AP (1 wA, 2 MI), 1 PP (nr), 2 TP (wA), CP (Tcs)[1]. Clifford Smith. D, BS, S.

1. Printed on same sheet with 1638–1642, untorn.

1644
Colophon (Principalities XIII). Jan 14–28, 1966. Brown (S). 38.4 × 29.8. Ed 20 (wA), 9 TI (JG), BAT (wA), 3 AP (2 wA, 1 JG), 2 TP (wA)[1], CP (Tcs). Robert Evermon. BS, S, D.

1. 1 TP varies from the edition.

1645
Title Page (Principalities II). Jan 11–25, 1966. Orange (S), blue (Z), violet (S), black (S). 38.4 × 29.2. Ed 20 (wA), 9 TI (JG), BAT (wA), 3 AP (1 wA, 2 JG), 5 TP (wA), CP (Tcs). Robert Evermon. BS, S, D.

Print not in
University Art Museum
Archive

1651
Cover Page (Principalities I). Jan
21–26, 1966. Red (Z). 40.6 × 62.6,
(cover size). Ed 20 (wN), 9 TI (wN),
BAT (wN), 2 AP (wN), CP (Tcs). Ernest
Rosenthal. WS, S (in black ink), D (in
pencil).

Print not in
University Art Museum
Archive

1656II
Untitled (The Black Pagoda VII).
Feb 15–16, 1966. Black (S). 57.2 ×
77.2. Ed 10 (MI), 9 TI (wN), BAT (MI), 3
AP (1 MI, 2 wN). Ernest Rosenthal. BS,
D, S.

1653
Untitled (The Black Pagoda IV).
Jan 24–Feb 11, 1966. Yellow (Z), red
(Z), blue (S)[1], black (Z). 76.2 × 55.9.
Ed 20 (wA), 9 TI (JG), BAT (wA), 3 AP
(JG), 3 TP (wA), CP (Tcs). Ernest
Rosenthal. D, BS, S.

1. Stone held from 1653II. 1653 differs
 from 1653II in color and in image.
 The tone around the large bottom
 and small upper irregular shapes is
 lighter. Small color accents have
 been added throughout the image.

1657
Untitled (The Black Pagoda IX).
Feb 15–Mar 8, 1966. Green (S), light
blue (S), dark blue (S), dark violet (S).
76.2 × 56.2. Ed 20 (wA), 9 TI (MI), BAT
(wA), 2 AP (MI), 1 TP (wA), CP (Tcs).
Donn Steward. D, BS, S.

1653II
Untitled (The Black Pagoda II). Jan
24–Feb 2, 1966. Black (S). 80.0 × 57.8.
Ed 10 (CW), 9 TI (Millbourne), BAT
(CW), 3 AP (Millbourne). Ernest
Rosenthal. D, BS, S.

1658
Untitled (The Black Pagoda VIII).
Feb 16–Mar 4, 1966. Yellow (S), red-
brown (S), black (S). 76.2 × 55.9. Ed
20 (JG), 9 TI (wA), BAT (JG), 3 AP (2
wA, 1 JG), 4 TP (1 wA, 3 JG), CP (Tcs).
Ernest de Soto. D, BS, S.

1654
Untitled (The Black Pagoda I). Jan
25–Feb 8, 1966. Yellow (Z), violet (Z),
blue (Z), red-brown (S), black (Z). 55.9
× 76.2. Ed 20 (wA), 9 TI (JG), BAT
(wA), 3 AP (JG), 3 TP (wA)[1], CP (Tcs).
Kinji Akagawa. BS, S, D.

1. 1 TP varies from the edition.

1659
Untitled (The Black Pagoda X). Feb
18–Mar 8, 1966. Yellow (S), yellow-
orange (S), yellow-green (S), pink (S),
violet (S). 57.5 × 77.5. Ed 20 (wA), 9
TI (wN), BAT (wA), 3 AP (1 wA, 2 wN),
3 TP (wA), CP (Tcs). Kinji Akagawa. D,
BS, S.

1655
Untitled (The Black Pagoda III).
Feb 8–17, 1966. Yellow (Z), green (S),
blue-violet (Z), black (S). 76.2 × 56.8.
Ed 20 (wA), 9 TI (JG), BAT (wA), 3 AP
(JG), 2 TP (wA), CP (Tcs). Robert
Evermon. D, BS, S.

1660
Untitled (The Black Pagoda V). Feb
18–24, 1966. Red-brown (S). 58.4 ×
77.5. Ed 20 (wN), 9 TI (nN), BAT (wN),
2 AP (wN), 2 TP (wN), CP (Tcs). Kinji
Akagawa. D, BS, S.

1661
Guarded Wood. Mar 8–10, 1966. Pink
(Z), yellow-green (Z), blue-black (Z).
51.4 × 41.3. Ed 20 (CD)[1], 9 TI
(GEP)[1], BAT (CD), 3 AP (CD)[1], CP
(Tcs). Robert Evermon. BS, D, S.

1. Ed 8–20/20, 9 TI, 3 AP vary from the
 edition.

1656
Untitled (The Black Pagoda VI).
Feb 15–Mar 3, 1966. Yellow-green (S),
yellow-orange (S), light violet (S)[1],
black (S). 55.9 × 76.2. Ed 20 (JG), 9 TI
(CD), BAT (JG), 3 AP (1 JG, 2 CD), 4 TP
(JG), CP (Tcs). Ernest Rosenthal. D, S,
BS.

1. Stone held from 1656II. 1656 differs
 from 1656II in color and in image.
 The center rectangle has been
 lightened. Shapes in the border are
 darker. Color accents have been
 added throughout the image.

2869
Untitled. Apr 13–22, 1970. Green (S), orange (Z), violet (Z). 55.9 × 76.2. Ed 20 (JG), 9 TI (cR), BAT (JG), 1 AP (JG), CP* (cR). Hitoshi Takatsuki. Recto: BS Verso: D, S.

Allen Jones

A Fleet of Buses, a suite of five lithographs. In order: 1693, 1695, 1696, 1698, 1697.

A New Perspective on Floors, a suite of six lithographs. In order: 1740, 1699, 1700, 1704, 1702, 1703.

1258
Untitled. Mar 2–3, 1965. Black (S). 76.2 × 56.8. Ed 20 (BFK), 9 TI (wA), BAT (BFK), 2 AP (1 BFK, 1 wA), 2 PP (BFK), 1 TP (BFK), CP (Tcs). Kenneth Tyler. D, S, Dat, BS.

1427
Daisy, Daisy. Jul 24–26, 1965. Black (A). 48.3 × 62.2. Ed 20 (bA), 9 TI (bA), BAT (bA), 3 AP (bA), 2 PP (bA), 2 TP (bA), CP (Tcs). Clifford Smith. BS, D, S, Dat.

1693
Untitled (Fleet of Buses I). May 3–Jun 1, 1966. Red (Z), yellow (Z), blue (Z), black (Z). 63.5 × 55.9. Ed 20 (wA), 9 TI (GEP), BAT (wA), 3 AP (1 wA, 2 GEP), 4 TP (wA), CP (Tcs). Donn Steward. D, S, Dat, BS.

1694
Large Bus. May 3–24, 1966. Yellow (S), dark red (S), red-orange (S), blue (S). 72.4 × 108.0. Ed 20 (CD), 9 TI (GEP), BAT (CD), 3 AP (2 CD, 1 GEP), 3 TP (CD)[1], CP (Patina cover stock). Clifford Smith. D, T, S, Dat, BS.

1. 2 TP vary from the edition, on paper 74.9 × 108.0.

1694A
Large Bus, part 2.[1] May 3–Jun 1, 1966. Orange (Z), red (Z), blue (Z). 30.2 × 51.4. Ed 20 (CD), 9 TI (GEP), BAT (CD), 3 AP (1 CD, 2 GEP), 1 TP (CD), CP (Tcs). Clifford Smith. Verso: D, T, S, Dat, WS.

1. Hinged to 1694, at lower center.

1695
Untitled (Fleet of Buses II). May 4–18, 1966. Light grey (Z), medium grey (S), dark grey (S), light blue (Z), black (S). 63.8 × 55.9. Ed 20 (wA), 9 TI (GEP), BAT (wA), 2 AP (GEP), 2 TP (wA), CP (Tcs). Ernest de Soto. D, S, Dat, BS.

1696
Untitled (Fleet of Buses III). May 4–26, 1966. Red (Z), green (Z), yellow (Z), blue (Z). 63.5 × 55.9. Ed 20 (wA), 9 TI (GEP), BAT (wA), 3 AP (GEP), 5 TP (wA)[1], CP (Tcs). Kinji Akagawa. D, S, Dat, BS.

1. 1 TP varies from the edition.

1697
Untitled (Fleet of Buses V). May 16–Jun 10, 1966. Red (Z), light pink (Z), silver (Z), black (Z). 63.5 × 55.9. Ed 20 (wA), 9 TI* (GEP), BAT (wA), 2 AP (GEP), 4 TP (wA), CP (Tcs). John Dowell. D, S, Dat, BS.

1698
Untitled (Fleet of Buses IV). May 27–Jun 20, 1966. Red (S), green (S), yellow (Z). 63.8 × 55.9. Ed 20 (wA), 9 TI (GEP), BAT (wA), 3 AP (1 wA, 2 GEP), 4 TP (wA), CP (EVB). Clifford Smith. D, S, Dat, BS.

1699
Untitled (New Perspective on Floors II). May 26–Jun 8, 1966. Red (Z), light pink (Z), blue (S), green (S). 76.5 × 55.9. Ed 20 (wA), 9 TI (CD), BAT (wA), 3 AP (CD), 4 TP (wA)[1], CP (Tcs). Ernest de Soto. D, S, Dat, BS.

1. 1 TP varies from the edition.

1700
***Untitled (New Perspective on
Floors III).*** May 27–Jun 13, 1966.
Yellow (Z), light green (Z), dark green
(S), black (Z). 76.5 × 56.2. Ed 20 (wA),
9 TI (CD), BAT (wA), 4 TP (wA), CP
(Tcs). Jack Lemon. D, S, Dat, BS.

1702
***Untitled (New Perspective on
Floors V).*** Jun 2–20, 1966. Yellow (Z),
light blue (Z), red (Z), black (S). 76.2 ×
55.9. Ed 20 (wA), 9 TI (CD), BAT (wA),
2 AP (CD), 5 TP (wA), 1 proof (bA)[1],
CP (EVB). Donn Steward. BS, D, S.

1. Pulled for paper testing,
 inadvertently designated "Trial
 Proof." Unsigned, defaced,
 unchopped, retained by Tamarind.

1703
***Untitled (New Perspective on
Floors VI).*** Jun 3–24, 1966. Red (Z),
grey (Z), blue (Z), black (Z). 76.2 ×
55.9. Ed 20 (wA), 9 TI (CD), BAT (wA),
3 AP (CD), 3 TP (wA), CP (EVB). Robert
Evermon. D, S, Dat, BS.

1704
***Untitled (New Perspective on
Floors IV).*** Jun 8–29, 1966. Green (Z),
pink (Z), red-brown (S), dark green (Z),
black (Z). 76.5 × 55.9. Ed 20 (wA), 9 TI
(CD), BAT (wA), 3 AP (CD), 5 TP (wA),
CP (EVB). Jack Lemon. D, S, Dat, BS.

1740
***Untitled (New Perspective on
Floors I).*** Jun 17–30, 1966. Dark
yellow (Z), grey (Z), black (Z). 76.2 ×
56.2. Ed 20 (wA), 9 TI* (CD), BAT (wA),
3 AP (2 wA, 1 CD), 1 TP (wA), CP
(EVB). John Dowell. D, S, Dat, BS.

1741
Subtle Siren. Jun 27–29, 1966. Black
(S). 57.2 × 76.5. Ed 20 (CD), 9 TI
(GEP), BAT (CD), 1 AP (GEP), 1 TP
(CD), CP (EVB). Robert Evermon. D, S,
Dat, BS.

John Paul Jones

670
Untitled. Nov 5–8, 1962. Black (S).
48.6 × 44.8. Ed 10 (BFK), 9 TI (wA),
PrP (BFK), 1 PP (BFK). Bohuslav Horak.
D, S, BS.

671
Friday's Lesson. Nov 9–12, 1962.
Black (S). 56.8 × 38.7. Ed 20 (BFK), 9
TI (wN), PrP (BFK), PrP II for Bohuslav
Horak (BFK), 2 AP (wN), 2 PP (BFK), 1
TP (BFK). Donald Roberts. T, D, BS, S.

671A
Untitled. Nov 19–21, 1962. Black
(S)[1]. 38.1 × 57.2. Ed 20 (BFK), 9 TI
(wA), PrP (BFK), PrP II for Bohuslav
Horak (wA), 3 AP (BFK), 1 PP (BFK).
Joe Zirker. D, I, BS.

1. Stone held from 671; deletions.
 671A differs from 671 in image and
 in presentation as a horizontal. All
 of the background and part of the
 face and shoulders of the figure
 have been eliminated.

676A
Untitled. Nov 21–28, 1962. Black (S).
28.6 × 19.1. Ed 20 (BFK), 9 TI (wA),
PrP (BFK), PrP II for Bohuslav Horak
(BFK), 3 AP (1 BFK, 2 wA). Joe Zirker.
D, I, BS.

676B
Untitled. Nov 21–28, 1962. Black (S).
28.3 × 19.1. Ed 20 (BFK), 9 TI (wA),
PrP (BFK), PrP II for Bohuslav Horak
(BFK), 3 AP (1 BFK, 2 wA). Joe Zirker.
D, I, BS.

677
Untitled. Nov 21–26, 1962. Grey (S).
19.7 × 28.6. Ed 20 (BFK), 9 TI (nN),
PrP (BFK), PrP II for Bohuslav Horak
(BFK), 3 AP (2 BFK, 1 nN). Joe Zirker.
D, BS, I.

681A
Untitled. Nov 26–29, 1962. Black (S). 38.1 × 28.3. Ed 20 (BFK), 9 TI (wA), PrP (BFK), 3 AP (2 BFK, 1 wA), 2 PP (1 BFK, 1 wA). Joe Zirker. BS, D, I.

681B
Untitled. Nov 26–29, 1962. Black (S). 38.1 × 28.6. Ed 20 (BFK), 9 TI (wA), PrP (BFK), 3 AP (2 BFK, 1 wA), 2 PP (1 BFK, 1 wA). Joe Zirker. BS, D, I.

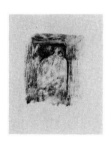

683
Untitled. Nov 28–30, 1962. Black (S). 38.1 × 28.6. Ed 20 (BFK), 9 TI (wA), PrP (BFK), PrP II for Bohuslav Horak (BFK), 3 AP (1 BFK, 2 wA), 2 PP (BFK). Joe Zirker. I, BS, D.

685A
Untitled. Nov 29–Dec 4, 1962. Black (S). 38.7 × 28.6. Ed 20 (BFK), 9 TI (nN), PrP (BFK), 3 AP (2 BFK, 1 nN), 3 PP (BFK). Joe Zirker. BS, D, I.

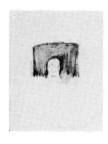

685B
Untitled. Nov 29–Dec 4, 1962. Black (S). 19.4 × 14.6. Ed 20 (BFK), 9 TI (nN), PrP (BFK), 3 AP (2 BFK, 1 nN), 3 PP (BFK). Joe Zirker. BS, D, I.

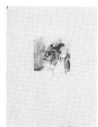

685C
Untitled. Nov 29–Dec 4, 1962. Black (S). 20.0 × 14.6. Ed 20 (BFK), 9 TI (nN), PrP (BFK), 3 AP (2 BFK, 1 nN), 3 PP (BFK). Joe Zirker. BS, D, I.

685D
Untitled. Nov 29–Dec 4, 1962. Black (S). 38.7 × 14.6. Ed 20 (BFK), 9 TI (nN), PrP (BFK), 3 AP (2 BFK, 1 nN), 3 PP (BFK). Joe Zirker. BS, D, I.

687A
Untitled. Dec 3–7, 1962. Black (S). 38.1 × 28.6. Ed 20 (BFK), 9 TI (wA), PrP (BFK), PrP II for Bohuslav Horak (BFK), 3 AP (2 BFK, 1 wA), 2 PP (BFK). Joe Zirker. D, BS, I.

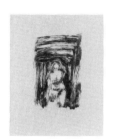

687B
Untitled. Dec 3–7, 1962. Black (S). 38.1 × 28.9. Ed 20 (BFK), 9 TI (wA), PrP (BFK), PrP II for Bohuslav Horak (BFK), 3 AP (2 BFK, 1 wA), 2 PP (BFK). Joe Zirker. D, BS, I.

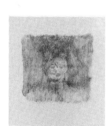

689
Untitled. Dec 5–6, 1962. Black (S). 57.2 × 48.3. Ed 20 (BFK), 9 TI (wA), PrP (BFK), PrP II for Bohuslav Horak (BFK), 2 AP (1 BFK, 1 wA), 2 PP (BFK), 2 TP (BFK). John Rock. D, BS, I.

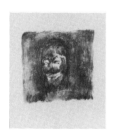

694
Brown Knight. Dec 11–19, 1962. Black (S), light blue (Z), brown (Z)[1]. 56.8 × 45.7. Ed 20 (BFK), 9 TI (wA), PrP (BFK), 3 AP (2 BFK, 1 wA), 3 PP (2 BFK, 1 wA), 2 TP (BFK). Joe Zirker. BS, D, I.

1. Same image as run 1, transferred to plate.

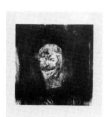

694A
Untitled. Dec 20–22, 1962. Black (S)[1]. 56.8 × 48.3. Ed 20 (BFK), 9 TI (wA), PrP (BFK), 3 AP (1 BFK, 2 wA), 1 PP (BFK), 2 TP (BFK). Joe Zirker. BS, D, I.

1. Stone held from 694, run 1; additions. 694A differs from 694 in color and in image. The background has been darkened considerably and extended to define a straight edged rectangle. The neck area has been lightened slightly.

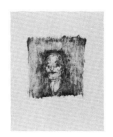

695
Untitled. Dec 11–12, 1962. Black (Z).
76.2 × 57.2. Ed 20 (BFK), 9 TI (wA),
PrP (BFK), PrP II for Bohuslav Horak
(BFK), 3 AP (2 BFK, 1 wA), 2 PP (BFK),
2 TP (1 wA, 1 nN). Joe Zirker. D, BS, I.

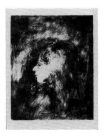

699
Woman in the Wind. Dec 20–26,
1962. Black (Z). 76.2 × 55.9. Ed 10
(BFK), 9 TI (BFK), PrP (BFK), PrP II for
Bohuslav Horak (BFK), 1 PP (BFK)[1].
John Rock. D, BS, I.

1. Printed on the verso: James
 McGarrell, "Head, #691."

700
Untitled. Dec 22–26, 1962. Black (S).
56.5 × 52.7. Ed 20 (BFK), 9 TI (wA),
PrP (BFK), 3 AP (1 BFK, 2 wA), 2 PP
(BFK), 2 TP (BFK). Joe Zirker. BS, D, I.

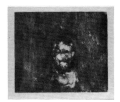

703
Untitled. Dec 27, 1962–Jan 2, 1963.
Black (S). 38.1 × 42.2. Ed 20 (bA), 9 TI
(bA), PrP (bA), 3 AP (2 bA, 1 nN), 3 PP
(1 bA, 2 nN), 2 TP (bA). Joe Zirker. D,
BS, I.

711
Girl for Goya. Jan 4–11, 1963. Black
(S). 76.2 × 56.2. Ed 20 (BFK), 9 TI
(wA), PrP (BFK), PrP II for Bohuslav
Horak (BFK), 3 AP (BFK), 1 PP (wA).
Joe Zirker. BS, D, I.

712
Young Girl. Jan 4–7, 1963. Black (S).
76.2 × 56.2. Ed 20 (BFK), 9 TI (wA),
PrP (BFK), 3 AP (BFK), 3 PP (BFK). Joe
Zirker. D, BS, I.

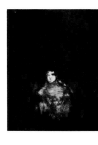

712A
Spanish Woman. Jan 14–16, 1963.
Black (S)[1]. 66.0 × 48.6. Ed 20 (bA), 9
TI (bA), PrP (bA), PrP II for Bohuslav
Horak (bA), 3 AP (bA), 1 PP (bA), 1 TP
(BFK). Joe Zirker. BS, D, I.

1. Stone held from 712; additions.
 712A differs from 712 in image and
 in size. A dark bleed tone has been
 added all around the figure. The
 hair has been filled in. The torso
 has been darkened eliminating
 most of the linear drawing.

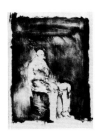

723
Night Lady. Jan 18–21, 1963. Black
(S). 63.5 × 48.3. Ed 20 (BFK), 9 TI
(wA), PrP (BFK), PrP II for Bohuslav
Horak (BFK), 3 AP (BFK), 2 PP (BFK), 1
TP (bA). Joe Zirker. BS, D, I.

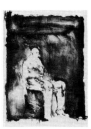

725
Bovitch in Egypt. Jan 21–23, 1963.
Black (S). 94.3 × 66.0. Ed 20 (BFK), 9
TI (BFK), PrP (BFK), PrP II for Bohuslav
Horak (BFK), 3 AP (BFK), 1 PP (BFK).
Joe Zirker. BS (Tam), D, BS (pr), I.

727
Girl with Fat Legs. Jan 23–24, 1963.
Black (S). 71.1 × 48.3. Ed 20 (BFK), 9
TI (wA), PrP (BFK). Joe Zirker. D, BS
(Tam), I, BS (pr).

728
Bovitch in Italy. Jan 25–28, 1963.
Black (S). 63.5 × 48.3. Ed 20 (wA), 9 TI
(wA), PrP (wA), 1 TP (bA). Joe Zirker.
BS, D, I.

Raymond Jonson

1302
A. Print, 1965. Apr 14–15, 1965.
Black (S). 38.4 × 52.7. Ed 15 (BFK), 9
TI (wA), 1 UNMI (BFK), PrP (BFK), 2 AP
(BFK), 2 PP (BFK) 1 TP (BFK). Robert
Evermon, NC. BS (Tam), T, D, S, BS
(UNM).

1305
B. Print, 1965. Apr 20–21, 1965.
Black (S). 38.1 × 50.8. Ed 15 (BFK), 9
TI (wA), 1 UNMI (BFK), PrP (BFK), 2 AP
(BFK). John Beckley, NC. BS (Tam), T,
D, S, BS (UNM).

1306
C. Print, 1965. Apr 21–25, 1965.
Yellow (S), red (S), blue (S), black (S),
green (S). 56.8 × 76.2. Ed 15 (BFK), 9
TI (wA), 1 UNMI (BFK), PrP (BFK), 1 AP
(BFK), 2 TP (BFK). Robert Evermon,
NC. BS (Tam), T, D, S, BS (UNM).

Reuben Kadish

298
Untitled. May 24–29, 1961. Black (Z).
53.3 × 38.4. Ed 10 (BFK), 9 TI (wA),
PrP (BFK), 1 AP (wA). Bohuslav Horak.
D, BS, S.

303
Untitled. May 26–Jun 7, 1961. Black
(S). 89.2 × 64.1. Ed 10 (BFK), 9 TI
(wN)[1], PrP (BFK), 2 AP (wN).
Bohuslav Horak. D, BS, S.

1. Unsigned and undesignated.

304
Untitled. May 30–Jun 5, 1961. Black
(S). 76.2 × 56.8. Ed 20 (wA), 9 TI
(BFK), PrP (BFK), 7 AP (wA), 1 TP
(wA)[1]. Bohuslav Horak. D, S, Dat,
BS.

1. An unrecorded lithograph is printed
 on the verso.

308
Untitled. Jun 3–6, 1961. Black (S).
76.2 × 56.5. Ed 15 (BFK), 9 TI (wA),
PrP (BFK), 4 AP (1 BFK, 3 wA).
Bohuslav Horak. S, Dat, D, BS.

314
Untitled. Jun 9, 1961. Black (S). 76.2
× 56.8. Ed 18 (wA)[1], 9 TI (BFK), PrP
(wA), 3 AP (1 BFK, 2 wA[2]), 3 TP (1
BFK, 2 wA). Bohuslav Horak. S, Dat, D,
BS.

1. The artist did not sign his edition
 while at Tamarind.
2. 1 AP varies from the edition.

315
Untitled. Jun 12–15, 1961. Black (S).
76.2 × 56.5. Ed 20 (BFK), 9 TI (wA),
PrP (BFK), 2 AP (1 BFK, 1 wA), 3 TP (2
wA, 1 bA)[1]. Bohuslav Horak. S, Dat,
D, BS.

1. 2 TP (1 wA, 1 bA) vary from the
 edition.

316
Untitled. Jun 12–13, 1961. Black (S).
76.2 × 56.8. Ed 20 (BFK), 9 TI (wA),
PrP (BFK), 1 AP (wA), 1 TP (BFK).
Bohuslav Horak. S, Dat, D, BS.

321
Untitled. Jun 16–19, 1961. Black (S).
76.2 × 56.5. Ed 20 (wA), 9 TI (BFK),
PrP (wA), 3 AP (2 BFK, 1 wA*).
Bohuslav Horak. BS, Dat, D, S.

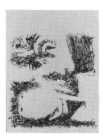

321A
Untitled. Jun 19–21, 1961. Black
(S)[1]. 76.8 × 56.8. Ed 10 (wA), 9 TI
(wN), PrP (wA), 3 AP (1 wA, 1 wN, 1
BFK[2]). Bohuslav Horak. BS (pr), S,
Dat, D, BS (Tam).

1. Stone held from 321; deletions.
 321A differs from 321 in image. The
 upper third of the image and all of
 the detail within the shapes has
 been eliminated. The image has
 been turned 90 degrees and a
 margin added on all four sides.
2. Signed in a horizontal format.

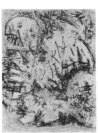

325
Untitled. Jun 22–26, 1961. Grey (S),
black (S). 76.8 × 56.8. Ed 20 (BFK), 9
TI (wN)[1], PrP (BFK), 1 AP (wN), 2 TP*
(BFK), CP (BFK). Bohuslav Horak. S, D,
BS.

1. Unsigned and undesignated.

Matsumi Kanemitsu

Mikey Mouse Series, a suite of
nineteen lithographs including title
page, enclosed in a shaped black
leather covered box, measuring 27.9
× 41.9, lined with grey plastic foam,
closed with a hinged lid, made by the
Earle Grey Bookbinding Co. Los
Angeles. Each lithograph enclosed in
a chemise of white Tableau paper. In
order: 2940, 2881, 2882, 2883, 2884,
2885, 2886, 2887, 2888, 2889, 2923,
2924, 2925, 2926, 2927, 2928, 2929,
2930, 2931.

Of the 3 AP listed with each suite
entry, except 2940, 1 AP is cut into 9
images of which 2887–2889 are on
ucR; 1 AP is cut vertically into three
images on paper 61.0 × 25.4; 1 AP is
cut horizontally into three images on
paper 20.3 × 76.2.

203
Untitled. Jan 8–9, 1961. Black (S).
38.4 × 56.5. Ed 10 (BFK), 9 TI (nN),
PrP (BFK), CP (BFK). Bohuslav Horak.
BS (Tam), D, S, Dat, BS (pr).

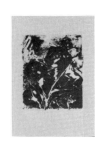

205
Spring. Jan 9–10, 1961. Black (Z).
56.8 × 38.7. Ed 12 (wA), 9 TI (BFK),
PrP (wA), 2 AP (BFK), CP (wA).
Bohuslav Horak. BS (Tam), D, S, Dat,
BS (pr).

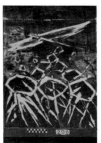

206
Spectre. Jan 10–12, 1961. Black (S).
76.8 × 56.5. Ed 20 (BFK), 9 TI (wN),
PrP (BFK), 3 AP (wN), CP (BFK).
Bohuslav Horak. BS (Tam), D, S, Dat,
BS (pr).

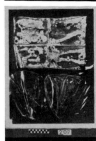

207
Still Life. Jan 12–13, 1961. Black (S).
76.8 × 56.5. Ed 10 (bA), 9 TI (nN), PrP
(bA), 1 AP (nN). Bohuslav Horak. BS
(Tam), D, S, Dat, BS (pr).

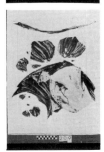

209
Sunday. Jan 16–17, 1961. Black (S).
76.8 × 56.5. Ed 20 (bA), 9 TI (nN), PrP
(bA), 2 AP (nN), CP (bA). Bohuslav
Horak. BS (Tam), D, S, Dat, BS (pr).

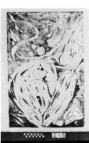

215
Wind II. Jan 18–20, 1961. Green-black
(S). 76.5 × 56.5. Ed 20 (bA), 9 TI (wN),
PrP (bA), 2 AP (bA), 3 TP (bA), CP
(wN). Bohuslav Horak. BS (Tam), D, S,
Dat, BS (pr).

216
Erection. Jan 22–23, 1961. Black (S).
76.5 × 56.8. Ed 10 (wA), 9 TI (BFK),
PrP (wA). Bohuslav Horak. BS (Tam),
D, S, Dat, BS (pr).

217
Wind I. Feb 17, 1961. Black (S). 76.2
× 56.5. Ed 12 (BFK), 9 TI (wA), PrP
(BFK), 2 AP (1 BFK, 1 wA), 2 TP (wA).
Bohuslav Horak. BS (Tam), D, S, Dat,
BS (pr).

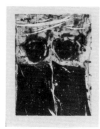

218
Winter. Jan 25–26, 1961. Black (S).
76.8 × 56.5. Ed 20 (BFK), 9 TI (wN),
PrP (BFK), 5 AP (2 BFK, 3 wN), 2 TP
(BFK), CP (BFK). Bohuslav Horak. BS
(Tam), D, S, Dat, BS (pr).

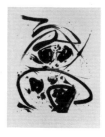

219
Brigitte Bardot. Jan 27, 1961. Black
(S). 76.2 × 56.8. Ed 10 (wA), 9 TI (bA),
PrP (wA), 1 AP (wA), CP (wA).
Bohuslav Horak. BS (Tam), D, S, Dat,
BS (pr).

223A
Color Formation II. Jan 30–Feb 2,
1961. Red (S), black (S). 76.5 × 56.8.
Ed 10 (wA), 9 TI (wN), PrP (wA), 5 AP
(1 wA, 4 wN). Bohuslav Horak. BS
(Tam), D, S, Dat, BS (pr).

223B
Color Formation I. Jan 30–Feb 3,
1961. Red (S)[1], black (S)[2], green-
grey (S). 76.2 × 56.5. Ed 12 (wA), 9 TI
(BFK), PrP (wA), 2 AP (wA), 3 TP (BFK),
1 CTP (BFK). Bohuslav Horak. BS
(Tam), D, S, Dat, BS (pr).

1. Stone held from 223A, run 1.
2. Stone held from 223A, run 2. 223B
 differs from 223A in color and in
 image. Wash drawing has been
 added around and in all the open
 areas of the image leaving a small
 margin.

230
Night I (H), and Night II (V). Feb 6–
9, 1961. Grey (S), black (S). 76.2 ×
56.5. Ed 18 (wA)[1], 9 TI (BFK)[1], PrP
(wA), 3 AP (wA). Joe Funk. BS (Tam),
D, S, Dat, BS (pr).

1. Indicates vertical presentation: Ed
 1–9/18, 9 TI.

232
Zen Blue. Feb 13–16, 1961. Blue (S),
black (S). 76.8 × 57.2. Ed 15 (BFK), 9
TI (wN), PrP (BFK), 2 AP (BFK), 5 TP
(BFK)[1]. Joe Funk. BS (Tam), D, S,
Dat, BS (pr).

1. 1 TP varies from the edition, may
 be designated "State Proof."

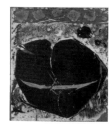

233
Oxnard Madame. Feb 14–27, 1961.
Orange (S), red (S), brown-green (S),
black (S). 46.4 × 38.1. Ed 25 (BFK)[1],
9 TI (wA), PrP (BFK), 2 AP (BFK), 3 TP
(BFK)[2], 12 PgP (6 wA[3], 6 BFK). Joe
Funk. BS (Tam), S, Dat, D, BS (pr).

1. Ed 16–25/25 vary from the edition.
2. 1 TP varies from the edition and
 may be designated "First State
 Proof."
3. 5 PgP (wA) retained by Tamarind.

237

Lovers. Feb 21–Mar 1, 1961. Grey-beige or dark yellow-beige (Z)[1], black (Z). 104.1 × 73.7. Ed 25 (BFK)[2], 9 Tl (wN), PrP[2] (BFK)[3], 7 AP (3 BFK[3], 4 wN)[2], 4 TP (BFK). Garo Z. Antreasian. BS (Tam), D, S, Dat, BS (pr).

1. Edition exists in two color variations. Variation I in grey-beige and black and Variation II in dark yellow-beige and black.
2. Indicates Variation II, Ed 16–25/25, PrP, 3 AP (2 BFK, 1 wN).
3. PrP, 1 TP, 1 AP vary from the edition.

1553

Tam. 1, 1965. Oct 18–20, 1965. Black (S). 65.1 × 47.3. Ed 20 (bA), 9 Tl (CD), BAT (bA), 1 AP (CD), 2 TP (bA), CP (Tcs). Kinji Akagawa. BS, D, S, Dat.

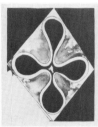

1554

Tam. 2, 1965. Oct 19–21, 1965. Brown-black (S). 55.9 × 57.2. Ed 20 (wN), 9 Tl (nN), BAT (wN), 1 AP (nN), 2 TP (wN). Kinji Akagawa. D, BS, S, Dat.

1555

Tam. 3, 1965. Oct 21–26, 1965. Black (S). 58.5 × 66.0. Ed 20 (BFK), 9 Tl (CD), BAT (BFK), 3 AP (2 BFK, 1 CD[1]), 1 TP (BFK)[1], CP (Tcs). Kinji Akagawa. BS, S, Dat, D.

1. 1 AP, 1 TP on paper 23 × 26 with 1556, untorn.

1556

Tam. 4, 1965. Oct 21–26, 1965. Black (S). 58.5 × 66.0. Ed 20 (BFK), 9 Tl (CD), BAT (BFK), 3 AP (2 BFK, 1 CD[1]), 1 TP (BFK)[1], CP (Tcs). Kinji Akagawa. D, BS, S, Dat.

1. 1 AP, 1 TP on paper 23 × 26 with 1555, untorn.

1573

Salt and Lake. Nov 4–11, 1965. Black (S). 62.2 × 90.5. Ed 9 (BFK), 9 Tl (CD), BAT (BFK), 3 AP (1 BFK, 2 CD), 2 TP (BFK), CP (Tcs). Clifford Smith. BS, S, Dat, D.

1574

Tam. 7, 1965. Oct 29–30, 1965. Grey-green (S)[1], red-orange (A). 56.2 × 56.2. Ed 20 (wA), 9 Tl (MI), BAT (wA), 3 AP (1 wA, 2 MI), 3 TP (wA), CP (Tcs). Kinji Akagawa. D, BS, S, Dat.

1. Stone held from 1554; deletions. 1574 differs from 1554 in color and in image. The image is the same except for being lighter over-all and the deletion of a small white dot at the lower left of the central diamond.

1575

Tam. 9, 1965. Nov 1–4, 1965. Orange (S), red (A), black (A). 57.2 × 53.3. Ed 20 (BFK), 9 Tl (wA), BAT (BFK), 2 AP (wA), CP (Tcs). Ernest de Soto. D, BS, S, Dat.

1576

Tam. 5, 1965 Oct 22–27, 1965. Black (S). 56.2 × 53.3. Ed 20 (wA), 9 Tl (CD), BAT (wA), 3 AP (wA), CP (Tcs). John Rock. D, BS, S, Dat.

1577

Tam. 12, 1965. Oct 23–26, 1965. Black (S). 56.2 × 83.8. Ed 20 (BFK), 9 Tl (CD), BAT (BFK), 2 AP (1 BFK, 1 CD), 1 TP (BFK). Jurgen Fischer. BS, S, Dat, D.

1578

Tam. 8, 1965. Oct 30–Nov 2, 1965. Green-black (S). 55.9 × 57.2, (diameter). Ed 20 (BFK), 9 Tl (wA), BAT (BFK), 1 AP (wA), CP (Tcs). Jurgen Fischer. D, BS, S, Dat.

1579

Tam. 10, 1965. Nov 2–3, 1965. Black (S). 76.8 × 56.5. Ed 20 (bA), 9 Tl (nN), BAT (bA), 1 AP (bA), 2 TP (bA). John Rock. BS, D, S, Dat.

1580
Tam. 11, 1965. Nov 4–10, 1965.
Green (A), red (S)[1], black (A), silver-black (A). 76.2 × 56.5. Ed 20 (wA), 9 TI (CD), BAT (wA), 1 TP (wA), CP (Tcs). John Rock. D, BS, S, Dat.

1. Stone held from 1579, deletions. 1580 differs from 1579 in color and in image. The footprints and horizontal line at the top and horizontal line and drawing below have been eliminated. Bleed horizontal bands have been added at top and bottom. The central curvilinear shape is lighter and a bleed tone has been added to either side.

1581
Tam. 6, 1965. Nov 10–11, 1965. Blue (A). 56.8 × 53.3. Ed 20 (BFK), 9 TI (wA), BAT (BFK), 3 AP (1 BFK, 2 wA), 1 TP (BFK), CP (Tcs). Robert Evermon. BS, S, Dat, D.

1582
Tam. 14, 1965. Nov 11–16, 1965. Black (S). 52.1 × 52.1. Ed 20 (wA), 9 TI (CD), BAT (wA), 1 AP (CD), 4 TP (wA)[1], CP (Tcs). Walter Gabrielson. BS, S, Dat, D.

1. 3 TP vary from the edition.

1996
Silence (Hollywood Series). Apr 22–26, 1967. Black (S). 66.7 × 94.6. Ed 20 (BFK), 9 TI (MI), BAT (BFK), 3 AP (2 MI, 1 BFK), 2 TP (BFK), CP (BFK). Maurice Sanchez. BS, D, S, Dat.

1997
Escape (Hollywood Series). Apr 13–15, 1967. Black (S). 56.8 × 76.2. Ed 20 (BFK), 9 TI (wA), BAT (BFK), 2 TP (BFK). Maurice Sanchez. BS, D, S, Dat.

1997II
Escape II (Hollywood Series). Apr 15–28, 1967. Pink (A), red (A), blue (A), brown-green (S)[1]. 56.8 × 76.2. Ed 20 (BFK), 9 TI (wA), BAT (BFK), 4 TP (BFK)[2], 8 CSP (BFK)[3], CP (BFK). Maurice Sanchez. BS, D, S, Dat.

1. Stone held from 1997. 1997II differs from 1997 in color and in image. Solid color tones have been added to the figure, the balloon shapes and semi-circle.
2. 1 TP varies from the edition.
3. 4 CSP retained by Tamarind.

1998
Birth (Hollywood Series). Apr 18–21, 1967. Black (S). 65.4 × 47.6. Ed 20 (BFK), 9 TI (wA), BAT (BFK), 2 AP (1 wA, 1 BFK), 2 TP (BFK), CP (BFK). Maurice Sanchez. S, Dat, D, BS.

2513
In Memory of Visit. Nov 26–Dec 24, 1968. Yellow (A), light yellow (S), orange (A), black (A). 71.1 × 55.9, cut. Ed 20 (GEP), 9 TI (GEP), BAT (GEP), 1 TP (CD), 8 CSP (GEP)[1], CP (GEP). Daniel Socha. BS, S, Dat, D.

1. 4 CSP retained by Tamarind.

2718
Try Out. Aug 14–Sep 29, 1969. Black (S). 76.2 × 55.9. Ed 10 (ucR), 9 TI (cR), BAT (ucR), 3 AP (ucR), 2 PP (1 cR, 1 ucR), 1 TP (ucR), 1 PTP (bA), CP (cR). David Trowbridge. D, S, Dat (top), BS (bottom).

Print not in University Art Museum Archive

2719
Homage to Jules Langsner. Aug 16–Sep 4, 1969. Yellow (S), pink-red (S), light violet (S), black (S). 75.9 × 55.6. Ed 20 (ucR), 9 TI (cR), BAT (ucR), 3 AP (ucR), 2 PP (cR), 6 TP* (ucR), 8 PgP (ucR)[1]. Serge Lozingot. D, S, Dat (top), BS (bottom).

1. 4 PgP retained by Tamarind.

2719II
So Long. Sep 5, 1969. Black (S)[1]. 76.2 × 55.9. Ed 10 (ucR), 9 TI (cR), BAT (ucR), 2 AP (1 cR, 1 ucR), 1 PP (ucR), 1 TP* (ucR), CP (ucR). Serge Lozingot. BS, D, S, Dat.

1. Stone held from 2719, run 4; additions. 2719II differs from 2719 in color and in image. All of the light wash tones have been eliminated. A bird and a balloon shape have been added at the upper left.

2881
Untitled (Mikey Mouse Series II). May 8–13, 1970. Black (S). 20.3 × 25.4, cut. Ed 20 (cR), 9 TI (ucR), BAT (cR), 3 AP (cR), 1 TP (cR), CP (ucR). Eugene Sturman. D, S, Dat (top) Verso: WS.

2882
Untitled (Mikey Mouse Series III).
May 8–13, 1970. Black (S). 20.3 ×
25.4, cut. Ed 20 (cR), 9 TI (ucR), BAT
(cR), 3 AP (cR), 2 TP (cR), CP (ucR).
Eugene Sturman. D, S, Dat (top)
Verso: WS.

2883
Untitled (Mikey Mouse Series IV).
May 8–13, 1970. Black (S). 20.3 ×
25.4, cut. Ed 20 (cR), 9 TI (ucR), BAT
(cR), 3 AP (cR), 1 TP (cR), CP (ucR).
Eugene Sturman. D, S, Dat (bottom)
Verso: WS.

2884
Untitled (Mikey Mouse Series V).
May 8–13, 1970. Black (S). 20.3 ×
25.4, cut. Ed 20 (cR), 9 TI (ucR), BAT
(cR), 3 AP (cR), 2 TP (cR), CP (ucR).
Eugene Sturman. D, S, Dat (bottom)
Verso: WS.

2885
Untitled (Mikey Mouse Series VI).
May 8–13, 1970. Black (S). 20.3 ×
25.4, cut. Ed 20 (cR), 9 TI (ucR), BAT
(cR), 3 AP (cR), 2 TP (cR), CP (ucR).
Eugene Sturman. D, S, Dat (top)[3]
Verso: WS.

2886
Untitled (Mikey Mouse Series VII).
May 8–13, 1970. Black (S). 20.3 ×
25.4, cut. Ed 20 (cR), 9 TI (ucR), BAT
(cR), 3 AP (cR), 4 TP (cR), CP (ucR).
Eugene Sturman. D, S, Dat (top)
Verso: WS.

2887
Untitled (Mikey Mouse Series VIII).
May 8–13, 1970. Black (S). 20.3 ×
25.4, cut. Ed 20 (cR), 9 TI (ucR), BAT
(cR), 3 AP (cR), 2 TP (cR), CP (ucR).
Eugene Sturman. D, S, Dat (bottom)
Verso: WS.

2888
Untitled (Mikey Mouse Series IX).
May 8–13, 1970. Black (S). 20.3 ×
25.4, cut. Ed 20 (cR), 9 TI (ucR), BAT
(cR), 3 AP (cR), 2 TP (cR), CP (ucR).
Eugene Sturman. D, S, Dat (top)
Verso: WS.

2889
Untitled (Mikey Mouse Series X).
May 8–13, 1970. Black (S). 20.3 ×
25.4, cut. Ed 20 (cR), 9 TI (ucR), BAT
(cR), 3 AP (cR), 2 TP (cR), CP (ucR).
Eugene Sturman. D, S, Dat (top)
Verso: WS.

2923
Untitled (Mikey Mouse Series XI).
May 10–15, 1970. Black (S). 20.3 ×
25.4, cut. Ed 20 (cR), 9 TI (ucR), BAT
(cR), 3 AP (cR), 1 PP (ucR), CP (ucR). S.
Tracy White. D, S, Dat (top)[2] Verso:
WS.

2924
Untitled (Mikey Mouse Series XII).
May 10–15, 1970. Black (S). 20.3 ×
25.4, cut. Ed 20 (cR), 9 TI (ucR), BAT
(cR), 3 AP (cR), 1 PP (ucR), CP (ucR). S.
Tracy White. D, S, Dat (bottom) Verso:
WS.

2925
Untitled (Mikey Mouse Series XIII).
May 10–15, 1970. Black (S). 20.3 ×
25.4, cut. Ed 20 (cR), 9 TI (ucR), BAT
(cR), 3 AP (cR), 1 PP (ucR), CP (ucR). S.
Tracy White. D, S, Dat (top) Verso:
WS.

2926
*Untitled (Mikey Mouse Series
XIV).* May 10–15, 1970. Black (S). 20.3
× 25.4, cut. Ed 20 (cR), 9 TI (ucR), BAT
(cR), 3 AP (cR), 1 PP (ucR), CP (ucR). S.
Tracy White. D, S, Dat, (bottom) Verso:
WS.

2927
Untitled (Mikey Mouse Series XV).
May 10–15, 1970. Black (S). 20.3 ×
25.4, cut. Ed 20 (cR), 9 TI (ucR), BAT
(cR), 3 AP (cR), 1 PP (ucR), CP (ucR). S.
Tracy White. D, S, (top), S, Dat,
(bottom) Verso: WS.

2928
*Untitled (Mikey Mouse Series
XVI).* May 10–15, 1970. Black (S). 20.3
× 25.4, cut. Ed 20 (cR), 9 TI (ucR), BAT
(cR), 3 AP (cR), 1 PP (ucR), CP (ucR). S.
Tracy White. D, S, Dat (top) Verso:
WS.

2929
Untitled (Mikey Mouse Series XVII). May 10–15, 1970. Black (S). 20.3 × 25.4, cut. Ed 20 (cR), 9 TI (ucR), BAT (cR), 3 AP (cR), 1 PP (ucR), CP (ucR). S. Tracy White. D, S, Dat (top) Verso: WS.

2930
Untitled (Mikey Mouse Series XVIII). May 10–15, 1970. Black (S). 20.3 × 25.4, cut. Ed 20 (cR), 9 TI (ucR), BAT (cR), 3 AP (cR), 1 PP (ucR), CP (ucR). S. Tracy White. D, S, Dat (top) Verso: WS.

2931
Untitled (Mikey Mouse Series XIX). May 10–15, 1970. Black (S). 20.3 × 25.4, cut. Ed 20 (cR), 9 TI (ucR), BAT (cR), 3 AP (cR), 1 PP (ucR), CP (ucR). S. Tracy White. D, S, Dat (top) Verso: WS.

2932
Friday. May 21–28, 1970. Orange (A), blue (S). 30.5 × 31.4, cut. Ed 13 (cR), 9 TI (6 cR, 3 BFK), BAT (cR), 1 TP* (cR)[1], 4 CTP (3 cR, 1 wA)[1]. Edward Hamilton. Recto: D, S, Dat (top) Verso: WS (bottom).

1. 1 TP, 4 CTP exist with 2933–2937, uncut. 1 TP, 3 CTP on paper 63.4 × 91.4; 1 CTP (wA) on paper 56.4 × 76.1.

2933
Kiss. May 21–28, 1970. Orange (A), blue (S). 31.4 × 30.2, cut. Ed 18 (cR), 9 TI (BFK), BAT (cR), 1 TP* (cR), 4 CTP (3 cR, 1 wA)[1]. Edward Hamilton. Recto: S, D, Dat (top) Verso: WS (bottom).

1. TP, 4 CTP exist with 2932, 2934–2937, uncut. 1 TP, 3 CTP on paper 63.3 × 101.4; 1 CTP (wA) on paper 56.5 × 76.1.

2934
Somehow. May 21–28, 1970. Orange (A), blue (S). 30.2 × 31.4, cut. Ed 15 (cR), 9 TI (1 cR, 8 BFK), BAT (cR), 1 TP* (cR), 4 CTP (3 cR, 1 wA)[1]. Edward Hamilton. Recto: D, Dat, S (top) Verso: WS (bottom).

1. 1 TP, 4 CTP exist with 2932–2933, 2935–2937, uncut. 1 TP, 3 CTP on paper 63.3 × 101.4; 1 CTP (wA) on paper 56.5 × 76.1.

2935
Monday's Witch. May 21–28, 1970. Orange (A), blue (S). 31.4 × 30.2, cut. Ed 12 (cR), 9 TI (1 cR, 8 BFK), BAT (cR), 1 TP* (cR), 4 CTP (# cR, 1 wA)[1]. Edward Hamilton. Recto: D, S, Dat (top) Verso: WS (bottom).

1. 1 TP, 4 CTP exist with 2932–2934, 2936–2937, uncut. 1 TP, 3 CTP on paper 63.3 × 101.4; 1 CTP (wA) on paper 56.5 × 76.1.

2936
Serge. May 21–28, 1970. Orange (A), blue (S). 31.4 × 30.5, cut. Ed 15 (cR), 9 TI (2 cR, 7 BFK), BAT (cR), 1 TP* (cR), 4 CTP (3 cR, 1 wA)[1]. Edward Hamilton. Recto: D, S, Dat (center) Verso: WS (bottom).

1. 1 TP, 4 CTP exist with 2932–2935, 2937, uncut. 1 TP, 3 CTP on paper 63.3 × 101.4; 1 CTP (wA) on paper 56.5 × 76.1.

2937
Pacific. May 21–28, 1970. Orange (A), blue (S). 31.4 × 30.2, cut. Ed 15 (cR), 9 TI (BFK), BAT (cR), 1 TP* (cR), 4 CTP (3 cR, 1 wA)[1]. Edward Hamilton. Recto: D, S, Dat (top) Verso: WS (bottom).

1. 1 TP, 4 CTP exist with 2932–2936, uncut. 1 TP, 3 CTP on paper 63.3 × 101.4; 1 CTP (wA) on paper 56.5 × 76.1.

2940
Title Page (Mikey Mouse Series I). May 28–Jun 1, 1970. Black (S). 20.3 × 25.4, cut. Ed 20 (cR), 9 TI (BFK), BAT (cR), 3 AP (cR), 1 TP (cR)[1], CP (BFK). Larry Thomas. Verso: D, S, Dat, WS.

1. Torn edges.

2942
Forty-Eight. Jun 5–10, 1970. Blue-black (S). 71.1 × 55.9. Ed 20 (cR), 9 TI (cR), BAT (cR), 3 AP (cR), 4 TP (cR)[1]. Hitoshi Takatsuki. S, Dat, D, BS.

1. 3 TP vary from the edition.

2942II
Forty-Eight II. Jun 11–16, 1970. Grey (A)[1], black (S)[2]. 71.1 × 55.9. Ed 20 (cR), 9 TI (cR), BAT (cR), 3 AP (cR), 1 CTP (cR), CP (cR). Hitoshi Takatsuki. S, Dat, D, BS.

1. Image from run 2 transferred to plate; reversal.
2. Stone held from 2942. 2942II differs from 2942 in color and in image. A bleed background tone has been added.

2943
Number Six State II. May 29, 1970.
Black (S)[1]. 63.5 × 91.4. Ed 10 (cR), 9
TI (cR), BAT (cR), 2 AP (cR), CP (cR).
Edward Hamilton. D, S, Dat (top), BS
(bottom).

1. stone held from 2932–37, run 2.
 2943 differs from 2932–2937 in
 color, image and size. 2943
 combines all six images and the
 bleed background tone has been
 eliminated.

Jerome Kaplan

519
Kapparah. Mar 6–9, 1962. Black (S).
76.2 × 57.2. Ed 20 (BFK), 9 TI (wA),
BAT (BFK), 2 AP (1 BFK, 1 wA), 3 TP
(BFK), CP (BFK). Joe Zirker. D, BS, S,
Dat.

523
Hatchery. Mar 8–13, 1962. Black (S).
28.9 × 47.3. Ed 20 (BFK), 9 TI (wA),
BAT (BFK), 2 TP (BFK), CP (BFK). Irwin
Hollander. D, BS, S, Dat.

524
Apes. Mar 12–14, 1962. Black (S). 48.3
× 52.7. Ed 20 (BFK), 9 TI (wA), BAT
(BFK), CP (BFK). Joe Zirker. D, BS, S,
Dat.

528
Portraits. Mar 14–16, 1962. Black (S).
67.9 × 48.9. Ed 20 (BFK), 9 TI (wA),
BAT (BFK), 2 AP (1 BFK, 1 wA), 3 TP
(BFK), CP (BFK). Irwin Hollander. D, S,
Dat, BS.

532
La Gattina Rossa. Mar 17–19, 1962
Black (S). 56.5 × 73.3. Ed 20 (BFK), 9
TI (wA), BAT (BFK), 2 AP (BFK), 3 TP (2
BFK, 1 wA), CP (BFK). Joe Zirker. D,
BS (Tam), S, Dat, BS (pr).

535
Ritual. Mar 21–28, 1962. Red (S),
green (S), blue (Z). 65.7 × 49.2. Ed 20
(BFK), 9 TI (nN), BAT (BFK), 2 AP (nN),
2 PP (BFK), 3 TP (BFK), 3 CTP (nr)[1],
CP (BFK). Joe Zirker. D, BS, S, Dat.

1. On proofing paper, unchopped.

539
Homage a J.D. Mar 27–29, 1962.
Brown-black (S). 59.7 × 56.5. Ed 20
(BFK), 9 TI (wA), BAT (BFK), 2 AP (wA),
4 PP (3 BFK, 1 wA), 3 TP (BFK), CP
(BFK). Joe Zirker. BS, D, S, Dat.

544
Ti Queen. Mar 30–Apr 10, 1962.
Yellow (Z), red (Z), brown (Z), black
(S). 75.9 × 56.8. Ed 20 (BFK), 9 TI
(wA), BAT (BFK), 2 AP (BFK), 5 PP (4
BFK, 1 wA), 3 TP (1 BFK, 2 wA), 6 CTP
(nr)[1], CP (BFK). Joe Zirker. D, BS, S,
Dat.

1. On proofing paper, unchopped.

550
Quarry. Apr 9–11, 1962. Black (S).
59.4 × 75.6. Ed 20 (BFK), 9 TI (wA),
BAT (BFK), 2 AP (BFK), 3 TP (BFK). Joe
Zirker. D, BS, S, Dat.

552
Burnt Quarry. Apr 12–13, 1962. Black
(S). 76.2 × 57.2. Ed 20 (BFK), 9 TI
(wA), BAT (BFK), 2 AP (BFK), 3 TP
(BFK). Joe Zirker. D, S, Dat, BS.

554
Figurative Landscape. Apr 13–20,
1962. Black (S). 54.0 × 66.0. Ed 20
(BFK), 9 TI (nN), BAT (BFK), 2 AP (1
BFK, 1 nN), 1 TP (BFK). Wesley
Chamberlin. D, BS, S, Dat.

555
Birds. Apr 16–23, 1962. Black (S). 48.3 × 56.8. Ed 20 (BFK), 9 TI (wA), BAT (BFK), 2 AP (1 BFK, 1 wA), 2 TP (BFK). Joe Zirker. D, BS, S, Dat.

563
Cocoons. Apr 20–21, 1962. Black (Z). 56.8 × 76.8. Ed 20 (BFK), 9 TI (nN), BAT (BFK), 2 AP (nN), 2 TP (BFK). Joe Zirker. D, S, Dat, BS.

Karl Kasten

2203
Civitaveccia. Feb 2–14, 1968. Black (S), transparent red (Z), blue (Z), blue-green (Z). 45.7 × 61.0. Ed 20 (JG)[1], 9 TI (ucR)[1], BAT (JG), 1 AP (JG), 3 TP (1 ucR, 2 JG)[1]. Manuel Fuentes. S, Dat, D, BS.

1. Ed 15–20/20, 9 TI, 3 TP vary from the edition.

2203II
Civitaveccia II. Feb 28–Mar 5, 1968. Black (S)[1]. 45.7 × 61.3. Ed 10 (cR), 9 TI (ucR), BAT (cR), 3 AP (cR), CP (ucR). Theodore Wujcik. BS, S, Dat, D.

1. Stone held from 2203, run 1; reversal, deletions, additions. 2203II differs from 2203 in color and in image. Solid color tones have been eliminated. A dark crescent has been added at the upper left of the reversed image.

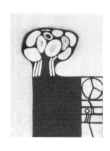

2204
Lebannon. Feb 5–6, 1968. Black (S). 50.8 × 38.1. Ed 20 (bA), 9 TI (nN), BAT (bA), 3 AP (1 nN, 2 bA), 2 TP* (1 bA, 1 nN), CP (bA). David Folkman. S, Dat, D, BS.

2205
Tarquinia. Feb 6–9, 1968. Yellow (A), black (S). 46.4 × 41.0. Ed 20 (wN), 9 TI (nN), BAT (wN), 3 AP (1 wN, 2 nN), 1 TP (wN), CP (wN). Theodore Wujcik. BS, S, Dat, D.

2206
Reliquary Paimpont. Feb 8–21, 1968. Black (S), red (Z), blue (Z), yellow (A)[1]. 76.2 × 55.6. Ed 20 (wA)[2], 9 TI (CD), BAT (wA), 2 AP (wA)[2], 1 TP (wA)[2]. David Folkman. BS, S, Dat, D.

1. Edition exists in two color variations. Variation I in a combination of the four colors and Variation II in three colors without yellow.
2. Indicates Variation I, Ed 11–20/20, TP and AP.

2206II
Reliquary Paimpont II. Feb 22–23, 1968. Dark green-grey (Z)[1], dark violet-grey (A)[2], black (S)[3]. 76.5 × 55.2. Ed 10 (wA), 9 TI (CD), BAT (wA), 3 AP (1 wA, 2 CD), 1 TP (wA), CP (wA). David Folkman. BS, S, Dat, D.

1. Plate held from 2206, run 3.
2. Plate held from 2206, run 4; deletions.
3. Stone held from 2206, run 1. 2206II differs from 2206 in color and in image. The tones behind most of the rectangles are darker. Color tone has been added in a horizontal strip in the center and eliminated in the square above.

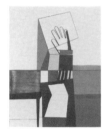

2207
Reliquary L'Abbé. Feb 9–20, 1968. Black (S), blue (Z), orange (Z). 76.2 × 55.9. Ed 20 (bA), 9 TI (nN), BAT (bA), 2 AP (nN), 1 TP (bA), 1 PTP (CD), CP (bA). Jean Milant. BS, S, Dat, D (in blue ink).

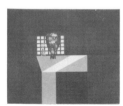

2208
Amalfi. Feb 15–Mar 11, 1968. Blue (A), brown-orange (A), transparent black (S). 46.1 × 54.3. Ed 20 (CD)[1], 9 TI (cR), BAT (CD)[1], 3 AP (cR), CP (CD). Frank Akers. BS, S, Dat, D.

1. There is a variation in color and finish throughout the edition.

Print not in
University Art Museum
Archive

2209
Reliquary Lozingot. Feb 23–Mar 15, 1968. Blue-green (A), brown (A), black (S). 76.2 × 57.2. Ed 20 (wA), 9 TI (GEP), BAT (wA), 3 AP (2 wA, 1 GEP), 2 TP (wA)[1], CP (wA). Anthony Stoeveken. BS, D, S, Dat.

1. 1 TP varies from the edition.

2210
Reliquary Ouest. Feb 22–Mar 8,
1968. Black (S), grey (A). 76.2 × 55.9.
Ed 20 (CD), 9 TI (GEP), BAT (CD), 3 AP
(2 CD, 1 GEP), 3 TP (CD)[1], CP* (CD).
Robert Rogers. BS, S, Dat, D.

1. 2 TP vary from the edition.

2211
Urbino. Mar 6–28, 1968. Green-blue
(Z), blue (Z), dark brown (S). 48.3 ×
55.2. Ed 20 (CD), 9 TI (cR), BAT (CD), 2
AP (1 cR, 1 CD), 1 PP (CD), 2 TP (1 CD,
1 cR*), CP (CD). Manuel Fuentes. BS,
D, S, Dat.

2212
Purple Egg. Mar 15–21, 1968. Dark
brown (A), blue-silver (S). 48.3 × 55.6.
Ed 20 (wA), 9 TI (JG), BAT (wA), 1 AP
(wA), 1 TP (wA), CP* (wA). David
Folkman. BS, S, Dat, D.

2237
Ostia. Mar 13–14, 1968. Grey (S). 55.2
× 48.3. Ed 20 (CD), 9 TI (ucR), BAT
(CD), 3 AP (1 ucR, 2 CD), 1 TP (CD), CP
(CD). Jean Milant. S, Dat, D, BS.

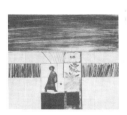

2239
Star. Mar 18–19, 1968. Black (S). 48.3
× 55.2. Ed 20 (CD), 9 TI (ucR), BAT
(CD), 3 AP (1 ucR, 2 CD), 1 TP* (CD),
CP (ucR). Jean Milant. BS, D, S, Dat.

2240
Parma. Mar 18–28, 1968. Yellow (A),
blue (A), brown (S). 48.6 × 55.6. Ed
20 (wA), 9 TI (GEP), BAT (wA), 3 AP
(GEP), CP (wA). Robert Rogers. BS, D,
S, Dat.

2241
Arborum Dinarii. Mar 20–26, 1968.
Brown-gold (S). 55.2 × 48.3. Ed 20
(BFK), 9 TI (JG), BAT (BFK), 2 AP (JG),
CP (BFK). Frank Akers. BS, D, S, Dat.

Harold Keeler

Print not in
University Art Museum
Archive

358
Untitled. Aug 12, 1961. Black (S).
34.6 × 50.8. 8 ExP (BFK)[1]. Harold
Keeler. D, BS (Tam), S, BS (pr).

1. Designated A–H. 4 ExP retained by
Tamarind.

361
Spring Mountains. Aug 18–Sep 2,
1961. Orange-yellow (S), green-blue
(S), orange-red (S), black (S). 56.8 ×
36.2. Ed 20 (BFK), 9 TI (A), 2 AP (A), 2
TP (BFK), CP* (BFK). Harold Emerson
Keeler. D, BS, T, S.

375
Sky, Clouds, and Trees. Sep 13–16,
1961. Black (S). 45.7 × 56.5. Ed 20
(BFK), 9 TI (A), 1 AP (A). Harold
Emerson Keeler. D, BS, T, S.

Print not in
University Art Museum
Archive

376
Kings of the Earth. Sep 4–9, 1961.
Green (S), yellow (S), black (S). 38.7
× 49.2. Ed 20 (A), 9 TI (wN), 2 AP (1 A,
1 wN), 2 TP* (A), CP* (A). Harold
Emerson Keeler. S, T, D (in black India
ink, top), BS (bottom).

Print not in
University Art Museum
Archive

395
Genesis I:7. Sep 23–25, 1961. Black
(Z). 38.4 × 28.3. 12 ExP (bA)[1].
Harold Keeler. D, BS, T, S.

1. Designated A–L. 6 ExP retained by
Tamarind.

397
Genesis I:4. Sep 24–29, 1961. Blue and gold (S), black (S). 38.1 × 28.3. Ed 20 (BFK), 9 TI (A), PrP (BFK), 2 AP (1 BFK, 1 A), 1 TP* (A), CP* (BFK)[1]. Harold Emerson Keeler. D, BS (Tam), T, S, BS (pr).

1. Paper measures 36.2 × 28.6.

Print not in
University Art Museum
Archive

481
Genesis I:5. Jan 2–16, 1962 Red (S), blue (Z), black (S). 51.5 × 38. Ed 20 (BFK), 9 TI (A), 2 AP (BFK), 3 TP (BFK), 4 CTP (3 Tcs, 1 BFK)[1]. Harold Emerson Keeler. D, T, S (top), BS (bottom).
1. 2 CTP (Tcs), unchopped.

Don Kelley

1861
Resurrection Series I. Apr 7–10, 1967. Black (S). 76.2 × 56.8. Ed 10 (BFK), 9 TI (wA), BAT (BFK), 2 AP (BFK), CP (blue cover stock). Donald Kelley. T, D, BS, S, Dat.

2062
Untitled. Aug 25–Sep 28, 1967. Green (A), light blue (A), black (S). 76.2 × 55.2, (GEP), 76.2 × 57.2 (GEP) Ed 20 (GEP), 9 TI (CD), BAT (GEP), 2 AP (CD), CP (CD). Donald Kelley. BS, D, S, Dat.

2196
Untitled. Nov 7–27, 1967. Black (S), B: yellow, medium yellow, transparent light yellow (S). 76.2 × 55.9, [1]. Ed 20 (BFK), 9 TI (wA), BAT (BFK), CP (wA). Donald Kelley. BS (bottom), D, S, Dat (center).

1. Torn to an irregular shape.

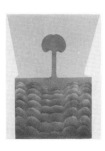

2450
Untitled. Sep 5–23, 1968. Orange (A), pink (A), blue (A), red (S), black (S)[1]. 63.5 × 46.4, cut, torn and deckle[2]. Ed 7 (GEP), 9 TI (CD), BAT (GEP), 3 AP (1 CD, 2 GEP), 1 PP (GEP), 5 CTP (3 GEP, 2 CD), CP (coverstock). Donald Kelley. Recto: BS Verso: D, S, Dat.

1. Stone same as run 4; deletions.
2. Cut to an irregular shape.

2467
Untitled. Oct 1–9, 1968. Blue (S), pearly yellow-grey (A), red (S), black (S). 38.1 × 55.9, cut[1]. Ed 11 (GEP), 9 TI (GEP), BAT (GEP), 3 AP (GEP), 4 CTP (GEP), CP (GEP). Donald Kelley. Recto: BS Verso: D, S, Dat.

1. Cut to an irregular shape; hinged to paper 56.5 × 76.2.

2468
Untitled. Oct 1–9, 1968. Blue (S), pearly yellow-grey (A), red (S), black (S). 38.7 × 55.9, cut[1]. Ed 11 (GEP), 9 TI (GEP), BAT (GEP), 3 AP (GEP), 4 CTP (GEP), CP (GEP). Donald Kelley. Recto: BS Verso: D, S, Dat.

1. Cut to an irregular shape; hinged to paper 56.1 × 76.2.

2475
Untitled. Oct 15, 1968–Mar 14, 1969 Grey (S), red (S), black (S)[1]. 34.0 × 47.0, cut[2]. Ed 10 (cR), 9 TI (wA), BAT (cR), 1 AP (wA), 1 TP (cR), 3 CTP (1 CD, 2 wA), CP (cR). Donald Kelley. Recto: BS Verso: D, S, Dat.

1. Stone same as run 2.
2. Cut to an irregular shape; hinged to paper 56.5 × 76.2.

2476
Untitled. Oct 15, 1968–Mar 15, 1969. Grey (S), red (S), black (S)[1]. 31.4 × 45.7, cut[2]. Ed 10 (cR), 9 TI (wA), BAT (cR), 1 AP (wA), 1 TP (cR), 3 CTP (1 CD, 2 wA), CP (cR). Donald Kelley. Recto: BS Verso: D, S, Dat.

1. Stone same as run 2.
2. Cut to an irregular shape; hinged to paper 56.8 × 76.2.

James Kelly

8 from 9, a suite of eight lithographs including title and colophon pages, enclosed in a folder of grey-green paper, measuring 50.2 × 35.6, with the suite title and the artist's name printed in black on the front cover. In order: 870, 844, 846, 861, 849, 866, 868, 871.

838
Untitled. Jul 1–2, 1963. Black (S). 53.3 × 39.4. Ed 20 (BFK), 9 TI (wA), BAT (BFK), 3 AP (2 BFK, 1 wA), 2 TP (BFK), CP (BFK). Aris Koutroulis. D, BS, S, Dat.

841
Untitled. Jul 3–22, 1963. Pink (Z), red (Z), yellow (Z), black (S). 56.5 × 67.3. Ed 20 (BFK), 9 TI (wA), BAT (BFK), PrP II for Irwin Hollander (wA), 3 TP (1 BFK, 2 wA), CP (BFK). Aris Koutroulis. D, BS, S, Dat.

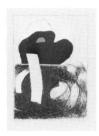

844
Cassius (8 from 9 II). Jul 15–17, 1963. Red (Z), black (S). 48.3 × 34.3. Ed 20 (BFK), 9 TI (wA), BAT (BFK), 3 AP (2 BFK, 1 wA), 1 TP (wA), CP (BFK). Aris Koutroulis. D, BS, S, Dat.

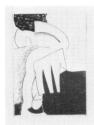

846
Aphrodite Resting (8 from 9 III). Jul 16–18, 1963. Yellow (Z), black (S). 48.3 × 34.6. Ed 20 (BFK), 9 TI (wA), BAT (BFK), 3 AP (1 BFK, 2 wA), 1 TP (BFK), CP (BFK). Aris Koutroulis. D, BS, S, Dat.

849
Tracy's Dilemma (8 from 9 V). Jul 19–29, 1963. Yellow (Z), red (Z), black (S). 48.6 × 34.6. Ed 20 (BFK), 9 TI (wA), BAT (BFK), PrP II for Irwin Hollander (BFK), 3 AP (1 BFK, 2 wA), 2 TP (BFK), CP (BFK). Aris Koutroulis. D, BS, S, Dat.

851
Untitled. Jul 23–Aug 8, 1963. Red (Z), yellow (Z), blue (Z), black (S). 43.2 × 49.5. Ed 20 (BFK), 9 TI (wA), BAT (BFK), PrP II for Irwin Hollander (BFK), 3 AP (BFK), 2 TP (1 BFK, 1 wA), CP (BFK). Aris Koutroulis. D, BS, S, Dat.

855
Untitled. Jul 29–Aug 1, 1963. Black (Z). 57.2 × 76.8. Ed 20 (BFK), 9 TI (wN), BAT (BFK), PrP II for Irwin Hollander (BFK), 3 AP (1 BFK, 2 wN), 1 TP (BFK), CP (BFK). Aris Koutroulis. D, S, Dat, BS.

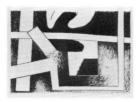

856
Untitled. Aug 1–12, 1963. Black (S). 56.5 × 75.6. Ed 20 (BFK), 9 TI (wA), BAT (BFK), PrP II for Irwin Hollander (BFK), 2 AP (1 BFK, 1 wA), 2 TP (BFK), CP (BFK). Aris Koutroulis. BS, D, S, Dat.

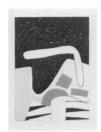

861
Nightshade (8 from 9 IV). Aug 8–26, 1963. Yellow (Z), red (Z), black (S). 48.6 × 34.3. Ed 20 (BFK), 9 TI (wA), BAT (BFK), PrP II for Irwin Hollander (BFK), 3 AP (wA), 2 TP (BFK), CP (BFK). Aris Koutroulis. D, BS, T, S, Dat.

866
Flight over India (8 from 9 VI). Aug 12–23, 1963. Yellow (Z), blue (Z), red (Z), black (Z). 48.3 × 34.6. Ed 20 (BFK), 9 TI (wA), BAT (BFK), PrP II for Irwin Hollander (BFK), 1 AP (wA), 6 PP (4 BFK, 2 wA), CP (BFK). Aris Koutroulis. D, T, BS, S, Dat.

868
Green Hornet (8 from 9 VII). Aug 15–23, 1963. Blue (Z), red (Z), green (Z), black (S). 48.6 × 34.6. Ed 20 (BFK), 9 TI (wA), BAT (BFK), PrP II for Irwin Hollander (BFK), 3 AP (wA), 4 TP* (BFK), CP (BFK). Aris Koutroulis. D, T, BS, S, Dat.

870
Title Page (8 from 9 I). Aug 19–22, 1963. Yellow (Z), black (S). 48.3 × 34.3. Ed 20 (BFK), 9 TI (wA), BAT (BFK), PrP II for Irwin Hollander (wA), 2 AP (1 BFK, 1 wA), CP (BFK). Aris Koutroulis. D, S, Dat, BS.

871
Colophon (8 from 9 VIII). Aug 20–26, 1963. Red (Z), black (S). 48.6 × 34.3. Ed 20 (BFK), 9 TI (wA), BAT (BFK), PrP II for Irwin Hollander (BFK), 3 AP (1 BFK, 2 wA), 2 TP (1 BFK, 1 wA), CP (BFK). Aris Koutroulis. D, BS, T, S, Dat.

Print not in
University Art Museum
Archive

875
Untitled. Aug 26, 1963. Black (Z). 34.3 × 48.3. 2 ExP (BFK)[1]. Aris Koutroulis. D, S, Dat.

1. 1 ExP printed on recto and verso, designated "Discontinued Zinc I-II/II," unchopped.

876
Untitled. Aug 26–28, 1963. Black (Z). 34.6 × 48.6. Ed 20 (BFK), 9 TI (wA), BAT (BFK), 3 AP (1 BFK, 2 wA), CP (BFK). Aris Koutroulis. BS, D, S, Dat.

G. Ray Kerciu

931
Twist Now. Nov 18–19, 1963. Black (S). 43.5 × 56.5. Ed 20 (BFK), 9 TI (wA), PrP (BFK), 3 AP (2 BFK, 1 wA), 1 PP (BFK), 2 TP (BFK), CP* (wA). Kenneth Tyler. D, BS, S.

Print not in
University Art Museum
Archive

933
Litho for Kids. Nov 19, 1963. Black (Z). 38.1 × 51.1. 10 ExP (bA)[1], PrP (bA), 1 AP (bA), CP (bA). Jason Leese. D, S, BS (top).

1. Designated A–J. 5 ExP retained by Tamarind.

994
Freedom Now. Jan 30–Feb 14, 1964. Blue (S), red (Z). 56.2 × 76.2. Ed 20 (BFK), 9 TI (wA), PrP (BFK), 3 AP (2 BFK, 1 wA), 1 PP (wA), 2 TP (BFK), CP (BFK). Irwin Hollander. D, S, BS.

1143
God Bless Mommy, Daddy, and the John Birch Society. Sep 11–23, 1964. Black (S). 76.2 × 56.8. Ed 20 (BFK), 9 TI (wA), PrP (BFK), PrP II for Kenneth Tyler (BFK), 2 AP (BFK), 6 PP (BFK), 3 TP (BFK), CP (BFK). Clifford Smith, NC. D (bottom), S (center).

Anthony Ko

1922
Untitled. Jan 19–22, 1967. Black (A). 38.1 × 49.5. Ed 15 (MI), 9 TI (BFK), BAT (MI), 3 AP (BFK), 2 TP (MI), CP (MI). Anthony Ko. D, S, Dat, BS.

1939
The King and His Princess. May 14–17, 1967. Black (S). 50.8 × 50.8. Ed 8 (MI), 9 TI (wA), BAT (MI), 2 AP (wA), 2 TP (1 MI, 1 EVB). Anthony Ko. D, T, S, BS.

Print not in
University Art Museum
Archive

1939II
The King and His Princess. Oct 28–Nov 6, 1967. B: Blue, yellow, red, green, orange, violet (A), B: light green, brown, violet, light violet (A), dark grey (S)[1]. 51.1 × 51.1. Ed 15 (GEP), 9 TI (CD), BAT (GEP), 3 AP (CD), 1 CTP (CD), CP (CD). Anthony Ko. D, T, BS, S.

1. Stone held from 1939. 1939II differs from 1939 in color only.

1940
Inner Perseverance. Mar 30, 1967. Black (Z). 51.1 × 50.8. Ed 10 (MI), 9 TI (wA), BAT (MI), 2 AP (wA), 1 TP (MI). Anthony Ko. D, T, BS, S, Dat.

1945
January in Venice. Feb 17–Apr 3, 1967. Beige (S), light brown (A), blue (Z). 51.4 × 51.1. Ed 10 (wA), 9 TI (GEP), BAT (wA), 2 AP (GEP), 2 TP (wA). Anthony Ko. D, BS, S.

Gabriel Kohn

880
Untitled. Sep 4–12, 1963. Brown, blue (Z), red, green (Z), black (S). 56.8 × 76.2. Ed 20 (BFK), 9 TI (wA), PrP (BFK), PrP II for Jason Leese (BFK), 3 AP (2 BFK, 1 wA), 2 PP (wA), CP (BFK). Robert Gardner. D, BS, S, Dat.

881
Untitled. Sep 4–10, 1963. Dark beige (Z), black (S). 38.4 × 46.1. Ed 20 (BFK), 9 TI (wA), PrP (BFK), 3 AP (1 BFK, 2 wA), 1 TP (BFK), CP (BFK). Kenneth Tyler. D, BS, S, Dat.

891
Untitled. Sep 17–20, 1963. Black (S). 38.7 × 46.1. Ed 20 (bA), 9 TI (nN), PrP (bA), PrP II for Irwin Hollander (bA), 3 AP (nN), 2 TP (bA), CP (bA). Aris Koutroulis. D, BS, S, Dat.

884
Untitled. Sep 10–16, 1963. Black (S). 56.2 × 76.2. Ed 20 (BFK), 9 TI (wA), PrP (BFK), 3 AP (1 BFK, 2 wA), 2 TP (BFK), CP (BFK). Jason Leese. D, BS, S, Dat.

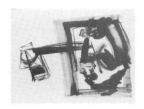

892
Untitled. Sep 17–24, 1963. Black (S). 38.4 × 48.3. Ed 20 (BFK), 9 TI (wA), PrP (BFK), 3 AP (1 BFK, 2 wA), 1 PP (BFK), 2 TP (BFK), CP (BFK). John Dowell. D, BS, S, Dat.

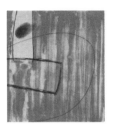

885
Untitled. Sep 10–20, 1963. Dark beige (S), red (Z), black (S). 66.0 × 56.2. Ed 20 (BFK), 9 TI (wA), PrP (BFK), PrP II for Irwin Hollander (BFK), 3 AP (wA), 2 TP (BFK), CP (BFK). Robert Gardner. D, BS, S, Dat.

Print not in
University Art Museum
Archive

893
Untitled. Sep 20–23, 1963. Black (S). 28.3 × 38.1. 10 ExP (BFK)[1], PrP (BFK), 3 AP (BFK). Aris Koutroulis. D, BS, S, Dat.

1. Designated A-J. 5 ExP retained by Tamarind.

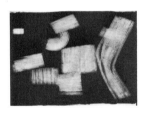

887
Untitled. Sep 12–13, 1963. Black (S). 34.3 × 44.1. Ed 20 (BFK), 9 TI (wA), PrP (BFK), 3 AP (wA), 2 TP (BFK), CP (BFK). Kenneth Tyler. D, BS, S, Dat.

895
Untitled. Sep 23–Oct 11, 1963. Blue (Z), red (Z). 38.1 × 48.3. Ed 20 (BFK), 9 TI (wA), PrP (BFK), PrP II for Irwin Hollander (BFK), 3 AP (BFK), 1 TP (wA). John Dowell. D, BS, S, Dat.

888
Untitled. Sep 16–17, 1963. Black (S). 33.0 × 40.6. Ed 20 (BFK), 9 TI (wA), PrP (BFK), 3 AP (1 BFK, 2 wA), 2 TP (BFK), CP (BFK). Aris Koutroulis. D, BS, S, Dat.

896
Untitled. Sep 24–Oct 29, 1963. Green (Z), orange (Z), black (Z), grey (Z). 63.5 × 50.8. Ed 20 (BFK), 9 TI (wA), PrP (BFK), PrP II for John Dowell (BFK), 3 AP (BFK), 3 PP (1 BFK, 2 wA), 1 TP (wA). Aris Koutroulis. D, BS, S, Dat.

889
Untitled. Sep 16–27, 1963. Grey (Z), black (Z). 31.1 × 42.2. Ed 20 (BFK), 9 TI (wA), PrP (BFK), 3 AP (wA), 2 TP (BFK), CP (BFK). Robert Gardner. D, BS, S, Dat.

899
Untitled. Oct 2–8, 1963. Black (S). 51.1 × 76.2. Ed 20 (BFK), 9 TI (wA), PrP (BFK), PrP II for Irwin Hollander (BFK), 2 AP (1 BFK, 1 wA), 2 TP (BFK), CP (BFK). Robert Gardner. D, BS, S, Dat.

890
Untitled. Sep 16–18, 1963. Black (S). 33.0 × 44.5. Ed 20 (BFK), 9 TI (wA), PrP (BFK), PrP II for Irwin Hollander (BFK), 3 AP (1 BFK, 2 wA), 2 TP (BFK), CP (BFK). John Dowell. D, BS, S, Dat.

900
Untitled. Oct 4–30, 1963. Blue (Z), orange (Z), black (Z). 51.1 × 38.1. Ed 10 (BFK), 9 TI (wA), PrP (BFK), PrP II for Irwin Hollander (BFK). Aris Koutroulis. D, BS, S, Dat.

900II
Untitled. Oct 4–30, 1963. Blue (Z)[1], orange (Z)[2], black (Z)[3], transparent grey (Z). 51.1 × 38.1. 5 ExP (BFK)[4]. Aris Koutroulis. D, BS, S, Dat.

1. Plate held from 900, run 1.
2. Plate held from 900, run 2.
3. Plate held from 900, run 3. 900II differs from 900 in color and in image. A light transparent vertical rectangle has been added on the right.
4. Designated A-E, 2 ExP retained by Tamarind.

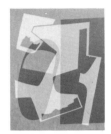

904
Untitled. Oct 21–24, 1963. Blue (Z), red (S). 51.1 × 37.8. Ed 16 (BFK), 9 TI (wA), PrP (BFK), CP (BFK). Aris Koutroulis. D, BS, S, Dat.

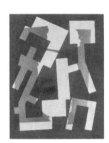

907
Untitled. Oct 22–Nov 1, 1963. Dark green (S), black (S). 51.1 × 38.1. Ed 20 (BFK), 9 TI (BFK), PrP (BFK), 3 AP (BFK), 2 TP (BFK), CP (BFK). Jason Leese. D, BS, S, Dat.

1418
Untitled. Jul 9–10, 1965. Red-orange (A), black (A). 56.5 × 76.2. Ed 20 (bA), 9 TI (CD), BAT (bA), 3 AP (2 bA, 1 CD), 2 TP (1 bA, 1 CD), CP (Tcs). Bernard Bleha. D, S, Dat, BS.

1420
Untitled. Jul 10–17, 1965. Black (A). 55.9 × 76.2. Ed 20 (BFK), 9 TI (CD), BAT (BFK), 3 AP (2 BFK, 1 CD), 1 TP (BFK), CP (Tcs). Bernard Bleha. BS (bottom), D, S, Dat (top).

Print not in
University Art Museum
Archive

Misch Kohn

330
Ikaros. Jul 5–6, 1961. Black (S). 76.2 × 57.2. 10 ExP (BFK)[1], PrP (BFK). Bohuslav Horak. D, S, BS.

1. Designated A-J. 5 ExP retained by Tamarind.

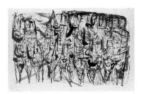

332
Procession. Jul 6–8, 1961. Grey (S), red (Z), black (Z). 65.4 × 94.9. Ed 20 (BFK), 9 TI (wN), PrP (wN), 2 AP (wN), 3 TP (BFK), CP (BFK). Bohuslav Horak. D, BS, S, Dat.

333
Soldiers. Jul 7–Aug 18, 1961. Red-brown (S), ochre (Z), black (S). 56.8 × 38.7. Ed 20 (wA), 9 TI (wN), BAT (wN), 3 AP (2 wN, 1 wA), CP (BFK). Harold Keeler. D, BS, S, Dat.

334
Stranger. Jul 7–14, 1961. Red (S), blue-green (S)[1], green-brown (S). 56.5 × 38.7. Ed 20 (wA), 9 TI (wN), 4 AP (wA). Joe Funk. D, BS, S.

1. Same stone as run 1.

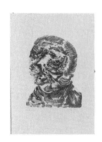

334A
Stranger II. Jul 10–11, 1961. Black (S)[1]. 56.8 × 38.4. Ed 18 (wA), 9 TI (BFK), 4 AP (3 wA, 1 BFK). John Muench. D, BS, S.

1. Stone held from 334, run 2; deletions. 334A differs from 334 in color and in image. The line drawing has been eliminated. The wash drawing has been lightened.

336
Patriarch. Jul 11–14, 1961. Black (S). 76.2 × 55.9. Ed 30 (BFK), 9 TI (wA), PrP (BFK), 4 AP (BFK). Bohuslav Horak. D, BS, T, S, Dat.

338
Patriarch II. Jul 12–13, 1961. Black (S). 56.5 × 38.1. Ed 20 (19 BFK, 1 wA), 9 TI (wA), PrP (BFK), 5 AP (4 BFK, 1 wA). Bohuslav Horak. D, BS, S, Dat.

347
Figure. Jul 24–Aug 2, 1961. Blue (Z), grey (Z), orange (Z). 76.8 × 56.5. Ed 11 (BFK), 9 TI (wN), PrP (BFK), 4 AP (2 BFK, 2 wN), 4 CTP (BFK). Bohuslav Horak. D, BS, S, Dat.

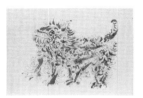

339
Red Beast. Jul 13–21, 1961. Red (Z), green-brown (Z). 74.0 × 104.8. Ed 20 (BFK), 9 TI (wN)[1], PrP (BFK), 5 AP (3 BFK[2], 2 wN). Bohuslav Horak. D, BS, S, Dat.

1. 9 TI printed by Horak.
2. 1 AP on paper 64.8 × 94.0.

353
Grand Canyon. Jul 27–Aug 10, 1961. Black (S). 38.1 × 50.8. Ed 20 (BFK), 9 TI (CW), PrP (BFK), 1 AP (CW), CP (BFK). Harold Keeler. D, BS, S, Dat.

Print not in University Art Museum Archive

340
Patriarch. Jul 14–18, 1961. Light violet (S). 76.2 × 56.5. 10 ExP (BFK)[1], PrP (BFK). Bohuslav Horak. D, BS (Tam), S, BS (pr).

1. Designated A-J. 5 ExP retained by Tamarind.

354
Landscape. Jul 27–Aug 8, 1961. Orange (S), green (S). 29.8 × 40.6. Ed 20 (BFK), 9 TI (CW), BAT (CW), 2 AP (1 BFK, 1 CW), 3 TP (2 BFK, 1 CW). Harold Keeler. D, BS, S, Dat.

341
Head. Jul 18–21, 1961. Black (S). 56.5 × 37.8. Ed 14 (BFK), 9 TI (wA), PrP (BFK). Bohuslav Horak. D, BS, S, Dat.

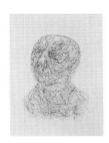

357
Simon. Aug 8–15, 1961. Orange (Z), yellow (Z), violet (S). 76.8 × 56.5. Ed 20 (BFK), 9 TI (wN), BAT (wN), 3 AP (1 BFK, 2 wN), 2 TP (BFK), CP (BFK). Bohuslav Horak. D, BS, S, Dat.

343
Black Beast. Jul 18, 1961. Black (Z)[1]. 74.3 × 105.4. Ed 20 (BFK), 9 TI (wN), PrP (BFK), 2 AP (1 BFK, 1 wN). John Muench. D, BS, S.

1. Plates held from 339, run 2. 343 differs from 339 in color and in image. Wash tones accenting the linear drawing have been eliminated.

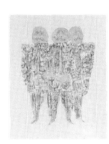

359
Three Generals. Aug 14–24, 1961. Yellow (Z), grey-green (Z), orange (Z), red (Z), blue (Z), green (S). 88.0 × 68.3. Ed 20 (BFK), 9 TI (wN), PrP (wN), 3 AP (wN), 2 TP* (BFK), CP (BFK). George Miyasaki. D, BS, S, Dat.

344
Spotted Beast. Jul 18–Aug 2, 1961. Green-brown (Z), dark pink (Z), black (Z). 56.8 × 76.2. Ed 20 (BFK), 9 TI (wA), BAT (wA), 2 AP (BFK), 3 TP (BFK), 1 CTP (BFK). Bohuslav Horak. D, BS, S, Dat.

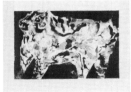

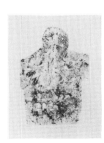

364
Figure. Aug 21–24, 1961. Black (S). 76.8 × 56.8. Ed 20 (BFK), 9 TI (wN), PrP (BFK), 2 AP (1 BFK, 1 wN), 2 TP (BFK). Bohuslav Horak. D, BS, S, Dat.

Print not in
University Art Museum
Archive

367
Three Generals. Aug 23, 1961. Black
(S)[1]. 88.9 × 69.8. 10 ExP (BFK)[2].
George Miyasaki, NC. D, BS (Tam), S,
Dat.

1. Stone held from 359, run 6;
 additions. 367 differs from 359 in
 color and in image. Light wash
 tones throughout the linear drawing
 have been eliminated. Minor
 addition of lines in the shoulders
 and legs of the figures.
2. Designated A-J. 5 ExP retained by
 Tamarind. 1 ExP on paper 87.6 ×
 53.3.

368
Beast. Aug 29, 1961. Black (S). 69.2 ×
99.1. Ed 20 (BFK), 9 Tl (nN), PrP (BFK),
3 AP (2 BFK, 1 nN), 2 TP (BFK), CP
(BFK)[1]. George Miyasaki. D, BS, S,
Dat.

1. On paper 74.9 × 104.1.

372
Giant. Aug 29–31, 1961. Black (S).
105.4 × 74.6. Ed 30 (BFK), 9 Tl (wN),
PrP (wN), 2 AP (BFK), 3 TP (BFK).
Bohuslav Horak. D, S, Dat (top), BS
(bottom).

374
Woman. Aug 31–Sep 5, 1961. Black
(S). 104.8 × 74.3. Ed 30 (BFK), 9 Tl
(wN), PrP (wN), 2 AP (BFK), 4 TP (BFK),
CP (BFK). Bohuslav Horak. D, S, Dat
(top), BS (bottom).

Aris Koutroulis

Greek, a suite of seven lithographs
including title and colophon pages. In
order: 990, 894, 901, 917, 942, 959,
908.

894
Theta, Fi, Omega (Greek suite II).
Sep 17–24, 1963. Black. 56.5 × 76.8.
Ed 10 (BFK), 9 Tl (wA), 1 AP (wA), CP
(BFK). Aris Koutroulis. D, T, BS, S.

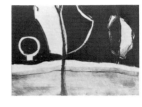

901
Psi, Fi, Omega (Greek suite III). Oct
7–8, 1963. Black (Z). 56.5 × 76.5. Ed
10 (BFK), 9 Tl (wA), PrP (BFK), 1 AP
(wA), CP (BFK). Aris Koutroulis. D, T, S
(top), BS (bottom).

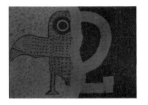

906
Owl. Oct 15–29, 1963. Black (Z), light
violet-grey (S)[1]. 56.5 × 76.2. Ed 10
(BFK), 9 Tl (wA), PrP (BFK), 3 AP (wA),
2 TP (BFK), CP (BFK). Aris Koutroulis.
D, BS, S.

1. After printing run 2, each
 impression was blotted in an
 additional press run.

Print not in
University Art Museum
Archive

908
Theta, Omega (Greek suite). Oct
22–27, 1963. Red (Z), green (S)[1]. 56.5
× 76.2. 10 ExP (BFK)[1], 5 AP (wA), 3
TP (BFK). Aris Koutroulis. D, BS, T, S.

1. Designated A-J. 5 ExP retained by
 Tamarind.

917
Pi, Psi (Greek suite IV). Nov 5–19,
1963. Grey-green (Z), transparent
black (Z), brown (Z)[1]. 56.5 × 76.2.
Ed 20 (BFK), 9 Tl (BFK), 3 AP (wA), 3
TP (BFK). Aris Koutroulis. BS, D, T, S,
Dat.

1. After printing run 3, the color was
 blotted leaving the texture of the
 blotter on each impression.

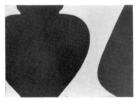

942
Fi (Greek suite V). Dec 1–17, 1963.
Light blue-green (Z), grey-green (Z)[1],
black (Z). 56.5 × 76.2. Ed 20 (BFK), 9
Tl (wA), 3 AP (wA), 2 TP (BFK), CP
(BFK). Aris Koutroulis. D, T, S, Dat, BS.

1. Reversal of run 3 image; deletions.

959
Urn Greek suite VI). Jan 11–15,
1964. Black (Z), black (Z). 56.8 × 76.2.
Ed 10 (BFK), 9 Tl (wA), 3 AP (2 wA, 1
BFK), 2 TP (BFK). Aris Kokutroulis. BS,
D, T, S, Dat.

990
***Greek (title and colophon, Greek
suite I).*** May 31–Jun 7, 1964. Black
(Z). 57.5 × 75.9. Ed 9 (BFK), 9 Tl (bA),
1 AP (bA). Aris Koutroulis. T, BS, D, S,
Dat.

Nicholas Krushenick

Print not in
University Art Museum
Archive

1327
Small I. May 3–12, 1965. Yellow (Z),
red (Z), blue (Z), silver (A). 44.5 ×
55.2, cut. Ed 18 (BFK), 9 TI (wA), BAT
(BFK), 5 TP (Tcs), CP (Tcs). Kenneth
Tyler. Verso: D, S, WS.

1332
Untitled. May 4–17, 1965. Yellow (Z),
red (Z), blue (Z), red-violet (Z), black
(S). 73.7 × 53.3. Ed nr (BFK, wA)[1], 1
CTP (JG)[2], CP (Tcs). Kenneth Tyler.

1. The Tamarind worksheet records a
 short edition, exact number
 unrecorded, pulled due to
 experimentation with the black
 keystone. Later notation indicates
 this edition was abandoned which
 according to Tamarind policy would
 imply that the impressions had
 been destroyed. The artist did not
 reply to correspondence attempting
 to verify this fact.
2. 1 CTP (JG) on paper 77.5 × 59.4,
 image size 63.5 × 56.5. Unsigned,
 unchopped, undesignated, retained
 by Tamarind.

1334
Untitled. May 5–21, 1965. Violet (Z),
black (A). 73.4 × 54.3, cut. Ed 15
(BFK)[1], 9 TI (wA), BAT (BFK), 2 TP*
(Tcs), CP (Tcs). Kenneth Tyler. Verso: D,
S, WS.

1. Erroneously numbered 1/20–15/20

1335
Untitled. May 5–19, 1965. Yellow (Z),
black (S). 74.3 × 54.6, cut. Ed 20
(BFK), 9 TI (wA), BAT (BFK), 3 AP (2
BFK, 1 wA), 3 TP (1 wA, 2 BFK), CP
(Tcs). Kenneth Tyler. Verso: D, S, WS.

1338
Untitled. May 12–19, 1965. Black (S).
76.2 × 56.8. Ed 20 (BFK), 9 TI (wA),
BAT (BFK), 2 PP (nr), 3 AP (1 BFK, 2
wA), 2 TP (wN), CP (Tcs). Clifford
Smith. Verso: D, S, WS.

1339
Silver Hispano Suiza. May 10–19,
1965. Black (Z), silver (S). 74.3 × 54.6,
cut. Ed 20 (BFK), 9 TI (wA), BAT (BFK),
3 AP (BFK), 3 TP* (wA), CP (Tcs).
Kenneth Tyler. Verso: D, S, WS.

1340
Untitled. May 27–Jun 15, 1965. Violet
(A), black (S). 73.0 × 53.7, cut. Ed 20
(BFK), 9 TI (wA), BAT (BFK), 1 AP (wA),
1 TP (BFK), CP (Tcs). Kenneth Tyler.
Verso: D, S, Dat, WS.

1341
Stony Point. May 11–Jun 1, 1965.
Red-violet (Z), blue (Z), black (Z). 73.7
× 53.7, cut. Ed 20 (BFK), 9 TI (wA),
BAT (BFK), 1 AP (BFK), 1 PP (nr), 4 TP
(BFK)[1], CP (Tcs). Kenneth Tyler.
Verso: D, S, Dat, WS.

1. 1 TP varies from the edition.

1342
Untitled. May 13–20, 1965. Orange
(Z), red (A), blue (Z), black (Z). 74.0 ×
54.0, cut. Ed 20 (wN), 9 TI (nN), BAT
(wN), 3 TP (wN), CP (wN). Kenneth
Tyler. Verso: D, S, Dat, WS.

1343
Untitled. May 19–Jun 1, 1965. Green
(A), red-violet (A), black (A). 73.0 ×
53.7, cut. Ed 20 (BFK), 9 TI (wA), BAT
(BFK), 3 AP (wA), 1 TP (BFK), CP (Tcs).
Kenneth Tyler. Verso: D, S, Dat, WS.

1344
Untitled. May 20–28, 1965. Red-violet (A), orange (A), black (A). 73.0 × 54.0, cut. Ed 20 (BFK), 9 TI (wA), BAT (BFK), 3 AP (wA), 4 TP (BFK)[1], CP (Tcs). Kenneth Tyler. Verso: D, S, Dat, WS.

1. 2 TP vary from the edition.

1345
Purple Passion. May 21–28, 1965. Yellow (A), red-violet (A), black (A). 73.0 × 53.3, cut. Ed 20 (BFK), 9 TI (wA), BAT (BFK), 3 AP (1 BFK, 2 wA), 3 PP (nr), 4 TP (BFK), 10 PgP (BFK)[1], CP (Tcs). Kenneth Tyler. Verso: D, S, Dat, WS.

1. 5 PgP retained by Tamarind, unchopped.

1346
Untitled. May 21–Jun 4, 1965. Red-violet (A), blue (A), black (S). 75.6 × 55.9, cut. Ed 20 (BFK), 9 TI (wA), BAT (BFK), 3 AP (1 BFK, 2 wA), 4 TP (BFK)[1], CP (Tcs). Kenneth Tyler. Verso: D, S, Dat, WS.

1. 3 TP vary from the edition.

1347
Untitled. May 25–Jun 8, 1965. Yellow (A), black (A). 73.7 × 53.7, cut. Ed 20 (BFK), 9 TI (wA), BAT (BFK), 3 AP (wA), 1 TP (BFK), CP (Tcs). Kenneth Tyler. Verso: D, S, Dat, WS.

1357
Untitled. Jun 17–Jul 25, 1965. Violet (A), black (A). 73.7 × 53.3, cut. Ed 20 (wA), 9 TI (wA), BAT (BFK), 1 TP (BFK), CP (Tcs). Clifford Smith. Verso: D, S, Dat, WS.

1366
Untitled. May 25–Jun 5, 1965. Yellow (A), orange (A), blue (A), black (S). 73.0 × 52.7, cut. Ed 20 (BFK), 9 TI (wA), BAT (BFK), 3 AP (wA), 4 TP (2 BFK, 2 Tcs*), CP (Tcs). Kenneth Tyler. Verso: D, S, Dat, WS.

1367
Untitled. May 25–Jun 9, 1965. Yellow (A), red-orange (A), black (A). 73.4 × 52.7, cut. Ed 20 (BFK), 9 TI (wA), BAT (BFK), 3 AP (BFK), 2 TP* (Tcs), CP (Tcs). Kenneth Tyler. Verso: D, S, Dat, WS.

1368
Untitled. Jun 1–14, 1965. Red (A), black (A), silver (S). 73.4 × 53.0, cut. Ed 20 (BFK), 9 TI (wA), BAT (BFK), 1 AP (wA), 1 TP (BFK), CP (Tcs). Kenneth Tyler. Verso: D, S, Dat, WS.

1369
Untitled. Jun 3–15, 1965. Blue (A), black (A), silver (S). 73.4 × 53.7, cut. Ed 20 (BFK), 9 TI (wA), BAT (BFK), CP (Tcs). Clifford Smith. Verso: D, S, Dat, WS.

1370
Untitled. Jun 3–18, 1965. Orange (A), blue (A), black (A). 73.4 × 52.7, cut. Ed 20 (BFK), 9 TI (wA), BAT (BFK), 3 AP (2 BFK, 1 wA), 3 TP (BFK), CP (Tcs). Clifford Smith. Verso: D, S, Dat, WS.

1371
Untitled. Jun 21–24, 1965. Yellow (Z), red (Z), black (A). 73.0 × 53.0, cut. Ed 20 (BFK), 9 TI (wA), BAT (BFK), 1 AP (wA), 1 TP (BFK), CP (Tcs). Clifford Smith. Verso: D, S, Dat, WS.

1376
Untitled. Jun 17–28, 1965. Blue (Z), black (A). 73.4 × 53.3, cut. Ed 20 (BFK), 9 TI (wA), BAT (BFK), 2 AP (wA), 2 TP (BFK), CP (Tcs). Clifford Smith. Verso: D, S, Dat, WS.

1379
Untitled. Jun 17–30, 1965. Orange (A), blue (A), black (A). 73.4 × 53.3, cut. Ed 17 (BFK), 9 TI (wA), BAT (BFK), CP (Tcs). Clifford Smith. Verso: WS, D, S, Dat.

Gerald Laing

1226
Pile. Jan 1–31, 1965. Gold (S). 76.8 × 56.8. Ed 20 (nN), 9 TI (nN), BAT (nN), 1 AP (nN), 6 PP (nN), 2 TP (nN), CP (nN). Kenneth Tyler. D, Dat, BS, S.

Jacob Landau

Charades, a suite of ten lithographs plus title and colophon pages, enclosed in a brown linen covered box, measuring 37.5 × 31.1, lined with white paper, made by the Schuberth Bookbindery, San Francisco. The title page and colophon printed at the Plantin Press, Los Angeles. In order: 1262, 1263, 1264, 1265, 1279, 1280, 1274, 1284, 1267, 1281.

1050
Ritual Happening. Mar 20–27, 1964. Black (S). 55.9 × 68.6. Ed 20 (wA), 9 TI (BFK), BAT (wA), 3 AP (2 wA, 1 BFK), 2 PP (1 wA, 1 BFK), 2 TP (1 wN, 1 nN), CP (wA). Aris Koutroulis. T, BS (Tam), D, S, BS (pr).

1262
Untitled (Charades I). Mar 12–26, 1965. Black (S). 35.6 × 27.9. Ed 20 (BFK), 9 TI (wA), BAT (BFK), 3 AP (2 BFK, 1 wA), 3 TP (2 BFK, 1 nr), CP (Tcs). Kenneth Tyler. BS, D, S.

1263
Untitled (Charades II). Mar 12–26, 1965. Black (S). 35.6 × 28.6, (diameter). Ed 20 (BFK), 9 TI (wA), BAT (BFK), 3 AP (2 BFK, 1 wA), 4 TP (2 BFK, 2 nr), CP (Tcs). Kenneth Tyler. BS, D, S.

1264
Untitled (Charades III). Mar 12–26, 1965. Black (S). 35.6 × 27.9, (diameter). Ed 20 (BFK), 9 TI (wA), BAT (BFK), 2 AP (wA), 4 TP (1 BFK, 3 nr), CP (Tcs). Kenneth Tyler. BS, D, S.

1265
Untitled (Charades IV). Mar 12–26, 1965. Black (S). 35.6 × 27.9. Ed 20 (BFK), 9 TI (wA), BAT (BFK), 4 TP (2 BFK, 2 nr), CP (Tcs). Kenneth Tyler. D, S, BS.

1267
Untitled (Charades IX). Mar 4–9, 1965. Red-brown (S). 35.6 × 28.9. Ed 20 (BFK), 9 TI (wA), BAT (BFK), 3 AP (BFK), 3 TP (2 BFK, 1 nr), CP (Tcs). Kenneth Tyler. BS, D, S.

1271
Palace. Mar 10–25, 1965. Black (S).
57.2 × 77.8. Ed 20 (bA), 9 TI (nN), BAT
(bA), 3 AP (2 bA, 1 nN), 5 TP (2 bA, 3
nr), CP (Tcs). Kenneth Tyler. BS, D, S.

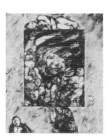

1274
Untitled (Charades VIII). Mar 26,
1965. Brown-black (S). 35.6 × 27.9. Ed
20 (BFK), 9 TI (wA), BAT (BFK), 3 AP
(wA), 4 TP (2 BFK, 2 nr), CP (Tcs).
Kenneth Tyler. D, S, BS.

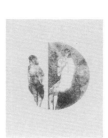

1279
Untitled (Charades V). Mar 12–26,
1965. Black (S). 35.6 × 28.6,
(diameter). Ed 20 (BFK), 9 TI (wA), BAT
(BFK), 3 AP (BFK), 3 TP (2 BFK, 1 nr),
CP (Tcs). Kenneth Tyler. BS, D, S.

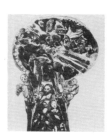

1280
Untitled (Charades VI). Mar 12–26,
1965. Black (S). 35.6 × 28.3. Ed 20
(BFK), 9 TI (wA), BAT (BFK), 3 AP
(BFK), 3 TP (2 BFK, 1 nr), CP (Tcs).
Kenneth Tyler. BS, D, S.

1281
Untitled (Charades X). Mar 24–25,
1965. Red-black (S). 35.6 × 28.3. Ed
20 (BFK), 9 TI (wA), BAT (BFK), 2 AP
(wA), 2 TP (1 wA, 1 BFK), CP (Tcs).
Kenneth Tyler. D, S, BS.

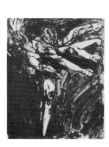

1284
Untitled (Charades VIII). Mar 26,
1965. Brown-black (S). 35.6 × 28.6. Ed
20 (BFK), 9 TI (wA), BAT (BFK), 3 AP (1
wA, 2 BFK), 7 TP (2 BFK, 5 nr), CP
(Tcs). Kenneth Tyler. D, S, BS.

William Law III

2647
Ta-Da. May 12–Jun 7, 1969. Dark
brown (A). 76.5 × 55.2. Ed 10 (bA), 9
TI (CD), BAT (bA), 3 CTP (1 bA, 1 cR, 1
CD), CP (bA). William Law III. D, BS, S,
Dat.

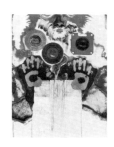

2707
Walnetto Man. Jun 25–Aug 14, 1969.
Yellow (Z), red (Z), blue (A). 74.3 ×
55.6. Ed 13 (CD), 9 TI (GEP), BAT (CD),
1 AP (GEP), 4 CTP (2 CD, 2 GEP), CP
(GEP). William Law III. T, D, BS, S, Dat.

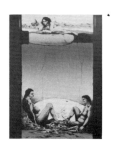

2794
Electric Tail. Sep 20, 1969–Feb 7,
1970. Blue, B: light blue, light blue,
medium blue, medium blue, blue,
blue, blue (A), green, B: yellow-beige,
yellow-green (A), pink, B: light pink,
pink, red (A), dark brown (A). 76.2 ×
55.6. Ed 15 (cream CD), 9 TI (bA), BAT
(cream CD), 3 AP (1 cream CD, 2 bA),
3 CTP (1 GEP, 1 cream CD, 1 CD), CP
(bA). William Law III. T, D, BS, S, Dat.

Ian Lawson

1799
L.A. 1. Aug 11–Sep 1, 1966. Orange
(Z), red-orange (Z), light blue (Z), dark
blue (S). 59.1 × 79.4. Ed 15 (JG), 9 TI
(JG), BAT (JG), 1 AP (JG), 4 TP (JG).
Ian Lawson. D, T, S, BS.

Rico Lebrun

Print not in
University Art Museum
Archive

379
Inferno Series A. Sep 6–7, 1969.
Black (S). 57.5 × 64.8. 10 ExP (BFK)[1],
PrP (BFK), CP (BFK). Bohuslav Horak.
D, S, Dat, BS.

1. Designated A–J. 5 ExP retained by
Tamarind.

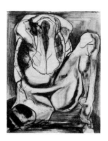

382
Inferno Series B. Sep 8–12, 1961. Black (S). 75.6 × 56.5. Ed 10 (BFK), 9 TI (wA), PrP (wA), 2 AP (wA), 2 TP (BFK), CP (wA). Bohuslav Horak. BS, S, D.

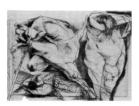

384
Brecht's Three-Penny Novel B. Sep 11–20, 1961. Black (Z). 56.5 × 75.9. Ed 11 (BFK), 9 TI (wA), PrP (wA), 3 AP (BFK), CP (BFK). Bohuslav Horak. BS, S, Dat, D.

389
Untitled. Sep 18–21, 1961. Black (S). 66.7 × 92.4. 19 ExP (BFK)[1], PrP (BFK), 2 TP (BFK), CP (BFK). Bohuslav Horak. BS (pr), D, BS (Tam), S, Dat.

1. Designated A–S. 1 ExP retained by Tamarind.

390
Inferno Series E. Sep 19–27, 1961. Grey (S), black (S). 58.4 × 38.4. Ed 3 (BFK), 9 TI (JG), PrP (BFK), 2 TP (JG), CP (BFK). Bohuslav Horak. T, D, S, Dat, BS.

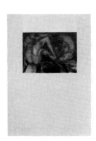

393
Inferno Series C. Sep 25–29, 1961. Grey (S), black (S). 56.5 × 38.1. Ed 6 (5 BFK, 1 wA), 9 TI (wA), PrP (BFK), 2 AP (wA), 3 TP (2 BFK, 1 wA). Bohuslav Horak. BS, D, T, S, Dat.

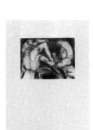

393A
Inferno Series D. Sep 25–27, 1961. Black (S)[1]. 56.8 × 37.8. Ed 3 (BFK), 9 TI (wA), 1 AP (BFK), 3 TP (2 BFK, 1 wA). Bohuslav Horak. BS, D, T, S, Dat.

1. Stone held from 393, run 2. 393A differs from 393 in color and in image. The background tone has been eliminated.

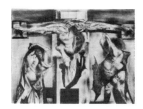

398
Grunewald Study. Sep 25–29, 1961. Black (S). 62.2 × 77.5. Ed 20 (BFK), 9 TI (BFK), PrP (BFK), 3 AP (BFK), 2 TP (BFK), 7 PTP (brown wrapping paper)[1]. Bohuslav Horak. S, Dat, BS, T, D.

1. 1 PTP hand colored on verso. 3 PTP retained by Tamarind.

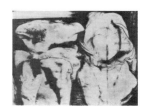

399
Study for Figures in Flood. Sep 28–Oct 2, 1961. Black (Z). 73.0 × 93.3. Ed 8 (BFK), 9 TI (BFK), PrP (BFK), CP (BFK). Bohuslav Horak. T, BS, D, S, Dat.

402
Brecht's Three-Penny Novel A. Oct 1–6, 1961. Black (Z). 37.8 × 50.8. Ed 5 (BFK), 9 TI (wA), PrP (BFK), 2 AP (wA), 4 TP* (BFK)[1], CP (BFK)[2]. Bohuslav Horak. T, BS, S, Dat, D.

1. 1 TP on paper 38.1 × 55.9, 1 TP on paper 45.7 × 58.4. 1 TP retained by Tamarind.
2. On paper 36.8 × 45.7.

404
Grunewald Study II. Oct 1–5, 1961. Grey (Z), black (S). 66.0 × 90.2. Ed 20 (BFK), 9 TI (BFK), PrP (BFK), 2 AP (BFK), 5 TP (BFK). Bohuslav Horak. D, BS, S, Dat.

1. Stone held from 398. 404 differs from 398 in color, image and size. A bleed background tone has been added creating some border on all four sides.

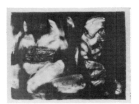

408
Dark Figures. Oct 6–12, 1961. Black (Z). 73.7 × 91.1. Ed 14 (BFK), 9 TI (BFK), PrP (BFK), 1 TP (BFK), CP (BFK). Bohuslav Horak. D, BS, S, Dat.

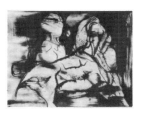

414
Centaur and Woman. Oct 11–13, 1961. Black (Z). 32.1 × 41.3. Ed 8 (BFK), 9 TI (BFK), PrP (BFK), 2 TP (BFK), CP (BFK). Bohuslav Horak. D, S, Dat, BS.

427
Poster for Marionette Theatre. Oct
23–25, 1961. Black (Z). 87.6 × 65.4. Ed
10 (BFK), 9 TI (nN), PrP (nN), 2 AP
(nN), 4 TP (3 nN, 1 BFK), CP (BFK).
Bohuslav Horak. BS, D, S, Dat.

Print not in
University Art Museum
Archive

428
Dante. Oct 23–24, 1961. Black (Z).
55.9 × 34.3. 1 proof (Tcs)[1]. Bohuslav
Horak.

1. Unsigned, unchopped.

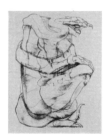

476
Inferno Series F. Jan 2–4, 1962.
Black (Z). 76.2 × 56.5. Ed 10 (BFK), 9
TI (wA), PrP (BFK), 2 AP (wA), 3 TP (2
BFK, 1 wA). Bohuslav Horak. D, BS, S,
Dat.

Print not in
University Art Museum
Archive

477
Brecht's Three Penny Novel C. Jan
2–15, 1962. Black (Z). 97.8 × 72.7. Ed
15 (BFK), 9 TI (nN), PrP (BFK), 2 AP (1
BFK, 1 nN), 3 TP (2 BFK, 1 nN). Joe
Funk. D, BS, S, Dat.

490
Inferno Series G. Jan 17–18, 1962.
Black (Z). 89.5 × 67.3, (BFK), Ed 10
(BFK)[1], 9 TI (nN), PrP (BFK)[1], 2 AP
(nN), 3 TP (2 nN, 1 BFK[1]). Bohuslav
Horak. D, BS, S, Dat.

1. Impressions on BFK are bleed
images.

Jason Leese

Scenes of Paris, a suite of twelve
lithographs including title and
colophon pages, plus handwritten
dedication page. In order: 857, 840,
834, 870, 853, 837, 819, 825, 809, 790,
785, 902, 747, 940, 944, 953.

747
Dépôt des Batignolles. Feb 14–16,
1963. Black (S). 50.8 × 66.0. Ed 19
(BFK), 9 TI (wA), BAT (BFK), 2 AP (wA).
Jason Leese. T, D, BS, S.

780
***The Bridge at Sèvres (Scenes of
Parfis IV).*** Apr 2, 1963. Black (S). 38.1
× 57.2. Ed 20 (BFK), 9 TI (wA), BAT
(BFK), 3 AP (BFK), 2 TP (BFK), CP
(BFK). Jason Leese. T, D, BS, S.

785
***House, 14e Arrondissement
(Scenes of Paris XI).*** Apr 12–13,
1963. Yellow (S), black (S). 57.2 ×
38.1. Ed 20 (BFK), 9 TI (wA), BAT
(BFK), 2 AP (BFK), CP (BFK). Jason
Leese. T, D, BS, S.

790
***Citroën Factory (Scenes of Paris
X).*** Apr 23–May 10, 1963. Blue-grey
(S), black (S). 38.1 × 56.2. Ed 20
(BFK), 9 TI (wA), BAT (BFK), 3 AP
(BFK), 2 TP (BFK), CP (BFK). Jason
Leese. T, D, BS.

Print not in
University Art Museum
Archive

809
***House in the Wine Market (Scenes
of Paris IX).*** May 18–25, 1963. Beige
(S), black (S). 38.4 × 56.2. Ed 20
(BFK), 9 TI (wA), BAT (BFK), 3 AP
(BFK), CP (BFK). Jason Leese. T, D, S,
BS.

819
***Viaduct at Arcueil-Cachan (Scenes
of Paris VII).*** May 30–31, 1963. Red-
brown (S). 38.1 × 56.2. Ed 20 (BFK), 9
TI (wA), BAT (BFK), 3 AP (BFK), 2 PP (1
BFK, 1 wA), 2 TP (BFK), CP (BFK).
Jason Leese. T, D, BS, S.

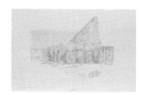

825
***Barrels in the Wine Market (Scenes
of Paris VIII).*** Jun 10–14, 1963. Red-
brown (S). 38.4 × 56.2. Ed 20 (BFK), 9
TI (wA), BAT (BFK), 3 AP (BFK), 2 PP
(BFK), CP (BFK). Jason Leese. T, D, BS,
S.

834
The Bridge at Sèvres, Early Morning (Scenes of Paris III). Jun 20–21, 1963. Black (S). 37.8 × 56.5. Ed 20 (BFK), 9 TI (wA), BAT (BFK), 3 AP (BFK), 1 PP (BFK), 2 TP (BFK), CP (BFK). Jason Leese. T, D, BS, S.

837
Factories along the Seine (Scenes of Paris VI). Jun 24–28, 1963. Blue (S). 38.1 × 56.8. Ed 20 (BFK), 9 TI (wA), BAT (BFK), 3 AP (BFK), 2 TP (BFK), CP (BFK). Jason Leese. T, D, BS, S.

840
Bridge at Neuilly (Scenes of Paris II). Jul 5, 1963. Black (S). 38.1 × 56.5. Ed 20 (BFK), 9 TI (wA), BAT (BFK), 3 AP (BFK), 2 PP (BFK), 2 TP (BFK), CP (BFK). Jason Leese. T, D, BS, S.

853
Near the Luxembourg Gardens (Scenes of Paris V). Jul 25–29, 1963. Brown (S). 37.8 × 56.5. Ed 20 (BFK), 9 TI (wA), BAT (BFK), 3 AP (BFK), 2 TP (BFK), CP (BFK). Jason Leese. T, D, BS, S.

857
Title page (Scenes of Paris I). Aug 2–Oct 4, 1963. Grey (S), black (S). 56.5 × 38.1. Ed 20 (BFK), 9 TI (wA), BAT (BFK), 3 AP (BFK), 2 TP (BFK), CP (BFK). Jason Leese. D, BS, S.

902
Colophon (Scenes of Paris XII). Oct 11–14, 1963. Black (S). 56.5 × 38.1. Ed 20 (BFK), 9 TI (wA), BAT (BFK), 3 AP (BFK), 2 TP (BFK), CP (BFK). Jason Leese. BS, S, D.

940
Les Batignolles. Nov 22–25, 1963. Black (Z). 38.4 × 50.8. Ed 10 (BFK), 9 TI (wA), BAT (BFK), 3 AP (wA), 1 PP (BFK), 2 TP (BFK). Jason Leese. T, D, BS, S.

944
Locomotive. Dec 2–6, 1963. Black (Z). 38.4 × 50.8. Ed 10 (BFK), 9 TI (wA), BAT (BFK), 3 AP (BFK), 2 TP (BFK), CP (BFK). Jason Leese. T, D, BS, S.

953
Repair Sheds. Dec 6–11, 1963. Black (Z). 38.1 × 50.8. Ed 10 (BFK), 9 TI (wA), BAT (BFK), 3 AP (wA), 2 TP (BFK), CP (BFK). Jason Leese. T, D, BS, S.

Jack Lemon

1318
Image-12. Jul 20–27, 1965. Grey-green (S), blue-green (S), dark red (S). 46.1 × 43.2. Ed 10 (wA), 9 TI (BFK), 1 UNMI (wA), 3 AP (wA). Jack Lemon. BS (Tam), T, D, S, BS (UNM).

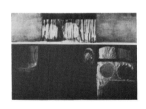

1319
Image-13. Jul 24–27, 1965. Black (S), blue-black (S). 33.4 × 45.7. 9 TI (wA), 1 UNMI (BFK), 6 AP (1 wA, 5 BFK). Jack Lemon. BS (Tam), T, D, S, BS (UNM).

Rita Eloul Letendre

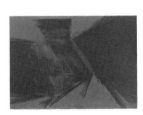

1455
Impact. Aug 19–25, 1965. Red (Z), black (S). 56.5 × 76.2. Ed 20 (BFK), 9 TI (wA), BAT (BFK), 3 AP (1 BFK, 2 wA), 3 TP (BFK), CP (Tcs). Clifford Smith. D, S, Dat, BS.

John Levee

2695
L-69—#1. Jul 2–Aug 1, 1969. Red (S), dark blue (A), light blue (A), light grey (A). 76.5 × 55.9. Ed 20 (CD), 9 TI (GEP), BAT (CD), 3 AP (1 CD, 2 GEP), 1 TP (GEP), 1 CTP (CD). William Law III. S, BS, D.

2695II
L-69—#2. Jul 11–Aug 1, 1969. Orange (S)[1], brown-green (A)[1], light brown-orange (A)[1], light grey (A)[1]. 76.5 × 55.6. Ed 10 (CD), 9 TI (GEP), BAT (CD), 3 AP (2 CD, 1 GEP), 2 CTP (1 GEP, 1 CD), CP (CD). William Law III. S, BS, D.

1. Stone and plates held from 2695, run 1, 2, 3, 4. 2695II differs from 2695 in color only.

2697
L-69—#3. Jul 16–Aug 4, 1969. Dark grey (A), blue (A), brown-green (A), light beige (A), beige (A)[1]. 76.5 × 55.6. Ed 15 (CD), 9 TI (GEP), BAT (CD), 2 CTP (1 CD, 1 GEP), CP (CD). John Sommers. S, BS, D.

1. Same plate as run 4.

2698
L-69—#4. Jul 28–Aug 12, 1969. Blue (A), black, dark grey (A), medium grey (A), light grey (A), beige (A). 76.2 × 55.9. Ed 20 (18 CD, 2 GEP), 9 TI (GEP), BAT (CD), 2 AP (CD), 1 TP (CD), 1 CTP (GEP), CP (CD). Paul Clinton. S, BS, D.

2699
L-69—#5. Jul 31–Aug 14, 1969. Orange, light beige (A), blue, beige (A), red-violet, light beige (A), violet, light beige (A). 76.5 × 56.2. Ed 20 (cR), 9 TI (ucR), BAT (cR), 1 AP (ucR), 5 CTP (cR). Charles Ringness. S, BS, D.

2699II
L-69—#6. Jul 31–Aug 13, 1969. Orange (A)[1], blue (A)[1], red-violet (A)[1], violet (A)[1]. 76.2 × 55.9. Ed 10 (cR), 9 TI (ucR), BAT (cR), 4 CTP (3 cR, 1 ucR), CP (ucR). Charles Ringness. S, D, BS.

1. Plates held from 2699, run 1, 2, 3, 4. 2699II differs from 2699 in color only.

2700
L-69—#7. Aug 1–15, 1969. Red, blue (A), light red-violet (A), orange (A), dark red (A). 55.9 × 76.5. Ed 20 (19 cR, 1 ucR), 9 TI (ucR), BAT (cR), 3 AP (cR), 1 PP (cR), 2 CTP (cR), CP (cR). Eugene Sturman. S, D, BS.

2701
L-69—#8. Aug 11–25, 1969. Light grey (A), dark grey (A), medium grey (A), silver-grey, red (A). 76.5 × 54.9. Ed 17 (14 GEP, 3 CD), 9 TI (CD), BAT (GEP), 5 CTP (1 GEP, 4 cR), CP (CD). Hitoshi Takatsuki. S, D, BS.

2702
L-69—#9. Aug 12–27, 1969. Blue (A), red (A), dark blue (A). 76.5 × 53.3. Ed 10 (cR), 9 TI (ucR), BAT (cR). Serge Lozingot. S, D, BS.

2702II
L-69—#10. Aug 12–30, 1969. Orange (A)[1], dark orange (A), green (A)[2]. 76.2 × 53.3. Ed 10 (cR), 9 TI (ucR), BAT (cR), 3 AP (2 cR, 1 ucR), CP (cR). Serge Lozingot. S, D, BS.

1. Plate held from 2702, run 1.
2. Plate held from 2702, run 3. 2702II differs from 2702 in color and in image. The glossy surface on the inside stripes has been eliminated.

Jacques Lipchitz

667
The Bull and the Condor[1]. Oct 29–Nov 4, 1962. Red-brown (Z), black (Z). 77.2 × 57.2. Ed 125 (100 BFK[2], 25 wA[3]), 9 TI (wN), PrP (wA), PrP II for Irwin Hollander (wA), 3 AP (2 wA, 1 wN), 6 TP[4] (3 BFK, 2 newsprint, 1 wN[5]), 2 CSP (BFK)[6], CP (BFK). Emiliano Sorini. BS (Tam), D, S, BS (pr).

1. Published by the UCLA Art Council and printed in the New York studio of Sorini. Tamarind procedures and documentation supervised by Irwin Hollander.
2. Numbered in Arabic numerals for UCLA Art Council.
3. Numbered in Roman numerals for the artist.
4. Signed, not chopped.
5. With drawing in sanguine crayon.
6. Designated and signed on verso, not chopped. Retained by Tamarind.

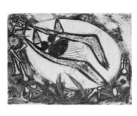

760
Untitled.[1] Mar 4–Apr 8, 1963. Red-brown (S), black (S). 56.5 × 77.2. Ed 20 (15 bA), 5 nN), 9 TI (nN), PrP (bA), PrP II for Bohuslav Horak (bA). Joe Zirker. BS.

1. During a visit to the workshop, Lipchitz inscribed a sheet of transfer paper; it was transferred to stone and printed as a memento. None of the impressions are signed or designated.

Frank Lobdell

1705
Untitled. Jun 7–10, 1966. Black (S). 51.1 × 68.6. Ed 20 (BFK), 9 TI (MI), BAT (BFK), 1 AP (MI), 2 TP (BFK), CP (Tcs). Clifford Smith. Recto: BS, I, Dat, D Verso: S.

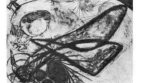

1706
Untitled. Jun 8–9, 1966. Black (S). 50.8 × 68.6. Ed 20 (BFK), 9 TI (MI), BAT (BFK), 1 AP (BFK), CP (Tcs). Kinji Akagawa. Recto: I, Dat, D, BS Verso: S.

1707
Untitled. Jun 10–13, 1966. Black (S). 50.8 × 68.6. Ed 20 (GEP), 9 TI (MI), BAT (GEP), 2 AP (1 MI, 1 GEP), 2 TP (1 bA, 1 GEP). Ernest de Soto. Recto: BS, D, I, Dat Verso: S.

1707A
Untitled. Jun 15–17, 1966. Black (S)[1]. 50.8 × 68.6. Ed 20 (GEP), 9 TI (MI), BAT (GEP), 2 AP (1 MI, 1 GEP), 2 TP (GEP). Ernest de Soto. Recto: I, Dat, D, BS Verso: S.

1. Stone held from 1707; deletions and additions. 1707A differs from 1707 in image. The dark central shapes have almost been eliminated. The shapes in the lower right have been lightened and the remaining drawing has been slightly darkened.

1707B
Untitled. Jun 21–28, 1966. Yellow (Z), red (Z), dark brown (S)[1], black (S). 50.8 × 68.6. Ed 20 (GEP), 9 TI (MI), BAT (GEP), 3 AP (MI), 3 TP (GEP), CP (EVB). Ernest de Soto. Recto: D, I, BS Verso: S.

1. Stone held from 1707A. 1707B differs from 1707A in color and in image. Dark shading has been added at the right and the rest of the drawing darkened.

1708
Untitled. Jun 13–14, 1966. Black (S). 68.6 × 50.8. Ed 20 (GEP), 9 TI (MI), BAT (GEP), 1 AP (GEP), 2 TP (GEP), 3 TP (GEP), CP (EVB). John Dowell. Recto: I, Dat, D, BS Verso: S.

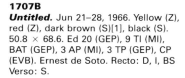

1708A
Untitled. Jun 17–Jul 6, 1966. Black (S)[1]. 68.6 × 50.8. Ed 20 (MI), 9 TI (CW), BAT (MI), 3 AP (CW), 2 TP (1 MI, 1 GEP), CP (EVB). John Dowell. Recto: D, I, BS Verso: S.

1. Stone held from 1708; deletions. 1708A differs from 1708 in image. The background and some of the shapes at the upper right and lower left have been eliminated.

1709
Untitled. Jun 14–15, 1966. Black (S). 68.6 × 50.8. Ed 20 (GEP), 9 TI (MI), BAT (GEP), 1 AP (GEP), 1 TP* (GEP). Kinji Akagawa. Recto: BS, D, I, Dat Verso: S.

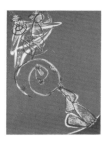

1709A
Untitled. Jun 17–24, 1966. Yellow, green (Z), orange (Z), red (S)[1], brown (S). 68.6 × 51.1. Ed 20 (GEP), 9 TI (CD), BAT (GEP), 3 AP (CD), 5 TP (GEP)[2], CP (EVB). Kinji Akagawa. Recto: BS, D, I, Dat Verso: S.

1. Stone held from 1709II.
2. 1 TP varies from the edition. 1709A differs from 1709II in color and in image. The image is lighter with the exception of the upper right corner and some of the line drawing.

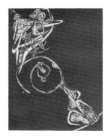

1709II
Untitled. Jun 14–16, 1966. Black (S)[1]. 68.6 × 50.8. Ed 20 (GEP), 9 TI (MI), BAT (GEP), 2 AP (1 MI, 1 GEP), 1 TP (GEP). Kinji Akagawa. Recto: BS, D, I, Dat Verso: S.

1. Stone held from 1709; reversal, additions. 1709II differs from 1709 in image. Slight addition of lines at the upper right and lower left corners.

1710
Untitled. Jun 17–21, 1966. Black (S). 68.6 × 50.8. Ed 20 (GEP), 9 TI (MI), BAT (GEP), 1 AP (GEP), 2 TP (GEP). Ernest de Soto. Recto: D, BS, I, Dat Verso: S.

1710A
Untitled. Jun 28–30, 1966. Black (S). 68.6 × 50.8. Ed 20 (MI), 9 TI (CD), BAT (MI), 3 AP (1 MI, 2 CD), 2 TP (MI), CP (EVB). Ernest de Soto. Recto: I, Dat, D, BS Verso: S.

1. Stone held from 1710; deletions. 1710A differs from 1710 in image. Some of the shapes in the upper left and all of the background except for the lower left and upper right corners have been eliminated.

1711
Untitled. Jun 20–23, 1966. Black (S). 51.1 × 68.6. Ed 20 (GEP), 9 TI (MI), BAT (GEP), 1 AP (MI). Kinji Akagawa. Recto: BS, D, I, Dat Verso: S.

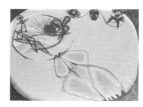

1711A
Untitled. Jun 27–Jul 8, 1966. Orange (Z), yellow (S)[1], red, violet (S), black (Z). 50.8 × 68.6. Ed 20 (JG), 9 TI (CD), BAT (JG), 2 AP (CD), 2 TP (JG), CP (EVB). Kinji Akagawa. Recto: BS, D, I, Dat Verso: S.

1. Stone held from 1711II; additions. 1711A differs from 1711II in color and in image. The image has been lightened considerably. The corners have been filled in. Some of the shapes have been accented with dark drawing and tone areas.

1711II
Untitled. Jun 23–24, 1966. Black (S)[1]. 50.8 × 68.6. Ed 20 (GEP), 9 TI (CD), BAT (GEP), 3 AP (1 CD, 2 GEP), 2 TP (GEP). Kinji Akagawa. Recto: BS, D, I, Dat Verso: S.

1. Stone held from 1711; reversal, additions. 1711II differs from 1711 in image. Slight addition of lines at upper right and upper center.

1712
Untitled. Jun 29–Jul 5, 1966. Grey, red (Z), black (S). 55.9 × 76.2. Ed 20 (BFK), 9 TI (MI), BAT (BFK), 2 AP (1 BFK, 1 MI), 3 TP (BFK), CP (EVB). Ernest de Soto. Recto: D, I, Dat, BS Verso: S.

1713
Untitled. Jul 5–13, 1966. Black (S). 53.0 × 77.5. Ed 20 (MI), 9 TI (CD), BAT (MI), 3 AP (CD), 2 TP (MI), CP (EVB). Robert Evermon. Recto: BS, D, I, Dat Verso: S.

1713II
Untitled. Jul 15–21, 1966. Black (S)[1]. 56.5 × 77.2. Ed 20 (GEP), 9 TI (CD), BAT (GEP), 1 AP (CD), 1 TP (GEP), CP (EVB). Robert Evermon. Recto: BS, D, I Verso: S.

1. Image transferred to a new stone from 1713 before cancellation; reversal, deletions. 1713II differs from 1713 in image and in size. Two small shapes at lower left and the spiral line at the center were eliminated. Line has been added around the central pear shapes reducing the white outline. Dark strip at the bottom and heavy dark line around the two triangular shapes at the lower left have been added.

1713III
Untitled. Jul 25–26, 1966. Black (S)[1].
58.4 × 82.6. Ed 20 (MI), 9 TI (BFK),
BAT (MI), 1 AP (BFK), 1 TP (MI), CP
(EVB). Robert Evermon. Recto: BS, D,
I Verso: S.

1. Image transferred to new stone
 from 1713II before cancellation;
 reversal, additions. 1713III differs
 from 1713II in image and in size.
 Light margin has been added at the
 top and sides; small oval at upper
 left has been filled in. Shapes at
 bottom and right have been
 darkened.

Print not in
University Art Museum
Archive

1742
Untitled. Jul 5–8, 1966. Blue-black
(S). 81.3 × 50.8. Ed 20 (GEP), 9 TI
(CD), BAT (GEP), 2 AP (CD), 2 TP
(GEP). Jack Lemon. Recto: BS, D, I
Verso: S.

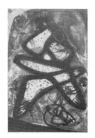

1742II
Untitled. Jul 13–20, 1966. Yellow (S),
red (S)[1], blue, black (S). 81.3 × 51.4.
Ed 20 (GEP), 9 TI (CD), BAT (GEP), 3
AP (2 CD, 1 GEP), 5 TP (GEP), CP
(EVB). Jack Lemon. Recto: BS, D, I
Verso: S.

1. Stone held from 1742, deletions.
 1742II differs from 1742 in color and
 in image. The background tone is
 slightly darker. The central shapes
 and the upper right corner have
 been darkened and dots added in
 the center. Color tone has been
 added at upper left, right and lower
 one-fourth.

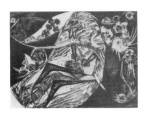

1743
Untitled. Jul 5–11, 1966. Black (S).
48.9 × 64.1. Ed 20 (MI), 9 TI (GEP),
BAT (MI), 2 TP (MI). Ernest de Soto.
Recto: BS, D, I Verso: S.

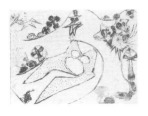

1743II
Untitled. Jul 25–26, 1966. Black
(S)[1]. 49.2 × 64.5. Ed 20 (JG), 9 TI
(GEP), BAT (JG), 1 AP (GEP), 2 TP (JG),
CP (EVB). Ernest de Soto. Recto: BS,
D, I Verso: S.

1. Stone held from 1743; deletions.
 1743II differs from 1743 in image.
 Background tone and dark shapes
 at lower left have been eliminated.

1744
Untitled. Jul 11–12, 1966. Black (S).
38.1 × 55.9. Ed 20 (BFK), 9 TI (MI),
BAT (BFK), 3 AP (2 MI, 1 BFK), 2 TP (1
wA, 1 BFK), CP (EVB). Robert Bigelow.
Recto: BS, D, I Verso: S.

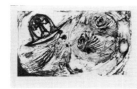

1745
Untitled. Jul 11–12, 1966. Black (S).
38.1 × 55.9. Ed 20 (BFK), 9 TI (MI),
BAT (BFK), 2 AP (MI), 2 TP (BFK), CP
(EVB). Robert Bigelow. Recto: BS, D, I
Verso: S.

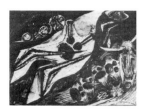

1746
Untitled. Jul 12–13, 1966. Black (S).
49.2 × 64.5. Ed 20 (CD), 9 TI (GEP),
BAT (CD), 2 AP (1 CD, 1 GEP), 2 TP
(CD). John Dowell. Recto: BS, D, I
Verso: S.

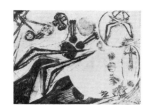

1746II
Untitled. Jul 13–15, 1966. Black
(S)[1]. 48.9 × 64.1. Ed 20 (CD), 9 TI
(GEP), BAT (CD), 1 AP (GEP), 2 TP
(CD), CP (EVB). John Dowell. Recto:
BS, D, I Verso: S.

1. Stone held from 1746; deletions.
 1746II differs from 1746 in image.
 Shapes in the lower right and
 background tone have been
 eliminated except for the upper and
 lower left and lower right corners.

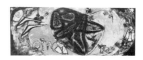

1747
Untitled[1]. Jul 14–26, 1966. Grey,
blue (S), black (S); grey, yellow (S),
black (S). 56.5 × 139.1, (one part). Ed
20 (BFK), 9 TI (CW), BAT (BFK), 2 AP
(CW), 2 TP (BFK), CP (EVB). Ernest de
Soto. Left: I, D Verso: S Right: BS.

1. A two part lithograph hinged
 together with grey, blue (S), black
 (S) printed on the left.

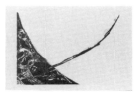

1748
Untitled. Jul 22–25, 1966. Black (S).
38.1 × 55.9. Ed 20 (BFK), 9 TI (MI),
BAT (BFK), 2 AP (1 BFK, 1 MI), 2 TP
(BFK), CP (EVB). Robert Evermon.
Recto: I, D, BS Verso: S.

1749
Untitled. Jul 22–25, 1966. Black (S).
38.1 × 55.9. Ed 20 (BFK), 9 TI (MI),
BAT (BFK), 2 AP (1 BFK, 1 MI), 2 TP
(BFK), CP (EVB). Robert Evermon.
Recto: BS, D, I Verso: S.

1772
Untitled. Jul 21–22, 1966. Black (S).
37.5 × 55.9. Ed 20 (BFK), 9 TI (MI),
BAT (BFK), 3 AP (2 MI, 1 BFK), 2 TP
(BFK), CP (EVB). Robert Bigelow.
Recto: BS, D, I Verso: S.

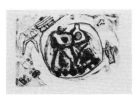

1773
Untitled. Jul 21–22, 1966. Black (S). 39.4 × 55.9. Ed 20 (BFK), 9 TI (MI), BAT (BFK), 3 AP (2 MI, 1 BFK), 2 TP (BFK), CP (EVB). Robert Bigelow. Recto: BS, D, I Verso: S.

Print not in
University Art Museum
Archive

Serge Lozingot

2445
Untitled. Nov 4–26, 1968. B: Green, yellow, red, violet (S). 50.8 × 66.0, cut. 6 ExP (CD)[1]. Serge Lozingot. Recto: D, S, Dat Verso: WS.

1. Designated A–F. 1 ExP varies from the edition. 3 ExP retained by Tamarind.

Erle Loran

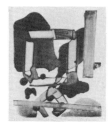

1087
Formation. May 7–Jun 4, 1964. Black (S). 40.0 × 33.0. Ed 20 (BFK), 9 TI (wA), PrP (BFK), PrP II for Irwin Hollander (BFK), 3 AP (BFK), 1 TP (BFK), CP (BFK). Jeff Ruocco. T, D, S, Dat, BS.

2474
Ballet. Nov 1–2, 1968. Black (S). 48.9 × 48.9, cut. Ed 10 (wA), 9 TI (BFK), BAT (wA), 1 AP (BFK), CP (wA). Serge Lozingot. D, BS, T, S, Dat.

1088
Fantasy Structure. May 7–Jun 9, 1964. Yellow (Z), black (S). 66.0 × 51.8. Ed 20 (wA), 9 TI (BFK), PrP (wA), PrP II for Irwin Hollander (wA), 3 AP (2 BFK, 1 wA), 3 TP (wA), CP (BFK). John Dowell. T, D, S, Dat, BS.

Samuel Maitin

2604
Laird-God-Army. Apr 4–8, 1969. Brown (S)[1]. 76.2 × 50.8. Ed 20 (wA), 9 TI (BFK), BAT (wA), 1 AP (BFK), 1 TP (wA), CP (wA). Jean Milant. S, D, BS.

1. Printing varies in lightness and darkness throughout the edition.

Bruce Lowney

2172
Moon Flower. Oct 21–Dec 31, 1967. Light yellow (A), B: black, grey (A), black (S). 55.6 × 45.7, cut. Ed 9 (GEP), 9 TI (GEP), 1 TP* (GEP). Bruce Lowney. Recto: D[1], T, S, Dat Verso: WS.

1. 1 TI was incorrectly designated; the edition number was crossed out and re-designated.

Robert Mallary

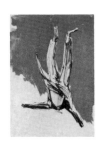

591
Suspended Figure. Jun 8–15, 1962. Red (Z), black (Z). 56.5 × 38.1. Ed 20 (BFK), 9 TI (wA), PrP (BFK), 2 AP (1 BFK, 1 wA), 2 PP (1 BFK, 1 wA), CP (wA). Irwin Hollander. S, D, BS.

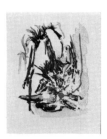

592
Germinal. Jun 11–18, 1962. Black (Z), red (Z). 61.0 × 45.1. Ed 20 (BFK), 9 TI (CW), PrP (BFK), 2 AP (BFK), 3 PP (CW), 3 TP (BFK), CP (CW). Irwin Hollander. S, D, BS.

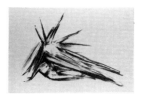

594
Sprawled Figure. Jun 18–20, 1962. Black (Z). 51.1 × 72.4. Ed 20 (bA), 9 TI (CW), PrP (bA), 2 AP (1 bA, 1 CW), 2 PP (1 bA, 1 CW), 3 TP (bA), CP (bA). Emil Weddige. S, D, BS.

596A
Tablet. Jun 21–22, 1962. Black (Z). 59.7 × 47.0[1]. Ed 20 (BFK)[2], 9 TI (BFK), PrP (BFK), 2 AP (BFK), 1 PP (BFK)[2], 3 TP (BFK). Emil Weddige. S, D, BS.

1. Torn to an irregular shape.
2. Ed 7–20/20 and PP on paper 76.2 × 55.9, were not torn to an irregular shape.

597
Vixen I. Jun 19–28, 1962. Black or blue (S)[1], grey-black (Z). 66.0 × 43.5. Ed 16 (BFK)[2], 9 TI (BFK)[3], PrP (BFK), 2 AP (BFK), 3 PP (BFK)[2], 2 TP (BFK)[2], CP (BFK)[2]. Robert Gardner. S, D, BS.

1. Stone was reworked after printing TI and then used to print 597A. The stone was then used to print the artist's edition of 597. Edition exists in two color variations. Variation I in black and grey-black and Variation II in blue and grey-black.
2. Indicates Variation II, Ed 6–16/16, 1 TP, 1 PP, CP.
3. 9 TI vary from the edition. (cf. footnote 1)

597A
Vixen II. Jun 20–22, 1962. Black (S)[1]. 66.4 × 43.5. Ed 10 (BFK), 9 TI (CW), PrP (BFK), 2 AP (1 BFK, 1 CW) 1 TP (CW). Robert Gardner. S, D, BS.

1. Stone held from 597, run 1; additions, deletions. After printing the TI for 597, the stone was reworked and used to print this edition. It was then returned to 597 to print the remainder of that edition. 597A differs from 597 in color and in image. The color drawing on top of the black has been eliminated. Slight darkening in the central image, the lower left, and the dark area at the top.

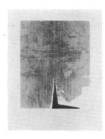

601
Summer Haze. Jun 13–Jul 17, 1962. Light green-grey (Z), red-brown (Z), yellow (Z), black (Z), grey-green (Z). 75.6 × 56.8. Ed 20 (BFK), 9 TI (wA), PrP (BFK), 2 AP (1 BFK, 1 wA), 2 PP (1 BFK, 1 wA), 3 TP (2 BFK, 1 wA). Irwin Hollander. S, D, BS.

601A
Grey Sky. Jun 29–Jul 10, 1962. Grey (Z), grey-ochre (Z)[1], grey-brown (Z)[2], black (Z). 75.6 × 56.8. Ed 20 (BFK), 9 TI (wA), PrP (BFK), 1 AP (wA), 6 PP (5 BFK, 1 wA), 4 TP (2 BFK, 2 wA). Robert Gardner. S, D, BS.

1. Plate held from 601, run 2.
2. Plate held from 601, run 3. 601A differs from 601 in color and in image. The tone area has been reduced on the top and sides and part of the lower right corner and bottom have been eliminated. The vertical striated texture is darker. The vertical lines at lower right have been eliminated. A dark "L" shape has been added at bottom center.

602
Incubus. Jul 2–3, 1962. Black (S). 56.8 × 37.8. Ed 20 (BFK), 9 TI (wA), PrP (BFK), 1 AP (BFK), 2 TP (BFK), CP (BFK). Bohuslav Horak. S, D, BS.

603
Blasted Figure. Jul 3–20, 1962. Black (Z). 62.9 × 48.0. Ed 19 (BFK), 9 TI (wN), PrP (BFK), 2 AP (1 wN, 1 nN), 6 PP (5 BFK, 1 wN), 2 TP (wN), CP (BFK). Robert Gardner. S, D, BS.

605
Calligraphic Drawing. Jul 10, 1962. Black (S). 57.5 × 39.1. Ed 20 (BFK), 9 TI (wN), PrP (BFK), 2 AP (BFK), 3 PP (BFK), 3 TP (2 BFK, 1 wN), CP (BFK). Emil Weddige. S, D, BS.

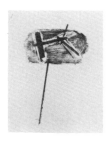

606
Debris. Jul 11–17, 1962. Grey-brown
(S). 66.0 × 49.2. Ed 20 (BFK), 9 TI
(nN), PrP (BFK), 2 AP (BFK), 3 TP (nN,
2 BFK). Emil Weddige. S, D, BS.

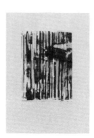

608
Wall. Jul 16–20, 1962. Yellow (Z),
black (Z). 75.6 × 51.1. Ed 20 (1 wA, 19
BFK), 9 TI (wA), PrP (BFK), 2 AP (BFK),
6 PP (3 BFK, 3 wA), 3 TP (BFK), CP
(BFK). Emil Weddige. S, D, BS.

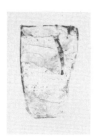

609
Playa. Jul 16–18, 1962. Black (S).
104.8 × 69.2. Ed 20 (BFK), 9 TI (BFK),
PrP (BFK), 2 AP (BFK), 3 PP (BFK), 3 TP
(BFK), CP (BFK). Bohuslav Horak. S, D,
BS.

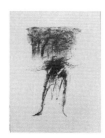

611
Masked Figure. Jul 23–24, 1962.
Black (Z). 75.6 × 54.0. Ed 20 (BFK), 9
TI (wA), PrP (BFK), 2 AP (1 BFK, 1 wA),
3 PP (2 BFK, 1 wA), 3 TP (2 BFK, 1
wA), CP (wA). Emil Weddige. S, D, BS.

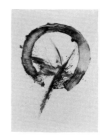

612
Encounter. Jul 23–24, 1962. Black (S).
94.6 × 66.0. Ed 20 (BFK), 9 TI (wN),
PrP (BFK), 2 AP (wN), 1 PP (BFK), 3 TP
(BFK), CP (BFK). Bohuslav Horak. S, D,
BS.

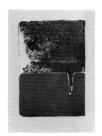

613
Duo. Jul 23–Aug 3, 1962. Brown (Z),
black (S). 94.9 × 65.7. Ed 20 (BFK), 9
TI (nN), PrP (BFK), 2 AP (nN), 1 PP
(BFK), 3 TP (2 BFK, 1 nN), CP (BFK).
Emil Weddige. S, D, BS.

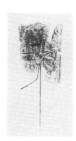

615
Flower. Jul 24–27, 1962. Red-violet
(Z), black (S). 101.9 × 54.6. Ed 20
(BFK), 9 TI (wN), PrP (BFK), 2 AP (wN),
1 PP (wN), 3 TP (BFK), CP (BFK). Emil
Weddige. S, BS, D.

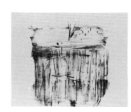

617
Abstraction. Jul 29–Aug 11, 1962.
Black (S). 69.2 × 82.6. Ed 14 (BFK), 9
TI (BFK), PrP (BFK), 1 TP (BFK), CP
(BFK). Bohuslav Horak. S, D, BS.

Maryan

1954
Untitled[1]. Apr 4–6, 1967. Black (S).
46.1 × 50.8. Ed 20 (wA), 9 TI (CD),
BAT (wA), 3 AP (2 GEP, 1 CD), 2 TP
(wA), CP (wA). Anthony Ko. D, S, Dat,
BS.

1. The artist informed Tamarind in
 1969 that the impressions in his
 possession had been destroyed.

1956
Untitled[1]. Apr 5–10, 1967. Black (S). 66.0 × 48.6. Ed 20 (CD), 9 TI (GEP), BAT (CD), 3 AP (GEP), 1 TP (CD), CP (CD). Serge Lozingot. D, S, Dat, BS.

1. The artist informed Tamarind in 1969 that the impressions in his possession had been destroyed.

1957
Untitled. Apr 5–10, 1967. Black (S). 70.5 × 54.9. Ed 20 (CD), 9 TI (GEP), BAT (CD), 3 AP (2 CD, 1 GEP), 2 TP (CD), CP (CD). David Folkman. D, S, Dat, BS.

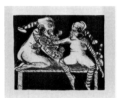

1959
Untitled. Apr 6–8, 1967. Black (S). 64.1 × 72.4. Ed 20 (BFK), 9 TI (GEP), BAT (BFK), 3 AP (GEP), 2 TP (BFK), CP (BFK). Maurice Sanchez. D, S, Dat, BS.

1960
Untitled[1]. Apr 6–12, 1967. Black (S). 55.2 × 57.5. Ed 20 (CD), 9 TI (GEP), BAT (CD), 2 AP (GEP), 2 TP (CD), CP (CD). John Butke. D, S, Dat, BS.

1. The artist informed Tamarind in 1969 that the impressions in his possession had been destroyed.

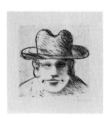

1965
Untitled[1]. Apr 11–12, 1967. Black (S). 59.1 × 55.2. Ed 20 (CD), 9 TI (BFK), BAT (CD), 2 AP (1 BFK, 1 CD), 1 TP (CD), CP (CD). Maurice Sanchez. D, S, Dat, BS.

1. The artist informed Tamarind in 1969 that the impressions in his possession had been destroyed.

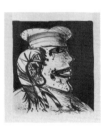

1967
Untitled[1]. Apr 11–14, 1967. Black (S). 60.3 × 51.4. Ed 20 (BFK), 9 TI (GEP), BAT (BFK), 3 AP (2 BFK, 1 GEP), 2 TP (1 BFK, 1 GEP), CP (BFK). Anthony Stoeveken. D, S, Dat, BS.

1. The artist informed Tamarind in 1969 that the impressions in his possession had been destroyed.

1969
Untitled[1]. Apr 12–13, 1967. Black (S). 53.7 × 38.1. Ed 20 (CD), 9 TI (GEP), BAT (CD), 3 AP (2 GEP, 1 CD), 2 TP (CD), CP (CD). David Folkman. D, BS, S, Dat.

1. The artist informed Tamarind in 1969 that the impressions in his possession had been destroyed.

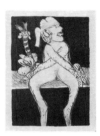

1973
Untitled[1]. Apr 13–20, 1967. Black (S). 74.0 × 54.0. Ed 20 (wA), 9 TI (GEP), BAT (wA), 2 AP (1 wA, 1 GEP), 1 TP (wA), CP (wA). Anthony Ko. D, S, Dat, BS.

1. The artist informed Tamarind in 1969 that the impressions in his possession had been destroyed.

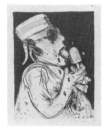

1976
Untitled. Apr 15–19, 1967. Black (S). 61.0 × 46.1. Ed 20 (CD), 9 TI (GEP), BAT (CD), 3 AP (1 CD, 2 GEP), 2 TP (CD), CP (CD). David Folkman. D, S, Dat, BS.

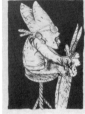

1980
Untitled. Apr 17–21, 1967. Black (Z). 84.2 × 57.5. Ed 13 (BFK), 9 TI (7 BFK, 2 GEP), BAT (BFK), 3 AP (GEP), 1 TP (BFK), CP (GEP). David Folkman. D, S, Dat, BS.

Print not in
University Art Museum
Archive

1981
Untitled[1]. Apr 17–21, 1967. Black (Z). 76.2 × 53.3. 9 ExP (BFK)[2]. Anthony Ko. D, BS, S, Dat.

1. The artist informed Tamarind in 1969 that the impressions in his possession had been destroyed.
2. Designated "State I Proof" and "State I Proof 1–8/8." State I Proof retained by Tamarind.

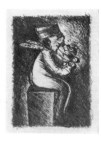

1981II
Untitled[1]. Apr 21–28, 1967. Black (S)[2]. 81.9 × 59.1. Ed 20 (CD), 9 TI (GEP), BAT (CD), 1 AP (GEP), 2 TP (CD), CP (CD). Anthony Ko. D, S, Dat, BS.

1. The artist informed Tamarind in 1969 that the impressions in his possession had been destroyed.
2. Stone held from 1981; additions, deletions. 1981II differs from 1981 in image and size. The margin is wider on all four sides. Slightly lighter on the right side of the seat and in the background to the left of the seat. The background at the right slightly darkened.

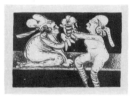

1983
Untitled[1]. Apr 18–21, 1967. Black (S). 53.3 × 71.5. Ed 20 (CD), 9 TI (GEP), BAT (CD), 3 AP (2 CD, 1 GEP), CP (CD). Serge Lozingot. D, S, Dat, BS.

1. The artist informed Tamarind in 1969 that the impressions in his possession had been destroyed.

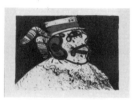

1984
Untitled. Apr 19–May 3, 1967. Pink (Z), yellow (Z), pink (Z), red (Z), green (Z), black (S). 57.2 × 74.3. Ed 20 (CD), 9 TI (GEP), BAT (CD), 3 AP (GEP), 4 TP (CD), CP (CD). Serge Lozingot. D, S, Dat, BS.

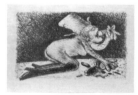

1985
Untitled. Apr 20–25, 1967. Black (S). 59.1 × 81.6. ED 20 (CD), 9 TI (GEP), BAT (CD), 3 AP (GEP), 1 TP (CD), CP (CD). Donald Kelley. D, S, Dat, BS.

1986
Untitled. Apr 20–27, 1967. Black (S). 44.8 × 54.3. Ed 20 (CD), 9 TI (GEP), BAT (CD), 3 AP (2 CD, 1 GEP), 1 TP (CD), CP (GEP). Donald Kelley. D, S, Dat, BS.

1988
Untitled. Apr 21–28, 1967. Black (S). 70.2 × 55.2. Ed 20 (wA), 9 TI (GEP), BAT (wA), 2 AP (1 wA, 1 GEP), 1 TP (wA), CP (wA). David Folkman. D, S, Dat, BS.

1991
Untitled. Apr 26–May 1, 1967. Black (S). 71.8 × 56.8. Ed 20 (wA), 9 TI (GEP), BAT (wA), 2 AP (GEP), 2 TP (wA), CP (wA). David Folkman. D, S, Dat, BS.

1993
Untitled. Apr 27–May 2, 1967. Black (S). 73.7 × 58.1. Ed 20 (CD), 9 TI (GEP), BAT (CD), 3 AP (2 GEP, 1 CD), 1 TP (CD), CP (CD). John Butke. D, S, Dat, BS.

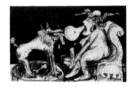

2004
Untitled. Apr 27–May 4, 1967. Black (S). 68.6 × 99.1. Ed 20 (CD), 9 TI (GEP), BAT (CD), 2 AP (GEP), 2 TP (CD), CP (CD). Maurice Sanchez. D, BS, S, Dat.

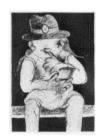

2006
Untitled. May 2–5, 1967. Black (S). 95.3 × 64.8. Ed 20 (CD), 9 TI (GEP), BAT (CD), 3 AP (2 GEP, 1 CD), 2 TP (CD), CP (CD). Anthony Stoeveken. D, BS, S, Dat.

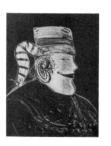

2008
Untitled. May 2–12, 1967. Black (S). 63.2 × 47.3. Ed 20 (wA), 9 TI (BFK), BAT (wA), 3 AP (2 wA, 1 BFK), 2 TP (wA), CP (wA). David Folkman. D, S, Dat, BS.

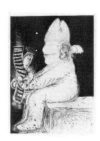

2009
Untitled. May 3–10, 1967. Black (S). 95.6 × 66.7. Ed 20 (CD), 9 TI (GEP), BAT (CD), 2 AP (GEP), 2 TP (CD), CP (CD). John Butke. D, BS, S, Dat.

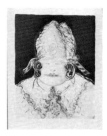

2010
Untitled. May 3–5, 1967. Black (S). 81.3 × 61.0. Ed 20 (CD), 9 TI (GEP), BAT (CD), 1 AP (CD), 3 TP (CD), CP (CD). Serge Lozingot. D, S, Dat, BS.

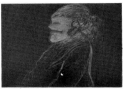

2011
Untitled. May 4–22, 1967. Ochre (Z), black (S). 44.5 × 59.7. Ed 20 (CD), 9 TI (GEP), BAT (CD), 3 AP (2 GEP, 1 CD), 3 TP (CD), CP (CD). John Butke. Recto: D, S, Dat Verso: WS.

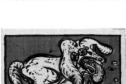

2017
Untitled. May 16–23, 1967. Yellow (A), pink (A), green (A), red (A), black (S). 54.3 × 74.0. Ed 20 (CD), 9 TI (GEP), BAT (CD), 3 AP (GEP), 4 TP (CD), CP (CD). Fred Genis. D, S, Dat, BS.

2018
Untitled. May 17–18, 1967. Black (A). 94.9 × 65.4. Ed 16 (7 red-brown Moriki, 2 yellow-ochre Moriki, 2 yellow Butten-Papier, 2 yellow with blue fiber Butten-Papier, 2 beige Butten-Papier, 1 white with blue fiber Butten-Papier)[1], 9 TI (red-brown Moriki), BAT (yellow-ochre Moriki), 3 AP (2 red-brown Moriki, 1 white with blue fiber Butten-Papier), 2 TP (red-brown Moriki), CP (BFK). Anthony Stoeveken. BS, D, S, Dat.

1. Distributed to Tamarind staff, exact number unrecorded.

2037
Untitled. May 17–26, 1967. Pink (A), red (A), black (S). 85.4 × 62.6. Ed 20 (CD), 9 TI (GEP), BAT (CD), 3 AP (GEP), 2 TP (CD), CP (CD). Donald Kelley. D, S, Dat, BS.

2044
Untitled. May 23–29, 1967. Ochre (S), black (S). 59.1 × 76.8. Ed 20 (CD), 9 TI (GEP), BAT (CD), 3 AP (GEP), 3 TP (CD), CP (CD). Anthony Stoeveken. D, BS, S, Dat.

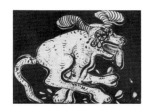

2044II
Untitled. May 23–26, 1967. Black (S)[1]. 59.1 × 76.2. Ed 10 (CD), 9 TI (GEP), BAT (CD), 3 AP (2 GEP, 1 CD), 2 TP (CD). Anthony Stoeveken. D, BS, S, Dat.

1. Stone held from 2044, run 2. 2044II differs from 2044 in color and in image. The bleed background tone has been eliminated.

Gregory Masurovsky

Western Duo, a suite of ten lithographs including title and colophon pages. Text by Michael Butor, enclosed in a black canvas covered portfolio, measuring 79.1 × 58.4, lined with black canvas, made by the Earle Grey Bookbinding Co. Los Angeles. In order: 2792, 2752, 2753, 2754, 2755, 2788, 2789, 2790, 2791, 2793.

2734
Tusche Brush. Sep 3–4, 1969. Black (S). 62.2 × 46.1. Ed 20 (CD), 9 TI (GEP), BAT (CD), 3 AP (2 CD, 1 GEP), 1 PP (CD), 1 TP (CD), 1 PTP (cR), CP (CD). Charles Ringness. D, BS, T, S, Dat.

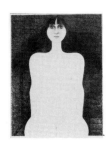

2735
Moon Maid. Sep 5–9, 1969. Black (S). 71.1 × 52.1. Ed 20 (ucR), 9 TI (CD), BAT (ucR), 1 AP (CD), 1 TP (ucR), CP (CD). Paul Clinton. D, BS, T, S, Dat.

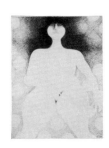

2737
Self Love. Sep 9–11, 1969. Black (S). 73.4 × 52.7. Ed 20 (ucR), 9 TI (CD), BAT (ucR), 3 AP (ucR), 1 TP (CD), CP (CD). Edward Hamilton. D, BS, T, S, Dat.

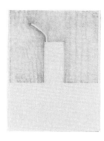

2738
Diet Soda. Sep 12–13, 1969. Black (S). 63.5 × 47.3. Ed 20 (ucR), 9 TI (cR), BAT (ucR), 3 AP (1 cR, 2 ucR), 2 TP (ucR), 1 PTP (CD), CP (ucR). Hitoshi Takatsuki. D, BS, T, S, Dat.

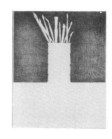

2742
Brushes. Sep 19–23, 1969. Black (S). 67.9 × 52.4. Ed 20 (ucR), 9 TI (8 MI, 1 ucR), BAT (ucR), 2 AP (ucR), 3 TP (ucR), CP (MI). John Sommers. D, BS, T, S, Dat.

Print not in
University Art Museum
Archive

2739
Heading East. Sep 15, 1969. Black (S). 71.1 × 54.6. 3 TP (1 CD, 2 ucR)[1]. S. Tracy White. D, BS, T, S, Dat.

1. Designated in arabic numerals. 1 TP (ucR) retained by Tamarind.

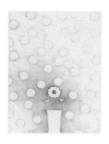

2743
Wall Flowers. Sep 24–25, 1969. Black (S). 72.4 × 53.3. Ed 20 (MI), 9 TI (cR), BAT (MI), 3 AP (MI), CP (MI). Paul Clinton. D, BS, T, S, Dat.

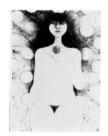

2740
Flower Girl. Sep 16–17, 1969. Black (S). 72.1 × 51.4. Ed 20 (ucR), 9 TI (BFK), BAT (CD), 3 AP (2 BFK, 1 CD), 1 TP (ucR). S. Tracy White. D, BS, T, S, Dat.

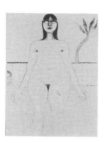

2744
Mis Marmont Pool. Sep 24–27, 1969. Black (S). 62.9 × 45.7. Ed 20 (ucR), 9 TI (CD), BAT (ucR), 3 AP (ucR), 2 TP (1 CD, 1 ucR), CP (CD). Hitoshi Takatsuki. D, BS, T, S, Dat.

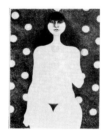

2740II
Flower Girl II. Sep 19, 1969. Black (S)[1]. 71.8 × 51.4. Ed 20 (BFK), 9 TI (BFK), BAT (BFK), 3 AP (BFK), 1 TP (CD), CP (BFK). S. Tracy White. D, BS, T, S, Dat.

1. Stone held from 2740; additions, deletions. 2740II differs from 2740 in image. The background has been filled in leaving light flowers in the center of the cirlces. Nipples have been added to the breasts; the flower, neck and the right eye of the figure have been lightened.

2745
Sunglasses. Sep 26–29, 1969. Black (S). 71.1 × 52.7. Ed 20 (MI), 9 TI (8 CW, 1 MI), BAT (MI), 1 AP (MI), 2 PTP (1 ucR, 1 JG), CP (CW). William Law III. D, BS, T, S, Dat.

2741
Ashtray. Sep 17–18, 1969. Black (S). 71.8 × 50.8. Ed 20 (ucR), 9 TI (cR), BAT (ucR), 3 AP (2 cR, 1 ucR), 1 PTP (CD), CP (cR). Eugene Sturman. D, BS, T, S, Dat.

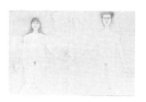

2747
Adam and Eve in Hollywood. Sep 29–Oct 1, 1969. Black (S). 61.6 × 90.8. Ed 20 (MI), 9 TI (BFK), BAT (MI), 1 TP (ucR), CP (BFK). Larry Thomas. D, BS, T, S, Dat.

2748
Diver. Sep 30–Oct 2, 1969. Black (S). 67.9 × 54.0. Ed 20 (MI), 9 TI (CW), BAT (MI), 3 AP (2 MI, 1 CW), 1 TP (MI), 1 PTP (ucR), CP (CW). David Trowbridge. D, BS, T, S, Dat.

2749
Poolside. Oct 2–7, 1969. Black (S).
82.9 × 58.4. Ed 20 (MI), 9 TI (cR), BAT
(MI), 3 AP (2 cR, 1 MI), 1 PP (MI), 2 TP
(MI)[1], 1 PTP (ucR), CP (cR). Edward
Hamilton. D, BS, T, S, Dat.

1. 1 TP on paper 62.9 × 55.9.

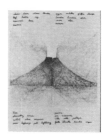

2754
Untitled (Western Duo IV). Oct 10–
13, 1969. Black (S). 76.2 × 55.9. Ed 20
(MI), 9 TI (ucR), BAT (MI), 1 AP (ucR), 9
Butor Impressions (MI), 1 TP (ucR), CP
(ucR). S. Tracy White. D, BS, S, Dat.

2750
Candle. Oct 6–7, 1969. Black (S). 70.5
× 53.3. Ed 20 (MI), 9 TI (CW), BAT
(MI), 2 AP (CW), 1 TP (MI), 1 PTP (CW),
CP (CW). Larry Thomas. D, BS, T, S,
Dat.

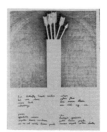

2755
Untitled (Western Duo V). Oct 13–
14, 1969. Black (S). 76.2 × 55.9. Ed 20
(MI), 9 TI (ucR), BAT (MI), 3 AP (2 ucR,
1 MI), 9 Butor Impressions (MI), 1 TP
(MI), CP (ucR). Eugene Sturman. D,
BS, S, Dat.

2751
Coffee Cup. Oct 7–8, 1969. Black (S).
69.9 × 52.7. Ed 20 (CW), 9 TI (JG),
BAT (CW), 3 AP (CW), 1 TP (CW), 1
PTP (MI), CP (JG). Hitoshi Takatsuki. D,
BS, T, S, Dat.

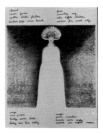

2788
Untitled (Western Duo VII). Oct 14–
16, 1969. Black (S). 76.2 × 55.9. Ed 20
(MI), 9 TI (ucR), BAT (MI), 3 AP (2 MI, 1
ucR), 9 Butor Impressions (MI), 1 TP
(MI), CP (ucR). William Law III. D, BS,
S, Dat.

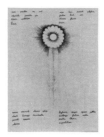

2752
Untitled (Western Duo II). Oct 7–9,
1969. Black (S). 76.5 × 55.9. Ed 20
(MI), 9 TI (ucR), BAT (MI), 3 AP (ucR), 9
Butor Impressions (MI), 1 TP (ucR), CP
(ucR). Larry Thomas. D, BS, S, Dat.

2789
Untitled (Western Duo VII). Oct 16–
21, 1969. Black (S). 76.2 × 55.9. Ed 20
(MI), 9 TI (ucR), BAT (MI), 3 AP (MI), 9
Butor Impressions (MI), 1 TP (MI), CP
(ucR). David Trowbridge. D, BS, S,
Dat.

2753
Untitled (Western Duo III). Oct 9–
11, 1969. Black (S). 76.2 × 55.9. Ed 20
(MI), 9 TI (ucR), BAT (MI), 1 AP (ucR), 9
Butor Impressions (MI), 1 TP (MI), CP
(MI). David Trowbridge. D, BS, S, Dat.

2790
Untitled (Western Duo VIII). Oct 20–22, 1969. Black (S). 76.2 × 55.9. Ed 20 (MI), 9 TI (ucR), BAT (MI), 3 AP (2 ucR, 1 MI), 9 Butor Impressions (MI), 2 TP (MI), CP (ucR). Edward Hamilton. D, BS, S, Dat.

2791
Untitled (Western Duo IX). Oct 22, 1969. Black (S). 76.2 × 55.9. Ed 20 (MI), 9 TI (ucR), BAT (MI), 3 AP (2 MI, 1 ucR), 9 Butor Impressions (MI), 1 TP (MI), CP (ucR). Eugene Sturman. D, BS, S, Dat.

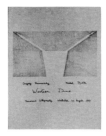

2792
Title Page (Western Duo I). Oct 22–27, 1969. Black (S), black (S). 76.2 × 55.9. Ed 20 (MI), 9 TI (ucR), BAT (MI), 2 AP (1 MI, 1 ucR), 9 Butor Impressions (MI), 1 TP (MI). Larry Thomas. D, BS, S, Dat.

2793
Colophon (Western Duo X). Oct 23–28, 1969. Black (S). 76.2 × 55.9. Ed 20 (MI), 9 TI (ucR), BAT (MI), 3 AP (1 ucR, 2 MI), 9 Butor Impressions (MI), 4 PP (3 MI, 1 ucR), 1 CP (ucR). Edward Hamilton. S (Artist), D, S (Poet), BS (6 prs, Tam).

Charles Mattox

2256
Green Realeau Form With Red Cube. Oct 23, 1968–Jan 16, 1969. Green (S), black (A), red (A), transparent green (S), transparent red (S). 50.8 × 69.9. Ed 20 (wA), 9 TI (BFK), 1 UNMI (BFK), BAT (wA). Eugene Sturman. BS (Tam), D, S, BS (UNM).

Michael Mazur

2316
Melrose Avenue. May 6–8, 1968. Black (S). 55.9 × 76.5. Ed 20 (BFK), 9 TI (GEP), BAT (BFK), 3 AP (2 BFK, 1 GEP), 1 TP (BFK), CP (GEP). Serge Lozingot. D, BS, S.

2317
The Mirror. May 8–9, 1968. Black (S). 76.2 × 57.5. Ed 20 (BFK), 9 TI (GEP), BAT (BFK), 3 AP (2 BFK, 1 GEP), 1 TP (BFK), CP (BFK). Manuel Fuentes. D, BS, S.

2318
Venice Boulevard. May 13–22, 1968. Pink (Z), light grey (S). 76.2 × 56.2. Ed 16 (BFK), 9 TI (GEP), BAT (BFK), 1 AP (GEP), 3 CTP (BFK), CP (BFK). Frank Akers. D, BS, S.

2319
Griffith Park #1. May 10–13, 1968. Black (S). 76.2 × 57.2. Ed 20 (BFK), 9 TI (GEP), BAT (BFK), 3 AP (GEP), 1 PP (GEP), 1 TP (BFK). Theodore Wujcik. BS, D, S.

2319II
Griffith Park #2. May 9–Jun 18, 1968. Orange (A), pink (A), black (S)[1]. 76.5 × 56.5. Ed 20 (BFK), 9 TI (GEP), BAT (BFK), 1 TP (BFK), CP (BFK). Theodore Wujcik. D, S, BS.

1. Stone held from 2319. 2319II differs from 2319 in color and in image. A color tone has been added under the image and in the light areas around the figure and shadow.

2320
Shadow Game[1]. May 13–21, 1968.
Light violet (A), black (A). 55.2 × 76.2.
Ed 20 (17 wA, 3 CD), 9 TI (CD), BAT
(wA), CP (wA). Jean Milant. D, S, BS.

1. The artist informed Tamarind in
 1973 that the impressions in his
 possession will be destroyed in the
 near future.

2325
Untitled. May 22–Jun 7, 1968. Light
blue (A), light blue, dark pink (S),
black (A). 76.8 × 56.8. Ed 20 (bA), 9 TI
(bA), BAT (bA), 3 AP (bA), 1 TP (bA),
CP (bA). Edward Hughes. D, BS, S.

2321
White Divisions #1[1]. May 17–22,
1968. Black (S). 61.6 × 70.5. Ed 20
(BFK), 9 TI (GEP), BAT (BFK), 3 AP
(BFK), CP (BFK). Anthony Stoeveken.
BS, D, S.

1. The artist informed Tamarind in
 1973 that the impressions in his
 possession will be destroyed in the
 near future.

2333
Untitled[1]. May 21–25, 1968. Black
(S). 35.3 × 52.1. Ed 20 (GEP), 9 TI
(CD), BAT (GEP), 3 AP (1 GEP, 2 CD), 1
TP (GEP). Maurice Sanchez. D, BS, S.

1. The artist informed Tamarind in
 1973 that the impressions in his
 possession will be destroyed in the
 near future.

Print not in
University Art Museum
Archive

2322
Untitled.[1] May 14–22, 1968. Black
(S). 58.4 × 44.5. Ed 6 (BFK)[2], BAT
(BFK), 4 TP (BFK)[3]. Maurice Sanchez.
D, BS, S.

1. The artist informed Tamarind in
 1973 that the impressions in his
 possession had been destroyed.
2. Designated A–F. Ed 3 retained by
 Tamarind.
3. Designated Trial Proof A–D. 2 TP
 retained by Tamarind.

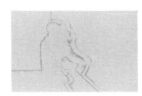

2333II
Untitled[1]. May 21–25, 1968. Dark
beige (S)[2]. 34.9 × 52.1. Ed 10 (GEP),
9 TI (CD), BAT (GEP), 3 AP (2 CD, 1
GEP), 2 TP (GEP), CP (GEP). Maurice
Sanchez. D, BS, S.

1. The artist informed Tamarind in
 1973 that the impressions in his
 possession will be destroyed in the
 near future.
2. Stone held from 2333. 2333II differs
 from 2333 in color only.

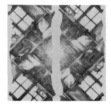

2324
Studio Views I. May 24–28, 1968.
Black (S)[1]. 50.8 × 50.8. Ed 20 (BFK),
9 TI (GEP), BAT (BFK), 3 AP (BFK), 2 TP
(BFK), CP (GEP). Robert Rogers. Verso:
D, WS, S.

1. This image combines four transfers
 of one key drawing from another
 stone (keystone). In this image, the
 outer portions of the transferred
 images and a strip through the
 center have been eliminated.

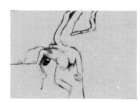

2334
Untitled[1]. May 21–25, 1968. Black
(S). 33.0 × 46.1. Ed 20 (GEP), 9 TI
(CD), BAT (GEP), 3 AP (1 GEP, 2 CD), 1
TP (GEP). Maurice Sanchez. D, BS, S.

1. The artist informed Tamarind in
 1973 that the impressions in his
 possession will be destroyed in the
 near future.

Print not in
University Art Museum
Archive

2324A
Studio Views II. Jun 4–13, 1968.
Black (S)[1]. 33.0 × 33.0, cut. Ed 20
(bA), 9 TI (cream CD), BAT (bA), 3 AP
(1 cream CD, 2 bA), 2 TP (bA), CP
(cream CD). Robert Rogers. Verso: D,
WS, S.

1. Transfer of keystone image, turned
 90 degrees, with a light outline of
 two figures added on the left and
 right.

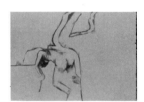

2334II
Untitled[1]. May 21–25, 1968. Dark
beige (S)[2]. 33.4 × 46.1. Ed 10 (GEP),
9 TI (CD), BAT (GEP), 3 AP (2 GEP, 1
CD), 2 TP (GEP), CP (GEP). Maurice
Sanchez. D, BS, S.

1. The artist informed Tamarind in
 1973 that the impressions in his
 possession will be destroyed in the
 near future.
2. Stone held from 2334. 2334II differs
 from 2334 in color only.

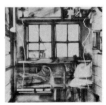

2324B
Studio Views III. Jun 4–13, 1968.
Black (S)[1]. 33.0 × 33.0, cut. Ed 20
(bA), 9 TI (cream CD), BAT (bA), 3 AP
(1 cream CD, 2 bA), 2 TP (bA), CP
(cream CD). Robert Rogers. Verso: D,
WS, S.

1. Transfer of keystone image with a
 light outline of two figures added
 on the left and right.

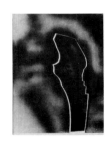

2335
White Divisions #2. May 24–27,
1968. Black (S). 61.3 × 44.5. Ed 20
(BFK), 9 TI (CD), BAT (BFK), 2 AP
(BFK), 1 TP (BFK), CP (BFK). Jean
Milant. Verso: D, S Recto: BS.

2336
Dark Division[1]. May 24, 1968.
Yellow-brown (S). 50.8 × 81.3. Ed 20
(GEP), 9 TI (CD), BAT (GEP), 3 AP
(GEP), 2 CTP (GEP). Manuel Fuentes.
D, BS, S.

1. The artist informed Tamarind in
 1973 that the impressions in his
 possession will be destroyed in the
 near future.

2336II
Van Ness Avenue. May 27–Jun 17,
1968. Light pearly orange (S)[1],
pearly green (A), light violet-pink (Z),
pearly orange (Z). 50.8 × 76.2. Ed 20
(bA), 9 TI (bA), BAT (bA), 3 TP (bA), CP
(bA). Manuel Fuentes. Recto: D, S
Verso: WS.

1. Stone held from 2336; additions,
 deletions. 2336II differs from 2336 in
 color, image and size. The over-all
 image is lighter. A bleed color
 background has been added. The
 vertical line at the lower left, dark
 shading in the horizontal bar below,
 and shading along the left side of
 the right shape have been
 eliminated. Some shading has been
 added around the shapes.

2337
Her Emergence. May 28–29, 1968.
Light red-violet (S). 45.7 × 31.8. Ed 20
(bA), 9 TI (cream CD), BAT (bA), 3 AP
(1 bA, 2 cream CD), 2 TP (GEP), CP
(bA). Serge Lozingot. D, S, BS.

2339
Angelina's Legs[1]. May 29–Jun 3,
1968. Black (S). 50.8 × 76.2. Ed 20
(GEP), 9 TI (CD), BAT (GEP), 3 AP (2
GEP, 1 CD). Anthony Stoeveken. D,
BS, S.

1. The artist informed Tamarind in
 1973 that the impressions in his
 possession will be destroyed in the
 near future.

2339A
Angelina's Legs A[1]. Jun 3–4, 1968.
Grey (S)[2]. 38.1 × 33.0. Ed 10 (GEP),
9 TI (CD), BAT (GEP), 3 AP (GEP), 1 TP
(BFK), CP (GEP). Anthony Stoeveken.
D, BS, S.

1. The artist informed Tamarind in
 1973 that the impressions in his
 possession will be destroyed in the
 near future.
2. Stone held from 2339. 2339A differs
 from 2339 in image and in size. It is
 the left side of 2339.

2339B
Angelina's Legs B[1]. Jun 3–4, 1968.
Grey (S)[2]. 38.1 × 33.0. Ed 10 (GEP),
9 TI (CD), BAT (GEP), 3 AP (GEP), 1 TP
(BFK), CP (GEP). Anthony Stoeveken.
D, BS, S.

1. The artist informed Tamarind in
 1973 that the impressions in his
 possession will be destroyed in the
 near future.
2. Stone held from 2339. 2339B differs
 from 2339 in image and in size. It is
 the right side of 2339.

2340
Self Portrait. Jun 6–11, 1968.
Black (S). 58.8 × 88.9. Ed 20 (GEP), 9
TI (CD), BAT (GEP), 2 AP (1 CD, 1
GEP), 1 TP (MI), CP (GEP). Anthony
Stoeveken. D, BS, S.

2341
Untitled[1]. May 29–Jun 3, 1968.
Black (S). 38.1 × 36.8. Ed 20 (GEP), 9
TI (CD), BAT (GEP), 3 AP (2 CD, 1
GEP), CP (GEP). Frank Akers. D, BS, S.

1. The artist informed Tamarind in
 1973 that the impressions in his
 possession will be destroyed in the
 near future.

2342
Untitled[1]. May 29–Jun 3, 1968.
Black (S). 38.4 × 34.6. Ed 20 (GEP), 9
TI (CD), BAT (GEP), 2 AP (1 CD, 1
GEP), CP (GEP). Frank Akers. D, BS, S.

1. The artist informed Tamarind in
 1973 that the impressions in his
 possession will be destroyed in the
 near future.

2343
Sunset Boulevard III. May 29–Jun
17, 1968.
Black (A), blue-black (S). 73.7 × 48.3.
Ed 20 (GEP), 9 TI (CD), BAT (GEP), 3
AP (2 CD, 1 GEP). Maurice Sanchez. D,
BS, S.

2343II
Untitled. Jun 20–24, 1968.
Light beige (A)[1], light blue (A)[2].
73.7 × 48.9. Ed 20 (bA), 9 TI (bA), BAT
(bA), 2 AP (bA). Maurice Sanchez. D,
BS, S.

1. Plate held from 2343, run 1.
2. Plate (retransferred from stone)
 held from 2343, run 2; deletions.
 2343II differs from 2343 in color and
 in image. The over-all image is
 lighter. Some of the shading in the
 figures and the narrow border have
 been eliminated.

2343III
Untitled. Jun 20–24, 1968.
Grey (A)[1], blue (A)[2]. 73.7 × 48.3.
Ed 10 (bA), 9 TI (bA), BAT (bA), 3 CTP
(bA), CP (bA). Maurice Sanchez. D, BS,
S.

1. Plate held from 2343II, run 1.
2. Plate held from 2343II, run 2. 2343III
 differs from 2343II in color only.

2360
Model's Entrance. Jun 14–21, 1968.
Black or yellow-grey (S)[1]. 58.4 ×
88.6. Ed 20 (10 MI[2], 10 GEP), 9 TI
(BFK)[2], BAT (MI)[2], 2 AP (1 BFK[2], 1
GEP), 2 PTP (1 GEP, 1 MI[2]), CP
(BFK)[2]. Anthony Stoeveken. D, BS, S.

1. Edition exists in two color
 variations. Variation I in black and
 Variation II in yellow-grey.
2. Indicates Variation II, Ed 1–10/20,
 BAT, 1 PTP, 1 AP, 9 TI, CP.

2361
Shadow Interior. Jun 14–19, 1968.
Black (S). 58.4 × 88.6. Ed 20 (MI), 9 TI
(BFK), BAT (MI), 2 AP (MI), 1 PP (MI),
CP (MI). Jean Milant. D, BS, S.

2362
Tamarind Avenue. Jun 19–24, 1968.
Black (S). 61.3 × 92.1. Ed 20 (GEP), 9
TI (CD), BAT (GEP), 3 AP (1 CD, 2
GEP), 1 TP (CD), CP (GEP). Manuel
Fuentes. D, BS, S.

2363
Self-Portrait II. Jun 20–24, 1968.
Black (S). 81.9 × 58.8. Ed 20 (GEP), 9
TI (CD), BAT (GEP), 3 AP (GEP), CP
(GEP). Theodore Wujcik. BS, D, S.

2364
Self-Portrait III. Jun 25–27, 1968.
Black (S). 58.4 × 88.9. Ed 20 (15 GEP,
5 CD), 9 TI (CD), BAT (CD), 2 AP (GEP),
CP (GEP). Manuel Fuentes. BS, D, S.

James McGarrell

672
Fragments. Nov 15, 1962.
Black (S). 38.7 × 28.6. Ed 20 (BFK), 9
TI (wA), PrP (BFK), PrP II for Bohuslav
Horak (BFK), 3 AP (2 BFK, 1 wA), 1 TP
(Tcs), CP (BFK). Irwin Hollander. D, S,
T, BS.

673
Bathers, First State. Nov 16–20,
1962.
Black (S). 57.2 × 76.2. Ed 20 (BFK),
PrP (BFK), 9 TI (wA), 3 AP (2 BFK, 1
wA), 2 PP (BFK), 2 TP (BFK). Donald
Roberts. D, S, T, BS.

673A
Bathers, Second State. Nov 21–27,
1962.
Black (S)[1]. 57.2 × 76.2. Ed 20 (BFK),
9 TI (wA), PrP (BFK), PrP II for
Bohuslav Horak (BFK), 3 AP (2 BFK, 1
wA), 2 PP (BFK), 1 TP (BFK), CP (BFK).
Donald Roberts. D, S, T, BS.

1. Stone held from 673; additions,
 deletions. 673A differs from 673 in
 image. Two figures and a dark
 background tone have been added.
 The shading on the original figures
 has been darkened. The face of the
 reclining woman has been turned.

674
Tondo. Nov 18–20, 1962.
Black (S). 54.0 × 57.2. Ed 20 (bA), 9 TI
(nN), PrP (bA), PrP II for Bohuslav
Horak (bA), 3 AP (bA), 2 PP (bA), 2 TP
(bA), CP (bA). Joe Zirker. D, S, T, BS.

675
Back. Nov 20–21, 1962.
Red-brown (S). 76.2 × 56.5. Ed 20
(BFK), 9 TI (wA), PrP (BFK), PrP II
(BFK)[1], 3 AP (2 BFK, 1 wA), 2 PP
(BFK), CP (BFK). Irwin Hollander. D, S,
T, BS.

1. Recipient unrecorded.

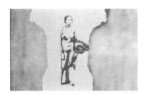

679
Venus. Nov 25–28, 1962.
Black (Z). 67.9 × 48.3. Ed 20 (BFK), 9 TI (wA), PrP (BFK), PrP II for Bohuslav Horak (BFK), 3 AP (2 BFK, 1 wA), 2 PP (BFK), 2 TP (BFK). Irwin Hollander. D, S, T, BS.

679A
Venus II. Nov 29, 1962.
Black (Z)[1]. 76.2 × 56.5. 10 ExP (BFK)[2], PrP (BFK). Irwin Hollander. T, BS (Tam), D, BS (pr), S.

1. Plate held from 679, additions. 679A differs from 679 in image and size. A solid bleed tone has been added around the figure eliminating all portions of the body except the central torso, which is darker.

682
Piano Bathers. Nov 28–29, 1962.
Black (S). 56.8 × 76.2. Ed 20 (BFK), 9 TI (wA), PrP (BFK), PrP II for Bohuslav Horak (BFK), 2 AP (BFK), 1 PP (BFK), 1 TP (BFK). Irwin Hollander. D, S, T, BS.

682A
Piano Bathers II. Nov 29–Dec 3, 1962.
Black (S)[1]. 56.8 × 76.2. Ed 20 (BFK), 9 TI (wA), PrP (BFK), PrP II for Bohuslav Horak (BFK), 3 AP (2 BFK, 1 wA), 2 PP (BFK), 1 TP (BFK), CP (BFK). John Rock. D, S, T, BS.

1. Stone held from 682; additions. 682A differs from 682 in image. Over-all image is darker and detail drawing has been added.

686
Elephant Bathers I. Dec 1–3, 1962.
Black (S). 56.8 × 76.2. Ed 20 (BFK), 9 TI (wA), PrP (BFK), PrP II for Bohuslav Horak (BFK), 3 AP (2 BFK, 1 wA), 2 PP (BFK). Irwin Hollander. D, S, T, BS.

686A
Elephant Bathers II. Dec 4–6, 1962.
Black (S)[1]. 57.5 × 77.5. Ed 20 (bA), 9 TI (nN), PrP (bA), PrP II for Bohuslav Horak (bA), 2 AP (1 bA, 1 nN), 1 PP (bA), CP (bA). Irwin Hollander. D, S, T, BS.

1. Stone held from 686, additions, deletions. 686A differs from 686 in image. Over-all image is darker and some of the areas at the lower left have been filled in considerably. Some of the shading in the landscape behind the figures has been eliminated.

690
Nude. Dec 6–11, 1962.
Black (S). 54.6 × 38.1. Ed 20 (BFK), 9 TI (wA), PrP (BFK), PrP II for Bohuslav Horak (BFK), 2 AP (1 BFK, 1 wA), 1 PP (BFK), 1 TP (BFK). Irwin Hollander. D, S, BS.

690A
Color Nude. Dec 11–21, 1962.
Ochre (Z), blue (Z), violet (Z), green (S)[1]. 54.9 × 38.1. Ed 20 (BFK), 9 TI (wA), PrP (BFK), 3 AP (1 BFK, 2 wA), 3 PP (2 BFK, 1 wA), 4 TP (BFK), CP (BFK). Irwin Hollander. D, S, BS.

1. Stone held from 690; additions, deletions. 690A differs from 690 in color and in image. A background tone and small wash areas in the figure have been added. Much of the solid tone around the figure has been eliminated. Part of the shoulder and shading on the legs have been eliminated.

691
Head. Dec 10–11, 1962.
Black (Z). 76.2 × 56.8. Ed 20 (bA), 9 TI (wA), PrP (bA), PrP II for Bohuslav Horak (bA), 3 AP (1 bA, 2 wA), 2 PP (bA), 1 TP (bA), CP (bA). John Rock. D, S, T, BS.

697
Wings I. Dec 17–18, 1962.
Black (S). 56.8 × 76.2. Ed 20 (bA), 9 TI (BFK), PrP (bA), PrP II for Bohuslav Horak (bA), 3 AP (2 bA, 1 BFK), 2 PP (bA), 1 TP (bA). Irwin Hollander. D, S, T, BS.

697A
Wings II. Dec 22–27, 1962.
Violet-black (S)[1]. 61.6 × 83.8. Ed 20 (BFK), 9 TI (wN), PrP (BFK), PrP II for Bohuslav Horak (BFK), 3 AP (2 BFK, 1 wN), 1 PP (BFK), CP (BFK). Irwin Hollander. D, S, T, BS.

1. Stone held from 697; additions, deletions. 697A differs from 697 in color and in image. Over-all image is darker. Some slight detail has been eliminated from the figure in the middle ground and the bird in the foreground.

698
Untitled. Dec 17–20, 1962.
Black (S). 57.2 × 38.1. Ed 20 (BFK), 9
TI (wA), PrP (BFK), PrP II for Bohuslav
Horak (BFK), 3 AP (1 BFK, 2 wA), 3 PP
(BFK), 1 TP (BFK), CP (BFK). John
Rock. D, S, BS.

702
Portland I. Dec 22–28, 1962.
Black (S). 97.2 × 68.6. Ed 14 (BFK), 9
TI (BFK), PrP (BFK), PrP II for Bohuslav
Horak (BFK). John Rock. D, S, T, BS.

702A
Portland II. Jan 2–8, 1963.
Dark blue[1]. 98.4 × 69.2. Ed 20 (BFK),
9 TI (wN), PrP (BFK), PrP II (BFK)[2], 2
AP (1 BFK, 1 wN), 1 TP (BFK). Irwin
Hollander. D, S, T, BS.

1. Stone held from 702; additions,
 deletions. 702A differs from 702 in
 color and in image. All of the detail
 drawing has been eliminated. Dark
 washes have been added in the
 background, figure, and foreground.
2. Recipient unrecorded.

705
Untitled. Dec 28, 1962.
Red-brown (S). 38.1 × 27.9. Ed 20
(BFK), 9 TI (wA), PrP (BFK), 2 AP (1
BFK, 1 wA), 1 PP (BFK), CP (BFK).
Irwin Hollander. D, S, BS.

706
Girl in Fur. Dec 28, 1962–Jan 10,
1963.
Red-brown (Z). 56.5 × 67.3. Ed 20
(BFK), 9 TI (wA), PrP (BFK), PrP II for
Bohuslav Horak (BFK), 2 AP (BFK), CP
(BFK). Irwin Hollander. D, S, T, BS.

709
Two Models. Jan 2–4, 1963.
Ochre (S). 77.5 × 57.2. Ed 20 (bA), 9
TI (nN), PrP (bA), PrP II for Bohuslav
Horak (bA), 2 AP (1 bA, 1 nN), 1 TP
(bA), CP (bA). Irwin Hollander. D, S, T,
BS.

714
Four Models. Jan 5–10, 1963.
Red-brown (S). 76.2 × 55.9. Ed 20
(bA), 9 TI (nN), PrP (bA), PrP II for
Bohuslav Horak (bA), 2 AP (1 bA, 1
nN), 1 TP (bA). John Rock. T, D, S, BS.

714A
Four Models II. Jan 10–15, 1963.
Brown-green (S)[1]. 76.2 × 56.8. Ed 20
(BFK), 9 TI (wA), PrP (BFK), PrP II for
Bohuslav Horak (BFK), 3 AP (2 BFK, 1
wA), 3 PP (BFK), CP (BFK). John Rock.
D, S, T, BS.

1. Stone held from 714; additions,
 deletions. 714A differs from 714 in
 color and in image. The dark areas
 have been filled in considerably and
 washes have been added to the
 figures and upper one-fourth of the
 image. A diagonal line has been
 added through the center.

719
Cup. Jan 11–14, 1963.
Black (S). 58.1 × 37.2. Ed 20 (CW), 9
TI (CW), PrP (CW), PrP II for Bohuslav
Horak (CW). John Rock. D, S, T, BS.

Byron McKeeby

1323
Monogatari. Jun 24–Jul 28, 1965.
Green-blue (S), yellow-green (S), pink
(S), light blue (S). 51.1 × 33.0. Ed 12
(CD), 9 TI (wA), 1 UNMI (wA), 2 AP
(wA), 1 TP (Radar Vellum Bristol).
Byron McKeeby. BS (Tam, UNM), T, D,
S, Dat.

1324
Okina. Jul 23–27, 1965.
Black (S). 45.7 × 61.0. Ed 10 (BFK), 9
TI (bA), 1 UNMI (bA), 3 AP (1 BFK, 2
bA), 1 TP (BFK). Byron McKeeby. BS
(Tam, UNM), T, D, S, Dat.

John McLaughlin

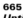

665
Untitled. Oct 23–29, 1962.
Red and yellow (Z). 27.9 × 38.1, cut.
Ed 20 (BFK), 9 TI (wA), PrP (BFK), PrP
II for Bohuslav Horak (BFK), 1 PP
(BFK), CP (nr)[1]. Donald Roberts.
Verso: D, S, BS.

1. Unsigned, unchopped,
 undesignated, retained by
 Tamarind.

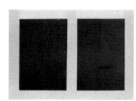

666
Untitled. Oct 24–Nov 2, 1962.
Black (S)[1]. 56.5 × 75.9, cut. Ed 8
(BFK), 9 TI (BFK), PrP (BFK), PrP II for
Bohuslav Horak (BFK), 3 AP (BFK).
Donald Roberts. D, S, BS.

1. Half of the image was deleted and a
 second run of varnish was then
 printed from this stone.

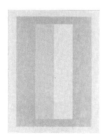

781
Untitled. Apr 8–11, 1963.
Grey (S), yellow (Z). 51.4 × 37.5, cut.
Ed 11 (BFK), 9 TI (wA), PrP (BFK), PrP
II for Bohuslav Horak (BFK), 1 AP (wA).
Jason Leese. Verso: D, S, Dat, WS.

783
Untitled. Apr 10–12, 1963.
Black (S). 45.7 × 57.2, cut. Ed 18
(BFK), 9 TI (BFK), PrP (BFK), PrP II for
Bohuslav Horak (BFK), 1 AP (BFK).
Jason Leese. Verso: D, S, Dat, WS.

784
Untitled. Apr 12–30, 1963.
Green (S), black (S)[1]. 45.7 × 54.6,
cut. Ed 10 (BFK), 9 TI (BFK), PrP (BFK),
PrP II for Bohuslav Horak (BFK), 3 AP
(BFK), 1 PP (BFK). Jason Leese. Verso:
D, S, Dat, WS.

1. Same stone as run 1.

786
Untitled. Apr 15–18, 1963.
Black (Z). 40.6 × 54.6, cut. Ed 19
(BFK), 9 TI (wA), PrP (BFK), 1 AP (BFK).
Bohuslav Horak. Verso: D, S, Dat, WS.

787
Untitled. Apr 17–23, 1963.
Black (Z). 46.4 × 57.2, cut. Ed 15
(BFK), 9 TI (BFK), PrP (BFK), PrP II for
Bohuslav Horak (BFK). Aris Koutroulis.
Verso: D, S, Dat, WS.

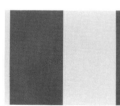

788
Untitled. Apr 18–25, 1963.
Black (S). 45.7 × 54.6, cut. Ed 20
(BFK), 9 TI (BFK), PrP (BFK), PrP II for
John Dowell (BFK). Bohuslav Horak.
Verso: D, S, Dat, WS.

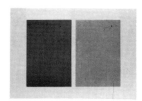

792
Untitled. Apr 23–May 6, 1963.
Red (S), blue (S)[1]. 56.2 × 76.2, cut.
Ed 15 (BFK), 9 TI (BFK), PrP (BFK), PrP
II for Bohuslav Horak (BFK), 3 AP
(BFK), 1 PP (BFK), CP (BFK). Irwin
Hollander. Verso: D, S, Dat, WS.

1. Same stone as run 1.

796
Untitled. May 1–8, 1963.
Black (S), black (S)[1]. 55.9 × 76.2,
cut. Ed 20 (BFK), 9 TI (BFK), PrP (BFK),
PrP II for Bohuslav Horak (BFK), 2 AP
(BFK), CP (BFK). Irwin Hollander.
Verso: D, S, Dat, WS.

1. Same stone as run 1.

800
Untitled. May 8–15, 1963.
Yellow (S), grey (Z). 45.7 × 54.9, cut.
Ed 13 (BFK), 9 TI (BFK), PrP (BFK), PrP
II for Bohuslav Horak (BFK). Irwin
Hollander. Verso: D, S, Dat, WS.

803
Untitled. May 13–Jul 30, 1963.
Black (S), grey (S). 45.7 × 55.2, cut.
Ed 16 (BFK), 9 TI (BFK), PrP (BFK), 3
TP (BFK). Irwin Hollander. Verso: D, S,
Dat, WS.

807
Untitled. May 16–21, 1963.
Black (S). 47.3 × 55.2, cut. Ed 20
(BFK), 9 TI (BFK), PrP (BFK), PrP II for
Bohuslav Horak (BFK), 2 AP (BFK), CP
(BFK). Irwin Hollander. Verso: D, S,
Dat, WS.

810
Untitled. May 21–23, 1963.
Grey-brown (S). 40.6 × 54.6, cut. Ed
20 (BFK), 9 TI (BFK), PrP (BFK), PrP II
for Bohuslav Horak (BFK), 2 AP (BFK),
CP (BFK). Irwin Hollander. Verso: D, S,
Dat, WS.

811
Untitled. May 21–24, 1963.
Yellow (S). 45.7 × 33.7, cut. Ed 20
(BFK), 9 TI (BFK), PrP (BFK), PrP II for
Bohuslav Horak (BFK). Aris Koutroulis.
Verso; D, S, Dat, WS.

813
Untitled. May 23–Jun 3, 1963.
Black (S), blue (S). 45.7 × 54.6, cut. Ed
11 (BFK), 9 TI (BFK), PrP (BFK), PrP II
for Bohuslav Horak (BFK). Jason
Leese. Verso: D, S, Dat, WS.

815
Untitled. May 28–Jun 3, 1963.
Black (S), grey (Z). 45.7 × 54.6, cut.
Ed 19 (BFK), 9 TI (BFK), PrP (BFK), PrP
II for Bohuslav Horak (BFK), 1 AP
(BFK). Aris Koutroulis. Verso: D, S,
Dat, WS.

Eleanore Mikus

2350A/2350
Tablet Litho 1[1]. Jun 3–6, 1968.
Light yellow (S)[2]. 182.9 × 61.3. Ed
20 (BFK), 9 TI (MI), BAT (BFK), 3 AP (2
BFK, 1 MI)[3], CTP (BFK)[4]. Jean
Milant. D, BS, S, Dat (2350).

1. A two-part lithograph, hinged
 together vertically with 2350A on
 top.
2. Same stone and color used for
 2350A and 2350. The paper was
 folded 11 times horizontally.
3. 1 AP (MI) of 2350 only, 91.4 × 61.3.
4. 2350 only, 91.4 × 61.3.

2350II
Tablet Litho 2. Jun 3–7, 1968.
Light yellow (S)[1], black (S)[2]. 91.4
× 60.7. Ed 10 (BFK), 9 TI (BFK), BAT
(BFK), 1 AP (BFK)[3], 2 TP (BFK)[3], 1
CTP (BFK)[3], CP (BFK)[3]. Jean Milant.
D, BS, S, Dat.

1. Stone held from 2350A and 2350.
2. Same stone as run 1, paper turned
 180 degrees. The paper was folded
 11 times horizontally. 2350II differs
 from 2350A in color, image and
 size. The over-all image is darker.
 The same drawing turned 180
 degrees is printed underneath the
 black in lighter color.
3. 1 AP, 2 TP, 1 CTP, CP chopped twice.
 1 TP varies from the edition.

2351
Tablet Litho 4. Jun 4–14, 1968.
Beige (S), white (S)[1]. 71.5 × 46.1. Ed
20 (GEP), 9 TI (CD), BAT (GEP), 5 AP (4
GEP, 1 CD), CP* (GEP). Frank Akers. D,
BS, S, Dat.

1. Same stone as run 1 printed .4 to
 the left. Paper folded 4 times
 vertically and 8 times horizontally.

2352
Tablet Litho 5. Jun 7–19, 1968.
Black (S)[1]. 76.2 × 55.2. Ed 20 (CD), 9
TI (GEP), BAT (CD), 5 AP (CD), 1 PP
(CD), CP (CD). Edward Hughes. D, BS,
S, Dat.

1. Paper creased 4 times horizontally.

2353
Tablet Litho 3. Jun 11–13, 1968.
Black (S), black (S)[1]. 51.8 × 35.6. Ed
10 (JG), 9 TI (GEP), BAT (JG), 5 AP (3
GEP, 2 JG), 1 TP* (JG), CP* (JG).
Serge Lozingot. D, BS, S, Dat.

1. Same stone as run 1 printed .4
 lower and to the right. Paper folded
 8 times horizontally and 8 times
 vertically.

2354
Tablet Litho 14. Jun 12–Jul 3, 1968.
White (A)[1], grey (A)[2]. 86.4 × 61.0.
Ed 20 (wN), 9 TI (wN), BAT (wN), 1 TP
(wN), 2 CTP (wN), CP* (wN). Robert
Rogers. D, BS, S, Dat.

1. Plate held from 2354II. 2354 differs
 from 2354II in color only.
2. Same plate as run 1 printed 1.3 to
 the right.

2354II
Tablet Litho 7. Jun 12–27, 1968.
Yellow-grey (A), yellow-grey (A)[1].
86.4 × 61.3. Ed 10 (wN), 9 TI (wN),
BAT (wN), 3 AP (wN), 2 TP (wN)[2], 3
CTP (wN). Robert Rogers. D, BS, S,
Dat.

1. Same plate as run 1 printed 1.2 to
 the right.
2. 1 TP varies from the edition.

2354III
Tablet Litho 8. Jun 12–28, 1968.
Black (A)[1], blue-black (A)[2]. 86.4 ×
61.0. Ed 10 (wN), 9 TI (wN), BAT (wN),
3 AP (wN), 3 TP (wN)[2], 1 PTP (wN).
Robert Rogers. D, BS, S, Dat.

1. Plate held from 2354II.
2. Same plate as run 1 printed 1.3 to
 the left. 2354III differs from 2354II in
 color only.
3. 2 TP vary from the edition.

2355/2355A
Tablet Litho 13. Jun 14–Jul 1, 1968.
Black (S)[2], red (S)[3]. 58.4 × 91.4,
(two parts), 58.9 × 45.7 (one part). Ed
20 (wN), 9 TI (wN), BAT (wN), 3 AP
(wN), 1 PP (wN), CP (wN). Frank Akers.
D, BS (2355), S, Dat (2355A).

1. A two part lithograph, hinged with
 2355 on the left.
2. Same stone and color used for 2355
 and 2355A.
3. Same stone as run 2, printed on
 2355A, paper turned 180 degrees.

2356
Tablet Litho 10. Jun 21–28, 1968.
Blue-black (A). 82.6 × 59.1. Ed 20
(nN), 9 TI (nN), BAT (nN), 2 TP (nN)[1],
1 CTP (nN)[1], CP (nN). Jean Milant. D,
BS, S, Dat.

1. 1 TP, 1 CTP on paper 86.3 × 61.0.

2357
Tablet Litho 11. Jun 20–Jul 1, 1968.
Black (S)[1], black (S)[2]. 81.3 × 58.4.
Ed 20 (GEP), 9 TI (CD), BAT (GEP), 3
AP (2 CD, 1 GEP), 1 TP (CD), CP (GEP).
Serge Lozingot. D, BS, S, Dat.

1. Stone held from 2357II.
2. Same stone as run 1, paper turned
 180 degrees. 2357 differs from
 2357II in image. The over-all image
 is darker and the horizontal and
 vertical lines are less distinct.

2357II
Tablet Litho 9. Jun 20–28, 1968.
Black (S). 81.3 × 58.4. Ed 10 (GEP), 9
TI (CD), BAT (GEP), 2 AP (1 CD, 1
GEP), 1 TP (GEP)[1]. Serge Lozingot.
D, BS, S, Dat.

1. 1 TP torn into 4 parts measuring
 39.4 × 29.2 hinged together to
 measure 39.4 × 116.9.

2365
Tablet Litho 6. Jun 19–25, 1968.
Blue (S). 51.8 × 35.6[1]. Ed 20 (CD), 9
TI (GEP), BAT (CD), 1 CTP (GEP), 1 PTP
(GEP), CP (CD). Serge Lozingot. D, BS,
S, Dat.

1. Paper folded 8 times vertically and
 8 times horizontally.

2366
Tablet Litho 12. Jun 28–Jul 1, 1968.
Light beige (O), light beige (O)[1]. 64.8
× 48.3. Ed 20 (GEP), 9 TI (CD), BAT
(GEP), 4 AP (2 CD, 2 GEP), 1 TP (GEP),
4 CTP (GEP), CP (GEP). David
Folkman. D, BS, S, Dat.

1. Same stone as run 1, paper turned
 180 degrees.

2367
Tablet Litho 17. Jun 26–Jul 5, 1968.
Black (S), black (S)[1]. 86.4 × 58.4. Ed
20 (GEP), 9 TI (CD), BAT (GEP), 2 AP (1
CD, 1 GEP), 1 TP* (GEP), CP (CD).
Daniel Socha. D, BS, S, Dat.

1. Same stone as run 1, paper turned
 180 degrees.

2368
Tablet Litho 18. Jul 9–11, 1968.
White (S)[1]. 105.4 × 74.9. Ed 20
(wN), 9 TI (wN), BAT (wN), 3 AP (wN),
1 PP (wN), 2 TP (wN)[2], CP* (wN).
Robert Rogers. D, BS, S, Dat.

1. Paper folded 15 times horizontally
 and 63 times vertically.
2. 1 TP varies from the edition.

2369
Tablet Litho 15. Jun 28–Jul 3, 1968.
Black (A). 81.6 × 58.4. Ed 20 (MI), 9 TI
(CD), BAT (MI), 3 AP (2 CD, 1 MI), 1
TP* (MI). Theodore Wujcik. D, BS, S,
Dat.

2369II
Tablet Litho 16. Jul 3, 1968.
Silver-black (A)[1]. 81.6 × 58.8. Ed 10
(MI), 9 TI (CD), BAT (MI), 2 AP (1 CD, 1
MI), CP (CD). Theodore Wujcik. D, BS,
S, Dat.

1. Plate held from 2369. 2369II differs
 from 2369 in color only.

2375
Tablet Litho 22. Jul 8–16, 1968.
Light yellow (S), light yellow (S)[1],
embossed. 48.6 × 83.8. Ed 20 (GEP), 9
TI (CD), BAT (GEP), 3 AP (1 CD, 2
GEP), 2 CTP (1 CD, 1 GEP), CP (CD).
Anthony Stoeveken. D, BS, S, Dat.

1. Same stone as run 1, paper turned
 180 degrees.

2376
Tablet Litho 25. Jul 10–17, 1968.
Silver-black (A). 87.0 × 58.8. Ed 15
(GEP), 9 TI (GEP), BAT (GEP), 3 AP
(GEP), 2 CTP (GEP), CP (GEP). Manuel
Fuentes. D, BS, S, Dat.

2377
Tablet Litho 19. Jul 5–13, 1968.
Black (S), blue-black (S)[1]. 46.1 ×
36.2. Ed 20 (wN), 9 TI (wN), BAT (wN),
3 AP (wN). Theodore Wujcik. D, BS, S,
Dat.

1. Same stone as run 1, paper turned
 180 degrees.

2377II
Tablet Litho 23. Jul 14–16, 1968.
Silver-black (S)[1]. 45.7 × 35.6. Ed 20
(GEP), 9 TI (GEP), BAT (GEP), 3 AP
(GEP), 1 CTP (GEP), CP (GEP).
Theodore Wujcik. D, BS, S, Dat.

1. Stone held from 2377; additions.
Paper folded 3 times horizontally
and 15 times vertically. 2377II differs
from 2377 in color and in image.
The over-all image is lighter and the
vertical striations are lighter and
larger.

2378
Tablet Litho 20. Jul 5–13, 1968.
Black (S), blue-black (S)[1]. 46.1 ×
36.2. Ed 20 (wN), 9 TI (wN), BAT (wN),
3 AP (wN). Theodore Wujcik. D, BS, S,
Dat.

1. Same stone as run 1, paper turned
180 degrees.

2378II
Tablet Litho 24. Jul 14–16, 1968.
Silver-black (S)[1]. 45.7 × 35.6[2]. Ed
20 (GEP), 9 TI (GEP), BAT (GEP), 3 AP
(GEP), 1 CTP (GEP), CP (GEP).
Theodore Wujcik. D, BS, S, Dat.

1. Stone held from 2378; additions.
2378II differs from 2378 in color and
in image. The over-all image is
lighter and the vertical striations are
lighter and larger.
2. Paper folded 3 times horizontally
and 15 times vertically.

2379A/2379
Tablet Litho 26[1]. Jul 12–22, 1968.
Violet-black (S)[2], blue-black (S)[3].
210.8 × 74.9. Ed 20 (wN), 9 TI (wN),
BAT (wN), 3 AP (wN), 2 PP (wN), 7 CTP
(wN)[4]. Robert Rogers. D, BS, S, Dat
(2379).

1. A two part lithograph, hinged
together vertically with 2379A on
top.
2. Stone held from 2368; additions.
Same stone and color used for
2379A and 2379.
3. Same stone as run 1, paper turned
180 degrees. Same stone and color
used for 2379A and 2379. 2379A
and 2379 differ from 2368 in color,
image, and size. The over-all image
is darker. Horizontal striations were
added between the five solid
horizontal bars.
4. Proofs of 2379 only, 105.4 × 74.9. 2
CTP hinged together like the
edition.

2379IIA/2379II
Tablet Litho 29[1]. Jul 12–24, 1968.
White (S)[2]. 210.8 × 74.9. Ed 10
(wN), 9 TI (wN), BAT (wN), 3 AP (wN),
3 CTP (wN)[3], CP (wN)[3]. Robert
Rogers. D, BS, S, Dat (2379II).

1. A two-part lithograph, hinged
together vertically with 2379IIA on
top. The TI were hinged in the
workshop; the remaining
lithographs were retained by the
artist to be hinged at a later date.
2. Stone held from 2379 and 2379A.
Same stone and color used for
2379II and 2379IIA. 2379IIA and
2379II differ from 2379A and 2379 in
color and in image. The over-all
image is lighter. There are fewer
horizontal striations.
3. Proofs of 2379II only, 105.4 × 74.9.
CP varies from the edition.

2380
Tablet Litho 28. Jul 15–22, 1968.
Light yellow-grey (A), light yellow-
grey (A)[1]. 89.2 × 62.2. Ed 20 (CD), 9
TI (GEP), BAT (CD), 3 AP (1 CD, 2
GEP), 1 CTP (GEP), CP (GEP). Serge
Lozingot. D, BS, S, Dat.

1. Same plate as run 1, paper turned
180 degrees.

2391
Tablet Litho 27. Jul 15–25, 1968.
Black (S), black (S)[1]. 83.8 × 58.8. Ed
20 (GEP), 9 TI (CD), BAT (GEP), 3 AP
(CD), 1 CTP (GEP), CP (CD). Daniel
Socha. D, BS, S, Dat.

1. Same stone as run 1, paper turned
180 degrees.

2392A, 2392, 2392B
Tablet Litho 30[1]. Jul 22–28, 1968.
Grey (O), white (O)[2], black (O)[3].
69.2 × 153.4. Ed 10 (CD), 9 TI (GEP),
BAT (CD), 3 AP (2 CD, 2 GEP)[4], 1 CTP
(CD), CP (GEP). Maurice Sanchez. D,
BS (2392A)[5], S, Dat (2392B).

1. A three part lithograph, hinged,
each part printed in a different
color. The colors are listed in the
order they appear on the hinged
print, not the order of printing. The
TI were hinged in the workshop, the
remaining lithographs were
retained by the artist to be hinged
at a later date.
2. Same stone as run 1.
3. Same stone as run 2.
4. 1 AP (CD) with 2392 and 2392A, 1 AP
(GEP) with 2392B, 69.2 × 51.4.
5. CP: D, BS on 2392, 69.2 × 51.4.

2393
Tablet Litho 21. Jul 5–13, 1968.
Black (A), black (A)[1]. 85.1 × 59.7. Ed
20 (GEP), 9 TI (CD), BAT (GEP), 3 AP
(GEP), 1 TP (GEP), 1 CSP (GEP), CP
(GEP). Edward Hughes. D, BS, S, Dat.

1. Same plate as run 1, paper turned
 180 degrees.

Jean Milant

2236
***Equitorial Cloud at the time of the
Equinox.*** Mar 1–May 21, 1968.
Blue (Z), B: Pink, yellow, silver-blue
(A). 55.2 × 76.5. Ed 15 (wA), 9 TI (CD),
BAT (wA), 3 AP (2 CD, 1 wA), 2 TP*
(wA), CP (CD). Jean Milant. D, T, BS,
S, Dat.

2338
Vertical Eclipse. Jun 1–30, 1968.
Pearly blue (A), light yellow (A). 55.6
× 76.2. Ed 15 (wA), 9 TI (CD), BAT
(wA), 3 AP (2 wA, 1 CD), 1 TP (wA), CP
(CD). Jean Milant. Verso: D, T, WS, S,
Dat.

2415
Joy over the Autumn Equinox. Sep
16–27, 1968.
Pearly grey (S), pearly yellow (S). 56.5
× 76.2. Ed 15 (wA), 9 TI (wA), BAT
(wA), 3 AP (wA), 3 TP* (wA). Jean
Milant. Verso: D, S, WS, T.

2477
Great Day. Nov 11–24, 1968.
B: Pink, yellow (A). 15.2 × 15.2, cut.
Ed 12 (wA), 9 TI (BFK), BAT (wA), 2 AP
(1 wA, 1 BFK), 1 TP* (BFK), 1 CTP
(wA), CP (wA). Jean Milant. Verso: D,
WS, T, S, Dat.

2478
Sky Filled Cream Puffs. Nov 11–24,
1968.
B: Pink, yellow, blue (A). 15.2 × 15.2,
cut. Ed 12 (wA), 9 TI (BFK), BAT (wA),
1 AP (BFK), 1 CTP (wA), CP (wA). Jean
Milant. Verso: D, WS, T, S, Dat.

2479
X Marks the Spot. Nov 11–24, 1968.
B: Pink, yellow, blue (A). 15.2 × 15.2,
cut. Ed 12 (11 wA, 1 BFK), 9 TI (BFK),
BAT (wA), 2 AP (1 wA, 1 BFK), CP
(wA). Jean Milant. Verso: D, WS, T, S,
Dat.

2480
100% Rag Sky. Nov 11–24, 1968.
B: Pink, yellow, blue (A). 15.2 × 15.2,
cut. Ed 12 (wA), 9 TI (BFK), BAT (wA),
2 AP (BFK), CP (wA). Jean Milant.
Verso: D, WS, T, S, Dat.

2481
Paralogistic. Nov 11–24, 1968.
B: Pink, yellow, blue (A). 15.2 × 15.2,
cut. Ed 12 (11 wA, 1 BFK), 9 TI (BFK),
BAT (wA), 2 AP (1 wA, 1 BFK), 1 CTP
(wA), CP (wA). Jean Milant. Verso: D,
WS, T, S, Dat.

2482
Ascending Nimbus. Nov 11–24,
1968.
B: Pink, yellow, blue (A). 15.2 × 15.2,
cut. Ed 12 (11 wA, 1 BFK), 9 TI (BFK),
BAT (wA), 1 AP (wA), 1 CTP (wA), CP
(wA). Jean Milant. Verso: D, WS, T, S,
Dat.

2483
Rose Twist. Nov 11–24, 1968.
B: Pink, yellow, blue (A). 15.2 × 15.2,
cut. Ed 12 (wA), 9 TI (BFK), BAT (wA),
2 AP (BFK), CP (wA). Jean Milant.
Verso: D, WS, T, S, Dat.

2484
Quad. Nov 11–24, 1968.
B: Pink, yellow, blue (A). 15.2 × 15.2,
cut. Ed 12 (11 wA, 1 BFK), 9 TI (BFK),
BAT (wA), 2 AP (1 wA, 1 BFK), 1 CTP
(wA), CP (wA). Jean Milant. Verso: D,
WS, T, S, Dat.

2485
My Window. Nov 11–24, 1968.
B: Pink, yellow, blue (A). 15.2 × 15.2,
cut. Ed 12 (wA), 9 TI (BFK), BAT (wA),
2 AP (1 wA, 1 BFK), 1 TP* (BFK), 1 CTP
(wA), CP (wA). Jean Milant. Verso: D,
WS, T, S, Dat.

2486
Sunshine. Nov 11–24, 1968.
B: Pink, yellow, blue (A). 15.2 × 15.2,
cut. Ed 12 (11 wA, 1 BFK), 9 TI (BFK),
BAT (wA), 2 AP (1 wA, 1 BFK), 1 TP*
(BFK), 1 CTP (wA), CP (wA). Jean
Milant. Verso: D, WS, T, S, Dat.

2487
Fun. Nov 11–24, 1968.
B: Pink, yellow, blue (A). 15.2 × 15.2,
cut. Ed 12 (11 wA, 1 BFK), 9 TI (BFK),
BAT (wA), 2 AP (1 wA, 1 BFK), 1 TP*
(BFK), 1 CTP (wA), CP (wA). Jean
Milant. Verso: D, WS, T, S, Dat.

2488
Pop C-o-r-n. Nov 11–24, 1968.
B: Pink, yellow, blue (A). 15.2 × 15.2,
cut. Ed 12 (wA), 9 TI (BFK), BAT (wA),
2 AP (BFK), 1 TP* (BFK), 1 CTP (wA),
CP (wA). Jean Milant. Verso: D, WS, T,
S, Dat.

2504
Untitled. Mar 20–Apr 22, 1969.
B: Pearly blue, light pearly blue,
pearly white (A). 38.1 × 30.5, cut. Ed
10 (GEP), 9 TI (CD), BAT (GEP), 3 AP (1
GEP, 2 CD), 4 TP* (GEP). Jean Milant.
Verso: D, WS, I, Dat.

2506
Untitled. Jan 23–Feb 20, 1969.
B: Blue, yellow (A), white (S). 38.1 ×
30.5, cut. Ed 10 (CD), 9 TI (GEP), BAT
(CD), 3 AP (1 CD, 2 GEP), 3 TP* (CD),
CP (GEP). Jean Milant. Verso: D, WS, I.

2507
Untitled. Jan 15–25, 1969.
B: Blue, light blue (A), blue-green (S)
or
B: Yellow, blue, pink (A), violet (S)[1].
38.1 × 30.5, cut. Ed 20 (CD)[2], 9 TI
(GEP), BAT (CD), 3 AP (1 GEP, 2 CD), 5
TP (4 CD, 1 GEP)[2], 6 CTP (CD)[2], CP
(CD)[2]. Jean Milant. Verso: D, WS, S,
Dat.

1. Edition exists in two color
 variations. Variation I in blue, light
 blue and blue-green, and Variation II
 in yellow, blue, pink and violet.
2. Indicates Variation II, Ed 11–20/20, 2
 TP, 3 CTP, CP.

2539
Untitled. May 1–24, 1969.
Blue-green (Z), B: silver-blue, pearly
silver, silver (A)[1]. 38.1 × 30.5, cut.
Ed 10 (CD), 9 TI (GEP), BAT (CD), 3 AP
(CD), 4 TP* (1 CD, 3 GEP). Jean
Milant. Verso: D, WS, I, Dat.

1. Plate held from 2504. 2539 differs
 from 2504 in color and in image.
 The over-all image is darker.
 Shading in the form of areas of fine
 dots has been added to the
 irregular shapes and background.

Thomas H. Minkler

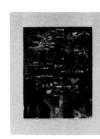

1321
Totem—2nd State. Jun 28–Jul 12,
1965.
Green-black (S). 75.6 × 52.7 (BFK),
76.2 × 52.7 (bA). Ed 12 (BFK), 9 TI
(bA), 1 UNMI (bA), 1 AP (bA), 1 TP
(bA). Thomas H. Minkler. D, T, S, Dat,
BS (Tam, UNM).

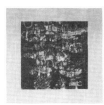

1322
Sisiutl Totem. Jul 8–Aug 2, 1965.
Yellow (S), violet (S), blue (S), red (S),
brown-black (S). 51.1 × 49.9. Ed 12
(BFK), 9 TI (wA), 1 UNMI (wA), 2 AP
(wA). Thomas H. Minkler. BS (Tam,
UNM), T, D, S, Dat.

1502
Owl Totem. Aug 8–10, 1965.
Brown-black (S). 81.3 × 75.6, (BFK).
Ed 10 (bA), 9 TI (BFK), 1 UNMI (BFK),
2 AP (1 BFK, 1 bA), 2 TP (1 BFK, 1 bA).
Thomas H. Minkler. T, D, S, Dat, BS
(Tam), bottom, BS (UNM), top.

1503
Dark Totem. Aug 2–11, 1965.
Green (S), violet (S), blue (S), red-
violet (S), blue-black (S). 73.7 × 52.4.
Ed 10 (BFK), 9 TI (wA), 1 UNMI (BFK),
4 TP (wA). Thomas H. Minkler. BS
(Tam, UNM), T, D, S, Dat.

George Miyasaki

362
Nocturnal Forms. Aug 18–20, 1961.
Black (S), pink, blue, violet (Z). 70.2 ×
54.3. Ed 15 (BFK), 9 TI (wA), 2 AP (1
BFK, 1 wA), 3 TP (wA). George
Miyasaki. BS, D, T, S, Dat.

369
Into Autumn. Aug 25, 1961.
Black (S). 105.4 × 74.9. Ed 15 (BFK), 9
TI (wN), 1 AP (wN), 2 TP (1 wN, 1
BFK[1]). George Miyasaki. BS (Tam),
D, T, BS (pr), S, Dat.

1. 1 TP on paper 87.6 × 54.6 varies
 from the edition.

Print not in
University Art Museum
Archive

Print not in
University Art Museum
Archive

Print not in
University Art Museum
Archive

370
Moon in August. Aug 25–26, 1961.
Black (Z), yellow (Z). 77.2 × 56.5. Ed
20 (bA), 9 TI (nN), 2 TP (nN). George
Miyasaki. BS (Tam), D, T, S, Dat, BS
(pr).

373
Hillside #2. Aug 30–Sep 4, 1961.
Black (S), yellow (S), blue-grey (S),
pink (S). 77.2 × 57.2. Ed 13 (bA), 9 TI
(nN), 3 AP (1 bA, 2 nN), 3 TP (1 bA, 2
nN). George Miyasaki. D, BS, T, S, Dat.

378
Dark Journey. Sep 5, 1961.
Black (S), grey (Z), black (S). 83.8 ×
58.4. 12 ExP (7 BFK, 5 wN)[1]. George
Miyasaki. D, BS (Tam), T, BS (pr), S,
Dat.

1. Designated A–L. 6 ExP (5 wN, 1
 BFK) retained by Tamarind. Printing
 varies throughout the edition.

381
Flight into September. Sep 7–9,
1961.
Grey (Z)[1], black (S)[2]. 84.5 × 59.1.
Ed 12 (BFK), 9 TI (wN), 1 AP (BFK), 3
TP (wN). George Miyasaki. D, BS, T, S,
Dat.

1. Plate held from 378, run 2;
 deletions.
2. Stone held from 378, run 3;
 additions, deletions. 381 differs
 from 378 in image. The image has
 been turned 180 degrees. The dark
 lines that form the large rectangle
 and small rectangle have been
 eliminated. A large rectangle of
 curvilinear lines has been added at
 the bottom. The background on all
 four sides was darkened and filled
 in more extensively.

383
Flying Machine. Sep 10–12, 1961.
Black (S), blue-green (S), orange (S),
pink (S), grey-brown (S). 92.1 × 66.7.
Ed 15 (BFK), 9 TI (wN), 3 TP (wN).
George Miyasaki. BS, D, T, S, Dat.

Enrique Montenegro

1510
Assassination. Jan 22–Feb 24, 1966.
Black (S). 75.6 × 49.9. Ed 15 (BFK), 9
TI (CD), 1 UNMI (CD), BAT (BFK), 3 AP
(BFK), 2 TP (BFK). John Beckley. BS
(Tam), T, Dat, D, S, BS (UNM).

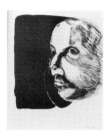

1511
Head. Feb 12–Mar 3, 1966.
Black (S). 45.7 × 34.9. Ed 15 (CD), 9 TI
(BFK), 1 UNMI (CD), BAT (CD). John
Beckley. BS (Tam), D, Dat, S, BS
(UNM).

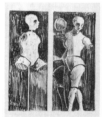

1512
Manikins. Feb 17–Apr 20, 1966.
Black (S). 48.3 × 38.1. Ed 15 (BFK), 9
TI (CD), 1 UNMI (BFK), BAT (CD), 3 AP
(BFK). Robert Weaver. BS (Tam), T, D,
S, BS (UNM).

1514
Woman on a Crosswalk. Mar 17–31,
1966.
Black (S), light violet-grey (S), light
pink and light yellow (S). 52.7 × 40.6.
Ed 15 (BFK), 9 TI (CD), 1 UNMI (BFK),
BAT (CD), 3 TP (BFK). Erwin Erickson.
BS (Tam), T, D, S, BS (UNM).

Carl Morris

482
Span. Jan 5–Feb 15, 1962.
Light yellow-beige (Z), dark yellow (Z),
red (Z), grey (Z), blue (Z), black (Z),
light grey (Z). 55.9 × 76.2. Ed 17
(BFK), 9 TI (nN), PrP (BFK), 7 AP (3
BFK, 4 nN), 3 TP (BFK). Irwin
Hollander. BS, D, S.

487
Floe. Jan 8–26, 1962.
Red (Z), dark beige (Z), black (Z). 56.5
× 76.2. Ed 20 (BFK), 9 TI (wA), PrP
(BFK), 3 AP (BFK), 6 TP (4 BFK, 2 wA).
Bohuslav Horak. D, S, BS.

487A
Black Floe. Mar 1, 1962.
Black (Z)[1]. 57.2 × 77.2. Ed 15 (bA), 9
TI (wN), PrP (BFK), 2 AP (wN), 3 TP (2
wN, 1 nN). Wesley Chamberlin. D, S,
BS.

1. Plate held from 487, run 3. 487A
 differs from 487 in color and in
 image. The solid tone under the
 texture extending through the
 center and some tone at the top
 and bottom have been eliminated.

500
Panel I. Feb 6–Mar 8, 1962.
Yellow (Z), light beige (Z), blue (Z),
black (Z), orange (Z), red (Z), ochre
(Z), brown (Z). 25.4 × 104.8. Ed 20
(BFK), 9 TI (wN), PrP (wN), 5 AP (2 wN,
3 BFK), 11 TP (BFK)[1], 1 PgP (BFK)[2].
Irwin Hollander. D, S, BS.

1. 3 TP vary from the edition, 2 TP on
 paper 22.8 × 104.1. An unrecorded
 number of TP (proofing paper),
 unchopped, retained by the artist.
2. 1 PgP retained by Tamarind.

501
Panel II. Feb 6–Mar 8, 1962.
Yellow (Z), light beige (Z), blue (Z),
black (Z), orange (Z), red (Z), ochre
(Z), brown (Z). 25.4 × 105.1. Ed 20
(BFK), 9 TI (wN), BAT (BFK), 5 AP (3
BFK, 2 wN), 5 TP (4 BFK, 1 wN)[1], 1
PgP (BFK)[2]. Irwin Hollander. D, S,
BS.

1. An unrecorded number of TP
 (proofing paper), unchopped,
 retained by the artist.
2. 1 PgP retained by Tamarind.

518
Flight. Mar 3–16, 1962.
Yellow (Z), light beige (Z), red (Z), dark
yellow (Z)[1], dark red (Z)[2], black (Z).
45.7 × 64.1. Ed 9 (BFK), 9 TI (BFK),
PrP (BFK), 8 TP (BFK)[3], CP* (BFK).
Wesley Chamberlin. D, S, BS.

1. Same plate as run 3.
2. Same plate as run 4.
3. 6 TP unchopped, retained by the
 artist.

Hilda Morris

526
Tuesday's Guest. Mar 13–Apr 5,
1962.
Black (Z). 57.2 × 77.2. Ed 20 (BFK), 9
TI (nN), PrP (BFK), 2 AP (1 BFK, 1 nN),
3 TP (2 BFK, 1 nN), CP (BFK). Irwin
Hollander. BS, D, S.

527
First Encounter. Mar 13–Apr 6, 1962. Black (Z). 57.2 × 77.5. Ed 10 (BFK), 9 TI (nN), PrP (BFK), 1 AP (nN), 2 TP (BFK), CP (BFK). Bohuslav Horak. BS (Tam), S, D, BS (pr).

Ed Moses

Untitled (Suite Number 1), a suite of eight lithographs. Each lithograph in this suite and 2383All contains a cut-out shape which when folded stands out from the face of the print .60. A 12.7 square of flat color is laid behind the cut-out. The artist's edition and the Tamarind Impressions are hinged to rag board and framed in a shadow box format. There is no fixed order to the suite. The suite consists of eight lithographs that are variations of the same image. In addition, five individual editions exist which are also variations. All thirteen lithographs bear the same linear image drawn on stone (keystone), but transferred to and printed from an aluminum plate for certain examples. The variations in background involve several combinations: linear image on a solid background of the same outline with or without some line (a and b), linear image on a solid bleed background (a and c) or a combination of linear image on both backgrounds (a, b and c). In order: 2383E, 2383B, 2383F, 2383G, 2383A, 2383, 2383D, 2383J.

Untitled (Suite Number 2), a suite of seven lithographs. The suite consists of seven lithographs that are variations of the same image. In addition, two individual editions and one experimental edition exist which are also variations. All ten editions bear the same solid central image with some line, drawn on stone (b). The variations consist of color differences and the addition of a secondary solid image (c) and/or a linear image which outlines the central image (a). The variations include a central solid image with some line and secondary solid image (b and c), printed in the blended inking method; central solid image with some line and secondary solid image (blended inking) and the linear image outline (b, c and a); or central solid image with some line or linear image outline (b and a). In order: 2382III, 2382IV, 2382VI, 2382V, 2382VII, 2382VIII, 2382IX.

2381
Untitled. Jul 1–10, 1968.
Yellow (S), black (S)[1]. 38.1 × 48.9. Ed 20 (MI), 9 TI (JG), BAT (MI), 4 CTP (3 JG, 1 CD), 3 PTP* (2 CD, 1 MI), CP (MI). Jean Milant. D, I, BS.

1. Same stone as run 1 printed off-register.

2382
Untitled.[1] Jul 22–25, 1968.
Black (S)[2], yellow (S)[3]. 33.7 × 42.2, cut. Ed 20 (CD), 9 TI (CD), BAT (CD), 3 AP (CD), 2 PTP (1 CD, 1 MI). Frank Akers. Verso: D, I, Dat, WS.

1. A portion of the central image contains a cut-out shape which when folded stands out from the face of the print .60.
2. Stone held from 2382II, run 2.
3. Stone held from 2382II, run 1. The central solid image with some line and linear image outline (b & a)

2382II
Untitled. Jul 5–12, 1968.
Yellow (S), red (S)[1]. 33.7 × 42.2, cut. Ed 10 (MI), 9 TI (MI), BAT (MI), 2 AP (MI), 2 TP (MI)[2]. Frank Akers. Verso: D, I, Dat, WS.

1. The central solid image with some line and linear image outline (b & a).
2. 1 TP varies from the edition.

2382III
Untitled (Suite Number 2). Aug 2–5, 1968.
Yellow (S)[1], B: violet, light violet, red, pink (Z). 33.7 × 42.5, cut. Ed 10 (CD), 9 TI (CD), BAT (CD), 1 TP (CD), 3 CTP (CD). Frank Akers. Verso: D, I, WS.

1. Stone held from 2382, run 1. A central solid image with some line and secondary solid image (blended inking). (b & c) There is an additional bar at right extending above image. Two of the smaller shapes within central image have been filled in and the designs δ and ε at lower center have been eliminated.

2382IV
Untitled (Suite Number 2). Aug 2–14, 1968.
Yellow (S)[1], B: blue, yellow (S)[2]. 33.7 × 42.5, cut. Ed 10 (CD), 9 TI (CD), BAT (CD), 1 AP (CD), 1 TP (CD), 12 CTP (CD). Frank Akers. Verso: D, I, WS.

1. Stone held from 2382III, run 1.
2. Same image as 2382III, run 2, redrawn on stone. A central solid image with some line and secondary solid image (blended inking). (b & c)

2382V
Untitled (Suite Number 2). Aug 14–16, 1968.
Yellow (S)[1], B: blue, pink (S)[2]. 33.7 × 42.5, cut. Ed 10 (CD), 9 TI (CD), BAT (CD), 2 TP (CD)[3]. Robert Rogers. Verso: D, I, WS.

1. Stone held from 2382VI, run 1.
2. Stone held from 2382VI, run 2. A central solid image with some line and secondary solid image (blended inking). (b&c)
3. 1 TP varies from the edition.

2382VI
Untitled (Suite Number 2). Aug 13–15, 1968.
Yellow (S)[1], B: blue, yellow (S)[2]. 33.7 × 42.5, cut. Ed 10 (CD), 9 TI (CD), BAT (CD), 2 CTP (CD). Manuel Fuentes. Verso: D, I, WS.

1. Stone held from 2382IV, run 1.
2. Stone held from 2382IV, run 2. A central solid image with some line and secondary solid image (blended inking). (b & c)

2382VII
Untitled (Suite Number 2). Aug 15–20, 1968.
Pink (S)[1], B: blue, yellow (S)[2]. 33.7 × 42.5, cut. Ed 10 (CD), 9 TI (CD), 3 AP (CD), 1 TP* (CD)[3]. Daniel Socha. Verso: D, I, WS.

1. Stone held from 2382V, run 1.
2. Stone held from 2382V, run 2. A central solid image with some line and secondary solid image (blended inking). (b & c)

2382VIII
Untitled (Suite Number 2). Aug 14–21, 1968.
White (S)[1], B: light yellow, light pink (S)[2], white (S)[3]. 33.7 × 42.5, cut. Ed 10 (CD), 9 TI (CD), BAT (CD), 1 AP (CD), 1 TP (CD), 2 CTP (CD). Edward Hughes. Verso: D, I, WS.

1. Stone held from 2382VII, run 1.
2. Stone held from 2382VII, run 2.
3. Stone held from 2382II, run 1; deletions. Central solid image with some line, secondary solid image (blended inking) and the linear image outline. (b, c & a) δ and ε at bottom end of solid and broken horizontal lines, one horizontal line and various lines around the outline adjacent to the six vertical bars have been eliminated.

2382IX
Untitled (Suite Number 2). Aug 21–23, 1968.
White (S)[1], B: yellow-grey, pink (S)[2], light orange (S)[3]. 34.3 × 42.5, cut. Ed 10 (CD), 9 TI (CD), BAT (CD), 1 AP (CD), 3 CTP (CD). Maurice Sanchez. Verso: D, I, WS.

1. Stone held from 2382VIII, run 1.
2. Stone held from 2382VIII, run 2.
3. Stone held from 2382VIII, run 3. Central solid image with some line, secondary solid image (blended inking) and linear image outline. (b, c, & a)

2382X
Untitled. Aug 23, 1968.
M[1]: Red, blue, green, white (S)[2]. 33.7 × 42.5, cut. 4 ExP (CD)[3], CP* (CD). Maurice Sanchez. Verso: D, I, WS.

1. Colors applied in a marble inking technique similar to Blended Inking. White ink was rolled onto the slab, the red, blue and green were laid over the white in an irregular pattern, so that when they were rolled out, they had a marbled appearance.
2. Stone held from 2382IX, run 1. The central solid image with some line. (b)
3. Designated A–D. 2 ExP vary from the edition. 1 ExP retained by Tamarind.

2383
Untitled (Suite Number 1). Jul 26, 1968.
Yellow (S)[1] with a 12.70 square of white paper. 33.7 × 42.5, cut. Ed 20 (CD), 9 TI (CD), BAT (CD), 2 AP (CD), 2 CTP (CD). Daniel Socha. Verso: D, I, WS.

1. Stone held from 2383A, run 2. Linear image. (a)

2383A
Untitled (Suite Number 1). Jul 24–27, 1968.
Grey (Z), white (S)[1] with a 12.70 square in grey. 33.7 × 42.5, cut. Ed 20 (CD), 9 TI (CD), BAT (CD), 3 AP (CD), 1 TP (CD), 1 CTP (CD). Theodore Wujcik. Verso: D, I, WS .

1. Stone held from 2383G, run 3. The linear image appears on a solid bleed background (grey). (a & c)

2383AII
Untitled. Jul 27–30, 1968.
Grey (Z), pink (S)[1]. 33.7 × 42.5, cut. Ed 10 (CD), 9 TI (CD), BAT (CD), 1 TP* (CD). Theodore Wujcik. Verso: D, I, WS.

1. Stone held from 2383. The linear image appears on a solid bleed background (grey). (a & c) Without cut-out, unframed.

2383B
Untitled (Suite Number 1). Jul 16–30, 1968.
Silver-black (S), silver (A)[1] with a 12.7 cm square in black. 33.7 × 42.5, cut. Ed 20 (CD), 9 TI (CD), BAT (CD), 4 AP (CD), 4 CTP (CD). Maurice Sanchez. Verso: D, I, WS.

1. Image same as 2383E, transferred from stone to plate. The linear image appears on a solid bleed background (silver-black). (a and c)

2383C
Untitled. Jul 31–Aug 22, 1968.
Pink (S)[1], beige (A)[2]. 33.7 × 42.5,
cut. Ed 10 (CD), 9 TI (CD), BAT (CD), 4
AP (CD), 6 CTP (CD). Anthony
Stoeveken. Verso: D, I, WS.

1. Stone held from 2383H, run 2.
2. Image from 2383D, run 1 redrawn
 on plate with deletions. The linear
 image appears on a solid
 background of its own outline. All
 lines on white background were
 printed only once. (a & b) Without
 cut-out, unframed.

2383D
Untitled (Suite Number 1). Jul 26–
31, 1968.
Pink (A)[1], yellow (A)[2] with 12.70
square in yellow. 33.7 × 42.5, cut. Ed
20 (CD), 9 TI (CD), BAT (CD), 1 AP (CD),
1 CTP (CD). Eugene Sturman. Verso:
D, I, WS[3].

1. Plate held from 2383G, run 1.
2. Plate held from 2383B, run 2. The
 linear image appears on a
 background of its own outline
 (pink). The vertical broken bars at
 left and right of the cut-out and
 designs δ and ϵ at bottom appear in
 yellow only. (a & b)
3. The chop of Maurice Sanchez
 appears inadvertently.

2383E
Untitled (Suite Number 1). Jul 8–
16, 1968.
B: Green, yellow, pink, light blue, blue
(S)[1] with 12.7 square in yellow. 33.7
× 42.5, cut. Ed 20 (CD), 9 TI (CD), BAT
(CD), 3 AP (CD). Maurice Sanchez.
Verso: D, I, WS.

1. Linear image. (a)

2383F
Untitled (Suite Number 1). Jul 18–
22, 1968.
Yellow (A), pink (S)[1] with a 12.7
square in pink. 33.7 × 42.5, cut. Ed 20
(CD), 9 TI (CD), BAT (CD), 4 AP (CD).
Edward Hughes. Verso: D, I, Dat, WS.

1. Stone held from 2383E. The liner
 image appears on a solid
 background (yellow) of its own
 outline and the vertical broken bars
 which appear to left and right of the
 cut-out and the linear design at
 bottom are over-printed in both
 colors. (a & b)

2383G
Untitled (Suite Number 1). Jul 23–
Aug 2, 1968.
Pink (A)[1], blue (A), yellow (S)[2] with
a 5" square in pink. 33.7 × 42.5, cut.
Ed 20 (CD), 9 TI (CD), BAT (CD), 1 AP
(CD), 4 CTP (CD). Edward Hughes.
Verso; D, I, WS.

1. Plate held from 2383F, run 1;
 deletions.
2. Stone held from 2383F, run 2. The
 linear image appears on two
 backgrounds, one of its own outline
 (pink) and the other bleed (blue).
 The vertical broken bars to left and
 right of cut-out and δ and ϵ appear
 in yellow only. (a, b & c)

2383H
Untitled. Aug 12–16, 1968.
Pink (A), yellow (S)[1]. 33.7 × 42.5,
cut. Ed 20 (CD), 9 TI (CD), BAT (CD), 1
AP (CD), 6 CTP (CD). Robert Rogers.
Verso: D, I, WS.

1. Stone held from 2383I, run 2. The
 linear image appears on a solid
 bleed background (pink). (a & c)
 Without cut-out, unframed.

2383I
Untitled. Aug 7–9, 1968.
Pink (A), green (S)[1]. 33.7 × 42.5, cut.
Ed 20 (CD), 9 TI (CD), BAT (CD), 3 AP
(CD), 2 CTP (CD). Manuel Fuentes.
Verso: D, I, WS.

1. Stone held from 2383AII, run 2. The
 linear image appears on solid bleed
 background (pink). (a & c) Without
 cut-out, unframed.

2383J
Memorial (Suite Number 1). Aug 8–
21, 1968.
B: Light pink, pink, light violet, light
blue (A)[1], B: pink, light blue (S)[2]
with a 12.7 square in pink. 33.7 ×
42.5, cut. Ed 20 (CD), 9 TI (CD), BAT
(CD), 3 AP (CD), 1 CTP (CD). Serge
Lozingot. Verso; D, I, T, WS.

1. Plate held from 2383C, run 2.
2. Stone held from 2383C, run 1. The
 linear image appears on a solid
 background of its own outline. (a &
 b)

2383K
Memorial Edit. Aug 9–28, 1968.
B: Pink, violet, blue (Z), B: pink, violet,
blue (A)[1], yellow (S)[2]. 33.7 × 42.5,
cut. Ed 10 (CD), 9 TI (CD), BAT (CD), 1
AP (CD), CP (CD). Serge Lozingot.
Verso: D, I, T, WS.

1. Plate held from 2383J, run 1.
2. Stone held from 2383J, run 2. The
 linear image (yellow) appears on
 two backgrounds, one of its own
 outline and the other bleed. (a, b &
 c)

2384
Untitled. Jul 12–26, 1968.
B: Pink, yellow, blue (A)[1], yellow
(A)[1], pink (A)[1]. 33.7 × 41.9, cut. Ed
20 (CD), 9 TI (CD), BAT (CD), 3 AP (CD),
5 TP (CD)[2], 5 CTP (CD), CP (CD). Jean
Milant. Verso: D, I, Dat, WS.

1. Central solid image with some line,
 secondary solid image (blended
 inking) and the linear image outline
 (b, c & a).
2. 4 TP vary from the edition.

2388
Untitled. Aug 18–29, 1968.
Light yellow (A), light orange (A), light
yellow-green (A). 94.3 × 76.5, cut. Ed
20 (10 cream CD, 10 CD), 9 TI (CD),
BAT (cream CD), 3 AP (1 CD, 2 cream
CD), 1 PP (CD), 15 CTP (5 CD[1], 4
N[1], 6 cream CD[2]), 1 PTP* (N)[1], CP
(CD). Jean Milant.
Verso: D, I, WS.

1. 3 CTP (CD), 4 CTP (N), PTP on paper
 94.0 × 68.6.
2. 3 CTP (cream CD), on paper 99.1 ×
 73.6, 1 CTP (cream CD) on paper
 99.1 × 73.0.

John Muench

Print not in
University Art Museum
Archive

323
Untitled. Jun 17–21, 1961.
Brown (Z), blue (Z), light blue (Z),
color unrecorded (Z). 55.9 × 73.7. 10.
ExP (C)[1]. John Muench.

1. Unchopped.

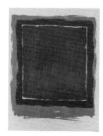

328
Voyage de Nuit. Jun 26–Jul 7, 1961.
Black (S), yellow (S), light blue (S),
violet (S), red, yellow (S), black (S).
76.8 × 57.2. Ed 12 (wA), 9 TI (wN), 1
AP (offset paper). John Muench. T, D,
S, BS.

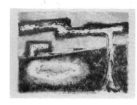

335
Lode. Jul 8–21, 1961.
Ochre (S), grey (S), orange-red (S),
blue-grey (S), black (S). 57.2 × 76.8.
Ed 12 (BFK), 9 TI (wN), PrP (wN), 1 AP
(wN). John Muench. T, D, S, BS.

Lee Mullican

Hungry Ghosts, a suite of twelve
lithographs including title and
colophon pages, enclosed in a red
linen covered box, measuring 48.2 ×
37.5, lined with white paper, stamped
with the artist's name in black on the
front cover, made by the Schuberth
Bookbindery, San Francisco. In order:
1221, 1199, 1161, 1162, 1167, 1172,
1178, 1200, 1202, 1208, 1230, 1224.

Fables, a suite of twelve lithographs
including title and colophon pages,
enclosed in black linen covered box,
measuring 80.0 × 53.3, lined with
white paper, secured with leather
straps and snaps, made by the
Schuberth Bookbindery, San
Francisco. In order: 1217, 1219, 1223,
1215, 1227, 1228, 1216, 1237, 1213,
1232, 1222, 1238.

1147
Sleeping Gypsy. Sep 17–Oct 12, 1964.
Blue (S), black (S), transparent green
(Z). 50.8 × 65.4. Ed 20 (BFK), 9 TI
(wA), BAT (BFK), PrP II for Kenneth
Tyler (BFK), 3 AP (2 BFK, 1 wA), 4 PP
(BFK), 5 TP (BFK). Ernest Rosenthal. S,
D (top), BS (bottom).

1149
Crayon Country. Sep 18–23, 1964.
Black (S). 61.0 × 39.4. Ed 20 (BFK), 9
TI (JG), BAT (BFK), PrP II for Kenneth
Tyler (BFK), 2 AP (BFK), 2 PP (BFK), 3
TP (BFK), CP (BFK). Jeff Ruocco. D, S,
Dat, T, BS.

1159
Meditations on a Landscape. Dec
9–29, 1964.
Orange (S)[1], orange-ochre (Z),
green-gold (A), pink (S). 53.7 × 63.5.
Ed 20 (BFK), 9 TI (wA), BAT (BFK), 2
AP (1 BFK, 1 wA), 3 TP (1 BFK, 2 wA),
CP (BFK). Kenneth Tyler. D, S, BS.

1. Stone held from 1182. 1159 differs
 from 1182 in color and in image.
 The over-all image is lighter. The
 dark dominant image has been
 turned 180 degrees. A light bleed
 tonal background with curvilinear
 striations has been added. Darker
 tonal areas have been added at the
 left, center, right and along the
 bottom edge. Dark shading has
 been added in the central portion of
 the image.

1161
Untitled (Hungry Ghosts III). Nov 24–Dec 3, 1964.
Black (A). 46.1 × 35.6. Ed 20 (BFK), 9 TI (wA), BAT (BFK), 1 AP (wA), 1 TP (wA), CP (BFK). Kenneth Tyler. D, S, BS.

1162
Untitled (Hungry Ghosts IV). Oct 24–Dec 3, 1964.
Black (A). 45.7 × 35.6. Ed 20 (bA), 9 TI (bA), BAT (bA), 1 AP (bA), 1 TP (bA), CP (bA). Kenneth Tyler. D, S, BS.

1167
Untitled (Hungry Ghosts V). Nov 24–30, 1964.
Black (A). 46.1 × 35.6. Ed 20 (bA), 9 TI (bA), BAT (bA), 1 AP (bA), 1 TP (bA), CP (bA). Kenneth Tyler. D, S, BS.

1172
Untitled (Hungry Ghosts VI). Dec 7–18, 1964.
Orange (A), transparent violet (A), blue (A). 45.7 × 35.6. Ed 20 (BFK), 9 TI (wA), BAT (BFK), 2 AP (BFK), 2 TP (BFK), CP (BFK). Kenneth Tyler. D, S, BS.

1178
Untitled (Hungry Ghosts VII). Nov 24–Dec 2, 1964.
Black (A). 45.7 × 35.6. Ed 20 (BFK), 9 TI (wA), BAT (BFK), 1 AP (wA), 1 TP (wA), CP (BFK). Kenneth Tyler. D, S, BS.

1182
Tide Flight. Dec 7–9, 1964.
Green-black (S). 53.3 × 63.8. Ed 20 (BFK), 9 TI (CW), BAT (BFK), 1 AP (BFK), 2 TP (BFK). Clifford Smith. D, S, BS.

1188
Pencil Head. Nov 23–Dec 1, 1964.
Black (A). 46.1 × 35.9. Ed 20 (BFK), 9 TI (wA), BAT (BFK), 1 AP (BFK), 1 TP (BFK), CP (BFK). Kenneth Tyler. D, S, BS.

1199
Untitled (Hungry Ghosts II). Nov 18–24, 1964.
Black (A). 46.1 × 35.9. Ed 20 (BFK), 9 TI (wA), BAT (BFK), 1 AP (BFK), 1 TP (BFK), CP (BFK). Kenneth Tyler. D, S, BS.

1200
Untitled (Hungry Ghosts VIII). Dec 11–18, 1964.
Blue-black (A). 46.1 × 35.6. Ed 20 (BFK), 9 TI (wA), BAT (BFK), PrP II for Kenneth Tyler (BFK), 2 AP (BFK), 1 TP (BFK), CP (BFK). Bernard Bleha. D, S, BS.

1201
Jam Passage. Jan 1–Feb 28, 1965.
Black (A). 45.7 × 35.6. Ed 20 (BFK), 9 TI (wA), BAT (BFK), 1 AP (wA), 1 TP (BFK), CP (BFK), 3 TP (1 BFK, 2 wA), CP (BFK). Bernard Bleha. D, S, BS.

1202
Untitled (Hungry Ghosts IX). Dec 14–31, 1964.
Transparent violet (A), black (A), transparent blue-green (Z). 46.1 × 35.9. Ed 20 (BFK), 9 TI (wA), BAT (BFK), 2 AP (BFK), 3 TP (BFK), CP (wA). Kenneth Tyler. D, S, BS.

1204
Feathered Presence. Dec 4–16, 1964.
Transparent grey (S), green-black (A). 46.1 × 35.6. Ed 8 (BFK), 9 TI (4 BFK, 5 wA), CP (BFK). Kenneth Tyler. D, S, BS[1].

1. Inadvertently, the printer's chop does not appear.

1206
Meditations in Thin Air. Dec 7–8, 1964.
Black (A). 57.5 × 50.8. Ed 20 (BFK), 9 TI (wN), BAT (BFK), CP (BFK). Kenneth Tyler. D, S, BS.

1207
Transfigured Night. Dec 7–10, 1964.
Black (A). 55.9 × 50.8. Ed 20 (BFK), 9 TI (wA), BAT (BFK), 2 AP (1 BFK, 1 wA), 1 TP (BFK), CP (BFK). Kenneth Tyler. D, S, BS.

1208
Untitled (Hungry Ghosts X). Dec 7–9, 1964.
Red-black (A). 46.1 × 35.6. Ed 20 (BFK), 9 TI (wA), BAT (BFK), 1 AP (BFK), 1 TP (BFK), CP (wA). Kenneth Tyler. D, S, BS.

1213
Untitled (Fables IX). Jan 1–Feb 28, 1965.
Black (A). 76.2 × 50.8. Ed 20 (BFK), 9 TI (wA), BAT (BFK), PrP II for Kenneth Tyler (BFK), 2 AP (1 BFK, 1 wA), 1 TP (BFK), 1 PTP (BFK)[1], CP (BFK). Bernard Bleha. BS (Tam), D, S, BS (pr).

1. Unsigned, undesignated, unchopped, retained by Tamarind.

1215
Untitled (Fables IV). Jan 1–Feb 28, 1965.
Black (A). 76.2 × 50.8. Ed 20 (BFK), 9 TI (wA), BAT (BFK), 2 AP (1 wA, 1 BFK), 2 TP (wA), CP (BFK). Kenneth Tyler. D, S, BS.

1216
Untitled (Fables VII). Jan 1–Feb 28, 1965.
Black (A). 76.2 × 50.8. Ed 20 (BFK), 9 TI (wA), BAT (BFK), 2 AP (BFK), 1 PP (nr), 2 TP (1 BFK, 1 wA), CP (wA). Kenneth Tyler. D, S, BS.

1217
Title Page (Fables I). Jan 1–Feb 28, 1965.
Black (A), black (S)[1]. 76.2 × 51.1. Ed 20 (BFK), 9 TI (wA), BAT (BFK), PrP II for Kenneth Tyler (wA), 3 AP (2 wA, 1 BFK), 2 TP (wA), 1 PTP (nr)[2], CP (BFK). Bernard Bleha. D, S, BS.

1. The typography printed at the Platin Press, Los Angeles, transferred to stone.
2. Typography only. Unsigned undesignated, unchopped, retained by Tamarind.

1218
Feathered Passage. Jan 1–Feb 28, 1965.
Black (A). 74.3 × 96.5. Ed 20 (BFK), 9 TI (wN), BAT (BFK), 3 AP (wA), 1 PP (nr), 2 TP (BFK), CP (BFK). Kenneth Tyler. D, S, Dat, T, BS.

1219
Untitled (Fables II). Jan 1–Feb 1, 1965.
Black (A). 76.2 × 50.8. Ed 20 (BFK), 9 TI (wA), BAT (BFK), PrP II for Kenneth Tyler (wA), 2 AP (wA), 2 TP (BFK), CP (BFK). Bernard Bleha. D, S, BS.

1221
Title Page (Hungry Ghosts I). Dec 30, 1964–Jan 8, 1965.
Transparent blue (S), blue-black (A). 46.1 × 35.6. Ed 20 (BFK), 9 TI (wA), BAT (BFK), 2 AP (BFK), 3 TP (BFK), 1 PTP (CD)[1], CD (C). Kenneth Tyler. D, S, BS.

1. Unsigned, undesignated, unchopped, retained by Tamarind.

1222
Untitled (Fables XI). Jan 1–Feb 28, 1965.
Black (S), transparent grey (S). 76.2 × 50.8. Ed 20 (BFK), 9 TI (wA), BAT (BFK), 2 AP (1 BFK, 1 wA), 4 TP (2 BFK, 2 wA), CP (BFK). Kenneth Tyler. D, S, BS.

1223
Untitled (Fables III). Jan 1–Feb 28, 1965.
Black (A). 76.5 × 51.0. Ed 20 (BFK), 9 TI (wA), BAT (BFK), PrP II for Kenneth Tyler (BFK), 1 AP (BFK), 2 TP (BFK), 1 PTP (CD)[1], CP (wA). Clifford Smith. D, S, BS.
1. Unsigned, undesignated, unchopped, retained by Tamarind.

1224
Colophon (Hungry Ghosts XII). Jan 4–15, 1965.
Pink (S), violet (S). 46.1 × 35.9. Ed 20 (BFK), 9 TI (wA), BAT (BFK), 2 AP (1 BFK, 1 wA), 3 TP (BFK), CP (wA). Kenneth Tyler. D, S, BS.

1227
Untitled (Fables V). Jan 1–Feb 28, 1965.
Red-black (A). 76.2 × 50.8. Ed 20 (BFK), 9 TI (wA), BAT (BFK), PrP II for Kenneth Tyler (BFK), 1 PP (nr), 2 AP (BFK), 2 TP (BFK), CP (wA). Bernard Bleha. D, S, BS.

1228
Untitled (Fables VI). Jan 1–Feb 28, 1965.
Black (A). 76.2 × 50.8. Ed 20 (BFK), 9 TI (wA), BAT (BFK), PrP II for Kenneth Tyler (wA), CP (wA). Clifford Smith. D, S, BS.

1230
Untitled (Hungry Ghosts XI). Jan 11–13, 1965.
Green-black (A). 46.4 × 35.9. Ed 20 (BFK), 9 TI (wA), BAT (BFK), PrP II for Kenneth Tyler (BFK), 2 AP (BFK), 2 TP (BFK), CP (BFK). Bernard Bleha. D, S, BS.

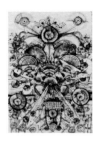

1232
Untitled (Fables X). Jan 1–Feb 28, 1965.
Black (A). 76.2 × 50.8. Ed 20 (BFK), 9 TI (wA), BAT (BFK), 2 AP (1 BFK, 1 wA), 1 PP (nr), 1 TP (BFK), CP (BFK). Kenneth Tyler. D, S, BS.

1237
Untitled (Fables VIII). Jan 1–Feb 28, 1965.
Black (A). 76.2 × 50.8. Ed 20 (BFK), 9 TI (wA), BAT (BFK), PrP II for Kenneth Tyler (BFK), 3 AP (wA), 1 PP (nr), 2 TP (BFK), CP (BFK). Bernard Bleha. D, S, BS.

1238
Colophon (Fables XII). Jan 1–Feb 28, 1965.
Black (S). 76.2 × 50.8. Ed 20 (BFK), 9 TI (wA), BAT (BFK), PrP II for Kenneth Tyler (BFK), 2 AP (BFK), 2 TP (BFK), CP (BFK). Bernard Bleha. D, S (center), BS (bottom).

2824
The Wave. Dec 1–20, 1969.
B: Blue-green, light blue-green, white (S), B: yellow, white (A), orange, yellow (A)[1], B: light blue, blue, white (A). 76.5 × 57.2. Ed 20 (19 wA, 1 GEP), 9 TI (1 wA, 8 GEP), BAT (wA), 1 AP (GEP), 2 TP* (1 wA, 1 GEP), 1 CTP (CD), CP (wA). Paul Clinton. D, S, Dat (top), BS (bottom).
1. Same plate as run 2; deletion and additions.

2825
The Mountain. Dec 5–24, 1969.
Silver (A), B: red-violet, violet, light violet, white (A), grey, B: white, light blue, transparent light blue, dark blue, yellow (S). 56.5 × 76.5. Ed 20 (wA), 9 TI (GEP), BAT (wA), 1 AP (wA), 2 CTP (wA), CP (GEP). David Trowbridge. D, S, Dat, BS.

Robert Murray

1429
Untitled. Jul 30–Aug 7, 1965.
Green-brown (A), black (A). 50.5 ×
47.6. Ed 18 (16 BFK, 2 wA), 9 TI (wA),
BAT (BFK), 3 TP (BFK)[1], CP (Tcs).
Bernard Bleha. BS, S, Dat, D.

1. 1 TP varies from the edition.

Reuben Nakian

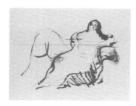

587
Untitled[1]. May 17, 1962.
Brown (Z). 38.4 × 48.6. Ed 30 (bA)
distributed as follows: 10 to Josef
Albers, 10 to Reuben Nakian, 9 to
Tamarind Lithography Workshop, 1 to
Bohuslav Horak. Bohuslav Horak.
Recto: BS Verso: D[2].

1. Nakian made a test drawing on a
 plate bearing a test drawing by
 Albers made earlier in May.
2. All impressions are unsigned and
 have the following note on verso:
 "Impression of a practice zinc plate
 on which Josef Albers and Reuben
 Nakian tested drawing with tusche."

Kenjilo Nanao

2466
On Valencia. Nov 8–23, 1968.
Black (S). 64.8 × 53.3. Ed 10 (JG), 9 TI
(JG), BAT (JG), CP (JG). Kenjilo
Nanao. D, BS, S.

2508
Autumn. Dec 28, 1968–Jan 22, 1969.
Red-black, B: yellow, red (A), blue-
black (A). 57.2 × 71.1. Ed 12 (cR), 9 TI
(GEP), BAT (cR), 3 AP (GEP), CP (GEP).
Kenjilo Nanao. BS, D, T, S.

Print not in
University Art Museum
Archive

2510
Broken Mirror. Dec 9–25, 1968.
Black (Z), grey (Z). 60.0 × 48.9. Ed 10
(bA), 9 TI (bA), BAT (bA), 1 AP (bA), CP
(bA). Kenjilo Nanao. D, T, BS, S.

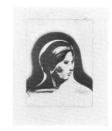

2514
Untitled. Dec 4–17, 1968.
Black (S). 55.9 × 43.2. Ed 12 (MI), 9 TI
(MI), BAT (MI), 2 AP (MI), CP (MI).
Kenjilo Nanao. BS, D, S.

Reginald Neal

660
Ancient Fragment. Oct 11–12, 1962.
Black (S). 77.5 × 57.2. Ed 20 (BFK), 9
TI (wN), PrP (BFK), PrP II for Bohuslav
Horak (BFK), 2 AP (1 BFK, 1 wN), 2 PP
(BFK), 2 TP (1 BFK, 1 wN), CP (wN).
Donald Roberts. D, BS (Tam), T, S, BS
(pr).

661
Old Flag. Oct 11–12, 1962.
Black (S). 77.5 × 57.2. Ed 20 (BFK), 9
TI (wN), PrP (BFK), PrP II for Bohuslav
Horak (BFK), 3 AP (2 BFK, 1 wN), 2 PP
(1 BFK, 1 wN), CP (BFK). Irwin
Hollander. BS (Tam), D, T, S, BS (pr).

Louise Nevelson

793
Untitled. Apr 29–May 7, 1963.
Black (S), red (Z). 47.6 × 52.1. Ed 20
(BFK), 9 TI (wA), PrP (BFK), PrP II for
Bohuslav Horak (BFK), 2 AP (1 BFK, 1
wA), 2 PP (1 BFK, 1 wA). Jason Leese.
D, S, BS.

794
Untitled. Apr 29–May 3, 1963.
Black (S). 86.4 × 59.7. Ed 20 (BFK), 9
TI (BFK), PrP (BFK), PrP II for Bohuslav
Horak (BFK), 1 AP (BFK), 2 PP (BFK).
Jason Leese. D, BS, S.

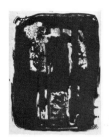

795
Untitled. May 1–8, 1963.
Brown (Z), black (S). 82.6 × 59.1. Ed
20 (BFK), 9 TI (BFK), PrP (BFK), PrP II
for Bohuslav Horak (BFK), 3 AP (BFK),
2 PP (BFK), CP (BFK). John Dowell. D,
BS, S.

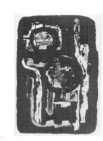

806
Untitled. May 16–21, 1963.
Black (S). 97.8 × 67.3. Ed 20 (BFK), 9
TI (BFK), PrP (BFK), PrP II for Bohuslav
Horak (BFK), 2 AP (BFK), 2 PP (BFK).
Jason Leese. D, BS, S.

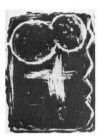

798
Untitled. May 3–10, 1963.
Black (Z). 80.6 × 57.2. Ed 20 (BFK), 9
TI (BFK), PrP (BFK), PrP II for Bohuslav
Horak (BFK), 1 AP (BFK). Aris
Koutroulis. Recto: D, S (top), BS
(bottom).

808
Untitled. May 16–21, 1963.
Brown (Z), black (S)[1]. 28.6 × 38.1.
Ed 20 (BFK), 9 TI (BFK), PrP (BFK), PrP
II for Bohuslav Horak (BFK), 2 AP
(BFK), 1 PP (BFK). Aris Koutroulis. D,
BS (Tam), S, BS (pr).

1. Stone held from 805; deletions. 808
 differs from 805 in color and in
 image. Most of the textural shapes
 have been eliminated. A medium
 tone calligraphic drawing has been
 added.

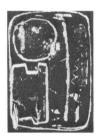

799
Untitled. May 3–13, 1963.
Black (Z). 81.3 × 55.9. Ed 20 (BFK), 9
TI (BFK), PrP (BFK), PrP II for Bohuslav
Horak (BFK), 3 AP (BFK), 2 PP (BFK).
Jason Leese. D, BS, S.

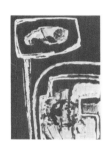

812
Untitled. May 22–27, 1963.
Black (S). 82.6 × 58.4. Ed 20 (BFK), 9
TI (BFK), PrP (BFK), PrP II for Bohuslav
Horak (BFK), 3 AP (BFK), 2 PP (BFK),
CP (BFK). John Dowell. S, BS, D.

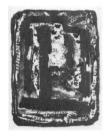

801
Untitled. May 9–14, 1963.
Black (S). 79.4 × 58.4. Ed 20 (BFK), 9
TI (BFK), PrP (BFK), PrP II for Bohuslav
Horak (BFK), 3 AP (BFK), 2 PP (BFK), 1
TP (BFK), CP (BFK). John Dowell. D,
BS, S.

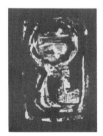

814
Untitled. May 24–28, 1963.
Green-black (Z)[1]. 72.4 × 50.8. Ed 20
(BFK), 9 TI (wA), PrP (BFK), PrP II for
Bohuslav Horak(BFK), 2 AP (1 BFK, 1
wA), 1 PP (BFK), 2 TP (1 BFK, 1 wA),
CP (BFK). Irwin Hollander. D, BS, S.

1. Plates held from 802; additions and
 deletions. 814 differs from 802 in
 image and in size. The border and
 the part of the image on all four
 sides, light textural areas and some
 line around the central shape have
 been eliminated. Light areas have
 been enlarged.

802
Untitled. May 10–23, 1963.
Black (Z). 80.3 × 57.5. Ed 20 (BFK), 9
TI (BFK), PrP (BFK), PrP II for Bohuslav
Horak (BFK), 3 AP (BFK), 1 PP (BFK).
Jason Leese. D, BS, S.

816
Untitled. May 28–31, 1963.
Black (S). 63.5 × 88.9. Ed 20 (BFK), 9
TI (BFK), PrP (BFK), PrP II for Bohuslav
Horak (BFK), 3 AP (BFK), 2 PP (BFK), 1
TP (BFK). John Dowell. D, BS, S.

805
Untitled. May 14–16, 1963.
Black (S). 29.2 × 38.1. Ed 20 (BFK), 9
TI (BFK), PrP (BFK), PrP II for Bohuslav
Horak (BFK), 2 AP (BFK), 2 PP (BFK).
Aris Koutroulis. D, S, BS.

817
Untitled. May 28–Jun 6, 1963.
Black (S)[1]. 89.2 × 50.5. Ed 20 (BFK),
9 Tl (BFK), PrP (BFK), PrP II for
Bohuslav Horak (BFK), 3 AP (BFK), 2
PP (BFK), CP (BFK). Jason Leese. D,
BS, S.

1. Stone held from 806; additions. 817
 differs from 806 in image and in
 size. The white border and part of
 dark image on the sides have been
 eliminated. Part of the line around
 the circle at the upper left, the lines
 of the lower left, two rectangular
 shapes at bottom center, and a
 linear semi-circle at the center were
 eliminated. The vertical linear
 shapes at right are narrower and
 line drawing has been added in the
 white shapes at bottom and right.

820
Untitled. May 31–Jun 4, 1963.
Black (S). 80.0 × 55.6. Ed 20 (BFK), 9
Tl (BFK), PrP (BFK), PrP II for Bohuslav
Horak (BFK), 3 AP (BFK), 2 PP (BFK),
CP (BFK). John Dowell. D, BS, S.

821
Untitled. Jun 3–11, 1963.
Blue (Z), brown-black (S)[1]. 83.8 ×
58.4. Ed 20 (BFK), 9 Tl (BFK), PrP
(BFK), PrP II for Bohuslav Horak (BFK),
2 AP (BFK), 2 PP (BFK), 1 TP (BFK), CP
(BFK). Irwin Hollander. D, BS, S.

1. Stone held from 816; deletions and
 additions. 821 differs from 816 in
 image, color, size, and presentation
 as a vertical. The white borders
 have been eliminated. Triangular
 shapes have been added in three
 corners. The central shape has been
 made into an oval and has less
 texture and more solid areas.

822
Untitled. Jun 5–6, 1963.
Black (S). 25.4 × 42.2. Ed 20 (BFK), 9
Tl (BFK), PrP (BFK), PrP II for Bohuslav
Horak (BFK), 2 AP (BFK), 2 PP (BFK).
Aris Koutroulis. D, S, BS.

823
Untitled. Jun 6–11, 1963.
Black (S). 77.5 × 57.2. Ed 20 (BFK), 9
Tl (wN), PrP (BFK), PrP II for Bohuslav
Horak (BFK), 3 AP (1 BFK, 2 wN), 2 PP
(BFK), 1 TP (BFK). John Dowell. D, BS,
S.

824
Untitled. Jun 7–10, 1963.
Black (S)[1]. 24.8 × 44.5. Ed 20 (BFK),
9 Tl (wN), PrP (BFK), PrP II for
Bohuslav Horak (BFK), 3 AP (1 BFK, 2
wN), 1 PP (wN). Aris Koutroulis. D, BS,
S.

1. Stone held from 822; additions and
 deletions. 824 differs from 822 in
 image, size, and in presentation as
 a horizontal. The image has been
 turned 180 degrees. The light shape
 at the lower right has been
 eliminated. The remaining light
 shapes are enclosed within
 rectangular outlines.

826
Untitled. Jun 11–14, 1963.
Black (S). 91.4 × 65.4. Ed 20 (BFK), 9
Tl (BFK), PrP (BFK), PrP II for Bohuslav
Horak (BFK), 3 AP (BFK), 2 PP (BFK).
John Dowell. D, BS, S.

828
Untitled. Jun 11–14, 1963.
Black (S). 42.9 × 31.1. Ed 20 (BFK), 9
Tl (BFK), PrP (BFK), PrP II for Bohuslav
Horak (BFK), 2 AP (BFK), 2 TP (BFK).
Aris Koutroulis. BS, S, D.

829
Untitled. Jun 12–19, 1963.
Grey (S), black (S)[1]. 37.5 × 76.2. Ed
20 (BFK), 9 Tl (BFK), PrP (BFK), PrP II
for Bohuslav Horak (BFK), 1 AP (BFK).
Aris Koutroulis. D, BS, S.

1. Stone held from 823; additions. 829
 differs from 823 in color, image,
 size, and in presentation as a
 horizontal. All of the white lines
 connecting the shapes and part of
 the dark image on the sides have
 been eliminated. A solid bleed
 background has been added.

830
Untitled. Jun 17–24, 1963.
Orange (Z), black (S). 94.0 × 64.8. Ed
20 (BFK), 9 Tl (BFK), PrP (BFK), PrP II
for Irwin Hollander (BFK), 3 AP (BFK),
2 PP (BFK), 1 TP (BFK). John Dowell.
D, BS, S.

830A
Untitled. Jun 27–Jul 1, 1963.
Black (S)[1]. 94.0 × 64.8. Ed 27 (BFK),
9 TI (wN), PrP (BFK), 3 AP (2 BFK, 1
wN), 3 PP (BFK). Kenneth Tyler. D, BS,
S.

1. Stone held from 830, run 2. 830A
 differs from 830 in color only.

832
Untitled. Jun 19–25, 1963.
Green-beige (Z), violet-black (S). 56.5
× 44.5. Ed 20 (BFK), 9 TI (wA), PrP
(BFK)[1], PrP II for Irwin Hollander
(BFK), CP (wA). Aris Koutroulis. D, BS,
S.

1. Inadvertently inscribed "Tamarind
 Impression."

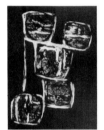

833
Untitled. Jun 20–Jul 1, 1963.
Black (S)[1]. 92.7 × 64.8. Ed 20 (BFK),
9 TI (BFK), PrP (BFK), PrP II for Irwin
Hollander (BFK), 3 AP (BFK), 2 PP
(BFK), 2 TP (BFK), CP (BFK). Aris
Koutroulis. D, BS, S.

1. Stone held from 826; deletions. 833
 differs from 826 in image. White
 lines have been added outlining
 and connecting all the shapes.

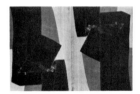

2157/2157A
Untitled[1]. Nov 20–Dec 7, 1967.
Black (S)[2], red (Z)[3]. 99.1 ×
139.7. Ed 20 (CD), 9 TI (GEP), BAT
(CD), 3 AP (1 CD, 2 GEP), CP (CD)[4].
Serge Lozingot. D, S, Dat, BS (2157).

1. A two part lithograph hinged with
 2157A turned 180 degrees to 2157.
2. Stone held from 2157B. Same stone
 and color printed on 2157 and
 2157A.
3. Same plate and color printed on
 2157 and 2157A. 2157 and 2157A
 differ from 2157B in color, image
 and size. 2157A is presented in the
 same position as 2157B with the
 addition of an irregular vertical
 shape (red) over the solid black
 shape and is hinged to an identical
 image (2157) turned 180 degrees.
4. CP for 2157 only, 99.1 × 66.0.

2157B
Untitled. Nov 20–30, 1967.
Black (S). 99.1 × 69.9. Ed 10 (CD), 9 TI
(GEP), BAT (CD), 1 AP (GEP), 2 TP (1
CD, 1 GEP). Serge Lozingot. D, BS, S,
Dat.

2158A/2158
Untitled[1]. Nov 29–Dec 8, 1967.
Black (S)[2], red (A)[3]. 92.7 × 132.1.
Ed 20 (BFK), 9 TI (GEP), BAT (BFK), 3
AP (2 BFK, 1 GEP), CP (BFK)[4]. Bruce
Lowney. D, BS, S, Dat (2158).

1. A two-part lithograph hinged
 together with 2158 turned 180
 degrees to 2158A.
2. Same stone and color printed on
 2158 and 2158A.
3. Same plate and color printed on
 2158 and 2158A.
4. CP for 2158 only, 92.7 × 66.0.

Print not in
University Art Museum
Archive

2159A/2159
Untitled[1]. Dec 4–28, 1967.
Grey (S)[2], blue (S)[3], red (Z)[4], red
(A)[5]. 144.8 × 86.4. Ed 20 (CD), 9 TI
(CD), BAT (CD), 1 TP (CD)[6], 6 CTP
(CD)[6]. Anthony Ko. D, BS, S, Dat
(2159).

1. A three-part lithograph hinged
 together with 2159A hinged
 horizontally to the top of 2159 and
 flap.
2. Stone held from 2159II. Same stone
 and color printed on 2159 and
 2159A. After printing grey, 2 flaps
 were blotted on left and right sides
 of each sheet. One of these flaps
 was hinged to 2159A and 2159;
 three were held from hinging to
 2159III.
3. Same stone and color printed on
 2159 and 2159A.
4. Printed on flap only.
5. Printed on 2159A only. 2159A and
 2159 differ from 2159II in color, size
 and image. Screen textured
 background and four solid
 rectangular shapes have been
 added inside the image shapes to
 both 2159 and 2159A. A solid tone
 area has been added to the top of
 2159A. A red flap has been hinged
 to left side (2159), and the three
 hinged parts are presented
 vertically.
6. 1 TP: 2159A, 86.3 × 58.4 and 2159
 86.3 × 58.4 without flap,
 unassembled. For 1 TP and 1 CTP,
 designation written by curator and
 thus noted on verso.

2159II
Untitled. Dec 21, 1967.
Dark grey (S). 86.4 × 58.4. Ed 10
(BFK), 9 TI (MI), BAT (BFK), 1 AP (MI).
Anthony Ko. D, BS, S, Dat.

2159III
Untitled[1]. Jan 2–9, 1968.
Red (Z)[2], grey (Z)[3], red (Z), gold (A), black (S)[4]. 106.7 × 134.6. Ed 10 (CD), 9 TI (CD), BAT (CD), 3 AP (CD)[5], 2 TP (CD)[5], 1 CTP (CD)[5], CP (CD)[5]. Anthony Ko. BS, D, S, Dat.

1. A six- or seven-part lithograph. This lithograph exists in 3 compositional variations composed of one central sheet and varying numbers and combinations of 4 different flap images. Compositional variations are as follows: Ed 10, 5 TI, BAT—one central sheet with 2 red flaps and 4 grey flaps. 3 TI—one sheet with 5 red flaps. 1 TI—one central sheet with 5 red flaps, arranged differently.
2. Printed on flaps, which have two different blotted impressions from 2159A and 2159.
3. Printed on flaps, which have two different blotted impressions from 2159A and 2159.
4. Stone differs from 2159, run 3; deletions. 2159III differs from 2159A and 2159 in color, size, image and in presentation as a horizontal. Screen textured background has been eliminated within the rectangular shapes which are lighter. Some of the lines within the shapes have been enlarged, some have been eliminated. Five or six flaps hinged on three or four sides.
5. Without flaps, 1 TP varies from the edition.

Print not in
University Art Museum
Archive

2160
Untitled. Dec 7–15, 1967.
Black (S). 92.7 × 66.0. 4 TP (BFK)[1]. Donald Kelley. BS, D, S, Dat.

1. Designated A–D. 2 TP retained by Tamarind.

2170/2170A
Untitled[1]. Dec 8, 1967–Jan 10, 1968.
Black (S)[2], red (A)[3]. 108.0 × 147.3. Ed 20 (GEP)[4], 9 TI (CD)[4], BAT (GEP), 3 AP (1 GEP, 2 CD[4]), CP (GEP)[4]. Anthony Stoeveken. D, BS, S, Dat (2170A).

1. A two-part lithograph, hinged together with 2170A turned 180 degrees to 2170.
2. Same stone and color printed on 2170 and 2170A.
3. Same plate and color printed on 2170 and 2170A.
4. Ed 18–20/20, 9 TI, 2 AP, CP vary from the edition. The CP is for 2170 only, 108.0 × 73.6.

Print not in
University Art Museum
Archive

2173/2173A
Untitled[1]. Nov 2–13, 1967.
Black (S)[2], red (S)[3]. 57.2 × 106.7. Ed 20 (BFK), 9 TI (wA), BAT (BFK), 4 AP (2 BFK, 2 wA), 3 TP (1 BFK, 2 wA)[4], CP (BFK)[5]. Maurice Sanchez. D, S, Dat (2173A).

1. A three-part lithograph, hinged together with flap hinged to upper right corner.
2. Same stone and color printed on 2173 and 2173A.
3. Same stone and color printed on 2173A, right half of 2173 and back of flap. The flap was folded against the front of 2173A at the upper right corner for the red run, thereby blotting off a light impression of the black image below.
4. 1 TP (BFK) for 2173 only 57.2 × 43.2; 2 TP (wA) for 2173A 57.2 × 43.2, one without flap.
5. CP for 2173 only 57.2 × 43.2, varies from the edition.

2174/2174A
Untitled[1]. Nov 6–28, 1967.
Black (S)[2], red (A)[3]. 91.4 × 177.8. Ed 20 (GEP), 9 TI (CD), BAT (GEP), 2 AP (CD), CP (GEP)[4]. Anthony Stoeveken. D, BS, S, Dat (2174).

1. A four-part lithograph, 2174 and 2174A hinged together side by side, one flap hinged to upper left and one flap hinged to upper left side of 2174A attached to the front upper right of 2174.
2. Same stone and color printed on 2174 and 2174A. Flaps were blotted from the upper left corner of 2174 and 2174A.
3. Printed at the bottom on 2174 only.
4. CP for 2174 only without flaps, 91.4 × 66.0; varies from the edition.

2175
Untitled[1]. Nov 7–Dec 8, 1967.
Black (S)[2], red (Z)[3]. 99.1 × 111.1. Ed 20 (CD), 9 TI (GEP), BAT (CD), 3 AP (1 CD, 2 GEP). David Folkman. D (right flap), S, Dat, BS (left flap).

1. A three-part lithograph hinged with one flap on each side.
2. After printing the black image, flaps were blotted.
3. Printed on left flap only.

2175A
Untitled[1]. Nov 7–Dec 8, 1967.
Black (S)[2], red (A). 99.1 × 111.1. Ed
20 (CD), 9 TI (GEP), BAT (CD), 2 AP
(CD), 1 TP (CD)[3]. David Folkman. D
(left flap), BS, S, Dat (right flap).

1. A three-part lithograph, hinged with one flap on each side.
2. Stone held from 2175, run 1. After printing the black image, flaps were blotted. 2175A differs from 2175 in image. The solid tone has been eliminated from the left flap. A solid rectangular shape has been added vertically in the central section.
3. Without flaps, 99.1 × 66.0.

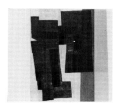

2175B
Untitled[1]. Nov 7–Dec 8, 1967.
Black (S)[2], red (A)[3]. 99.1 × 111.1.
Ed 20 (CD), 9 TI (GEP), BAT (CD), 2 AP
(1 CD, 1 GEP), 1 TP (GEP)[4], CP
(CD)[4]. David Folkman. D (left flap), S,
Dat, BS (right flap).

1. A three-part lithograph hinged with one flap on each side.
2. Stone held from 2175A, run 1. After printing the black image, flaps were blotted.
3. Same plate on paper 99.1 × 66.0 (run 2) and 1 flap (run 3). 2175B differs from 2175A in image. The solid rectangular shape in the central section has been eliminated. A rectangular tone has been added on the right side of the center section and the left side of right flap.
4. 1 TP and CP are without flaps, 99.1 × 66.0; CP varies from the edition.

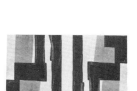

2176/2176A
Untitled[1]. Dec 12–29, 1967.
Black (S)[2], red (A)[3]. 92.7 × 142.2.
Ed 20 (BFK), 9 TI (MI), BAT (BFK), 3 AP
(MI), CP (BFK)[4]. Bruce Lowney. D,
BS, S, Dat (2176A).

1. A three-part lithograph hinged together in this order: 2176, flap and 2176A, turned 180 degrees.
2. Same stone and color printed on 2176 and 2176A. After printing the black image, the flap was blotted from right side of 2176.
3. Same plate and color printed on 2176 and 2176A.
4. For 2176 only, 92.7 × 66.0; CP varies from the edition.

2177/2177A
Untitled[1]. Dec 15, 1967–Jan 5,
1968.
Black (S)[2], red (A)[3], red (A)[4]. 92.7
× 132.1. Ed 20 (BFK), 9 TI (MI), BAT
(BFK), 3 AP (MI), CP (BFK). Donald
Kelley. BS, D, S, Dat (2177A).

1. A two-part lithograph hinged together.
2. Same stone and color printed on 2177 and 2177A.
3. Printed on 2177.
4. Printed on 2177A.

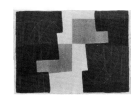

2178/2178A
Untitled[1]. Dec 22, 1967–Jan 4,
1968.
Black (S)[2], red (Z)[3]. 91.4 × 121.9.
Ed 20 (MI), 9 TI (CD), BAT (MI), 3 AP (1
MI, 2 CD)[4], CP (CD)[5]. Serge
Lozingot. D, S, Dat, BS (2178A).

1. A two-part lithograph hinged together with 2178A turned 180 degrees to 2178.
2. Stone held from 2178II. Same stone and color printed on 2178 and 2178A.
3. Same plate and color printed on 2178 and 2178A. 2178 and 2178A differ from 2178II in color, image and size. 2178 has a larger and lighter screen textured area. The right side of 2178 has been eliminated resulting in a smaller black image with an irregular shape. The white line drawing has been eliminated in the dark area. A red horizontal band has been added across the center of 2178 and near the top of 2178A.
4. 1 AP (CD) is for 2178A only, 91.4 × 61.0.
5. For 2178 only, 91.4 × 61.0. Designation written by curator on verso.

Print not in
University Art Museum
Archive

2178II
Untitled. Dec 22, 1967–Jan 3, 1968.
Black (S), black (S)[1]. 91.4 × 61.0. Ed
10 (MI), 9 TI (CD), BAT (MI), 3 AP (1
CD, 2 MI). Serge Lozingot. D, S, Dat,
BS.

1. Same stone as run 1, turned 180 degrees.

Francis Noel

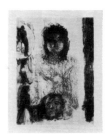

1313
Elizabeth. Jun 28–Jul 1, 1965.
Brown-black (S). 76.2 × 56.8 (wA),
75.60 × 52.40 (BFK). Ed 12 (BFK), 9 TI
(wA), 1 UNMI (wA), 2 AP (wA). Francis
Noel. BS (Tam), T, D, S, Dat, BS
(UNM).

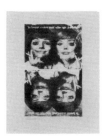

1317
Untitled. Jan 1–Feb 28, 1965.
Red-violet (S). 50.8 × 38.1. 12 ExP (6
bA[1], 6 BFK). Francis Noel. D, S, Dat,
BS (Tam & UNM).

1. 6 ExP retained by Tamarind.

Thom O'Connor

1014
Head. Feb 8–26, 1964.
Black (Z). 34.6 × 27.0. Ed 10 (BFK), 9
TI (wA), 3 AP (2 BFK, 1 wA). Thom
O'Connor. D, S, top, BS, bottom.

Print not in
University Art Museum
Archive

1032
De Gaulle. Apr 3–29, 1964.
Black (Z). 63.5 × 53.3. 10 ExP (BFK)[1].
Thom O'Connor. D, BS, S.

1. Designated A–J. 5 ExP retained by
 Tamarind.

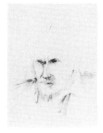

1062
Ezra Pound. Apr 5–11, 1964.
Black (Z). 61.3 × 43.8. Ed 20 (bA), 9 TI
(nN), 3 AP (bA), 2 TP (nN). Thom
O'Connor. D, S, BS.

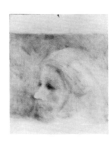

1078
Henry's Anne. May 4–7, 1964.
Black (Z). 35.6 × 28.6. Ed 10 (BFK), 9
TI (wA), 2 AP (BFK), 1 TP (wA). Thom
O'Connor. D, S, BS.

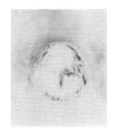

1097
Father Damion. Jun 4–19, 1964.
Black (S). 57.8 × 45.7. Ed 10 (JG), 9 TI
(JG), BAT (JG), 3 AP (JG), 1 PP (JG), 2
TP (JG). Thom O'Connor. D, S, BS.

1124
Little Head. Jun 30–Jul 2, 1964.
Black (Z). 33.0 × 25.4. Ed 15 (BFK), 9
TI (BFK), 1 AP (BFK). Thom O'Connor.
D, S, BS.

Frederick O'Hara

252
Antelope Priest. Mar 28–Apr 2,
1961.
Grey-green (S), grey (S)[1], brown (S),
yellow (S). 61.6 × 37.5. Ed 10 (BFK), 9
TI (wN), 4 AP (2 BFK, 2 wN), 2 TP
(BFK)[2], 2 CStP (BFK)[3], 14 Proofs
(newsprint)[4]. Garo Z. Antreasian, NC.
D, S, BS (Tam)[5].

1. Same stone as run 1; reversal.
2. 1 TP varies from the edition.
3. 1 CStP unchopped, retained by
 Tamarind.
4. 14 proofs unsigned, unchopped,
 undesignated, 2 proofs retained by
 Tamarind.
5. TI do not bear printer's BS.

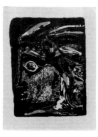

646
War Bonnet. Sep 17–Oct 2, 1962.
Blue (S), light green (Z), grey-green
(S), dark green (Z), red-brown (Z). 77.5
× 57.2. Ed 20 (BFK), 9 TI (wN), PrP
(BFK), PrP II for Bohuslav Horak (BFK),
3 AP (2 BFK, 1wN), 2 PP (1 BFK, 1 wN),
2 TP (1 BFK, 1 wN), CP (BFK). Irwin
Hollander. D, S, T, BS.

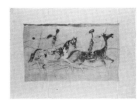

653
Riders. Sep 28–Oct 24, 1962.
Light grey (Z), light green (Z), yellow
(Z), orange (Z), dark green (S), light
blue (Z), red (Z). 57.2 × 76.2. Ed 20
(BFK), 9 TI (wA), PrP (BFK), PrP II For
Bohuslav Horak (wA), 3 AP (wA), 1 PP
(wA), 5 TP (BFK), 3 proofs (2
coverstock, 1 J)[1], 5 transfer proofs
(nr)[1]. Joe Zirker. D, S, T, BS.

1. 8 proofs unsigned, unchopped,
 undesignated, retained by
 Tamarind. 1 proof (J) printed from a
 carved woodblock.

659
Morning Hunter. Oct 11–Nov 13,
1962.
Light blue-green (S), red-brown (Z),
pink (Z), blue, grey (Z), black (Z). 56.5
× 75.9. Ed 20 (wA), 9 TI (BFK), PrP
(wA), 2 PrP II for Bohuslav Horak and
Irwin Hollander (BFK), 3 AP (wA), 2 PP
(BFK), 4 TP (wA), 1 proof*
(coverstock)[1]. Joe Zirker. D, S, T, BS.

1. Unsigned, unchopped,
 undesignated, retained by
 Tamarind.

664
Hunter. Oct 22–Nov 8, 1962.
Yellow-orange (Z), brown (Z)[1], black
(Z)[2] . 57.2 × 76.2. Ed 20 (BFK), 9 TI
(wA), PrP (BFK), PrP II for Bohuslav
Horak (BFK), 3 AP (2 BFK, 1 wA), 3 PP
(2 BFK, 1 wA), 1 TP (BFK). Donald
Roberts. D, S, T, BS.

1. Plate held from 659, run 2.
2. Plate held from 659, run 5. 664
 differs from 659 in color and in
 image. The background tone, the
 bird in the upper left corner, and
 color accents have been eliminated.
 Textural tone added behind the dark
 image shape.

204
Untitled.[1] Jan 16–23, 1961.
Red (Z), black (Z), light beige, beige
(Z), blue (Z). 105.1 × 74.3. Ed 20
(BFK), 9 TI (wN), PrP (BFK), 2 TP (BFK).
Joe Funk. D, S, BS.

1. Impressions of this edition may be
 misnumbered on the back as
 Tamarind No. 224.

210
Untitled. Jan 19–24, 1961.
Red, red-brown (Z), black (S), red,
black (Z). 56.8 × 76.8. Ed 20 (BFK), 9
TI (wN), PrP (BFK), 1 AP (wN), 3 TP (1
wN, 2 BFK). Joe Funk. D, S, BS.

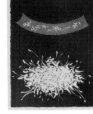

Print not in
University Art Museum
Archive

214
Untitled. Jan 24–31, 1961.
Red, black (S), black (S)[1], white (Z),
black (Z). 76.8 × 57.2. Ed 20 (bA), 9 TI
(wN), PrP (bA), 2 AP (bA), 1 TP (bA).
Joe Funk. D, S, BS.

1. Same stone as run 1; reworked,
 additions.

224
Untitled.[1] Jan 30–Feb 16, 1961.
Blue (Z), red (Z), black (Z), dark red,
dark beige (Z), black (Z). 105.1 × 74.9.
Ed 19 (BFK), 9 TI (wN), PrP (BFK), 3 AP
(BFK), 1 TP (BFK). Garo Antreasian. D,
S, BS.

1. Impressions of this edition may be
 misnumbered on the back as
 Tamarind No. 204.

228
Untitled. Feb 1–8, 1961.
Violet (S), grey-black (S), black (S).
57.2 × 77.2. Ed 15 (bA), 9 TI (wN), PrP
(bA), 3 AP (bA), 2 TP (bA), 2 CSP (bA).
Garo Antreasian. D, S, BS.

668
The Canyon. Oct 29–Nov 13, 1962.
Violet-pink (S), green (S)[1]. 56.8 ×
76.2. Ed 20 (BFK), 9 TI (wA), PrP (BFK),
PrP II for Bohuslav Horak (wA), 3 AP (2
BFK, 1 wA), 1 PP (BFK), 2 TP (proofing
paper)[2], 2 CTP (coverstock)[2], 4 PgP
(coverstock)[3], 1 proof (nr)[4]. Irwin
Hollander. D, S, T, BS.

1. Image transferred from run 1;
 reworked, partial reversal.
2. 2 TP, 2 CTP unchopped, retained by
 Tamarind.
3. 4 PgP unchopped, 1 PgP printed on
 recto and verso. Retained by
 Tamarind.
4. Unchopped, undesignated, retained
 by Tamarind.

Tetsuo Ochikubo

200
Untitled. Jan 7–10, 1961.
Blue (S), dark blue (S), black (S). 38.1
× 45.7. Ed 20 (wA), 9 TI (BFK), PrP
(wA), 2 AP (wA), 3 TP (wA). Joe Funk.
D, S, BS.

202
Untitled. Jan 9–16, 1961.
Yellow (S), dark yellow (S), black,
grey-brown (S), dark grey (S). 76.8 ×
57.2. Ed 18 (wA), 9 TI (wN), PrP (wA),
2 TP (wN). Joe Funk. D, S, BS.

Numbers 204, 210, 214, 224, 228 see
page 281.

229
Untitled. Feb 7–14, 1961.
Brown (Z), blue-grey (Z), dark beige
(Z). 74.9 × 104.8. Ed 15 (BFK), 9 TI
(wN), PrP (BFK), 3 AP (BFK), 1 TP
(BFK), 3 CSP (BFK). Bohuslav Horak.
D, S, BS.

234
Untitled. Feb 17–22, 1961.
Ochre (Z), brown (S), dark beige (S).
57.2 × 76.8. Ed 20 (BFK), 9 TI (wN),
PrP (BFK), 1 AP (BFK), 3 TP (BFK).
Bohuslav Horak. D, S, BS.

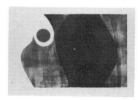

236
Untitled. Feb 21–27, 1961.
Yellow-ochre (Z), yellow-ochre (Z),
black (Z). 57.2 × 76.8. Ed 11 (BFK), 9
TI (wN), PrP (BFK), 3 AP (BFK), 3 TP
(BFK). Garo Antreasian. D, S, BS.

Nathan Oliveira

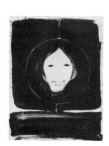

923
Homage to Carriere. Nov 11–14,
1963.
Black (S). 76.2 × 56.5. Ed 20 (BFK), 9
TI (wA), PrP (BFK), PrP II for Irwin
Hollander (BFK), 3 AP (wA), 2 PP
(BFK), 2 TP (BFK). Aris Koutroulis. D,
S, Dat, BS.

925
Black Christ II. Nov 13–Dec 7, 1963.
Black (Z)[1], dark metallic red-violet
(Z). 76.2 × 56.5. Ed 20 (BFK), 9 TI
(wA), PrP (BFK), PrP II for Irwin
Hollander (BFK), 3 AP (2 wA, 1 BFK), 3
TP (BFK). Aris Koutroulis. D, S, Dat, T,
BS.

1. Image from 923 transferred to
 plate; reversal, additions and
 deletions. 925 differs from 923 in
 color and in image. A dark solid
 tone outlining the face has been
 added. The inscription "Carriere"
 has been eliminated at the bottom
 and a fine line drawing added in
 this area.

925A
Black Christ I. Dec 5, 1963.
Black (Z)[1]. 76.2 × 55.9. Ed 10 (BFK),
9 TI (wA), PrP (BFK), 3 AP (BFK). Aris
Koutroulis. D, S, Dat, T, BS.

1. Plate held from 925, run 1. 925a
 differs from 925 in color and in
 image. The solid background tone
 has been eliminated.

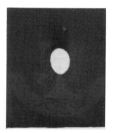

927
Head and Blue. Nov 14–Dec 17,
1963.
Black (Z), blue (Z). 72.7 × 56.5. Ed 20
(BFK), 9 TI (wA), PrP (BFK), 3 AP (wA),
4 TP (BFK). Aris Koutroulis. D, S, Dat,
T, BS.

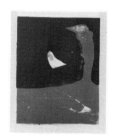

928
Red Chief. Nov 14–25, 1963.
Violet-red (S), black (Z), ochre (Z). 46.7
× 35.6. Ed 19 (BFK), 9 TI (wA), PrP
(BFK), PrP II for Irwin Hollander (wA),
2 AP (wA). John Dowell. D, S, Dat, T,
BS.

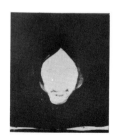

930
November 22, 1963. Nov 18–25,
1963.
Blue-black (S)[1], dark red (Z). 56.5 ×
46.1. Ed 20 (BFK), 9 TI (wA), PrP (BFK),
3 AP (2 wA, 1 BFK), 2 TP (BFK). Aris
Koutroulis. D, S, Dat, T, BS.

1. Stone held from 923; deletions and
 additions. 930 differs from 923 in
 color, image and size. The white
 margin, bottom quarter of the
 image and the eyes have been
 eliminated. A solid tone has been
 added over the dark part of the
 image creating a circular frame.

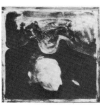

945
Georgia O'Keeffe. Nov 27–Dec 3, 1963.
Black (S). 51.1 × 51.1. Ed 20 (bA), 9 TI (wA), PrP (bA), 3 AP (2 wA, 1 bA), 1 TP (bA). Robert Gardner. D, S, Dat, T, BS.

954
Man Animal. Dec 9–13, 1963.
Black (S). 76.8 × 56.5. Ed 20 (BFK), 9 TI (wA), PrP (BFK), PrP II for Irwin Hollander (BFK), 3 AP (2 BFK, 1 wA), 1 TP (BFK), CP (BFK). John Dowell. D, S, Dat, T, BS.

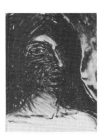

1084
Spanish Woman. May 4–5, 1964.
Black (S). 48.3 × 35.6. Ed 20 (wA), 9 TI (BFK), PrP (wA), PrP II for Irwin Hollander (wA), 3 AP (2 BFK, 1 wA), 2 TP (wA). Aris Koutroulis. D, S, Dat, T, BS.

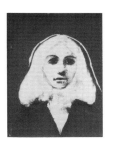

1085
White Lady. May 4–15, 1964.
Black (S). 75.9 × 56.5. Ed 20 (18 wA, 2 BFK), 9 TI (BFK), PrP (wA), PrP II for Irwin Hollander (wA), 3 AP (wA), 4 PP (1 BFK, 3 wA), 2 TP (wA). John Dowell. D, S, T, BS.

Print not in University Art Museum Archive

1086
Rabbit. May 5–7, 1964.
Red-brown (Z). 62.2 × 57.2. 10 ExP (bA)[1], PrP (bA), PrP II for Irwin Hollander (bA), 1 TP* (wA)[2]. Thom O'Connor. D, T, BS, S, Dat.

1. Designated A–J. 5 ExP retained by Tamarind.
2. 1 TP on paper 76.2 × 55.9; image size 64.8 × 50.2.

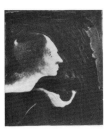

1089
Head and Shape I. May 8–28, 1964.
Pink (Z), orange (Z), black (S). 68.6 × 56.5. Ed 18 (wA), 9 TI (BFK), PrP (wA), 2 AP (1 wA, 1 BFK). Robert Gardner. D, S, Dat, T, BS.

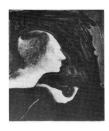

1089A
Head and Shape II. May 1, 1964.
Light beige (Z)[1], orange (Z)[2], green (Z)[3], black (S)[4]. 69.2 × 56.8. 10 ExP (6 wA, 4 BFK)[5], PrP (wA), PrP II for Irwin Hollander (wA), 1 TP* (wA). Robert Gardner. D, S, Dat, T, BS.

1. Plate held from 1089, run 1.
2. Plate held from 1089, run 2.
3. Same plate as run 2.
4. Stone held from 1089, run 3. 1089A differs from 1089 in color only.
5. Designated A–J. 5 ExP retained by Tamarind.

1090
White Faced Owl I. May 8–27, 1964.
Black (Z), orange (Z). 64.1 × 57.2. Ed 10 (6 wA, 4 BFK), 9 TI (wA). Ernest Rosenthal. D, S, Dat, T, BS.

Print not in University Art Museum Archive

1090A
White Faced Owl II. May 27–28, 1964.
Black (Z)[1], orange (Z)[2], red (Z)[3]. 64.1 × 56.8. 10 ExP (wA)[4], PrP (BFK), PrP II (BFK)[5], 2 TP (BFK), 3 AP (BFK). Ernest Rosenthal. D, T, BS, S, Dat.

1. Plate held from 1090, run 1.
2. Plate held from 1090, run 2.
3. Same plate as run 2. 1090A differs from 1090 in color only.
4. Designated A–J. 5 ExP retained by Tamarind.
5. Recipient unrecorded.

Print not in University Art Museum Archive

1091
Head. May 12–20, 1964.
Black (S)[1]. 61.9 × 57.5. 3 proofs (1 BFK, 1 wA, 1 nN)[2]. Aris Koutroulis. D, T, S, Dat.

1. Stone held from 1084; additions and deletions. 1091 differs from 1084 in image and size. The face is lighter with very light washes defining the features. The dark area around the face has been filled in solid with a defined outline against a white background. A halo of shading was added surrounding the dark area and at the top left and right.
2. 1 proof (BFK), unchopped, retained by Tamarind.

1092
Variation on a Head II. May 19–22, 1964.
Black (Z)[1]. 63.5 × 55.9. Ed 20 (wA), 9 TI (BFK), PrP (wA), PrP II for Robert Gardner (wA), 3 AP (wA), 2 TP (wA). Thom O'Connor. D, S, Dat, T, BS.

1. Image from 1091 transferred from stone; additions and deletions. 1092 differs from 1091 in image. The dark shape around the head has been enlarged. Light drawing has been added within the shape. The right side of the face has been eliminated. The top of the face and mouth are darker.

1093
Variation on a Head IV. May 20–28, 1964.
Black (Z)[1]. 63.5 × 56.5. Ed 20 (wA), 9 TI (BFK), PrP (wA), PrP II for Irwin Hollander (wA), 3 AP (wA), 2 TP (1 BFK, 1 wA). John Dowell. D, S, Dat, T, BS.

1. Image from 1091 transferred from stone; additions and deletions. 1093 differs from 1094 in color and in image. The dark shape around the head has been enlarged to include the halo area and the shading at the top has been eliminated. The right side of the face has been eliminated. Light streaked hair areas added above face at left and right. The face has dark shading around the facial features.

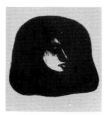

1094
Variation on a Head III. May 21–Jun 2, 1964.
Black (Z)[1], handcolored with red watercolor. 63.5 × 56.4. Ed 10 (wA), 9 TI (wA), PrP (BFK), PrP II for Irwin Hollander (BFK), 3 AP (2 BFK, 1 wA), 1 TP (BFK). Jeff Ruocco. D, S, T, BS.

1. Image from 1091 transferred from stone; additions and D, S, BS deletions. 1094 differs from 1092 in color and in image. The dark shape around the head has been enlarged to include the halo area and the shading at the top has been eliminated. The right side of the face has been eliminated. The face has dark shading around the facial features.

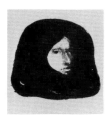

1096
Variation on a Head I. May 28, 1964.
Black (Z)[1]. 63.5 × 56.5. Ed 20 (wA), 9 TI (BFK), PrP (wA), 3 AP (2 BFK, 1 wA), 2 TP (wA). Aris Koutroulis. D, S, Dat, T, BS.

1. Image from 1091 transferred from stone; additions and deletions. 1096 differs from 1091 in image. The solid dark area around the head has been extended to include the halo shading. The shading has been added to the left side of the nose, right side of the face and the pupil of the left eye has been darkened. The shading at the top left and right has been eliminated.

George Ortman

Oaxaca, a suite of fourteen lithographs plus title and colophon pages, enclosed in a folder of white Nacre, measuring 67.0 × 94.0, consisting of the title page and colophon on the front cover and back inside leaf, printed at the Plantin Press, Los Angeles. In order: 1679, 1679II, 1677, 1677II, 1676, 1676II, 1678, 1678II, 1672III, 1672, 1672II, 1691, 1692, 1692II.

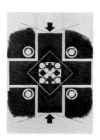

1671
Five. Mar 5–11, 1966.
Black (S). 66.0 × 45.7. Ed 20 (CD), 9 TI (GEP), BAT (CD), 1 AP (GEP), 2 TP (CD). Clifford Smith. D, T, S, BS.

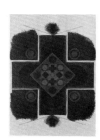

1671II
Five. Mar 14–25, 1966.
Light blue (Z), medium blue (S), dark blue (S)[1]. 66.0 × 45.7. Ed 20 (CD), 9 TI (GEP), BAT (CD), 3 AP (GEP), 3 TP (CD). Clifford Smith. D, T, S, BS.

1. Stone held from 1671; deletions. 1671II differs from 1671 in color and in image. Cross-hatching has been added around the arrows at the top and bottom. Color tones have been added in the central square and the four circles outside of it. A solid tone quatrefoil has been added behind the central square. A colored band and a thin line have been added inside the corners of the cross.

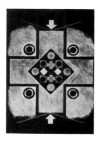

1671III
Five. Apr 13–22, 1966.
Black (S)[1]. 66.0 × 45.7. Ed 20 (CD), 9 TI (GEP), BAT (CD), 1 AP (CD), 1 PP (CD), 2 TP (CD)[2]. Clifford Smith. D, T, S, BS.

1. Stone held from 1671II, run 3; reversal, deletions. 1671III differs from 1671II in color and in image. The cross-hatching around the arrows and in the central diamond have been eliminated. The quatrefoil and two lines at each corner of the cross have been eliminated. The border of the central diamond was eliminated.
2. 2 TP exist on paper 66.0 × 91.4 with 1672III.

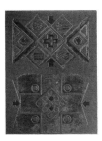

1671IV
Landlock. Apr 25–May 5, 1966.
Brown-grey (S)[1], dark grey (S)[2].
66.0 × 91.4. Ed 20 (CD), 9 TI (GEP),
BAT (CD), 2 AP (1 CD, 1 GEP), 1 TP*
(CD), 5 CTP (4 CD, 1 GEP), CP (Tcs).
Clifford Smith. T, D, S, BS.

1. Image transferred from 1671III and 1672III to stone.
2. Image transferred from run 1 to stone; re-reversed. 1671IV differs from 1671III and 1672III in color, image, size and presentation. 1671IV combines in one image the image of 1672III and 1671III as horizontals, top and bottom respectively. Dark tone has been added in all of the light areas leaving thin halos of light outlining most of the areas.

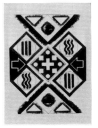

1672
Dance of Life (Oaxaca X). Mar 5–11, 1966.
Black (S). 66.0 × 45.7. Ed 20 (CD), 9 TI (GEP), BAT (CD), 2 AP (GEP), 1 TP (CD). Clifford Smith. D, T, S.

1672II
Dance of Life (Oaxaca XI)[1]. Mar 14–25, 1966.
Light blue (Z), medium blue (S), dark blue (S)[2]. 66.0 × 45.7. Ed 20 (CD), 9 TI (GEP), BAT (CD), 3 AP (1 CD, 2 GEP), 2 TP (CD). Clifford Smith. D, T, S, BS.

1. This lithograph contains two circles and a cross as cut-out shapes. 1672II is meant to be seen with 1691; 1672II placed in front.
2. Stone held from 1672; deletions. 1672II differs from 1672 in color and in image. A solid tone has been added in all of the square areas and in the triangles at top and bottom. Solid tone in the triangles around the arrows has been eliminated and a cross-hatched tone added in these areas.

1672III
Dance of Life (Oaxaca IX). Apr 13–22, 1966.
Black (S)[1]. 66.0 × 45.7. Ed 20 (CD), 9 TI (GEP), BAT (CD), 1 AP (CD), 2 TP (CD)[2]. Clifford Smith. D, T, S, BS.

1. Stones same as 1672II; reversal.
2. 2 TP exist on paper 66.0 × 91.4 with 1671III.

1673
Sleep. Mar 9–14, 1966.
Black (S). 66.0 × 45.7. Ed 20 (CD), 9 TI (GEP), BAT (CD), 3 AP (2 CD, 1 GEP), 2 TP (CD). Kinji Akagawa. D, T, S, BS.

1673II
Sleep. Mar 15–22, 1966.
Red (S), red-orange (S)[1]. 66.0 × 45.7. Ed 20 (CD), 9 TI (GEP), BAT (CD), 3 AP (1 CD, 2 GEP), 2 TP (CD), CP (Tcs). Kinji Akagawa. D, T, S, BS.

1. Stone held from 1673; deletions and additions. 1673II differs from 1673 in color and in image. The over-all image is lighter. Color tones have been added in the geometric shapes.

1674
Cue Up. Mar 14–16, 1966.
Black (S). 66.0 × 45.7. Ed 20 (CD), 9 TI (GEP), BAT (CD), 2 AP (1 CD, 1 GEP), 1 TP (CD). Robert Evermon. D, T, S, BS.

1674II
Cue Up. Mar 23–30, 1966.
Yellow, dark yellow (A), brown-orange (A), black (S)[1]. 66.0 × 45.7. Ed 20 (CD), 9 TI (GEP), BAT (CD), 3 AP (1 CD, 2 GEP), 1 TP (CD), CP (Tcs). Robert Evermon. D, T, S, BS.

1. Stone held from 1674; deletions. 1674II differs from 1674 in color, image and presentation. The image has been turned 180 degrees. Solid bleed background has been added except in the two inner circles.

1675
Signal. Mar 11–16, 1966.
Black (S). 66.7 × 46.1. Ed 20 (CD), 9 TI (GEP), BAT (CD), 3 AP (1 CD, 2 GEP), 2 TP (CD). Ernest de Soto. D, T, S, BS.

1675II
Signal. Mar 17–24, 1966.
Yellow (Z), ochre (Z), dark brown
(S)[1]. 66.7 × 46.1. Ed 20 (CD), 9 TI
(GEP), BAT (CD), 3 AP (GEP), 2 TP
(CD), CP (Tcs). Ernest de Soto. D, T, S,
BS.

1. Stone held from 1675; deletions.
 1675II differs from 1675 in color,
 image, and presentation. The image
 has been turned 180 degrees. The
 solid tone in the four circles at the
 top and bottom has been lightened
 considerably. Color tone has been
 added in triangle and square
 shapes.

1676
Eye (Oaxaca V). Mar 24–25, 1966.
Black (S). 66.0 × 45.7. Ed 20 (CD), 9 TI
(GEP), BAT (CD), 1 AP (CD), 3 TP (grey
de Laga cement paper)[1]. Ernest de
Soto. D, T, S, BS.

1. 1 TP retained by Tamarind.

1676II
Eye (Oaxaca VI). Mar 25–Apr 1,
1966.
Light yellow (Z), yellow (Z), medium
yellow (Z), orange-brown (S)[1]. 66.0
× 45.7. Ed 20 (CD), 9 TI (GEP), BAT
(CD), 3 AP (GEP), 1 PP (GEP), 5 TP
(CD), 2 PTP (grey de Laga cement
paper)[2], CP (Tcs). Ernest de Soto. D,
T, S, BS.

1. Stone held from 1676; deletions.
 1676II differs form 1676 in color and
 in image. Solid color tone has been
 added in all of the geometric
 shapes.
2. 2 PTP on paper 66.0 × 48.3, 1 PTP
 retained by Tamarind.

1677
Flight (Oaxaca III). Apr 4–6, 1966.
Black (S). 66.0 × 45.7. Ed 20 (CD), 9 TI
(GEP), BAT (CD), 3 AP (GEP), 1 TP
(CD). Robert Evermon. D, T, S, BS.

1677II
Flight (Oaxaca IV). Apr 6–14, 1966.
Light blue (A), light red-violet (A), red
(A), blue (S)[1]. 66.0 × 45.7. Ed 20
(CD), 9 TI (GEP), BAT (CD), 3 AP (GEP),
5 TP (CD), 8 CSP (CD)[2], CP (Tcs).
Robert Evermon. D, S, BS.

1. Stone held from 1677; additions.
 1677II differs from 1677 in color and
 in image. Background tone has
 been added behind the image
 except for the side borders. The two
 central vertical bands have been
 extended to the edges. The central
 diamond shape has been darkened.
2. 4 CSP retained by Tamarind.

1678
Monte Alban (Oaxaca VII). Apr 7–
11, 1966.
Black (S). 66.0 × 45.7. Ed 20 (CD), 9 TI
(GEP), BAT (CD), 1 AP (GEP), 2 TP
(CD). Donn Steward. D, T, S, BS.

1678II
Monte Alban (Oaxaca VIII). Apr 11–
18, 1966.
Red-orange (Z), red (Z), transparent
red (S), dark red (S)[1]. 66.0 × 45.7.
Ed 20 (CD), 9 TI (GEP), BAT (CD), 3 AP
(1 CD, 2 GEP), 2 PP (CD), 5 TP (CD), 8
CSP (CD)[2], CP (Tcs). Donn Steward.
D, T, S, BS.

1. Stone held from 1678. 1678II differs
 from 1678 in color and in image.
 Background tone has been added.
 Color tones have been added in
 many geometric shapes throughout
 the composition.
2. 4 CSP retained by Tamarind.

1679
Oaxaca (Oaxaca I). Apr 1–4, 1966.
Black (S). 66.0 × 45.7. Ed 20 (CD), 9 TI
(GEP), BAT (CD), 2 AP (CD). Ernest de
Soto. D, T, S, BS.

1679II
Oaxaca (Oaxaca II). Apr 4–11, 1966.
Ochre (Z), light yellow (Z), light blue
(Z), brown (S)[1]. 66.0 × 45.7. Ed 20
(CD), 9 TI (GEP), BAT (CD), 1 AP (CD),
4 TP (CD), CP (Tcs). Ernest de Soto. D,
T, S, BS.

1. Stone held from 1679. 1679II differs
 from 1679 in color and image. The
 middle horizontal stripe at both top
 and bottom has been eliminated.
 Medium background tone has been
 added behind the geometric shapes
 in the center and a lighter tone
 within some of the geometric
 shapes and in two horizontal bands
 both at the top and bottom has also
 been added.

1691
Red Print[1] (Oaxaca XII). Mar 26–
Apr 6, 1966.
Red (S). 66.0 × 45.7. Ed 20 (CD), 9 TI
(GEP), BAT (CD), 3 AP (2 CD, 1 GEP), 4
TP (3 CD, 1 GEP)[2], CP (Tcs). Clifford
Smith. D, T, S, BS.

1. Cf. 1672II, footnote 1.
2. 2 TP (1 CD, 1 GEP) vary from the
 edition; 1 TP (CD) retained by
 Tamarind.

1692
Two (Oaxaca XIII). Apr 11–12, 1966.
Black (S). 66.0 × 45.7. Ed 20 (CD), 9 TI
(GEP), BAT (CD), 2 AP (1 CD, 1 GEP), 2
TP (CD). Kinji Akagawa. D, T, S, BS.

1692II
Two (Oaxaca XIV). Apr 13–22, 1966.
Yellow (Z), dark yellow (Z), light
yellow (S), orange-yellow (S)[1]. 66.0
× 45.7. Ed 20 (CD), 9 TI (GEP), BAT
(CD), 3 AP (2 GEP, 1 CD), 2 PP (GEP), 2
TP (CD), CP (Tcs). Kinji Akagawa. D, T,
S, BS.

1. Stone held from 1692. 1692II differs
 from 1692 in color and in image.
 The over-all image is lighter. A
 bleed background tone and color
 tones in the various geometric
 shapes have been added.

Harold Paris

360
December. Aug 18, 1961.
Black (S). 56.8 × 40.3. Ed 20 (BFK), 9
TI (wA), BAT (BFK), 2 AP (BFK), 2 TP
(BFK), CP (BFK). Bohuslav Horak. D,
BS (Tam), T, BS (pr), S, Dat.

Raymond Parker

285
Untitled. May 3–5, 1961.
Violet, dark brown (Z), blue (Z). 74.9 ×
105.4. Ed 18 (BFK), 9 TI (wN), PrP
(BFK), 4 AP (BFK), 3 TP (1 wN[1], 2
BFK), 2 rough proofs (CD)[2]. Garo
Antreasian. BS (Tam), D, S, BS (pr).

1. Retained by Joe Funk for assistance
 in printing.
2. Unsigned and unchopped.

Robert Andrew Parker

Country, Clare, Erie, a suite of twelve
lithographs, enclosed in a wrap-
around folder of white Nacre,
measuring 31.8 × 45.7, with the suite
title and artist's name on the front
cover, printed at the Plantin Press, Los
Angeles. In order: 2133, 2135, 2136,
2137, 2138, 2139, 2140, 2141, 2142,
2143, 2144.

2122
Squirrel Monkey. Sep 7–19, 1967.
Grey-green (Z), red (A), red-brown (S).
71.1 × 53.3. Ed 20 (GEP), 9 TI (BFK),
BAT (GEP), 1 AP (BFK), CP (GEP).
Serge Lozingot. D, T, BS, S.

2123
Untitled. Sep 7–8, 1967.
Black (S). 40.6 × 58.4. Ed 20 (BFK), 9
TI (wA), BAT (BFK), 2 AP (1 BFK, 1
wA). Serge Lozingot. D, BS, S.

2124
Barbary Ape. Sep 8–18, 1967.
Dark-brown (S), blue (A). 71.1 × 53.3.
Ed 20 (GEP), 9 TI (BFK), BAT (GEP), 2
AP (BFK), 1 TP (GEP), 2 CTP (1 GEP, 1
EVB), CP (GEP). David Folkman. D, BS,
T, S.

2125
Proboscis Monkey. Sep 13–25, 1967.
Orange-yellow (Z), light brown (Z),
black (S). 71.1 × 53.3. Ed 20 (GEP), 9
TI (BFK), BAT (GEP), 3 AP (1 BFK, 2
GEP), 1 TP (GEP), CP (GEP). Serge
Lozingot. D, BS, T, S.

2126
Untitled. Sep 12–15, 1967.
Red-black (S). 71.1 × 53.3. Ed 20
(GEP), 9 TI (BFK), BAT (GEP), 3 AP (2
BFK, 1 GEP), CP (GEP). Bruce Lowney.
D, BS, S.

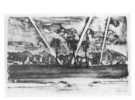

2128
Hooray for Hollywood. Oct 3, 1967.
Blue-black (S). 58.4 × 86.4. Ed 10 (MI),
9 TI (CD), BAT (MI), 3 AP (1 CD, 2 MI),
1 TP (MI). Anthony Ko. D, BS, T, S.

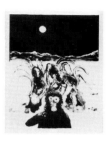

2129
Untitled. Sep 19–27, 1967.
Black (S). 69.2 × 54.0. Ed 20 (JG), 9 TI
(5 BFK, 4 JG), BAT (JG), CP (JG).
David Folkman. D, BS, S.

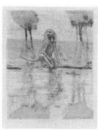

2130
Baboon. Sep 21–Oct 6, 1967.
Yellow-beige (Z), blue (Z), pink-brown
(Z), black (S), brown (Z). 71.1 × 53.3.
Ed 20 (GEP), 9 TI (BFK), BAT (GEP), 3
AP (1 GEP, 2 BFK), 3 TP (1 BFK, 2
GEP), CP (GEP). Serge Lozingot. D, BS,
S.

2131
Indian Lady III. Oct 6, 1967.
Blue-black (S)[1]. 58.4 × 86.4. Ed 10
(MI), 9 TI (CD), BAT (MI), 3 AP (1 CD, 2
MI), CP (CD). David Folkman. D, BS, T,
S.

1. Stone held from 2131II; reversal.

2131II
Indian Lady I. Sep 21–Oct 4, 1967.
Black (S). 58.4 × 86.4. Ed 10 (MI), 9 TI
(CD), BAT (MI), 3 AP (MI). David
Folkman. D, T, BS, S.

2133
Untitled (County Clare, Eire I). Sep
27–Oct 16, 1967.
Yellow (A), red (A), blue (S), white (A).
29.2 × 43.2. Ed 20 (18 CD, 2 GEP), 9 TI
(GEP), BAT (CD), 1 TP* (CD), CP
(CD)[1]. David Folkman. D, BS, S.

1. CP exists on paper 58.4 × 86.3 with
 2134–2136, untorn.

2134
Untitled (County Clare, Eire II).
Sep 27–Oct 16, 1967.
Yellow (A), red (A), blue (S), white (A).
29.2 × 43.2. Ed 14 (13 CD, 1 GEP), 9 TI
(GEP), BAT (CD), 1 TP* (CD), CP
(CD)[1]. David Folkman. D, BS, S.

1. CP exists on paper 58.4 × 86.3 with
 2133, 2135–2136, untorn.

2135
Untitled (County Clare, Eire III).
Sep 27–Oct 16, 1967.
Yellow (A), red (A), blue (S), white (A).
29.2 × 43.2. Ed 18 (17 CD, 1 GEP), 9 TI
(GEP), BAT (CD), 1 TP* (CD), CP
(CD)[1]. David Folkman. D, BS, S.

1. CP exists on paper 58.4 × 86.3 with
 2133–2134, 2136, untorn.

2136
Untitled (County Clare, Eire IV).
Sep 27–Oct 16, 1967.
Yellow (A), red (A), blue (S), white (A).
29.2 × 43.2. Ed 19 (17 CD, 2 GEP), 9 TI
(GEP), BAT (CD), 1 TP* (CD), CP
(CD)[1]. David Folkman. D, BS, S.

1. CP exists on paper 58.4 × 86.3 with
 2133–2135, untorn.

2137
Untitled (County Clare, Eire V).
Sep 29–Oct 24, 1967.
Blue-grey (A), yellow-grey (A), red-
grey (S), light-grey (A). 28.9 × 43.8.
Ed 20 (GEP), 9 TI (CD), BAT (GEP), 3
AP (2 CD, 1 GEP), 1 PP (GEP), CP
(GEP). Bruce Lowney. D, BS, S.

2138
Untitled (County Clare, Eire VI).
Sep 29–Oct 24, 1967.
Blue-grey (A), yellow-grey (A), red-
grey (S), light-grey (A). 30.5 × 43.2.
Ed 20 (GEP), 9 TI (CD), BAT (GEP), 3
AP (2 GEP, 1 CD), CP (GEP). Bruce
Lowney. D, BS, S.

2139
Untitled (County Clare, Eire VII).
Sep 29–Oct 24, 1967.
Blue-grey (A), yellow-grey (A), red-
grey (S), light-grey (A). 29.8 × 43.8.
Ed 20 (GEP), 9 TI (CD), BAT (GEP), CP
(GEP). Bruce Lowney. D, BS, S.

2140
Untitled (County Clare, Eire VIII).
Sep 29–Oct 24, 1967.
Blue-grey (A), yellow-grey (A), red-
grey (S), light-grey (A). 29.2 × 43.2.
Ed 20 (GEP), 9 TI (CD), BAT (GEP), 3
AP (CD), 4 PP (2 GEP, 2 CD), CP (GEP).
Bruce Lowney. D, BS, S.

2141
Untitled (County Clare, Eire IX).
Sep 28–Oct 10, 1967.
Transparent green (Z), transparent
blue (Z), brown (S), blue (S). 29.2 ×
43.2. Ed 20 (CD), 9 TI (GEP), BAT (CD),
3 AP (2 GEP, 1 CD), 3 TP (CD), CP (CD).
Serge Lozingot. D, BS, S.

2142
Untitled (County Clare, Eire X).
Sep 28–Oct 10, 1967.
Transparent green (Z), transparent
blue (Z), brown (S), blue (S). 29.2 ×
43.2. Ed 20 (CD), 9 TI (GEP), BAT (CD),
3 AP (2 GEP, 1 CD), 3 TP (CD), CP (CD).
Serge Lozingot. D, BS, S.

2143
Untitled (County Clare, Eire XI).
Sep 28–Oct 10, 1967.
Transparent green (Z), transparent
blue (Z), brown (S), blue (S). 29.2 ×
43.2. Ed 20 (CD), 9 TI (GEP), BAT (CD),
3 AP (2 GEP, 1 CD), 3 TP (CD), CP (CD).
Serge Lozingot. D, BS, S.

2144
Untitled (County Clare, Eire XII).
Sep 28–Oct 10, 1967.
Transparent green (Z), transparent
blue (Z), brown (S), blue (S). 29.2 ×
43.2. Ed 20 (CD), 9 TI (GEP), BAT (CD),
3 AP (2 GEP, 1 CD), 3 TP (CD), CP (CD).
Serge Lozingot. D, BS, S.

2145
Indian Lady II. Sep 25–Oct 3, 1967.
Black (A). 58.8 × 86.4. Ed 20 (MI), 9 TI
(CD), BAT (MI), 2 AP (1 CD, 1 MI), CP
(MI). David Folkman. D, T, BS, S.

2161
Hollywood, Sleeping. Oct 10–19,
1967.
Blue-black (S). 59.1 × 86.4. Ed 20
(GEP), 9 TI (CD), BAT (CD), 3 AP (CD),
CP (GEP). Bruce Lowney. D, T, BS, S.

2162
Hollywood. Oct 9–11, 1967.
Dark brown (S). 58.4 × 86.4. Ed 20
(MI), 9 TI (wN), BAT (MI), 1 TP (wN),
CP (MI). Anthony Ko. D, T, BS, S.

2163
Hollywood Beach II. Oct 12–18,
1967.
Brown (S). 58.4 × 86.4. Ed 20 (BFK), 9
TI (MI), BAT (BFK), 1 TP (BFK), CP (MI).
Anthony Ko. D, T, BS, S.

2164
Beach—Hollywood Zoo II. Oct 18–
19, 1967.
Brown (S). 58.4 × 86.4. Ed 20 (BFK), 9
TI (MI), BAT (BFK), 2 AP (1 BFK, 1 MI),
CP (MI). Anthony Ko. D, T, BS, S.

2165
Hollywood Zoo. Oct 20–23, 1967.
Black (S). 58.4 × 86.4. Ed 20 (BFK), 9
TI (GEP), BAT (BFK), 2 AP (BFK), 1 TP
(BFK), CP (GEP). Maurice Sanchez. D,
T, BS, S.

2166
Hollywood—Tamarind. Oct 19–20,
1967.
Black (S). 58.4 × 86.4. Ed 20 (GEP), 9
TI (BFK), BAT (GEP), 3 AP (2 GEP, 1
BFK), CP (GEP). Maurice Sanchez. D, T,
BS, S.

2167
Hollywood—Beach III. Oct 20–23,
1967.
Black (S). 58.4 × 86.4. Ed 20 (BFK), 9
TI (GEP), BAT (BFK), 3 AP (2 BFK, 1
GEP), 1 TP (BFK), CP (BFK). Anthony
Stoeveken. D, T, BS, S.

2168
Hollywood—Sleeping II. Oct 23–26,
1967.
Black (S). 58.4 × 86.4. Ed 20 (BFK), 9
TI (GEP), BAT (BFK), 3 AP (1 BFK, 2
GEP), 1 PP (GEP), 1 TP (BFK), 1 PTP
(BFK)[1], CP (BFK). Anthony
Stoeveken. D, T, BS, S.

1. 1 PTP on paper 55.9 × 76.2,
 unsigned, unchopped, retained by
 Tamarind.

2169
Hollywood—Sleeping III. Oct 24–25,
1967.
Black (S). 58.8 × 86.7. Ed 20 (GEP), 9
TI (GEP), BAT (BFK), 2 AP (1 BFK, 1
GEP), 1 TP (BFK), CP (GEP). Maurice
Sanchez. D, T, BS, S.

Henry Pearson

The Rime of the Ancient Mariner by
Samual Taylor Coleridge, a *livre de
luxe* comprised of eighty pages
including sixteen pages of
illustrations, thirty-five pages of text,
title and colophon pages, seven pages
of Roman numerals, twenty blank
pages, and one lithograph printed on
acetate. It is enclosed in a hard
chemise, measuring 30.8 × 28.9, and
a slipcase, measuring 31.8 × 29.2,
both covered in a natural Nacre. The
hard chemise is lined with a
lithograph and inscribed with the suite
title, artist's and author's names
handwritten in black ink by the artist
on the spine. The designation appears
on the front of the slipcase at the
lower right. The lithographs are
enclosed in a soft chemise with the
title and colophon pages on the front
cover and back inside leaf. A slipcase
of white Tableau paper is placed
between each printed page. The
binding was made by Margaret Lecky,
Los Angeles. In order: 40 sheets, each
numbered 1075.

All impressions in the suite bear the
Tamarind number 1075. Within the
edition of fifty, forty-five suites on
white Arches are numbered in Arabic
numerals, three suites of buff Arches
are numbered in Roman numerals,
two suites, one on white Nacre and
one on natural Nacre, include an
original drawing, designation
unrecorded. The artist retained extra
impressions of text pages, exact
number unrecorded.

The artist collaborated with printer fellows John Dowell, Robert Gardner, Aris Koutroulis and Tom O'Connor under the supervision of technical director, Irwin Hollander.

1055A
Study for Albatross. Apr 9, 1964.
Black (Z). 26.7 × 33.0. Ed 10 (BFK), 9 TI (wA), PrP (BFK), PrP II for Irwin Hollander (BFK), 3 AP (1 wA, 2 BFK), 3 TP* (BFK). John Dowell. Recto: D, S, Dat Verso: WS.

1059
Untitled. Apr 6–7, 1964.
Black (Z). 55.9 × 55.9. Ed 20 (wA), 9 TI (BFK), PrP (wA), 3 AP (1 BFK, 2 wA), 2 TP (wA). Robert Gardner. D, S, BS.

1060
Coleridge Poem I. Apr 6–20, 1964.
Yellow (Z), black (Z). 75.6 × 56.5. Ed 20 (wA), 9 TI (BFK), PrP (wA), PrP II for Irwin Hollander (wA), 3 AP (BFK), 2 TP (wA). Robert Gardner. D, S, Dat, BS.

1060
Untitled. Apr 13–21, 1964.
Red (Z)[1], black (Z)[2]. 56.8 × 55.9. Ed 10 (wA), 9 TI (1 wA, 8 BFK), PrP (wA), 3 AP (1 BFK, 2 wA), 4 TP (1wA, 3 BFK), CP (wA). Robert Gardner. D, S, Dat, BS.

1. Plate held from 1060, run 1.
2. Plate held from 1060, run 2; additions and deletions. 1060A differs from 1060 in color, image, and size. The text has been eliminated. The area around the circle has been filled in solid as a bleed image eliminating the outline of the circle.

1063
Part III. Apr 10–15, 1964.
Red (Z). 30.8 × 28.3. Ed 20 (wA), 9 TI (BFK), PrP (wA), PrP II for Irwin Hollander (wA), 3 AP (1 wA, 2 BFK). John Dowell. D, T, S, Dat, BS.

1075
Title Page (The Rime of the Ancient Mariner). Jun 5–12, 1964.
Black (Z). 30.5 × 59.1. Ed 50 (45 wA, 3 bA, 1 wN, 1 nN), 9 TI (BFK), BAT (wA) 1 PP (wA). None. printer (nr).

1. Numbered in Arabic numerals.
2. Numbered in Roman numerals.
3. Includes an original drawing, designation unrecorded.
4. In addition, the artist has retained extra impressions of text pages, exact number unrecorded.

No photograph

1075
Chemise lining (The Rime of the Ancient Mariner). Apr 17–22, 1964.
Blue (Z). 30.5 × 59.7, cut. Ed 50 (45 wA, 3 bA, 1 wN, 1 nN), 9 TI (BFK), BAT (wA), 1 PP (wA) PrP II for Irwin Hollander (BFK)[1]. John Dowell, NC.

1. Uncut.

1075
Pages 8 and 3 (The Rime of the Ancient Mariner). Apr 23–28, 1964.
Black (Z). 30.5 × 56.5. Ed 50 (45 wA, 3 bA, 1 wN, 1 nN), 9 TI (BFK), BAT (wA) 1 PP (wA). None. printer (nr).

1075
Page 5 (The Rime of the Ancient Mariner). May 4–6, 1964.
Light green-blue (Z). 30.5 × 28.3. Ed 50 (45 wA, 3 bA, 1 wN, 1 nN), 9 TI (BFK), BAT (wA), PrP II for Irwin Hollander (wA), 5 AP (3 BFK, 2 wA), 2 PP (wA). John Dowell. Verso: D, S, WS.

Blank
page

1075
*Pages 4 and 7 (The Rime of the
Ancient Mariner).* Apr 23–28, 1964.
Black (Z). 30.5 × 56.5. Ed 50 (45 wA, 3
bA, 1 wN, 1 nN), 9 TI (BFK), BAT (wA),
1 PP (wA). None. printer (nr).

1075
*Page 15 (The Rime of the Ancient
Mariner).* Apr 9–14, 1964.
Yellow (Z). 30.5 × 27.9. Ed 50 (45 wA,
3 bA, 1 wN, 1 nN), 9 TI (BFK), BAT
(wA), 1 PP (wA). John Dowell. Verso:
D,S, WS .

1075
*Page 12 (The Rime of the Ancient
Mariner).* Apr 15–May 1, 1964.
Black (Z). 30.5 × 56.5. Ed 50 (45 wA, 3
bA, 1 wN, 1 nN), 9 TI (BFK), BAT (wA),
1 PP (wA). John Dowell. D, I, WS.

Blank
page

1075
*Pages 14 and 17 (The Rime of the
Ancient Mariner).* Apr 21–May 1,
1964.
Black (Z). 30.5 × 56.2. Ed 50 (45 wA, 3
bA, 1 wN, 1 nN), 9 TI (BFK), BAT (wA),
1 PP (wA). None. printer (nr).

1075
*Pages 10 and 11 (The Rime of the
Ancient Mariner).* Apr 15–May 1,
1964.
Violet (Z), black (Z). 30.5 × 56.5. Ed 50
(45 wA, 3 bA, 1 wN, 1 nN), 9 TI (BFK),
BAT (wA) 1 PP (wA) PrP II for Irwin
Hollander (wA)[1], 10 AP (3 bA, 3 BFK,
3 wA, 1 nN)[1]. None. printer (nr).

1. For page 11 only.

Blank
page

1075
*Pages 22 and 19 (The Rime of the
Ancient Mariner).* May 11–Jun 2,
1964.
Black (Z). 30.5 × 56.5. Ed 50 (45 wA, 3
bA, 1 wN, 1 nN), 9 TI (BFK), BAT (wA),
1 PP (wA). Thom O'Connor. D, T, I,
WS.

1075
*Page 18 and 13 (The Rime of the
Ancient Mariner).* Apr 21–May 1,
1964.
Black (Z). 30.5 × 56.2. Ed 50 (45 wA, 3
bA, 1 wN, 1 nN), 9 TI (BFK), BAT (wA),
1 PP (wA). None. printer (nr).

1075
Pages 20 and 21, "All in a hot and copper sky" (The Rime of the Ancient Mariner). May 11–Jun 2, 1964.
Brown-orange (Z), light blue (Z). 30.5 × 56.5. Ed 50 (45 wA, 3 bA, 1 wN, 1 nN), 9 TI (BFK), BAT (wA), 1 PP (wA) PrP II for Irwin Hollander (wA)[1], 10 AP (3 nN, 3 bA, 3 wA, 1 wN)[1], 10 TP (wA)[1]. Thom O'Connor.

1. For pages 20 and 21 only.

1075
Pages 32 and 29 (The Rime of the Ancient Mariner). Apr 24–May 21, 1964.
Black (Z). 30.5 × 55.9. Ed 50 (45 wA, 3 bA, 1 wN, 1 nN), 9 TI (BFK), BAT (wA), 1 PP (wA) 4 AP (1 bA, 3 wA), 5 PP (wA)[1]. Aris Koutroulis. D, I, WS.

1. Designation unrecorded.

1075
Pages 28 and 23 (The Rime of the Ancient Mariner). Apr 21–May 1, 1964.
Black (Z). 30.5 × 56.5. Ed 50 (45 wA, 3 bA, 1 wN, 1 nN), 9 TI (BFK), BAT (wA), 1 PP (wA). None. printer (nr).

1075
Pages 30 and 31 (The Rime of the Ancient Mariner). Apr 24–May 21, 1964.
Red (Z), black (Z), grey (Z). 30.5 × 55.9. Ed 50 (45 wA, 3 bA, 1 wN, 1 nN), 9 TI (BFK), BAT (wA), 4 AP (1 bA, 3 wA), 6 PP (wA). Aris Koutroulis. D, I, WS.

1. Designation unrecorded.

1075
Pages 38 and 33 (The Rime of the Ancient Mariner). Apr 23–28, 1964.
Black (Z). 30.5 × 56.5. Ed 50 (45 wA, 3 bA, 1 wN, 1 nN), 9 TI (BFK), BAT (wA), 1 PP (wA). None. printer (nr).

1075
Page 25, "Almost upon the western wave/ Rested the broad, bright sun" (The Rime of the Ancient Mariner). May 11, 1964.
Red-orange (Z). 30.5 × 27.9. Ed 50 (45 wA, 3 bA, 1 wN, 1 nN), 9 TI (BFK), BAT (wA), 1 PP (wA) PrP II for Irwin Hollander (wA), 5 AP (3 wA, 2 BFK), 2 TP (wA). John Dowell. Verso: D, T, S, WS.

Blank page

1075
Pages 24 and 27 (The Rime of the Ancient Mariner). Apr 21–May 1, 1964.
Black (Z). 30.5 × 56.5. Ed 50 (45 wA, 3 bA, 1 wN, 1 nN), 9 TI (BFK), BAT (wA), 1 PP (wA). None. printer (nr).

1. Numbered in Arabic numerals.
2. Numbered in Roman numerals.
3. Includes an original drawing, designation unrecorded.
4. In addition the artist has retained extra impressions of text pages, exact number unrecorded.

1075
Page 35, "As is the ribbed sea-sand" (The Rime of the Ancient Mariner). Apr 23–27, 1964.
Light brown (Z). 30.5 × 27.9. Ed 50 (45 wA, 3 bA, 1 wN, 1 nN), 9 TI (BFK), BAT (wA), 1 PP (wA) PrP II for Irwin Hollander (wA), 5 AP (3 wA, 2 BFK). John Dowell. Verso: D, T, S, WS.

Blank page

1075
Pages 34 and 37 (The Rime of the Ancient Mariner). Apr 23–28, 1964.
Black (Z). 30.5 × 56.5. Ed 50 (45 wA, 3 bA, 1 wN, 1 nN), 9 TI (BFK), BAT (wA), 1 PP (wA). None.

1075
Pages 48 and 43 (The Rime of the Ancient Mariner). Apr 30–May 1, 1964.
Black (Z). 30.5 × 56.5. Ed 50 (45 wA, 3 bA, 1 wN, 1 nN), 9 TI (BFK), BAT (wA), 1 PP (wA). None. printer (nr).

Blank page

1075
Pages 42 and 39 (The Rime of the Ancient Mariner). May 4–Jun 16, 1964.
Black (Z). 30.5 × 56.5. Ed 50 (45 wA, 3 bA, 1 wN, 1 nN), 9 TI (BFK), BAT (wA), 1 PP (wA). Robert Gardner. D, I, WS.

1075
Page 45 (The Rime of the Ancient Mariner). Apr 16, 1964.
Light brown-grey (Z). 30.5 × 27.9. Ed 50 (45 wA, 3 bA, 1 wN, 1 nN), 9 TI (BFK), BAT (wA), 1 PP (wA) PrP II for Irwin Hollander (wA), 5 AP (3 BFK, 2 wA). John Dowell. Verso: D, S, WS.

1075
Page 41a (The Rime of the Ancient Mariner). May 4–Jun 16, 1964.
Green-blue (Z)[5], on acetate. 29.2 × 26.7, cut. Ed 50 (45 wA, 3 bA, 1 wN, 1 nN), 9 TI (BFK), BAT (wA), 1 PP (wA) PrP II for Irwin Hollander (wA), 5 AP (1 wN, 3 wA, 1 nN), 2 PP (wA), 9 TP (2 Tcs, 7 wA). None.

1. Plate held from page 41, run #2. Page 41a differs from page 41 in color and in image. The color tone has been eliminated.

Blank page

1075
Pages 44 and 47 (The Rime of the Ancient Mariner). Apr 30–May 1, 1964.
Black (Z). 30.5 × 56.5. Ed 50 (45 wA, 3 bA, 1 wN, 1 nN), 9 TI (BFK), BAT (wA), 1 PP (wA). None. printer (nr).

1075
Pages 40 and 41 (The Rime of the Ancient Mariner). May 4–Jun 16, 1964.
Yellow (Z), black (Z). 30.5 × 56.5. Ed 50 (45 wA, 3 bA, 1 wN, 1 nN), 9 TI (BFK), BAT (wA), 1 PP (wA) PrP II for Irwin Hollander (wA)[1], 5 AP (1 wN, 3 wA, 1 nN)[1], 2 PP (wA)[1], 9 TP (2 Tcs, 7 wA)[1]. None. printer (nr).

1. For page 41 only.

1075
Pages 54 and 49 (The Rime of the Ancient Mariner). Apr 22–May 4, 1964.
Black (Z). 30.5 × 55.9. Ed 50 (45 wA, 3 bA, 1 wN, 1 nN), 9 TI (BFK), BAT (wA), 1 PP (wA). None.

Blank page

1075
Page 51, "For whom it dawned—they dropped their arms, and and clustered round the mast" (The Rime of the Ancient Mariner). Apr 27–May 26, 1964.
Pink (Z), grey (Z). 30.5 × 27.9. Ed 50 (45 wA, 3 bA, 1 wN, 1 nN), 9 TI (BFK), BAT (wA), 1 PP (wA) PrP II for Irwin Hollander (wA), 14 AP (3 bA, 3 wA, 3 BFK, 2 nN, 3 wN), 1 PP (wA), 6 TP (2 bA, 4 wA). Thom O'Connor. Verso: D, T, I, WS.

1075
Page 52 (The Rime of the Ancient Mariner). Apr 27–May 26, 1964.
Black (Z). 30.5 × 27.9. Ed 50 (45 wA, 3 bA, 1 wN, 1 nN), 9 TI (BFK), BAT (wA), 1 PP (wA). None. printer (nr).

1075
Page 50 and 53 (The Rime of the Ancient Mariner). Apr 22–May 4, 1964.
Black (Z). 30.5 × 55.9. Ed 50 (45 wA, 3 bA, 1 wN, 1 nN), 9 TI (BFK), BAT (wA), 1 PP (wA). None. printer (nr).

1075
Pages 60 and 55 (The Rime of the Ancient Mariner). Apr 30–May 1, 1964.
Black (Z). 30.5 × 56.2. Ed 50 (45 wA, 3 bA, 1 wN, 1 nN), 9 TI (BFK), BAT (wA), 1 PP (wA). None. printer (nr).

1075
Page 57 "I viewed the ocean green,/And looked far by Same (The Rime of the Ancient Mariner). Apr 30–May 5, 1964.
Blue-green (Z). 30.5 × 27.9. Ed 50 (45 wA, 3 bA, 1 wN, 1 nN), 9 TI (BFK), BAT (wA). PrP II for Irwin Hollander (wA), 6 AP (3 BFK, 3 wA), 2 PP (wA). John Dowell. Verso: D, T, S, WS.

Blank page

1075
Pages 56 and 59 (The Rime of the Ancient Mariner). Apr 30–May 1, 1964.
Black (Z). 30.5 × 56.2. Ed 50 (45 wA, 3 bA, 1 wN, 1 nN), 9 TI (BFK), BAT (wA), 1 PP (wA). None. printer (nr).

1075
Pages 66 and 61 (The Rime of the Ancient Mariner). Apr 22–May 4, 1964.
Black (Z). 30.5 × 55.6. Ed 50 (45 wA, 3 bA, 1 wN, 1 nN), 9 TI (BFK), BAT (wA), 1 PP (wA). None. printer (nr).

1075
Page 63, "Full many shapes, that shadows were,/in crimson crimson colours came" (The Rime of the Ancient Mariner). May 8–28, 1964.
Blue (Z), red (Z), black (Z). 30.5 × 27.9. Ed 50 (45 wA, 3 bA, 1 wN, 1 nN), 9 TI (BFK), BAT (wA). PrP II (wA)[1], 12 AP (3 bA, 3 wA, 3 BFK, 1 nN, 2 wN), 2 PP (wA), 3 TP (wA). Robert Gardner. Verso: D, T, S, WS.

1. Recipient unrecorded.

1075
Pages 62 and 65 (The Rime of the Ancient Mariner). Apr 22–May 4, 1964.
Black (Z). 30.5 × 55.6. Ed 50 (45 wA, 3 bA, 1 wN, 1 nN), 9 TI (BFK), BAT (wA), 1 PP (wA). None. printer (nr).

1075
Pages 72 and 67 (The Rime of the Ancient Mariner). Apr 28–Jun 1, 1964.
Black (Z). 30.5 × 55.9. Ed 50 (45 wA, 3 bA, 1 wN, 1 nN), 9 TI (BFK), BAT (wA), 1 PP (wA). None. printer (nr).

1075
Page 75 (The Rime of the Ancient Mariner). Apr 24–May 20, 1964.
Black (Z). 30.5 × 27.9. Ed 50 (45 wA, 3 bA, 1 wN, 1 nN), 9 TI (BFK), BAT (wA), 1 PP (wA). None. printer (nr).

1075
Page 76 (The Rime of the Ancient Mariner). Apr 24–May 20, 1964.
Black (Z). 30.5 × 27.9. Ed 50 (45 wA, 3 bA, 1 wN, 1 nN), 9 TI (BFK), BAT (wA), 1 PP (wA). None. printer (nr).

1075
Page 69 (The Rime of the Ancient Mariner). May 18–20, 1964.
Green (Z). 30.5 × 27.9. Ed 50 (45 wA, 3 bA, 1 wN, 1 nN), 9 TI (BFK), BAT (wA), 1 PP (wA) PrP II for Irwin Hollander (wA), 6 AP (3 BFK, 3 wA), 2 PP (wA), 1 TP (wA). John Dowell. Verso: D, S, WS.

1075
Pages 74 and 77 (The Rime of the Ancient Mariner). Apr 24–May 21, 1964.
Yellow (Z), light violet (Z), black (Z). 30.5 × 55.9. Ed 50 (45 wA, 3 bA, 1 wN, 1 nN), 9 TI (BFK), BAT (wA), 1 PP (wA) PrP II for Irwin Hollander (wA)[1], 9 AP (3 BFK, 3 wA, 2 bA, 1 nN), 2 PP (wA)[1], 1 TP (wA)[1]. Aris Koutroulis. Verso: D, I, WS.

1. For page 77 only.

Blank page

1075
Pages 68 and 71 (The Rime of the Ancient Mariner). Apr 28–Jun 1, 1964.
Black (Z). 30.5 × 55.9. Ed 50 (45 wA, 3 bA, 1 wN, 1 nN), 9 TI (BFK), BAT (wA), 1 PP (wA). None. printer (nr).

1075
Colophon (The Rime of the Ancient Mariner). Jun 5–12, 1964.
Black (Z). 30.5 × 59.1. Ed 50 (45 wA, 3 bA, 1 wN, 1 nN), 9 TI (BFK), BAT (wA), 1 PP (wA). None. D, S, BS (Tam).

Blank page

1075
Pages 78 and 73 (The Rime of the Ancient Mariner). Apr 24–May 21, 1964.
Black (Z). 30.5 × 56.2. Ed 50 (45 wA, 3 bA, 1 wN, 1 nN), 9 TI (BFK), BAT (wA), 1 PP (wA). None. printer (nr).

1099
Untitled. Jun 5–17, 1964.
Red (Z), blue (Z). 76.2 × 55.9. Ed 20 (wA), 9 TI (BFK), PrP (wA), PrP II for Irwin Hollander (wA), 3 AP (wA), 9 CTP (wA)[1]. Robert Gardner. D, S, Dat, BS.

1. Numbered in roman numerals. 3 CTP retained by Tamarind.

John Pearson

1739
Untitled. Mar 18–28, 1968.
Violet-grey (S), blue (S), green-yellow
(S). 38.4 × 38.4. Ed 20 (CD), 9 TI
(GEP), 1 UNMI (GEP), BAT (GEP), 5 AP
(3 GEP, 2 CD). Daniel Socha, NC.
Verso: WS (Tam), D, S, WS (UNM).

2255
Untitled. May 1–10, 1968.
Light violet (S), light yellow-green (S),
light blue-green (S). 50.8 × 50.8, cut.
Ed 18 (wA), 9 TI (BFK), 1 UNMI (wA),
BAT (wA), 4 TP (wA). Daniel Socha,
NC. Verso: WS (Tam), D, S, WS
(UNM).

William Pettet

2841
Untitled. Feb 3–25, 1970.
Yellow (A), light beige-yellow (A),
grey-brown, dark pink (A), beige (A).
53.3 × 76.2. Ed 20 (bA), 9 TI (bA), BAT
(bA), 2 AP (bA), PP (bA), 8 CTP (bA),
CP (bA). Eugene Sturman. Verso: D, S,
BS.

2842
Untitled. Feb 6–Mar 16, 1970.
Light green (A), red (A), grey-blue (A),
green-yellow (A), red-brown (A). 45.7
× 96.5. Ed 20 (cream CD), 9 TI (cream
CD), BAT (cream CD), 2 AP (cream
CD), 16 CTP (cream CD), CP (cream
CD). Larry Thomas. Verso: D, S, WS.

2843
Untitled. Feb 17–24, 1970.
B: Light violet, yellow, red, dark red
(S)[1], orange (S). 40.6 × 49.5. Ed 20
(CW), 9 TI (wA), BAT (CW), 7 AP (3 wA,
4 CW), 7 CTP (CW), CP (CW). Edward
Hamilton. Recto: D, S Verso: WS.

1. Image from run 2 transferred;
reversal.

2844
Untitled. Feb 26–Mar 25, 1970.
Violet (A), light red (A), green (A), pink
(A), dark violet (A). 12.7 × 30.2. Ed 20
(GEP), 9 TI (GEP), BAT (GEP), 3 AP
(GEP), 10 CTP (GEP), CP (GEP). S.
Tracy White. Verso: D, S, WS.

2845
Untitled. Feb 26–Mar 25, 1970.
Violet (A), orange (A), green (A),
orange-red (A), dark violet (A). 35.6 ×
76.8. Ed 20 (GEP), 9 TI (GEP), BAT
(GEP), 2 AP (GEP), 8 CTP (GEP), CP
(GEP). S. Tracy White. Verso: D, WS,
S.

2846
Untitled. Feb 26–Mar 25, 1970.
Violet (A), light red (A), green (A), pink
(A), dark violet (A). 7.6 × 7.6. Ed 20
(GEP), 9 TI (GEP), BAT (GEP), 2 AP
(GEP), 10 CTP (GEP), CP (GEP). S.
Tracy White. Verso: WS (top), D, I
(bottom).

2847
Untitled. Feb 26–Mar 25, 1970.
Violet (A), light red (A), green (A), pink
(A), dark violet (A). 12.4 × 17.8. Ed 20
(GEP), 9 TI (GEP), BAT (GEP), 3 AP
(GEP), 10 CTP (GEP), CP (GEP). S.
Tracy White. D, S, WS.

2848
Untitled. Feb 26–Mar 25, 1970.
Violet (A), light-red (A), green (A), pink
(A), dark-violet (A). 25.4 × 30.2. Ed 20
(GEP), 9 TI (GEP), BAT (GEP), 2 AP
(GEP), 10 CTP (GEP), CP (GEP). S.
Tracy White. Verso: D, S, WS.

2849
Untitled. Feb 26–Mar 25, 1970.
Violet (A), orange (A), green (A),
orange-red (A), dark violet (A). 22.9 ×
38.7. Ed 20 (GEP), 9 TI (GEP), BAT
(GEP), 3 AP (GEP), 10 CTP (GEP), CP
(GEP). S. Tracy White. Verso: D, S,
WS.

2850
Untitled. Mar 2–29, 1970.
Light blue (A), green (A), violet-pink
(A), yellow (A), violet-brown (A),
medium yellow (A). 59.1 × 71.5. Ed
20 (JG), 9 TI (JG), BAT (JG), 1 AP (JG),
12 CTP (JG), CP (JG). David
Trowbridge. Verso; D, S, WS.

2851
Untitled. Mar 3–28, 1970.
Red-brown (A), red (A), dark red-
brown (A), yellow-green (A), dark blue
(A). 75.3 × 101.9. Ed 20 (BFK), 9 TI
(BFK), BAT (BFK), 3 AP (BFK), 8 CTP
(BFK), CP (BFK). Hitoshi Takatsuki.
Verso: D, S, WS.

2855
Untitled. Mar 19–24, 1970.
Blue-black (S). 67.3 × 76.2. Ed 20
(ucR), 9 TI (ucR), BAT (ucR), 3 AP
(ucR), PTP (GEP), CP (ucR). Harry
Westlund. Verso: D, S, WS.

Peter Phillips

1428
Custom Print #1. Jul 24–27, 1965.
Black (A). 63.5 × 51.1. Ed 20 (BFK), 9
TI (wA), BAT (BFK), 1 AP (BFK), 1 PP
(BFK), 2 TP (bA), CP (Tcs). Clifford
Smith. BS, D, S, Dat.

Otto Piene

Sky Art, a suite of twenty-five
lithographs including title and
colophon pages. In order: 2730, 2725,
2722, 2713, 2720, 2728, 2711, 2712,
2710, 2709, 2723, 2746, 2729, 2724,
2715, 2726, 2733, 2732, 2714, 2727,
2706, 2716, 2708, 2721, 2731.

2706
Black Sun (Sky Art XXI). Aug 12–
25, 1969.
Red-orange (A), black (S). 88.9 × 63.5.
Ed 20 (BFK), 9 TI (cR), BAT (BFK), 2 AP
(BFK), 1 TP (cR), CP (cR). William Law
III. D, BS, S, Dat.

2708
Light Night (Sky Art XXIII). Aug
12–Sep 4, 1969.
Blue (S), black (A). 88.9 × 63.5. Ed 20
(BFK), 9 TI (cR), BAT (BFK), 3 AP (BFK),
CP (cR). Edward Hamilton. D, BS, S,
Dat.

2709
Clouds on Silver 2 (Sky Art X).
Aug 26–Sep 2, 1969.
Black (A), on aluminum Fasson foil.
88.9 × 63.5. Ed 20 (BFK), 9 TI (4 BFK,
5 cR), BAT (cR), 1 TP (cR), CP (BFK).
Charles Ringness. D, BS, S, Dat.

2710
Clouds on Silver 1 (Sky Art IX).
Aug 25–28, 1969.
Black (A), on aluminum Fasson foil.
88.9 × 63.5. Ed 20 (BFK), 9 TI (cR),
BAT (BFK), 3 AP (1 BFK, 2 cR), CP
(BFK). Jean Milant. D, BS, S, Dat.

2711
People People 1 (Sky Art VII). Aug
26–27, 1969.
Black (S). 88.9 × 63.5. Ed 20 (BFK), 9
TI (cR), BAT (BFK), 4 AP (3 cR, 1 BFK).
Paul Clinton. D, BS, S, Dat.

2712
People People 2 (Sky Art VIII). Aug
28–Sep 4, 1969.
Black (S)[1]. 88.9 × 63.5. Ed 20 (BFK),
9 TI (cR), BAT (BFK), 1 AP (BFK), 1 TP
(BFK), CP (BFK). Paul Clinton. D, BS, S,
Dat.

1. Stone held from 2711; reversal.

2713
Looping (Sky Art IV). Aug 29–Sep 3,
1969.
Black (A). 88.9 × 63.5. Ed 20 (BFK), 9
TI (cR), BAT (BFK), 3 AP (BFK), CP (cR).
S. Tracy White. D, BS, S, Dat.

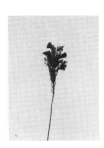

2714
Plain Sky Flower (Sky Art XIX).
Sep 2–4, 1969.
Black (A). 88.9 × 63.5. Ed 20 (BFK), 9
TI (cR), BAT (BFK), 2 AP (cR), 1 TP
(BFK), CP (BFK). Hitoshi Takatsuki. D,
BS, S, Dat.

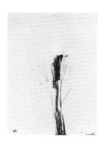

2715
Imagine a City Below (Sky Art XV). Sep 3–5, 1969.
Black (S). 88.9 × 63.5. Ed 20 (BFK), 9 TI (cR), BAT (BFK), 2 AP (1 BFK, 1 cR), CP (cR). William Law III. D, BS, S, Dat.

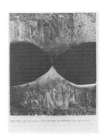

2723
New York Mirage (Sky Art XI). Sep 8–15, 1969.
Blue (S), black (A). 88.9 × 63.5. Ed 20 (BFK), 9 TI (cR), BAT (BFK), 1 TP (BFK), 1 CTP (BFK), CP (cR). John Sommers. D, BS, S, Dat.

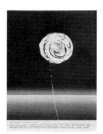

2716
Migrant Apparition (Sky Art XXII). Sep 4–12, 1969.
B: Violet, blue-violet, blue, dark green, green, yellow-green, yellow, orange, red, pink-red (S). 88.9 × 63.5. Ed 20 (BFK), 9 TI (cR), BAT (BFK), PrP II for Eugene Sturman (cR), 1 AP (cR), CP (cR). Jean Milant. D, BS (Tam, 2 Pr), S, Dat.

2724
Campus (Sky Art XIV). Sep 9–15, 1969.
Black (A). 88.9 × 63.5. Ed 20 (BFK), 9 TI (cR), BAT (BFK), 3 AP (2 cR, 1 BFK), 1 TP (BFK), CP (cR). William Law III. D, BS, S, Dat.

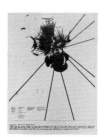

2720
Manned Helium Sculpture (Sky Art V). Sep 2–8, 1969.
Black (A). 88.9 × 63.5. Ed 20 (BFK), 9 TI (cR), BAT (BFK), 4 AP (2 BFK, 2 cR), 1 TP (BFK), CP (BFK). S. Tracy White. D, BS, S, Dat.

2725
Table of Contents (Sky Art II). Sep 10–12, 1969.
Black, yellow (A). 88.9 × 63.5. Ed 20 (BFK), 9 TI (cR), BAT (BFK), 1 AP (BFK), 3 TP (BFK), CP (cR). Paul Clinton. D, BS, S, Dat.

2721
Flaming Rainbow (Sky Art XXIV). Sep 5–12, 1969.
Black (A), yellow (A). 88.9 × 63.5. Ed 20 (BFK), 9 TI (cR), BAT (BFK), 3 AP (1 BFK, 2 cR), 1 TP (BFK), CP (BFK). Charles Ringness. D, BS, S, Dat.

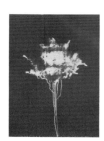

2726
Imagine a City Below by Night (Sky Art XVI). Sep 12–16, 1969.
Black (S). 88.9 × 63.5. Ed 20 (BFK), 9 TI (cR), BAT (BFK), 2 AP (cR), CP (BFK). Eugene Sturman. D, BS, S, Dat.

2722
Flying (Sky Art III). Sep 5–8, 1969.
Black (A). 88.9 × 63.5. Ed 20 (BFK), 9 TI (cR), BAT (cR), 6 AP (BFK), 1 TP (BFK), CP (BFK). Hitoshi Takatsuki. D, BS, S, Dat.

2727
Boston Harbor Project (Sky Art XX). Sep 16–18, 1969.
Black (S). 88.9 × 63.5. Ed 20 (BFK), 9 TI (cR), BAT (BFK), 3 AP (2 BFK, 1 cR), CP (cR). Edward Hamilton. D, BS, S, Dat.

2728
Y-O-U (Sky Art VI). Sep 17–18, 1968.
Black (A). 88.9 × 63.5. Ed 20 (BFK), 9
TI (cR), BAT (BFK), 5 AP (2 cR, 3 BFK),
CP (BFK). Paul Clinton. D, BS, S, Dat.

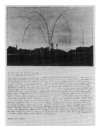

2729
*A Sequence of Equilibrium (Sky
Art XIII).* Sep 15–17, 1969.
Black (A). 88.9 × 63.5. Ed 20 (BFK), 9
TI (cR), BAT (BFK), 3 AP (BFK), CP
(BFK). John Sommers. D, BS, S, Dat.

2730
Title Page (Sky Art I). Sep 18–24,
1969.
B: Red, orange, light yellow, yellow-
green, blue, violet, red-violet, red (A),
B: orange, black (S). 88.9 × 63.5. Ed
20 (BFK), 9 TI (cR), BAT (BFK), 3 AP (1
cR, 2 BFK), 1 TP (BFK), 1 CP (cR).
William Law III. D, BS, S, Dat.

2731
*Colophon with California Grapes
(Sky Art XXV).* Sep 18–23, 1969.
Violet (A). 88.9 × 63.5. Ed 20 (BFK), 9
TI (cR), BAT (BFK), 2 AP (BFK), 1 TP
(BFK), CP (cR). Hitoshi Takatsuki. D,
BS, S, Dat.

2732
Theater in the Sky (Sky Art XVIII).
Sep 19–26, 1969.
Light blue (S). 88.9 × 63.5. Ed 20
(BFK), 9 TI (cR), BAT (BFK), CP (cR).
Edward Hamilton. D, BS, S, Dat.

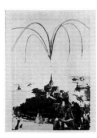

2733
*Mt. St. Michel and Above (Sky Art
XVII).* Sep 25–26, 1969.
Black (A). 88.9 × 63.5. Ed 20 (BFK), 9
TI (cR), BAT (BFK), 2 AP (BFK), CP
(BFK). Eugene Sturman. D, BS, S, Dat.

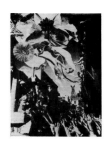

2746
*In and Over Mardi Gras (Sky Art
XII).* Sep 24–26, 1969.
Black (A). 88.9 × 63.5. Ed 20 (BFK), 9
TI (cR), BAT (BFK), 3 AP (BFK), CP
(BFK). S. Tracy White. D, S, Dat.

Gio Pomodoro

Tamarind Squares, a suite of sixteen
lithographs. In order: 2065, 2066,
2067, 2068, 2069, 2070, 2070II, 2071,
2071II, 2072, 2073, 2073II, 2074, 2075,
2076, 2076II.

1450
Out-In. Aug 5–6, 1965.
Red-black (S). 56.8 × 76.5. Ed 20
(BFK), 9 TI (wA), BAT (BFK), 2 AP (wA),
1 TP (BFK) CP (Tcs). Clifford Smith. D,
S, BS.

2065
*Study for a Seal (Tamarind
Squares I).* Jun 1–16, 1967.
Light yellow or blue or dark yellow
(S), blue or light yellow (S)[1]. 76.5 ×
56.5. Ed 20 (wA)[2], 9 TI (GEP)[2], BAT
(wA)[2], 3 AP (GEP)[2], 4 TP (wA)[2],
CP (wA)[2]. Serge Lozingot. D, S, BS.

1. Edition exists in three color
 variations. Variation I in light yellow
 and blue. Variation II in blue and
 light yellow and Variation III in dark
 yellow and light yellow.
2. Indicates Variation I, 1 AP, 2 TP, CP;
 indicates Variation II, Ed 1–10/20,
 BAT, 1 AP, 1 TP; indicates Variation
 III, Ed 11–20/20, 1 AP, 1 TP, 9 TI. One
 TP was originally signed as a BAT;
 the redesignation and date are
 noted on the verso and signed by
 the artist.

2066
Black Seal (Tamarind Squares II).
Jun 2–16, 1967.
Red (A), black (S). 76.5 × 56.5. Ed 20
(wA), 9 TI (GEP), BAT (wA), 3 AP
(GEP), 2 TP (wA), 2 CSP (wA), CP
(GEP). Maurice Sanchez. D, S, BS.

2067
White Seal (Tamarind Squares III).
Jun 6–21, 1967.
Brown (S), red (A), black (A). 76.8 ×
56.5. Ed 20 (wA), 9 TI (7 GEP, 2 wA),
BAT (wA), 2 TP (wA), CP (wA). Fred
Genis. D, S, BS.

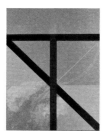

2068
*Square Against the Light
(Tamarind Squares IV).* Jun 9–28,
1967.
Light yellow (S), orange-yellow (S),
light green-yellow (S), black (A). 76.8
× 56.8. Ed 20 (wA), 9 TI (GEP), BAT
(wA), 2 AP (wA), 1 CTP (wA), CP (wA).
Maurice Sanchez. D, S, BS.

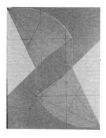

2069
*Yellow Spiral (Tamarind Squares
V).* Jul 7, 1967.
Yellow (S), black (A), orange (A). 76.8
× 56.5. Ed 15 (BFK), 9 TI (GEP), BAT
(BFK), 3 AP (1 BFK, 2 GEP) 1 TP (BFK),
3 CTP (wA), CP (BFK). David Folkman.
D, S, BS.

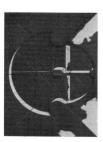

2070
*Double Green Seal (Tamarind
Squares VI).* Jun 21–29, 1967.
Red (S), green (A). 77.5 × 57.2. Ed 20
(BFK), 9 TI (GEP), BAT (BFK), 3 AP
(GEP), CP (BFK). Serge Lozingot. D, S,
BS.

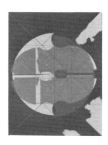

2070II
*Double Pink Seal (Tamarind
Squares VII).* Jun 22–Jul 5, 1967.
Red (S)[1], pink (A)[2]. 76.2 × 55.9. Ed
20 (BFK), 9 TI (GEP), BAT (BFK), 3 AP
(2 BFK, 1 GEP), 3 PP (1 BFK, 2 GEP), 1
CTP (BFK). Serge Lozingot. D, S, BS.

1. Stone held from 2070, run 1.
2. Plate held from 2070, run 2. 2070II
 differs from 2070 in color and in
 image. The central irregular shape
 was turned 180 degrees.

2071
*Blue Seal I (Tamarind Squares
VIII).* Jun 22–Jul 1, 1967.
Blue (A)[1], silver (S)[2], black (S)[3].
76.8 × 56.8. Ed 20 (BFK), 9 TI (GEP),
BAT (BFK), 3 AP (2 BFK, 1 GEP), 1 TP
(GEP), CP (BFK). Donald Kelley. D, S,
BS.

1. Plate held from 2071II, run 1.
2. Stone held from 2071II, run 2.
3. Same stone as run 2, registration
 moved slightly. 2071 differs from
 2071II in color and in image. The
 area around the broken circle shape
 is lighter. Light lines within the
 circle and in the lower portion of
 the image have been added. A light
 outline has been added at the left
 side of the main shape and
 outlining the light shape in the
 upper right.

2071II
Blue Seal II (Tamarind Squares IX).
Jun 22–29, 1967.
Blue (A), black (S). 76.8 × 56.5. Ed 20
(BFK), 9 TI (GEP), BAT (BFK), 2 AP (1
BFK, 1 GEP), 1 TP (GEP), 2 CSP (1 GEP,
1 BFK). Donald Kelley. D, S, BS.

2072
*Four Squares (Tamarind Squares
X).* Jun 27–Jul 14, 1967.
Orange-yellow (S), yellow (A). 76.5 ×
56.8. Ed 20 (BFK), 9 TI (GEP), BAT
(BFK), 3 AP (GEP), 3 PP (BFK), 2 CTP
(BFK), 4 CSP (GEP)[1], CP (GEP).
Anthony Ko. D, S, BS.

1. 2 CSP retained by Tamarind.

2073
*Male and Female Seal I (Tamarind
Squares XI).* Jun 29–Jul 19, 1967.
Black (S), red (A), yellow (A)[1]. 76.2
× 55.9 (acetate), cut. Ed 20 (BFK), 9 TI
(GEP), BAT (BFK), 3 AP (GEP). Anthony
Stoeveken. D, S, BS.

1. Runs 1 and 2 are printed on paper;
 run 3 is printed on clear acetate.

2073II
Male and Female Seal II (Tamarind Squares XII). Jun 29–Jul 28, 1967. Yellow (S)[1], red (A)[2], yellow-orange (S)[3]. 56.5 × 76.2 (acetate), cut. Ed 20 (18 GEP, 2 CD), 9 TI (CD), BAT (GEP), 2 AP (GEP), 1 TP* (BFK), 1 CTP (wA), 2 CSP (CD), CP* (GEP). Anthony Stoeveken. D, S, BS.

1. Stone held from 2073, run 3.
2. Plate held from 2073, run 2.
3. Stone held from 2073, run 1. runs 1 and 2 are printed on paper; run 3 is printed on clear acetate. 2073II differs from 2073 in color and in presentation as a horizontal. The image has been turned clockwise 90 degrees.

2074
Double Red Spiral (Tamarind Squares XIII). Jun 26–Jul 7, 1967. Red (S), silver (Z). 76.5 × 56.5. Ed 20 (BFK), 9 TI (GEP), BAT (BFK), 3 AP (GEP), 1 TP (BFK), CP (BFK). John Butke. D, S, BS.

2075
History of Five Squares (Tamarind Squares XIV). Jul 5–18, 1967. Yellow (A), red (A), black (S)[1]. 106.0 × 76.5 (acetate), cut. Ed 20 (GEP), 9 TI (GEP), BAT (GEP), 3 AP (GEP), 2 TP (GEP)[2], 1 CTP (GEP)[2], 4 CSP (GEP)[3], CP* (GEP). Maurice Sanchez. D, S, BS.

1. Runs 1 and 2 are printed on paper; run 3 is printed on clear acetate.
2. 2 TP, CTP on paper 101.6 × 76.2.
3. 2 CSP retained by Tamarind.

2076
Four Circles I (Tamarind Squares XV). Jul 10–19, 1967. Violet (S), brown (S). 76.5 × 56.8. Ed 20 (BFK), 9 TI (GEP), BAT (BFK), 2 AP (1 BFK, 1 GEP), 2 TP (BFK)[1]. John Butke. D, S, BS.

1. 1 TP varies from the edition.

2076
Four Circles II (Tamarind Squares XVI). Jul 22, 1967. Orange (S)[1]. 56.5 × 76.5. Ed 20 (GEP), 9 TI (CD), BAT (GEP), 2 AP (GEP), 1 TP (GEP), CP (GEP). John Butke. D, S, BS.

1. Stone held from 2076, run 2. 2076II differs from 2076 in color, image and in presentation as a horizontal. The medium tone double irregular curvilinear shape and an irregular line along the bottom edge have been eliminated. The lines forming a grid pattern in three-quarters of the composition have been eliminated. The image of 2076II has been turned clockwise 90 degrees.

Clayton Pond

2861
Mr. Huff's Teeth in the Articulator. Apr 8–9, 1970. Blue, red, pink (A). 76.2 × 55.9. Ed 20 (wA), 9 TI (GEP), BAT (wA), 2 AP (1 wA, 1 GEP), 5 CTP (1 GEP, 1 wA, 2 bA, 1 cR), 1 PTP* (bA). S. Tracy White. BS (Tam), T, D, S, BS (pr).

2861II
Mr. Huff's Teeth in the Articulator. Apr 8–9, 1970. Black (A)[1]. 76.2 × 56.5. Ed 10 (wA), 9 TI (bA), BAT (wA), 2 AP (1 wA, 1 bA), CP (bA). S. Tracy White. BS (Tam), T, D, S, BS (pr).

1. Plate held from 2861. 2861II differs from 2861 in color only.

2862
Nude in the Dentist Chair. Apr 10–13, 1970. Black (S). 76.2 × 56.5. Ed 20 (wA), 9 TI (GEP), BAT (wA), 2 AP (1 wA, 1 GEP), 6 PP (5 wA, 1 GEP), 1 TP (wA), 1 CTP (wA), 1 PTP (bA), CP (GEP). Larry Thomas. BS, D, T, S.

Rudy Pozzatti

XII Romans, a suite of fifteen lithographs including title, dedication and colophon pages, enclosed in a brown cloth covered box, measuring 44.6 × 31.8, lined with brown paper, secured with leather ties, made by the National Bindery, Indianapolis. The lithographs are enclosed in a soft chemise with the title page (Tamarind #773) on the recto and an image (Tamarind #766) on the verso. Each lithograph is enclosed in a brown Japanese paper chemise with the title printed in white from a woodblock carved by the artist. In order: 773, 766, 745A, 745B, 745C, 745D, 751A, 751B, 751D, 756A, 756B, 756C, 756D, 748, 762.

Bugs, a suite of ten lithographs including title, dedication and colophon pages, enclosed in a hard beige cloth covered wrap-around folder, measuring 26.7 × 20.3, lined with Arches paper, and a brown cloth covered slipcase, measuring 27.6 × 20.6, both made by the National Bindery, Indianapolis. In order: 770H, 770G, 770A, 770B, 770C, 770D, 770E, 770F, 770I, 776.

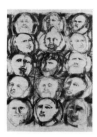

732
Council. Feb 4–5, 1963.
Black (S). 56.2 × 38.1. Ed 20 (BFK), 9
TI (wA), PrP (BFK), PrP II for Bohuslav
Horak (BFK), 3 AP (2 wA, 1 BFK), 2 PP
(BFK). John Rock. T, D, BS, S, Dat.

734
Forum. Feb 6–7, 1963.
Black (S). 56.5 × 76.2. Ed 20 (BFK), 9
TI (wA), PrP (BFK), PrP II for Bohuslav
Horak (BFK), 3 AP (1 BFK, 2 wA), 2 PP
(1 BFK, 1 wA). Joe Zirker. T, BS, S,
Dat.

737
Classic Ruins I. Feb 7–8, 1963.
Black (S). 50.2 × 52.7. Ed 20 (BFK), 9
TI (wN), PrP (BFK), PrP II for Bohuslav
Horak (BFK), 3 AP (2 BFK, 1 wN), 2 PP
(BFK), CP (BFK). Jason Leese. T, D, BS,
S, Dat.

738
Portraits in Stone I. Feb 8–12, 1963.
Black (S). 55.9 × 68.6. Ed 20 (BFK), 9
TI (wA), PrP (BFK), PrP II for Bohuslav
Horak (BFK), 3 AP (BFK), 2 PP (1 BFK,
1 wA). Joe Zirker. T, D, S, Dat, BS.

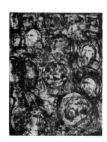

740
Portraits in Stone II. Feb 11–14,
1963.
Brown (S), black (S). 69.2 × 51.1. Ed
24 (wA), 9 TI (wN), PrP (wA), PrP II for
Bohuslav Horak (wA), 3 AP (2 wA, 1
wN), 2 PP (wN). John Rock. D, S, Dat,
BS.

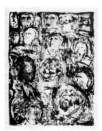

740A
Stone Portraits. Feb 14–15, 1963.
Black (S)[1]. 76.2 × 55.9. Ed 14 (BFK),
9 TI (wA), PrP (BFK), 2 AP (wA). Jason
Leese. BS, T, D, S, Dat.

1. Stone held from 740, run 2;
 deletions. 740A differs from 740 in
 color, image, and size. The
 background washes in the faces
 and some dark drawing at the left
 center edge have been eliminated.

744
Classic Ruins II. Feb 12–15, 1963.
Black (S). 52.7 × 55.9. Ed 20 (BFK), 9
TI (JG), PrP (BFK), PrP II for Bohuslav
Horak (BFK), 3 AP (2 JG, 1 BFK), 2 PP
(BFK). Joe Zirker. T, D, BS, S, Dat.

745A
Marcus Aurelius (XII Romans III).
Feb 14–18, 1963.
Red-black (S). 38.7 × 28.6. Ed 20 (bA),
9 TI (nN), PrP (bA), PrP II for Bohuslav
Horak (bA), 3 AP (2 nN, 1 bA), 1 PP
(bA). John Rock. T, D, S, Dat, BS.

745B
Numa Pompilius (XII Romans IV).
Feb 14–18, 1963.
Red-black (S). 38.7 × 28.6. Ed 20 (bA),
9 TI (nN), PrP (bA), PrP II for Bohuslav
Horak (bA), 3 AP (2 nN, 1 bA). John
Rock. T, D, S, Dat, BS.

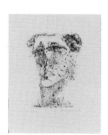

745C
Agrippa (XII Romans V). Feb 14–18,
1963.
Red-black (S). 38.7 × 28.6. Ed 20 (bA),
9 TI (nN), PrP (bA), PrP II for Bohuslav
Horak (bA), 3 AP (2 nN, 1 bA), 2 PP
(bA). John Rock. T, D, S, Dat, BS.

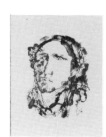

745D
Scipio Africanus (XII Romans VI).
Feb 14–18, 1963.
Red-black (S). 38.7 × 28.6. Ed 20 (bA),
9 TI (nN), PrP (bA), PrP II for Bohuslav
Horak (bA), 3 AP (2 nN, 1 bA), 2 PP
(bA). John Rock. T, D, S, Dat, BS.

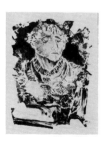

748
Julius Ceasar (XII Romans XIV).
Feb 18–19, 1963.
Red-black (S). 38.7 × 28.6. Ed 20 (bA),
9 TI (nN), PrP (bA), PrP II for Bohuslav
Horak (bA), 3 AP (2 bA, 1 nN), 2 TP
(bA). Jason Leese. T, BS, D, S, Dat.

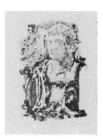

751A
Caligula (XII Romans VII). Feb 20–21, 1963.
Red-black (S). 38.7 × 28.6. Ed 20 (bA), 9 TI (nN), PrP (bA), PrP II for Bohuslav Horak (bA), 3 AP (2 bA, 1 nN), 1 PP (bA). John Rock. T, D, BS, S, Dat.

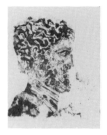

751B
Hadrian (XII Romans VIII). Feb 20–21, 1963.
Red-black (S). 38.7 × 28.6. Ed 20 (bA), 9 TI (nN), PrP (bA), PrP II for Bohuslav Horak (bA), 3 AP (2 bA, 1 nN), 1 PP (bA). John Rock. T, D, S, Dat, BS.

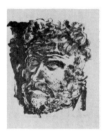

751C
Caracalla. Feb 20–21, 1963.
Red-black (S). 38.7 × 28.6. Ed 20 (bA), 9 TI (nN), PrP (bA), PrP II for Bohuslav Horak (bA), 3 AP (2 bA, 1 nN), 1 TP (bA). John Rock. T, D, BS, S, Dat.

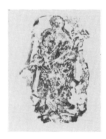

751D
Titus (XII Romans IX). Feb 20–21, 1963.
Red-black (S). 38.7 × 28.6. Ed 20 (bA), 9 TI (nN), PrP (bA), PrP II for Bohuslav Horak (bA), 3 AP (2 bA, 1 nN), 1 PP (bA). John Rock. T, D, BS, S, Dat.

752
Classic Ruins III. Feb 21–Mar 1, 1963.
Ochre (S), black (S). 56.5 × 76.2. Ed 25 (BFK), 9 TI (wN), PrP (BFK), PrP II for Bohuslav Horak (BFK), 1 AP (wN), 1 PP (wN). John Rock. T, D, S, Dat, BS.

756A
Cicero (XII Romans X). Feb 23–26, 1963.
Red-black (S). 38.7 × 28.6. Ed 20 (bA), 9 TI (nN), PrP (bA), PrP II for Bohuslav Horak (bA), 2 AP (bA), 2 PP (bA), 2 TP (bA). John Rock. T, D, BS, S, Dat.

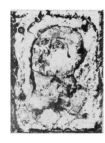

756B
Trajan (XII Romans XI). Feb 23–26, 1963.
Red-black (S). 38.7 × 28.6. Ed 20 (bA), 9 TI (nN), PrP (bA), PrP II for Bohuslav Horak (bA), 2 AP (bA), 1 PP (bA), 2 TP (bA). John Rock. T, D, S, Dat, BS.

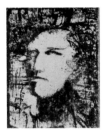

756C
Vespasian (XII Romans XII). Feb 23–26, 1963.
Red-black (S). 38.7 × 28.6. Ed 20 (bA), 9 TI (nN), PrP (bA), PrP II for Bohuslav Horak (bA), 2 AP (bA), 2 PP (1 nN, 1 bA), 2 TP (bA). John Rock. T, D, S, Dat, BS.

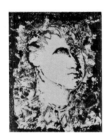

756D
Octavius (XII Romans XIII). Feb 23–26, 1963.
Red-black (S). 38.7 × 28.6. Ed 20 (bA), 9 TI (nN), PrP (bA), PrP II for Bohuslav Horak (bA), 3 AP (2 bA, 1 nN), 2 PP (1 nN, 1 bA), 2 TP (bA). John Rock. BS, T, D, S, Dat.

758
Ruins at Night. Mar 1–5, 1963.
Black (S). 49.5 × 53.3. Ed 20 (BFK), 9 TI (wA), PrP (BFK), PrP II for Bohuslav Horak (BFK), 3 AP (2 BFK, 1 wA), 2 PP (1 BFK, 1 wA), 1 TP (BFK). John Rock. T, D, S, Dat, BS.

759
Janus. Mar 2–8, 1963.
Blue-green (S), red-brown (S). 56.8 × 71.1. Ed 20 (BFK), 9 TI (wN), PrP (BFK), PrP II for Bohuslav Horak (BFK), 3 AP (1 BFK, 2 wN), 2 PP (BFK), 1 TP (BFK). John Rock. BS, T, D, S, Dat.

Numbers 759A, 762, 764, 766, 766A, 767, 770A, 770B, 770C, 770D, 770E, 770F, 770G, 770H, 770I, 773, 774, 776. 779 see page 281.

Kenneth Price

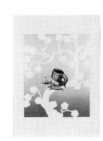

2491
Japanese Tree Frog Cup. Nov 15–Dec 10, 1968.
B: Light violet, light blue, dark blue (A) red (S), violet, green (A), dark violet (A). 63.5 × 43.8. Ed 20 (GEP)[1], 9 TI (BFK), BAT (GEP), 4 AP (1 GEP, 3 BFK), 1 TP (GEP), 4 CTP (1 GEP, 1 BFK, 1 CD, 1 wA). Manuel Fuentes. Verso: WS, D, T, S, Dat.

1. Ed 8–20/20 vary from the edition.

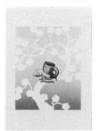

2491A
Japanese Tree Frog Cup. Nov 16–
Dec 31, 1968.
Red-violet (A)[1], red (S)[2], brown,
black (A)[3], brown (A)[4], with gold
leaf. 63.5 × 45.7. 6 ExP (MI)[5], 1 PP
(MI), 1 TP (MI), CP* (MI). Manuel
Fuentes. Verso: WS, D, T, S, Dat.

1. Plate held from 2491, run 1.
2. Stone held from 2491, run 2.
3. Plate held from 2491, run 3.
4. Plate held from 2491, run 4. 2491A
 differs from 2491 in color only.
5. Designated A–F. 3 ExP retained by
 Tamarind.

2492
Frog Cup. Nov 15–Dec 10, 1968.
Violet (A), green (S), red, blue (A),
blue (A). 63.5 × 50.2. Ed 20 (GEP), 9
TI (BFK), BAT (GEP), 3 AP (2 BFK, 1
GEP), 1 TP (GEP), 5 CTP (1 wA, 1 BFK,
3 CD), CP (MI). Manuel Fuentes. Verso:
WS, D, T, S, Dat.

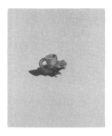

Print not in
University Art Museum
Archive

2494
Acrobatic Frog Cup. Nov 21–Dec 24,
1968.
Green, red, grey (A), blue (S), light
orange (A), violet (A). 58.1 × 76.8, cut.
Ed 20 (CD), 9 TI (GEP), BAT (GEP), 2
AP (CD), 6 CTP (1 MI, 1 BFK, 1 CD, 3
GEP), CP (GEP). Robert Rogers. Verso:
WS, D, T, S, Dat.

2495
Jivaroland Frog Cup. Nov 25–Dec
11, 1968.
Yellow (A), B: red, black (A), green (S).
55.9 × 43.2, cut. Ed 20 (CD), 9 TI (CD),
BAT (CD), 6 AP (CD), 1 TP (GEP), 6 CTP
(GEP), 6 PgP (CD)[1], CP (CD). Jean
Milant. Verso: WS, D, T, S, Dat.

1. 3 PgP retained by Tamarind.

2496
Double Frog Cup. Nov 25–Dec 11,
1968.
Violet (A), yellow, red (A), blue (S).
55.9 × 41.9, cut. Ed 20 (CD), 9 TI (CD),
BAT (CD), 3 AP (CD), 1 TP (GEP), 5 CTP
(GEP), 6 PgP (CD)[1], CP (CD). Jean
Milant. Verso: WS, D, T, S, Dat.

1. 3 PgP retained by Tamarind.

2497
Frog Cup. Dec 7–23, 1968.
Yellow (A), black, blue-grey (A), red
(A), blue (S). 57.2 × 43.2, cut. Ed 20
(GEP), 9 TI (CD), BAT (GEP), 3 AP
(GEP), 1 TP* (CD), 7 CTP (2 GEP, 5
CD), CP (GEP). Daniel Socha. Verso:
WS, D, T, S, Dat.

Print not in
University Art Museum
Archive

2498
Untitled. Dec 7–16, 1968.
Red, violet (A), blue (A), yellow (A),
dark blue (S). 54.6 × 40.6, cut. 4 TP (2
GEP, 2 CD)[1]. Daniel Socha. D, BS, S,
Dat.

1. 2 TP (1 GEP, 1 CD) vary from the
 edition. 1 TP (GEP) retained by
 Tamarind.

2499
Acrobatic Frog Cup II. Dec. 21–Jan.
14, 1969
Green (A), B: grey, pink (A), red (A),
black (A)[1]. 58.4 × 78.7. Ed 20 (CD), 9
TI (GEP), BAT (CD), 7 AP (5 CD, 2
GEP), 3 CTP (1 CD, 2 GEP), CP (GEP).
Donald Kelley. Verso: WS, D, T, S, Dat.

1. Same plate as run 3.

2500
Cup Gets the Worm. Dec 10–13,
1968.
Black (A). 36.2 × 27.9. Ed 20 (GEP), 9
TI (CD), BAT (GEP), 3 AP (2 CD, 1
GEP), 3 TP (1 GEP*, 1 CD, 1 BFK*), CP
(CD). Kenjilo Nanao. Verso: WS, D, T,
S, Dat.

2501
Turtle Cup. Dec 13–24, 1968.
Brown (S). 50.8 × 66.0. Ed 20 (GEP), 9
TI (CD), BAT (GEP), 5 AP (1 CD, 4
GEP), 1 TP (GEP), 2 CTP (GEP). Serge
Lozingot. Verso: WS, D, T, S, Dat.

2501II
Sea Turtle Cup. Dec 27, 1968–Jan 3,
1969.
Blue (S), brown (S)[1]. 44.8 × 50.8,
cut. Ed 20 (CD), 9 TI (GEP), BAT (CD), 4
AP (3 CD, 1 GEP) 4 TP* (1 CD, 3 GEP),
3 CTP (CD), CP (GEP). Robert Rogers.
Verso: WS, D, T, S, Dat.

1. Stone held from 2501, run 2. 2501II
 differs from 2501 in color, image
 and size. A background drawing
 forming a rectangle and border on
 all four sides has been added.

Krishna N. Reddy

1229
Landscape. Jan 1–14, 1965.
Blue-grey (S), dark blue (S),
transparent beige (Z). 44.5 × 64.5. Ed
20 (BFK), 9 TI (wA), BAT (BFK), 3 AP*
(BFK), 4 TP* (BFK), CP (BFK). Kenneth
Tyler. D, BS, S.

Jesse Reichek

e.g.a., a suite of six lithographs plus title and colophon pages, enclosed in a wrap-around folder of white Nacre. Title page and colophon printed at the Plantin Press, Los Angeles. In order: 1755, 1768, 1752, 1751, 1753, 1754.

e.g.b., a suite of six lithographs plus title and colophon pages, enclosed in a wrap-around folder of white Nacre. Title page and colophon printed at the Plantin Press, Los Angeles. In order: 1763, 1756, 1757, 1759, 1758, 1760.

Hommage à Kandinsky, a suite of twenty-four lithographs plus title and colophon pages, enclosed in a black cloth covered box, measuring 18.1 × 17.8, lined with beige paper, made by the Schuberth Bookbindery, San Francisco. The lithographs are enclosed in a three-part wrapper of Copperplate Deluxe with the title page and colophon in black printed at the Plantin Press, Los Angeles. Each lithograph enclosed in a chemise of white Sekishu paper. In order: 1774, 1775, 1776, 1777, 1778, 1779, 1780, 1781, 1782, 1783, 1784, 1785, 1786, 1787, 1788, 1789, 1790, 1791, 1792, 1793, 1795, 1796, 1797, 1798.

Hommage à Klee, a suite of twenty-four lithographs plus title and colophon pages, enclosed in a grey cloth covered box, measuring 18.1 × 17.8, lined with beige paper, made by the Schuberth Bookbindery, San Francisco. The lithographs are enclosed in a three-part wrapper of Copperplate Deluxe with the title page and colophon in yellow printed at the Plantin Press, Los Angeles. Each lithograph enclosed in a chemise of white Sekishu paper. One suite designated "Tamarind Impression" contains only twelve lithographs; 1774II, 1776II, 1778II, 1779II, 1783II, 1785II, 1786II, 1788II, 1795II-1798II. There may be a discrepancy in CD and GEP for the Tamarind Impressions. Images for 1774II-1793II, 1795II-1798II were transferred stone to stone from 1774–1793, 1795–1798; reversal. The new images vary in color and in image. In order: 1774II, 1775II, 1776II, 1777II, 1778II, 1779II, 1780II, 1781II, 1782II, 1783II, 1784II, 1785II, 1786II, 1787II, 1788II, 1789II, 1790II, 1791II, 1792II, 1793II, 1795II, 1796II, 1797II, 1798II.

Hommage à Mondrian, a suite of twenty-four lithographs plus title and colophon pages, enclosed in green-grey cloth covered box, measuring 18.1 × 17.8, lined with beige paper, made by the Schuberth Bookbindery, San Francisco. The lithographs are enclosed in a three-part wrapper of Copperplate Deluxe with the title page and colophon in red printed at the Plantin Press, Los Angeles. Each lithograph is enclosed in a chemise of white Sekishu paper. The stone was held from 1774–1793, 1795–1798.

1774II-1793II and 1795II-1798II differ from 1774–1793, 1795–1798 in color and in image. A solid bleed background has been added. 1 TP is on paper 66.0 × 92.7, uncut. In order: 1774III, 1775III, 1776III, 1777III, 1778III, 1779III, 1780III, 1781III, 1782III, 1783III, 1784III, 1785III, 1786III, 1787III, 1788III, 1789III, 1790III, 1791III, 1792III, 1793III, 1795III, 1796III, 1797III, 1798III.

1750
Untitled. Jun 30–Jul 11, 1966. Black (S). 45.0 × 57.5. Ed 16 (JG), 9 TI (8 GEP, 1 JG), BAT (JG), CP (EVB). Donn Steward Verso: D, S, Dat, WS.

1751
Untitled (e.g.a., IV). Jul 5–8, 1966. Blue-black (Z), black (Z). 45.4 × 57.8. Ed 20 (JG), 9 TI (GEP), BAT (JG), 2 AP (1 JG, 1 GEP), 1 TP (JG), 2 CSP (EVB)[1], CP (EVB). Robert Evermon. Verso: D, S, Dat, WS.

1. Unsigned, unchopped.

1752
Untitled (e.g.a., III). Jul 2–14, 1966. Brown (S), black (Z). 45.1 × 57.8. Ed 20 (JG), 9 TI (GEP), BAT (JG), 2 AP (1 JG, 1 GEP), 2 CSP (EVB)[1], CP (EVB). Ernest de Soto. Verso: D, S, Dat, WS.

1. Unsigned, unchopped.

1753
Untitled (e.g.a., V). Jul 5–26, 1966. Brown (S), black (S). 45.1 × 57.8. Ed 20 (JG), 9 TI (GEP), BAT (JG), 3 AP (GEP), 3 TP (JG), 2 CSP (EVB)[1], CP (EVB). John Dowell. Verso: D, S, Dat, WS.

1. Unsigned, unchopped.

1754
Untitled (e.g.a., VI). Jul 6–Aug 1, 1966. Violet (Z), black (Z). 45.1 × 57.8. Ed 20 (JG), 9 TI (GEP), BAT (JG), 3 AP (1 GEP, 2 JG), 3 TP (JG)[1], 2 CSP (EVB)[2], CP (EVB). Jack Lemon. Verso: D, S, Dat, WS.

1. 1 TP varies from the edition.
2. Unsigned, unchopped.

1755
Untitled (e.g.a., I). Jul 11–21, 1966. Transparent black (Z), opaque black (Z). 45.1 × 57.8. Ed 20 (JG), 9 TI (GEP), BAT (JG), 3 AP (GEP), 2 TP (JG), 2 CSP (EVB)[1], CP (EVB). Erwin Erickson. Verso: D, S, Dat, WS.

1. Unsigned, unchopped.

1756
Untitled (e.g.b., II). Aug 2–3, 1966.
Blue-black (A). 45.1 × 57.8. Ed 20
(JG), 9 TI (GEP), BAT (JG), 2 AP (1 JG,
1 GEP), CP (EVB). Robert Evermon.
Verso: D, S, Dat, WS.

1757
Untitled (e.g.b., III). Jul 27–Aug 2,
1966.
Blue (S), black (Z). 45.1 × 57.8. Ed 20
(JG), 9 TI (GEP), BAT (JG), 3 AP (1 JG,
2 GEP), 3 TP (JG), 2 CSP (EVB)[1], CP
(EVB). Erwin Erickson. Verso: D, S,
Dat, WS.

1. Unsigned, unchopped.

1758
Untitled(e.g.b., V). Jul 28–Aug 1,
1966.
Blue (S), black (Z). 45.1 × 57.8. Ed 20
(JG), 9 TI (GEP), BAT (JG), 2 AP (GEP),
2 TP (JG), 2 CSP (EVB)[1], CP (EVB).
Ian Lawson. Verso: D, S, Dat, WS.

1. Unsigned, unchopped.

1759
Untitled (e.g.b., IV). Jul 28–Aug 4,
1966.
Blue (Z), black (Z). 45.1 × 57.8. Ed 20
(JG), 9 TI (GEP), BAT (JG), 3 AP (1 JG,
2 GEP), 3 TP (JG), 2 CSP (EVB[1], CP
(EVB). Robert Bigelow. Verso: D, S,
Dat, WS.

1. Unsigned, unchopped.

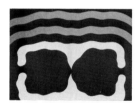

1760
Untitled (e.g.b., VI). Aug 3–5, 1966.
Blue (A), black (A). 45.1 × 57.8. Ed 20
(JG), 9 TI (GEP), BAT (JG), 3 AP (JG), 2
CSP (EVB)[1], CP (EVB). Robert
Evermon. Verso: D, S, Dat, WS.

1. Unsigned, unchopped.

1761
Untitled. Jul 20–22, 1966.
Black (S). 45.1 × 57.8. Ed 20 (JG), 9 TI
(GEP), BAT (JG), 3 AP (2 JG, 1 GEP), 2
TP (JG), CP (EVB). Ian Lawson. Verso:
D, S, Dat, WS.

1762
Untitled. Aug 11–16, 1966.
Orange (S), yellow (Z). 45.1 × 58.1. Ed
20 (JG), 9 TI (GEP), BAT (JG), 3 AP (1
JG, 2 GEP), 3 TP (JG), CP (EVB).
Ernest de Soto. Verso: D, S, Dat, WS.

1. Unsigned, unchopped.

1763
Untitled (e.g.b., I). Aug 1–2, 1966.
Black (A). 45.1 × 57.8. Ed 20 (JG), 9 TI
(GEP), BAT (JG), 1 AP (GEP), 1 TP (JG),
CP (EVB). Ernest de Soto. Verso: D, S,
Dat, WS.

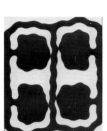

1764
Untitled. Aug 2–4, 1966.
Black (A). 74.3 × 58.1. Ed 20 (BFK), 9
TI (GEP), BAT (BFK), 1 AP (GEP), 1 TP
(BFK). Ian Lawson. Verso: D, S, Dat,
WS.

1765
Untitled. Aug 8–18, 1966.
Orange (S), black (S). 104.1 × 79.4. Ed
20 (GEP), 9 TI (GEP), BAT (GEP), 3 AP
(GEP), 2 TP (GEP), CP (EVB). Robert
Bigelow. Verso: D, S, Dat, WS.

1766
Untitled. Aug 10–18, 1966.
Blue (S), black (Z). 99.1 × 55.9. Ed 20
(GEP), 9 TI (CD), BAT (GEP), 1 AP (CD),
CSP (EVB)[1]. Ian Lawson. Verso: D, S,
Dat, WS.

1. Unsigned, unchopped.

1766II
Untitled. Aug 19–22, 1966.
Black (Z)[1]. 99.1 × 55.9. Ed 10 (GEP),
9 TI (CD), BAT (GEP), CP (EVB). Ian
Lawson. Verso: D, S, Dat, WS.

1. Plate held from 1766, run 2. 1766II
differs from 1766 in color and in
image. At the top, the light irregular
halo and the dark background that
divided the image into three equal
parts has been eliminated. The
central portion of the middle shape
and the dark irregular halo
surrounding the lower shape have
been eliminated.

1767
Untitled. Aug 4–15, 1966.
Red (Z), black (Z). 57.8 × 90.2. Ed 20
(BFK), 9 TI (GEP), BAT (BFK), 2 AP
(GEP), 2 PP (BFK), 2 CSP (EVB)[1], CP
(EVB). Erwin Erickson. Verso: D, S,
Dat, WS.

1. Unsigned, unchopped.

1768
Untitled (e.g.a., II). Aug 15–23, 1966.
Transparent black (S), opaque black
(Z). 45.1 × 57.8. Ed 20 (JG), 9 TI
(GEP), BAT (JG), 3 AP (GEP), 2 TP (JG),
CP (EVB). Erwin Erickson. Verso: D, S,
Dat, WS.

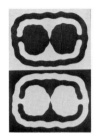

1769
Untitled. Aug 11–12, 1966.
Black (Z). 90.2 × 57.8. Ed 20 (BFK), 9
TI (GEP), BAT (BFK), 2 PP (BFK), 2 TP
(BFK), CP (EVB). Robert Evermon.
Verso: D, S, Dat, WS.

1770
Untitled. Aug 4–9, 1966.
Red (S), black (A). 57.8 × 86.4. Ed 20
(BFK), 9 TI (GEP), BAT (BFK), 2 AP
(GEP), 2 CSP (EVB)[1], CP (EVB). Jack
Lemon. Verso: D, S, Dat, WS.

1. Unsigned, unchopped.

1771
Untitled. Aug 19–26, 1966.
Yellow (S), black (S). 106.0 × 75.6. Ed
20 (GEP), 9 TI (GEP), BAT (GEP), 2 AP
(GEP), 3 TP (GEP), CP (GEP). Robert
Evermon. Verso: D, S, Dat, WS.

1774
Untitled (Hommage à Kandinsky I).
.Aug 15, 1966.
Black (S). 15.2 × 15.2, cut. Ed 20 (MI),
9 TI (GEP), BAT (MI), 1 AP (GEP), 2 TP
(MI). Jack Lemon. D, S, Dat, BS
(colophon).

1774II
Untitled (Hommage à Klee I). Aug
18–23, 1966.
Yellow (S). 15.2 × 15.2, cut. Ed 20
(GEP), 9 TI (8 CD, 1 GEP), BAT (GEP), 3
AP (1 GEP, 2 CD), 2 TP (GEP). Jack
Lemon. D, S, Dat, BS (colophon).

1774III
Untitled (Hommage à Mondrian I).
Aug 25–30, 1966.
Red (S), black (S). 15.2 × 15.2, cut. Ed
20 (GEP), 9 TI (CD), BAT (GEP), 2 AP
(CD), 1 TP (GEP), CP (EVB). Jack
Lemon. D, S, Dat, BS (colophon).

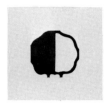

1775
*Untitled (Hommage à Kandinsky
II).* Aug 15, 1966.
Black (S). 15.2 × 15.2, cut. Ed 20 (MI),
9 TI (GEP), BAT (MI), 2 AP (GEP, MI), 2
TP (MI). Jack Lemon. D, S, Dat, BS
(colophon).

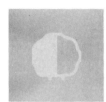

1775II
Untitled (Hommage à Klee II). Aug
18–23, 1966.
Yellow (S). 15.2 × 15.2, cut. Ed 20
(GEP), 9 TI (8 CD, 1 GEP), BAT (GEP), 2
AP (1 GEP, 1 CD), 1 TP (GEP). Jack
Lemon. D, S, Dat, BS (colophon).

1775III
Untitled (Hommage à Mondrian II).
Aug 25–30, 1966.
Red (S), black (S). 15.2 × 15.2, cut. Ed
20 (GEP), 9 TI (CD), BAT (GEP), 3 AP
(CD), 2 TP (GEP),CP (EVB). Jack
Lemon. D, S, Dat, BS (colophon).

1776
*Untitled (Hommage à Kandinsky
III).* Aug 15, 1966.
Black (S). 15.2 × 15.2, cut. Ed 20 (MI),
9 TI (GEP), BAT (MI), 2 AP (GEP), 2 TP
(MI). Jack Lemon. D, S, Dat, BS,
(colophon).

1776II
Untitled (Hommage à Klee III). Aug
18–23, 1966.
Yellow (S)[1]. 15.2 × 15.2, cut. Ed 20
(GEP), 9 TI (8 CD, 1 GEP), BAT (GEP), 3
AP (1 GEP, 2 CD), 2 TP (GEP). Jack
Lemon. D, S, Dat, BS (colophon).

1776III
*Untitled (Hommage à Mondrian
III).* Aug 25–30, 1966.
Red (S), black (S). 15.2 × 15.2, cut. Ed
20 (GEP), 9 TI (CD), BAT (GEP), 3 AP
(CD), 2 TP (GEP), CP (EVB). Jack
Lemon. D, S, Dat, BS (colophon).

1777
*Untitled (Hommage à Kandinsky
IV).* Aug 15, 1966.
Black (S). 15.2 × 15.2, cut. Ed 20 (MI),
9 TI (GEP), BAT (MI), 2 AP (GEP MI), 2
TP (MI). Jack Lemon. D, S, Dat, BS
(colophon).

1777II
Untitled (Hommage à Klee IV). Aug 18–23, 1966.
Yellow (S). 15.2 × 15.2, cut. Ed 20 (GEP), 9 TI (8 CD, 1 GEP), BAT (GEP), 2 AP (1 GEP, 1 CD), 2 TP (GEP). Jack Lemon. D, S, Dat, BS (colophon).

1777III
Untitled (Hommage à Mondrian IV). Aug 25–30, 1966.
Red (S), black (S). 15.2 × 15.2, cut. Ed 20 (GEP), 9 TI (CD), BAT (GEP), 3 AP (CD), 2 TP (GEP), CP (EVB). Jack Lemon. D, S, Dat, BS (colophon).

1778
Untitled (Hommage à Kandinsky V). Aug 15, 1966.
Black (S). 15.2 × 15.2, cut. Ed 20 (MI), 9 TI (GEP), BAT (MI), 2 AP (GEP MI), 2 TP (MI). Jack Lemon. D, S, Dat, BS, (colophon).

1778II
Untitled (Hommage à Klee V). Aug 18–23, 1966.
Yellow (S)[1]. 15.2 × 15.2, cut. Ed 20 (GEP), 9 TI (8 CD[2], 1 GEP)[3], BAT (GEP), 3 AP (1 GEP, 2 CD), 2 TP (GEP). Jack Lemon. D, S, Dat, BS (colophon).

1778III
Untitled (Hommage à Mondrian V). Aug 25–30, 1966.
Red (S), black (S). 15.2 × 15.2, cut. Ed 20 (GEP), 9 TI (CD), BAT (GEP), 3 AP (CD), 2 TP (GEP), CP (EVB). Jack Lemon. D, S, Dat, BS (colophon).

1779
Untitled (Hommage à Kandinsky VI). Aug 15, 1966.
Black (S). 15.2 × 15.2, cut. Ed 20 (MI), 9 TI (GEP), BAT (MI), 2 AP (GEP)[1], 2 TP (MI). Jack Lemon. D, S, Dat, BS (colophon).

1779II
Untitled (Hommage à Klee VI). Aug 18–23, 1966.
Yellow (S). 15.2 × 15.2, cut. Ed 20 (GEP), 9 TI (8 CD, 1 GEP), BAT (GEP), 3 AP (1 GEP, 2 CD), 2 TP (GEP). Jack Lemon. D, S, Dat, BS (colophon).

1779III
Untitled (Hommage à Mondrian VI). Aug 25–30, 1966.
Red (S), black (S). 15.2 × 15.2, cut. Ed 20 (GEP), 9 TI (CD), BAT (GEP), 3 AP (CD), 2 TP (GEP), CP (EVB). Jack Lemon. D, S, Dat, BS (colophon).

1780
Untitled (Hommage à Kandinsky VII). Aug 15, 1966.
Black (S). 15.2 × 15.2, cut. Ed 20 (MI), 9 TI (GEP), BAT (MI), 2 AP (GEP), 2 TP (MI). Jack Lemon. D, S, Dat, BS (colophon).

1780II
Untitled (Hommage à Klee VII). Aug 18–23, 1966.
Yellow (S). 15.2 × 15.2, cut. Ed 20 (GEP), 9 TI (8 CD, 1 GEP), BAT (GEP), 2 AP (1 GEP, 1 CD), 2 TP (GEP). Jack Lemon. D, S, Dat, BS (colophon).

1780III
Untitled (Hommage à Mondrian VII). Aug 25–30, 1966.
Red (S), black (S). 15.2 × 15.2, cut. Ed 20 (GEP), 9 TI (CD), BAT (GEP), 3 AP (CD), 2 TP (GEP), CP (EVB). Jack Lemon. D, S, Dat, BS (colophon).

1781
Untitled (Hommage à Kandinsky VIII). Aug 15, 1966.
Black (S). 15.2 × 15.2, cut. Ed 20 (MI), 9 TI (GEP), BAT (MI), 1 AP (GEP), 2 TP (MI). Jack Lemon. D, S, Dat, BS (colophon).

1781II
Untitled (Hommage à Klee XIII). Aug 18–23, 1966.
Yellow (S). 15.2 × 15.2, cut. Ed 20 (GEP), 9 TI (8 CD, 1 GEP), BAT (GEP), 2 AP (1 GEP, 1 CD), 1 TP (GEP). Jack Lemon. D, S, Dat, BS (colophon).

1781III
Untitled (Hommage à Mondrian VIII). Aug 25–30, 1966.
Red (S), black (S). 15.2 × 15.2, cut. Ed 20 (GEP), 9 TI (CD), BAT (GEP), 2 AP (CD), 2 TP (GEP), CP (EVB). Jack Lemon. D, S, Dat, BS (colophon).

1782
Untitled (Hommage à Kandinsky IX). Aug 15, 1966.
Black (S). 15.2 × 15.2, cut. Ed 20 (MI), 9 TI (GEP), BAT (MI), 1 AP (GEP), 2 TP (MI). Jack Lemon. D, S, Dat, BS (colophon).

1784II
Untitled (Hommage à Klee XI). Aug 18–23, 1966.
Yellow (S). 15.2 × 15.2, cut. Ed 20 (GEP), 9 TI (8 CD, 1 GEP), BAT (GEP), 2 AP (1 GEP, 1 CD), 2 TP (GEP). Jack Lemon. D, S, Dat, BS (colophon).

1782II
Untitled (Hommage à Klee IX). Aug 18–23, 1966.
Yellow (S). 15.2 × 15.2, cut. Ed 20 (GEP), 9 TI (8 CD, 1 GEP), BAT (GEP), 2 AP (1 GEP, 1 CD), 2 TP (GEP). Jack Lemon. D, S, Dat, BS (colophon).

1784III
Untitled (Hommage à Mondrian XI). Aug 25–30, 1966.
Red (S), black (S). 15.2 × 15.2, cut. Ed 20 (GEP), 9 TI (CD), BAT (GEP), 3 AP (CD), 2 TP (GEP), CP (EVB). Jack Lemon. D, S, Dat, BS (colophon).

1782III
Untitled (Hommage à Mondrian IX). Aug 25–30, 1966.
Red (S), black (S). 15.2 × 15.2, cut. Ed 20 (GEP), 9 TI (CD), BAT (GEP), 3 AP (CD), 2 TP (GEP), CP (EVB). Jack Lemon. D, S, Dat, BS (colophon).

1785
Untitled (Hommage à Kandinsky XII). Aug 15, 1966.
Black (S). 15.2 × 15.2, cut. Ed 20 (MI), 9 TI (GEP), BAT (MI), 2 AP (GEP), 2 TP (MI). Jack Lemon. D, S, Dat, BS (colophon).

1783
Untitled (Hommage à Kandinsky X). Aug 15, 1966.
Black (S). 15.2 × 15.2, cut. Ed 20 (MI), 9 TI (GEP), BAT (MI), 1 AP (GEP), 2 TP (MI). Jack Lemon. D, S, Dat, BS (colophon).

1785II
Untitled (Hommage à Klee XII). Aug 18–23, 1966.
Yellow (S). 15.2 × 15.2, cut. Ed 20 (GEP), 9 TI (8 CD, 1 GEP), BAT (GEP), 3 AP (1 GEP, 2 CD), 2 TP (GEP). Jack Lemon. D, S, Dat, BS (colophon).

1783II
Untitled (Hommage à Klee X). Aug 18–23, 1966.
Yellow (S). 15.2 × 15.2, cut. Ed 20 (GEP), 9 TI (8 CD, 1 GEP), BAT (GEP), 3 AP (1 GEP, 2 CD), 2 TP (GEP). Jack Lemon. D, S, Dat, BS (colophon).

1785III
Untitled (Hommage à Mondrian XII). Aug 25–30, 1966.
Red (S), black (S). 15.2 × 15.2, cut. Ed 20 (GEP), 9 TI (CD), BAT (GEP), 3 AP (CD), 2 TP (GEP), CP (EVB). Jack Lemon. D, S, Dat, BS (colophon).

1783III
Untitled (Hommage à Mondrian X). Aug 25–30, 1966.
Red (S), black (S). 15.2 × 15.2, cut. Ed 20 (GEP), 9 TI (CD), BAT (GEP), 3 AP (CD), 2 TP (GEP), CP (EVB). Jack Lemon. D, S, Dat, BS (colophon).

1786
Untitled (Hommage à Kandinsky XIII). Aug 15, 1966.
Black (S). 15.2 × 15.2, cut. Ed 20 (MI), 9 TI (GEP), BAT (MI), 2 AP (GEP MI), 2 TP (MI). Jack Lemon. D, S, Dat, BS, (colophon).

1784
Untitled (Hommage à Kandinsky XI). Aug 15, 1966.
Black (S). 15.2 × 15.2, cut. Ed 20 (MI), 9 TI (GEP), BAT (MI), 2 AP (GEP), 2 TP (MI). Jack Lemon. D, S, Dat, BS (colophon).

1786II
Untitled (Hommage à Klee XIII). Aug 18–23, 1966.
Yellow (S). 15.2 × 15.2, cut. Ed 20 (GEP), 9 TI (8 CD, 1 GEP), BAT (GEP), 3 AP (1 GEP, 2 CD), 2 TP (GEP). Jack Lemon. D, S, Dat, BS (colophon).

1786III
Untitled (Hommage à Mondrian XIII). Aug 25–30, 1966.
Red (S), black (S). 15.2 × 15.2, cut. Ed 20 (GEP), 9 TI (CD), BAT (GEP), 3 AP (CD), 2 TP (GEP), CP (EVB). Jack Lemon. D, S, Dat, BS (colophon).

1787
Untitled (Hommage à Kandinsky XIV). Aug 15, 1966.
Black (S). 15.2 × 15.2, cut. Ed 20 (MI), 9 TI (GEP), BAT (MI), 2 AP (GEP), 2 TP (MI). Jack Lemon. D, S, Dat, BS (colophon).

1787II
Untitled (Hommage à Klee XIV).
Aug 18–23, 1966.
Yellow (S). 15.2 × 15.2, cut. Ed 20 (GEP), 9 TI (8 CD, 1 GEP), BAT (GEP), 2 AP (1 GEP, 1 CD), 2 TP (GEP). Jack Lemon. D, S, Dat, BS (colophon).

1787III
Untitled (Hommage à Mondrian XIV). Aug 25–30, 1966.
Red (S), black (S). 15.2 × 15.2, cut. Ed 20 (GEP), 9 TI (CD), BAT (GEP), 3 AP (CD), 2 TP (GEP), CP (EVB). Jack Lemon. D, S, Dat, BS (colophon).

1788
Untitled (Hommage à Kandinsky XV). Aug 15, 1966.
Black (S). 15.2 × 15.2, cut. Ed 20 (MI), 9 TI (GEP), BAT (MI), 2 AP (GEP), 2 TP (MI). Jack Lemon. D, S, Dat, BS (colophon).

1788II
Untitled (Hommage à Klee XV).
Aug 18–23, 1966.
Yellow (S). 15.2 × 15.2, cut. Ed 20 (GEP), 9 TI (8 CD, 1 GEP), BAT (GEP), 3 AP (1 GEP, 2 CD). Jack Lemon. D, S, Dat, BS (colophon).

1788III
Untitled (Hommage à Mondrian XV). Aug 25–30, 1966.
Red (S), black (S). 15.2 × 15.2, cut. Ed 20 (GEP), 9 TI (CD), BAT (GEP), 3 AP (CD), 2 TP (GEP), CP (EVB). Jack Lemon. D, S, Dat, BS (colophon).

1789
Untitled (Hommage à Kandinsky XVI). Aug 15, 1966.
Black (S). 15.2 × 15.2, cut. Ed 20 (MI), 9 TI (GEP), BAT (MI), 2 AP (GEP MI), 2 TP (MI). Jack Lemon. D, S, Dat, BS (colophon).

1789II
Untitled (Hommage à Klee XVI).
Aug 18–23, 1966.
Yellow (S). 15.2 × 15.2, cut. Ed 20 (GEP), 9 TI (8 CD, 1 GEP), BAT (GEP), 2 AP (1 GEP, 1 CD), 2 TP (GEP). Jack Lemon. D, S, Dat, BS (colophon).

1789III
Untitled (Hommage à Mondrian XVI). Aug 25–30, 1966.
Red (S), black (S). 15.2 × 15.2, cut. Ed 20 (GEP), 9 TI (CD), BAT (GEP) 3 AP (CD), 1 TP (GEP), CP (EVB). Jack Lemon. D, S, Dat, BS (colophon).

1790
Untitled (Hommage à Kandinsky XVII). Aug 15, 1966.
Black (S). 15.2 × 15.2, cut. Ed 20 (MI), 9 TI (GEP), BAT (MI), 2 AP (GEP MI), 2 TP (MI). Jack Lemon. D, S, Dat, BS (colophon).

1790II
Untitled (Hommage à Klee XVII).
Aug 18–23, 1966.
Yellow (S). 15.2 × 15.2, cut. Ed 20 (GEP), 9 TI (8 CD, 1 GEP), BAT (GEP), 2 AP (1 GEP, 1 CD), 2 TP (GEP). Jack Lemon. D, S, Dat, BS (colophon).

1790III
Untitled (Hommage à Mondrian XVIII). Aug 25–30, 1966.
Red (S), black (S). 15.2 × 15.2, cut. Ed 20 (GEP), 9 TI (CD), BAT (GEP), 3 AP (CD), 1 TP (GEP), CP (EVB). Jack Lemon. D, S, Dat, BS (colophon).

1791
Untitled (Hommage à Kandinsky XVIII). Aug 15, 1966.
Black (S). 15.2 × 15.2, cut. Ed 20 (MI), 9 TI (GEP), BAT (MI), 2 AP (GEP), 2 TP (MI). Jack Lemon. D, S, Dat, BS (colophon).

1791II
Untitled (Hommage à Klee XVIII).
Aug 18–23, 1966.
Yellow (S). 15.2 × 15.2, cut. Ed 20
(GEP), 9 TI (8 CD, 1 GEP), BAT (GEP), 2
AP (1 GEP, 1 CD), 2 TP (GEP). Jack
Lemon. D, S, Dat, BS (colophon).

1791III
*Untitled (Hommage à Mondrian
XVIII).* Aug 25–30, 1966.
Red (S), black (S). 15.2 × 15.2, cut. Ed
20 (GEP), 9 TI (CD), BAT (GEP), 3 AP
(CD), 1 TP (GEP), CP (EVB). Jack
Lemon. D, S, Dat, BS (colophon).

1792
*Untitled (Hommage à Kadinsky
XIX).* Aug 15, 1966.
Black (S). 15.2 × 15.2, cut. Ed 20 (MI),
9 TI (GEP), BAT (MI), 2 AP (GEP), 2 TP
(MI). Jack Lemon. D, S, Dat, BS
(colophon).

1792II
Untitled (Hommage à Klee XIX).
Aug 18–23, 1966.
Yellow (S). 15.2 × 15.2, cut. Ed 20
(GEP), 9 TI (8 CD, 1 GEP), BAT (GEP), 2
AP (1 GEP, 1 CD), 1 TP (GEP). Jack
Lemon. D, S, Dat, BS (colophon).

1792III
*Untitled (Hommage à Mondrian
XIX).* Aug 25–30, 1966.
Red (S), black (S). 15.2 × 15.2, cut. Ed
20 (GEP), 9 TI (CD), BAT (GEP), 3 AP
(CD), 1 TP (GEP), CP (EVB). Jack
Lemon. D, S, Dat, BS (colophon).

1793
*Untitled (Hommage à Kandinsky
XX).* Aug 15, 1966.
Black (S). 15.2 × 15.2, cut. Ed 20 (MI),
9 TI (GEP), BAT (MI), 2 AP (GEP), 2 TP
(MI). Jack Lemon. D, S, Dat, BS
(colophon).

1793II
Untitled (Hommage à Klee XX).
Aug 18–23, 1966. Yellow (S). 15.2 ×
15.2, cut. Ed 20 (GEP), 9 TI (8 CD, 3
GEP), BAT (GEP), 2 AP (1 GEP, 1 CD).
Jack Lemon. D, S, Dat, BS (colophon).

1. Image transferred from 1774–1793,
 1795–1798 to new stone; reversal.
 1774II–1793II, 1795II–1798II differs
 from 1774–1793, 1795–1798 in color
 and in image.
2. One suite designated Tamarind
 Impression contains only twelve
 lithographs: 1774II, 1776II, 1778II,
 1779II, 1783II, 1785II, 1786II, 1788II,
 1795II–1798II.
3. There may be a discrepancy in CD
 and GEP for the Tamarind
 Impressions.

4. In addition: 1 AP (CD) for 1774II,
 1776II, 1778II, 1779II, 1783II, 1785II,
 1786II, 1788II, 1795II–1798II plus 1
 TP (GEP) for 1774II–1787II, 1789II–
 1793II, 1795II–1798II and 1 TP (GEP)
 for 1774II, 1776II–1780II, 1782II–
 1787II, 1789II–1791II, 1793II, 1795II–
 1798II.

1793III
*Untitled (Hommage à Mondrian
XX).* Aug 25–30, 1966.
Red (S), black (S). 15.2 × 15.2, cut. Ed
20 (GEP), 9 TI (CD), BAT (GEP), 3 AP
(CD), 2 TP (GEP), CP (EVB). Jack
Lemon. D, S, Dat, BS (colophon).

1795
*Untitled (Hommage à Kandinsky
XXI).* Aug 15, 1966.
Black (S). 15.2 × 15.2, cut. Ed 20 (MI),
9 TI (GEP), BAT (MI), 1 AP (GEP), 2 TP
(MI). Jack Lemon. D, S, Dat, BS
(colophon).

1795II
Untitled (Hommage à Klee XXI).
Aug 18–23, 1966.
Yellow (S). 15.2 × 15.2, cut. Ed 20
(GEP), 9 TI (8 CD, 1 GEP), BAT (GEP), 3
AP (1 GEP, 2 CD), 2 TP (GEP). Jack
Lemon. D, S, Dat, BS (colophon).

1795III
*Untitled (Hommage à Mondrian
XXI).* Aug 25–30, 1966.
Red (S), black (S). 15.2 × 15.2, cut. Ed
20 (GEP), 9 TI (CD), BAT (GEP), 3 AP
(CD), 2 TP (GEP), CP (EVB). Jack
Lemon. D, S, Dat, BS (colophon).

1796
*Untitled (Hommage à Kandinsky
XXII)* Aug 15, 1966.
Black (S). 15.2 × 15.2, cut. Ed 20 (MI),
9 TI (GEP), BAT (MI), 2 AP (GEP MI), 2
TP (MI). Jack Lemon. D, S, Dat, BS
(colophon).

1796II
Untitled (Hommage à Klee XXII).
Aug 18–23, 1966.
Yellow (S). 15.2 × 15.2, cut. Ed 20
(GEP), 9 TI (8 CD, 1 GEP), BAT (GEP), 3
AP (1 GEP, 2 CD), 2 TP (GEP). Jack
Lemon. D, S, Dat, BS (colophon).

1796III
*Untitled (Hommage à Mondrian
XXII).* Aug 25–30, 1966.
Red (S), black (S). 15.2 × 15.2, cut. Ed
20 (GEP), 9 TI (CD), BAT (GEP), 3 AP
(CD), 2 TP (GEP), CP (EVB). Jack
Lemon. D, S, Dat, BS (colophon).

1797
Untitled (Hommage à Kandinsky XXIII). Aug 15, 1966.
Black (S). 15.2 × 15.2, cut. Ed 20 (MI), 9 TI (GEP), BAT (MI), 2 AP (GEP MI), 2 TP (MI). Jack Lemon. D, S, Dat, BS (colophon).

1797II
Untitled (Hommage à Klee XXIII).
Aug 18–23, 1966.
Yellow (S). 15.2 × 15.2, cut. Ed 20 (GEP), 9 TI (8 CD, 1 GEP), BAT (GEP), 3 AP (1 GEP, 2 CD), 2 TP (GEP). Jack Lemon. D, S, Dat, BS (colophon).

1797III
Untitled (Hommage à Mondrian XXIII). Aug 25–30, 1966.
Red (S), black (S). 15.2 × 15.2, cut. Ed 20 (GEP), 9 TI (CD), BAT (GEP), 3 AP (CD), 2 TP (GEP), CP (EVB). Jack Lemon. D, S, Dat, BS (colophon).

1798
Untitled (Hommage à Kandinsky XXIV). Aug 15, 1966.
Black (S). 15.2 × 15.2, cut. Ed 20 (MI), 9 TI (GEP), BAT (MI), 2 AP (GEP), 2 TP (MI). Jack Lemon. D, S, Dat, BS (colophon).

1798II
Untitled (Hommage à Klee XXIV).
Aug 18–23, 1966.
Yellow (S). 15.2 × 15.2, cut. Ed 20 (GEP), 9 TI (8 CD, 1 GEP), BAT (GEP), 3 AP (1 GEP, 2 CD), 2 TP (GEP). Jack Lemon. D, S, Dat, BS (colophon).

1798III
Untitled (Hommage à Mondrian XXIV). Aug 25–30, 1966.
Red (S), black (S). 15.2 × 15.2, cut. Ed 20 (GEP), 9 TI (CD), BAT (GEP), 3 AP (CD), 1 TP (GEP), CP (EVB). Jack Lemon. D, S, Dat, BS (colophon).

1801
Untitled. Aug. 16–17, 1966
Black (S)[1]. 76.6 × 106.0. Ed 9 (nN), 9 TI (nN), BAT (nN), 1 AP (nN), 1 TP (nN). Jack Lemon. D, S, Dat, BS.

1. Stone held from 1774–1793, 1795–1798. 1801 differs from 1774–1793, 1795–1798 in image and in size. 1801 combines all twenty-four imges reading numerically left to right, top to bottom.

Charles Ringness

Print not in
University Art Museum
Archive

2540
Untitled. Jan 15–27, 1969.
B: Red-brown, white (Z)[1], embossed. 35.6 × 25.4. Ed 12 (wA), 9 TI (8 BFK, 1 wA), 2 AP (BFK), 1 TP* (wA), CP (wA). Charles Ringness. D, S, Dat, BS.

1. Inscribed with notations and drawing in pencil by the artist.

2555
Untitled. Feb 1–May 27, 1969.
White (A), beige (A), embossed. 48.6 × 34.3. Ed 8 (7 wA, 1 cR)[1], BAT (wA), 1 TP* (cR), 9 CSP (6 cR, 3 wA)[2], 2 PTP* (1 cR, 1 wA). Charles Ringness. D, BS, S.

1. Ed 8/8 retained by Tamarind.
2. 7 CSP (4 cR, 3 wA), are unsigned and unchopped. 1 CSP (cR) retained by Tamarind.

2603
Untitled. Mar 6–Apr 4, 1969.
B: Black, red, black-green, black-brown (A), red, beige (Z), white, brown (Z). 80.3 × 52.7. Ed 11 (uCR), 9 TI (cR), BAT (ucR), 1 TP (cR), 2 CTP* (ucR), CP (cR). Charles Ringness. D, S, Dat (center), BS.

2796
Untitled. Sep 15–Oct 6, 1969.
Grey (A), orange (A), violet (Z), orange-yellow (Z). 61.0 × 86.4. Ed 5 (BFK), 9 TI (BFK), BAT (BFK), 2 AP (BFK), 4 CTP (BFK). Charles Ringness. D, S, Dat (center), BS.

Donald Roberts

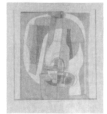

Print not in
University Art Museum
Archive

645
Lamp—Norton Cove. Sep 15–Oct 14, 1962.
Violet-grey (Z), ochre (Z), grey (Z). 51.1 × 43.8. Ed 8 (BFK), 9 TI (BFK), PrP (BFK), 3 AP (BFK), 3 PP (BFK), 2 TP (wA). Donald Roberts. T, D, S, BS.

662
Penobscot Islands. Oct 17–Nov 11, 1962.
Black (Z). 33.0 × 56.5. 10 ExP (BFK)[1], BAT (BFK), 2 PP (BFK), 2 TP (BFK). Donald Roberts. T, D, S, BS.

1. Designated A–J. 5 ExP retained by Tamarind.

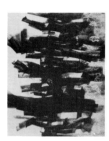

663
Motivity—October 62. Oct 19–21, 1962.
Black (Z). 64.8 × 49.9. Ed 20 (BFK), 9 TI (wA), PrP (BFK), 1 AP (wA), 3 PP (1 wA, 2 BFK). Donald Roberts. BS, T, Dat, D, S.

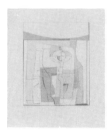

669
Gyroscope—Santa Monica 62. Oct 29–Nov 17, 1962.
Ochre (Z), grey (Z), brown (Z). 71.1 × 56.5. Ed 20 (BFK), 9 TI (wA), PrP (BFK), 3 AP (BFK), 3 PP (2 BFK, 1 wA). Donald Roberts. T, BS (Tam), D, S, BS (pr).

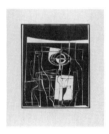

669A
Gyroscope—December 1. Nov 25, 1962.
Black (Z)[1]. 71.1 × 56.5. Ed 12 (BFK), 9 TI (wA), PrP (BFK), 1 AP (wA), 3 PP (BFK). Donald Roberts. T, BS (Tam), D, S, Dat, BS (pr).

1. Plate held from 669, run 3; additions, deletions, reversal. 669A differs from 669 in color and in image. At the left a narrow vertical line connecting the wide horizontal bar to the top border and the left portion of the bar were deleted. A similar line at the right from the bar to the lower border was deleted. A line forming a rectangle above and to the right of the circular shape in the center and a narrow solid dark border were added.

John Rock

678
The Vase. Nov 25–27, 1962.
Black (S). 38.4 × 35.6. Ed 20 (BFK), 9 TI (BFK), PrP (BFK), 3 AP (BFK), 1 PP (BFK), CP (BFK). John Rock. T, BS (Tam), D, BS (pr), S.

684
Glacial Strata. Nov 29–Dec 3, 1962.
Black (S). 43.2 × 35.6. Ed 20 (BFK), 9 TI (wA), PrP (BFK), 3 AP (2 BFK, 1 wA), CP (BFK). John Rock. T, D, S, BS.

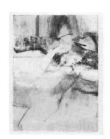

688
Reclining Figure. Dec 12–22, 1962.
Blue (S), yellow (Z), grey (Z), black (S). 75.6 × 56.8. Ed 20 (BFK), 9 TI (wA), PrP (BFK), 3 AP (1 BFK, 2 wA), 3 PP (BFK), 4 TP (2 BFK, 2 wA). John Rock. T, BS (Tam), D, BS (pr), S.

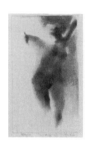

696
Figure. Dec 14–15, 1962.
Black (S). 30.5 × 19.1. Ed 20 (bA), 9 TI (BFK), PrP (bA), 1 PP (bA), 2 AP (1 BFK, 1 bA), 2 TP (bA), CP (bA). John Rock. BS (Tam), T, D, S, BS (pr).

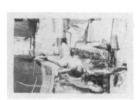

701
Interior. Dec 22, 1962–Feb 3, 1963.
Brown-green (S), violet (S), yellow-ochre (Z), black (S). 34.0 × 46.7. Ed 20 (BFK), 9 TI (wA), PrP (BFK), 2 AP (wA). John Rock. T, D, BS, S.

708
Landscape. Dec. 29, 1962–Jan. 5, 1963
Yellow and blue (S), black (S). 28.6 × 34.3. Ed 20 (BFK), 9 TI (wN), PrP (BFK), 3 AP (BFK), 2 PP (wN). John Rock. BS, T, S, D.

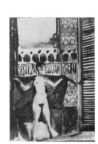

720
The Shawl. Jan 13–16, 1963.
Black (S). 57.2 × 39.4. Ed 20 (BFK), 9 TI (wN), PrP (BFK), 2 AP (BFK), 1 PP (wN). John Rock. BS, T, D, S.

730
Reclining Figure #2. Jan 31–Feb 5, 1963.
Black (S). 39.1 × 51.4. Ed 20 (bA), 9 TI (nN), PrP (bA), 2 AP (1 bA, 1 nN). John Rock. D, T, S, BS.

736
Gently a Summer Breeze. Feb 7–8, 1963.
Black (S). 56.2 × 76.5. Ed 20 (BFK), 9 TI (wA), PrP (BFK), 2 AP (BFK), 1 PP (wA). John Rock. T, D, S, BS.

741
Landscape with Rain. Feb 11–17, 1963.
Blue (S), black (S), black (S)[1]. 27.9 × 48.9. Ed 20 (BFK), 9 TI (BFK), PrP (BFK), 3 AP (BFK), 2 PP (BFK). John Rock. T, D, BS, S.

1. Same stone as run 2, registration moved slightly.

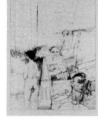
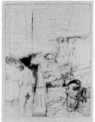

754
Models. Feb 20–Mar 2, 1963.
Black (S). 77.5 × 57.2. Ed 20 (BFK), 9 TI (wN), PrP (BFK), 3 AP (2 BFK, 1 wN), 2 PP (1 BFK, 1 wN). John Rock. BS, T, D, S.

Robert Rogers

2216
Sample. Jun 22–26, 1968.
Yellow-white (A)[1]. 39.1 × 57.5. Ed 12 (wN), 9 TI (wN), BAT (wN), 3 AP (wN), 1 TP* (wN), 1 CTP (wN), CP (wN). Robert Rogers. Verso: D, T, S, WS.

1. Upper left corner has been creased diagonally.

2398
Hard Edge Image at Least 22″ × 30″ in Size. Aug 31–Sep 14, 1968.
Yellow (A), green (A), pink-grey (A). 57.5 × 81.0. Ed 10 (GEP), 9 TI (GEP), BAT (GEP), 1 AP (GEP), 1 TP (GEP), CP (GEP). Robert Rogers. D, BS, S.

2416
L.A. 737. Aug 28–Sep 19, 1968.
Blue-black (S), orange (S)[1]. 76.5 × 53.7. Ed 10 (GEP), 9 TI (CD), BAT (GEP), 2 AP (GEP), CP (CD). Robert Rogers. T, BS (Tam), D, BS (pr), S.

1. Same stone as run 1; reversal.

Bernard Rosenthal

132
Untitled. Sep 27–Oct 7, 1960.
Black (Z). 56.5 × 76.2. Ed 20 (BFK), 9 TI (wN), PrP (BFK). Garo Antreasian. BS, D, S.

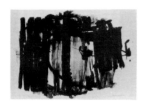

145
Untitled. Oct 25–27, 1960.
Black (Z). 56.5 × 77.2. Ed 15 (BFK), 9 TI (nN), PrP (BFK), 3 AP (BFK), 1 TP (BFK). Garo Antreasian. BS, D, S, Dat.

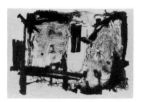

146
Things Invisible to See. Oct 25–Nov 1, 1960.
Black (Z). 56.5 × 76.5. Ed 20 (BFK), 9 TI (nN), PrP (BFK), 3 AP (BFK), 1 TP (BFK). Garo Antreasian. BS, D, S, Dat.

147
Untitled. Oct 25–Nov 2, 1960.
Black (Z). 56.5 × 76.8. Ed 20 (BFK), 9 TI (nN), PrP (BFK), 1 AP (BFK), 3 TP (BFK). Garo Antreasian. BS, D, S, Dat.

148
Sanctuary. Oct 25–31, 1960.
Black (Z). 56.5 × 76.2. Ed 20 (BFK), 9 TI (nN), PrP (BFK), 5 AP (BFK), 1 TP (BFK). Garo Antreasian. BS, D, S, Dat.

150
Untitled. Nov 2–4, 1960.
Black (Z). 56.5 × 76.2. Ed 20 (BFK), 9 TI (nN), PrP (BFK), 4 AP (3 BFK, 1 nN). Garo Antreasian. BS, D, S, Dat.

Seymour Rosofsky

The Good Burghers of Lunidam, a suite of seven lithographs. In order: 2401, 2402, 2403, 2404, 2405, 2406, 2422.

2401
***Untitled (The Good Burghers of
Lunidam I).*** Jul 31–Aug 19, 1968.
Blue (A), brown (S)[1], grey (A). 61.0
× 81.3. Ed 20 (CD), 9 TI (GEP), BAT
(CD), 1 AP (GEP), 1 TP (CD), 2 CTP
(CD). Jean Milant. D, S, BS.

1. Stone held from 2401II; additions.
 2401 differs from 2401II in color and
 in image. Solid drawing has been
 added on the wall of the building
 and drawing has been added to the
 windows, water and boats.

2401II
Untitled. Aug 13–15, 1968.
Black (S). 61.0 × 81.3. Ed 10 (CD), 9 TI
(GEP), BAT (CD), 3 AP (2 CD, 1 GEP).
Jean Milant. D, S, BS.

2402
***Untitled (The Good Burghers of
Lunidam II).*** Aug 1–24, 1968.
Green-brown (A), yellow (A), brown
(S)[1]. 61.0 × 81.3. Ed 20 (CD), 9 TI
(GEP), BAT (CD), 4 AP (2 GEP, 2 CD), 3
TP (CD). Daniel Socha. D, S, BS.

1. Stone held from 2402II; additions.
 2402 differs from 2402II in color and
 in image. The water and the trim on
 the building is darker with
 additional drawing on the windows.
 Slight drawing detail has been
 added throughout the image.

2402II
Untitled. Aug 17, 1968.
Black (S). 61.0 × 81.3. Ed 10 (CD), 9 TI
(GEP), BAT (CD), 6 AP (2 GEP, 4 CD).
Daniel Socha. D, S, BS.

2402III
Untitled. Aug 30–Sep 12, 1968.
Green-brown (A)[1], yellow (A)[2], red
(A), black (S)[3]. 61.0 × 81.3. Ed 10
(CD), 9 TI (GEP), BAT (CD), 3 AP (GEP),
CP (GEP). Daniel Socha. D, S, BS.

1. Plate held from 2402, run 1.
2. Plate held from 2402, run 2.
3. Stone held from 2402, run 3;
 deletions. 2402III differs from 2402
 in color and in image. The over-all
 image is darker. A diagonal strip to
 the left of the pool and drawing
 between the base of the house and
 the left figure has been added.

2403
***Untitled (The Good Burghers of
Lunidam III).*** Aug 8–23, 1968.
Red, blue, green (A), brown (S)[1],
black (A). 61.0 × 81.3. Ed 20 (CD), 9 TI
(GEP), BAT (CD), 2 AP (GEP), CP (CD).
Maurcie Sanchez. D, S, BS.

1. Stone held from 2403II; additions.
 2403 differs from 2403II in color and
 in image. A solid tone has been
 added to the windows and door
 and drawing accents added to the
 boats and figures.

2403II
Untitled. Aug 13–16, 1968.
Black (S). 61.0 × 81.3. Ed 10 (GEP), 9
TI (CD), BAT (CD), 1 TP* (CD). Maurice
Sanchez. D, S, BS.

2404
***Untitled (The Good Burghers of
Lunidam IV).*** Aug 23–Sep 10, 1968.
Pink (A), yellow (A), black (S)[1]. 61.6
× 81.3. Ed 20 (CD), 9 TI (GEP), BAT
(CD), 2 AP (CD), 2 TP (1 CD, 1 GEP), CP
(GEP). Anthony Stoeveken. D, S, BS.

1. Stone held from 2404II; additions.
 2404 differs from 2404II in color and
 in image. A solid tone has been
 added to the ground, wall and sky
 areas and drawing details added to
 the figures, sea horses and
 sailboat on the left.

2404II
Untitled. Aug 23–30, 1968.
Black (S). 61.0 × 81.3. Ed 10 (CD), 9 TI
(GEP), BAT (CD), 3 AP (2 CD, 1 GEP).
Anthony Stoeveken. D, BS, S.

2405
***Untitled (The Good Burghers of
Lunidam V).*** Sep 14–28, 1968.
Red (A), yellow (A), black (S). 61.0 ×
81.3. Ed 20 (CD)[1], 9 TI* (GEP), BAT
(CD), 1 AP (CD), 2 TP (1 CD, 1 GEP), CP
(GEP). Donald Kelley. D, S, BS.

1. Ed 14–20/20 vary from the edition.

2406
***Untitled (The Good Burghers of
Lunidam VI).*** Sep 13–20, 1968.
Light red-brown (A), black (S). 61.0 ×
81.3. Ed 20 (CD), 9 TI (GEP), BAT (CD),
3 AP (1 CD, 2 GEP), 2 TP (1 GEP, 1 CD),
CP (GEP). Robert Rogers. D, S, BS.

2407
Untitled. Aug 16–26, 1968.
Black (S). 81.3 × 61.0. Ed 20 (GEP), 9
TI (CD), BAT (GEP), 3 AP (1 CD, 2
GEP), 1 TP (GEP). Frank Akers. D, BS,
S.

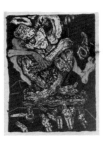

2407II
Untitled. Aug 26–Sep 4, 1968.
Silver (A), black (S)[1]. 81.6 × 61.0. Ed
10 (GEP), 9 TI (CD), BAT (GEP), 3 AP (2
CD, 1 GEP), 1 TP (GEP), CP (GEP).
Frank Akers. D, BS, S.

1. Stone held from 2407, run 2. 2407II
 differs from 2407 in color and in
 image. A solid tone has been added
 to the boat at the right and the
 figure at the left.

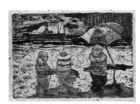

2408
Untitled. Aug 16–21, 1968.
Black (S). 61.0 × 81.3. Ed 20 (GEP), 9
TI (GEP), BAT (GEP), 3 TP (GEP), CP
(GEP). Manuel Fuentes. D, S, BS.

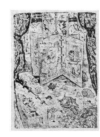

2409
Untitled. Aug 9–26, 1968.
Black (S). 94.3 × 66.0. Ed 20 (10 GEP,
10 cream CD), 9 TI (GEP), BAT (cream
CD), 4 AP (1 cream CD, 3 GEP), 4 PTP
(1 wN, 1 cream CD, 1 CD, 1 GEP), CP
(GEP). Robert Rogers. D, BS, S.

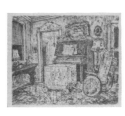

2410
Untitled. Aug 22–30, 1968.
Brown-red (S)[1]. 66.0 × 77.5. Ed 20
(cream CD), 9 TI (cream CD), BAT
(cream CD), 3 AP (cream CD), 1 CTP
(cream CD), 2 PTP* (GEP), CP (CD).
Manuel Fuentes. D, BS, S.

1. Stone held from 2410II. 2410 differs
 from 2401II in color only.

2410II
Untitled. Aug 29, 1968.
Black (S). 66.0 × 77.5. Ed 10 (GEP), 9
TI (GEP), BAT (GEP), 4 AP (GEP), 1 TP
(GEP). Manuel Fuentes. D, BS, S.

2411
Untitled. Aug 29–Sep 6, 1968.
Black or blue (S)[1]. 64.8 × 94.0. Ed
20 (BFK)[2], 9 TI (BFK), BAT (BFK)[2], 3
AP (BFK)[2], 1 TP (MI), 4 CTP (1 BFK, 2
wN, 1 MI), CP (MI). Maurice Sanchez.
D, BS, S.

1. Edition exists in two color
 variations. Variation I in black and
 Variation II in blue.
2. Indicates Variation II, Ed 1–10/20,
 BAT, 1 AP.

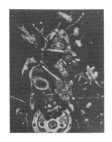

2412
Untitled. Aug 30–Sep 10, 1968.
Black (S). 64.8 × 48.3. Ed 20 (wN), 9
TI (wN), BAT (wN), 1 AP (wN), 1 TP
(wN), 2 PTP (1 MI, 1 JG), CP (wN).
Robert Rogers. D, S, (top), BS
(bottom).

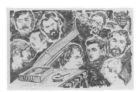

2418
Ce sont des bons imprimeurs. Sep
3–6, 1968.
Black (S). 95.3 × 64.8. Ed 20 (GEP), 9
TI (CD), BAT (GEP), 1 AP (GEP), CP
(GEP). Donald Kelley. D, T, S, BS.

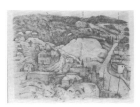

2419
Untitled. Sep 4–12, 1968.
Black (S). 58.4 × 74.9. Ed 10 (GEP), 9
TI (GEP), BAT (GEP), 5 AP (GEP), 5 CTP
(1 white CD, 1 MI, 1 JG, 2 cream CD),
1 PTP (JG), CP (GEP). Jean Milant. D,
S, BS.

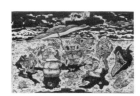

2420
Untitled. Sep 6–12, 1968.
Black (S). 73.7 × 106.7. Ed 20 (CD), 9
TI (CD), BAT (CD), 3 AP (CD)[1], 2 PP
(CD), CP (CD). Manuel Fuentes. D, S
(top), BS (bottom).

1. 1 AP varies from the edition.

2421
Untitled. Sep 10–16, 1968.
Black (S). 65.1 × 48.3. Ed 20 (wN), 9
TI (JG), BAT (wN), 1 AP (wN), 1 TP
(wN), 2 PTP (1 MI, 1 JG), CP (JG).
Daniel Socha. D, S, BS (top).

2422
Untitled (The Good Burghers of Lunidam VII). Sep 16–25, 1968.
Green (A), black (S)[1]. 61.0 × 81.3.
Ed 20 (CD), 9 TI (GEP), BAT (GEP), 3 AP (2 CD, 1 GEP), 3 TP (GEP), CP (CD). Jean Milant. D, S, BS.

1. Stone held from 2422II; additions. 2422 differs from 2422II in color and in image. Drawing has been added to the figures and boats making them darker. Dark tone has been added to the background. Drawing detail has been added to the ground and swimming pool. Tone has been added to the two drains, along the edges of the bottom of the pool and to the creatures within.

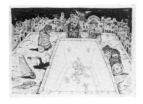

2422II
Untitled. Sep 16–25, 1968.
Black (S). 61.0 × 81.3. Ed 10 (CD), 9 TI (GEP), BAT (GEP), 2 AP (1 GEP, 1 CD), 1 TP (GEP). Jean Milant. D, S, BS.

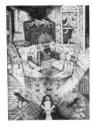

2423
Untitled. Sep 24–26, 1968.
Black (S). 107.0 × 73.7. Ed 20 (CD), 9 TI (CD), BAT (CD), 5 AP (CD), 1 TP (CD), CP (CD). Daniel Socha. D, S, BS.

Richards Ruben

386
Untitled. Sep 15–Oct 24, 1961.
Black (S). 76.8 × 56.5. Ed 20 (BFK), 9 TI (nN), PrP (BFK), PrP II for Bohuslav Horak (BFK), 3 AP (2 BFK, 1 nN), CP (BFK). Harold Keeler. D, S, BS.

388
Untitled. Sep 18–Nov 7, 1961.
Black (S). 56.5 × 54.9. Ed 20 (BFK), 9 TI (BFK), PrP (BFK), 2 TP (BFK), CP (BFK). Bohuslav Horak. BS, D, S.

455
Untitled. Nov 21–29, 1961.
Black (S). 74.9 × 101.6. Ed 20 (BFK), 9 TI (BFK), PrP (BFK), 2 AP (BFK), 3 TP (BFK). Bohuslav Horak. D. S. BS.

465
Untitled. Nov 28, 1961–Jan 23,1962
Pink (Z), light blue-green (Z), yellow (Z), white (Z), medium grey (Z), dark grey (Z). 52.1 × 75.6. Ed 20 (BFK), 9 TI (wA), PrP (BFK), 2 AP (1 BFK, 1 wA), 2 PP (BFK), 3 TP (2 BFK, 1 wA). Harold Keller. D, BS, S.

Print not in
University Art Museum
Archive

Edward Ruscha

2503
Untitled. Jan 6–Feb 21, 1969.
Red (S)[1], blue (S)[1], black (S)[2]. 58.8 × 86.4. Ed 40 (CD), 9 TI (CD), BAT (CD), 7 AP (CD), 1 TP (CD), 7 CTP (CD), CP (CD). Daniel Socha. WS, D, S (Price), Dat, S, (Ruscha), Dat.

1. Drawn by Kenneth Price, Nov 15, 1968–Jan 15, 1969.
2. Drawn by Ed Ruscha, Jan–Feb, 1969.

2527
Mint. Jan 2–9, 1969.
Red (A), grey (S). 43.2 × 61.0. Ed 20 (JG), 9 TI (GEP), BAT (JG), 3 AP (1 JG, 2 GEP), 1 TP* (BFK), 3 CTP (1 JG, 2 GEP), 1 PTP* (BFK), CP (JG). Manuel Fuentes. D, S, Dat, BS.

2528
Carp. Jan 8–9, 1969.
Green (S). 43.2 × 61.0. Ed 20 (wA), 9 TI (CD), BAT (wA), 3 AP (1 CD, 2 wA), 1 TP (wA), 2 CTP (1 CD, 1 wA). Charles Ringness. D, S, Dat, BS.

2528A
Carp with Shadow and Fly. Jan 14–23, 1969.
Light grey (S), green (S)[1], dark brown (A). 43.2 × 61.0. Ed 20 (wA), 9 TI (wA), BAT (wA), 3 AP (wA), 1 TP* (wA), 6 CTP (wA), CP (wA). Charles Ringness. D, S, Dat, BS.

1. Stone held from 2528. 2528A differs from 2528 in color and in image. A fly has been added inside the "C" at bottom right. Dark shading has been added to the right sides of all letters and to the water drops.

2529
Eye. Jan 9–22, 1969.
Blue (S). 43.2 × 61.0. Ed 20 (wA), 9 TI (BFK), BAT (wA), 3 AP (1 wA, 2 BFK), 10 TP* (wA), CP (wA). Ronald Glassman. D, S, Dat, BS.

2530
Annie. Jan 17–29, 1969.
Orange-yellow (A), orange-brown (S). 43.2 × 60.7. Ed 20 (BFK), 9 TI (BFK), BAT (BFK), 5 AP (BFK), 2 TP* (wA), 3 CTP (wA), CP (BFK). Kenjilo Nanao. Recto: D, S, Dat Verso: WS.

2531
Rodeo. Jan 22–24, 1969.
Silver-brown, black (S). 43.2 × 61.0. Ed 20 (wA), 9 TI (BFK), BAT (wA), 3 AP (1 wA, 2 BFK), 1 TP (BFK), 4 CTP (2 GEP, 1 wA, 1 BFK), CP (BFK). Manuel Fuentes. D, S, Dat, BS.

2532
Hollywood and Observatory. Jan 25–Feb 7, 1969.
Light blue (A), black (S). 16.8 × 81.3. Ed 17 (cR), 9 TI (cR), BAT (cR), 1 TP (cR), 2 CTP (cR), CP (cR). Donald Kelley. D, S, BS, Dat.

2533
Long Hollywood. Jan 25–Feb 7, 1969.
Light blue (A), black (S). 24.1 × 81.3. Ed 7 (cR), 9 TI (cR), BAT (cR), 1 TP (cR), 2 CTP (cR), CP (cR). Donald Kelley. D, S, Dat, BS.

2534
Hollywood in the Rain. Jan 25–Feb 7, 1969.
Light blue (A), black (S). 17.8 × 30.5. Ed 8 (cR), 9 TI (cR), BAT (cR), 1 CTP (cR), CP (cR). Donald Kelley. D, S, BS, Dat.

2535
Short Hollywood. Jan 25–Feb 7, 1969.
Light blue (A), black (S). 17.8 × 50.5. Ed 18 (cR), 9 TI (cR), BAT (cR), 2 CTP (cR), CP (cR). Donald Kelley. D, S, BS, Dat.

2536
City. Jan 27–Feb 7, 1969.
Grey-blue (A), white (S). 43.2 × 61.0. Ed 20 (cR), 9 TI (ucR), BAT (cR), 3 AP (2 cR, 1 ucR), 1 TP (cR), 3 CTP (cR), CP (ucR). Robert Rogers. Recto: D, S, Dat Verso: WS.

2537
Air. Jan 28–Feb 10, 1969.
Yellow-green (A), grey (S). 43.2 × 61.0. Ed 20 (18 CD, 2 BFK), 9 TI (BFK), BAT (CD), 1 AP (CD), 1 TP (CD), 2 CTP (1 CD, 1 BFK), CP (CD). John Sommers. D, S, BS, Dat.

2538
Adios. Jan 30–Feb 18, 1969.
B: Brown, red-borwn, red (A), brown (S). 23.5 × 55.9. Ed 20 (cR), 9 TI (8 cR, 1 ucR), BAT (cR), 3 AP (cR), 2 TP (1 wA*, 1 cR), 3 CTP (1 wA, 2 cR), CP (ucR). Jean Milant. Recto: D, S, Dat Verso: WS.

2541
Sin. Feb 4–11, 1969.
Red (A), green (A), black (S). 45.4 × 38.7. Ed 20 (wA), 9 TI (cR), BAT (wA), 3 AP (2 cR, 1 wA), 1 TP (wA), 4 CTP (2 wA, 2 cR), CP (wA). Daniel Socha. D, S, Dat, BS.

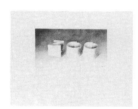

2542
Zoo. Jan 28–Feb 17, 1969.
Blue-black (S), blue-black (S)[1], black (S)[1]. 24.5 × 30.5. Ed 20 (cR), 9 TI (cR), BAT (cR), CP (cR). Jean Milant. D, S, Dat, BS.

1. Same stone used for run 1, 2, and 3.

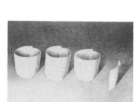

2543
Ooo. Jan. 28–Feb. 17, 1969
Blue-black (S), blue-black (S)[1], black (S)[1]. 24.8 × 30.5. Ed 20 (cR), 9 TI (cR), BAT (cR), CP (cR). Jean Milant. D, S, BS, Dat.

1. Same stone used for run 1, 2 and 3.

2544
Olive and Screw. Feb 7–28, 1969.
Black (S), red (A), green (A), grey (A). 24.8 × 30.5. Ed 20 (cR), 9 TI (cR), BAT (cR), 2 AP (cR), 1 TP* (cR), CP (cR). Jean Milant. D, S, BS, Dat.

2547
Olive and Marble. Feb 7–28, 1969.
Black (S), red, red-orange (A), grey-green, blue (A), grey (A). 24.8 × 30.5. Ed 20 (cR), 9 TI (cR), BAT (cR), 1 AP (cR), 2 TP (cR)[1], CP (cR). Jean Milant. D, S, BS, Dat.

1. 1 TP varies from the edition.

2548
Boiling Blood. Feb 13–27, 1969.
Orange (S), red (S), black (A). 29.8 ×
34.3. Ed 20 (cR), 9 TI (ucR), BAT (cR), 4
AP (2 cR, 1 ucR), 1 TP (cR), 4 CTP (cR),
CP (ucR). Robert Rogers. D, S, BS, Dat.

2549
Hey. Feb 13–27, 1969.
Green-grey (S), white (A). 30.2 × 34.3.
Ed 20 (cR), 9 TI (ucR), BAT (ucR), 4 AP
(cR), 2 CTP (cR), CP (cR). Robert
Rogers. D, S, BS, Dat.

2550
Anchovy. Feb 22–27, 1969.
Silver (A), light blue (S). 48.3 × 71.1,
torn and cut. Ed 20 (cR), 9 TI (ucR),
BAT (cR), 3 AP (2 cR, 1 ucR), 4 CTP
(cR), CP (cR). Serge Lozingot. D, S, BS,
Dat.

Maurice L. Sanchez

1842
Ann and Oct 8–Dec 4, 1966.
Yellow (Z), orange (Z), black (S). 56.2
× 71.1. Ed 20 (BFK), 9 TI (CD), BAT
(BFK), 2 AP (1 BFK, 1 CD), 2 TP (1 BFK,
1 CD). Maurice Sanchez. D, BS, S.

1842II
Ann and Ann. Dec 9–11, 1966.
Orange (Z)[1], dark grey (S)[2]. 50.8 ×
51.1. Ed 10 (GEP), 9 TI (CD), BAT
(GEP), 1 AP (CD), 2 TP (GEP), CP
(GEP). Maurice Sanchez. D, BS, S.
1. Plate held from 1842, run 2;
 deletions.
2. Stone held from 1842, run 3;
 deletions. 1842II differs from 1842 in
 color, image and size. Solid tone
 has been deleted from the circular
 band surrounding the figure. The
 irregular shape above the circle has
 been eliminated. The light areas
 under and above the arms and
 above the head of the figure have
 been filled in solid with dark tone.
 The width has been reduced
 substantially on the left and right.

1858
Dottie, LA 196667. Jan 6–16, 1967.
Brown (S). 56.5 × 50.8. Ed 10 (bA), 9
TI (bA), BAT (bA), 3 AP (bA), 1 TP (bA).
Maurice Sanchez. D, S, BS.

1859
Cream Cheese, L.A. Cream. May
13–Jun 3, 1967.
Pink-red (A), green (A), blue (A). 56.5
× 51.1. Ed 10 (MI), 9 TI (GEP), BAT
(MI), 3 AP (2 MI, 1 GEP), 2 TP (MI), 4
PTP* (3 bA, 1 wA). David Folkman. D,
T, BS, S, Dat.

2043
Hollywood Fuck-Me-Not. May 23–
Jul 1, 1967.
Transparent pink (S), grey (A). 56.5 ×
50.8. Ed 10 (wA), 9 TI (bA), BAT (wA),
3 AP (1 wA, 2 bA), 1 TP (wA). Maurice
Sanchez. D, BS, S, Dat.

2054
L.A. Sunset, L.A. May 26–Sep 6,
1967.
B: Red-black, black, blue-black, B:
light grey-green, grey-green (A)[1].
64.8 × 51.1. Ed 10 (BFK), 9 TI (wA),
BAT (BFK), 1 AP (BFK), 2 TP (BFK)[1],
CP (wA). David Folkman. D, BS, S.
1. 1 TP on paper 56.5 × 50.8, 1 TP on
 paper 56.5 × 41.9.

2063
Number One. Jan 6–20, 1968.
Blue (A), red (A). 56.8 × 76.2. Ed 10
(BFK), 9 TI (wA), BAT (BFK), 3 AP (1
BFK, 2 wA), CP (wA). David Folkman.
D, BS, S, Dat.

2201
Number Two. Jan 26–31, 1968.
Blue (A), green (A), red (A). 56.8 ×
76.2, (wA), 55.3 × 76.2 (CD) Ed 10
(wA), 9 TI (1 wA, 8 CD), BAT (wA), 1
AP (wA), CP (CD). David Folkman. D,
BS, S, Dat.

2215
Number Three. Feb 17–Jul 6, 1968.
Red, yellow (A), black (A). 55.2 × 76.8.
Ed 9 (wA), 9 TI (CD), BAT (wA), 2 AP (1
wA, 1 CD). Maurice Sanchez. D, BS, S,
Dat.

Miriam Schapiro

Shrine, a four part lithograph. In order: 1120D, 1120C, 1120B, 1120A.

1120A
Shrine IV. Jul 1–30, 1964.
Grey (Z), silver-grey (S), medium violet (Z), dark grey (Z), blue-green (S). 30.5 × 30.5, cut. Ed 20 (BFK), 9 TI (wA), BAT (BFK), PrP II for Irwin Hollander (BFK), 5 AP (BFK), 7 TP (BFK). John Dowell. Verso: T, WS (Tam), D, WS (pr), S.

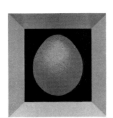

1120B
Shrine III. Jul 2–Aug 20, 1964.
Pink (Z), brown-red (Z), blue (Z), violet, light blue (Z), black-brown (Z). 33.0 × 30.5, cut. Ed 20 (BFK), 9 TI (wA), BAT (BFK), PrP II for Irwin Hollander (BFK), 5 AP (wA), 6 TP (BFK). Ernest Rosenthal. Verso: I, D, WS (pr).

1120C
Shrine II. Jul 10–30, 1964.
Yellow-orange (S), dark brown-pink (S), green (S), black (S), blue (Z), violet blue, light violet-blue (Z), black (S), light yellow (S). 30.5 × 30.5, cut. Ed 20 (BFK), 9 TI (wA), BAT (BFK), PrP II for Irwin Hollander (BFK), 5 AP (wA), 7 TP (wA). Robert Gardner. Verso: I, D, WS (pr).

1120D
Shrine I. Jul 17–Aug 11, 1964.
Blue-green (Z), gold (Z), light blue-green (Z). 33.0 × 30.5, cut. Ed 20 (BFK), 9 TI (wA), BAT (BFK), PrP II for Irwin Hollander (BFK), 5 AP (BFK), 4 TP (BFK). Ernest Rosenthal. Verso: I, D, WS (pr).

1132
Souvenir. Aug 11–14, 1964.
Red-black (S). 62.9 × 52.7. Ed 20 (bA), 9 TI (nN), BAT (BFK), PrP II for Kenneth Tyler (BFK), 3 AP (nN), 5 PP (nN), 2 TP (nN), 1 PTP (light weight Rives)[1], CP (BFK). Kaye Dyal. BS, T, D, S, Dat.

1. Unsigned, unchopped, undesignated, retained by Tamarind.

1133
Untitled. Aug 17–19, 1964.
Red-black (S). 61.6 × 52.1. Ed 20 (bA), 9 TI (nN), BAT (bA), PrP II for Kenneth Tyler (bA), 3 AP (bA), 2 TP (nN), 1 PTP (JG)[1], CP (bA). Frank Berkenkotter. BS, D, S, Dat.

1. Unsigned, unchopped, designated Barcham Green Paper Development Research, retained by Tamarind.

1134
Poster. Aug 20–31, 1964.
Light beige (Z), light grey (S), light brown (Z). 61.6 × 52.1. Ed 20 (bA), 9 TI (nN), BAT (BFK), PrP II for Kenneth Tyler (BFK), 3 AP (nN), 2 PP (nN), 4 TP (bA). Clifford Smith. BS, T, D, S, Dat.

Karl Schrag

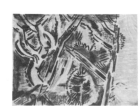

553
Woods and Open Sea. May 28–Jun 7, 1962.
Yellow (Z), red (Z), dark blue (S), light blue (S). 64.1 × 84.5. Ed 20 (BFK), 9 TI (wN), PrP (BFK), 2 AP (wN), 3 PP (BFK), 3 TP (BFK), CP (BFK). Joe Zirker. BS, D, S, Dat.

565
End of the Island. Jun 6–14, 1962.
Yellow (Z), blue (Z). 52.7 × 77.5. Ed 30 (BFK)[1], 9 TI (wN), 2 PrP (BFK)[1], 4 AP (BFK)[1], 2 PP (BFK), 2 TP (1 BFK, 1 wN), CP* (BFK)[1]. Joe Zirker. T, S, D, Dat, BS.

1. Ed 21–30/30, 1 PrP, 2 AP, CP were printed by the Kanthos Press and do not bear Tamarind's chop.

571
Pond in a Forest. May 2–7, 1962.
Green (S), black (S). 91.4 × 44.5. Ed 35 (BFK)[1], 9 TI (BFK), PrP (BFK), 2 AP (BFK), 1 PP (BFK), 3 TP (BFK), CP* (BFK). Irwin Hollander. S, BS, D.

1. Ed 21–35/35 were printed under separate contract by Wesley Chamberlin and Irwin Hollander.

573
Path of the Sun. May 4–11, 1962.
Yellow (S), orange (Z), red (S). 37.8 × 57.2. Ed 30 (BFK)[1], 9 TI (wA), PrP (BFK), 2 AP (wA), 2 PP (BFK), 3 TP (1 BFK, 2 wA), CP (WA). Irwin Hollander. D, S, BS.

1. Ed 21–30/30 were printed under separate contract by Irwin Hollander.

578
Rocky Landscape. May 14–15, 1962.
Black (S). 56.5 × 76.8. Ed 40 (20 BFK, 20 bA)[1], 9 TI (nN), PrP (bA), 2 AP (1 bA, 1 nN), 2 PP (bA), 3 TP (1 BFK, 2 bA), CP (BFK). Irwin Hollander. D, S, Dat, BS.

1. Ed 21–40/40 were printed under separate contract by Irwin Hollander.

585
Rocks, Trees and Clouds. May 16–25, 1962.
Yellow (Z), violet (Z), grey-green (S), black (S). 56.5 × 75.9. Ed 35 (BFK)[1], 9 TI (wA), 2 PrP (BFK)[1], 4 AP (3 BFK[1], 1 wA) 4 PP (3 BFK, 1 wA), 3 TP (2 BFK, 1 wA). Joe Zirker. T, D, S, Dat, BS.

1. Ed 21–35/35, 1 PrP, 2 AP (BFK) were printed by the Kanthos Press and do not bear the Tamarind chop.

590
Storm Cloud. May 21–24, 1962.
Black (Z). 56.5 × 75.6. Ed 30 (BFK)[1], 9 TI (wA), 2 PrP (BFK)[1], 2 AP (1 BFK, 1 wA), 2 TP (BFK), CP (BFK)[1]. Irwin Hollander. T, D, S, Dat, BS.

1. Ed 21–30/30, 1 PrP, CP were printed by the Kanthos Press and do not bear the Tamarind chop.

595
Overgrown Path. Jun 15–18, 1962.
Black (S). 93.3 × 57.8. Ed 20 (BFK), 9 TI (wN), PrP (BFK), 2 AP (1 BFK, 1 wN), 3 PP (BFK), 3 TP (BFK). Joe Zirker. S, BS, D.

595A
Overgrown Path. Jun 18–28, 1962.
Yellow (Z), orange (Z), violet (Z), green (Z), blue-grey (Z), black (S)[1]. 92.7 × 57.2. Ed 30 (BFK)[2], 9 TI (wN), 2 PrP (BFK)[2], 9 AP (8 BFK[2], 1 wN), 2 PP (BFK), 3 TP (2 BFK, 1 wN). Joe Zirker. D, S, BS.

1. Stone held from 595. 595A differs from 595 in color and in image. A broken background tone has been added.
2. Ed 21–30/30, 1 PrP, 7 AP (BFK) printed by the Kanthos Press and do not bear the Tamarind chop.

598
Rocks Below the Sea. Jun 21–28, 1962.
Yellow or green (Z)[1], black or blue (S)[1]. 57.2 × 61.6. Ed 20 (BFK)[2], 9 TI (nN), PrP (BFK), 1 AP (nN), 2 PP (BFK)[2], 2 TP (1 BFK[2], 1 nN), CP (nN). Emil Weddige. T, D, S, Dat, BS.

1. Edition exists in two color variations. Variation I in yellow and black and Variation II in green and blue.
2. Indicates Variation II, Ed 1–10/20, 1 TP (BFK), 1 PP.

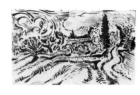

600
Road to the Shore. Jun 25–29, 1962.
Black (S). 58.1 × 89.5. Ed 20 (BFK), 9 TI (wN), PrP (BFK), 2 AP (1 BFK, 1 wN), 3 TP (BFK), CP (BFK). Emil Weddige. D, BS, S.

Aubrey Schwartz

The Midget and the Dwarf, a suite of ten lithographs plus title and colophon pages, enclosed in a brown linen covered portfolio, measuring 80.0 × 59.7, lined with Rives BFK, made by Margaret Lecky, Los Angeles. Title page and colophon printed at the Gehenna Press, Northampton, Mass. In order: 126, 125, 127, 128, 130, 133, 149, 135, 140.

125
Woman (The Midget and the Dwarf II). Sep 27–Oct 3, 1960.
Grey (Z), black (S). 76.2 × 56.5. Ed 20 (wA), 9 TI (BFK), BAT (wA), 5 AP (wA), 2 TP (wA), 1 PTP* (Moriki)[1], CP (nr). Garo Z. Antreasian. BS, D, S,.

1. Unsigned, unchopped, designated "Moriki 1009," retained by Tamarind.

126
Clown's Head (The Midget and the Dwarf I). Sep 20–Oct 4, 1960.
Grey (Z), black (S). 75.9 × 56.5. Ed 20 (wA), 9 TI (BFK), BAT (wA), 5 AP (wA), 2 TP (wA), CP (nr). Garo Z. Antreasian. BS, D, S.

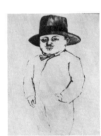

127
Confidence Man (The Midget and the Dwarf III). Sep 26–Oct 5, 1960.
Light grey (S), black (S). 76.2 × 56.5. Ed 20 (wA), 9 TI (BFK), BAT (wA), 5 AP (wA), 2 TP (wA), CP (nr). Garo Z. Antreasian. BS, D, S.

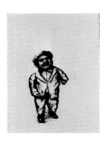

128
Jolly Dwarf (The Midget and the Dwarf IV). Sep 23–Oct 11, 1960. Brown-black (S). 76.2 × 56.5. Ed 20 (wA), 9 TI (BFK), BAT (wA), 5 AP (wA), 3 TP (2 wA, 1 BFK), CP (nr). Garo Z. Antreasian. BS, D, S,.

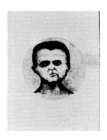

130
The Face of the Midget (The Midget and the Dwarf V). Sep 26–Oct 6, 1960.
Light-grey (Z), dark brown (S). 76.2 × 56.5. Ed 20 (wA), 9 TI (BFK), BAT (wA), 5 AP (wA), 2 TP (BFK), CP (nr). Garo Z. Antreasian. BS, D, S.

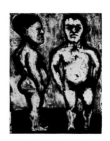

133
Nude Dwarfs (The Midget and the Dwarf VI). Oct 4–19, 1960.
Black (S). 76.2 × 56.5. Ed 20 (wA), 9 TI (BFK), BAT (wA), 5 AP (wA), 3 TP (BFK). Garo Z. Antreasian. BS, D, S.

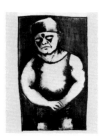

135
The Dwarf Clown (The Midget and the Dwarf VIII). Oct 12–17, 1960.
Grey (S), black (S). 76.2 × 56.5. Ed 20 (wA), 9 TI (BFK), BAT (wA), 5 AP (wA), 8 TP (7 wA, 1 BFK), CP (nr). Garo Z. Antreasian. BS, D, S.

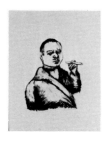

136
Man with Cigar (The Midget and the Dwarf IX). Oct 13, 1960.
Black (S). 76.2 × 56.5. Ed 20 (wA), 9 TI (BFK), BAT (wA), 5 AP (wA), 1 TP (BFK), CP (nr). Garo Z. Antreasian. BS, D, S.

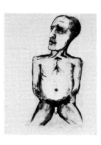

140
The Dwarf (The Midget and the Dwarf X). Oct 24–Nov 3, 1960.
Dark grey (S), black (S). 76.2 × 56.5. Ed 20 (wA), 9 TI (BFK), BAT (wA), 5 AP (wA), 1 TP (BFK), CP (nr). Garo Z. Antreasian. BS, D, S.

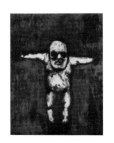

149
Nude Man (The Midget and the Dwarf VII). Oct 31–Nov 2, 1960.
Light-grey (S), black (S). 76.2 × 56.5. Ed 20 (wA), 9 TI (BFK), BAT (wA), 5 AP (wA), 1 TP (BFK), CP (nr). Garo Z. Antreasian. BS, D, S.

153
Garden. Nov 8, 1960.
Black (S). 56.5 × 76.2. Ed 50 (BFK), 9 TI (wN), BAT (BFK), 5 AP (BFK), 4 TP (2 wN, 1 wA, 1 nr[1]), CP (nr). Bohuslav Horak. S, D, BS.

1. Unchopped, retained by Tamarind.

155
Flowers. Nov 10, 1960.
Black (S). 76.2 × 55.9. Ed 50 (wA), 9 TI (nN), BAT (wA), 5 AP (wA), CP (nr). Bohuslav Horak. S, D, BS.

655
Untitled. Oct 2–15, 1962.
Black (S). 32.7 × 28.6. Ed 50 (20 nN, 30 bA[1]), 9 TI (wN), PrP (nN), 3 AP (1 wN, 2 nN), 1 TP (nN)[2]. Joe Zirker. BS, S, D.

1. Ed 21–50/50 were printed by the Kanthos Press and do not bear Tamarind's chop.
2. Unchopped, retained by Tamarind.

Antonio Scordia

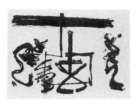

269
Untitled. Apr 7, 1961.
Black (S). 76.8 × 57.2. Ed 20 (wA), 9 TI (wN), PrP (wA), 4 AP (3 wA, 1 wN), 1 TP (wA), CP (wA). Garo Z. Antreasian[1]. BS (Tam), D, S, Dat, BS (pr).

1. TI bear the chop of Bohuslav Horak; all others bear the chop of Garo Antreasian.

Arthur Secunda

2858
Love Lightning. Mar 31–Apr 6, 1970.
Blue (S), black (Z). 58.4 × 78.7. Ed 20
(GEP), 9 TI (cR), BAT (GEP), 1 AP
(GEP), 3 CTP (2 GEP, 1 cR), CP (GEP).
S. Tracy White. BS (Tam), D, T, S, BS
(pr).

2859
Confrontation. Apr 2–16, 1970.
B: Orange, red-orange (A), grey (A).
48.3 × 81.9. Ed 20 (GEP), 9 TI (cR),
BAT (GEP), 3 AP (cR), 1 TP (GEP), 1
CTP (GEP). David Trowbridge. BS
(Tam), T, D, S, BS (pr).

2859II
Confrontation II. Apr 2–16, 1970.
Grey (A)[1]. 48.3 × 76.2. Ed 20 (bA), 9
TI (bA), BAT (bA), 3 AP (bA), 1 TP (bA),
CP (bA). David Trowbridge. BS (Tam),
T, D, S, BS (pr).

1. Plate held from 2859, run 2. 2859II
 differs from 2859 in color, image
 and size. The blended orange
 background has been eliminated.

2860
Moon Mountain. Apr 6–10, 1970.
Black (A). 57.2 × 55.9. Ed 20 (ucR), 9
TI (cR), BAT (ucR), 3 AP (1 cR, 2 ucR),
2 TP (ucR)[1], CP (cR). Hitoshi
Takatsuki. BS (Tam), T, BS, (pr), D, S.

1. 2 TP vary from the edition on paper
 66.0 × 67.3; 58.4 × 58.4.

2863
Night Man. Apr 8–14, 1970.
Blue-black (S). 76.2 × 55.2. Ed 20
(GEP), 9 TI (CD), BAT (GEP), 3 AP
(GEP), 1 PP (ucR), 2 CTP (1 cR, 1 GEP),
CP (CD). Harry Westlund. BS (Tam), D,
T, S, BS (pr).

Doris Seidler

986
Arkhaios Jan 21, 1964.
Beige (S), embossed. 38.1 × 50.8. Ed
20 (BFK), 9 TI (wA), PrP (BFK), 3 AP (2
wA, 1 BFK), 1 PP (BFK), 2 TP (BFK), 2
PTP (Howell handmade paper)[1], CP
(BFK). Kenneth Tyler. D, BS, S, Dat.

1. Unsigned, unchopped,
 undesignated, 1 PTP retained by
 Tamarind.

Jun'ichiro Sekino

882
Untitled. Sep 5–11, 1963.
Blue (S), red-violet (S). 57.2 × 76.8.
Ed 20 (bA), 9 TI (nN), PrP (bA), 3 AP (1
bA, 2 nN), 3 TP (bA). John Dowell. BS,
D, S.

886
Untitled. Sep 11–12, 1963.
Black (Z). 76.8 × 57.2. Ed 20 (BFK), 9
TI (wN), PrP (BFK), PrP II for Irwin
Hollander (BFK), 3 AP (1 BFK, 2 wN), 2
TP (BFK), CP (BFK). Aris Koutroulis. D,
S, BS.

Artemio Sepulveda

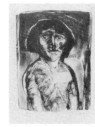

1083
Untitled. May 1, 1964.
Black (S). 74.9 × 55.9. Ed 20 (wA), 9 TI
(BFK), PrP (wA), PrP II for Irwin
Hollander (wA), 3 AP (1 BFK, 2 wA), 1
PP (BFK), 2 TP (1 BFK, 1 wA), CP (wA).
Thom O'Connor. D, BS, S.

Irene Siegel

Untitled Suite, a suite of four
lithographs. In order: 2094, 2095,
2096, 2099.

Bliss Suite, a suite of four lithographs.
In order: 2101, 2102, 2116, 2117.

Ogg, Zog, Zap and Xis, a suite of four
lithographs. In order: 2118, 2119,
2120, 2121.

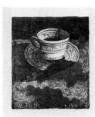

2094
Wedgewood (Untitled Suite I). Jul
31–Aug 3, 1967.
Red, green (Z), black (S)[1]. 45.7 ×
38.1. Ed 20 (CD), 9 TI (BFK), BAT (CD),
3 AP (2 CD, 1 BFK), CP (CD). Serge
Lozingot. D, BS, Dat, S.

1. Stone held from 2094II. 2094 differs
 from 2094II in color and in image.
 Solid color tones have been added
 in the irregular shapes on the table,
 inside the cup, and in the tea-bag
 label.

2094II
Wedgewood. Aug 3, 1967.
Black (S). 45.7 × 38.1. Ed 10 (wA), 9 TI (BFK), BAT (wA), 2 AP (1 BFK, 1 wA). Serge Lozingot. D, BS, Dat, S.

2095
Utensil (Untitled Suite II). Aug 1–9, 1967.
Yellow (A), silver (A), black (S). 45.7 × 37.8. Ed 20 (CD)[1], 9 TI (BFK)[1], BAT (CD), 3 AP (2 BFK, 1 CD), CP (CD). Maurice Sanchez. D, BS, Dat, S.

1. Ed 15–20/20, 9 TI differ from the edition.

2096
His and Hers (Untitled Suite III).
Aug 2–9, 1967.
Silver, green (Z), violet (Z), black (S). 45.7 × 38.1. Ed 20 (CD), 9 TI (BFK), BAT (CD), 3 AP (BFK), CP (CD). Serge Lozingot. D, BS, Dat, S.

2097
Module for a split level ranch house[1]. Aug 3–Sep 5, 1967.
Pink, yellow, B: red, light red (A), light pink, light yellow-green, yellow-green, light blue (A), blue (A), light blue (S), dark blue-green, medium blue (A). 82.6 × 61.0. Ed 20 (GEP), 9 TI (CD), BAT (GEP), 3 AP (2 GEP, 1 CD), 1 TP (GEP), CP (GEP). Anthony Ko. D, BS, D, S.

1. 2097 and 2098 are designed to be seen together as one image.

2098
Module for a split level ranch house[1]. Aug 4–31, 1967.
Ochre, violet, dark yellow, B: green, light green (A), dark green, medium blue, light blue (A), light blue-green (S), dark blue, light blue-green (A). 82.6 × 61.0. Ed 20 (GEP), 9 TI (CD), BAT (GEP), 3 AP (2 GEP, 1 CD), 2 TP (1 CD, 1 GEP), CP (GEP). Serge Lozingot. D, BS, Dat, S.

1. 2097 and 2098 are designed to be seen together as one image.

2099
Spoon (Untitled Suite IV). Aug 8–21, 1967.
B: Yellow, red, light yellow, green (A), silver-green (A), silver (A), black (S). 45.7 × 38.1. Ed 20 (CD), 9 TI (BFK), BAT (CD), 3 AP (2 CD, 1 BFK), 1 TP (CD), CP (BFK). Donald Kelley. BS, D, Dat, S.

2100
Double Bed, I Presume. Aug 10–Sep 14, 1967.
Yellow-green, pink, B: light blue, blue (A), orange, violet (A), red-black (S)[1], yellow (A). 76.2 × 56.5. Ed 20 (CD), 9 TI (GEP), BAT (CD), 3 AP (GEP), 1 TP (CD), CP (GEP). Donald Kelley. D, BS, Dat, S.

1. Stone held from 2100II. 2100 differs from 2100II in color and in image. Solid tones have been added to the breasts, faces, the tie, the glasses and to very small areas in the lower two-thirds of the image.

2100II
Double Bed, I Presume. Aug 10–29, 1967.
Black (S). 76.2 × 55.9. Ed 10 (CD), 9 TI (GEP), BAT (CD), 2 AP (CD). Donald Kelley. D, BS, Dat, S.

2101
Hollywood Nap (Bliss Suite I). Aug 16–Sep 18, 1967.
Yellow (A), blue, orange-yellow (A), pink, violet (A), brown, green (A), blue (S)[1]. 58.4 × 86.4. Ed 20 (CD), 9 TI (GEP), BAT (CD), 3 AP (CD), CP (GEP)[2]. Maurice Sanchez. D, Dat, S, BS.

1. Stone held from 2101II. 2101 differs from 2101II in color and in image. Addition of solid tones have been added in lightning, semi-circles, torsos of the figures and in the wavy band at the bottom.
2. Torn in half; each half on paper 58.4 × 43.2.

2101II
Hollywood Nap. Aug 16–18, 1967.
Black (S). 58.4 × 86.4. Ed 10 (BFK), 9 TI (GEP), BAT (BFK), 3 AP (2 BFK, 1 GEP). Maurice Sanchez. D, BS, S, Dat.

2102
Space Face (Bliss Suite II). Aug 18–Sep 12, 1967.
Blue (A)[1], yellow (A), red (A), green (S)[2]. 58.4 × 87.0. Ed 20 (CD), 9 TI (GEP), BAT (CD), 3 AP (1 CD, 2 GEP), 1 TP (CD), 1 CTP (GEP), CP (CD). David Folkman. D, BS, S, Dat.

1. Plate held from 2102II, run 2, deletions.
2. Stone held from 2102II, run 1. 2102 differs from 2102II in color and in image. Solid tones have been added in the lightning at the left. Drawing accents have been added throughout the image.

2102II
Space Face. Aug 18–31, 1967.
Red-black (S), green-black (A). 58.4 ×
86.4. Ed 10 (MI), 9 TI (GEP), BAT (MI),
3 AP (GEP), 2 TP* (MI). David
Folkman. D, Dat, S, BS.

2116
*The Collection, or La Nouvelle
Middle Class . . . (Bliss Suite III).*
Sep 12–25, 1967.
Light blue (A)[1], light yellow (Z),
black (S)[2]. 58.4 × 86.4. Ed 20 (CD), 9
TI (GEP), BAT (CD), 3 AP (2 CD, 1
GEP), 2 PP (CD), 2 TP (CD), CP (GEP).
Bruce Lowney. D, BS, S, Dat.

1. Plate held from 2116II, run 2.
2. Stone held from 2116II, run 1. 2116
 differs from 2116II in color and in
 image. A solid background tone has
 been added. The over-all image is
 lighter. Central shape at top edge
 and two clumps of leaves at the
 bottom edge are considerably
 lighter.

2116II
*The Collection, or La Nouvelle
Middle Class.* Sep 6–12, 1967.
Green-black (S), blue-black (A). 59.1 ×
87.0. Ed 10 (CD), 9 TI (GEP), BAT (CD),
3 AP (2 CD, 1 GEP), 1 PP (CD). Bruce
Lowney. D, BS, Dat, S.

2117
*Twin Beds, I Presume (Bliss Suite
IV).* Sep 9–20, 1967.
Yellow (A), red (S), black (A). 58.4 ×
86.4. Ed 20 (CD), 9 TI (GEP), BAT (CD),
3 AP (GEP), 1 CTP (CD), CP* (CD).
Anthony Stoeveken. D, Dat, S.

2118
Zog (Ogg, Zog, Zap and Xis I). Sep
14–29, 1967.
Brown (A), dark pink (A), black (S).
55.2 × 76.2. Ed 20 (CD), 9 TI (4 GEP, 5
CD), BAT (CD), CP (GEP). Anthony Ko.
D, BS, S, Dat.

2119
Ogg (Ogg, Zog, Zap and Xis II).
Sep 21–27, 1967.
Grey-green (S), B: red, orange-red,
orange (A), black (A). 55.2 × 76.2. Ed
20 (CD), 9 TI (GEP), BAT (CD), 3 AP (2
GEP, 1 CD), CP (GEP). Maurice
Sanchez. D, BS, S, Dat.

2120
Zap (Ogg, Zog, Zap and Xis III).
Sep 17–30, 1967.
Blue (A), blue-green (S), black (A).
55.2 × 76.2. Ed 20 (CD), 9 TI (GEP),
BAT (CD), 3 AP (1 CD, 2 GEP), 1 TP
(CD), CP (CD). Anthony Stoeveken. D,
BS, S, Dat.

2121
Xis (Ogg, Zog, Zap and Xis IV).
Sep 21–28, 1967.
Black (S). 55.2 × 76.2. Ed 20 (CD), 9 TI
(GEP), BAT (CD), 3 AP (CD), CP (CD).
Bruce Lowney. D, BS, S, Dat.

2132
Zippy Linnae, or the Collectors [1].
Sept. 15–22, 1967
Red (A), yellow (A), black (S). 101.6 ×
75.6. Ed 20 (CD), 9 TI (GEP), BAT (CD),
1 AP (GEP), 3 PP (CD), CP (CD). Donald
Kelley. D, BS, S, Dat.

1. The two top corners are torn at 45
 degree angles, the left torn 10.2
 from the corner and the right torn
 12.7 from the corner.

Noemi Smilansky

2358
Split Image I. Jun 6–12, 1968.
Blue-gold (S). 50.8 × 50.8. Ed 20 (JG),
9 TI (JG), BAT (JG), 1 AP (JG), 2 CTP
(1 bA, 1 nN), 3 PTP (1 CD, 1 GEP, 1
CW), CP (JG). David Folkman. D, BS,
S[1].

1. Indecipherable marks follow S.

2359
Split Image II. Jun 13–18, 1968.
Red (A)[1], black or gold (S)[1]. 50.8 ×
34.3. Ed 20 (bA)[2], 9 TI (bA), BAT
(bA), 2 AP (bA)[2], 1 TP (bA), 3 CTP (2
bA[2], 1 wA), 1 PTP (bCD), CP (bA).
Daniel Socha. D, BS, S[3].

1. Edition exists in two color
 variations. Variation I in gold and
 Variation II in red and black.
2. Indicates Variation II, Ed 11–20/20, 2
 CTP (bA), 1 AP.
3. Indecipherable marks follow S.

Clifford Smith

1225
United Nations. Jan 1, 1965.
Black (S). 32.7 × 25.1. Ed 10 (BFK), 9
TI (bA), BAT (BFK), 1 AP (bA), 3 PP (1
R, 2 bA), 1 TP (BFK). Clifford Smith. T,
D, BS, S, Dat.

1248
Operation Redwing. Mar 1, 1965.
Yellow (S), red-orange (S), violet (S),
red (S), violet (S). 32.4 × 24.8. Ed 10
(BFK), 9 TI (wA), BAT (BFK), 4 PP
(BFK), 2 AP (BFK), 1 TP (BFK), CP (Tcs).
Clifford Smith. BS, T, D, S, Dat.

1529
Tonkin Gulf. Sep 10–13, 1965.
Yellow-ochre (Z), violet (S). 32.4 ×
24.8. Ed 10 (BFK), 9 TI (wA), BAT
(BFK), 3 AP (BFK), 1 TP (BFK), CP (Tcs).
Clifford Smith. T, D, S, Dat, BS.

1537
Orbit. Nov 8, 1965.
Transparent orange-beige (Z), dark
blue (Z). 32.7 × 25.1. Ed 10 (BFK), 9 TI
(wA), BAT (BFK), 3 AP (1 wA, 2 BFK), 1
TP (BFK), CP (Tcs). Clifford Smith. T, D,
BS, S, Dat.

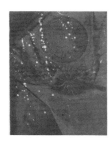

1538
Budapest '56. Nov 8–15, 1965.
Dark blue (Z), dark red (Z). 32.7 ×
25.1. Ed 10 (BFK), 9 TI (wA), BAT
(BFK), 3 AP (1 wA, 2 BFK), 1 TP (BFK),
CP (Tcs). Clifford Smith. T, D, BS, S,
Dat.

1601
Discothêque. Nov 26–29, 1965.
Red (Z), transparent light green (Z),
pink (Z), blue-violet (Z). 32.7 × 24.8.
Ed 10 (BFK), 9 TI (wA), BAT (BFK), 3
AP (2 BFK, 1 wA), 3 TP (BFK), CP (Tcs).
Clifford Smith. T, BS, D, S, Dat.

1619
Watt's Summer. Dec 4–6, 1965.
Yellow (Z), red (Z), blue (Z). 32.4 ×
24.8. Ed 10 (BFK), 9 TI (wA), BAT
(BFK), 3 AP (1 BFK, 2 wA), 2 TP (BFK),
CP (Tcs). Clifford Smith. T, BS, D, S,
Dat.

1624
Unanimous Decision. Dec 21–22,
1965.
Black (Z). 32.7 × 24.8. Ed 10 (BFK), 9
TI (wA), BAT (BFK), 3 AP (1 BFK, 2
wA), 2 TP (BFK), CP (Tcs). Clifford
Smith. T, D, BS, S, Dat.

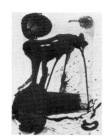

2200
Black Spider Man. Jan 18–26, 1968.
Transparent black (Z), black (Z), black
(Z). 71.1 × 50.8. Ed 10 (wA), 9 TI (CD),
BAT (wA), 2 AP (wA), 1 TP (wA), CP
(wA). Clifford Smith. T, center, D, S,
Dat, BS.

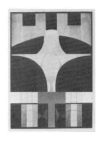

2448
*Habitable Sculpture, Series #1:
Branch Bank.* Sep 27–Oct 10, 1968.
Gold-black (S) on silver Fasson foil.
60.3 × 41.9 (paper). Ed 10 (bA), 9 TI
(cream CD), BAT (bA), 2 AP (1 bA, 1
cream CD), 1 TP* (bA), CP (bA).
Clifford Smith. T, D, BS, S, Dat.

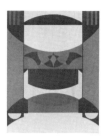

2449
Habitable Sculpture, Series #1:
People's Pleasure Palace. Sep 18–
Oct 4, 1968.
Blue (A), black (S) on gold Fasson foil.
76.2 × 55.9 (paper). Ed 10 (CD), 9 TI
(GEP), BAT (CD), 1 AP (GEP), 2 TP (1
CD), 1 (GEP), CP (CD). Clifford Smith.
T, D, BS, S, Dat.

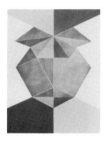

2469
Habitable Sculpture, Series #1:
Welfare Office. Dec 2–18, 1968.
Violet (S), yellow (A). 76.2 × 55.9. Ed
10 (CD), 9 TI (GEP), BAT (CD), 2 AP
(GEP), 1 TP (CD), 1 CTP (CD), CP (CD).
Clifford Smith. T, D, S, Dat, BS.

2509
Habitable Sculpture, Series #1:
Urban Renewal. Feb 24–Mar 21,
1969.
Green (S), orange (S)[1], violet (S)[1],
blue (S)[1]. 76.2 × 55.9. Ed 10 (CD), 9
TI (GEP), BAT (CD), 2 AP (GEP), 2 TP*
(CD), CP (CD). Clifford Smith. T, D, S,
Dat, BS.

1. Same stone as previous run, re-
 registered .90 to the left.

Leon Polk Smith

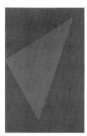

2452
Untitled. Oct 3–28, 1968.
Red (A), blue-green (A). 75.3 × 47.3,
cut. Ed 11 (7 wA, 4 JG), 9 TI (wA), BAT
(wA), 2 AP (wA), 1 TP (wA), CP (wA).
Manuel Fuentes. D, BS, S.

2453
Untitled. Oct 9–17, 1968.
Violet (A). 75.3 × 52.7, cut. Ed 20
(wA), 9 TI (JG), BAT (wA), 2 AP (wA), 2
CTP (1 wA, 1 JG), 1 PTP (JG)[1].
Robert Rogers. D, BS, S.

1. 1 PTP on paper 75.6 × 50.2.

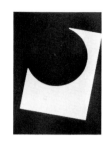

2453A
Untitled. Oct 15–30, 1968.
Black (A)[1]. 75.3 × 52.7, cut. Ed 20
(wA), 9 TI (JG), BAT (wA), 1 AP (wA), 2
TP (wA), CP (JG). Robert Rogers. D,
BS, S.

1. Plate held from 2453. 2453A differs
 from 2453 in color only.

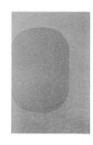

2454
Untitled. Oct 1–21, 1968.
Orange (A), blue (A). 75.3 × 47.3, cut.
Ed 20 (wA), 9 TI (1 wA, 8 BFK), BAT
(wA), 1 AP (BFK), 1 TP (JG), CP (BFK).
Jean Milant. D, BS, S.

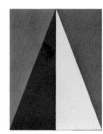

2455
Untitled. Oct 16–30, 1968.
Violet (A), green (A), black (A). 75.9 ×
55.6, cut. Ed 20 (CD), 9 TI (JG), BAT
(CD), 3 AP (1 JG, 2 CD), 2 TP (CD), CP
(JG). Daniel Socha. D, BS, S.

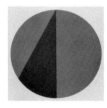

2456
Untitled. Oct 19–Nov 9, 1968.
Green (A), blue (A), black (S). 66.0 ×
66.0, cut, (diameter). Ed 20 (CD), 9 TI
(CD), BAT (CD), 3 AP (CD), 1 TP (CD),
CP (CD). Donald Kelley. D, BS, S.

2457
Untitled. Oct 28–Nov 12, 1968.
Green (A), blue (A). 66.0 × 66.0, cut,
(diameter). Ed 20 (CD), 9 TI (CD), BAT
(CD), 3 AP (CD), 2 TP (CD), CP (CD).
Daniel Socha. D, BS, S.

2458
Untitled. Oct 28–Nov 11, 1968.
Green (A), blue (A). 58.1 × 44.1, cut.
Ed 20 (wA), 9 TI (JG), BAT (wA), 3 AP
(2 wA, 1 JG), 1 TP (wA), CP (JG).
Kenjilo Nanao. D, BS, S.

2459
Untitled. Oct 29–Nov 8, 1968.
Yellow (A), blue (A). 66.0 × 65.7, cut,
(diameter). Ed 20 (CD), 9 TI (CD), BAT
(CD), 3 AP (CD), 1 TP (CD), CP (CD).
Manuel Fuentes. D, BS, S.

2460
Untitled. Nov 1–14, 1968.
Yellow (A)[1], blue (A). 76.2 × 55.9,
cut. Ed 20 (GEP), 9 TI (JG), BAT (GEP),
3 AP (JG), 1 TP (JG), CP (GEP). Serge
Lozingot. D, BS, S.

1. Plate held from 2460A. 2460 differs
from 2460A in color and in image.
The image was turned 180 degrees.
A solid dark tone was added on the
left half.

2460A
Untitled. Nov 1–7, 1968.
Yellow (A). 76.2 × 55.6, cut. Ed 20
(GEP), 9 TI (JG), BAT (GEP), 3 AP (1
JG, 2 GEP). Serge Lozingot. D, BS, S.

2461
Untitled. Nov 5–21, 1968.
Red (A), black (A). 76.2 × 44.5, cut. Ed
20 (GEP), 9 TI (JG), BAT (GEP), 3 AP (1
GEP, 2 JG), 1 TP (GEP), 2 CTP (1 GEP,
1 JG), CP (JG). Robert Rogers. D, BS,
S.

2462
Untitled. Nov 8–26, 1968.
Red (A), violet (A). 76.2 × 55.9, cut.
Ed 20 (CD), 9 TI (GEP), BAT (CD), 3 AP
(CD), 1 PP (GEP), 1 TP (GEP), CP (GEP).
Jean Milant. D, BS, S.

2463
Untitled. Nov 14–Dec 2, 1968.
Yellow (A), red (A), blue (A). 66.0 ×
66.0, cut, (diameter). Ed 16 (CD), 9 TI
(CD), BAT (CD), 3 AP (CD), 1 TP (CD),
CP (CD). Donald Kelley. D, BS, S.

2464
Untitled. Nov 11–20, 1968.
Black (A). 76.2 × 55.6, cut. Ed 20 (CD),
9 TI (GEP), BAT (CD), 3 AP (1 CD, 2
GEP), CP (GEP). Kenjilo Nanao. D, BS,
S.

2465
Untitled. Nov 11–25, 1968.
Green (A), blue (A)[1]. 66.0 × 66.0,
cut, (diameter). Ed 20 (CD), 9 TI (CD),
BAT (CD), 3 AP (CD), 1 PP (CD), 1 CTP
(CD), CP (CD). Serge Lozingot. D, BS,
S.

1. Same plate as run 1; the paper was
turned 180 degrees.

Daniel Socha

2396
Boxed Bakery Goodies. Sep 18–24,
1968.
Pink, yellow (A), black (S). 76.2 ×
57.2. Ed 12 (bA), 9 TI (bA), BAT (bA), 1
AP (bA), 3 TP* (bA), CP (bA). Daniel
Socha. D, T, S, Dat, BS.

2442
A Prune Cake Delight. Sep 27–29,
1968.
Blue-black (S). 58.8 × 80.0. Ed 12
(JG), 9 TI (JG), BAT (JG), 1 AP (JG), 1
TP* (JG), CP (JG). Daniel Socha. D, T,
BS, S, Dat.

2446
Untitled. Oct 12–21, 1968.
Yellow (A), red (A), black (S). 38.4 ×
57.8. Ed 15 (GEP), 9 TI (GEP), BAT
(GEP), 2 AP (1 BFK, 1 GEP), 1 TP (BFK),
CP (BFK). Daniel Socha. D, BS, S, Dat.

2447
Untitled. Oct 12–21, 1968.
Yellow (A), red (A), black (S). 38.7 ×
57.2. Ed 15 (GEP), 9 TI (GEP), BAT
(GEP), 2 AP (1 BFK, 1 GEP), 1 TP (BFK),
CP (GEP). Daniel Socha. D, BS, S, Dat.

2472
Untitled. Oct 30–Nov 12, 1968.
Black (S). 38.7 × 56.8. Ed 15 (GEP), 9
TI (GEP), BAT (GEP), 3 AP (GEP), 1 TP
(GEP), CP (GEP). Daniel Socha. D, BS,
S, Dat.

2473
Untitled. Oct 30–Nov 12, 1968.
Black (S). 38.1 × 56.8. Ed 15 (GEP), 9
TI (GEP), BAT (GEP), 1 AP (GEP), CP
(GEP). Daniel Socha. D, BS, S, Dat.

2489
Untitled. Nov 5–Dec 11, 1968.
B: Light green, green, yellow (A),
black (S). 38.1 × 57.8. Ed 16 (GEP), 9
TI (GEP), BAT (GEP), 3 AP (GEP), 2 TP*
(1 BFK[1], 1 GEP), 2 CTP (GEP). Daniel
Socha. D, BS, S, Dat.

1. 1 TP (BFK) measures 31.7 × 55.2,
cut.

2490
Untitled. Nov 5–Dec 11, 1968.
B: Light green, green, yellow (A),
black (S). 38.7 × 57.2. Ed 16 (GEP), 9
TI (GEP), BAT (GEP), 3 AP (GEP), 2 TP*
(1 BFK[1], 1 GEP), 2 CTP (GEP). Daniel
Socha. D, BS, S, Dat.

1. 1 TP (BFK) measures 31.7 × 55.2,
cut.

2505
Chichi. Jan 6–19, 1969.
Silver-ochre (S), B: orange-pink,
yellow (A), beige (A). 54.0 × 39.7, cut.
Ed 12 (GEP), 9 TI (CD), BAT (GEP), 3
AP (CD), CP (GEP). Daniel Socha. D,
BS (Tam), T, BS (pr), S, Dat.

2546
Untitled. Jan 20–Feb 22, 1969.
B: Yellow, light green (A), beige (A),
pink (S). 64.8 × 51.1. Ed 13 (cR), 9 TI
(GEP), BAT (cR), 2 AP (GEP), 1 TP (cR),
3 CTP (1 cR, 2 GEP), CP (cR). Daniel
Socha. D, BS, S, Dat.

2551
Untitled. Feb 24–Mar 28, 1969.
B: Light violet, grey, light grey-yellow
(A), pearly beige (Z), green (Z). 58.8 ×
46.1. Ed 9 (6 cR, 3 GEP), 9 TI (GEP),
BAT (GEP), 3 AP (2 cR, 1 GEP), 3 CTP
(1 GEP, 2 cR), CP (GEP). Daniel Socha.
D, BS, S, Dat.

2666
Alone in the Pantry. Jun 13–14,
1969.
Grey (A). 48.3 × 71.5. Ed 10 (MI), 9 TI
(cR), BAT (MI), 3 AP (1 cR, 2 MI), 1 TP*
(cR), CP (MI). Daniel Socha. D, T, S,
Dat, BS.

Frederick Sommer

416
Untitled. Oct 13, 1961.
Black (S). 38.1 × 45.7. Ed 5 (BFK), 9 TI
(wA), PrP (BFK), 1 unique proof*(Tcs).
Harold Keeler. BS, S, D.

418
Untitled. Oct 18, 1961.
Black (S). 38.1 × 50.8. Ed 20 (BFK), 9
TI (wA), PrP (wA), CP (Tcs). Joe Funk.
BS, S, D.

John Sommers

2553
California PKR 888. Mar 1–Apr 7,
1969.
Ochre (A), brown (A). 73.7 × 48.6. Ed
5 (GEP), 9 TI (cR), BAT (GEP), 2 AP
(GEP), 1 CTP (GEP), CP (cR). John
Sommers. BS, D, S.

2568
Starlett. Jan 23–Mar 24, 1969.
B: Light violet, pink (S), gold (S)[1],
violet (A). 70.5 × 48.9. Ed 7 (nN), 9 TI
(wN), BAT (wN), 3 CTP (1 bA, 1 MI, 1
JG), CP (wN). John Sommers. D, BS
(Tam), T, BS (pr), S.

1. Same stone as run 1.

Print not in
University Art Museum
Archive

2618
Women In. May 9–19, 1969.
Silver-yellow (Z), pearly light blue (Z),
dark grey-blue (A), pearly light blue
(Z). 70.2 × 48.3. Ed 14 (wA), 9 TI
(GEP), BAT (wA), 1 AP (GEP), CP
(GEP). John Sommers. Recto: BS
Verso: D, S.

2661
"Seck" Fantasy. Dec 1–15, 1969.
Black (Z). 74.9 × 104.1. Ed 8 (cR), 9 TI
(ucR), BAT (CR), 2 AP (cR), 2 TP* (cR),
CP (ucR). John Sommers. T, BS, D, S.

2703
Divine is Dead. Aug 18–Oct 20, 1969.
White (Z), light violet (Z), pink (Z),
black (Z). 52.1 × 74.9. Ed 10 (cream
CD), 9 TI (bA), BAT (cream CD), 3 AP
(bA), 3 PP (cream CD), 2 PTP (1 cR, 1
cream CD), CP (bA). John Sommers.
BS, T, Dat, D, S.

Emiliano Sorini

472
Untitled. Dec 13–20, 1961.
Black (Z), pink (Z), black (Z). 75.6 ×
56.5. Ed 9 (wA), 9 TI (wA), 3 TP (Tcs).
Emiliano Sorini. BS (Tam), D, S, BS
(pr).

Print not in
University Art Museum
Archive

(unnumbered)
Fossil I. ND
Brown-pink (Z), black (Z)[1], brown-
violet (Z)[2]. 56.5 × 76.2. Ed 15 (wA),
9 TI (wA), 3 AP (wA). Emiliano Sorini.
Recto: D, S, BS (pr) Verso: T.

1. Plate held from run 1; deletions.
2. Plate held from run 2; deletions.

Print not in
University Art Museum
Archive

(unnumbered)
Fossil II. ND
Black (Z), blue-grey (Z)[1], green-grey
(Z)[2]. 57.2 × 76.2. Ed 15 (wA), 9 TI
(wA), 4 AP (wA). Emiliano Sorini.
Recto: D, S, BS (pr) Verso: T.

1. Plate held from run 1, deletions.
2. Plate held from run 2, deletions.

Print not in
University Art Museum
Archive

(unnumbered)
Modern Death. Jan 1, 1962.
Yellow-beige (Z), black (Z), green-grey
(Z), red-brown (Z). 76.2 × 56.2. Ed 15
(wA), 9 TI (wA), BAT (wA), 3 AP (wA).
Emiliano Sorini. Recto: D, BS (pr), S
Verso: T, Dat.

Print not in
University Art Museum
Archive

(unnumbered)
Untitled. ND
Brown-green (Z), transparent yellow-
beige (Z), transparent blue-black (Z).
56.5 × 76.2. Ed 15 (wA), 9 TI (wA), 3
AP (wA). Emiliano Sorini. Recto: D, S,
BS (pr) Verso: T, Dat.

Benton Spruance

363
The Sea—Galilee. Aug 22, 1961.
Black (S). 76.2 × 56.5. Ed 22 (BFK)[1],
9 TI (wA)[2], BAT (BFK), 3 TP (BFK).
Bohuslav Horak. BS, D, T, S, Dat.

1. Artist's edition inscribed "Ed. 31."
2. Tamarind Impressions inscribed
 "Ed. 31" by the artist and "Tam.
 Imp. JW" by Tamarind.

Hedda Sterne

Metaphores and Metamorphoses, a
suite of nine lithographs plus title and
colophon pages, enclosed in a wrap-
around folder of white Nacre. Title
page and colophon printed at the
Plantin Press, Los Angeles. In order:
2048, 2049, 2049II, 2050, 2050A,
2050B, 2050C, 2053, 2056.

Vertical Horizontals, a suite of five
lithographs. In order: 2021, 2022,
2023, 2024, 2025.

2021
***Untitled (The Vertical Horizontals
I).*** May 4–5, 1967.
Black (S). 55.2 × 35.6. Ed 20 (CD), 9 TI
(GEP), BAT (CD), 3 AP (2 GEP, 1 CD), 1
TP (CD), CP (CD). Anthony Ko. D, S,
BS.

2029
Untitled. May 9–11, 1967.
Black (S). 73.7 × 53.3. Ed 20 (BFK), 9
TI (wA), BAT (BFK), 2 AP (1 BFK, 1
wA), 2 TP (BFK), 2 PTP (1 CD, 1 GEP),
CP (BFK). Anthony Ko. D, S, BS.

2022
***Untitled (The Vertical Horizontals
II).*** May 4–5, 1967.
Black (S). 55.2 × 36.2. Ed 20 (CD), 9 TI
(GEP), BAT (CD), 3 AP (2 CD, 1 GEP), 2
TP (CD), CP (CD). Anthony Ko. D, S,
BS.

2030
Untitled. May 11–12, 1967.
Black (S). 73.0 × 53.3. Ed 20 (wA), 9 TI
(BFK), BAT (wA), 1 AP (BFK), 2 TP
(wA), CP (wA). Serge Lozingot. D, S,
BS.

2023
***Untitled (The Vertical Horizontals
III).*** May 5–8, 1967.
Black (S). 55.2 × 35.6. Ed 20 (CD), 9 TI
(GEP), BAT (CD), 1 AP (GEP), 2 TP
(CD), CP (CD). David Folkman. D, S,
BS.

2031
Untitled. May 11, 1967.
Yellow (S). 56.2 × 40.3. Ed 20 (wA), 9
TI (BFK), BAT (wA), 3 AP (2 BFK, 1
wA), 2 TP (wA), CP (wA). Maurice
Sanchez. D, S, BS.

2024
***Untitled (The Vertical Horizontals
IV).*** May 5–8, 1967.
Black (S). 54.6 × 35.6. Ed 20 (CD), 9 TI
(GEP), BAT (CD), 1 AP (GEP), 2 TP
(CD), CP (CD). David Folkman. D, S,
BS.

2032
Untitled. May 15, 1967.
Black (S). 61.0 × 50.8. Ed 20 (wA), 9 TI
(BFK), BAT (wA), 1 AP (BFK), 2 TP
(wA), CP (wA). Serge Lozingot. D, S,
BS.

2025
***Untitled (The Vertical Horizontals
V).*** May 6, 1967.
Black (S). 55.6 × 35.6. Ed 20 (CD), 9 TI
(GEP), BAT (CD), 2 AP (1 CD, 1 GEP), 2
TP (CD), CP (GEP). Maurice Sanchez.
D, S, BS.

2034
Untitled. May 19–22, 1967.
Black (S). 55.9 × 36.2. Ed 20 (wA), 9 TI
(CD), BAT (wA), 1 AP (CD), 2 TP (wA),
CP (wA). David Folkman. D, S, BS.

Print not in
University Art Museum
Archive

2028
Untitled. May 8–15, 1967.
Black (S). 71.5 × 49.9. Ed 18 (CD), 9 TI
(GEP), BAT (CD), 3 AP (2 CD, 1 GEP), 2
TP (CD), CP (CD). David Folkman. D, S,
BS.

2038
Untitled. May 19–23, 1967.
Grey-blue (S). 55.9 × 36.8. Ed 20
(wA), 9 TI (CD), BAT (wA), 1 AP (CD), 2
TP (wA), CP (wA). Anthony Ko. D, S,
BS.

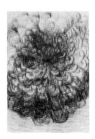

2039
Untitled. May 22–23, 1967.
Yellow (S)[1], green-blue (S)[1], black
(S)[1]. 55.2 × 36.2. Ed 20 (wA), 9 TI
(CD), BAT (wA), 3 AP (CD), 4 TP (wA),
CP (wA). Serge Lozingot. D, S, BS.

1. Same stone used for run 1, 2 and 3,
 registration moved .60

2047
Untitled. May 24–Jun 6, 1967.
Yellow (Z), beige (Z), black (S). 50.8 ×
50.8. Ed 20 (CD), 9 TI (GEP), BAT (CD),
1 TP (wN), CP (CD). John Butke. D, S,
BS.

2048
*Untitled (Metaphores and
Metamorphoses I).* May 24–26, 1967.
Yellow (S)[1], green (S)[1], black (S)[1].
50.8 × 50.8. Ed 20 (wA)[2], 9 TI (CD),
BAT (wA), 2 AP (CD), 4 TP (wA)[2], CP
(wA). Serge Lozingot. D, BS, S.

1. Same stone used for run 1, 2 and 3.
 Edition exists in two color
 variations. Variation I in yellow and
 green and Variation II in yellow,
 green and black.
2. Indicates Variation I, Ed 1–10/20, 2
 TP.

2049
*Untitled (Metaphores and
Metamorphoses II).* May 26, 1967.
Black (S). 50.8 × 50.8. Ed 20 (bA), 9 TI
(nN), BAT (bA), 1 AP (nN), 1 TP (bA).
Fred Genis. D, BS, S.

2049II
*Untitled (Metaphores and
Metamorphoses III).* May 29–Jun 12,
1967.
Violet (A), beige (A), black (S)[1],
brown-grey (A). 50.8 × 50.8. Ed 20
(wA)[2], 9 TI (CD), BAT (wA), 2 AP
(CD), 4 TP (wA)[2], 2 CP* (CD). Fred
Genis. D, S, BS.

1. Stone held from 2049. 2049II differs
 from 2049 in color and in image. A
 band of light color around the
 central drawing and linear drawing
 around the whole image have been
 added.
2. Ed 1–5/20, 4 TP vary from the
 edition.

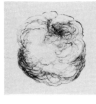

2050
*Untitled (Metaphores and
Metamorphoses IV).* Jun 2–16, 1967.
Black (S). 50.8 × 50.8. Ed 20 (CD), 9 TI
(GEP), BAT (CD), 3 AP (GEP), 2 TP
(CD). Donald Kelley. D, S, BS.

2050A
*Untitled (Metaphores and
Metamorphoses V).* Jun 2–8, 1967.
Grey (S), green (S)[1]. 51.1 × 50.8. Ed
20 (CD), 9 TI (GEP), BAT (CD), 3 AP
(GEP), 2 TP (CD). Donald Kelley. D, S,
BS.

1. Stone held from 2050; additions.
 2050A differs from 2050 in color and
 in image. The linear image is lighter
 and a bleed background tone of the
 same color has been added around
 the drawing. A darker tone has been
 added underneath the linear
 drawing.

2050B
*Untitled (Metaphores and
Metamorphoses VI).* Jun 2–14, 1967.
Grey (S), yellow-green (S)[1]. 50.8 ×
50.8. Ed 20 (CD), 9 TI (GEP), BAT (CD),
3 AP (GEP), 3 TP (CD). Donald Kelley.
D, S, BS.

1. Stone held from 2050A, run 2.
 2050B differs from 2050A in color
 only.

2050C
*Untitled (Metaphores and
Metamorphoses VII).* Jun 2–21,
1967.
Grey (S), silver (S)[1]. 50.8 × 50.8. Ed
20 (CD), 9 TI (GEP), BAT (CD), 2 AP
(GEP), 3 TP (CD), 8 PTP* (GEP)[2], CP
(GEP). Donald Kelley. D, S, BS.

1. Stone held from 2050B, run 2;
 deletions. 2050C differs from 2050B
 in color and in image. Background
 tone the same color as the linear
 drawing has been eliminated. A
 dark bleed background tone has
 been added.

2052
Untitled. May 31–Jun 8, 1967.
Black (S). 49.5 × 29.2. Ed 20 (wA), 9 TI
(BFK), BAT (wA), 1 AP (BFK), 2 TP
(wA), CP (wA). Anthony Stoeveken. D,
S, BS.

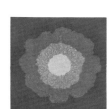

2053
*Untitled (Metaphores and
Metamorphoses VIII).* Jun 5–22,
1967.
Light blue (A), blue (A), ochre (S). 50.8
× 50.8. Ed 20 (CD), 9 TI (GEP), BAT
(CD), 3 AP (GEP), 4 PP (CD), 2 TP (CD),
1 CTP (EVB), 6 CSP (CD)[1], CP (CD).
Anthony Ko. D, S, BS.

1. 3 CSP retained by Tamarind.

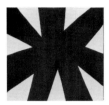

2056
Untitled (Metaphores and Metamorphoses IX). Jun 12–26, 1967.
Dark green (S). 50.8 × 51.1. Ed 20 (CD), 9 TI (GEP), BAT (CD), 2 AP (CD), CP (CD). John Butke. D, S, BS.

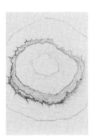

2058
Untitled. Jun 15–16, 1967.
Dark red-violet (S). 55.9 × 36.2. Ed 20 (wA), 9 TI (CD), BAT (wA), 1 AP (CD), 2 TP (wA), CP (wA). Anthony Stoeveken. D, S, BS.

2059
Untitled. Jun 15–21, 1967.
Pink (A), black (S). 55.9 × 36.2. Ed 20 (wA), 9 TI (CD), BAT (wA), 4 TP (1 CD*, 3 wA)[1]. Anthony Stoeveken. D, S, BS.

1. 1 TP (wA) is actually an artist's proof but was inadvertently signed as a TP.

2059II
Untitled. Jun 22, 1967.
Blue-violet (S)[1]. 56.5 × 36.2. Ed 10 (wA), 9 TI (CD), BAT (wA), 2 AP (CD), 1 TP (wA). Anthony Stoeveken. D, S, BS.

1. Stone held from 2059, run 2. 2059II differs from 2059 in color and in image. Some of the spiral lines have been eliminated from the oval shape at right.

2059III
Untitled. Jun 23–26, 1967.
Black (S)[1]. 41.9 × 47.0. Ed 10 (wA), 9 TI (BFK), BAT (wA), 1 AP (BFK), 2 TP (wA), CP (wA). Anthony Stoeveken. D, S, BS.

1. Stone held from 2059II; reversal. 2059III differs from 2059II in color, image, size and presentation. Some of the background has been eliminated from the top and bottom. Background and a thin black line have been added on the sides. The image was turned 180 degrees.

Donn Steward

1714
Untitled. May 1–Jun 4, 1966.
Green-grey (Z), black (S). 49.9 × 34.6. Ed 10 (CD), 9 TI (GEP), BAT (CD), CP (Tcs). Donn Steward. D, BS, S, Dat.

Anthony Stoeveken

1948
Homage to K. Mar 24–Apr 11, 1967.
Brown-yellow (Z), black (Z). 65.7 × 50.8. Ed 10 (MI), 9 TI (BFK), BAT (MI), 2 AP (BFK), 2 TP (MI), 1 PTP (wN), CP (EVB). Anthony Stoeveken. D, S, Dat, BS.

1949
Homage to G. Mar 5–18, 1967.
Black (Z). 75.9 × 51.4. Ed 10 (wA), 9 TI (BFK), BAT (wA), 3 AP (2 BFK, 1 wA), 2 TP (wA), CP (EVB). Anthony Stoeveken. D, S, Dat, BS.

2042
Two plus—two blue. May 16–Aug 12, 1967.
Black (S), red (S)[1], dark violet (A), light green (A). 76.2 × 55.6. Ed 5 (GEP), 9 TI (CD), BAT (CD), 3 AP (2 CD, 1 GEP), 1 TP (GEP), CP (CD). Anthony Stoeveken. D, S, Dat, BS.

1. Same stone as run 1; deletions.

2078
Poor Old Marat. Oct 4–Nov 8, 1967.
Orange-brown (A), yellow (A)[1], black (S). 76.2 × 56.8. Ed 14 (GEP), 9 TI (wA), BAT (GEP), 2 AP (wA), 2 TP (1 GEP[2], 1 MI), CP (EVB). Anthony Stoeveken. D, BS, S, Dat.

1. Same plate as run 1; deletions.
2. 1 TP (GEP) on paper 80.0 × 56.8.

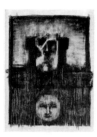

2199
Jack a Moon. Jan 18–Feb 19, 1968.
Yellow (A), blue, violet (A), black (S).
87.6 × 62.2. Ed 12 (GEP), 9 TI (CD),
BAT (GEP), 2 AP (1 CD, 1 GEP), 3 CTP
(GEP). Anthony Stoeveken. D, S, Dat,
BS.

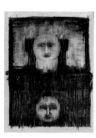

2223
Jill a Moon. Feb 26–Jun 5, 1968.
Yellow (A), black (S)[1], red (A). 87.6 ×
62.2. Ed 12 (GEP), 9 TI (CD), BAT
(GEP), 3 AP (2 CD, 1 GEP), 1 CTP
(GEP), 1 PTP (CD)[2], CP (GEP).
Anthony Stoeveken. D, S, Dat, BS.

1. Stone held from 2199, run 3;
 deletions and additions. 2223 differs
 from 2199 in image and color. The
 black shapes inside two vertical
 bars at top center have been
 eliminated and a face has been
 added.
2. 1 PTP on paper 55.9 × 87.6.

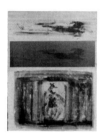

2293
Man in Space. Apr 8–22, 1968.
Black (A), grey-green (A), orange (A),
blue-green (A)[1], on Fasson gold or
silver foil. 51.1 × 71.1 (paper).
Ed 19 (9 wA[2], 10 nN[3]), 9 TI
(GEP)[3], BAT (nN)[3], 2 AP (GEP)[3].
Anthony Stoeveken. BS, D, S, Dat
(top).

1. Plate held from run 1, left half of
 image deleted.
2. On gold foil.
3. On silver foil.

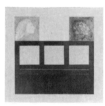

2294
Grey ☐. Apr 18–29, 1968.
Black (A), blue-grey (A), on silver
Fasson foil, embossed. 50.8 × 50.8,
(paper). Ed 12 (JG), 9 TI (wA), BAT
(JG), 3 TP* (1 wA, 2 JG), CP (JG).
Anthony Stoeveken. D, S, Dat, BS.

2400
Tötentanz. Jun 1–Aug 30, 1968.
Blue (A), brown-red (A), light beige
(A). 76.2 × 55.9. Ed 14 (wA), 9 TI (JG),
BAT (wA), 2 AP (JG), 4 CTP (2 MI, 1
JG, 1 wA). Anthony Stoeveken. D, S,
Dat, BS.

James Strombotne

Recognitions, a suite of twelve
lithographs including title and
colophon pages, enclosed in a red
linen covered portfolio, measuring
53.3 × 69.2, lined with white Nacre,
made by Margaret Lecky, Los Angeles.
The lithographs are separated with
slipsheets and white Tableau paper. In
order: 2235, 2231, 2233, 2230, 2224,
2227, 2225, 2226, 2228, 2229, 2232,
2246.

920
Artist. Nov 8–11, 1963.
Black (S). 56.5 × 76.2. Ed 20 (BFK), 9
TI (wA), PrP (BFK), PrP II for Irwin
Hollander (BFK), 3 AP (1 BFK, 2 wA), 2
TP (BFK). John Dowell. T, D, S, Dat,
BS.

924
The Incredible Nathan Irwin. Nov
14–18, 1963.
Green-black (S)[1], pink (Z). 56.2 ×
72.4. Ed 20 (BFK), 9 TI (wA), PrP (BFK),
PrP II for Irwin Hollander (BFK), 3 AP
(1 BFK, 2 wA), CP (BFK). Robert
Gardner. T, D, BS, S, Dat.

1. Stone held from 920; additions and
 deletions. 924 differs from 920 in
 color, image and size. The thin
 border line at the right has been
 eliminated. The inner rectangular
 frame has been thickened and
 figures and creatures added within
 and below it. A checkered pattern
 was added beneath the reclining
 figure. Facial features were added
 to the male figure on the left and
 his garment filled in solid.

1329
The Window. May 19–26, 1965.
Black (S). 56.5 × 57.2. Ed 20 (bA), 9 TI
(bA), BAT (bA), 3 AP (bA), CP (Tcs).
Bernard Bleha. T, D, BS, S, Dat.

1331
John Henry. May 3–5, 1965.
Black (S). 56.8 × 76.2. 15 ExP (BFK)[1],
BAT (BFK). Bernard Bleha. T, D, BS, S,
Dat.

1. Designated A–O. 8 ExP retained by
 Tamarind.

1336
Grand Hotel. May 12–15, 1965.
Black (S). 56.5 × 76.2. Ed 20 (BFK), 9
TI (wA), BAT (BFK), 2 AP (1 BFK, 1
wA), 1 TP (BFK), CP (Tcs). Bernard
Bleha. T, D, BS, S, Dat.

1337
Rod Random. May 5–13, 1965.
Yellow (S), brown (A). 47.6 × 71.1. Ed
20 (BFK), 9 TI (wA), BAT (BFK), 3 AP
(wA), 1 TP* (BFK), CP (Tcs). Bernard
Bleha. T, D, BS, S, Dat.

1363
Circus. Jun 21–Jul 3, 1965.
Pink (A), blue-violet (S). 53.3 × 68.6.
Ed 15 (BFK), 9 TI (wA), BAT (BFK), 1
AP (wA), 3 TP (BFK), CP (Tcs). Bernard
Bleha. T, D, BS, S, Dat.

1349
Kabuki. May 7–10, 1965.
Black (S). 56.5 × 76.2. Ed 20 (BFK), 9
TI (wA), BAT (BFK), 1 AP (BFK), 2 TP
(BFK), CP (Tcs). Kenneth Tyler. T, D,
BS, S, Dat.

1374
The Maze. May 28–Jun 12, 1965.
Black (S). 53.7 × 76.2. Ed 20 (BFK), 9
TI (wA), BAT (BFK), 2 AP (1 BFK, 1
wA), 1 TP (BFK), CP (Tcs). Bernard
Bleha. T, BS, D, S, Dat.

1350
Medusa. May 10, 1965.
Black (S). 56.5 × 76.2. Ed 20 (BFK), 9
TI (wA), BAT (BFK), 1 AP (wA), 1 TP
(BFK), CP (Tcs). Kenneth Tyler. T, D,
BS, S, Dat.

2224
Pink (Recognitions V). Mar 1–15,
1968.
Red (S), light green (Z), pink (Z). 50.8
× 66.0. Ed 20 (wA), 9 TI (CD), BAT
(wA), 1 TP* (wA), CP* (wA). David
Folkman. T, D, BS, S, Dat.

1355
Love. May 14–22, 1965.
Black (S), red (Z). 56.5 × 76.2. Ed 20
(BFK), 9 TI (wA), BAT (BFK), 3 AP (wA),
4 TP (BFK)[1], CP (Tcs). Bernard Bleha.
T, D, BS, S, Dat.

1. 1 TP varies from the edition.

2225
Military (Recognitions VII). Mar 4–
12, 1968.
Green-black (S), red (A). 50.8 × 66.0.
Ed 20 (wA), 9 TI (CD), BAT (wA), 3 AP
(1 wA, 2 CD), 1 TP (wA), CP (wA). Jean
Milant. T, D, BS, S, Dat.

1359
Evening. May 17–24, 1965.
Green-black (S), yellow (Z). 32.4 ×
41.9. Ed 20 (BFK), 9 TI (wA), BAT
(BFK), 2 AP (wA), 2 TP (BFK)[1], CP
(Tcs). Kenneth Tyler. BS, T, D, S, Dat.

1. 1 TP varies from the edition.

2226
Bird Lady (Recognitions VIII). Mar
5–26, 1968.
Yellow (A), red (A), brown (A), blue-
grey (S). 50.8 × 66.0. Ed 20 (wA), 9 TI
(CD), BAT (wA), 3 AP (2 wA, 1 CD), 1
TP (wA), 1 PTP (buff CD), CP (CD).
Theodore Wujcik. T, D, BS, S, Dat.

1360
Family. Jun 1–11, 1965.
Black (S). 56.5 × 76.2. Ed 20 (BFK), 9
TI (wA), BAT (BFK), 3 AP (wA), 2 TP
(BFK), CP (Tcs). Clifford Smith. T, D,
BS, S, Dat.

2227
Smokers (Recognitions VI). Mar 5–
12, 1968.
Black (S). 50.8 × 66.0. Ed 20 (bA), 9 TI
(cream CD), BAT (bA), 3 AP (1 bA, 2
cream CD). Frank Akers. T, D, BS, S,
Dat.

1362
Flight. May 21–26, 1965.
Black (S). 56.5 × 76.2. Ed 20 (BFK), 9
TI (wA), BAT (BFK), 2 AP (BFK), 1 TP
(BFK), CP (Tcs). Bernard Bleha. BS, T,
D, S, Dat.

2227II
Smokers, II. Mar 13–Apr 1, 1968.
Blue (Z), dark brown (S)[1]. 50.8 ×
66.0. Ed 10 (wA), 9 TI (CD), BAT (wA),
3 AP (2 wA, 1 CD), CP* (CD). Frank
Akers. T, D, BS, S, Dat.

1. Stone held from 2227; additions.
2227II differs from 2227 in color and
in image. A narrow blue border has
been added around the composition
and color accent has been added to
the smoke puffs.

2228
Big Henry (Recognitions IX). Mar 9–28, 1968.
Orange (A), pink (A), grey-green (S). 50.8 × 66.0. Ed 20 (wA), 9 TI (CD), BAT (wA), 3 AP (1 wA, 2 CD), 1 PP (wA), 1 TP (wA)[1], CP (wA). Anthony Stoeveken. T, D, BS, S, Dat.

1. 1 TP on paper 47.0 × 63.5, varies from the edition.

2229
Ice Cream Cone (Recognitions X). Mar 6–Apr 1, 1968.
Red (A), dark ochre (A), brown (S). 50.8 × 66.0. Ed 20 (wA), 9 TI (CD), BAT (wA), 3 AP (2 wA, 1 CD), 2 TP (wA)[1], CP (CD). Jean Milant. T, D, BS, S, Dat.

1. 1 TP varies from the edition.

2230
Asylum (Recognitions IV). Mar 15–Apr 8, 1968.
Yellow (A), orange (A), grey-green (S). 50.8 × 66.0. Ed 20 (wA), 9 TI (CD), BAT (wA), 1 TP (wA), CP* (wA). Theodore Wujcik. T, D, BS, S, Dat.

2231
Rally Round the Flag (Recognitions II). Mar 25–Apr 20, 1968.
Orange (Z), blue (Z), grey-green (Z), brown (S). 50.8 × 66.0. Ed 20 (wA), 9 TI (CD), BAT (wA), 2 AP (1 wA, 1 CD), CP (CD). Manuel Fuentes. T, D, BS, S, Dat.

2232
March (Recognitions XI). Mar 19–Apr 11, 1968.
Pink (A), red (A), gold (S), brown (S). 50.8 × 66.0. Ed 18 (3 CD, 15 wA), 9 TI (CD), BAT (wA). David Folkman. T, D, BS, S, Dat.

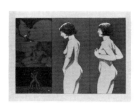

2233
Co Co (Recognitions III). Mar 19–Apr 5, 1968.
Light blue-green (A), silver-black (S). 50.8 × 66.0. Ed 20 (wA), 9 TI (CD), BAT (wA), 3 AP (1 wA, 2 CD), 1 TP* (wA), CP (wA). Theodore Wujcik. T, D, BS, S, Dat.

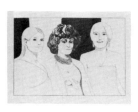

2234
String. Mar 27–29, 1968.
Black (S). 76.2 × 55.2. Ed 20 (ucR), 9 TI (CD), BAT (ucR), 3 AP (2 ucR, 1 CD), CP (ucR). Serge Lozingot. T, D, BS, S, Dat.

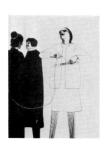

2235
Title Page (Recognitions I). Apr 12–16, 1968.
Silver-black (A), brown (S)[1]. 50.8 × 66.0. Ed 20 (wA), 8 TI (CD), BAT (wA), 1 AP (CD)[2], CP (wA). David Folkman. T, D, BS, S, Dat.

1. Stone held from 2232, run 4; deletions. 2235 differs from 2232 in color and in image. The two nude female figures at the right and the solid background tones have been eliminated. The suite title, a cross and the artist's name have been added at the right.
2. 1 AP exists as a TI.

2242
Gypsy. Apr 3–19, 1968.
Light blue (A), pink (A), black (S). 73.0 × 55.2. Ed 20 (wA), 9 TI (JG), BAT (wA), 3 AP (JG), CP* (wA). Frank Akers. T, D, S, Dat, BS.

2244
Self-Portrait. Apr 4–19, 1968.
Gold (Z), black (A), brown (S). 76.2 × 55.9. Ed 20 (ucR), 9 TI (cR), BAT (ucR). Manuel Fuentes. BS, T, D, S, Dat[1].

1. Titled, designated, signed and dated along the right edge.

2245
Cowboy. Apr 12–20, 1968.
Red (Z), black (S). 61.3 × 61.0. Ed 20 (CD), 9 TI (GEP), BAT (CD), 1 AP (CD), CP* (CD). Manuel Fuentes. T, D, BS, S, Dat.

2246
Colophon (Recognitions XII). Apr 10–11, 1968.
Blue (S). 50.8 × 66.0. Ed 20 (wA), 9 TI (CD), BAT (wA), 3 AP (1 CD, 2 wA), CP (CD). Robert Rogers. T, D, BS, S, Dat.

2247
Movies. Apr 17, 1968.
Black (S). 76.8 × 57.2. Ed 20 (nN), 9 TI (wN), BAT (nN), 2 AP (wN), CP (nN). Maurice Sanchez. T, D, BS, S, Dat.

2248
W.C. Apr 17–18, 1968.
Red-brown (S). 56.5 × 77.5. Ed 20 (wN), 9 TI (nN), BAT (wN), 3 AP (2 wN, 1 nN), 2 TP (wN)[1], CP (wN). Robert Rogers. T, D, BS, S, Dat.

1. 1 TP varies from the edition.

2249
The Ladies. Apr 19–22, 1968.
Brown-black (S). 76.2 × 55.9. Ed 20 (wA), 9 TI (BFK), BAT (wA), 3 AP (1 BFK, 2 wA), 1 TP (wA), CP (wA). Robert Rogers. T, D, S, Dat, BS.

2250
Demented Truck. Apr 23, 1968.
Black (S). 55.9 × 76.2. Ed 20 (wA), 9 TI (GEP), BAT (wA), 2 AP (wA), CP (GEP). Serge Lozingot. T, D, BS, S, Dat.

2300
Execution. Apr 24–25, 1968.
Red (S). 57.2 × 76.2. Ed 20 (wN), 9 TI (GEP), BAT (wN), 2 AP (1 GEP, 1 wN), CP (GEP). Serge Lozingot. T, D, BS, S, Dat.

Jan Stussy

A Family of Acrobatic Jugglers, a suite of eighteen lithographs plus folder with silk-screened title, enclosed in a wrap-around folder of natural Nacre, measuring 26.0 × 20.9. The front cover silk-screened in black with the suite title, the artist's name and date in a design by the artist. In order: 2890, 2890II, 2891, 2891II, 2892, 2892II, 2893, 2893II, 2894, 2894II, 2895, 2895II, 2896, 2896II, 2897, 2897II, 2898, 2898II.

9 of the 8 Views of Omi, a suite of nine lithographs plus folder with silk-screened title, enclosed in a wrap-around folder of Arches, measuring

23.5 × 20.3. The front cover silk-screened in black with the suite title, the artist's name and date in a design by the artist. In order: 2913, 2914, 2915, 2916, 2917, 2918, 2919, 2920, 2921.

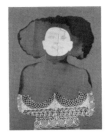

2840
Boxed Man in a Box. Mar 26–30, 1970.
Black (S). 55.9 × 73.0. Ed 20 (cR), 9 TI (BFK), BAT (cR), 3 AP (2 BFK, 1 cR), CP (cR). Edward Hamilton. D, BS, T, S, Dat.

2856
Self Contained Man. Mar 31–Apr 6, 1970.
Red-brown (Z), black (S). 55.9 × 76.2. Ed 20 (cR), 9 TI (BFK), BAT (cR), 3 AP (cR), 2 TP (1 cR, 1 BFK)*, 1 CTP (cR), 1 CSP (UCR), CP (BFK). Larry Thomas. D, BS, T, S, Dat.

2864
Impossible Act Performed by a Boxed Animal Posing as a Man. Apr 3–6, 1970.
Black (S). 56.5 × 76.2. Ed 20 (bA), 9 TI (bA), BAT (bA), 3 PTP (1 GEP, 1 cR, 1 bA). Harry Westlund. D, BS, T, S, Dat.

2864II
Second Impossible Act Performed by a Boxed Animal Posing as a Man. Apr 6–7, 1970.
Black (S)[1]. 56.5 × 76.2. Ed 10 (bA), 9 TI (bA), BAT (bA), 3 AP (bA), CP (bA). Harry Westlund. D, BS, T, S, Dat.

1. Stone held from 2864; deletions. 2864II differs from 2864 in image. The head, shoulder and upper portion of the legs have been deleted.

2865
Kim's Decision. Apr 8–16, 1970.
Orange (A), black (S). 76.2 × 56.5. Ed 20 (cR), 9 TI (wA), BAT (cR), 3 AP (wA), 2 PP (wA), 1 TP (cR), 1 CTP (cR). Edward Hamilton. D, BS, T, S, Dat.

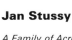

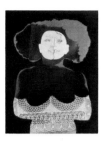

2865II
Kim's Other Decision. Apr 8–16, 1970.
Black (A)[1], grey (S)[2]. 76.2 × 56.5. Ed 10 (bA), 9 TI (bA), 1 AP (bA), 3 TP (2 bA), 1 cR)*, 2 CSP (bA)[3], CP (cR)*. Edward Hamilton. D, BS, T, S, Dat.

1. Aluminum plate held from 2865, run 1.
2. Stone held from 2865, run 2. 2865II differs from 2865 in color only.
3. One CSP was retained by Tamarind.

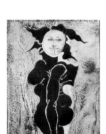

2866
Girl of My Dreams in a Peau de Crapaud. Apr 7–8, 1970.
Black (Z). 76.2 × 55.9. Ed 20 (cR), 9 TI (BFK), BAT (cR), 1 AP (cR), 2 TP (1 cR, 1 CD*), CP (cR). Larry Thomas. BS (bottom), D, T, S, Dat (in India ink, top).

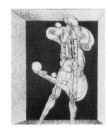

2890
Untitled (Family of Acrobatic Jugglers I). May 11–12, 1970.
Black (S). 25.4 × 20.3, cut. Ed 10 (cR), 9 TI (ucR), BAT (cR), 2 AP (cR). Hitoshi Takatsuki. BS, D, S.

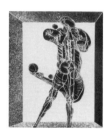

2890II
Untitled (Family of Acrobatic Jugglers II). May 13–15, 1970.
Black (S)[1]. 25.4 × 20.3, cut. Ed 10 (cR), 9 TI (ucR), BAT (ucR), 4 AP (cR). Hitoshi Takatsuki. D, BS, S.

1. Stone held from 2890; reversal.

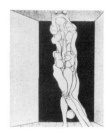

2891
Untitled (Family of Acrobatic Jugglers III). May 11–12, 1970.
Black (S). 25.4 × 20.3, cut. Ed 10 (cR), 9 TI (ucR), BAT (cR), 3 AP (cR). Hitoshi Takatsuki. BS, D, S.

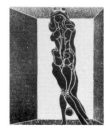

2891II
Untitled (Family of Acrobatic Jugglers IV). May 13–15, 1970.
Black (S)[1]. 25.4 × 20.3, cut. Ed 10 (cR), 9 TI (ucR), BAT (ucR), 4 AP (cR). Hitoshi Takatsuki. BS, D, S.

1. Stone held from 2891; reversal.

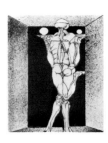

2892
Untitled (Family of Acrobatic Jugglers V). May 11–12, 1970.
Black (S). 25.4 × 20.3, cut. Ed 10 (cR), 9 TI (ucR), BAT (cR), 3 AP (cR). Hitoshi Takatsuki. BS, D, S.

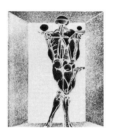

2892II
Untitled (Family of Acrobatic Jugglers VI). May 13–15, 1970.
Black (S)[1]. 25.4 × 20.3, cut. Ed 10 (cR), 9 TI (ucR), BAT (ucR), 6 AP (5 cR, 1 ucR). Hitoshi Takatsuki. BS, D, S.

1. Stone held from 2892; reversal.

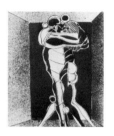

2893
Untitled (Family of Acrobatic Jugglers VII). May 11–12, 1970.
Black (S). 25.4 × 20.3, cut. Ed 10 (cR), 9 TI (ucR), BAT (cR), 2 AP (cR). Hitoshi Takatsuki. BS, D, S.

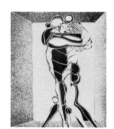

2893II
Untitled (Family of Acrobatic Jugglers VIII). May 13–15, 1970.
Black (S)[1]. 25.4 × 20.3, cut. Ed 10 (cR), 9 TI (ucR), BAT (ucR), 4 AP (cR). Hitoshi Takatsuki. BS, D, S.

1. Stone held from 2893; reversal.

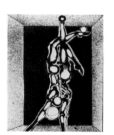

2894
Untitled (Family of Acrobatic Jugglers IX). May 11–12, 1970.
Black (S). 25.4 × 20.3, cut. Ed 10 (cR), 9 TI (ucR), BAT (cR), 3 AP (cR). Hitoshi Takatsuki. BS, D, S.

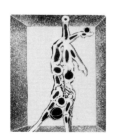

2894II
Untitled (Family of Acrobatic Jugglers X). May 13–15, 1970.
Black (S)[1]. 25.4 × 20.3, cut. Ed 10 (cR), 9 TI (ucR), BAT (ucR), 4 AP (3 cR, 1 ucR). Hitoshi Takatsuki. BS, D, S.

1. Stone held from 2894; reversal.

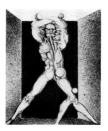

2895
Untitled (Family of Acrobatic Jugglers XI). May 11–12, 1970.
Black (S). 25.4 × 20.3, cut. Ed 10 (cR), 9 TI (ucR), BAT (cR), 3 AP (cR). Hitoshi Takatsuki. BS, D, S.

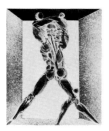

2895II
Untitled (Family of Acrobatic Jugglers XII). May 13–15, 1970.
Black (S)[1]. 25.4 × 20.3, cut. Ed 10 (cR), 9 TI (ucR), BAT (ucR), 6 AP (cR). Hitoshi Takatsuki. BS, D, S.

1. Stone held from 2895; reversal.

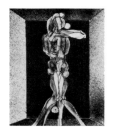

2896
Untitled (Family of Acrobatic Jugglers XIII). May 11–12, 1970.
Black (S). 25.4 × 20.3, cut. Ed 10 (cR), 9 TI (ucR), BAT (cR), 3 AP (cR). Hitoshi Takatsuki. BS, D, S.

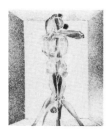

2896II
Untitled (Family of Acrobatic Jugglers XIV). May 13–15, 1970.
Black (S)[1]. 25.4 × 20.3, cut. Ed 10 (cR), 9 TI (ucR), 6 AP (5 cR, 1 ucR). Hitoshi Takatsuki. BS, D, S.

1. Stone held from 2896; reversal.

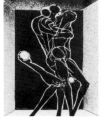

2897
Untitled (Family of Acrobatic Jugglers XV). May 11–12, 1970.
Black (S). 25.4 × 20.3, cut. Ed 10 (cR), 9 TI (ucR), BAT (cR), 2 AP (cR). Hitoshi Takatsuki. BS, D, S.

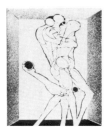

2897II
Untitled (Family of Acrobatic Jugglers XVI). May 13–15, 1970.
Black (S)[1]. 25.4 × 20.3, cut. Ed 10 (cR), 9 TI (ucR), BAT (ucR), 2 AP (cR). Hitoshi Takatsuki. BS, D, S.

1. Stone held from 2897; reversal.

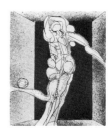

2898
Untitled (Family of Acrobatic Jugglers XVII). May 11–12, 1970.
Black (S). 25.4 × 20.3, cut. Ed 10 (cR), 9 TI (ucR), BAT (cR), 3 AP (cR). Hitoshi Takatsuki. BS, D, S.

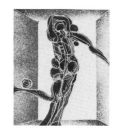

2898II
Untitled (Family of Acrobatic Jugglers XVIII). May 13–15, 1970.
Black (S)[1]. 25.4 × 20.3, cut. Ed 10 (cR), 9 TI (ucR), BAT (ucR), 6 AP (5 cR, 1 ucR). Hitoshi Takatsuki. BS, D, S.

1. Stone held from 2898; reversal.

2913
Untitled (9 of the 8 Views of Omi I). May 13–19, 1970.
Black (S). 20.3 × 25.4, cut. Ed 10 (cR), 9 TI (BFK), BAT (cR). David Trowbridge. Recto: D, S, rso: WS.

2914
Untitled (9 of the 8 Views of Omi II). May 13–19, 1970.
Black (S). 20.3 × 25.4, cut. Ed 10 (cR), 9 TI (BFK), BAT (cR). David Trowbridge. Recto: D, S Verso: WS.

2915
Untitled (9 of the 8 Views of Omi III). May 13–19, 1970.
Black (S). 20.3 × 25.4, cut. Ed 10 (cR), 9 TI (BFK), BAT (cR). David Trowbridge. Recto: D, S Verso: WS.

2916
Untitled (9 of the 8 Views of Omi IV). May 13–19, 1970.
Black (S). 20.3 × 25.4, cut. Ed 10 (cR), 9 TI (BFK), BAT (cR). David Trowbridge. Recto: D, S Verso: WS.

2917
Untitled (9 of the 8 Views of Omi V). May 13–19, 1970.
Black (S). 20.3 × 25.4, cut. Ed 10 (cR), 9 TI (BFK), BAT (cR). David Trowbridge. Recto: D, S Verso: WS.

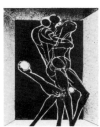

2918
Untitled (9 of the 8 Views of Omi VI). May 13–19, 1970.
Black (S). 20.3 × 25.4, cut. Ed 10 (cR), 9 TI (BFK), BAT (cR). David Trowbridge. Recto: D, S Verso: WS.

2919
Untitled (9 of the 8 Views of Omi VII). May 13–19, 1970.
Black (S). 20.3 × 25.4, cut. Ed 10 (cR), 9 TI (BFK), BAT (cR). David Trowbridge. Recto: D, S Verso: WS.

2920
Untitled (9 of the 8 Views of Omi VIII). May 13–19, 1970.
Black (S). 20.3 × 25.4, cut. Ed 10 (cR), 9 TI (BFK), BAT (cR). David Trowbridge. Recto: D, S Verso: WS.

2921
Untitled (9 of the 8 Views of Omi IX). May 13–19, 1970.
Black (S). 20.3 × 25.4, cut. Ed 10 (cR), 9 TI (BFK), BAT (cR). David Trowbridge. Recto: D, S Verso: WS.

2922
Family of Acrobatic Jugglers. May 11–12, 1970.
Black (S)[1]. 76.2 × 60.7, cut. Ed 10 (cR), 9 TI (ucR), BAT (cR), 3 AP (cR), 1 PP (cR). Hitoshi Takatsuki. D, BS, S.

1. Stone held from 2890—2898. 2922 differs from 2890—2898 in image and size. 2922 combines all 9 images reading numerically left to right, top to bottom.

2922II
Family of Acrobatic Jugglers. May 13–15, 1970.
Black (S)[1]. 76.2 × 61.0, cut. Ed 10 (cR), 9 TI (ucR), BAT (cR), 1 AP (cR), CP (ucR). Hitoshi Takatsuki. D, BS, S.

1. Stone held from 2890II–2898II. 2922II combines all 9 images reading numerically left to right, top to bottom. 2922II differs from 2922, as do 2890–2898 from 2890II–2898II, only in that it is a reversal.

2938
9 of the 8 Views of Omi. May 13–19, 1970.
Black (S)[1]. 61.0 × 76.2, cut. Ed 10 (cR), 9 TI (BFK), BAT (cR), 2 AP (BFK), 4 PP (cR), 1 TP (cR)*, CP (BFK). David Trowbridge. D, BS, S.

1. Stone held from 2913–2921. 2938 differs from 2913–2921 in image and size. 2938 combines all 9 images reading numerically left to right, top to bottom.

George Sugarman

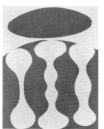

Print not in
University Art Museum
Archive

1430
Red and White. Aug 2–5, 1965.
Red (S). 74.6 × 55.9, cut. Ed 20 (CW), 9 TI (CW), BAT (CW), 2 AP (CW), 2 TP (1 CW, 1 bA), CP (Tcs). Ernest de Soto. Verso: WS, D, S, Dat.

1431
Yellow and Green. Aug 6–11, 1965.
Yellow (Z), green (S). 75.6 × 50.8, cut. 8 ExP (2 BFK, 6 wA)[1], BAT (wA), CP (Tcs). Ernest de Soto. Verso; D, S, Dat, WS.

1. Designated A–H. 4 ExP retained by Tamarind.

1432
Poem. Aug 6–10, 1965.
White (A). 75.9 × 40.6, cut. Ed 20 (bA), 9 TI (bA), BAT (bA), 1 AP (bA), CP (Tcs). Kinji Akagawa. Verso: D, S, Dat, WS.

1432A
Poem. Aug 18–20, 1965.
Orange-beige (A). 22.6 × 40.3, cut. Ed 20 (bA), 9 TI (bA), BAT (bA), 1 AP (bA), CP (Tcs). Kinji Akagawa. Verso: D, S, Dat, WS.

1433
Green, White and Orange. Aug 9–13, 1965.
Orange (A), green (A). 61.0 × 45.7, cut. Ed 20 (CW), 9 TI (CW), BAT (CW), 3 AP (CW), 1 TP (CW), CP (Tcs). Kinji Akagawa. Verso: D, S, Dat, WS.

1439
Litho Drawing II. Aug 23–Sep 2, 1965.
Yellow (A), pink (A), black (A), light green-grey (A). 57.2 × 76.2. Ed 20 (BFK), 9 TI (wA), BAT (BFK), 3 AP (wA), 4 TP (BFK), 1 PTP (sample Rives II)[1], CP (Tcs). Clifford Smith. D, S, Dat, BS.

1. Unsigned, unchopped, undesignated, retained by Tamarind.

1434
Green, Blue and Black. Aug 11–20, 1965.
Green (Z), blue (A), black (A). 61.0 × 45.7, cut. Ed 17 (wA), 9 TI (wA), BAT (wA), 2 TP (1 wA, 1 CD), CP (Tcs). Ernest de Soto. Verso: D, S, Dat, WS.

1440
Black and White. Aug 24–27, 1965.
Black (S). 86.4 × 61.0, cut. Ed 20 (BFK), 9 TI (CD), BAT (BFK)[1], 1 AP (CD), CP (Tcs). Jurgen Fischer. Verso: D, S, Dat, WS.

1. Retained by Tamarind.

1435
Red, White and Blue. Aug 13–17, 1965.
Red (A), blue (A). 75.6 × 55.9, cut. Ed 20 (BFK), 9 TI (wA), BAT (BFK), 2 AP (wA), 2 TP (BFK), CP (Tcs). Kinji Akagawa. Verso: D, S, Dat, WS.

1441
Blue and Black. Aug 27–Sep 14, 1965.
Blue (Z), black (A). 50.2 × 49.5, cut. Ed 20 (wA), 9 TI (CD), BAT (wA), 1 AP (CD), CP (Tcs). Robert Evermon. Verso: D, S, Dat, WS.

1436
The Second Green, White and Orange. Aug 16–24, 1965.
Orange (A), green (A). 54.9 × 68.3, cut. Ed 20 (CW), 9 TI (CW), BAT (CW), 2 TP (CW), CP (Tcs). Kinji Akagawa. Verso: D, S, Dat, WS.

1442
Yellow and Black. Aug 27–Sep 2, 1965.
Yellow (Z), black (A). 73.7 × 49.5, cut. Ed 20 (wA), 9 TI (CD), BAT (wA), 3 AP (1 wA, 2 CD), 1 PP (CD), 2 TP (wA), CP (Tcs). John Beckley. Verso: D, S, Dat, WS.

1437
Yellow and Purple. Aug 18–30, 1965.
Violet (A), yellow-orange (A). 62.2 × 45.7, cut. Ed 20 (wA), 9 TI (wA), BAT (wA), 3 AP (wA), 3 PP (wA), 2 TP* (wA), CP (Tcs). Ernest de Soto. Verso: D, S, Dat, WS.

1443
Hope and Peace. Aug 27–Sep 9, 1965.
Red-orange (A), violet (A), brown (A), white (A). 56.8 × 76.2. Ed 20 (bA), 9 TI (bA), BAT (bA), 1 AP (bA), CP (Tcs). Jurgen Fischer. Verso: D, S, Dat, WS.

1438
Red, White and Grey. Aug 19–28, 1965.
Red (A), grey (A). 67.6 × 45.7, cut. Ed 20 (BFK), 9 TI (wA), BAT (BFK), 3 AP (wA), 2 PP (BFK), CP (Tcs). Clifford Smith. Verso: D, S, Dat, WS.

1444
Green and White. Aug 31–Sep 1, 1965.
Green (A). 75.9 × 55.6, cut. Ed 17 (wA), 9 TI (3 BFK, 6 wA), BAT (CD), 2 TP (Tcs), CP (Tcs). John Rock. Verso: D, S, Dat, WS.

1445
Orange, Magenta and Blue. Sep 1–18, 1965.
Orange (A), red-violet (A), blue (A). 67.9 × 55.9, cut. Ed 20 (BFK), 9 TI (wA), BAT (BFK), 3 AP (1 BFK, 2 wA), 4 TP (BFK), CP (Tcs). John Rock. Verso: D, S, Dat, WS.

1446
Red, White and Yellow. Sep 1–9, 1965.
Red (S), yellow (S). 101.3 × 41.3, cut. Ed 20 (BFK), 9 TI (CD), BAT (BFK), 3 AP (2 BFK, 1 CD), 3 TP (2 BFK, 1 CD), CP (Tcs). John Rock. Verso: D, S, Dat, WS.

1447
Litho Drawing I. Sep 1, 1965.
Black (A)[1]. 57.2 × 76.2. Ed 20 (BFK), 9 TI (wA), BAT (BFK), 3 AP (wA), 2 TP (BFK), CP (Tcs). Jurgen Fischer. Recto: D, S, Dat Verso: WS.

1. Plate held from 1439, run 3; deletions. 1447 differs from 1439 in color and in image. The three solid oval color tones on the right two-thirds of the composition have been eliminated.

1448
Blue and White. Sep 7–10, 1965.
Blue (A). 76.2 × 56.5, cut. Ed 20 (CW), 9 TI (CW), BAT (CW), 1 TP (CW), CP (Tcs). Ernest de Soto. Verso: D, S, Dat, WS.

1449
Green, White and Red. Sep 8–16, 1965.
Dark-green (S), red (S). 78.4 × 71.5, cut. Ed 20 (BFK), 9 TI (CD), BAT (BFK), 3 AP (CD), 1 TP (BFK), CP (Tcs). Robert Evermon. Verso: D, S, Dat, WS.

1465
Grey and White. Sep 10–17, 1965.
Grey (A). 76.5 × 56.2, cut. Ed 13 (11 BFK, 1 wA, 1 CW), 4 proofs (BFK)[1], CP (Tcs). Ernest de Soto.

1. Unsigned, undesignated, unchopped; retained by Tamarind.

1465II
Orange and White. Sep 24–25, 1965.
Orange (A). 75.3 × 55.2. Ed 20 (BFK), 9 TI (wA), BAT (BFK), 2 AP (BFK), 4 proofs (BFK)[1], CP (Tcs). Kinji Akagawa. Verso: D, S, Dat, WS.

1. Unsigned, undesignated, unchopped, retained by Tamarind.

1466
Red and Purple. Sep 14–24, 1965.
Red (S), violet (S). 78.7 × 71.5, cut. Ed 20 (BFK), 9 TI (CD), BAT (BFK), 3 AP (1 BFK, 2 CD), 3 TP (BFK)[1], CP (Tcs). Robert Evermon. Verso: D, S, Dat, WS.

1. 1 TP varies from the edition.

1467
Brown, Black and White. Sep 17–22, 1965.
Brown (S), black (S). 45.7 × 88.6, cut. Ed 20 (BFK), 9 TI (CD), BAT (BFK), 3 AP (CD), 2 TP (BFK), CP (Tcs). Clifford Smith. Verso: D, S, Dat, WS.

1468
Purple and White. Sep 22–23, 1965.
Blue-violet (A). 60.3 × 55.6, cut. Ed 20 (BFK), 9 TI (wA), BAT (BFK), 3 AP (1 BFK, 2 wA), CP (Tcs). Ernest de Soto. Verso: D, S, Dat, WS.

Peter Takal

Of Nature, Of Man, a suite of twenty lithographs including title and colophon pages. In order: 983, 952, 955, 947, 951, 970, 982, 949, 968, 962, 987, 948, 967, 988, 956, 973, 966, 969, 965, 984.

947
Wave (Of Nature, Of Man IV). Dec 2–3, 1963.
Red-brown (Z). 56.8 × 77.2. Ed 20 (bA), 9 TI (nN), PrP (bA), PrP II for Irwin Hollander (bA), 3 AP (2 bA, 1 nN), 2 TP (bA), 1 PTP (white J)[1], CP (bA). John Dowell. D, BS, S.

1. Unsigned, unchopped, undesignated, retained by Tamarind.

948
Birds (Of Nature, Of Man XII). Dec 2, 1963–Jan 27, 1964.
Grey (Z), black (Z). 46.1 × 56.5. Ed 20 (BFK), 9 TI (wA), PrP (BFK), PrP II for Irwin Hollander (BFK), 3 AP (1 BFK, 2 wA), 3 TP (BFK), CP (BFK). Robert Gardner. D, BS, S.

949
Kneeling Nude (Of Nature, Of Man VIII). Dec 3, 1963.
Brown (Z). 56.5 × 76.2. Ed 20 (BFK), 9 TI (wA), PrP (BFK), PrP II for Irwin Hollander (BFK), 3 AP (BFK), CP (BFK). Jason Leese. D, BS, S.

951
Winter Vine (Of Nature, Of Man V). Dec 5–17, 1963.
Light brown-green (Z), red or brown (Z)[1]. 76.5 × 56.8. Ed 20 (BFK)[2], 9 TI (wA), PrP (BFK)[2], PrP II for Irwin Hollander (BFK)[2], 3 AP (1 BFK, 2 wA), 2 TP (BFK), CP (BFK)[2]. Robert Gardner. D, BS, S.

1. Edition exists in two color variations. Variation I in brown-green and red and Variation II in brown-green and brown. Ten impressions of the artist's edition with run 2 in brown were designated I/II Color State; the remaining ten with run 2 in red were designated II/II Color State. Both were numbered 1–10/10.
2. Indicates Variation I, Ed 1–10/10, PrP, PrP II, 1 TP, CP.

952
Queen Anne's Lace (Of Nature, Of Man II). Dec 5–6, 1963.
Black (S). 77.5 × 57.2. Ed 20 (bA), 9 TI (nN), PrP (bA), PrP II for Irwin Hollander (bA), 3 AP (1 bA, 2 nN), 1 PP (bA), 2 TP (bA), CP (bA). Aris Koutroulis. D, S, BS.

955
Reclining Nude (Of Nature, Of Man III). Dec 9, 1963–Jan 6, 1964.
Black (Z). 56.8 × 76.2. Ed 20 (bA), 9 TI (bA), PrP (bA), 3 AP (bA), 3 TP (2 bA, 1 nN), CP (bA). Kenneth Tyler. D, BS, S.

956
Head of a Woman (Of Nature, Of Man XV). Dec 10–17, 1963.
Brown (Z), black (S). 56.5 × 76.5. Ed 20 (BFK), 9 TI (wA), PrP (BFK), 3 AP (2 wA, 1 BFK), 1 PP (BFK), 3 TP (2 BFK, 1 wA), CP (BFK). Kenneth Tyler. D, BS, S.

962
Wood (Of Nature, Of Man X). Dec 18–24, 1963.
Tan (Z), black (S). 76.5 × 56.5. Ed 20 (BFK), 9 TI (wA), PrP (BFK), 3 AP (2 BFK, 1 wA), 2 TP (BFK). Kenneth Tyler. D, S, BS.

965
Snow Fields (Of Nature, Of Man XIX). Dec. 23, 1963–Jan. 9, 1964
Black (Z). 57.5 × 77.8. Ed 20 (BFK), 9 TI (wN), PrP (BFK), PrP II for Irwin Hollander(BFK), 3 AP (2 BFK, 1 wN), 2 TP (BFK), CP (BFK). Aris Koutroulis. BS, D, S.

966
Landscape (Of Nature, Of Man XVII). Dec 23–27, 1963.
Brown (Z), black (Z). 55.9 × 76.2. Ed 20 (BFK), 9 TI (wA), PrP (BFK), 3 AP (2 wA, 1 BFK), 1 PP (BFK), 3 TP (BFK). Aris Koutroulis. D, BS, S.

967
City Windows (Of Nature, Of Man XIII). Dec 26, 1963–Jan 2, 1964.
Black (Z). 56.5 × 76.2. Ed 20 (BFK), 9 TI (wA), PrP (BFK), PrP II for Irwin Hollander (BFK), 3 AP (2 BFK, 1 wA), 2 TP (BFK), 1 PTP (Italian paper)[1], CP (BFK). John Dowell. D, BS, S.

1. Unsigned, unchopped, undesignated, retained by Tamarind.

968
Bougainvillaea (Of Nature, Of Man IX). Dec 27, 1963–Jan 16, 1964.
Black (S). 76.8 × 56.8. Ed 20 (bA), 9 TII (nN), PrP (bA), PrP II for Irwin Hollander (bA), 3 AP (2 bA, 1 nN), 2 TP (bA), CP (bA). John Dowell. BS, D, S.

969
Eclipse (Of Nature, Of Man XVIII). Dec 30, 1963–Jan 16, 1964.
Black (Z), black (Z), black (Z). 76.2 × 56.5. Ed 20 (BFK), 9 TI (wA), PrP (BFK), PrP II for Irwin Hollander (BFK), 3 AP (wA), 1 PP (wA), 3 TP (BFK), 3 ExP (white J)[1]. Kenneth Tyler. BS, D, S.

1. Adhered to BFK 104.1 × 73.6 during printing. Designated A–C/C. 1 ExP unchopped, retained by Tamarind.

970
Tree Opening (Of Nature, Of Man VI). Jan 2–9, 1964.
Black (Z). 76.2 × 55.9. Ed 20 (BFK), 9 TI (wA), PrP (BFK), PrP II for Aris Koutroulis (BFK), 3 AP (2 BFK, 1 wA), 2 TP (BFK), CP (BFK). John Dowell. S, BS, D.

973
Autumn Lake (Of Nature, Of Man XVI). Jan 6–7, 1964.
Brown (Z), black (Z). 56.8 × 76.2. Ed 20 (BFK), 9 TI (wA), PrP (BFK), 3 AP (2 wA, 1 BFK), 3 TP (BFK), CP (BFK). Aris Koutroulis. D, S, BS.

982
Open Barn Door (Of Nature, Of Man VII). Jan 16–22, 1964.
Black (S). 56.5 × 76.2. Ed 20 (BFK), 9 TI (wA), PrP (BFK), PrP II for Irwin Hollander (BFK), 3 AP (2 BFK, 1 wA), 1 PP (wA), 2 TP (BFK), CP (BFK). Robert Gardner. BS, D, S.

983
Title Page (Of Nature, Of Man I).
Jan 17–23, 1964.
Light beige (S)[1], black (Z)[2], black (Z). 76.2 × 56.8. Ed 20 (BFK), 9 TI (wA), PrP (BFK), 3 AP (BFK), 1 PP (BFK), 2 TP (BFK), CP (BFK). Aris Koutroulis. BS, D, S.

1. Stone held from 962, run 2.
2. Plate held from 969, run 3. 983 differs from 962 and 969 in color and in image. 983 superimposes the light figure of dots of 969 over the large textural shape of 962 considerably lighter with the addition of a written title in the lower portion of the image.

984
Colophon (Of Nature, Of Man XX).
Jan 17–20, 1964.
Brown (S)[1], black (Z). 76.2 × 56.5. Ed 20 (BFK), 9 TI (wA), PrP (BFK), PrP II for Aris Koutroulis (BFK), 3 AP (wA), 1 TP (BFK). John Dowell. D, BS, S.

1. Stone held from 962, run 2. 984 differs from 962 in color and in image. The bleed color background has been eliminated. The large textural shape is considerably lighter. Dark written text has been added in the right center and lower left.

987
Winter Weeds (Of Nature, Of Man XI). Jan 20–23, 1964.
Black (Z). 77.2 × 56.8. Ed 20 (bA), 9 TI (nN), PrP (bA), PrP II for Irwin Hollander (bA), 3 AP (1 bA, 2 nN), CP (bA). Aris Koutroulis. BS, D, S.

988
Flowers in Barn (Of Nature, Of Man XIV). Jan 20–27, 1964.
Black (S). 77.5 × 57.5. Ed 20 (bA), 9 TI (nN), PrP (bA), PrP II for Irwin Hollander (bA), 2 AP (nN), 2 TP (bA), CP (bA). Aris Koutroulils. D, BS, S.

Hitoshi Takatsuki

2878
Untitled. Apr 30, 1970.
Silver-blue or silver-yellow (Z). 71.5 × 51.8. Ed 9 (nN)[1], 9 TI (nN), BAT (nN), 1 TP (wN), CP (nN)[2]. Hitoshi Takatsuki. D, S, Dat, BS.

1. Printed in silver-yellow.
2. Printed twice, once in each of the two color variations.

2879
Untitled. May 5–8, 1970.
Black (A), light violet (Z). 74.9 × 54.6. Ed 6 (GEP), 9 TI (GEP), BAT (GEP), 1 AP (GEP), 3 TP* (GEP), CP (GEP). Hitoshi Takatsuki. D, BS, S.

2912
Untitled. May 8–12, 1970.
Violet (A)[1], green (Z). 50.8 × 71.1. Ed 14 (cR), 9 TI (cR), BAT (cR), 1 AP (GEP), 3 TP* (1 cR, 1 EVB[2]), CP (cR). Hitoshi Takatsuki. D, BS, S.

1. Same plate as run 2; reversal.
2. Unchopped.

Print not in
University Art Museum
Archive

P103
Cho-Cho. Jun 5–17, 1970.
Yellow-orange (A), orange (A), blue-violet (A), B: yellow-green, violet (Z). 45.7 × 57.5. Ed 10 (wN)[1], BAT (wN), 3 AP (wN), 6 TP* (wN). Hitoshi Takatsuki. D, WS (pr), S, Dat.

1. Ed 5/10 retained by Tamarind.

1156
Deux Fils. Oct 1–7, 1964.
Pink (Z), green (Z), violet (Z), grey-black (S). 62.2 × 46.4. Ed 20 (nN), 9 TI (wN), BAT (nN), PrP II for Kenneth Tyler (nN), 3 AP (2 wN, 1 nN), 4 TP (nN), 4 PgP (3 BFK, 1 wN)[1]. Ernest Rosenthal. D, S, BS.

1. Retained by Tamarind.

1157
Variation on a Man #2. Nov 13–Dec 4, 1964.
Beige (A), transparent green-yellow (Z), pink-brown (S)[1], transparent green-grey (A). 97.8 × 71.1. Ed 20 (BFK), 9 TI (BFK), BAT (BFK), 2 AP (BFK), 7 TP (BFK)[2], CP (BFK). Kenneth Tyler. BS, S, D.

1. Stone held from 1150; additions. 1157 differs from 1150 in color, image, and size. Light bleed background tone has been added. The lines of the figure have been widened and most of the dark tone has been eliminated from all but the four corners. The light area in the upper left has been eliminated and drawing has been added along the bottom.
2. 2 TP designated "unique color proof."

Tamarind Group

2872
The Great Roller Derby. Apr 22–23, 1970.
Black-violet (A). 61.6 × 88.0. Ed 30 (MI), 9 TI (cR), BAT (MI), 2 AP (1 cR, 1 MI), 2 CTP (1 GEP, 1 MI). Edward Hamilton. S[1], Dat, BS, D.

1. Signed "A Tamarind Group Creation."

Print not in
University Art Museum
Archive

0
Untitled[1]. Oct 17, 1963.
Black (nr), yellow-beige (nr). 76.2 × 55.9. Ed nr (BFK). Unrecorded. BS (Tam).

1. This lithograph was printed to commemorate the birth of Miles Tamarind Kelly. The edition was small, exact number unrecorded, and was distributed only to those participating.

1160
Man with Hat. Oct 8–9, 1964.
Red-black (S). 55.9 × 45.7. Ed 20 (BFK), 9 TI (wA), BAT (BFK), PrP II for Kenneth Tyler (BFK), 3 AP (2 BFK, 1 wA), 2 TP (BFK), CP (wA). Bernard Bleha. D, S, BS.

1163
Ghost. Oct 9–12, 1964.
Green-black (S). 55.9 × 46.1. Ed 20 (BFK), 9 TI (wA), BAT (BFK), PrP II for Kenneth Tyler (BFK), 2 AP (BFK), 3 TP (BFK). Clifford Smith. D, S, BS.

Rufino Tamayo

1150
Variations on a Man #1. Nov 13–16, 1964.
Green-black (S). 92.7 × 66.0. Ed 20 (BFK), 9 TI (BFK), BAT (BFK), 6 AP (BFK), 3 TP (BFK). Kenneth Tyler. BS, D, S.

Print not in
University Art Museum
Archive

1164
Hands. Oct 12–Nov 25, 1964.
Black (S). 55.6 × 45.7. 8 ExP (BFK)[1], BAT (BFK). Kenneth Tyler. D, S, BS.

1. Designated A–H. 4 ExP retained by Tamarind.

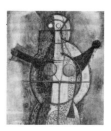

1166
Woman. Oct 12–13, 1964.
Black (S). 55.9 × 46.4. Ed 20 (BFK), 9
TI (wA), BAT (BFK), PrP II for Kenneth
Tyler (BFK), 2 AP (BFK), 3 TP (BFK).
Bernard Bleha. BS, D, S.

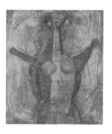

1168
Woman. Oct 14–23, 1964.
Orange (S), ochre (S), transparent
brown (S)[1], red-brown (Z), red (Z).
55.9 × 45.7. Ed 20 (BFK), 9 TI (wA),
BAT (BFK), PrP II for Kenneth Tyler
(BFK), 3 AP (BFK), 6 TP (BFK). Ernest
Rosenthal. BS, D, S.

1. Image from 1166 transferred to new
 stone; deletions. 1168 differs from
 1166 in color and in image. The
 over-all image is lighter. Most of the
 linear drawing and the tone along
 the left side of the figure have been
 eliminated.

1169
Ghost. Oct 16–26, 1964.
Green (Z), pink (Z), red (S)[1], blue (A).
55.9 × 45.7. Ed 20 (BFK), 9 TI (wA),
BAT (BFK), PrP II for Kenneth Tyler
(wA), 3 AP (1 BFK, 2 wA), 5 TP (4 BFK,
1 wA). Michael Knigin. BS, D, S.

1. Stone held from 1163; additions,
 deletions. 1169 differs from 1163 in
 color and in image. A dark stripe
 and texture have been eliminated
 from both sides and bottom. Dark
 tones have been added above and
 on each side of the head and on
 each side of the lower body. The
 line drawing in and around the
 figure is less distinct.

1171
Profile of a Man. Oct 19–22, 1964.
Black (S). 55.9 × 45.7. Ed 20 (BFK), 9
TI (wA), BAT (BFK), PrP II for Kenneth
Tyler (BFK), 2 AP (BFK), 2 TP (BFK).
Joe Zirker. BS, D, S.

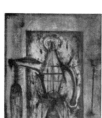

1173
Man at the Door. Oct 22–Nov 9,
1964.
Orange (S), black (S). 55.9 × 46.1. Ed
20 (BFK), 9 TI (wA), BAT (BFK), PrP II
for Kenneth Tyler (BFK), 1 AP (wA), 2
TP (1 BFK, 1 wA). Ernest Rosenthal. D,
S, BS.

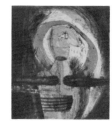

1175
Profile of a Man. Oct 23–Nov 2,
1964.
Violet (S), pink (S), green (Z), dark
brown (S)[1]. 55.9 × 46.1. Ed 20
(BFK), 9 TI (wA), BAT (BFK), PrP II for
Kenneth Tyler (BFK), 1 AP (wA), 1 PP
(BFK), 7 TP (4 BFK, 3 wA), CP (BFK).
Joe Zirker. D, S, BS.

1. Stone held from 1171. 1175 differs
 from 1171 in color and in image.
 The head and body of the figure
 have been filled in with color tones.
 An irregular halo has been added
 around the head. A curvilinear band
 was added to the right edge of the
 image.

1176
Ghost. Oct 23–27, 1964.
Transparent green (Z)[1], brown-green
(Z). 55.9 × 46.1. Ed 20 (BFK), 9 TI
(wA), BAT (BFK), PrP II for Kenneth
Tyler (BFK), 2 AP (1 BFK, 1 wA), 3 TP
(BFK). Kaye Dyal. BS, D, S.

1. Plate held from 1169, run 1;
 additions. 1176 differs from 1169 in
 color and in image. The image is
 different except for the lightly
 shaded area within the outline of
 the figure.

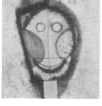

1177
Mask. Oct 26–Nov 11, 1964.
Green (Z), red (Z), transparent black
(S), grey (Z). 55.9 × 45.7. Ed 14 (BFK),
9 TI (wA), BAT (BFK), 2 AP (BFK), 3 TP
(wA), CP (BFK). Michael Knigin. D, S,
BS.

Print not in
University Art Museum
Archive

1179
Head. Oct 28, 1964.
Green-black (S). 42.2 × 30.5. Ed 20
(bA), 9 TI (bA), BAT (bA), PrP II for
Kenneth Tyler (bA), 2 AP (bA), 2 TP
(bA), CP (bA). Kaye Dyal. BS, D, S.

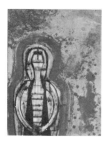

1187
Personage in a Cave. Oct 30–Nov
30, 1964.
Ochre (A), red-violet (A), grey (S),
transparent violet (Z), black (S). 91.4
× 67.0. Ed 20 (BFK), 9 TI (BFK), BAT
(BFK), 5 AP (BFK), 6 TP (BFK), CP
(BFK). Kenneth Tyler. D, S, BS.

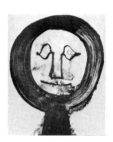

1189
Moon Face. Oct 30–Nov 4, 1964.
Red-black (S). 36.2 × 28.6. Ed 20
(BFK), 9 TI (wA), BAT (BFK), PrP II for
Kenneth Tyler (BFK), 2 AP (wA), 1 TP
(BFK), CP (BFK). Kaye Dyal. BS, D, S.

1190
Head of Colossus. Nov 2–5, 1964.
Black (S). 55.9 × 45.7. Ed 20 (BFK), 9
TI (wA), BAT (BFK), PrP II for Kenneth
Tyler (BFK), 2 AP (wA), 1 TP (wA).
Ernest Rosenthal. BS, D, S.

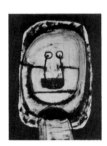

1191
Transparent Man. Nov 3–4, 1964.
Black (S). 67.3 × 48.3. Ed 20 (BFK), 9
TI (wA), BAT (BFK), PrP II for Kenneth
Tyler (BFK), 1 AP (BFK), 1 TP (BFK), CP
(BFK). Joe Zirker. BS, D, S.

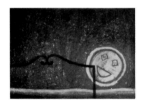

1193
Full Moon. Nov 6–Dec 3, 1964.
Green-blue (Z), violet (Z), dark blue
(S), blue (A). 57.2 × 76.2. Ed 20 (BFK),
9 TI (wA), BAT (BFK), 2 AP (BFK), 4 TP
(1 BFK, 3 wA), CP (wA). Kenneth Tyler.
BS (Tam)[1], D, S.

1. No printer's chop.

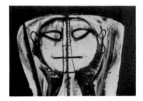

1194A
Head. Nov 2–6, 1964.
Black (S). 31.8 × 23.5. Ed 20 (BFK), 9
TI (wA), BAT (BFK), PrP II for Kenneth
Tyler(BFK), 2 TP (1 BFK, 1 wA), CP
(wA). Joe Zirker. BS, D, S.

1194B
Head. Nov 2–6, 1964.
Black (S). 23.5 × 31.8. Ed 20 (BFK), 9
TI (wA), BAT (BFK), PrP II for Kenneth
Tyler (BFK), 2 TP (1 BFK, 1 wA), CP
(wA). Joe Zirker. D, S, BS.

Print not in
University Art Museum
Archive

1194C
Head. Nov 2–6, 1964.
Black (S). 26.0 × 28.3. Ed 20 (BFK), 9
TI (wA), BAT (BFK), PrP II for Kenneth
Tyler (BFK), 2 TP (1 BFK, 1 wA), CP
(wA). Joe Zirker. D, S, BS.

1195
Variations on a Man #3. Nov 30–
Dec 3, 1964.
Black (S)[1]. 93.0 × 68.3. Ed 20 (BFK),
9 TI (BFK), BAT (BFK), 3 AP (BFK), 2 TP
(BFK), CP (BFK). Kenneth Tyler. BS, D,
S.

1. Stone from 1150, transferred to
new stone; additions, deletions.
1195 differs from 1150 in color,
image and size. The image is
different except for the placement
of a few lines in the figure and the
background tone in the corners.

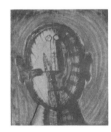

1196
Man in the Doorway #2. Nov 11,
1964.
Black (S)[1]. 55.9 × 45.7. Ed 9 (BFK), 9
TI (BFK), BAT (BFK). Kenneth Tyler. BS,
D, S.

1. Stone held from 1173, run 2. 1196
differs from 1173 in color and in
image. Solid color background tone
has been eliminated.

1197
Head of Colossus. Nov 11–17, 1964.
Ochre (A), violet (S), red (S)[1]. 55.9 ×
45.7. Ed 12 (BFK), 9 TI (wA), BAT
(BFK), PrP II for Kenneth Tyler (BFK), 2
AP (1 BFK, 1 wA), 5 TP (3 BFK, 2 wA),
CP (wA). Kaye Dyal. D, S, BS.

1. Stone held from 1190; deletions.
1197 differs from 1190 in color and
in image. The over-all image is
lighter. Some of the background
tone around the head has been
eliminated and concentric linear
pattern has been added in its place.

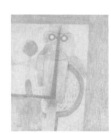

1198
Man in the Sun. Nov 11–24, 1964.
Light pink (S), green (Z), orange (Z),
grey (S), green (Z), dark pink (Z). 55.9
× 45.7. Ed 20 (BFK), 9 TI (wA), BAT
(BFK), PrP II for Kenneth Tyler (BFK), 6
TP (3 BFK, 3 wA), CP (BFK). Clifford
Smith. D, S, BS.

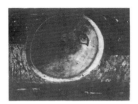

1203
Half-Moon. Dec 3, 1964.
Black (S). 30.5 × 38.1. Ed 20 (BFK), 9 TI (wA), BAT (BFK), 2 AP (wA), 2 TP (BFK), CP (BFK). Kenneth Tyler. BS, D, S.

1148
Hollywood Star (Hollywood Honeymoon III). Jan 16–Sep 23, 1964.
Yellow (S), red-violet (Z), blue-green (Z), violet-black (S). 71.1 × 96.5. Ed 20 (BFK), 9 TI (BFK), BAT (BFK), PrP II for Bernard Bleha (BFK), 2 AP (BFK), 5 TP (BFK), CP (BFK). Kenneth Tyler. D, S, Dat, BS.

Prentiss Taylor

Print not in
University Art Museum
Archive

371
White House—Canyon de Chelly.
Aug 24–29, 1961.
Black (S). 56.5 × 74.0. Ed 20 (BFK), 9 TI (wA), PrP (BFK), 1 AP (wA), 1 TP (BFK), CP (BFK). Harold Keeler. T, D, BS, S, Dat.

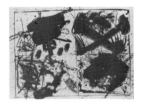

1151
Untitled (Fortune Kookie VI). Oct 27–Nov 11, 1964.
Yellow (Z), brown (S). 39.4 × 50.8. Ed 20 (BFK), 9 TI (wA), BAT (BFK), PrP II for Kenneth Tyler (BFK), 1 AP (BFK), 2 TP (1 BFK, 1 wA). Ernest Rosenthal. D, S, Dat (top), BS (bottom).

Larry Thomas

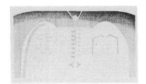

2797
I (T). Oct 6–26, 1969.
Light grey (A), beige (A), black (A). 48.3 × 76.2. Ed 7 (wA), 9 TI (ucR), BAT (wA), 2 AP (1 ucR, 1 wA), 2 TP (wA)[1], CP (wA). Larry Thomas. BS, D, S, Dat.

1. 1 TP varies from the edition.

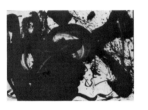

1152
Dragon from China Sea (Hollywood Honeymoon VII). Sep 28–Nov 13, 1964.
Black (Z). 71.1 × 96.5. Ed 20 (BFK), 9 TI (BFK), BAT (BFK), PrP II for Bernard Bleha (BFK), 2 AP (BFK), 2 TP (BFK). Kenneth Tyler. D, S, Dat (top), BS (bottom).

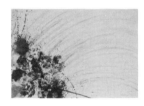

1153
Moonlight Ice Cream (Hollywood Honeymoon IV). Sep 29–Oct 14, 1964.
Yellow (Z), transparent blue (S), transparent blue-green (S), yellow-green (Z). 71.1 × 96.5. Ed 20 (BFK), 9 TI (BFK), BAT (BFK), PrP II for Kenneth Tyler (BFK), 2 AP (BFK), 4 TP (BFK), CP (BFK). Kaye Dyal. D, S, Dat (top), BS (bottom).

Walasse Ting

Hollywood Honeymoon, a suite of ten lithographs including title and colophon pages. In order: 1174, 1145, 1148, 1153, 1154, 1158, 1152, 1170, 1192, 1165.

Fortune Kookie, a suite of eight lithographs including title and colophon pages. The artist informed Tamarind in 1971 that impressions of the suite in his possession had been destroyed. In order: 1184, 1180, 1181, 1183, 1186, 1151, 1155, 1185.

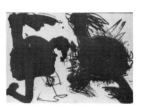

1154
Green Bombshell (Hollywood Honeymoon V). Sep 28–Oct 6, 1964.
Green (A). 71.1 × 96.9. Ed 20 (BFK), 9 TI (BFK), BAT (BFK), PrP II for Kenneth Tyler (BFK), 2 AP (BFK), 3 TP (BFK), CP (BFK). Joe Zirker. BS, D, S, Dat.

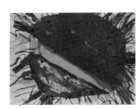

1145
Sunset Strip (Hollywood Honeymoon II). Sep 14–Oct 6, 1964.
Red (S), green (A), yellow (A), blue (S). 71.1 × 96.5. Ed 20 (BFK), 9 TI (BFK), BAT (BFK), PrP II for Kenneth Tyler (BFK), 3 AP (BFK), 2 PP (BFK), 6 TP (BFK)[1], CP (BFK). Bernard Bleha. D, S, Dat, BS.

1. 1 TP varies from the edition.

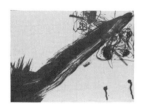

1155
Red Thing (Fortune Kookie VII). Oct 27–Nov 13, 1964.
Red (S). 39.4 × 50.8. Ed 20 (BFK), 9 TI (wA), BAT (BFK), PrP II for Kenneth Tyler (BFK), 2 AP (BFK), 3 TP (2 BFK, 1 wA), CP (BFK). Kaye Dyal. D, S, Dat, BS.

1158
Black Orpheus (Hollywood Honeymoon VI). Oct 5–8, 1964.
Black (S). 71.1 × 96.5. Ed 20 (BFK), 9 TI (BFK), BAT (BFK), PrP II for Kenneth Tyler (BFK), 2 AP (BFK), 1 PP (BFK), 3 TP (BFK), CP (BFK). Clifford Smith. D, S, Dat, BS.

1165
Colophon (Hollywood Honeymoon X). Oct 12–16, 1964.
Red (S). 71.1 × 96.5. Ed 20 (BFK), 9 TI (BFK), BAT (BFK), PrP II for Kenneth Tyler (BFK), 3 AP (BFK), 3 TP (BFK), CP (BFK). Bernard Bleha. T, D, S, Dat (in blue ink)(top), BS (bottom).

1170
Double Bubble Gum (Hollywood Honeymoon VIII). Oct 16–27, 1964.
Light blue (S), transparent green (A), transparent blue (A). 71.1 × 96.5. Ed 20 (BFK), 9 TI (BFK), BAT (BFK), PrP II for Kenneth Tyler (BFK), 2 AP (BFK), 1 PP (BFK), 4 TP (BFK), 3 PgP (BFK)[1]. Clifford Smith. BS, D, S, Dat.

1. Designated PgP but actually are CTP. 2 PgP retained by Tamarind.

1174
Title Page (Hollywood Honeymoon I). Oct 22–28, 1964.
Black (S). 71.1 × 96.5. Ed 20 (BFK), 9 TI (BFK), BAT (BFK), PrP II for Kenneth Tyler (BFK), 2 AP (BFK), 4 TP (BFK), CP (BFK). Bernard Bleha. D, S, Dat.

1180
Untitled (Fortune Kookie II). Oct 27–30, 1964.
Black (S). 39.4 × 50.8. Ed 20 (bA), 9 TI (Shintori), BAT (bA), PrP II for Kenneth Tyler (bA), 2 AP (bA), 2 TP (bA), 2 PTP (1 yellow J, 1 thin white J)[1], CP (bA). Ernest Rosenthal. D, S, Dat, BS.

1. Unsigned, unchopped, undesignated, retained by Tamarind.

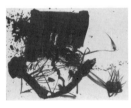

1181
Untitled (Fortune Kookie III). Oct 27–30, 1964.
Black (S). 39.4 × 50.8. Ed 20 (BFK), 9 TI (Shintori), BAT (BFK), PrP II for Kenneth Tyler (BFK), 2 AP (BFK), 4 TP (BFK), 1 PTP (yellow J)[1], CP (BFK). Clifford Smith. D, S, Dat, BS.

1. Unsigned, unchopped, undesignated, retained by Tamarind.

Print not in
University Art Museum
Archive

1182
Untitled. Oct 27–Nov 2, 1964.
Brown (S). 39.4 × 50.8. 2 proofs (Shintori)[1]. Bernard Bleha, NC.

1. Unsigned, unchopped, undesignated, retained by Tamarind.

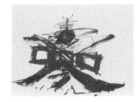

1183
Blue Tango (Fortune Kookie IV).
Oct 27–Nov 3, 1964.
Blue-black (Z). 39.4 × 50.8. Ed 20 (BFK), 9 TI (wA), BAT (BFK), PrP II for Kenneth Tyler (BFK), 1 AP (wA), 2 TP (1 BFK, 1 wA), CP (BFK). Kaye Dyal. D, S, Dat (top), BS (bottom).

1184
Title Page (Fortune Kookie I). Nov 3–6, 1964.
Green (Z). 39.4 × 51.1. Ed 20 (BFK), 9 TI (wA), BAT (BFK), PrP II for Kenneth Tyler (BFK), 1 AP (BFK), 2 TP (1 BFK, 1 wA). Kaye Dyal. D, S, Dat (top), BS (bottom).

1185
Colophon (Fortune Kookie VIII).
Oct 27–Nov 9, 1964.
Black (Z). 39.7 × 51.1. Ed 20 (BFK), 9 TI (BFK), BAT (BFK), PrP II for Kenneth Tyler (BFK), 2 AP (BFK), 2 TP (BFK). Clifford Smith. T, D, S, Dat (in blue ink) (top), BS (bottom).

1186
Untitled (Fortune Kookie V). Oct 27–Nov 6, 1964.
Black (A). 39.4 × 51.1. Ed 20 (BFK), 9 TI (wA), BAT (BFK), PrP II for Kenneth Tyler (BFK), 1 AP (wA), 4 TP (3 BFK, 1 wA). Ernest Rosenthal. D, S, Dat, BS.

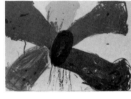
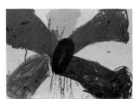

1192
Hollywood Freeway (Hollywood Honeymoon IX). Nov 3–11, 1964.
Yellow (Z), transparent blue-green (A), red (Z), blue (A). 71.1 × 96.5. Ed 20 (BFK), 9 TI (BFK), BAT (BFK), PrP II for Kenneth Tyler (BFK), 2 AP (BFK), 2 PP (BFK), 6 TP (BFK), CP (BFK). Bernard Bleha. D, S, Dat, BS .

Hugh Townley

The Magus, a suite of twelve lithographs including title and colophon pages, enclosed in a red and black cloth covered box, measuring 32.4 × 27.9, lined with red cloth, made by the Earle Grey Bookbinding Co. Los Angeles. The suite title and the artist's name stamped in red on the spine. Each lithograph enclosed in a chemise of white paper. In order: 2632, 2631, 2628, 2625, 2627, 2622, 2630, 2626, 2623, 2629, 2624, 2642.

Seventy-Eight Spells, a suite of thirteen lithographs, enclosed in a three-part wrapper of buff Arches, measuring 14.0 × 17.8 with the title page in red and the colophon in black, printed at the Plantin Press, Los Angeles. Each lithograph enclosed in a chemise of white Tableau paper. In order: 2673, 2675, 2676, 2677, 2678, 2679, 2680, 2681, 2682, 2683, 2684, 2685, 2686.

2621
Untitled. May 1–2, 1969.
Light beige (S). 38.1 × 36.2. Ed 20
(MI), 9 TI (CD), BAT (MI), 3 AP (2 CD, 1
MI), 4 CTP (MI), CP (MI). Daniel Socha.
Recto: BS Verso: D, S, Dat.

2622
Untitled (The Magus VI). May 2–10,
1969.
Red (S), red (S). 30.8 × 25.4, cut. Ed
20 (wA), 9 TI (BFK), BAT (wA), 3 AP
(wA), 6 CTP (3 BFK, 3 wA). John
Sommers. Recto: BS Verso: D, S, Dat.

2622II
Untitled May 2–12, 1969.
Black (S)[1], black (S)[2]. 30.8 × 25.4,
cut. Ed 10 (wA), 9 TI (BFK), BAT (wA),
CP (wA). John Sommers. Verso: D,
WS, S, Dat.

1. Stone held from 2622, run 1.
2. Stone held from 2622, run 2. 2622II
 differs from 2622 in color only.

2623
Untitled (The Magus IX). May 2–10,
1969.
Red (S), red (S). 30.8 × 25.4, cut. Ed
20 (wA), 9 TI (BFK), BAT (wA), 3 AP (1
BFK, 2 wA), 5 CTP (3 BFK, 2 wA). John
Sommers. Recto: BS Verso: D, S, Dat.

2623II
Untitled. May 2–12, 1969.
Black (S)[1], black (S)[2]. 30.8 × 25.4,
cut. Ed 10 (wA), 9 TI (BFK), BAT (wA),
2 AP (1 BFK, 1 wA), CP (wA). John
Sommers. Verso: D, WS, S, Dat.

1. Stone held from 2623, run 1.
2. Stone held from 2623, run 2. 2623II
 differs from 2623 in color only.

2624
Untitled (The Magus XI). May 2–10,
1969.
Red (S), red (S). 30.8 × 25.4, cut. Ed
20 (wA), 9 TI (BFK), BAT (wA), 3 AP
(wA), 4 CTP (3 BFK, 1 wA). John
Sommers. Recto: BS Verso: D, S, Dat.

2624II
Untitled. May 2–12, 1969.
Black (S)[1], black (S)[2]. 30.8 × 25.4,
cut. Ed 10 (wA), 9 TI (BFK), BAT (wA),
2 AP (1 BFK, 1 wA), CP (wA). John
Sommers. Verso: D, WS, S, Dat.

1. Stone held from 2624, run 1.
2. Stone held from 2624, run 2. 2624II
 differs from 2624 in color only.

2625
Untitled (The Magus IV). May 2–10,
1969.
Red (S), red (S). 30.5 × 25.4, cut. Ed
20 (wA), 9 TI (BFK), BAT (wA), 3 AP (1
BFK, 2 wA), 4 CTP (3 BFK, 1 wA). John
Sommers. Recto: BS Verso: D, S, Dat.

2625II
Untitled. May 2–12, 1969.
Black (S)[1], black (S)[2]. 30.8 × 25.4,
cut. Ed 10 (wA), 9 TI (BFK), BAT (wA),
3 AP (2 BFK, 1 wA), CP (wA). John
Sommers. Verso: D, WS, S, Dat.

1. Stone held from 2625, run 1.
2. Stone held from 2625, run 2. 2625II
 differs from 2625 in color only.

2626
Untitled (The Magus VIII). May 6–
16, 1969.
Black (S), black (S). 30.8 × 25.4, cut.
Ed 20 (wA), 9 TI (BFK), BAT (wA), 4 AP
(wA), 1 CTP (ucR)[1], 2 CSP (wA)[2], 1
PTP* (yellow vinyl on cR)[3]. Charles
Ringness. Verso: D, WS, S, Dat.

1. CTP on paper 32.4 × 27.3.
2. 1 CSP retained by Tamarind.
3. PTP on paper 34.3 × 27.3.

2626II
Untitled. May 12–16, 1969.
Transparent red (S)[1], red (S)[2]. 30.8
× 25.4, cut. Ed 10 (wA), 9 TI (BFK),
BAT (wA), 3 AP (2 BFK, 1 wA), 1 TP*
(wA), 2 CSP (wA)[3], CP* (wA).
Charles Ringness. Recto: BS Verso: D,
S, Dat.

1. Stone held from 2626, run 1.
2. Stone held from 2626, run 2. 2626II
 differs from 2626 in color only.
3. 1 CSP retained by Tamarind.

2627
Untitled (The Magus V). May 6–16,
1969.
Black (S), black (S). 30.8 × 25.4, cut.
Ed 20 (wA), 9 TI (BFK), BAT (wA), 4 AP
(2 BFK, 2 wA), 1 CTP (ucR)[1], 2 CSP
(wA)[2], 1 PTP* (yellow vinyl on
cR)[3]. Charles Ringness. Verso: D,
WS, S, Dat.

1. CTP on paper 37.5 × 27.3.
2. 1 CSP retained by Tamarind.
3. PTP on paper 34.3 × 27.3.

2627II
Untitled. May 12–16, 1969.
Transparent red (S)[1], red (S)[2]. 30.8 × 25.4, cut. Ed 10 (wA), 9 TI (BFK), BAT (wA), 1 AP (wA), 1 TP* (wA), 2 CSP (wA)[3], CP* (wA). Charles Ringness. Recto: BS Verso: D, S, Dat.

1. Stone held from 2627, run 1.
2. Stone held from 2627, run 2. 2627II differs from 2627 in color only.
3. 1 CSP retained by Tamarind.

2628
Untitled (The Magus III). May 6–16, 1969.
Black (S), black (S). 30.8 × 25.4, cut. Ed 20 (wA), 9 TI (BFK), BAT (wA), 4 AP (wA), 1 CTP (ucR)[1], 2 CSP (wA)[2], 1 PTP* (yellow vinyl on cR)[3]. Charles Ringness. Verso: D, WS, S, Dat.

1. CTP on paper 32.4 × 27.3.
2. 1 CSP retained by Tamarind.
3. PTP on paper 34.3 × 27.3.

2628II
Untitled. May 12–16, 1969.
Transparent red (S)[1], red (S)[2]. 30.8 × 25.4, cut. Ed 10 (2 BFK, 8 wA), 9 TI (BFK), BAT (wA), 1 AP (wA), 1 TP* (wA), 2 CSP (wA)[3], CP (wA). Charles Ringness. Recto: BS Verso: D, S, Dat.

1. Stone held from 2628, run 1.
2. Stone held from 2628, run 2. 2628II differs from 2628 in color only.
3. 1 CSP retained by Tamarind.

2629
Untitled (The Magus X). May 6–16, 1969.
Black (S), black (S). 30.8 × 25.4, cut. Ed 20 (wA), 9 TI (BFK), BAT (wA), 3 AP (wA), 1 CTP (ucR)[1], 2 CSP (wA)[2], 1 PTP* (yellow vinyl on cR)[3]. Charles Ringness. Verso: D, WS, S, Dat.

1. CTP on paper 37.5 × 27.3.
2. 1 CSP retained by Tamarind.
3. PTP on paper 34.3 × 27.3.

2629II
Untitled. May 12–16, 1969.
Transparent red (S)[1], red (S)[2]. 30.8 × 25.4, cut. Ed 10 (wA), 9 TI (8 BFK, 1 wA), BAT (wA), 1 TP* (wA), 2 CSP (wA)[3], CP* (wA). Charles Ringness. Verso: D, WS, S, Dat.

1. Stone held from 2629, run 1.
2. Stone held from 2629, run 2. 2629II differs from 2629 in color only.
3. 1 CSP retained by Tamarind.

2630
Untitled (The Magus VII). May 6–18, 1969.
Transparent red (A), red (S). 30.8 × 25.4, cut. Ed 20 (wA), 9 TI (BFK), BAT (wA), 5 AP (3 BFK, 2 wA), 1 PTP* (yellow vinyl on cR)[1]. Ronald Glassman. Verso: D, WS, S, Dat.

1. PTP on paper 33.7 × 27.9.

2630II
Untitled. May 6–19, 1969.
Black (A)[1], black (S)[2]. 30.8 × 25.4, cut. Ed 10 (wA), 9 TI (BFK), BAT (wA), 4 AP (2 wA, 2 BFK), CP (wA). Ronald Glassman. Verso: D, WS, S, Dat.

1. Plate held from 2630, run 1.
2. Stone held from 2630, run 2. 2630II differs from 2630 in color only.

2631
Untitled (The Magus II). May 6–18, 1969.
Transparent red (A), red (S). 30.8 × 25.4, cut. Ed 20 (wA), 9 TI (BFK), BAT (wA), 4 AP (3 BFK, 1 wA), 1 PTP* (yellow vinyl on cR)[1]. Ronald Glassman. Verso: D, WS, S, Dat.

1. PTP on paper 33.7 × 27.9.

2631II
Untitled. May 6–19, 1969.
Black (A)[1], black (S)[2]. 30.8 × 25.4, cut. Ed 10 (wA), 9 TI (BFK), BAT (wA), 5 AP (3 wA, 2 BFK), CP (wA). Ronald Glassman. Verso: D, WS, S, Dat.

1. Plate held from 2631, run 1.
2. Stone held from 2631, run 2. 2631II differs from 2631 in color only.

2632
Title Page (The Magus I). May 14–17, 1969.
Black (S). 30.8 × 25.4, cut. Ed 20 (wA), 9 TI (BFK), BAT (wA), 5 AP (3 wA, 2 BFK), CP (BFK). Paul Clinton. Recto: D, S, Dat Verso: WS.

2637
Untitled. May 20–29, 1969.
Pearly white (A). 64.5 × 48.9. Ed 20 (wN), 9 TI (nN), BAT (wN), 3 AP (wN), 1 TP* (cR), 6 CTP (3 wN, 3 cR), CP (nN). William Law III. D, BS, S, Dat.

2638
Untitled. May 20–Jun 3, 1969.
Pearly white (A), red-brown (Z). 63.5 × 48.3. Ed 20 (wN), 9 TI (nN), BAT (wN), 3 AP (2 wN, 1 nN), 7 CTP (3 wN, 4 cR), CP (nN). William Law III. D, BS, S, Dat.

2639
Untitled. May 27–Jun 4, 1969.
Green (S), blue-green (S), blue (S)[1].
45.7 × 38.1. Ed 20 (wA), 9 TI (CD),
BAT (wA), 1 AP (wA), CP (CD). Ronald
Glassman. D, S, BS.

1. Same stone as run 2 printed .3 to
the right.

2640
Untitled. May 27–Jun 4, 1969.
Green (S), blue-green (S), blue (S)[1].
45.7 × 38.1. Ed 20 (wA), 9 TI (CD),
BAT (wA), 1 AP (wA), CP (CD). Ronald
Glassman. D, S, Dat, BS.

1. Same stone as run 2 printed .3 to
the right.

2642
Colophon (The Magus XII). May 23–
27, 1969.
Red, black (S). 30.8 × 25.4, cut. Ed 20
(wA), 9 TI (BFK), BAT (wA), 3 AP (1
wA, 2 BFK), 4 CTP (3 ucR, 1 cR), CP
(wA). John Sommers. BS, D, S, Dat.

2643
Untitled. May 26–Jun 12, 1969.
Blue (Z), yellow (A), red (A)[1]. 50.8 ×
38.1, (stainless steel)[1], cut. Ed 16, 9
TI, BAT, 3 AP, 1 TP*, 1 CTP, 3 PTP[2],
CP. Jean Milant. D, S, Dat (with
diamond-point needle), WS.

1. Printed on 20-gauge, mirror-finish
stainless steel, machine cut.
2. 3 PTP vary from the edition. 1 PTP
on chrome Fasson self-adhesive
mylar 50.8 × 38.1 adhered to cR
58.4 × 46.0. 1 PTP on gold Fasson
on yellow Fasson self-adhesive
vinyl 39.4 × 33.0 adhered to JG
47.0 × 40.3.

2644
Untitled. May 26–Jun 17, 1969.
Orange, yellow, green-blue, B: blue,
green, blue (A), red orange, light
green, dark green, violet (A), light
beige (A). 72.4 × 60.7. Ed 20 (cR), 9 TI
(ucR), BAT (cR), 5 AP (2 ucR, 3 cR), 2
PP (1 cR, 1 ucR), 2 CTP (cR). Daniel
Socha. D, S, Dat, BS.

2644II
Untitled. Jun 17, 1969.
Light beige (A)[1]. 72.7 × 60.3. Ed 10
(cR), 9 TI (ucR), BAT (cR), 3 AP (2 ucR,
1 cR), CP (ucR). Daniel Socha. D, S,
Dat, BS.

1. Plate held from 2644, run 3. 2644II
differs from 2644 in color and in
image. The dark solid tones within
the shapes have been eliminated.

2645
Untitled. Jun 3–6, 1969.
Pink (S), orange (A). 68.9 × 58.4. Ed
20 (ucR), 9 TI (CD), BAT (ucR), 4 AP (1
ucR, 3 CD), 1 PP (ucR), 1 TP (ucR), 2
CTP (1 ucR, 1 CD), 2 CSP (ucR).
Charles Ringness. D, S, Dat, BS.

2645II
Untitled. Jun 10–12, 1969.
Yellow-green (S), light blue (A)[1]. 68.9
× 58.4. Ed 10 (8 cR, 2 ucR), 9 TI (ucR),
BAT (ucR), 1 AP (cR), 1 TP (ucR), 1 CTP
(ucR), CP (cR). Charles Ringness. D, S,
Dat, BS.

1. Plate held from 2645, run 2. 2645II
differs from 2645 in color only.

2646
Untitled. Jun 4–9, 1969.
Pink (S), red (A). 71.5 × 57.5. Ed 20
(ucR), 9 TI (CD), BAT (ucR), 2 AP (1
ucR, 1 CD), 1 PP (ucR), 1 TP (ucR), 2
CTP (1 ucR, 1 CD), CP (CD). Paul
Clinton. D, BS, (Tam), S, BS, (pr).

2665
Untitled. Jun 11–16, 1969.
Brown-black (S), blue-black (A). 64.8
× 55.9. Ed 20 (ucR), 9 TI (cR), BAT
(ucR), 3 AP (ucR), 2 CTP (1 ucR, 1
cR)[1]. Paul Clinton. BS (Tam), D, S,
Dat, BS (pr).

1. 2 CTP on paper 61.9 × 53.3.

2665II
Untitled. Jun 16–20, 1969.
Green-black (A), red-black (A)[1]. 64.8
× 55.9. Ed 10 (ucR), 9 TI (cR), BAT
(ucR), 5 AP (3 ucR, 2 cR), CP (cR). Paul
Clinton. BS (Tam), D, S, Dat, BS (pr).

1. Plate held from 2665, run 2. 2665II
differs from 2665 in color only.

2669
Untitled. Jun 13–19, 1969.
Brown-black (A), on Fasson gold
mylar. 57.2 × 41.6, cut (mylar).
Ed 18 (bA), 9 TI (bA), BAT (bA), CP
(bA). Jean Milant. D, S, BS.

2670
Untitled. Jun 13–19, 1969.
Brown-black (A), on Fasson gold
mylar. 47.9 × 52.1, cut (mylar).
Ed 20 (bA), 9 TI (bA), BAT (bA), 3 AP
(bA)[1], CP (bA). Jean Milant. D, S, BS.

1. 1 AP on paper 48.3 × 52.7.

2671
Untitled. June 17–20, 1969
Black (Z)[1], perforated. 84.8 × 63.5.
Ed 20 (MI), 9 TI (BFK), BAT (MI), 3 AP
(MI), 1 TP (MI), 4 CTP (1 BFK, 2 CD, 1
MI). John Sommers. D, BS, S, Dat.

1. Plate held from 2672–2686. 2671
 differs from 2672–2686 in image
 and in size. 2671 combines all
 fifteen images reading numerically
 left to right, top to bottom.

2671II
Untitled. Jun 17–20, 1969.
Beige (Z)[1]. 76.2 × 57.2. Ed 10 (bA), 9
TI (bA), BAT (bA), 2 AP (bA), 3 CTP
(bA), CP* (bA). John Sommers. D, BS,
S, Dat.

1. Plate held from 2671. 2671II differs
 from 2671 in color, image and size.
 The outer border on all four sides is
 smaller.

2672
Untitled. Jun 17–19, 1969.
Black (Z). 14.0 × 17.1, cut. Ed 20 (bA),
9 TI (bA), BAT (bA), 5 AP (bA), 1 CTP
(bA)[1]. John Sommers. Verso: D, WS,
S, Dat.

1. CTP exists on paper 84.4 × 63.5
 with 2673, 2675–2686 plus 2674,
 uncut.

2673
Untitled (Seventy-Eight Spells I).
Jun 17–19, 1969.
Black (Z). 14.0 × 17.1, cut. Ed 20 (bA),
9 TI (bA), BAT (bA), 5 AP (bA), 2 CTP
(bA)[1]. John Sommers. Verso: D, WS,
S, Dat.

1. CTP on paper 84.4 × 63.5.

2674
Untitled. Jun 17–19, 1969.
Black (Z). 14.0 × 17.1, cut. Ed 20
(bA), 9 TI (bA), BAT (bA), 5 AP (bA), 1
CTP (bA)[1]. John Sommers. Verso: D,
WS, S, Dat.

1. CTP exists on paper 84.4 × 63.5
 with 2673, 2675–2686 plus 2672,
 uncut.

2675
Untitled (Seventy-Eight Spells II).
Jun 17–19, 1969.
Black (Z). 14.0 × 17.1, cut. Ed 20 (bA),
9 TI (bA), BAT (bA), 4 AP (bA), 2 CTP
(bA)[1]. John Sommers. Verso: D, WS,
S, Dat.

1. CTP on paper 84.4 × 63.5.

2676
Untitled (Seventy-Eight Spells III).
Jun 17–19, 1969.
Black (Z). 14.0 × 17.1, cut. Ed 20 (bA),
9 TI (bA), BAT (bA), 5 AP (bA), 2 CTP
(bA)[1]. John Sommers. Verso: D, WS,
S, Dat.

1. CTP on paper 84.4 × 63.5.

2677
Untitled (Seventy-Eight Spells IV).
Jun 17–19, 1969.
Black (Z). 14.0 × 17.1, cut. Ed 20 (bA),
9 TI (bA), BAT (bA), 5 AP (bA), 2 CTP
(bA)[1]. John Sommers. Verso: D, WS,
S, Dat.

1. CTP on paper 84.4 × 63.5.

2678
Untitled (Seventy-Eight Spells V).
Jun 17–19, 1969.
Black (Z). 14.0 × 17.1, cut. Ed 20 (bA),
9 TI (bA), BAT (bA), 5 AP (bA), 2 CTP
(bA)[1]. John Sommers. Verso: D, WS,
S, Dat.

1. CTP on paper 84.4 × 63.5.

2679
Untitled (Seventy-Eight Spells VI).
Jun 17–19, 1969.
Black (Z). 14.0 × 17.1, cut. Ed 20 (bA),
9 TI (bA), BAT (bA), 5 AP (bA), 2 CTP
(bA)[1]. John Sommers. Verso: D, WS,
S, Dat.

1. CTP on paper 84.4 × 63.5.

2680
Untitled (Seventy-Eight Spells VII).
Jun 17–19, 1969.
Black (Z). 14.0 × 17.1, cut. Ed 20 (bA),
9 TI (bA), BAT (bA), 4 AP (bA), 2 CTP
(bA)[1]. John Sommers. Verso: D, WS,
S, Dat .

1. CTP on paper 84.4 × 63.5.

2681
Untitled (Seventy-Eight VIII). Jun 17–19, 1969.
Black (Z). 14.0 × 17.1, cut. Ed 20 (bA), 9 TI (bA), BAT (bA), 5 AP (bA), 2 CTP (bA)[1]. John Sommers. Verso: D, WS, S, Dat.

1. CTP on paper 84.4 × 63.5.

2682
Untitled (Seventy-Eight Spells IX).
Jun 17–19, 1969.
Black (Z). 14.0 × 17.1, cut. Ed 20 (bA), 9 TI (bA), BAT (bA), 5 AP (bA), 2 CTP (bA)[1]. John Sommers. Verso: D, WS, S, Dat.

1. CTP on paper 84.4 × 63.5.

2683
Untitled (Seventy-Eight Spells X).
Jun 17–19, 1969.
Black (Z). 14.0 × 17.1, cut. Ed 20 (bA), 9 TI (bA), BAT (bA), 5 AP (bA), 2 CTP (bA)[1]. John Sommers. Verso: D, WS, S, Dat.

1. CTP on paper 84.4 × 63.5.

2684
Untitled (Seventy-Eight Spells XI).
Jun 17–19, 1969.
Black (Z). 14.0 × 17.1, cut. Ed 20 (bA), 9 TI (bA), BAT (bA), 5 AP (bA), 2 CTP (bA)[1]. John Sommers. Verso: D, WS, S, Dat.

1. CTP on paper 84.4 × 63.5.

2685
Untitled (Seventy-Eight Spells XII). Jun 17–19, 1969.
Black (Z). 14.0 × 17.1, cut. Ed 20 (bA), 9 TI (bA), BAT (bA), 6 AP (bA), 2 CTP (bA)[1]. John Sommers. Verso: D, WS, S, Dat.

1. CTP on paper 84.4 × 63.5.

2686
Untitled (Seventy-Eight Spells XIII). Jun 17–19, 1969.
Black (Z). 14.0 × 17.1, cut. Ed 20 (bA), 9 TI (bA), BAT (bA), 5 AP (bA), 2 CTP (bA)[1]. John Sommers. Verso: D, WS, S, Dat.

1. CTP on paper 84.4 × 63.5.

2687
Untitled. Jun 23–25, 1969.
Grey-green (A). 66.4 × 57.2. Ed 20 (ucR), 9 TI (cR), BAT (ucR), 3 AP (2 ucR, 1 cR), 4 CTP (2 cR, 2 ucR), CP (cR). Serge Lozingot. D, BS, S, Dat.

2688
Untitled. Jun 23–24, 1969.
Yellow (A). 74.9 × 59.1. Ed 20 (MI), 9 TI (JG), BAT (MI), 3 AP (MI), 1 TP (MI), 1 CTP (bA), 1 PTP (silver mylar on BFK)[1], CP (MI). Serge Lozingot. D, S, Dat, BS.

1. PTP on mylar 50.8 × 66.0 and on paper 56.9 × 76.2.

Joyce Treiman

The Mirrored Couple, a suite of fifteen lithographs including title, quotation and colophon pages, enclosed in a red cloth covered box, measuring 54.0 × 40.3, lined with Nacre, made by the Schuberth Bookbindery, San Francisco. In order: 454, 453, 387, 394, 400, 410, 411, 417, 419, 431, 437, 438, 444, 451, 457.

387
Untitled (The Mirrored Couple III).
Sep 18–22, 1961.
Black (S). 51.4 × 38.1. Ed 20 (BFK), 9 TI (wN), PrP (BFK), 3 AP (BFK), CP (BFK). Bohuslav Horak. D, S, BS.

394
Untitled (The Mirrored Couple IV).
Sep 22–Oct 4, 1961.
Black (S). 50.8 × 38.4. Ed 20 (11 BFK, 9 wA), 9 TI (wN), PrP (BFK), PrP II for Bohuslav Horak (BFK), 3 AP (2 BFK, 1 wN), 3 TP (2 bA, 1 BFK), CP (BFK). Joe Funk. D, S, BS.

400
Untitled (The Mirrored Couple V).
Sep 28–Oct 6, 1961.
Black (Z). 51.1 × 38.7. Ed 20 (BFK), 9 TI (wN), PrP (BFK), 2 AP (BFK), 1 TP (BFK), CP (BFK). Joe Funk. D, S, BS.

410
Untitled (The Mirrored Couple VI).
Oct 5–11, 1961.
Black (S). 50.8 × 38.4. Ed 20 (BFK), 9
TI (wN), PrP (BFK), 2 AP (1 BFK, 1 wN),
2 TP (1 BFK, 1 Tcs), CP (BFK). Harold
Keeler. D, S, BS.

411
Untitled (The Mirrored Couple VII).
Oct 10–16, 1961.
Green-black (S), yellow-green (S). 50.8
× 38.1. Ed 20 (BFK), 9 TI (wN), PrP
(BFK), PrP II (BFK)[1], 2 AP (1 BFK, 1
wN), 2 TP (BFK), CP (Tcs). Harold
Keeler. BS, S, D.

1. Recipient unrecorded.

417
*Untitled (The Mirrored Couple
VIII).* Oct 10–17, 1961.
Red (S). 50.8 × 38.1. Ed 20 (BFK), 9 TI
(wN), PrP (BFK), 1 AP (BFK), 4 TP (3
BFK*, 1 Tcs), CP (Tcs). Harold Keeler.
D, S, BS.

419
Untitled (The Mirrored Couple IX).
Oct 27, 1961.
Black (S)[1]. 50.8 × 38.1. Ed 20 (BFK),
9 TI (wN), PrP (BFK), PrP II (BFK)[2], 2
AP (1 BFK, 1 wN), 2 TP (1 BFK*, 1 Tcs),
CP (BFK). Harold Keeler. D, S, BS.

1. Stone held from 419l; additions.
419 differs from 419l in image. The
features on the face of the figure to
the left have been more clearly
defined. With the exception of the
irregular circular area in the center
of the figure to the right, both
figures have been darkened.
2. Recipient unrecorded.

419l
Untitled. Oct 19–23, 1961.
Black (S). 50.8 × 38.1. Ed 13 (BFK), 9
TI (wN), PrP (BFK), PrP II (BFK)[1], 2 AP
(wN). Harold Keeler. D, BS, S.

1. Recipient unrecorded.

431
Untitled (The Mirrored Couple X).
Oct 25–26, 1961.
Black (S). 50.8 × 38.4. Ed 20 (BFK), 9
TI (wN), PrP (BFK), PrP II (BFK)[1], 2 AP
(1 BFK, 1 wN), 4 TP (2 BFK, 1 bA, 1
wA), CP (BFK). Harold Keeler. D, BS, S.

1. Recipient unrecorded.

437
Untitled (The Mirrored Couple XI).
Oct 30–31, 1961.
Black (S). 51.1 × 38.4. Ed 20 (BFK), 9
TI (wN), PrP (BFK), PrP II (BFK)[1], 2 AP
(1 BFK, 1 nN), 3 TP (2 BFK, 1 bA), CP
(BFK). Harold Keeler. D, BS, S.

1. Recipient unrecorded.

438
Untitled (The Mirrored Couple XII).
Nov 1–2, 1961.
Black (S). 50.8 × 38.4. Ed 20 (BFK), 9
TI (wN), PrP (BFK), PrP II (BFK)[1], 3 AP
(2 BFK, 1 wN), 2 TP (BFK), CP (BFK).
Harold Keeler. D, S, BS.

1. Recipient unrecorded.

444
*Untitled (The Mirrored Couple
XIII).* Nov 6–9, 1961.
Black (S). 50.8 × 38.1. Ed 20 (BFK), 9
TI (wN), PrP (BFK), PrP II (BFK)[1], 4 AP
(3 BFK[2], 1 wN), 4 TP (3 BFK, 1
lightweight R)[3], CP (BFK). Harold
Keeler. D, S, BS.

1. Recipient unrecorded.
2. 2 AP on paper 76.2 × 55.9.
3. 4 TP on paper 66.0 × 48.3.

451
*Untitled (The Mirrored Couple
XIV).* Nov 10–14, 1961.
Black (S). 50.8 × 38.1. Ed 20 (BFK), 9
TI (wN), PrP (BFK), PrP II (BFK)[1], 6 AP
(5 BFK[2], 1 wN), 3 TP (BFK), CP (BFK).
Harold Keeler. D, S, BS.

1. Recipient unrecorded.
2. 3 AP on paper 76.2 × 57.2.

453
*Quotation Page (The Mirrored
Couple II).* Nov 14–20, 1961.
Black (S), red (Z). 51.1 × 38.7. Ed 20
(BFK), 9 TI (wN), PrP (BFK), PrP II
(BFK)[1], 3 AP (2 BFK, 1 wN), 2 TP
(BFK), CP (BFK). Harold Keeler. D, BS,
S.

1. Recipient unrecorded.

454
Title Page (The Mirrored Couple I).
Nov 17–27, 1961.
Black (S). 50.8 × 38.4. Ed 20 (BFK), 9
TI (wN), PrP (BFK), PrP II (BFK)[1], 2 AP
(1 BFK, 1 wN), 3 TP (BFK), CP (BFK).
Harold Keeler. BS, D, S.

1. Recipient unrecorded.

457
Colophon (The Mirrored Couple XV). Nov 22–24, 1961.
Black (S). 50.8 × 38.4. Ed 20 (BFK), 9
TI (wN), PrP (BFK), PrP II (BFK)[1], 5 AP
(3 BFK[2], 2 wN), 2 TP (BFK), CP (BFK).
Harold Keeler. D, S, BS.

1. Recipient unrecorded.
2. 3 AP on paper 76.2 × 55.9.

David Trowbridge

2945
Ripplet II. Jun 22–30, 1970.
Green (A)[1], yellow (A), orange (A).
45.7 × 46.1. Ed 20 (cR), 9 TI (cR), BAT
(cR), 1 AP (cR), 6 CTP (cR), CP (wA).
David Trowbridge. Recto: BS Verso: D,
T, S.

1. Image from run 2 transferred to
new stone; reversal.

Donna Tryon

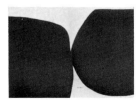

2061
Arcadian Night. Jun 17–Jul 5, 1967.
Orange (A), pink (A), brown-green (A),
blue-green (A), blue (A). 43.2 × 53.3.
Ed 20 (GEP), 9 TI (wA), BAT (GEP), 1
AP (wA), 5 TP* (1 wA, 4 GEP), CP
(wA). David Folkman. D, S, BS.

William Turnbull

Sextet, a suite of six lithographs. In
order: 1680, 1680II, 1680III, 1680IV,
1680V, 1681.

441
Untitled. Nov 7–10, 1961.
Black (Z). 56.8 × 75.9. Ed 20 (BFK), 9
TI (wA), PrP (wA), 2 AP (wA), 3 TP
(BFK), CP (BFK). Bohuslav Horak. BS,
S, Dat, D (top)[1].

1. The image was conceived by the
artist in a vertical format, but was
signed as a horizontal image.

442
Untitled. Nov 8–9, 1961.
Black (Z). 75.6 × 56.5. Ed 20 (BFK), 9
TI (wA), PrP (wA), 1 AP (BFK), 2 TP
(BFK), CP (BFK). Bohuslav Horak. S,
Dat, D (top), BS.

1680
White (Sextet I). Mar 15–17, 1966.
White (Z). 55.9 × 55.9. Ed 20 (wA), 9
TI (CD), BAT* (wA), 1 AP* (wA), 1 TP*
(wA). Clifford Smith. Verso: D, WS, S,
Dat.

1680II
Blue (Sextet II). Mar 18–24, 1966.
Medium blue (A), blue (Z)[1]. 55.9 ×
55.9. Ed 20 (wA), 9 TI (CD), BAT (wA),
3 AP (CD), 3 TP (wA). Clifford Smith.
Verso: D, WS, S, Dat.

1. Plate held from 1680. 1680II differs
from 1680 in color and in image. A
solid color bleed tone background
has been added.

1680III
Grey (Sextet III). Mar 18–25, 1966.
Dark grey (A)[1], dark red-violet (Z)[2].
55.9 × 55.9. Ed 20 (wA), 9 TI (CD),
BAT (wA), 3 AP (2 wA, 1 CD), 3 TP
(wA). Clifford Smith. Verso: D, WS, S,
Dat.

1. Plate held from 1680II, run 1.
2. Plate held from 1680II, run 2. 1680III
differs from 1680II in color only.

1680IV
Yellow (Sextet IV). Mar 28–31, 1966.
Medium yellow (Z)[1], yellow (Z)[2].
56.2 × 55.9. Ed 20 (CD), 9 TI (GEP),
BAT (CD), 3 AP (2 CD, 1 GEP), 1 TP
(wA). Clifford Smith. Verso: D, WS, S,
Dat.

1. Plate held from 1680III, run 2.
2. Same plate as run 1, paper turned
180 degrees. 1680IV differs from
1680III in color and in image. The
solid color bleed tone background
has been eliminated.

1680V
Green (Sextet V). Mar 31–Apr 4,
1966.
Medium green (Z)[1], green (Z)[2].
56.2 × 56.2. Ed 20 (GEP), 9 TI (CD),
BAT (CD), 3 AP (2 CD, 1 GEP), 2 TP*
(CD), CP (Tcs). Clifford Smith. Verso:
D, WS, S, Dat.

1. Plate held from 1680IV.
2. Same plate as run 1, paper turned
180 degrees. 1680V differs from
1680IV in color only.

1681
Orange (Sextet VI). Mar 18–Apr 1, 1966.
Orange (A). 55.9 × 55.9. Ed 20 (CD), 9 TI (GEP)[1], BAT (CD), 3 AP (2 CD, 1 GEP)[1], 2 TP (wA), CP (Tcs). Clifford Smith. Verso: D, WS, S, Dat.

1. 5 TP, 1 AP vary from the edition.

Kenneth Tyler

860
Head I[1]. Aug 6–Oct 23, 1963.
Gold (Z), ochre (Z), brown-black (S). 56.8 × 37.8. Ed 20 (BFK), 9 TI (wA), PrP (BFK), 3 AP (BFK), 4 TP (2 BFK, 1 wA, 1 JG), CP (BFK). Kenneth Tyler. D, T, S, BS.

1. The artist informed Tamarind in 1969 that the impressions in his possession had been destroyed.

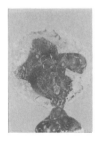

860A
Untitled[1]. Aug 7, 1963.
Black (S). 76.5 × 56.2. 10 ExP (BFK)[2]. Kenneth Tyler. D, BS, S, Dat.

1. This number inadvertently assigned to this edition. It is not related to 860.
2. Designated A–J. 5 ExP retained by Tamarind.

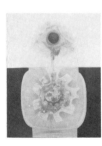

922
Head II[1]. Nov 2–10, 1963.
Yellow (A), beige (Z), beige (Z), light green (Z), dark green (Z). 55.9 × 38.1. Ed 20 (BFK), 9 TI (wA), PrP (BFK), 3 AP (2 BFK, 1 wA), 1 PP (BFK), 6 TP (BFK), 2 PgP (1 BFK, 1 wA). Kenneth Tyler. D, T, S, BS.

1. The artist informed Tamarind in 1969 that the impressions in his possession had been destroyed.

929
Solar Bird. Nov 30–Dec 28, 1963.
Yellow (S), violet-red (Z), blue (Z), blue (Z), beige (Z), orange, violet-red, violet (Z), yellow (Z), orange-red (Z), black and blue-green (Z). 75.9 × 56.5. Ed 20 (BFK), 9 TI (wA), PrP (BFK), 3 AP (wA), 6 TP (BFK). Kenneth Tyler. D, T, BS, S.

937
Head III[1]. Nov 16–18, 1963.
Brown (Z), grey-green (Z), blue-black (Z). 56.5 × 38.1. Ed 20 (BFK), 9 TI (wA), PrP (BFK), 3 AP (BFK), 2 TP (BFK), 4 CTP (BFK)[2]. Kenneth Tyler. D, BS, S.

1. The artist informed Tamarind in 1969 that the impressions in his possession had been destroyed.
2. Unsigned, unchopped, printed on recto and verso.

1074
Reflection. May 31–Jul 24, 1964.
Green-black (Z), blue-green (Z), blue (Z), violet (Z), yellow-grey (Z), transparent grey (A). 50.8 × 33.0. Ed 20 (BFK), 9 TI (wA), BAT (BFK), 2 AP (BFK), 2 TP (BFK). Kenneth Tyler. D, T, BS, S.

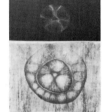

1142
Homage to Susan Jonas. Sep 10–Oct 25, 1964.
Transparent brown-grey (S), blue-black (S)[1]. 76.2 × 56.8. Ed 15 (BFK), 9 TI (wA), BAT (BFK), PrP II for Bernard Bleha (wA), 2 AP (BFK), 3 TP (BFK). Kenneth Tyler. D, BS, S.

1. Portion of image, run 1, transferred to new stone, reversal.

Reva Urban

Trembling Then, a suite of fourteen lithographs including eight images, four pages of text, title and colophon pages. In order: 627, 631, 630, 633, 632, 599, 607, 610, 618, 614, 620, 623, 604, 634.

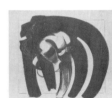

599
Dawn is the Morning (Trembling Then VI). Jul 11–18, 1962.
Orange (Z), violet (Z). 75.3 × 84.8. Ed 20 (BFK), 9 TI (BFK), PrP (BFK), 2 AP (BFK), 5 PP (BFK), 3 TP (BFK), CP (BFK). Joe Zirker. S, D, BS.

604
Tic-Tac-Toe #2 (Trembling Then XIII). Jul 9–11, 1962.
Black (S). 74.9 × 84.8. Ed 20 (BFK), 9 TI (BFK), PrP (BFK), 2 AP (BFK), 5 PP (BFK), 3 TP (BFK). Joe Zirker. S, D, BS.

607
Purple Concrete (Trembling Then VII). Jul 12–24, 1962.
Violet (Z). 74.9 × 84.5. Ed 20 (BFK), 9 TI (BFK), PrP (BFK), 3 AP (BFK), 3 PP (BFK), 3 TP (BFK), CP (BFK). Joe Zirker. S, D, BS.

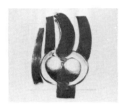

610
Returned to Ancient Islands (Trembling Then VIII). Jul 18–31, 1962.
Brown (Z). 75.3 × 84.8. Ed 20 (BFK), 9 TI (BFK), PrP (BFK), 2 AP (BFK), 2 PP (BFK), 3 TP (BFK), CP (BFK). Irwin Hollander. S, D, BS.

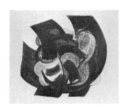

614
With Heart of Stethoscope Beat (Trembling Then X). Jul 23–30, 1962.
Black (Z). 74.9 × 84.5. Ed 20 (BFK), 9 TI (BFK), PrP (BFK), 2 AP (BFK), 1 TP (BFK), CP (BFK). Robert Gardner. S, D, BS.

618
Those Walls of Stone (Trembling Then IX). Jul 30–Aug 6, 1962.
Yellow (Z), grey (Z), black (Z). 75.3 × 84.8. Ed 20 (BFK), 9 TI (BFK), PrP (BFK), 2 AP (BFK), 3 TP (BFK), CP (BFK). Robert Gardner. S, D, BS.

620
Descending Helix (Trembling Then XI). Aug 1–13, 1962.
Orange (Z), brown-green (Z), black (Z). 75.3 × 84.8. Ed 20 (BFK), 9 TI (BFK), PrP (BFK), 2 AP (BFK), 3 PP (BFK), 3 TP (BFK), CP (BFK). Irwin Hollander. S, D, BS.

623
Red City—A Child's World (Trembling Then XII). Aug 7–22, 1962.
Yellow (Z), red (Z), black (Z). 74.9 × 84.5. Ed 20 (BFK), 9 TI (BFK), PrP (BFK), 2 AP (BFK), 1 PP (BFK), 1 TP (BFK), CP (BFK). Irwin Hollander. S, D, BS.

627
Title Page (Trembling Then I). Aug 23–29, 1962.
Orange (Z), violet (Z). 75.3 × 84.8. Ed 20 (BFK), 9 TI (BFK), PrP (BFK), 2 AP (BFK), 1 PP (BFK), 3 TP (BFK), CP (BFK). Irwin Hollander. S, D, BS.

630
Poetry Page (Trembling Then III). Aug 27–Sep 5, 1962.
Grey (Z). 74.9 × 84.5. Ed 20 (BFK), 9 TI (BFK), PrP (BFK), 2 AP (BFK), CP (BFK). Joe Zirker. S, D, BS.

631
Poetry Page (Trembling Then II). Aug 27–Sep 6, 1962.
Grey (Z). 74.9 × 84.5. Ed 20 (BFK), 9 TI (BFK), PrP (BFK), 3 AP (BFK), 2 TP (BFK), CP (BFK). Joe Zirker. S, D, BS.

632
Poetry Page (Trembling Then V). Aug 27–Sep 7, 1962.
Grey (Z). 74.9 × 85.1. Ed 20 (BFK), 9 TI (BFK), PrP (BFK), 3 AP (BFK), 2 TP (BFK), CP (BFK). Joe Zirker. S, D, BS.

633
Poetry Page (Trembling Then IV). Aug 27–Sep 10, 1962.
Grey (Z). 75.3 × 84.5. Ed 20 (BFK), 9 TI (BFK), PrP (BFK), 3 AP (BFK), 1 PP (BFK), 3 TP (BFK), CP (BFK). Joe Zirker. S, D, BS.

634
Colophon (Trembling Then XIV). Aug 29–Sep 11, 1962.
Grey (Z). 75.3 × 84.8. Ed 20 (BFK), 9 TI (BFK), PrP (BFK), 2 AP (BFK), CP (BFK). Joe Zirker. S, D, BS.

Ernst Van Leyden

1686
Untitled. Mar 8–14, 1966.
Ochre (S), black (S). 76.5 × 56.2. Ed 20 (CD), 9 TI (GEP), BAT (CD), 3 AP (1 GEP, 2 CD[1]), 3 TP (CD)[2], CP (Tcs). Ernest de Soto. D, S, Dat, BS.

1. 1 AP (CD) varies from the edition and is actually a TP although designated AP.
2. 1 TP varies from the edition.

1686II
Untitled. Mar 14–15, 1966.
Black (S)[1]. 76.2 × 56.2. Ed 10 (CD), 9 TI (GEP), BAT (CD), 1 TP (CD), CP (Tcs). Ernest de Soto. D, BS, S, Dat.

1. Stone held from 1686, run 1. 1686II differs from 1686 in color and in image. The light diagonal grid, the dark calligraphic lines and the dark letters have been eliminated. The white dots and letters spelling "TAMARIND" are more distinct. The background has been filled in solid.

1928
Whirl. Feb 2–8, 1967.
Yellow-green (Z), orange (Z). 76.2 × 56.2. Ed 20 (CD), 9 TI (GEP), BAT (CD), 2 AP (1 CD, 1 GEP), 3 TP (CD), 2 CTP (1 GEP, 1 CD), 1 PTP* (Daumier paper)[1], CP (CD). Serge Lozingot. BS, D, S, Dat.

1. Unsigned, unchopped, undesignated, retained by Tamarind.

1929
Octavio Paz. Feb 8–Mar 3, 1967.
Yellow (S), light blue (S), blue (S). 56.2 × 76.2. Ed 20 (GEP), 9 TI (CD), BAT (GEP), 1 AP (CD), 4 TP (GEP), 3 CTP (CD), CP (CD). Anthony Ko. D, BS, S, Dat.

1930
Here and Now I. Feb 9–24, 1967.
Yellow (S), light blue (S), blue (S), pink (S). 56.2 × 76.2. Ed 20 (GEP), 9 TI (CD), BAT (GEP), 3 AP (CD), 3 TP (GEP), 2 CTP (GEP), CP (GEP). Serge Lozingot. D, BS, S, Dat.

1931
Here and Now II. Feb 20–Mar 1, 1967.
Yellow (S)[1], light blue (S)[2], blue (S), white (S). 55.9 × 76.5. Ed 20 (GEP), 9 TI (CD), BAT (GEP), 1 AP (CD), 4 TP (GEP), 1 CTP (GEP), CP (CD). Serge Lozingot. D, BS, S, Dat.

1. Stone held from 1930, run 1.
2. Stone held from 1930, run 2. 1931 differs from 1930 in color and in image. This image is different except for the central row of six shapes and some of the wash background tone and the light circle at the bottom.

1932
A Constellation of Considerations I. Feb 17–Mar 2, 1967.
Green (A), pink (S), light blue-green (S), grey (S). 56.8 × 63.5. Ed 20 (BFK), 9 TI (wA), BAT (BFK), 2 AP (BFK), 4 TP (BFK). Maurice Sanchez. D, S, Dat, BS.

1932II
A Constellation of Considerations II. Feb 24–27, 1967.
Grey (S)[1], black (S)[2]. 56.5 × 63.8. Ed 10 (MI), 9 TI (wN), BAT (MI), 2 AP (MI), 3 TP (MI). Maurice Sanchez. D, BS, S, Dat.

1. Stone held from 1932, run 4.
2. Stone held from 1932, run 2. 1932II differs from 1932 in color and in image. The central shapes are darker. The borders defining the central large circle and triangle and the semi-circular shapes within the central circle have been eliminated.

1932III
A Constellation of Considerations III. Feb 9–Mar 6, 1967.
Orange (Z), yellow (S), green (S)[1], light yellow (S)[2]. 56.5 × 64.8. Ed 10 (wN), 9 TI (nN), BAT (wN), 1 AP (nN), 2 TP (wN), 2 CTP (wN), CP (nN). Maurice Sanchez. D, S, Dat, BS.

1. Stone held from 1932II, run 2.
2. Stone held from 1932II, run 1. 1932III differs from 1932II in color and in image. Half-circles of cross-hatching were added to three small circles in the points of the triangle. Two irregular shapes of cross-hatching were added within the large circle and an overall texture was added to the background.

1933
Japanese Moon I. Feb 20–Mar 11, 1967.
Light green-blue (Z), pink (Z), light blue (S), violet (S). 54.0 × 71.1. Ed 20 (GEP), 9 TI (CD), BAT (GEP), 3 AP (CD), 2 TP (GEP), 1 CTP (CD). Anthony Ko. D, S, Dat, BS.

1933II
Japanese Moon II. Mar 15–17, 1967.
Beige (S)[1], orange (S)[2]. 51.4 × 68.6. Ed 10 (GEP), 9 TI (CD), BAT (GEP), 2 AP (CD), 2 TP (GEP). Anthony Ko. D, S, Dat, BS.

1. Stone held from 1933, run 3; additions.
2. Stone held from 1933, run 4. 1933II differs from 1933 in color, image and size. The vertical division of the shapes in the center was eliminated. The left side of the small left circle, small center circle, and the upper right side of the large center circle are darker. The triangular area on the left is lighter and three concentric circles have been added inside the small central circle.

1933III
Japanese Moon III. Mar 16–18, 1967.
Beige (S)[1], black (S)[2]. 51.8 × 68.6.
Ed 10 (GEP), 9 TI (CD), BAT (GEP), 3
AP (2 CD, 1 GEP), 3 TP (GEP), CP
(GEP)[3]. Anthony Ko. D, BS, S, Dat.

1. Stone held from 1933II, run 1.
2. Stone held from 1933II, run 2;
 additions and deletions. 1933III
 differs from 1933II in color and in
 image. The linear pattern is darker.
 Two small dark circles have been
 added in the centers of the two
 small upper circles and an almond
 eye shape outline has been added
 around these. A dark vertical line
 and a nose have been added
 through the center. The dark grid in
 the small lower circle has been
 eliminated and a dark semi-circle
 and triangles at the corners have
 been added.
3. CP printed over CTP from same
 edition at 180 degree angle to the
 CTP; deletions.

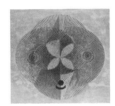

1934
Rotation I. Feb 24–Mar 17, 1967.
Orange (S), green (A), yellow (S)[1],
violet (S)[2]. 66.7 × 66.4. Ed 20 (wN),
9 TI (nN), BAT (wN), 3 AP (nN), 2 PP
(nN), 3 TP (wN), CP (wN). Donald
Kelley. D, S, Dat, BS.

1. Stone held from 1934II, run 1.
2. Stone held from 1934II, run 2. 1934
 differs from 1934II in color and in
 image. A vertical division has been
 added through the center. Color
 tones have been added in various
 areas made by the over-lapping
 circles. Dark tones have been added
 in the upper right and lower left
 sections to the sides of the central
 division. The left half of the left
 small circle and the right small
 circle are darker.

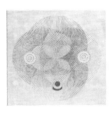

1934II
Rotation II. Mar 7–14, 1967.
Yellow (S), violet (S). 66.4 × 66.4. Ed
10 (nN), 9 TI (wN), BAT (nN), 3 AP (2
wN, 1 nN), 2 TP (nN). Donald Kelley.
D, W, Dat, BS.

1935
Green Apparition. Mar 6–17, 1967.
Yellow (A), red (A), blue (A), yellow-
green (S). 66.4 × 61.3. Ed 20 (CD), 9
TI (GEP), BAT (CD), 3 AP (GEP), 4 TP
(CD). Anthony Stoeveken. D, BS, S,
Dat.

1935II
Baumgeist. Mar 23–31, 1967.
Yellow-green (S), blue (A)[1], brown
(S)[2]. 66.7 × 61.3. Ed 10 (CD), 9 TI
(GEP), BAT (CD), 3 AP (1 CD, 2 GEP), 4
PP (CD), 1 TP (CD), CP (CD). Anthony
Stoeveken. D, BS, S, Dat.

1. Plate held from 1935, run 3.
2. Stone held from 1935, run 4. 1935II
 differs from 1935 in color and in
 image. The over-all image is darker.
 The grid of circles is more distinct
 and light.

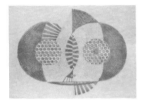

1936
Blue Cheeks. Mar 3–23, 1967.
Light beige (S), blue (S), red (S)[1].
66.0 × 86.4. Ed 20 (GEP), 9 TI (CD),
BAT (GEP), 3 AP (2 CD, 1 GEP), 1 TP*
(GEP), 1 CTP (BFK), CP (GEP). John
Butke. D, BS, S, Dat.

1. Stone held from 1936II. 1936 differs
 from 1936II in color and in image. A
 vertical division has been added
 through the center. Outside areas of
 the left and right circles and small
 areas made by the overlap and
 division of the circles have been
 filled in with color tone. Stripes of
 color have been added in the
 radiating lines in the upper left,
 center and lower right. A portion of
 the grid of circles has been
 eliminated from the center of the
 small right circle and shading has
 been added to both grids of circles.
 Wash background, a nose and
 mouth in the lower center circle
 have been added.

1936II
Golden Radiance. Mar 3, 1967.
Yellow-beige (S). 67.0 × 87.3. Ed 10
(wN), 9 TI (nN), BAT (wN), 3 AP (1 wN,
2 nN), 2 TP (wN). John Butke. D, S,
Dat, BS.

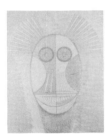

1937
Emaciated Owl I. Mar 9–23, 1967.
Light yellow (A), pink (A), grey (S).
56.2 × 43.5. Ed 20 (CD), 9 TI (GEP),
BAT (CD), 3 AP (GEP), 4 TP (CD).
Donald Kelley. D, BS, S, Dat.

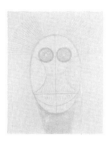

1937II
Emaciated Owl II. Mar 24, 1967.
Grey (S)[1]. 56.8 × 43.2. Ed 10 (BFK),
9 TI (wA), BAT (BFK), 2 AP (wA), 2 TP
(BFK). Donald Kelley. D, BS, S, Dat.

1. Stone held from 1937, run 3. 1937II
 differs from 1937 in color and in
 image. Background tone has been
 eliminated from sides and top. The
 solid tone stripes have been
 eliminated from the lines at the top.
 Tone has been eliminated from the
 left side of the face, right cheek and
 two lines delineating a mouth.

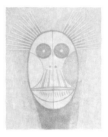

1937III
Emaciated Owl III. Mar 24–28, 1967.
Blue (S), grey (S)[1]. 56.8 × 43.5. Ed
10 (BFK), 9 TI (wA), BAT (BFK), 3 AP (1
BFK, 2 wA), 2 TP (BFK)[2], CP (BFK).
Donald Kelley. D, BS, S, Dat.

1. Stone held from 1937, run 3. 1937III
 differs from 1937 in color and in
 image. The over-all image is darker.
 Background shading has been
 added at the top, left side of the
 face. Stripes of shading have been
 added in the lines at top and in the
 center of the face.
2. 1 TP varies from the edition.

1938
Provo. Mar 20–29, 1967.
Pink (Z), light blue (S), grey (S). 73.7
× 53.7. Ed 20 (BFK), 9 TI (wA), BAT
(BFK), 2 AP (wA), 2 TP (BFK), CP (BFK).
Fred Genis. D, BS, S, Dat.

Esteban Vicente

Five Lithographs, a suite of six
lithographs including title page,
enclosed in a portfolio, measuring
38.4 × 30.5, covered and lined with
white Nacre. The lithographs are
enclosed in a chemise of ochre
Japanese paper. In order: 647, 636,
639, 640, 642, 644.

239
Untitled. Feb 22–24, 1961.
Black (S). 56.8 × 76.8. Ed 20 (bA), 9 TI
(nN), BAT (bA), 3 AP (bA). Bohuslav
Horak. BS, D, S.

Print not in
University Art Museum
Archive

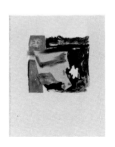

619
Untitled. Aug 1–7, 1962.
Red (Z), grey (Z), black (S). 41.3 ×
51.4. 9 ExP (wA)[1], PrP (BFK). Irwin
Hollander. D, S, BS.

1. Designated A–I. 4 ExP retained by
 Tamarind.

622
Untitled. Aug 6–16, 1962.
Orange-red (Z), red (Z), grey-green (Z),
green (Z). 41.0 × 50.8. Ed 20 (17 BFK,
3 wA), 9 TI (wA), PrP (BFK), 2 AP
(BFK), 2 PP (BFK), 1 TP (BFK), CP
(BFK). Joe Zirker. D, S, BS.

626
Untitled. Aug 10–22, 1962.
Black (S). 41.6 × 51.1. Ed 20 (BFK), 9
TI (wA), PrP (BFK), 2 AP (BFK), 3 PP (2
wA, 1 BFK), 3 TP (BFK). Joe Zirker. D,
S, BS.

626A
Untitled. Aug 22–24, 1962.
Light brown (Z), blue-black (S)[1]. 41.3
× 50.8. Ed 20 (BFK), 9 TI (wA), PrP
(BFK), 3 AP (1 BFK, 2 wA), 2 PP (BFK),
2 TP (BFK), CP (BFK). Joe Zirker. D, S,
BS.

1. Stone held from 626; deletions.
 626A differs from 626 in color and
 in image. Most of the textural
 drawing in the center light shape
 has been eliminated. A light
 horizontal shape has been added to
 the left of the light center shape
 and most of the light vertical shape
 on the right has been eliminated.
 Color tone has been added in the
 upper and lower left corners, upper
 right corner, left center light shape
 and right half of the right center
 light shape.

629
Untitled. Aug 23–30, 1962.
Red (Z), black (S). 41.6 × 51.1. Ed 20
(BFK), 9 TI (wA), PrP (BFK), 3 AP (2
BFK, 1 wA), 2 TP (1 BFK, 1 wA), CP
(BFK). Joe Zirker. D, S, BS.

636
Untitled (Five Lithographs II). Aug
30–Sep 10, 1962.
Grey (Z), red (Z), black (S). 34.9 ×
27.3. Ed 20 (BFK), 9 TI (wA), PrP (BFK),
2 AP (BFK), 2 TP (BFK), CP (wA). Irwin
Hollander. D, S, BS.

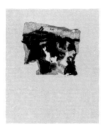

639
Untitled (Five Lithographs III). Sep
5–10, 1962.
Blue (Z), black (S). 35.6 × 28.6. Ed 20
(wN), 9 TI (nN), PrP (nN), PrP II for
Bohuslav Horak (wN), 3 AP (2 wN, 1
nN), 1 PP (wN), 2 TP (wN), CP (nN).
Irwin Hollander. D, S, BS.

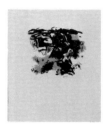

640
Untitled (Five Lithographs IV). Sep
10–12, 1962.
Ochre (Z), black (S). 35.9 × 28.6. Ed
20 (wN), 9 TI (nN), PrP (wN), 3 AP
(wN), 1 PP (wN), 2 TP (1 wN, 1 nN), CP
(nN). Irwin Hollander. D, S, BS.

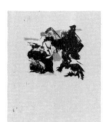

642
Untitled (Five Lithographs V). Sep
12–17, 1962.
Orange (Z), blue (Z), black (S). 35.9 ×
28.6. Ed 20 (wN), 9 TI (nN), PrP (wN),
PrP II for Bohuslav Horak (wN), 3 AP (2
wN, 1 nN), 2 PP (1 wN, 1 nN), 2 TP (1
wN, 1 nN), CP (wN). Irwin Hollander.
D, S, BS.

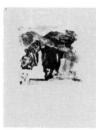

644
Untitled (Five Lithographs VI). Sep
14–21, 1962.
Red (Z), brown (Z), black (S)[1]. 35.3
× 27.9. Ed 20 (BFK), 9 TI (wA), PrP
(BFK), PrP II for Bohuslav Horak (BFK),
3 AP (2 BFK, 1 wA), 1 PP (BFK), 2 TP (1
BFK, 1 wA), CP (BFK). Irwin Hollander.
D, S, BS.

1. Stone held from 644A. 644 differs
 from 644A in color and in image.
 Wash drawing and color tone has
 been added in the light area
 extending from the upper left
 diagonally to center right.

Print not in
University Art Museum
Archive

644A
Untitled. Sep 21, 1962.
Black (S). 35.6 × 27.6. 10 ExP (BFK)[1],
PrP (BFK), 3 AP (BFK). Irwin Hollander.
D, S, BS.

1. Designated A–I. 5 ExP retained by
 Tamarind.

647
Title Page (Five Lithographs I). Sep
19–20, 1962.
Red-brown (S). 35.6 × 27.9. Ed 20
(BFK), 9 TI (wA), PrP (BFK), PrP II for
Bohuslav Horak (wA), 3 AP (2 BFK, 1
wA), 2 TP (BFK), CP (wA). Irwin
Hollander. D, S, BS.

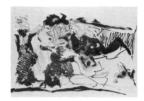

648
Untitled. Sep 21–25, 1962.
Black (S). 57.8 × 77.5. Ed 20 (BFK), 9
TI (wN), PrP (BFK), PrP II for Bohuslav
Horak (BFK), 3 AP (BFK), 1 TP (BFK),
CP (wN). Irwin Hollander. D, S, BS.

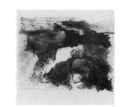

649
Untitled. Sep 24–25, 1962.
Brown-black (S). 39.1 × 56.8. Ed 20
(BFK), 9 TI (wN), PrP (BFK), 3 AP (BFK),
2 TP (1 BFK, 1 wN), CP (BFK). Donald
Roberts. D, S, BS.

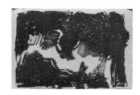

650
Untitled. Sep 25–26, 1962.
Black (S). 36.2 × 35.6. Ed 20 (BFK), 9
TI (wA), PrP (BFK), PrP II for Bohuslav
Horak (BFK), 3 AP (BFK), 1 TP (BFK),
CP (BFK). Joe Zirker. D, S, BS.

651
Untitled. Sep 26–27, 1962.
Black (S). 29.2 × 39.1. Ed 20 (BFK), 9
TI (wA), PrP (BFK), PrP II For Bohuslav
Horak (wA), 3 AP (BFK), 3 PP (2 wA, 1
BFK), 2 TP (BFK), CP (BFK). Donald
Roberts. D, S, BS.

Romas Viesulas

Toro Desconocido, a suite of eleven
lithographs including title, poetry and
colophon pages, enclosed in a dark
brown burlap covered portfolio,
measuring 80.0 × 60.0, lined with
white paper, made by Margaret Lecky,
Los Angeles. In order: 115, 114, 117,
102, 102A, 105A, 104, 104A, 113, 116,
118.

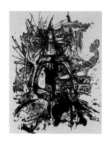

102
Toro! Toro! (Toro Desconocido IV).
Jul 11, 1960.
Black (S). 76.5 × 56.5. Ed 20 (BFK), 9
TI (bR), BAT (BFK), 3 AP (2 BFK, 1 bR),
1 ExP (Suzuki)[1]. Garo Z. Antreasian.
BS, D, T, S.

1. Unchopped, retained by Tamarind.

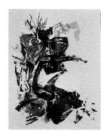

102A
Paso Doble (Toro Desconocido V).
Jul 14–Aug 30, 1960.
Dark grey (S), pink (Z), light blue (Z),
light grey (S), black (S)[1], beige,
orange (S). 76.2 × 56.8. Ed 20 (BFK), 9
TI (BFK), BAT (BFK), 2 AP (BFK), 2 TP
(BFK). Garo Z. Antreasian. BS, D, T, S.

1. Stone held from 102; deletions.
 102A differs from 102 in color and
 in image. Most of the wash tones
 and lines around the face have
 been eliminated. The two right eyes
 and the dark tone in the mouth
 have been eliminated. Small areas
 of color tone have been added
 throughout the image.

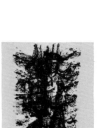

104
*With Trumpet of Shadow (Toro
Desconocido VII).* Jul 21, 1960.
Black (S)[1]. 76.2 × 56.8. Ed 20 (BFK),
9 TI (BFK), BAT (BFK), 3 AP (BFK).
Garo Z. Antreasian. BS, D, T, S.

1. Image from 104 transferred to new
 stone; additions and deletions. 104
 differs from 104 ExP in image.
 Minor deletions have been made at
 top center, the bottom left center
 and along both sides. The torso of
 the figure has been lightened.
 Additions were made in the lower
 right corner.

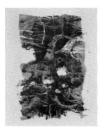

104A
*Is Grass Yellow Today (Toro
Desconocido VIII).* Aug 1–27, 1960.
Beige (Z), dark grey (S)[1], light blue
(Z), light yellow (Z), black, yellow,
orange (Z). 56.8 × 75.9. Ed 20 (BFK), 9
TI (BFK), BAT (BFK), 3 AP (BFK), 5 TP
(BFK). Garo Z. Antreasian. BS, D, T, S.

1. Stone held from 104; additions and
 deletions. 104A differs from 104 in
 color, image and in presentation as
 a horizontal. Part of the dark texture
 and line drawing has been
 eliminated in places along all of the
 edges. Light irregular and horn
 shapes have been added in the
 center. Light lines have been added
 throughout the image. An irregular
 color tone has been added behind
 the drawing and in small areas
 throughout.

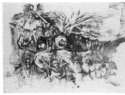

105
Picadores. Jul 8–13, 1960.
Black (S). 56.8 × 76.2. Ed 20 (13 BFK,
7 CD), 9 TI (BFK), BAT (BFK), 2 AP (1
BFK, 1 CD). Garo Z. Antreasian. BS, D,
T, S.

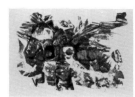

105A
*My Neck Flares (Toro Desconocido
VI).* Jul 20–Aug 11, 1960.
Red-brown (S)[1], pink-orange (Z),
blue-grey (Z), red-brown (S)[2], dark
red-brown (S)[3], light blue (Z). 56.8 ×
76.2. Ed 20 (BFK), 9 TI (BFK), BAT
(BFK), 2 AP (BFK), 2 TP (BFK). Garo Z.
Antreasian. BS, D, T, S.

1. Stone held from 105; deletions.
2. Same stone as run 1.
3. Same stone as run 4. 105A differs
 from 105 in color and in image.
 Much of the tone and line drawing
 has been eliminated from the upper
 and lower left side, upper right side,
 and from the center to the lower
 right. Some areas of color tone
 added throughout.

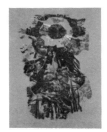

113
*Traje de Luces (Toro Desconocido
IX).* Aug 12–17, 1960.
Violet-grey (S), black (S)[1]. 76.2 ×
56.8. Ed 20 (BFK)[2], 9 TI (BFK), BAT
(BFK), 13 AP (10 BFK, 3 N*), 2 TP
(BFK). Garo Z. Antreasian. BS, D, T, S.

1. Image from 104 transferred to new
 stone; additions and deletions. 113
 differs from 104 in color and in
 image. A solid background tone has
 been added. The drawing has been
 turned 180 degrees and is different
 except for very small areas of
 texture.
2. 6/20 is also signed "artist proof."

114
*To Unknown Bulls Facing
Unknown Swords (Toro
Desconocido II)* Aug 15–17, 1960.
Beige (Z), black (S). 76.2 × 56.8. Ed 20
(BFK), 9 TI (BFK), BAT (BFK), 3 AP
(BFK), 2 TP (BFK). Garo Z. Antreasian.
BS, D, T, S.

115
Title Page (Toro Desconocido I).
Aug 16–25, 1960.
Black (S), beige (S). 76.2 × 56.8. Ed 20
(BFK), 9 TI (BFK), BAT (BFK), 6 AP
(BFK), 3 TP (2 BFK, 1 nr[1]). Garo Z.
Antreasian. BS, D, S, Dat.

1. 1 TP retained by Tamarind.

116
*In the Sun, in the Sand (Toro
Desconocido X).* Aug 18–31, 1960.
Red-orange (S), pink (S), red, light
grey (S), dark red, grey (S), light blue
(S). 75.9 × 56.8. Ed 20 (BFK), 9 TI
(BFK), BAT (BFK), 4 AP (BFK), 4 TP (3
BFK, 1 W). Garo Z. Antreasian. BS, D,
T, S.

117
Poem (Toro Desconocido III). Aug 24, 1960.
Black (S). 76.2 × 56.8. Ed 20 (BFK), 9 TI (BFK), BAT (BFK), 3 AP (BFK). Garo Z. Antreasian. BS, D, S.

118
Colophon (Toro Desconocido XI).
Jul 1–Aug 31, 1960.
Black (S). 76.2 × 56.8. Ed 20 (BFK), 9 TI (BFK), BAT (BFK), CP (BFK)[1]. Garo Z. Antreasian. BS, D, S.

1. Unsigned, unchopped, retained by Tamarind.

June Wayne

107
Dorothy the Last Day. Jul 28–Aug 26, 1960.
Light blue-grey (Z), light green-grey (Z), dark beige (Z), brown (Z). 57.2 × 76.5. Ed 20 (BFK), 9 TI (wN), PrP (BFK), 4 AP (BFK)[1], 1 artist's copy (wN)[2], 1 artist's impression (BFK)[3], 8 TP (2 N, 6 nr)[4], 3 CSP (BFK)[5], 1 PgP (BFK). Garo Z.
Antreasian. BS (Wayne), S, Dat, T, D, BS (Tam, pr).

1. 1 AP varies from the edition; 3 AP without printer's chop.
2. Without printer's chop.
3. Inscribed "Dorothy on the Last Day, 8:15 p.m. June 25, 1960."
4. 7 TP vary from the edition; 1 TP (N), 2 TP (nr) without printer's chop. Information for 2 TP unrecorded.
5. 1 CSP also designated "trial proof."

107A
Cornelia's Bird. Sep 8, 1960.
Black (Z)[1]. 57.2 × 76.5. Ed 20 (5 Suzuki[2], 1 Troya, 2 Yamoto, 1 Kimwashi, 11 BFK), 9 TI (wN), BAT (Suzuki), 1 AP (wN), 2 TP (1 J, 1 nr), 1 FSP (BFK)[3]. Garo Z. Antreasian. BS, S, Dat, D, T.

1. Plate held from 107, run 3; deletions. 107A differs from 107 in color and in image. The over-all image is darker. The figure and concentric rectangles have been eliminated. The center area has been lightened very slightly.
2. Ed 3–5/20 have wide borders.
3. Without printer's chop. Before deletions.

Print not in
University Art Museum
Archive

143
Spectator. Oct 20–Nov 3, 1960.
Grey-brown (Z)[1], black (Z). 76.5 × 56.8. 10 ExP (BFK)[2], 1 TP (wA), 3 FSP (1 wA, 2 coverstock)[3], 1 CTP (coverstock)[4], 7 proof fragments (BFK)[5]. Joe Funk. S, BS.

1. Plate held from 107A; additions and deletions. 143 differs from 107A in color, image and presentation as a vertical. The over-all image is lighter. Three figures and drapery, which were suggested by shapes in 107A, have been added.
2. Designated A–J. 5 ExP retained by Tamarind.
3. 2 FSP (coverstock) with cut edges, one retained by Tamarind, 1 FSP (wA) drawn upon, without Tamarind's chop.
4. CTP drawn upon; without Tamarind's chop.
5. Designated K–P, on paper various sizes smaller than original format. Proof M was drawn upon and bears artist's chop, but not Tamarind's. 3 proofs retained by Tamarind.

154
Nine Memories. Nov 8, 1960–May 22, 1961.
Light yellow (Z), ochre (Z), red-brown (Z), light blue (Z), green-grey (Z). 57.2 × 76.8. Ed 8 (BFK), 9 TI (wN), PrP (BFK), 2 AP (1 wN, 1 BFK), 5 TP* (2 BFK, 1 wN, 2 wA), 2 rough proofs* (Tcs)[1]. Bohuslav Horak. T, S, D, BS.

1. Rough proofs unsigned and unchopped.

305
Orator. Jun 7–8, 1961.
Black (Z)[1]. 56.5 × 76.8. Ed 20 (wA), 9 TI (nN), BAT (wA), 2 AP (1 wA, 1 nN), 1 TP (wA), CP (BFK). Bohuslav Horak. D, T, S, Dat, BS (Wayne, Tam, pr).

1. Plate held from 154, run 5; deletions and additions. 305 differs from 154 in color and in image. The over-all image is darker. Rectangle at the upper left, upper right and lower right have been filled in solid. The linear drawing and shading on the figures has been eliminated. More pronounced texture has been added in the figures and geometric shapes.

317
Twelfth Memory[1]. May 26–Oct 19, 1961.
Yellow-green (Z), light violet (Z), red-brown (Z), grey-green (Z). 76.8 × 56.8. Ed 20 (BFK), 9 TI (wN), BAT (BFK), 1 AP (wN), 9 TP* (5 BFK, 1 wA, 3 wN). Bohuslav Horak. BS (Tam, pr), S, Dat, BS (Wayne), T, D.

1. The artist informed Tamarind in 1973 that she destroyed the impressions in her possession in March, 1971.

365
Tenth Memory. Aug 1–24, 1961.
Black (Z). 76.2 × 56.5. Ed 25 (BFK), 9
TI (wA), BAT (BFK), 3 AP (wA), 4 TP (1
wA, 3 BFK[1]), 3 proofs (nr)[2], CP
(BFK). Bohuslav Horak. BS, S, Dat, T,
D.

1. Designated "Presentation Trial
 Proofs."
2. 1 proof with drawing in white chalk,
 two with X drawn through them.

657
Last Conversation[1]. Oct 9, 1962–
Jul 25, 1963.
Black (Z), ochre (Z), white (Z), black
(Z). 73.7 × 48.9. Ed 20 (BFK), 9 TI (7
wA, 2 BFK), BAT (BFK), 1 AP (BFK), 1
TP (BFK). Irwin Hollander. T, D, BS, S,
Dat.

1. The artist informed Tamarind in
 1973 that she destroyed the
 impressions in her possession in
 March 1971.

658
Second Hero[1]. Oct 9–Nov 14, 1962.
Black (Z), light pink (Z). 76.2 × 56.5.
Ed 8 (1 wA, 7 BFK), 9 TI (BFK), PrP
(BFK), PrP II for Bohuslav Horak or Joe
Zirker (BFK), 1 AP (BFK), 2 TP (BFK), 5
CTP (BFK)[2]. Irwin Hollander. D, S,
Dat, T, BS.

1. The artist informed Tamarind in
 1973 that she destroyed the
 impressions in her possession in
 March, 1971.
2. 4 CTP have rejected impressions by
 Jose Luis Cuevas (Tam. #654) on
 the verso, defaced with pencil.

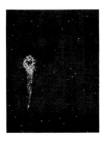

913
Dead Center II. Oct 25–Nov 6, 1963.
Black (Z)[1], transparent grey (Z). 76.2
× 56.5. Ed 20 (BFK), 9 TI (wA), BAT
(BFK), 2 AP (wA), 7 PP (6 BFK, 1 wA), 4
TP (2 BFK, 2 wN)[2]. Irwin Hollander.
D, S, Dat, T, BS, (Tam, pr, Wayne).

1. Plate held from 913A. 913 differs
 from 913A in color and in image.
 Vertical strokes of color tone have
 been added throughout the image.
2. 2 TP vary from the edition.

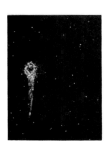

913A
Dead Center I. Oct 25–Nov 6, 1963.
Black (Z). 76.2 × 56.2. Ed 10 (BFK), 9
TI (wA), BAT (BFK), 3 AP (2 wA, 1
BFK), 1 PP (BFK), 1 TP (wN). Irwin
Hollander. D, T, S, Dat, BS (Tam, pr,
Wayne).

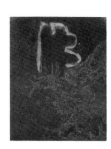

916
Green Key. Nov 12–Dec 30, 1963.
Grey-green (Z)[1], blue (Z)[2]. 50.2 ×
38.1. Ed 20 (BFK), 9 TI (wA), BAT (wA),
PrP II for John Dowell (wA), 1 AP
(wA), 1 TP (BFK), CP (BFK). Jason
Leese. T, D, S, Dat, BS.

1. Plate held from 916A.
2. Image from run 1; reversal,
 deletions and additions. 916 differs
 from 916A in color and in image.
 The light swirled pattern in the
 lower half of the image has been
 filled in with color tone.

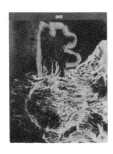

916A
First Key. Nov 1–8, 1963.
Black (Z). 49.2 × 38.1. Ed 10 (BFK), 9
TI (wA), PrP (BFK), 2 AP (1 BFK, 1 wA),
2 PP (BFK). Jason Leese. BS, T, D, S,
Dat.

935
Three Observers. Dec 27, 1963–Jan
14, 1964.
Dark beige (Z)[1], light blue (Z)[2],
orange-brown (Z), brown (Z). 76.8 ×
56.8. Ed 20 (BFK), 9 TI (wA), BAT
(BFK), 1 AP (BFK), 1 PP (BFK), 3 TP *
(BFK). Aris Koutroulis. D, S, Dat, T, BS.

1. Plate held from 935A.
2. Plate held from 913, run 2. 935
 differs from 935A and 913 in color
 and in image. 935 superimposes the
 vertical tone strokes from 913 over
 the background and figure of 935a.
 The tone strokes have been partially
 eliminated in the lower left and in
 the area around the lower large
 figure. The light spots in the
 background tone are less distinct.
 Additional line drawing and shading
 has been added to all figures.

935A
Walk on the Rocks. Nov 20–21,
1963.
Black (Z). 76.2 × 56.5. Ed 9 (BFK), 9 TI
(8 wA, 1 BFK), BAT (BFK), 1 TP (BFK).
Jason Leese. D, S, Dat, T, BS.

1000A

At Last a Thousand I. Oct 1–4, 1965.
Black (Z). 61.3 × 86.7. Ed 10 (BFK), 9
TI (CD), BAT (BFK), PrP II for Walter
Gabrielson (BFK), 2 TP (BFK)[1].
Jurgen Fischer. Recto: BS, S, Dat, D
Verso: S, T.

1. 2 TP on paper 73.6 × 104.1. 1 TP
 varies from the edition; 1 TP
 designated "Trial Proof of Entire
 First Plate for Tamarind
 Experimental Collection," retained
 by Tamarind.

1000B

At Last a Thousand II. Oct 5–12,
1965.
Blue (A), orange (A), light green (A),
black (Z)[1]. 63.5 × 88.9. Ed 20
(BFK)[2], 9 TI (wN), BAT (BFK), PrP II
for Ernest de Soto (BFK), 10 AP (5 wN,
5 GEP), 1 TP* (wN), 6 PgP (5 BFK[3], 1
wN). Jurgen Fischer. Recto: BS, D, S
Verso: D, T, S, Dat.

1. Plate held from 1000A. 1000B
 differs from 1000A in color, image
 and size. Color tones and textures
 have been added throughout the
 image. Some of the texture in the
 center of the image is less distinct.
 The upper corners and lower edge
 are darker.
2. Ed 1–7/20—Recto: S, T, Dat, D only.
3. 3 PgP retained by Tamarind.

1000C

At Last a Thousand III. Oct 13–15,
1965.
Black (Z)[1]. 61.0 × 86.7. Ed 10 (BFK),
9 TI (CD), BAT (BFK), 3 AP (1 BFK, 2
CD), 2 TP* (BFK). Jurgen Fischer. BS,
D, T, S, Dat.

1. Plate held from 1000B, run 4;
 additions and deletions. 1000C
 differs from 1000B in color, image
 and size. The upper corners, left
 side and bottom have been filled in
 solid. The center of the image is
 darker. Figures and more texture
 have been added to the lower
 portion of the central shape.

1000D

At Last a Thousand IV. Oct 18, 1965.
Black (Z)[1]. 61.0 × 74.0. Ed 15 (BFK),
9 TI (CD), BAT (BFK), 3 AP (2 BFK, 1
CD), 4 TP* (Tcs). Jurgen Fischer. BS,
S, Dat, T, D.

1. Plate held from 1000C; reversal,
 deletions. 1000D differs from 1000C
 in image and in size. Most of the
 background on the left side and
 part of the background on the right
 side have been eliminated. Dark
 wedge shapes have been added in
 the upper and lower right and lower
 left corners.

2000

Two Thousand Too Soon. Mar 6–
Apr 3, 1967.
Yellow-orange (A), light green (A),
transparent red (A), red (A). 77.5 ×
48.6. Ed 20 (GEP), 9 TI (wN), BAT
(GEP), 8 AP (2 GEP, 6 wN), 5 TP*
(GEP)[1], 2 CTP (GEP)[2]. Fred Genis.
BS, T, D, S, Dat.

1. 1 TP retained by Tamarind;
 designated "Trial Proof—Orange
 Stone (1st run) is without
 deletions—no 4th overprinting of
 Figures."
2. 1 CTP retained by Tamarind,
 designated "Color Trial Proof Run 1
 without Deletions."

2001

Lemmings Crush. Apr 5–May 8,
1967.
Yellow (A), yellow-green (A), light
violet (A), orange (A), dark red (A),
green (A), blue (A). 54.3 × 76.5. Ed 30
(20 GEP, 10 wN[1]), 9 TI (7 CD, 2 GEP),
BAT (GEP), 3 AP (CD), 6 PP (3 wN, 1
CD, 2 GEP), 1 TP* (GEP), 4 CTP (1 wN,
3 GEP), CP (EVB). Fred
Genis. D, T, S, Dat, BS (Wayne, Tam,
pr).

1. Designated Nacre edition,
 numbered 1–10/10.

2002

Stone Circle[1]. Apr 21–May 15,
1967.
Grey-green (S), black (S), light yellow,
orange-brown, pink (A). 61.3 × 47.3.
Ed 16 (CD)[2], 9 TI (GEP), BAT (CD), 2
AP (dLN), 2 TP* (GEP), 4 CTP (3 CD, 1
EVB), 3 CSP (1 GEP, 2 EVB[3]), 1 PTP
(dLN), CP (EVB). Donald Kelley. BS
(Tam, pr, Wayne), S, Dat, T, D.

1. The artist informed Tamarind in
 1973 that she destroyed the
 impressions in her possession in
 March, 1971.
2. After signing, Ed 4 were rejected
 and the numbers erased to make an
 edition of 16.
3. 1 CSP (EVB) retained by Tamarind;
 designated "1st State—1st Run
 Separation."

2003

The Shelf. Jun 1–Sep 27, 1967.
Black (S), black (A). 61.0 × 47.0. Ed 25
(20 GEP, 5 wN), 9 TI (CD), BAT (GEP), 5
AP (2 CD, 3 GEP[1]). Maurice Sanchez.
S, Dat, D, T, BS (Wayne, Tam, pr).

1. 2 AP (GEP) vary from the edition.

2003II
Thirteenth Memory[1]. Sep 29–Oct 13, 1967.
Grey (S)[2], brown, ochre (S), white (S)[3]. 61.0 × 47.0. Ed 20 (bA), 9 TI (bA), BAT (bA), 7 AP (bA), 6 TP* (2 cs, 4 bA)[4], 2 PTP (1 wN, 1 nN). Maurice Sanchez. BS (Tam, pr), D, T, S, Dat, BS (Wayne).

1. The artist informed Tamarind in 1973 that she destroyed the impressions in her possession in March, 1971.
2. Stone held from 2003, run 1.
3. Same stone as run 2. 2003II differs from 2003 in color and in image. The over-all image is lighter. Figures have been eliminated. Two irregular shapes at the upper left and words in the center have been added.
4. 3 TP (1 cs, 2 bA) retained by Tamarind; designated "Unique Color Trial—1st State," "2nd State—Trial," "Third State—Trial Proof."

2003III
Lemmings' Choice[1]. Oct 1, 1967–Dec 3, 1968.
Yellow (S), red (S)[2], red (S)[2], orange, brown-green (S), red, green or brown (S)[3]. 66.0 × 49.5. Ed 25 (20 GEP[4], 5 JG[5]), 9 TI (wN), BAT (GEP), 3 AP (wN)[6], 1 PP (wN), 3 TP* (GEP)[7], CP (GEP). Maurice Sanchez. BS (Tam, pr, Wayne), D, T, S, Dat.

1. The artist informed Tamarind in 1973 that she destroyed the impressions in her possession in March, 1971.
2. Stone held from 2003II, run 1. Same stone used for runs 2 and 3 with run 3 turned 180 degrees. 2003III differs from 2003II in color, image and size. The over-all image is darker. The words and two small irregular shapes have been eliminated. Additional horizontal bands and crinkled paper texture have been added throughout the image. Many small figures have been added to the lower half of the image.
3. The first 4 runs were printed by Maurice Sanchez in 1967. In 1968 the artist added a 5th run of two colors on most of the impressions, then later changed this to a one-color run printed on the remaining impressions. Red and green image transferred to new stone for brown run: additions. Run 5 was printed by Serge Lozingot. The following impressions have run 5 in Variation I (red and green): Ed 24 (19 GEP, 5 JG), 1 TI, 2 AP, 3 TP, CP.
4. Ed 1–4/20 vary from the edition.
5. Designated J. Green edition, numbered 1–5/5.
6. 1 AP varies from the edition.
7. 3 TP arabic numbered.

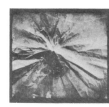

2171
To Get to the Other Side. Oct 10, 1967–Jan 29, 1968.
Red-black (A)[1], black (S). 40.6 × 41.9. Ed 25 (23 wA, 2 R), 9 TI (R), 1 Shapiro Impression (wA), 1 Hill Impression (CW), BAT (wA), 7 TP* (4 wA, 2 R, 1 EVB)[2], 1 CTP (wA). Maurice Sanchez. BS (Tam, pr), T, D, BS (Wayne), S, Dat.

1. Originally drawn on onyx; the stone broke. Image transferred to plate. A crack is visible crossing the upper part of the image in all impressions except 3 TP (wA) and 1 Shapiro Impression.
2. 1 TP (wA) designated "Trial State I for Tamarind (pulled from original image on onyx stone)," retained by Tamarind. 1 TP (R) was pulled as a Cancellation Proof. 1 TP (EVB), unchopped.

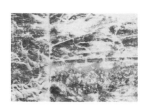

2195
Lemmings Day. Dec 21, 1967–Mar 26, 1968.
Black (S), black (S)[1]. 52.1 × 71.1. Ed 7 (2 wN[2], 2 CD[3], 2 MI[4], 1 dLN[5]). David Folkman. BS (Tam, pr), S, Dat, T, BS (Wayne), D.

1. Stone held from 2238, run 3. 2195 differs from 2238 in color, image, and size. The medium tone bleed background has been eliminated. A textural bleed background with greater contrast of lights and darks has been added. The foreground grouping of figures has been printed on the right two-thirds of the sheet eliminating the right one-third of the previous image.
2. Designated Nacre Proof I and II, on paper 57.2 × 77.5. 1 Nacre Proof varies from the edition.
3. Designated Copperplate Proof I and II; 1 retained by Tamarind.
4. Designated Magnani Proof I and II; II varies from the edition.
5. Designated de Laga Proof.

2197
Plus ça Change —. Jan 2–Mar 7, 1968.
Black (O, S)[1]. 58.8 × 74.3. Ed 20 (cR), 9 TI (CD), 1 Shapiro Impressions (cR), 1 Hill Impression (cR), BAT (cR), PrP II (cR) for Maurice Sanchez, 3 AP (1 cR, 2 CD), 1 CTP (cR). Serge Lozingot. BS (Tam, pr, Wayne), D, S, Dat, T.

1. Onyx held from 2197MS, run 1. Onyx broke after 13 impressions, image transferred to stone; additions and deletions. Impressions from stone show crack crossing right side of image. 2197II differs from 2197MS in image and in size. The dark areas are darker and larger. More texture and dark areas have been added at the top, right and bottom edges. The left side is lighter. Small figures along the bottom have been eliminated and larger figures have been added throughout.

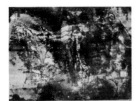

2197II
Lemmings Twenty-One. Jan 2–Mar 11, 1968.
Black (O), black (S)[1]. 56.5 × 71.1. Ed 4 (2 MI, 2 JG), 1 TI (wN)[2]. Maurice Sanchez. BS (Tam, pr, Wayne), D, S, T.

1. Stone held from 2238, run 3. 2197MS differs from 2238 in color, image, and size. The medium tone bleed background has been eliminated. A dark bleed textured background has been added behind the foreground figure grouping.
2. Unsigned, undesignated, retained by Tamarind.

Print not in
University Art Museum
Archive

2197SL
Plus ça Reste—Même[1]. Mar 13, 1968–Jan 10, 1969.
Brown-green (S), blue (S)[2], black (S)[3], black (S)[4]. 55.9 × 71.1. Ed 20 (wN)[5], 9 TI (ucR), BAT (wN), 2 AP (ucR), 1 PP (ucR), 1 TP* (wN), CP (ucR). Serge Lozingot. T, D, BS (Tam, pr, Wayne), S, Dat.

1. The artist informed Tamarind in 1973 that she destroyed the impressions in her possession in March, 1971.
2. Same stone as run 1; reversal.
3. Stone held from 2197II; deletions. 2197SL differs from 2197II in color, image and size. The dark areas along the top, bottom and lower right side have been eliminated. Light shapes in the center and lower right have been added. A bleed background tone has been added. Figures have been added at the upper left and some of the drawing around all of the figures has been eliminated.
4. In Jan, 1969, the artist added a 4th run to the impressions on Nacre: Ed 1–4/20 and 6–19/20, BAT, 1 TP.
5. Ed 5/20 has the image of 4th run drawn in ink. Ed 20/20 exists as 3–color lithograph.

2238
Lemmings' Night. Mar 20–26, 1968.
Light brown (S)[1], grey (S)[2], black (S). 55.6 × 71.5. Ed 20 (ucR)[3], 9 TI (CD), 1 Shapiro Impression (ucR), 1 Hill Impression (ucR), BAT (ucR), 4 AP (2 ucR, 2 CD), 1 TP* (CD), 16 CTP (4 ucR, 7 wN, 5 CD)[4], CP (ucR). Serge Lozingot. BS (Wayne, Tam, pr), S, Dat, T, D.

1. Stone held from 2197SL, run 1.
2. Stone held from 2197SL, run 2; deletions. 2238 differs from 2197SL in color and in image. The dark portion of the image and the figures have been eliminated. The background tone has been turned 180 degrees and many small white spots added in the upper portion. Many small figures and a dark tone have been added along the bottom.
3. Ed 2/20 does not bear a Tamarind number and is unchopped. Noted on the verso by the artist as an authorized impression with Hotel Westbury, N.Y. as the place where this was done.
4. 16 CTP arabic numbered. 1 CTP on paper 57.8 × 71.1.

2512
Wave Nineteen Twenty. Nov 22–Dec 4, 1968.
Black (S). 84.5 × 61.3. Ed 20 (CD), 9 TI (GEP), 1 Shapiro Impression (CD), 1 Hill Impression (CD), BAT (CD), 7 AP (2 wN, 4 CD, 1 GEP), 1 TP (GEP), CP (GEP). Serge Lozingot. BS (Tam, pr), T, D, S, Dat, BS (Wayne).

2717
One Up, One Down. Aug 7–Oct 31, 1969.
Black (S)[1], black (S), red-black (S)[2]. 58.4 × 88.6. Ed 20 (ucR), 9 TI (cR), BAT (ucR), 5 AP (3 ucR, 2 cR), 4 TP (3 ucR[3], 1 cR). Serge Lozingot. BS (Tam), T, BS (pr, Wayne), D, S, Dat (in black ink).

1. Image transferred from run 2; reversal, deletions.
2. Stone held from 2717II, run 2; deletions and additions.
3. 3 TP vary from the edition. 1 TP printed on recto and verso, unchopped.

2717II
Because It's There. Oct 20–Nov 5, 1969.
B: Light blue, grey-green, ochre, orange, red (S)[1], blue (S)[2], dark blue (S)[3]. 58.4 × 88.9. Ed 20 (cR), 9 TI (ucR), BAT (cR), 3 AP (1 cR, 2 ucR[4]), 7 TP* (4 cR, 2 GEP, 1 CD)[5], CP* (cR)[6]. Serge Lozingot. S, Dat, T, D, BS (Tam, pr, Wayne).

1. Stone held from 2717, run 1; deletions.
2. Stone held from 2717, run 2; additions.
3. Stone held from 2717, run 3; deletions. 2717II differs from 2717 in color and in image. Bleed color background tone and color tones throughout the image have been added. the shapes and texture are more distinct.
4. 1 AP designated Shapiro Impression.
5. 1 TP (cR) designated AKA Hill Impression. 7 TP Arabic numbered.
6. CP printed on recto and verso, unchopped.

2854
Tamarind Decade[1]. Mar 3–20, 1970.
Red-black (S), black (Z). 94.3 × 61.3. Ed 20 (cR), 9 TI (ucR), BAT (cR), 2 AP (1 cR, 1 ucR), 2 PP (1 cR, 1 ucR), 3 TP* (cR)[2], 2 CTP (cR). Serge Lozingot. S, Dat, D, BS (Tam, pr, Wayne).

1. This lithograph was photographed and an offset poster printed by Koltun Bros. Los Angeles, in an edition of 500 as a souvenir to celebrate the 10th year of Tamarind.
2. 3 TP arabic numbered.

2854II
C'mona My House[1]. May 4–15, 1970.
B: Orange-brown, green (S)[2], red (S)[3], B: blue, brown-red (Z). 94.0 × 59.1. Ed 20 (cR), 9 TI (ucR), BAT (cR), 7 AP (5 cR, 2 ucR), 1 TP* (ucR), 4 CTP (cR)[4], CP* (ucR)[5]. Serge Lozingot. D, S, Dat, T, BS, (Tam, pr, Wayne).

1. The artist informed Tamarind in 1973 that she destroyed the impressions in her possession in March, 1971.
2. Stone held from 2854 proofing, used to print 2 CTP of 2854 and then abandoned for that edition.
3. Stone held from 2854, run 1. 2854II differs from 2854 in color and in image. The words have been eliminated. A bleed background tone and color tones throughout the image have been added. Light line drawing of figures and structures have been added in the lower half of the image.
4. 4 CTP arabic numbered.
5. CP on paper 94.0 × 61.0.

Hugo Weber

996
Untitled. Feb 3–13, 1964.
Blue (Z), black (Z). 35.6 × 48.3. Ed 20 (BFK), 9 TI (wA), PrP (BFK), PrP II for Aris Koutroulis (BFK), 3 AP (2 BFK, 1 wA), 3 TP (BFK), CP (BFK). Irwin Hollander. D, BS, S, Dat.

997
Black Punch. Feb 5–Mar 3, 1964.
Light yellow (Z), black (Z). 56.5 × 76.2. Ed 20 (BFK), 9 TI (wA), PrP (BFK), PrP II for Irwin Hollander (BFK), 2 AP (wA), 2 TP (BFK). Robert Gardner. D, T, BS, S, Dat.

999
Untitled. Feb 6–17, 1964.
Black (Z). 38.1 × 56.5. Ed 20 (BFK), 9 TI (wA), PrP (BFK), PrP II for Irwin Hollander (BFK), 3 AP (2 BFK, 1 wA), 2 TP (BFK). John Dowell. D, BS, S, Dat.

1002
L.A. Sunset. Feb 10–Mar 25, 1964.
Orange-red (Z), black (S). 56.5 × 76.2. Ed 20 (wA), 9 TI (wA), PrP (wA), PrP II for Irwin Hollander (wA), 1 AP (wA), 2 TP (wA). Thom O'Connor. D, T, BS, S, Dat.

1005
Plum De De. Feb 10–Mar 20, 1964.
Blue-violet (Z), light blue (Z). 38.4 × 56.5. Ed 20 (BFK), 9 TI (wA), PrP (BFK), PrP II for Aris Koutroulis (BFK), 3 AP (2 BFK, 1 wA), 2 TP (BFK). John Dowell. D, T, S, Dat, BS.

1009
Untitled. Feb 12–13, 1964.
Black (Z). 27.0 × 40.6. Ed 18 (BFK), 9 TI (wA), PrP (BFK), 2 TP (BFK), CP (BFK). Aris Koutroulis. D, BS, S, Dat.

1012
Untitled. Feb 14–18, 1964.
Black (Z). 46.1 × 66.4. Ed 20 (BFK), 9 TI (wA), PrP (BFK), 3 AP (2 wA, 1 BFK), 1 PP (BFK), 2 TP (BFK), CP (BFK). Robert Gardner. D, BS, I, Dat.

1016
La Grisaille. Feb 17–Mar 3, 1964.
Grey (S). 38.1 × 47.0. Ed 20 (BFK), 9 TI (wA), PrP (BFK), PrP II for Irwin Hollander (BFK), 3 AP (2 wA, 1 BFK), 2 TP (BFK). Aris Koutroulis. D (top), BS, T, S, Dat (bottom).

1019
Smog Ballade. Feb 19–28, 1964.
Grey-blue (Z), black (Z). 38.1 × 56.5. Ed 20 (BFK), 9 TI (wA), PrP (BFK), 3 AP (2 wA, 1 BFK), CP (BFK). Robert Gardner. D, T, BS, S, Dat.

1021
Untitled. Feb 24–28, 1964.
Orange (Z)[1], black (Z). 55.9 × 76.2. Ed 20 (bA), 9 TI (nN), PrP (bA), 3 AP (2 nN, 1 bA), 2 TP (bA). Aris Koutroulis. D, BS, S, Dat.

1. Plate held from 997, run 1. 1021 differs from 997 in color and in image. The over-all image is considerably lighter. The dark central shape has been eliminated and a dark linear drawing has been added.

1028
Blue Up. Mar 2–6, 1964.
Blue (S). 68.6 × 83.8. Ed 20 (BFK), 9 TI (wN), PrP (BFK), PrP II for Irwin Hollander (BFK), 3 AP (wN), 2 TP (BFK). Aris Koutroulis. D, T, S, Dat, BS.

1030
P.L. Mar 4–9, 1964.
Black (Z). 51.1 × 66.7. Ed 20 (bA), 9 TI
(nN), PrP (bA), PrP II for Irwin
Hollander (bA), 3 AP (2 nN, 1 bA), 2 TP
(bA). Robert Gardner. D, T, BS, S, Dat.

Print not in
University Art Museum
Archive

1046
Freeway. Mar 19–26, 1964.
Black (S). 57.2 × 76.8. 10 ExP (nN)[1],
PrP (nN), PrP II for Irwin Hollander
(nN), 1 AP (nN). John Dowell. D, T, BS,
S, Dat.

1. Designated A–J. 5 ExP retained by
 Tamarind.

1031
Verdure. Mar 4–12, 1964.
Green (Z). 49.5 × 68.6. Ed 20 (10 wA,
10 bA), 9 TI (bA), PrP (bA), 3 AP (2 wA,
1 wN), 2 TP (wA). Robert Gardner. D,
T, BS, S, Dat.

1048
Late, Late. Mar 24–25, 1964.
Black (S). 36.2 × 47.0. Ed 20 (BFK), 9
TI (wA), PrP (BFK), 3 AP (2 BFK, 1 wA),
2 TP (BFK), CP (BFK). John Dowell. D,
T, S, Dat, BS.

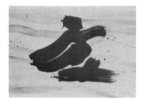

1033
Black II. Mar 6–9, 1964.
Black (S)[1]. 56.5 × 76.2. Ed 20 (BFK),
9 TI (wA), PrP (BFK), PrP II for Irwin
Hollander (BFK), 3 AP (2 wA, 1 BFK), 1
PP (BFK), 2 TP (BFK). John Dowell. D,
T, BS, S, Dat.

1. Stone held from 1028; additions
 and deletions. 1033 differs from
 1028 in color, image and size.
 Horizontal bands of tone and
 horizontal lines have been added.

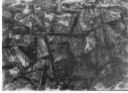

Emil Weddige

621
Sierra Nevada's. Jul 31–Aug 15,
1962.
Grey (Z), brown (Z), black (Z). 56.8 ×
75.6. Ed 20 (BFK), 9 TI (wA), PrP (BFK),
2 AP (1 BFK, 1 wA), 7 PP (6 BFK, 1
wA), 1 TP (BFK), CP (BFK). Emil
Weddige. BS, D, S.

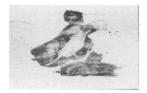

1039
Spook Noir. Mar 12–16, 1964.
Black (S)[1]. 57.2 × 76.2. Ed 20 (BFK),
9 TI (wA), PrP (BFK), PrP II for Irwin
Hollander (BFK), 3 AP (1 wA, 2 BFK), 2
PP (1 R, 1 wA), 2 TP (BFK). John
Dowell. D, BS, T, S, Dat.

1. Stone held from 1033; deletions.
 1039 differs from 1033 in image.
 Most of the horizontal lines and
 bands have been eliminated. The
 dark shape is considerably lighter
 and textured.

1040
Black Up and Down. Mar 16–18,
1964.
Green-black (S)[1]. 56.5 × 76.2. Ed 20
(BFK), 9 TI (wA), PrP (BFK), 3 AP (2
BFK, 1 wA), 2 TP (1 BFK, 1 wA). John
Dowell. D, BS, T, S, Dat.

1. Stone held from 1039; additions
 and deletions. 1040 differs from
 1039 in color and in image. A dark
 band has been added at the top and
 dark lines and tone at the upper left
 and right center. A dark horizontal
 line has been added at the bottom
 and thin light lines at the upper
 right.

H.C. Westermann

See America First, a suite of eighteen
lithographs including title and
colophon pages, enclosed in a
wooden slipcase, measuring 81.9 ×
61.0, designed and made by the artist.
A design by the artist has been wood
burned into the top. The lithographs
are enclosed in a wrap-around folder
of transparent mylar and are placed
on a pull-tab cardboard liner. The
lithographs are separated with
slipsheets of white Tableau paper. In
order: 2444, 2425, 2426, 2427, 2428,
2429, 2430, 2431, 2432, 2434, 2433,
2435, 2436, 2437, 2438, 2429, 2440,
2443.

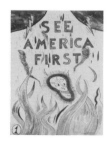

2425
Untitled (See America First II). Sep
6–11, 1968.
Yellow (Z), red (Z), black (S). 76.2 ×
55.2. Ed 20 (GEP), 9 TI (CD), BAT
(GEP), 2 AP (CD), 1 TP* (GEP), CP
(GEP). Maurice Sanchez. D, BS, S, Dat.

1043
Chez Elle. Mar 17–24, 1964.
Black (Z). 55.9 × 84.2. Ed 10 (BFK), 9
TI (BFK), PrP (BFK), 3 AP (2 BFK, 1
wN), 2 TP (BFK). Robert Gardner. D, T,
BS, S, Dat.

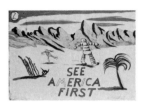

2426
Untitled (See America First III).
Sep 5–21, 1968.
Yellow (Z), red (Z), blue (Z), black (S).
55.2 × 76.2. Ed 20 (GEP), 9 TI (CD),
BAT (GEP), 2 AP (CD), 1 TP* (GEP).
Donald Kelley. D, BS, S, Dat.

2427
Untitled (See America First IV).
Sep 6–27, 1968.
Yellow (Z), blue (Z), red (Z), black (S).
76.2 × 55.2. Ed 20 (GEP), 9 TI (CD),
BAT (GEP), 2 AP (1 CD, 1 GEP), CP
(CD). Jean Milant. D, BS, S, Dat.

2428
Untitled (See America First V). Sep
13–19, 1968.
Yellow (A), black (A). 55.6 × 76.2. Ed
20 (GEP), 9 TI (CD), BAT (GEP), 2 AP
(CD), CP (CD). Manuel Fuentes. D, BS,
S, Dat.

2429
Untitled (See America First VI).
Sep 11–19, 1968.
Blue (A). 55.2 × 76.2. Ed 20 (GEP), 9
TI (CD), BAT (GEP), 3 AP (2 CD, 1
GEP), 2 TP* (GEP), CP (CD). Robert
Rogers. D, BS, S, Dat.

2430
Untitled (See America First VII).
Sep 18–Oct 2, 1968.
Yellow (A), blue (S), light blue (S)[1],
black (A). 55.2 × 76.2. Ed 20 (GEP), 9
TI (CD), BAT (GEP), 2 AP (CD), 1 TP*
(CD). Daniel Socha. D, BS, S, Dat.

1. Same stone as run 2.

2430II
Untitled. Sep 23–Oct 3, 1968.
Yellow (A)[1], black (A)[2]. 55.2 × 76.2.
Ed 10 (GEP), 9 TI (CD), BAT (GEP), 1
AP (GEP), 1 TP* (GEP), CP (CD). Daniel
Socha. D, BS, S, Dat.

1. Plate held from 2430, run 1.
2. Plate held from 2430, run 4;
 deletions. 2430II differs from 2430 in
 color and in image. The tower, left
 tree and ground are lighter and the
 dark clouds and water tone have
 been eliminated. The number "6"
 and a circle in the lower right
 corner have been eliminated.

2431
Untitled (See America First VIII).
Sep 24–Oct 7, 1968.
Yellow (A), pink (A), blue (A). B:
yellow, pink, blue (A), black (S). 55.2
× 76.2. Ed 20 (GEP), 9 TI (CD), BAT
(GEP), 4 AP (1 CD, 3 GEP), 3 TP
(GEP)[1], CP (CD). Robert Rogers. D, S,
Dat, BS.

1. 2 TP vary from the edition.

2432
Untitled (See America First IX).
Sep 20–Oct 3, 1968.
Yellow (Z), orange (A), light orange
(A), green (Z), black (S). 76.2 × 55.6.
ED 20 (GEP), 9 TI (CD), BT (GEP), 1 AP
(GEP), 1 TP (CD), 2 CTP (1 GEP, 1 CD),
CP (CD). Manuel Fuentes. D, BS, S,
Dat.

2433
Untitled (See America First XI).
Sep 27–Oct 15, 1968.
Yellow (A), orange (A)[1], blue (A),
black (A). 55.6 × 76.2. Ed 20 (GEP), 9
TI (CD), BAT (GEP), 5 AP (3 CD, 2
GEP), 1 TP* (GEP), CP (GEP). Serge
Lozingot. D, BS, S, Dat.

1. Hand-colored in red over the
 orange by the artist.

2434
Untitled (See America First X). Oct
1–14, 1968.
Yellow (A), red (A), blue (A), black (A).
55.2 × 76.2. Ed 20 (GEP), 9 TI (CD),
BAT (GEP), 3 AP (1 CD, 2 GEP), 1 TP*
(GEP), 1 CTP (GEP), CP (CD). Donald
Kelley. D, BS, S, Dat.

2435
Untitled (See America First XII).
Oct 3–9, 1968.
Pink (A), black (A). 76.2 × 55.6. Ed 20
(GEP), 9 TI (CD), BAT (GEP), 4 AP (1
CD, 3 GEP), CP (CD). Jean Milant. D,
BS, S, Dat.

2436
Untitled (See America First XIII).
Oct 8–10, 1968.
Black (S). 55.2 × 76.2. Ed 20 (GEP), 9
TI (CD), BAT (GEP), 4 AP (2 CD, 2
GEP), 3 TP (2 CD, 1 GEP)[1], CP (CD).
Daniel Socha. D, BS, S, Dat.

1. 2 TP (1 CD, 1 GEP) vary from the
 edition.

2437
Untitled (See America First XIV).
Oct 14–21, 1968.
Yellow (A), black (S). 55.2 × 76.2. Ed
20 (GEP), 9 TI (CD), BAT (GEP), 4 AP (2
CD, 2 GEP), CP (GEP). Donald Kelley.
D, BS, S, Dat.

2438
Untitled (See America First XV).
Oct 11–22, 1968.
Red (A), black (S). 76.2 × 55.2. Ed 20
(GEP), 9 TI (CD), BAT (GEP), 3 AP (1
CD, 2 GEP), CP (GEP). Jean Milant. D,
S, Dat, BS.

2439
Untitled (See America First XVI).
Oct 16–17, 1968.
Black (S). 55.2 × 76.2. Ed 20 (GEP), 9
TI (CD), BAT (GEP), 4 AP (3 CD, 1
GEP), 2 TP (GEP)[1], CP (GEP). Serge
Lozingot. D, BS, S, Dat.

1. 1 TP varies from the edition.

2440
Untitled (See America First XVII).
Oct 17–25, 1968.
Green (A), black (S). 76.2 × 55.2. Ed
20 (GEP), 9 TI (CD), BAT (GEP), 4 AP (1
CD, 3 GEP), 1 TP* (GEP), CP (CD).
Robert Rogers. D, BS, S, Dat.

2443
Untitled (See America First XVIII).
Oct 23–25, 1968.
Yellow (A), black (S). 55.2 × 76.2. Ed
20 (GEP), 9 TI (CD), BAT (GEP), 3 AP
(GEP), 1 CTP (GEP), CP (CD). Manuel
Fuentes. D, BS, S, Dat.

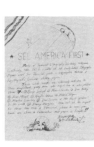

2444
***Title Page and Colophon (See
America First I).*** Oct 23–24, 1968.
Black (S). 76.2 × 55.2. Ed 20 (GEP), 9
TI (CD), BAT (GEP), 3 AP (1 CD, 2
GEP), CP (CD). Serge Lozingot. D, BS,
S, Dat.

Harry Westlund

2876
Untitled. May 13–23, 1970.
B: Green, blue and red (A), black (A).
81.3 × 58.4. Ed 8 (cR), 9 TI (cR), BAT
(cR), 2 AP (cR), 1 TP* (cR), CP (cR).
Harry Westlund. S, Dat, D, BS.

2877
Untitled. Apr 27–May 5, 1970.
B: Green and orange (A), black (A).
55.9 × 76.2. Ed 12 (bA), 9 TI (bA), BAT
(bA), 1 AP (bA), 3 CTP (2 cR, 1 bA), CP
(bA). Harry Westlund. S, Dat, BS, D.

Charles White

2873
Untitled. Apr 29–May 1, 1970.
Brown (S). 57.2 × 40.6. Ed 20 (bA), 9
TI (bA), BAT (bA), 2 AP (bA), 2 TP*
(bA)[1], 1 PTP (GEP). Larry Thomas. D,
S, Dat, BS.

1. 1 TP on paper 55.9 × 38.1.

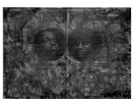

2873II
Untitled. May 1–7, 1970.
Brown (S)[1]. 57.2 × 40.4. Ed 20 (bA),
9 TI (bA), BAT (bA), 2 AP (bA), 2 TP* (1
GEP, 1 bA), CP (bA). Larry Thomas. D,
BS, S, Dat.

1. Stone held from 2873; reversal.

2874
Untitled. May 12–26, 1970.
Yellow (Z)[1], grey (A)[2], black (S)[3].
55.9 × 76.2. Ed 20 (cR), 9 TI (cR), BAT
(cR), 3 AP (cR), 6 PP (cR), 4 TP (2 cR, 2
bA)[4], CP (cR). Harry Westlund. D, BS,
S, Dat.

1. Plate held from 2874II, run 1.
2. Image transferred from run 3 to
 plate; reversal.
3. Stone held from 2874II, run 2. 2874
 differs from 2874II in color and in
 image. A second background tone
 has been added.
4. 3 TP (1 cR, 2 bA) vary from the
 edition.

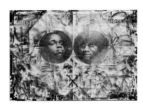

2874II
Untitled. May 12–20, 1970.
Yellow (Z), brown (S). 55.9 × 76.2. Ed
10 (cR), 9 TI (cR), BAT (cR), 2 AP (cR), 2
TP* (cR). Harry Westlund. D, BS, S,
Dat.

2875
Untitled. May 28–29, 1970.
Brown (S). 63.5 × 94.0. Ed 20 (cR), 9
TI (ucR), BAT (cR), 2 AP (1 cR, 1 ucR).
Eugene Sturman. D, BS, S, Dat.

2875II
Untitled. Jun 1–19, 1970.
Dark pink (A), green (A)[1], black (A).
63.5 × 94.0. Ed 20 (cR), 9 TI (cR), BAT
(cR), 2 AP (cR), 2 TP* (cR), CP (cR).
Eugene Sturman. D, BS, S, Dat.

1. Image transferred from 2875 to
plate; reversal, 2875II differs from
2875 in color and in image. Two
background tones have been added.

2941
Untitled. Jun 2–11, 1970.
Brown (S). 53.3 × 68.6. Ed 20 (bA), 9
TI (bA), BAT (bA), 1 AP (bA), 2 TP
(bA)[1], CP (bA)[2]. Edward Hamilton.
D, S, Dat, BS.

1. 1 TP varies from the edition.
2. CP on paper 55.9 × 71.1.

S. Tracy White

2787
Queer Fruits II. Sep 8–Oct 7, 1969.
Yellow (A), B: red, green (A). 50.8 ×
40.6. Ed 8 (5 BFK, 3 wA), 9 TI (1 BFK, 8
wA), BAT (wA), 3 AP (2 BFK, 1 wA), 9
TP* (6 BFK, 3 wA), CP (wA). S. Tracy
White. D, BS, T, S, Dat.

2839
J.P. ♥. Nov 25, 1969–Apr 10, 1970.
Dark beige (Z), black (S), orange-red,
green (A), dark brown (A). 63.5 ×
50.8. Torn and deckle edges, bleed
image. Ed 6 (3 ucR, 3 wA), 9 TI (wA),
BAT (ucR), 2 AP (1 wA, 1 ucR), 4 TP*
(wA), 6 CTP (4 wA, 2 ucR), CP (GEP).
S. Tracy White. D, T, BS, S, Dat.

Print not in
University Art Museum
Archive

2880
Alquipa. Jan 20–May 11, 1970.
Beige-green (Z), B: dark grey-blue,
grey-blue, green-grey (A), B: blue,
red-brown (A), B: dark grey, grey-
green (Z). 52.1 × 49.5. Ed 9 (bA), 9 TI
(bA), BAT (bA), 4 TP* (bA), CP (bA). S.
Tracy White. D, BS, T, S, Dat.

P111
Untitled. Mar 10–Apr 16, 1970.
Dark beige (Z), brown or black (A)[1].
16.5 × 20.3. Ed 21 (1 BFK, 2 wA, 10
bA, 8 GEP)[2], 3 AP (bA)[2], 2 PP (1 bA,
1 BFK)[2], CP (GEP)[2]. S. Tracy White.
D, S, Dat, BS.

1. Edition exists in four color
variations. Variation I in brown only,
Variation II in black only, Variation III
in beige and black, and Variation IV
in beige and brown.
2. Variation I, Ed 7 (5 bA, 2 GEP), 2 AP,
1 PP (bA), CP; Variation II, Ed 7 (5
bA, 1 wA, 1 GEP), 1 AP; Variation III,
Ed 2 (1 wA, 1 GEP); Variation IV, Ed
5 (4 GEP, 1 BFK), 1 PP (BFK). 1 AP
on paper 20.3 × 22.8. 1 AP on
paper 19.7 × 23.5. 1 AP on paper
25.4 × 29.2; image size 20.3 ×
24.1. CP on paper 24.1 × 27.9.

Ulfert Wilke

380
Wall. Sep 6–13, 1961.
Brown-grey (S), brown (S), red (Z).
72.1 × 56.8. Ed 20 (BFK), 9 TI (wA),
PrP (BFK). George Miyasaki, NC. D, S,
Dat, BS (Tam).

380A
Arrow. Sep 13–15, 1961.
Black (Z)[1]. 75.9 × 56.5. Ed 10 (BFK),
9 TI (wA), PrP (BFK), 4 TP (3 wA, 1
BFK), CP (BFK). George Miyasaki, NC.
BS (Tam), T, D, S.

1. Plate held from 380, run 3. 380A
differs from 380 in color and in
image. The background surrounding
the central image has been
eliminated.

385
Glyphs. Sep 13–15, 1961.
Black (Z). 76.5 × 56.5. Ed 10 (bA), 9 TI
(nN), PrP (bA), 2 AP (nN), 4 TP (bA),
CP (bA). George Miyasaki, NC. BS
(Tam), D, S, Dat.

Emerson Woelffer

300
Untitled. May 31–Jun 7, 1961.
Black (S). 56.5 × 38.7. Ed 16 (BFK), 9
TI (wN), PrP (BFK), 5 AP (3 BFK, 2 wN),
CP (wN). Garo Antreasian. D, BS, S,
Dat.

302
Untitled. Jun 1–23, 1961.
Ochre (Z), black (S). 54.0 × 38.7. Ed
20 (15 wA, 5 BFK), 9 TI (wN), PrP
(BFK), 4 AP (1 BFK, 1 wA, 2 wN). John
Muench. D, BS, S, Dat.

324
Hommage à Dina. Jun 21–22, 1961.
Black (S). 76.8 × 56.5. Ed 20 (bA), 9 TI
(nN), PrP (bA), PrP II for Garo
Antreasian (bA), 4 AP (2 nN, 2 bA), CP
(bA). John Muench. BS, D, S, Dat.

329
Untitled. Jun 28–Jul 27, 1961.
Red, black (S), dark red, blue (S), blue-
green (Z). 76.2 × 56.8. Ed 20 (BFK), 9
TI (wN), PrP (BFK), 5 AP (3 BFK, 2 wN).
John Muench. BS, D, S, Dat.

331
Untitled Jul 5–7, 1961.
Black (S). 76.5 × 56.8. Ed 20 (bA), 9 TI
(wN), PrP (bA), 4 AP (bA). John
Muench. BS, D, S, Dat.

337
Untitled. Jul 12–19, 1961.
Black (S), ochre, violet (Z). 76.5 ×
56.8. Ed 20 (BFK), 9 TI (wN)[1], PrP
(BFK), 4 AP (2 BFK, 2 wN), CP* (BFK).
Joe Funk. D, BS, S, Dat.

1. 9 TI bear the chop of Bohuslav
Horak.

346
Untitled. Jul 20, 1961.
Black (S). 56.5 × 38.1. Ed 20 (BFK), 9
TI (wA), PrP (BFK), 4 AP (3 BFK, 1 wA),
CP (BFK). Bohuslav Horak. D, S, Dat,
BS.

351
Untitled. Jul 26–Sep 13, 1961.
Blue, yellow-green (Z), black (Z). 76.8
× 56.5. Ed 20 (R), 9 TI (wN), PrP (R), 5
AP (4 R, 1 wN), CP* (R). Bohuslav
Horak. D, BS, S, Dat.

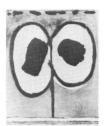

352
Untitled. Jul 27–Sep 21, 1961.
Black (S). 38.4 × 28.6. Ed 20 (bA), 9 TI
(wN), PrP (bA), 2 AP (bA), 3 TP (bA),
CP (bA). Harold Keeler. D, BS, S, Dat.

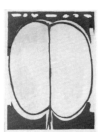

391
Untitled. Sep 20–Oct 4, 1961.
Yellow-brown (Z), black (Z). 76.8 ×
56.8. Ed 20 (bA), 9 TI (nN), PrP (bA), 2
AP (bA), 1 TP (bA), CP (bA). Harold
Keeler. D, BS, S, Dat.

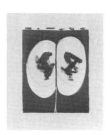

409
Untitled. Oct 7–10, 1961.
Black (S). 48.3 × 38.1. Ed 20 (BFK), 9
TI (wN), PrP (BFK), 2 TP (BFK), CP
(BFK). Emiliano Sorini. D, BS, S, Dat.

413
Untitled. Oct 12–Nov 6, 1961.
Blue-green (Z), brown (Z), black (Z).
56.5 × 43.2. Ed 20 (BFK), 9 TI (wA),
PrP (wA), 2 AP (1 BFK, 1 wA), 3 TP (2
BFK, 1 wA), CP (BFK). Bohuslav Horak.
D, BS, S, Dat.

456
Untitled. Dec 6–11, 1961.
Black (S). 76.8 × 56.5. Ed 20 (bA), 9 TI
(nN), PrP (bA), 2 AP (bA), 1 TP (bA).
Emiliano Sorini. BS, D, S, Dat.

425
Untitled. Oct 19–31, 1961.
Red (Z), blue (Z), black (Z). 56.8 ×
43.2. Ed 20 (BFK), 9 TI (wA), PrP (BFK),
2 AP (BFK), 2 TP (BFK). Irwin
Hollander. D, BS, S, Dat.

466
Untitled. Nov 29–30, 1961.
Black (S). 75.6 × 56.8. Ed 20 (BFK), 9
TI (wA), PrP (BFK), 2 AP (BFK), 3 TP (2
BFK, 1 wA), CP (BFK). Bohuslav Horak.
D, BS, S, Dat.

436
Untitled. Oct 30–Dec 13, 1961.
Brown-orange (Z), black (Z), black (Z).
57.5 × 45.7. Ed 20 (BFK), 9 TI (wN),
PrP (BFK), 2 AP (BFK), 3 TP (BFK).
Harold Keeler. D, BS, S, Dat.

1667
Untitled. Feb 23–Mar 2, 1966.
Blue (S), red (A). 77.5 × 57.8. Ed 20
(wA), 9 TI (wN), BAT (wA), 3 AP (1 wA,
2 wN), 2 TP (wA), CP (Tcs). Ernest de
Soto. D, BS, S, Dat.

439
Untitled. Nov 6–22, 1961.
Blue (Z), beige (Z)[1], black (Z). 56.8 ×
43.5. Ed 20 (BFK), 9 TI (wA), PrP (BFK),
3 AP (BFK). Irwin Hollander. D, BS, S,
Dat.

1. Plate held from 413, run 2. 439
 differs from 413 in color and in
 image. The image is different
 except for the stripe across the top,
 the two wide oval stripes and the
 two smaller brushstrokes within the
 left oval.

2826
Figure. Dec 22–31, 1969.
Blue (S), black (Z). 61.0 × 45.7. Ed 20
(19 JG, 1 BFK), 9 TI (BFK), BAT (JG), 1
TP (BFK), 1 PTP (CW), CP (BFK).
Hitoshi Takatsuki. D, BS, S, Dat.

446
Untitled. Nov 9–Dec 1, 1961.
Black (Z). 56.8 × 43.8. Ed 20 (BFK), 9
TI (wA), PrP (BFK), 1 AP (wA), 2 TP
(BFK), CP (BFK). Irwin Hollander. D,
BS, S, Dat.

2827
Head. Dec 24, 1969–Jan 8, 1970.
Red (S), black (Z). 61.0 × 45.7. Ed 20
(JG), 9 TI (BFK), BAT (JG), 1 TP (BFK),
1 CTP (BFK), CP (BFK). Larry Thomas.
D, BS, S, Dat.

2828
Homage à Duchamp. Dec. 31, 1969–
Jan. 7, 1970.
Red, blue (Z), black (S). 61.0 × 45.7.
Ed 20 (JG), 9 TI (BFK), BAT (JG), 3 AP
(2 JG, 1 BFK), 1 TP (BFK), CP (BFK).
David Trowbridge. D, T, BS, S, Dat.

2829
Pont Neuf. Jan 6–9, 1970.
Red, blue (Z), dark brown (S). 76.2 ×
55.9. Ed 20 (JG), 9 TI (GEP), BAT (JG),
3 AP (2 JG, 1 GEP), 2 TP* (1 JG, 1
BFK), CP (JG). S. Tracy White. D, S,
Dat, BS.

2830
Figure. Jan 7–15, 1970.
Green (Z), black, orange (Z), violet (S).
61.0 × 45.7. Ed 20 (JG), 9 TI (BFK),
BAT (JG), 3 AP (2 JG, 1 BFK), 1 TP
(JG), 1 PTP (GEP), CP (BFK). Eugene
Sturman. D, BS, S, Dat.

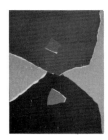

2831
Portrait of Max Ernst. Jan 12–19,
1970.
Light blue (Z), green, blue (Z), grey,
red (Z). 61.0 × 45.7. Ed 20 (BFK), 9 TI
(ucR), PrP (BFK), 2 AP (ucR), CP (ucR).
Hitoshi Takatsuki. D, BS, S, Dat.

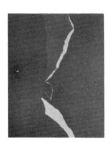

2832
Tri-Color. Jan 13–26, 1970.
Red (S), blue (Z). 61.0 × 45.7. Ed 20
(GEP), 9 TI (CD), BAT (GEP), 2 AP (CD),
CP (GEP). Larry Thomas. D, BS, S, Dat.

2833
Two Figures. Jan 15–27, 1970.
Yellow, blue (S), black (Z). 61.3 × 46.4.
Ed 20 (MI), 9 TI (GEP), BAT (MI), 2 AP
(GEP), 1 TP (MI), CP (MI). S. Tracy
White. D, BS, S, Dat.

2834
Homage to Man Ray. Jan 20–Feb 13,
1970.
Grey (Z), black (S). 61.0 × 45.7. Ed 20
(MI), 9 TI (wA), BAT (MI), 1 AP (wA), 1
TP (BFK)[1], CP (wA). Edward
Hamilton. D, BS, S, Dat.

1. TP printed on silver self-adhesive
 Fasson foil adhered to Rives BFK.

Dick Wray

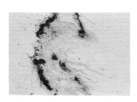

972
Untitled. Jan 3–7, 1964.
Black (Z). 75.3 × 104.8. Ed 20 (BFK), 9
TI (BFK), BAT (BFK), PrP II for Irwin
Hollander (BFK), 3 AP (BFK), 2 TP
(BFK), CP (BFK). Robert Gardner. D, S,
BS.

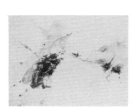

974
Untitled. Jan 9–15, 1964.
Black (Z). 43.2 × 54.0. Ed 20 (BFK), 9
TI (wA), BAT (BFK), PrP II for Irwin
Hollander (BFK), 3 AP (BFK), 1 PP
(wA), 2 TP (BFK), CP (BFK). John
Dowell. D, S, BS.

975
Untitled. Jan 8–10, 1964.
Black (Z). 36.8 × 49.2. Ed 20 (BFK), 9
TI (wA), BAT (BFK), PrP II for Irwin
Hollander (BFK), 3 AP (1 BFK, 2 wA), 2
TP (BFK), CP (BFK). Robert Gardner. D,
S, BS.

976
Untitled. Jan 8–10, 1964.
Black (Z). 48.9 × 36.8. Ed 20 (BFK), 9
TI (wA), BAT (BFK), PrP II for Irwin
Hollander (BFK), 3 AP (1 BFK, 2 wA), 2
TP (BFK), CP (BFK). Robert Gardner. D,
S, BS.

977
Untitled. Jan 9–20, 1964.
Black (Z). 48.0 × 67.9. Ed 20 (BFK), 9 TI (wA), BAT (BFK), PrP II for Irwin Hollander (BFK), 3 AP (BFK), 2 TP (BFK), CP (BFK). Robert Gardner. BS, D, S.

978
Untitled. Jan 28–30, 1964.
Black (Z). 50.8 × 101.6. Ed 20 (BFK), 9 TI (BFK), BAT (BFK), 3 AP (BFK), 2 TP (BFK), CP (BFK). Kenneth Tyler. D, S, BS.

979
Untitled. Jan 13–15, 1964.
Black (Z). 71.8 × 96.5. Ed 20 (BFK), 9 TI (BFK), BAT (BFK), 1 AP (BFK), 2 TP (BFK), CP (BFK). Irwin Hollander. BS, D, S.

981
Untitled. Feb 4, 1964.
Black (Z). 38.1 × 40.6. Ed 20 (BFK), 9 TI (wA), BAT (BFK), 3 AP (BFK), 2 TP (BFK), CP (BFK). Robert Gardner. BS, D, S.

985
Untitled. Feb 3–5, 1964.
Black (Z). 83.5 × 72.4. Ed 12 (BFK), 9 TI (BFK), BAT (BFK), 2 TP (BFK). Aris Koutroulis. BS, D, S.

989
Untitled. Jan 22–24, 1964.
Black (Z). 71.1 × 94.0. Ed 20 (BFK), 9 TI (BFK), BAT (BFK), 3 AP (BFK), 2 TP (BFK), CP (BFK). Kenneth Tyler. D, BS, S.

991
Untitled. Jan 24–28, 1964.
Black (Z). 56.2 × 76.2. Ed 20 (BFK), 9 TI (wA), BAT (BFK), 3 AP (2 BFK, 1 wA), 2 TP (1 BFK, 1 wN), CP (BFK). Kenneth Tyler. BS, D, S.

993
Untitled. Jan 27–31, 1964.
Black (Z). 56.5 × 75.9. Ed 20 (BFK), 9 TI (wA), BAT (BFK), PrP II for Irwin Hollander (BFK), 2 AP (1 BFK, 1 wA), CP (BFK). Aris Koutroulis. BS, D, S.

998
Untitled. Feb 5, 1964.
Black (Z). 56.5 × 38.1. Ed 20 (BFK), 9 TI (wA), BAT (BFK), PrP II for Robert Gardner (BFK), 3 AP (2 BFK, 1 wA), 1 PP (wA), 2 TP (BFK), CP (BFK). Kenneth Tyler. D, S, BS.

1001
Untitled. Feb 6, 1964.
Black (Z). 53.7 × 63.5. Ed 20 (BFK), 9 TI (wA), BAT (BFK), 3 AP (1 BFK, 2 wA), 2 TP (BFK), CP (BFK). Kenneth Tyler. D, S, BS.

1003
Untitled. Feb 7–11, 1964.
Black (Z). 56.2 × 76.2. Ed 20 (BFK), 9 TI (wA), BAT (BFK), 3 AP (1 BFK, 2 wA), 2 TP (BFK), CP (BFK). Robert Gardner. D, S, BS.

1006
Untitled. Feb 10–11, 1964.
Black (Z). 50.8 × 38.1. Ed 20 (BFK), 9 TI (wA), BAT (BFK), 3 AP (2 BFK, 1 wA), 2 TP (BFK), CP (BFK). Aris Koutroulis. D, S, BS.

1007
Untitled. Feb 11–13, 1964.
Black (Z). 70.2 × 86.7. Ed 20 (BFK), 9 TI (BFK), BAT (BFK), 3 AP (BFK), 1 PP (BFK), 2 TP (BFK), CP (BFK). Robert Gardner. BS, D, S.

1008
Untitled. Feb 12–19, 1964.
Black (Z). 38.1 × 50.8. Ed 20 (BFK), 9
TI (wA), BAT (BFK), 3 AP (1 BFK, 2
wA), 2 TP (BFK), CP (BFK). Aris
Koutroulis. D, S, BS.

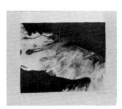

1011
Untitled. Feb 14–17, 1964.
Black (Z). 28.3 × 31.8. Ed 20 (BFK), 9
TI (wA), BAT (BFK), 3 AP (2 BFK, 1
wA), 2 TP (BFK), CP (BFK). Aris
Koutroulis. D, BS, S.

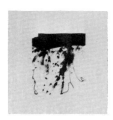

1017
Untitled. Feb 18–19, 1964.
Black (Z). 31.8 × 29.2. Ed 20 (BFK), 9
TI (wA), BAT (BFK), 3 AP (wA), 2 TP
(BFK), CP (BFK). Thom O'Connor. D, S,
BS.

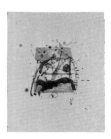

1022
Untitled. Feb 24–26, 1964.
Orange (Z), black (Z). 50.8 × 39.7. Ed
20 (BFK), 9 TI (wA), BAT (BFK), 3 AP
(BFK), 2 TP (1 BFK, 1 wA), CP (BFK).
Thom O'Connor. D, S, BS.

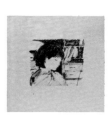

1023
Untitled. Feb 24–25, 1964.
Black (Z). 38.1 × 38.1. Ed 20 (BFK), 9
TI (wA), BAT (BFK), 3 AP (BFK), 1 PP
(BFK), 2 TP (BFK), CP (BFK). Robert
Gardner. D, S, BS.

Theodore Wujcik

2295
Grasshopper T #2. Mar 18–May 24,
1968.
Pink (A), green-black (A), yellow-green
(A), green (A). 74.9 × 48.9. Ed 10
(wN), 9 TI (nN), BAT (wN), 2 AP (1 wN,
1 nN), 1 TP* (wN). Theodore Wujcik.
Recto: BS Verso: D, S, Dat.

2295II
Grasshopper. Jul 10–19, 1968.
Black (A)[1], light pearly grey (A), light
pearly pink (A)[2], light pearly pink
(A). 75.6 × 49.5. Ed 12 (wN), 9 TI
(wN), BAT (wN), 1 AP (wN), 2 CTP
(wN), CP (wN). Theodore Wujcik.
Recto: BS Verso: D, S, Dat.

1. Black printed on verso.
2. Plate held from 2295, run 4. 2295II
 differs from 2295 in color and in
 image. The light color tone
 background has been eliminated.
 The dark spotted area that defines
 the shape of the grasshopper has
 been eliminated, leaving a light
 shape with a texture of small spots.
 A background of very light small
 spots has been added. A thin border
 of black has been added to the
 fibers of the paper.

2371
Harelip. Jun 16–27, 1968.
Black (S), black (A). 72.1 × 55.2. Ed 9
(GEP), 9 TI (CD), BAT (GEP). Theodore
Wujcik. Recto: BS Verso: S, Dat, D.

2395
Homage to BAB. Jul 22–Aug 1, 1968.
Orange (A)[1], light pearly yellow (A),
light pearly silver (S). 41.3 × 36.5. Ed
16 (nN), 9 TI (nN), BAT (nN), 2 AP (nN),
3 CTP (nN), CP (nN). Theodore Wujcik.
Recto: BS Verso: T, D, S, Dat.

1. Orange printed on verso.

Alfred Young

1724
Dunes. Apr 14–May 5, 1967.
Beige (S), B: dark blue, light blue (S),
black (S). 68.6 × 38.1, cut. Ed 20 (CD),
9 TI (wA)[1], UNMI (CD), BAT (wA), 4
AP (1 wA, 3 CD). Bruce Lowney. BS
(Tam), D, T, S, BS (UNM).

1. Numbered in Arabic numerals.

Adja Yunkers

Skies of Venice, a suite of ten lithographs including title page. In order: 193, 184, 185, 186A, 187, 188, 192, 194, 195, 196.

Salt, a suite of five lithographs. In order: 158, 164, 165, 168, 160.

152
Composition I. Nov 8–10, 1960.
Black (S). 61.6 × 46.7. Ed 20 (wA), 9 TI (nN), BAT (wA), CP (wA). Garo Antreasian. BS, D, S, Dat.

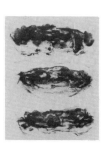

156
Composition II. Nov 11, 1960.
Black (S). 55.9 × 38.1 (BFK). Ed 20 (BFK), 9 TI (nN), BAT (BFK), 2 AP (nN), 2 TP (BFK), CP (BFK). Garo Antreasian. BS, D, S, Dat.

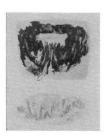

158
Untitled (Salt I). Nov 15–22, 1960.
Light grey (S), dark grey-green, orange (S). 43.5 × 33.7. Ed 125 (100 BFK, 10 N, 15 A)[1], 9 TI (nN)[1], 2 BAT (wA)[2], 11 AP (2 nN, 3 wN, 6 BFK[3]), 3 PP (nN), 4 PgP (nr)[4], CP (BFK)[5]. Bohuslav Horak. BS, D, S.

1. Ed 100 (BFK) designated "1–100/100R"; Ed 10 (N) designated "I–X/X N"; Ed 15 (A) designated "1–15/15 A." Ed (10 N, 15 A), 9 TI were printed by Garo Antreasian and bear his chop.
2. 2 BAT, one of a first state for Garo Antreasian and one of a final state for Bohuslav Horak.
3. 6 AP on paper 55.9 × 45.7 vary from the edition.
4. 2 PgP retained by Tamarind.
5. CP on paper 55.9 × 45.7.

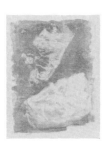

159
Shell. Nov 15–21, 1960.
Brown (S), pink (S). 43.2 × 33.0. 8 ExP (wA)[1], PrP (wA), 2 PgP (BFK)[2]. Bohuslav Horak. BS (Tam), D, S, BS (pr).

1. Designated A–H, 4 ExP retained by Tamarind.
2. 1 PgP retained by Tamarind.

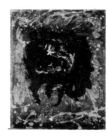

160
Untitled (Salt V). Nov 15–Dec 12, 1960.
Grey, red (S), black (S). 43.2 × 33.0. Ed 125 (100 BFK, 10 N, 15 A)[1], 9 TI (nN), BAT (nr), 5 AP (wN), 3 PP (BFK), 2 PgP* (nr), CP (BFK). Joe Funk. BS (Tam), D, S, BS (pr).

1. Ed 100 (BFK) designated "1–100/100R"; Ed 10 (N) designated "I–X/X N"; Ed 15 (A) designated "1–15/15 A."

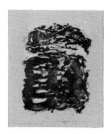

164
Untitled (Salt II). Nov 28–29, 1960.
Black (S). 43.2 × 33.4. Ed 125 (100 BFK, 10 N, 15 A)[1], 9 TI (nN), BAT (nr), 15 AP (8 BFK, 4 nN, 3 wA)[1], 2 PP (BFK), CP (BFK)[2]. Bohuslav Horak. BS, D, S.

1. Ed 100 (BFK) designated "1–100/100R"; Ed 10 (N) designated "I–X/X N"; Ed 15 (A) designated "1–15/15 A." Ed I–II/X (N), 1 AP (nN) were printed by Garo Antreasian and bear his chop.
2. CP on paper 55.9 × 45.7.

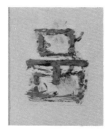

165
Untitled (Salt III). Nov 28–Dec 1, 1960.
Dark green-brown (S), light green (S). 43.8 × 33.7. Ed 125 (100 BFK, 10 N, 15 A)[1], 9 TI (nN), BAT (nr), 5 AP (2 nN, 1 BFK, 2 wA), 2 PgP* (nr), CP (BFK)[2]. Bohuslav Horak. D, S, BS.

1. Ed 100 (BFK) designated "1–100/100R"; Ed 10 (N) designated "I–X/X N"; Ed 15 (A) designated "1–15/15 A."
2. CP on paper 55.9 × 45.7.

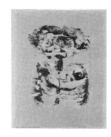

168
Untitled (Salt IV). Dec 5–7, 1960.
Beige (S), black (S). 43.5 × 33.4. Ed 125 (100 BFK, 10 N, 15 A)[1], 9 TI (nN), BAT (nr), 11 AP (7 wA[2], 2 BFK, 2 wN), 2 PP (1 BFK, 1 wA), 2 PgP* (1 BFK, 1 wA), CP (BFK)[3]. Bohuslav Horak. BS, D, S.

1. Ed 100 (BFK) designated "1–100/100R"; Ed 10 (N) designated "I–X/X N"; Ed 15 (A) designated "1–15/15 A."
2. 7 AP on paper 55.9 × 45.7.
3. CP on paper 55.9 × 45.7.

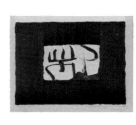

173
Calligraphy. Dec 9–12, 1960.
Black (S). 40.6 × 51.1. Ed 20 (BFK), 9 TI (BFK), BAT (BFK), 1 AP (BFK), 1 TP (BFK), CP (BFK)[1]. Bohuslav Horak. BS, D, S.

1. CP on paper 45.7 × 55.9.

180
Moonface. Dec 13, 1960.
Black (S). 50.8 × 40.6. Ed 20 (wA), 9 TI (BFK), BAT (BFK), 7 AP (wA), CP (wA)[1]. Bohuslav Horak. BS, D, S.

1. CP on paper 55.9 × 45.7.

182A
Untitled. Dec 14–15, 1960.
Black (S). 74.9 × 105.4. 3 ExP (BFK)[1]. Bohuslav Horak. BS (Tam), D, S, Dat, BS (pr).

1. Designated A–C. 1 ExP retained by Tamarind.

182B
Untitled. Dec 16, 1960.
Red-black (S)[1]. 64.8 × 54.6, cut. 6 ExP (Suzuki)[2], 3 TP (nr)[3]. Garo Z. Antreasian. S, Dat, BS (Tam), D, BS (pr).

1. Stone held from 182A; deletions. 182B differs from 182A in image and size. The upper left quarter and a narrow strip along the bottom of the image have been eliminated. Some lightening at the lower left corner.
2. Designated A–F. 1 ExP retained by Tamarind. Proof F is the cancellation proof.
3. 3 TP are initialed, not signed.

183
Little Landscape. Dec 15, 1960.
Black (S). 30.8 × 40.6. Ed 20 (BFK), 9 TI (wA), BAT (BFK), 9 AP (BFK), 1 PP (BFK), CP (BFK)[1]. Bohuslav Horak. BS, D, S.

1. CP on paper 55.9 × 45.7.

184
Untitled (Skies of Venice II). Dec 18–19, 1960.
Black (S). 74.6 × 105.7. ED 10 (BFK), 5 HS (BFK)[1], 9 TI (BFK), BAT (BFK), 4 AP (BFK), 2 TP (BFK)[2], CP (BFK). Bohuslav Horak. BS, D, T, S, Dat.

1. Designated in Roman numerals.
2. 2 TP designated rough proofs, one with the image printed on both sides of the paper, one with Tamarind #185 printed on verso.

185
Untitled (Skies of Venice III). Dec 18–20, 1960.
Black (S). 74.3 × 104.8. Ed 10 (BFK), 5 HS (BFK)[1], 9 TI (wN), BAT (BFK), 7 AP (4 BFK, 2 wN), 3 TP (BFK), CP (BFK). Bohuslav Horak. BS, D, T, S, Dat.

1. Designated in Roman numerals.

186A
Untitled (Skies of Venice IV). Dec 20–21, 1960.
Black (S). 104.8 × 74.3. Ed 10 (BFK), 5 HS (BFK)[1], 9 TI (wN), BAT (BFK), 5 AP (4 BFK, 1 wN), CP (BFK). Bohuslav Horak. BS, D, T, S, Dat.

1. Designated in Roman numerals.

187
Untitled (Skies of Venice V). Dec 20–22, 1960.
Black (S). 105.1 × 74.3. Ed 10 (BFK), 5 HS (BFK)[1], 9 TI (wN), BAT (BFK), 3 AP (2 BFK, 1 wN), 2 TP (BFK)[2], CP (BFK). Bohuslav Horak. BS, D, T, S, Dat.

1. Designated in Roman numerals.
2. 1 TP designated "rough proof" with Tamarind #186A printed on the verso.

188
Untitled (Skies of Venice VI). Dec 22–23, 1960.
Brown-red (S). 104.8 × 74.3. Ed 10 (BFK), 5 HS (BFK)[1], 9 TI (wN), BAT (BFK), 3 AP (2 BFK, 1 wN), 4 TP (BFK)[2], CP (BFK). Bohuslav Horak. D, T, S, Dat (center), BS (bottom).

1. Designated in Roman numerals.
2. 1 TP designated "rough proof."

192
Untitled (Skies of Venice VII). Dec 23–26, 1960.
Black (S). 74.3 × 104.8. Ed 10 (BFK), 5 HS (BFK)[1], 9 TI (wN), BAT (BFK), 2 AP (1 BFK, 1 wN), CP (BFK). Bohuslav Horak. BS, D, T, S, Dat.

1. Designated in Roman numerals.

193
Title Page (Skies of Venice I). Dec 27, 1960.
Yellow-green (S)[1]. 104.8 × 74.3. Ed 10 (BFK), 5 HS (BFK)[2], 9 TI (wN), BAT (BFK), 1 TP (BFK), CP (BFK). Bohuslav Horak. BS.

1. Some of the impressions exist with the image inverted at the top of the paper; the title on these impressions was printed by letterpress over the image.
2. Designated in Roman numerals.

194
Untitled (Skies of Venice VIII). Dec 27–28, 1960.
Black (S). 74.3 × 104.8. Ed 10 (BFK), 5 HS (BFK)[1], 9 TI (wN), BAT (BFK), 4 AP (3 BFK, 1 wN), 1 TP (BFK), CP (BFK). Bohuslav Horak. D, T, S, Dat, BS.

1. Designated in Roman numerals.

195
Untitled (Skies of Venice IX). Dec 27–28, 1960.
Black (S). 74.3 × 104.8. Ed 10 (BFK), 5 HS (BFK)[1], 9 TI (wN), BAT (BFK), 7 AP (6 BFK, 1 wN), 2 proofs (1 wA, 1 BFK)[2], CP (BFK). Garo Antreasian. BS, D, T, S, Dat.

1. Designated in Roman numerals.
2. 1 proof (wN) marked "spoiled proof" and "wrongly signed"; 1 proof (BFK) torn in the margin and unchopped.

196
Untitled (Skies of Venice X). Dec 29, 1960.
Black (S). 74.3 × 104.8. Ed 10 (BFK), 5 HS (BFK)[1], 9 TI (wN), BAT (BFK), 4 AP (3 BFK, 1 wN), 1 TP (BFK), CP (BFK). Garo Antreasian. D, T, S, Dat.

1. Designated in Roman numerals.

Norman Zammitt

2146
Untitled. Oct 2–18, 1967.
Transparent light blue (S)[1], transparent light red (S)[1], transparent yellow (S)[1]. 35.6 × 43.5. Ed 20 (wA), 9 TI (CD), BAT (wA), 2 AP (wA), 3 TP (2 wA*, 1 CD). Donald Kelley. Verso: D, WS, S, Dat.

1. Same stone used for runs 1, 2, and 3.

2147
Untitled. Oct 5–Nov 21, 1967.
B: Transparent grey, transparent light blue, transparent grey (S)[1], B: transparent light grey, transparent grey, transparent light grey (S)[1], B: transparent medium grey, brown, black (S)[1]. 26.4 × 34.9, cut. Ed 10 (wA)[2], 9 TI (CD), BAT (wA)[2], 2 AP (wA)[2], 12 TP (11wA, 1 CD)[3], CP (wA). Donald Kelley. Verso: D, S, Dat, WS.

1. Same stone used for runs 1, 2 and 3.
2. Ed 10, BAT, 2 AP are hinged to a sheet of buff Arches 31.1 × 40.0.
3. 12 TP designated A–L vary from the edition; A on paper 26.0 × 36.2, B on paper 26.7 × 35.6, C–H uncut, I on paper 33.0 × 43.2 J on paper 34.3 × 43.2, torn, K carries run 3 of the edition on the verso on paper 26.7 × 36.2, L on paper 26.7 × 35.6.

2148
Untitled. Oct 6–Nov 7, 1967.
Light blue (S)[1], light red (S)[1], medium blue (S)[1]. 49.5 × 72.4, cut. Ed 20 (GEP), 9 TI (BFK), BAT (GEP), 3 AP (BFK) 7TP* (5 GEP, 2 EVB)[2], CP (GEP). Anthony Stoeveken. Verso: D, S, Dat, WS.

1. Stone held from 2149, run 3 used for run 1, 2, and 3; image for run 2 turned 180 degrees. 2148 differs from 2149 in color and in image. Cloudy background tone is darker around the edges and lighter in the center.
2. 1 TP (GEP) on paper 49.5 × 70.5, torn; 1 TP (EVB) on paper 49.5 × 71.7, torn; 1 TP (EVB) on paper 49.5 × 70.5, torn.

2149
Untitled. Oct 6–24, 1967.
Yellow (A), red (S)[1], transparent blue (S)[1]. 50.8 × 72.4, cut. Ed 20 (GEP), 9 TI (BFK), BAT (GEP), 3 AP (2 BFK, 1 GEP), 3 TP* (GEP). Anthony Stoeveken. Verso: D, WS, S, Dat.

1. Same stone used for run 2 and 3 with run 3 turned 180 degrees.

2150
Untitled. Oct 18–Nov 3, 1967.
Blue (S)[1], red (S)[1], yellow (S)[1], violet (S)[1], black (S)[1]. 47.0 × 74.0, cut. Ed 18 (GEP), 9 TI (BFK), BAT (GEP), 3 AP (GEP), 6 TP (4 GEP), 2 BFK)[2]. Serge Lozingot. Verso: D, S, Dat, WS.

1. Same stone used for runs 1–5.
2. 5 TP vary from the edition; 1 TP (BFK) on paper 47.6 × 73.6.

2151
Untitled. Oct 24–Nov 8, 1967.
Light blue (S)[1], light pink (S)[1], light orange (S)[1], yellow (S)[2]. 48.3 × 74.3, cut. Ed 12 (GEP), 9 TI (CD), BAT (GEP), 3 AP (CD), 18 TP* (16 GEP, 1 wN, 1 BFK)[3], CP (GEP). David Folkman. Verso: D, S, Dat, WS.

1. Image from 2150 transferred to new stone and turned 180 degrees for run 1, 2 and 3; additions and deletions.
2. Stone held from 2150. 2151 differs from 2150 in color and in image. The over-all image is lighter. The solid hexagonal border on the right side has been eliminated. a solid light tone has been added in regular intervals in the hexagons. The center of the twelfth hexagon from the top and the fourth from the left has been eliminated.
3. 18 TP designated A–R; M on paper 45.1 × 73.6.

2152
Untitled. Nov 1–18, 1967.
Yellow (S)[1], light blue (S)[1], dark pink (S)[1], blue-violet (S). 51.1 × 76.2, cut. Ed 20 (BFK), 9 TI (GEP), BAT (BFK), 3 AP (2 BFK, 1 GEP), 6 PP (5 BFK, 1 GEP), 11 TP* (BFK)[2], CP* (BFK)[3]. Serge Lozingot. Verso: D, S, Dat, WS.

1. Same stone used for runs 1, 2 and 3.
2. 11 TP designated A–K; D–E on paper 49.5 × 74.3, cut; H on paper 50.5 × 76.0, cut; J on paper 51.1 × 75.3, cut.
3. CP on paper 51.1 × 75.3, cut.

2153
Untitled. Oct 27–Nov 7, 1967.
Black (S), pink (S)[1]. 73.0 × 103.8. Ed 10 (CD), 9 TI (CD), BAT (CD), 3 AP (CD), 3 TP (CD)[2]. Anthony Ko. Verso: D, S, Dat, WS.

1. Same stone as run 1.
2. 2 TP vary from the edition.

2154
Untitled. Nov 7–21, 1967.
Black (S)[1], light blue (S)[1], orange-red (S)[1]. 72.7 × 102.9. Ed 10 (CD), 9 TI (CD), BAT (CD), 7 TP* (6 CD, 1 EVB)[2], CP (CD). Anthony Ko. Verso: D, S, Dat, WS.

1. Stone held from 2153 used for runs 1, 2 and 3. 2154 differs from 2153 in color and in image. A third identical hexagonal grid has been added.
2. 7 TP designated A–G; B on paper 68.6 × 102.9, C on paper 72.4 × 104.1, D–E on paper 72.4 × 104.8.

2155
Untitled. Oct 9–Nov 19, 1967.
Light blue (S)[1], transparent yellow-orange (S)[1], transparent orange-red (S)[1]. 73.0 × 102.9. Ed 20 (CD), 9 TI (CD), BAT (CD), 3 AP (CD), 10 TP* (6 CD, 4 EVB)[2]. Bruce Lowney. Verso: D, S, Dat, WS.

1. Same stone as 2154 used for runs 1, 2 and 3. 2155 differs from 2154 in color only.
2. 10 TP designated A–J.

2156
Untitled. Nov 16–Dec 5, 1967.
Light blue (S)[1], blue (S)[1], violet (S)[1], violet-red (S)[1], orange (S)[1], yellow (S)[1]. 54.6 × 77.2. Ed 16 (BFK), 9 TI (GEP), BAT (BFK), 3 AP (GEP), 14 TP* (BFK)[2], CP (BFK). Maurice Sanchez. Verso: D, S, Dat, WS.

1. Same stone used for runs 1, 2, 3, 4, 5 and 6.
2. 14 TP designated A–N; G on paper 53.3 × 75.5, I–J on paper 54.6 × 79.4, K on paper 53.9 × 76.2.

Joe Zirker

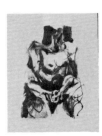

637
Torso. Aug 30–31, 1962.
Black (S). 76.2 × 57.2. Ed 20 (BFK), 9 TI (wA), PrP (BFK), 8 PP (7 BFK, 1 wA), CP (BFK). Joe Zirker. BS, D, T, S.

638
Seated Figure. Sep 1–3, 1962.
Black (Z). 76.2 × 57.2. Ed 20 (BFK), 9 TI (wA), PrP (BFK), 2 AP (1 BFK, 1 wA), 5 PP (BFK), CP (BFK). Joe Zirker. BS, D, T, S, Dat.

641
Untitled. Sep 10–Dec 9, 1962.
Light green (Z), ochre (Z), blue-green (Z), blue (Z), black (Z), violet-red (Z). 76.2 × 57.2. Ed 20 (BFK), 9 TI (wA), PrP (BFK), 3 AP (1 BFK, 2 wA). Joe Zirker. BS, D, S, Dat.

Tetsuo Ochikubo
(continued from page 180)

204
Untitled[1]. Jan 16–23, 1961.
Red (Z), black (Z), light beige, beige
(Z), blue (Z). 105.1 × 74.3. Ed 20
(BFK), 9 TI (wN), PrP (BFK), 2 TP (BFK).
Joe Funk. D, S, BS.

1. Impressions of this edition may be
 misnumbered on the back as
 Tamarind No. 224.

210
Untitled. Jan 19–24, 1961.
Red, red-brown (Z), black (S), red,
black (Z). 56.8 × 76.8. Ed 20 (BFK), 9
TI (wN), PrP (BFK), 1 AP (wN), 3 TP (1
wN, 2 BFK). Joe Funk. D, S, BS.

214
Untitled. Jan 24–31, 1961.
Red, black (S), black (S)[1], white (Z),
black (Z). 76.8 × 57.2. Ed 20 (bA), 9 TI
(wN), PrP (bA), 2 AP (bA), 1 TP (bA).
Joe Funk. D, S, BS.

1. Same stone as run 1; reworked,
 additions.

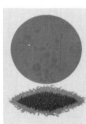
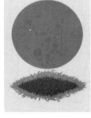

224
Untitled[1]. Jan 30–Feb 16, 1961.
Blue (Z), red (Z), black (Z), dark red,
dark beige (Z), black (Z). 105.1 × 74.9.
Ed 19 (BFK), 9 TI (wN), PrP (BFK), 3 AP
(BFK), 1 TP (BFK). Garo Antreasian. D,
S, BS.

1. Impressions of this edition may be
 misnumbered on the back as
 Tamarind No. 204.

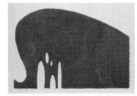

228
Untitled. Feb 1–8, 1961.
Violet (S), grey-black (S), black (S).
57.2 × 77.2. Ed 15 (bA), 9 TI (wN), PrP
(bA), 3 AP (bA), 2 TP (bA), 2 CSP (bA).
Garo Antreasian. D, S, BS.

Rudy Pozzatti
(continued from page 201)

759A
Janus. Mar 11, 1963.
Black (S). 57.2 × 71.1. Ed 10 (BFK), 9
TI (wA), PrP (BFK), 3 AP (2 BFK, 1 wA),
2 TP (BFK). John Rock. BS, T, D, S,
Dat.

1. Stone held from 759, run 2. 759A
 differs from 759 in color and in
 image. The background washes
 have been eliminated.

762
Colophon (XII Romans XV). Mar 6–
12, 1963.
Red-black (S), black (S). 38.7 × 28.6.
Ed 20 (bA), 9 TI (nN), PrP (bA), PrP II
for Bohuslav Horak (bA), 3 AP (1 bA, 2
nN), 2 PP (1 bA, 1 nN), 1 TP (bA), CP
(nN). John Rock. D, BS, S.

764
Classic Ruins IV. Mar 11–13, 1963.
Brown (S). 51.4 × 71.1. Ed 20 (BFK), 9
TI (wA), PrP (BFK), PrP II for Bohuslav
Horak (BFK), 3 AP (2 BFK, 1 wA), 2 PP
(wA), 2 TP (BFK). Joe Zirker. T, D, BS,
S, Dat.

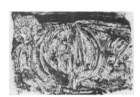

766
Title Page (XII Romans II). Mar 14–
20, 1963.
Red-violet (Z), black (S). 40.3 × 59.4.
Ed 20 (bA), 9 TI (nN), PrP (bA), PrP II
for Bohuslav Horak (bA), 3 AP (2 nN, 1
bA), 2 PP (1 bA, 1 nN), 2 TP (bA).
Jason Leese. D, S, Dat, BS.

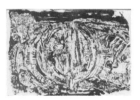

766A
Colosseum. Mar 20, 1963.
Black (S)[1]. 40.0 × 59.1. Ed 10 (BFK),
9 TI (wA), PrP (BFK), 3 AP (2 BFK, 1
wA), 2 PP (1 BFK, 1 wA), CP (BFK).
Jason Leese. BS, T, D, S, Dat.

1. Stone held from 766, run 2. 766A
 differs from 766 in color and in
 image. The background washes
 have been eliminated.

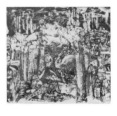

767
Classic Ruins V. Mar 15–18, 1963.
Brown-black (S). 50.8 × 53.3. Ed 20
(BFK), 9 TI (wA), PrP (BFK), PrP II for
Bohuslav Horak (BFK), 3 AP (2 BFK, 1
wA), 1 TP (BFK). Joe Zirker. T, D, BS,
S, Dat.

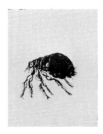

770A
Tiny but Mighty (Bugs III). Mar 21–25, 1963.
Green-black (S). 25.7 × 19.4. Ed 20 (bA), 9 TI (nN), PrP (bA), PrP II for Bohuslav Horak (bA), 3 AP (2 bA, 1 nN), 2 PP (1 bA, 1 nN), CP (nr)[1]. Joe Zirker. D, S, Dat, T, BS.

1. CP on paper 55.9 × 76.2 with 770B–770I, untorn.

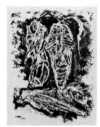

770B
Mummies (Bugs IV). Mar 21–25, 1963.
Green-black (S). 25.7 × 19.4. Ed 20 (bA), 9 TI (nN), PrP (bA), PrP II for Bohuslav Horak (bA), 3 AP (2 bA, 1 nN), 2 PP (1 bA, 1 nN), CP (nr)[1]. Joe Zirker. D, S, Dat, T, BS.

1. CP on paper 55.9 × 76.2 with 770A, 770C–770I, untorn.

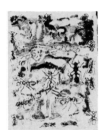

770C
Ants Aplenty (Bugs V). Mar 21–25, 1963.
Green-black (S). 25.7 × 19.4. Ed 20 (bA), 9 TI (nN), PrP (bA), PrP II for Bohuslav Horak (bA), 3 AP (2 bA, 1 nN), 2 PP (1 bA, 1 nN), CP (nr)[1]. Joe Zirker. D, S, Dat, T, BS.

1. CP on paper 55.9 × 76.2 with 770A–770B, 770D–770I, untorn.

770D
Four Gnats, One Fossil (Bugs VI). Mar 21–25, 1963.
Green-black (S). 25.7 × 19.4. Ed 20 (bA), 9 TI (nN), PrP (bA), PrP II for Bohuslav Horak (bA), 3 AP (2 bA, 1 nN), 2 PP (nN), CP (nr)[1]. Joe Zirker. D, S, Dat, T, BS.

1. CP on paper 55.9 × 76.2 with 770A–770C, 770E–770I, untorn.

770E
Beetles (Bugs VII). Mar 21–25, 1963.
Green-black (S). 25.7 × 19.4. Ed 20 (bA), 9 TI (nN), PrP (bA), PrP II for Bohuslav Horak (bA), 3 AP (2 bA, 1 nN), 1 PP (nN), CP (nr)[1]. Joe Zirker. D, S, Dat, T, BS.

1. CP on paper 55.9 × 76.2 with 770A–770D, 770F–770I, untorn.

770F
Five Wooly Bears (Bugs VIII). Mar 21–25, 1963.
Green-black (S). 25.7 × 19.4. Ed 20 (bA), 9 TI (nN), PrP (bA), PrP II for Bohuslav Horak (bA), 3 AP (2 bA, 1 nN), 2 PP (nN), CP (nr)[1]. Joe Zirker. D, S, Dat, T, BS.

1. CP on paper 55.9 × 76.2 with 770A–770E, 770G–770I, untorn.

770G
Dedication Page (Bugs II). Mar 21–25, 1963.
Green-black (S). 25.7 × 19.4. Ed 20 (bA), 9 TI (nN), PrP (bA), PrP II for Bohuslav Horak (bA), 3 AP (2 bA, 1 nN), 2 PP (1 bA, 1 nN), CP (nr)[1]. Joe Zirker. D, S, Dat, Dedication[2], BS.

1. CP on paper 55.9 × 76.2 with 770A–770F, 770H–770I, untorn.
2. Inscribed by the artist in pencil at the top "This suite was made especially for the pleasure of my children."

770H
Title Page (Bugs I). Mar 21–25, 1963.
Green-black (S). 25.7 × 19.4. Ed 20 (bA), 9 TI (nN), PrP (bA), PrP II for Bohuslav Horak (bA), 3 AP (2 bA, 1 nN), 2 PP (1 bA, 1 nN), CP (nr)[1]. Joe Zirker. D, S, Dat, BS.

1. CP on paper 55.9 × 76.2 with 770 A–770 G, 770I, untorn.

770I
Moth (Bugs IX). Mar 21–25, 1963.
Green-black (S). 25.7 × 19.4. Ed 20 (bA), 9 TI (nN), PrP (bA), PrP II for Bohuslav Horak (bA), 3 AP (2 bA, 1 nN), 2 PP (1 bA, 1 nN), CP (nr)[1]. Joe Zirker. D, S, Dat, T, BS.

1. CP on paper 55.9 × 76.2 with 770A–770H, untorn.

No photograph

773
Title Page (XII Romans I). Mar 22–27, 1963.
Black (S). 40.3 × 59.4. Ed 20 (bA), 9 TI (nN), PrP (bA), PrP II for Bohuslav Horak (bA), 3 AP (2 nN, 1 bA), 2 PP (1 bA, 1 nN), 2 TP (bA), CP (bA). Jason Leese. D, S, Dat.

774
Etruscan Lady. Mar 25–29, 1963.
Brown-black (S). 52.1 × 49.5. Ed 20 (BFK), 9 TI (wA), PrP (BFK), PrP II for Bohuslav Horak (BFK), 3 AP (1 BFK, 2 wA), 2 PP (BFK), 2 TP (BFK). Joe Zirker. T, D, S, Dat, BS.

776
Colophon (Bugs X). Mar 26–27, 1963.
Green-black (S). 25.4 × 19.1. Ed 20 (bA), 9 TI (nN), PrP (bA), PrP II for Bohuslav Horak (bA), 3 AP (1 bA, 2 nN), 2 PP (1 bA, 1 nN), 2 TP (bA), CP (bA). Joe Zirker. D, S, Dat, BS.

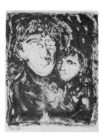

779
Mother and Child. Apr 1–4, 1963.
Yellow-ochre (Z), blue (S). 77.5 × 57.2.
Ed 20 (BFK), 9 TI (wN), PrP (BFK), PrP
II for Joe Zirker (BFK), 3 AP (2 wN, 1
BFK), 2 PP (1 BFK, 1 wN), 2 TP (BFK),
CP (BFK). Jason Leese. T, D, BS, S,
Dat.

Artists Represented in the 1960–70
Tamarind Catalogue Raisonné